UNDER THE
DOME

STEPHEN KING

UNDER THE DOME

A Novel

HODDER &
STOUGHTON

Grateful acknowledgement is made for permission to
print excerpts from the following copyrighted material:

'Play It All Night Long'
Copyright © 1980 Zevon Music
All rights reserved. Used by permission.
Published by Zevon Music and Imagem Music.

'Talkin' At the Texaco'
Words and Music by James McMurtry
© 1989 SHORT TRIP MUSIC (BMI) Administered by BUG MUSIC
All Rights Reserved. Used by Permission.

First published in Great Britain in 2009 by Hodder & Stoughton
An Hachette UK Company

6

A CIP catalogue record for this title is
available from the British Library

ISBN 978 0 340 99257 9

Typeset in Bembo by
Palimpsest Book Production Limited, Grangemouth, Stirlingshire

Printed and bound by Clays Ltd, St Ives plc

Hodder Headline's policy is to use papers that are natural,
renewable and recyclable products and made from wood grown
in sustainable forests. The logging and manufacturing processes
are expected to conform to the environmental regulations
of the country of origin

Hodder & Stoughton
338 Euston Road
London NW1 3BH

www.hodder.co.uk

In memory of Surendra Dahyabhai Patel.

We miss you, my friend.

Who you lookin for
What was his name
you can prob'ly find him
at the football game
it's a small town
you know what I mean
it's a small town, son
and we all support the team
— JAMES MCMURTRY

Some (But Not All) of Those in Chester's Mill on Dome Day:

Town Officials
Andy Sanders, First Selectman
Jim Rennie, Second Selectman
Andrea Grinnell, Third Selectman

Sweetbriar Rose Staff
Rose Twitchell, Owner
Dale Barbara, Cook
Anson Wheeler, Dishwasher
Angie McCain, Waitress
Dodee Sanders, Waitress

Police Department
Howard 'Duke' Perkins, Chief
Peter Randolph, Assistant Chief
Marty Arsenault, Officer
Freddy Denton, Officer
George Frederick, Officer
Rupert Libby, Officer
Toby Whelan, Officer
Jackie Wettington, Officer
Linda Everett, Officer
Stacey Moggin, Officer/Dispatch
Junior Rennie, Special Deputy
Georgia Roux, Special Deputy
Frank DeLesseps, Special Deputy
Melvin Searles, Special Deputy
Carter Thibodeau, Special Deputy

Pastoral Care
Rev Lester Coggins, Christ the Holy Redeemer Church
Piper Libby, Congregational Church

Medical Staff
Ron Haskell, Doctor
Rusty Everett, Physicians Assistant
Ginny Tomlinson, Nurse
Dougie Twitchell, Nurse
Gina Buffalino, Volunteer Nurse
Harriet Bigelow, Volunteer Nurse

Town Kids
'Scarecrow' Joe McClatchey
Norrie Calvert
Benny Drake
Judy and Janelle Everett
Ollie and Rory Dinsmore

Townspeople of Note
Tommy and Willow Anderson, Owner/Operators of Dipper's
 Roadhouse
Stewart and Fernald Bowie, Owner/Operators of Bowie Funeral
 Home
Joe Boxer, Dentist
Romeo Burpee, Owner/Operator of Burpee's Department Store
Phil Bushey, Chef of Dubious Repute
Samantha Bushey, his wife
Jack Cale, Supermarket Manager
Ernie Calvert, Supermarket Manager (ret.)
Johnny Carver, Convenience Store Operator
Alden Dinsmore, Dairy Farmer
Roger Killian, Chicken Farmer
Lissa Jamieson, Town Librarian
Claire McClatchey, Scarecrow Joe's Mom
Alva Drake, Benny's Mom
Stubby Norman, Antique Dealer
Brenda Perkins, Sheriff Perkins's wife
Julia Shumway, Owner/Editor of the Local Newspaper
Tony Guay, Sports Reporter
Pete Freeman, News Photographer
'Sloppy' Sam Verdreaux, Town Drunk

Out-of-Towners
Alice and Aidan Appleton, Dome Orphans ('Dorphans')
Thurston Marshall, Literary Man with Medical Skills
Carolyn Sturges, Graduate Student

Dogs of Note
Horace, Julia Shumway's Corgi
Clover, Piper Libby's German Shepherd
Audrey, the Everetts' Golden Retriever

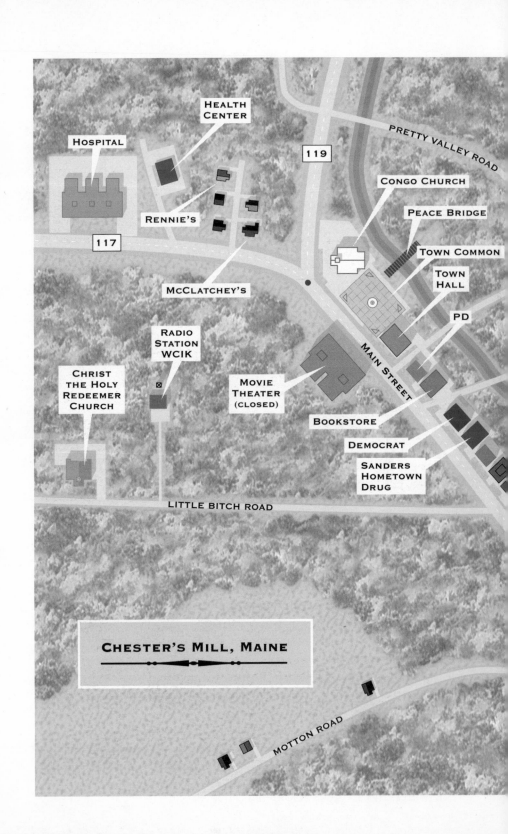

HEALTH CENTER

HOSPITAL

119

PRETTY VALLEY ROAD

CONGO CHURCH

PEACE BRIDGE

RENNIE'S

TOWN COMMON

TOWN HALL

117

PD

McCLATCHEY'S

RADIO STATION WCIK

MAIN STREET

CHRIST THE HOLY REDEEMER CHURCH

MOVIE THEATER (CLOSED)

BOOKSTORE

DEMOCRAT

SANDERS HOMETOWN DRUG

LITTLE BITCH ROAD

CHESTER'S MILL, MAINE

MOTTON ROAD

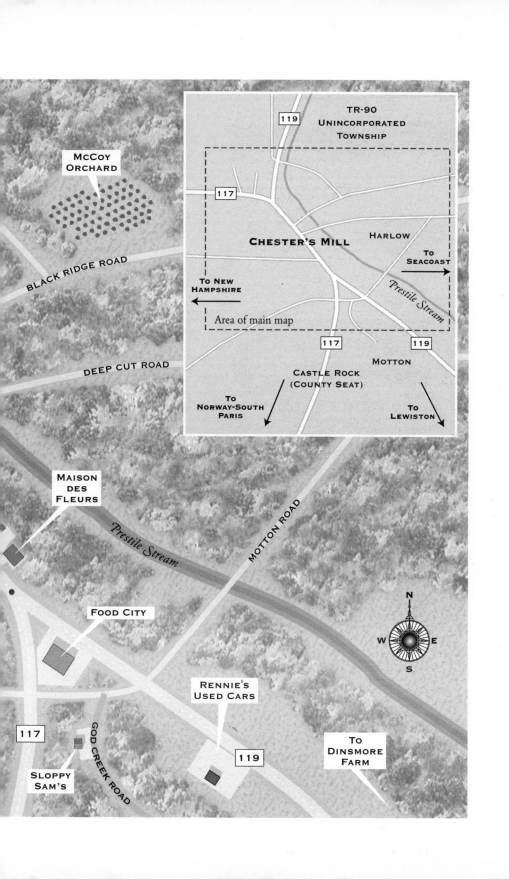

UNDER THE
DOME

THE AIRPLANE
AND THE WOODCHUCK

1

From two thousand feet, where Claudette Sanders was taking a flying lesson, the town of Chester's Mill gleamed in the morning light like something freshly made and just set down. Cars trundled along Main Street, flashing up winks of sun. The steeple of the Congo Church looked sharp enough to pierce the unblemished sky. The sun raced along the surface of Prestile Stream as the Seneca V overflew it, both plane and water cutting the town on the same diagonal course.

'Chuck, I think I see two boys beside the Peace Bridge! Fishing!' Her very delight made her laugh. The flying lessons were courtesy of her husband, who was the town's First Selectman. Although of the opinion that if God had wanted man to fly, He would have given him wings, Andy was an extremely coaxable man, and eventually Claudette had gotten her way. She had enjoyed the experience from the first. But this wasn't mere enjoyment; it was exhilaration. Today was the first time she had really understood what made flying great. What made it cool.

Chuck Thompson, her instructor, touched the control yoke gently, then pointed at the instrument panel. 'I'm sure,' he said, 'but let's keep the shiny side up, Claudie, okay?'

'Sorry, sorry.'

'Not at all.' He had been teaching people to do this for years, and he liked students like Claudie, the ones who were eager to learn something new. She might cost Andy Sanders some real money before long; she loved the Seneca, and had expressed a desire to have one just like it, only new. That would run somewhere in the neighborhood of a million dollars. Although not exactly spoiled, Claudie Sanders had undeniably expensive tastes which, lucky man, Andy seemed to have no trouble satisfying.

Chuck also liked days like this: unlimited visibility, no wind, perfect teaching conditions. Nevertheless, the Seneca rocked slightly as she overcorrected.

'You're losing your happy thoughts. Don't do that. Come to one-twenty. Let's go out Route 119. And drop on down to nine hundred.'

She did, the Seneca's trim once more perfect. Chuck relaxed.

They passed above Jim Rennie's Used Cars, and then the town was behind them. There were fields on either side of 119, and trees burning with color. The Seneca's cruciform shadow fled up the blacktop, one dark wing briefly brushing over an ant-man with a

pack on his back. The ant-man looked up and waved. Chuck waved back, although he knew the guy couldn't see him.

'*Beautiful* goddam day!' Claudie exclaimed. Chuck laughed.

Their lives had another forty seconds to run.

2

The woodchuck came bumbling along the shoulder of Route 119, headed in the direction of Chester's Mill, although the town was still a mile and a half away and even Jim Rennie's Used Cars was only a series of twinkling sunflashes arranged in rows at the place where the highway curved to the left. The chuck planned (so far as a woodchuck can be said to plan anything) to head back into the woods long before he got that far. But for now, the shoulder was fine. He'd come farther from his burrow than he meant to, but the sun had been warm on his back and the smells were crisp in his nose, forming rudimentary images – not quite pictures – in his brain.

He stopped and rose on his back paws for an instant. His eyes weren't as good as they used to be, but good enough to make out a human up there, walking in his direction on the other shoulder.

The chuck decided he'd go a little farther anyway. Humans sometimes left behind good things to eat.

He was an old fellow, and a fat fellow. He had raided many garbage cans in his time, and knew the way to the Chester's Mill landfill as well as he knew the three tunnels of his own burrow; always good things to eat at the landfill. He waddled a complacent old fellow's waddle, watching the human walking on the other side of the road.

The man stopped. The chuck realized he had been spotted. To his right and just ahead was a fallen birch. He would hide under there, wait for the man to go by, then investigate for any tasty—

The chuck got that far in his thoughts – and another three waddling steps – although he had been cut in two. Then he fell apart on the edge of the road. Blood squirted and pumped; guts tumbled into the dirt; his rear legs kicked rapidly twice, then stopped.

His last thought before the darkness that comes to us all, chucks and humans alike: *What happened?*

3

All the needles on the control panel dropped dead.

'What the *hell?*' Claudie Sanders said. She turned to Chuck. Her

eyes were wide, but there was no panic in them, only bewilderment. There was no time for panic.

Chuck never saw the control panel. He saw the Seneca's nose crumple toward him. Then he saw both propellers disintegrate.

There was no time to see more. No time for anything. The Seneca exploded over Route 119 and rained fire on the countryside. It also rained body parts. A smoking forearm — Claudette's — landed with a thump beside the neatly divided woodchuck.

It was October twenty-first.

BARBIE

1

Barbie started feeling better as soon as he passed Food City and left downtown behind. When he saw the sign reading YOU ARE LEAVING THE VILLAGE OF CHESTER'S MILL **COME BACK REAL SOON!**, he felt better still. He was glad to be on his way, and not just because he had taken a pretty good beating in The Mill. It was plain old moving on that had lightened him up. He had been walking around under his own little gray cloud for at least two weeks before getting his shit handed to him in the parking lot of Dipper's.

'Basically, I'm just a ramblin guy,' he said, and laughed. 'A ramblin guy on his way to the Big Sky.' And hell, why not? Montana! Or Wyoming. Fucking Rapid City, South Dakota. Anyplace but here.

He heard an approaching engine, turned around – walking backward now – and stuck out his thumb. What he saw was a lovely combination: a dirty old Ford pickemup with a fresh young blonde behind the wheel. *Ash* blonde, his favorite blonde of all. Barbie offered his most engaging smile. The girl driving the pickemup responded with one of her own, and oh my Lord if she was a ticktock over nineteen, he'd eat his last paycheck from Sweetbriar Rose. Too young for a gentleman of thirty summers, no doubt, but perfectly street-legal, as they'd said back in the days of his cornfed Iowa youth.

The truck slowed, he started toward it . . . and then it sped up again. She gave him one more brief look as she went past. The smile was still on her face, but it had turned regretful. *I had a brain-cramp there for a minute*, the smile said, *but now sanity has reasserted itself.*

And Barbie thought he recognized her a little, although it was impossible to say with certainty; Sunday mornings in Sweetbriar were always a madhouse. But he thought he'd seen her with an older man, probably her dad, both of them with their faces mostly buried in sections of the Sunday *Times*. If he could have spoken to her as she rolled past, Barbie would have said: *If you trusted me to cook your sausage and eggs, surely you can trust me for a few miles in the shotgun seat.*

But of course he didn't get the chance, so he simply raised his hand in a little no-offense-taken salute. The truck's taillights flickered, as if she were reconsidering. Then they went out and the truck sped up.

During the following days, as things in The Mill started going from bad to worse, he would replay this little moment in the warm

October sun again and again. It was that second reconsidering flicker of the taillights he thought of . . . as if she had recognized him, after all. *That's the cook from Sweetbriar Rose, I'm almost sure. Maybe I ought to—*

But maybe was a gulf better men than him had fallen into. If she *had* reconsidered, everything in his life thereafter would have changed. Because she must have made it out; he never saw the fresh-faced blonde or the dirty old Ford F-150 again. She must have crossed over the Chester's Mill town line minutes (or even seconds) before the border slammed shut. If he'd been with her, he would have been out and safe.

Unless, of course, he'd think later, when sleep wouldn't come, *the stop to pick me up was just long enough to be too long. In that case, I probably still wouldn't be here. And neither would she. Because the speed limit out that way on 119 is fifty miles an hour. And at fifty miles an hour . . .*

At this point he would always think of the plane.

2

The plane flew over him just after he passed Jim Rennie's Used Cars, a place for which Barbie had no love. Not that he'd bought a lemon there (he hadn't owned a car in over a year, had sold the last one in Punta Gorda, Florida). It was just that Jim Rennie Jr. had been one of the fellows that night in Dipper's parking lot. A frat boy with something to prove, and what he could not prove alone he would prove as part of a group. That was the way the Jim Juniors of the world did business, in Barbie's experience.

But it was behind him now. Jim Rennie's, Jim Junior, Sweetbriar Rose (Fried Clams Our Specialty! Always *'Whole'* Never *'Strips'*), Angie McCain, Andy Sanders. The whole deal, including Dipper's. (Beatings Administered in the Parking Lot Our Specialty!) All behind him. And ahead of him? Why, the gates of America. Goodbye smalltown Maine, hello Big Sky.

Or maybe, hell, he'd head down south again. No matter how beautiful this particular day, winter was lurking a page or two over on the calendar. The south might be good. He'd never been to Muscle Shoals, and he liked the sound of the name. That was goddam poetry, Muscle Shoals was, and the idea so cheered him that when he heard the little plane approaching, he looked up and gave a big old exuberant wave. He hoped for a wing-waggle in return, but didn't get one, although the plane was slowpoking at low altitude. Barbie's guess was sightseers – this was a day for them, with the trees in full flame – or maybe some young kid on his learner's permit, too worried about

screwing up to bother with groundlings like Dale Barbara. But he wished them well. Sightseers or a kid still six weeks from his first solo cruise, Barbie wished them very well. It was a good day, and every step away from Chester's Mill made it better. Too many assholes in The Mill, and besides: travel was good for the soul.

Maybe moving on in October should be a law, he thought. *New national motto: EVERYBODY LEAVES IN OCTOBER. You get your Packing Permit in August, give your required week's notice in mid-September, then—*

He stopped. Not too far ahead of him, on the other side of the blacktop highway, was a woodchuck. A damned fat one. Sleek and sassy, too. Instead of scurrying off into the high grass, it was coming on ahead. There was a fallen birch sticking its top half out onto the shoulder of the road, and Barbie was betting the woodchuck would scurry under there and wait for the big bad Two-Legs to go by. If not, they would pass each other like the ramblin guys they were, the one on four legs headed north, the one on two headed south. Barbie hoped that would happen. It would be cool.

These thoughts went through Barbie's mind in seconds; the shadow of the airplane was still between him and the chuck, a black cross racing along the highway. Then two things happened almost simultaneously.

The first was the woodchuck. It was whole, then it was in two pieces. Both were twitching and bleeding. Barbie stopped, mouth hanging open on the suddenly lax hinge of his lower jaw. It was as if an invisible guillotine blade had dropped. And that was when, directly above the severed woodchuck, the little airplane exploded.

3

Barbie looked up. Falling from the sky was a squashed Bizarro World version of the pretty little airplane that had passed over him seconds before. Twisting orange-red petals of fire hung above it in the air, a flower that was still opening, an American Disaster rose. Smoke billowed from the plummeting plane.

Something clanged to the road and sprayed up clods of asphalt before spinning drunkenly into the high grass to the left. A propeller.

If that had bounced my way—

Barbie had a brief image of being cut in two – like the unfortunate woodchuck – and turned to run. Something thudded down in front of him and he screamed. But it wasn't the other propeller; it was a man's leg dressed in denim. He could see no blood, but the

side-seam had been blown wide open, revealing white flesh and wiry black hair.

There was no foot attached.

Barbie ran in what felt like slow motion. He saw one of his own feet, clad in an old scuffed workboot, stride out and clop down. Then it disappeared behind him as his other foot strode out. All slow, slow. Like watching the baseball replay of a guy trying to steal second.

There was a tremendous hollow clang from behind him, followed by the boom of a secondary explosion, followed by a blast of heat that struck him from heels to nape. It shoved him on his way like a warm hand. Then all thoughts blew away and there was nothing but the body's brute need to survive.

Dale Barbara ran for his life.

4

A hundred yards or so down the road, the big warm hand became a ghost hand, although the smell of burning gas – plus a sweeter stench that had to be a mixture of melting plastic and roasting flesh – was strong, carried to him on a light breeze. Barbie ran another sixty yards, then stopped and turned around. He was panting. He didn't think it was the running; he didn't smoke, and he was in good shape (well . . . fair; his ribs on the right side still hurt from the beating in Dipper's parking lot). He thought it was terror and dismay. He could have been killed by falling pieces of airplane – not just the runaway propeller – or burned to death. It was only blind luck that he hadn't been.

Then he saw something that made his rapid breathing stop in mid-gasp. He straightened up, looking back at the site of the accident. The road was littered with debris – it really was a wonder that he hadn't been struck and at least wounded. A twisted wing lay on the right; the other wing was poking out of the uncut timothy grass on the left, not far from where the runaway propeller had come to rest. In addition to the bluejeans-clad leg, he could see a severed hand and arm. The hand seemed to be pointing at a head, as if to say *That's mine.* A woman's head, judging from the hair. The power lines running beside the highway had been severed. They lay crackling and twisting on the shoulder.

Beyond the head and arm was the twisted tube of the airplane's fuselage. Barbie could read **NJ3.** If there was more, it was torn away.

But none of this was what had caught his eye and stopped his

breath. The Disaster Rose was gone now, but there was still fire in the sky. Burning fuel, certainly. But . . .

But it was running down the air in a thin sheet. Beyond it and through it, Barbie could see the Maine countryside — still peaceful, not yet reacting, but in motion nevertheless. Shimmering like the air over an incinerator or a burning-barrel. It was as if someone had splashed gasoline over a pane of glass and then set it alight.

Almost hypnotized — that was what it felt like, anyway — Barbie started walking back toward the scene of the crash.

5

His first impulse was to cover the body parts, but there were too many. Now he could see another leg (this one in green slacks), and a female torso caught in a clump of juniper. He could pull off his shirt and drape it over the woman's head, but after that? Well, there were two extra shirts in his backpack—

Here came a car from the direction of Motton, the next town to the south. One of the smaller SUVs, and moving fast. Someone had either heard the crash or seen the flash. Help. Thank God for help. Straddling the white line and standing well clear of the fire that was still running down from the sky in that weird water-on-a-windowpane way, Barbie waved his arms over his head, crossing them in big **X**s.

The driver honked once in acknowledgment, then slammed on his brakes, laying forty feet of rubber. He was out almost before his little green Toyota had stopped, a big, rangy fellow with long gray hair cascading out from under a Sea Dogs baseball cap. He ran toward the side of the road, meaning to skirt the main firefall.

'What happened?' he cried. 'What in the blue fu—'

Then he struck something. Hard. There was nothing there, but Barbie saw the guy's nose snap to the side as it broke. The man rebounded from the nothing, bleeding from the mouth, nose, and forehead. He fell on his back, then struggled to a sitting position. He stared at Barbie with dazed, wondering eyes as blood from his nose and mouth cascaded down the front of his workshirt, and Barbie stared back.

JUNIOR AND ANGIE

1

The two boys fishing near the Peace Bridge didn't look up when the plane flew overhead, but Junior Rennie did. He was a block farther down, on Prestile Street, and he recognized the sound. It was Chuck Thompson's Seneca V. He looked up, saw the plane, then dropped his head fast when the bright sunlight shining through the trees sent a bolt of agony in through his eyes. Another headache. He'd been having a lot of them lately. Sometimes the medication killed them. Sometimes, especially in the last three or four months, it didn't.

Migraines, Dr Haskell said. All Junior knew was that they hurt like the end of the world, and bright light made them worse, especially when they were hatching. Sometimes he thought of the ants he and Frank DeLesseps had burned up when they were just kids. You used a magnifying glass and focused the sun on them as they crawled in and out of their hill. The result was fricasseed formicants. Only these days, when one of his headaches was hatching, his brain was the anthill and his eyes turned into twin magnifying glasses.

He was twenty-one. Did he have this to look forward to until he was forty-five or so, when Dr Haskell said they might let up?

Maybe. But this morning a headache wasn't going to stop him. The sight of Henry McCain's 4Runner or LaDonna McCain's Prius in the driveway might have; in that case he might've turned around, gone back to his own house, taken another Imitrex, and lain down in his bedroom with the shades drawn and a cool washcloth on his forehead. Possibly feeling the pain start to diminish as the headache derailed, but probably not. Once those black spiders really got a foothold—

He looked up again, this time squinting his eyes against the hateful light, but the Seneca was gone, and even the buzz of its engine (also aggravating – all sounds were aggravating when he was getting one of these bitchkitties) was fading. Chuck Thompson with some flyboy or flygirl wannabe. And although Junior had nothing against Chuck – hardly knew him – he wished with sudden, childish ferocity that Chuck's pupil would fuck up bigtime and crash the plane.

Preferably in the middle of his father's car dealership.

Another sickish throb of pain twisted through his head, but he went up the steps to the McCains' door anyway. This had to be done. This was over-fucking-due. Angie needed a lesson.

But just a little one. Don't let yourself get out of control.

As if summoned, his mother's voice replied. Her maddeningly complacent voice. *Junior was always a bad-tempered boy, but he keeps it under much better control now. Don't you, Junior?*

Well. Gee. He *had*, anyway. Football had helped. But now there was no football. Now there wasn't even college. Instead, there were the headaches. And they made him feel like one mean motherfucker.

Don't let yourself get out of control.

No. But he would talk to her, headache or no headache.

And, as the old saying was, he just might have to talk to her by hand. Who knew? Making Angie feel worse might make him feel better.

Junior rang the bell.

2

Angie McCain was just out of the shower. She slipped on a robe, belted it, then wrapped a towel around her wet hair. 'Coming!' she called as she not-quite-trotted down the stairs to the first floor. There was a little smile on her face. It was Frankie, she was quite sure it must be Frankie. Things were finally coming rightside up. The bastardly short-order cook (good-looking but still a bastard) had either left town or was leaving, and her parents were out. Combine the two and you got a sign from God that things were coming rightside up. She and Frankie could put all the crap in the rearview and get back together.

She knew exactly how to handle it: open the door and then open her robe. Right there in the Saturday-morning daylight, where anybody passing might see her. She'd make sure it was Frankie first, of course – she had no intention of flashing fat old Mr Wicker if he'd rung the bell with a package or a registered mail – but it was at least half an hour too early for the mail.

No, it was Frankie. She was sure.

She opened the door, the little smile widening to a welcoming grin – perhaps not fortunate, since her teeth were rather crammed together and the size of jumbo Chiclets. One hand was on the tie of her robe. But she didn't pull it. Because it wasn't Frankie. It was Junior, and he looked so *angry*—

She had seen his black look before – many times, in fact – but never this black since eighth grade, when Junior broke the Dupree kid's arm. The little fag had dared to swish his bubble-butt onto the town common basketball court and ask to play. And she supposed Junior must have had the same thunderstorm on his face that night

in Dipper's parking lot, but of course she hadn't been there, she had only heard about it. Everybody in The Mill had heard about it. She'd been called in to talk to Chief Perkins, that damn Barbie had been there, and eventually that had gotten out, too.

'Junior? Junior, what—'

Then he slapped her, and thinking pretty much ceased.

3

He didn't get much into that first one, because he was still in the doorway and there wasn't much room to swing; he could only draw his arm back to half-cock. He might not have hit her at all (at least not to start with) had she not been flashing a grin – God, those *teeth*, they'd given him the creeps even in grammar school – and if she hadn't called him Junior.

Of course *everyone* in town called him Junior, he thought of *himself* as Junior, but he hadn't realized how much he hated it, how much he hoped-to-die-in-a-maggot-pie *hated* it until he heard it come bolting out from between the spooky tombstone teeth of the bitch who had caused him so much trouble. The sound of it went through his head like the sunglare when he'd looked up to see the plane.

But as slaps from half-cock go, this one wasn't bad. She went stumbling backward against the newel post of the stairway and the towel flew off her hair. Wet brown snaggles hung around her cheeks, making her look like Medusa. The smile had been replaced by a look of stunned surprise, and Junior saw a trickle of blood running from the corner of her mouth. That was good. That was fine. The bitch deserved to bleed for what she had done. So much *trouble*, not just for him but for Frankie and Mel and Carter, too.

His mother's voice in his head: *Don't let yourself get out of control, honey.* She was dead and still wouldn't stop giving advice. *Teach her a lesson, but make it a little one.*

And he really might have managed to do that, but then her robe came open and she was naked underneath it. He could see the dark patch of hair over her breeding-farm, her goddam itchy breeding-farm that was all the fucking *trouble*, when you got right down to it those farms were all the fucking trouble in the *world*, and his head was throbbing, thudding, whamming, smashing, splitting. It felt like it was going to go thermonuclear at any moment. A perfect little mushroom cloud would shoot out of each ear just before everything exploded above the neck, and Junior Rennie (who didn't know he had

a brain tumor – wheezy old Dr Haskell had never even considered the possibility, not in an otherwise healthy young man hardly out of his teens) went crazy. It wasn't a lucky morning for Claudette Sanders or Chuck Thompson; in point of fact, it wasn't a lucky morning for anyone in Chester's Mill.

But few were as unlucky as the ex-girlfriend of Frank DeLesseps.

4

She *did* have two more semi-coherent thoughts as she leaned against the newel post and looked at his bulging eyes and the way he was biting his tongue – biting it so hard his teeth sunk into it.

He's crazy. I have to call the police before he really hurts me.

She turned to run down the front hall to the kitchen, where she would pull the handset off the wall phone, punch 911, and then just start screaming. She got two steps, then stumbled on the towel she'd wrapped around her hair. She regained her balance quickly – she had been a cheerleader in high school and those skills hadn't left her – but it was still too late. Her head snapped back and her feet flew out in front of her. He had grabbed her by her hair.

He yanked her against his body. He was baking, as if with a high fever. She could feel his heartbeat: quick-quick, running away with itself.

'*You lying bitch!*' he screamed directly into her ear. It sent a spike of pain deep into her head. She screamed herself, but the sound seemed faint and inconsequential compared to his. Then his arms were wrapped around her waist and she was being propelled down the hall at a manic speed, nothing but her toes touching the carpet. Something went through her mind about being the hood ornament on a runaway car, and then they were in the kitchen, which was filled with brilliant sunshine.

Junior screamed again. This time not with rage but pain.

5

The light was killing him, it was frying his howling brains, but he didn't let it stop him. Too late for that now.

He ran her straight into the Formica-topped kitchen table without slowing. It struck her in the stomach, then slid and slammed into the wall. The sugar bowl and the salt and pepper went flying. Her breath escaped her in a big woofing sound. Holding her around the waist with one hand and by the wet snaggles of her hair with

the other, Junior whirled her and threw her against the Coldspot. She struck it with a bang that knocked off most of the fridge magnets. Her face was dazed and paper-pale. Now she was bleeding from her nose as well as her lower lip. The blood was brilliant against her white skin. He saw her eyes shift toward the butcher block filled with knives on the counter, and when she tried to rise, he brought his knee into the center of her face, hard. There was a muffled crunching sound, as if someone had dropped a big piece of china – a platter, maybe – in another room.

It's what I should have done to Dale Barbara, he thought, and stepped back with the heels of his palms pressed against his throbbing temples. Tears from his watering eyes spilled down his cheeks. He had bitten his tongue badly – blood was streaming down his chin and pattering on the floor – but Junior wasn't aware of it. The pain in his head was too intense.

Angie lay facedown among the fridge magnets. The largest said **WHAT GOES IN YOUR MOUTH TODAY SHOWS UP ON YOUR ASS TOMORROW.** He thought she was out, but all at once she began to shiver all over. Her fingers trembled as if she were preparing to play something complex on the piano. (*Only instrument this bitch ever played is the skinflute*, he thought.) Then her legs began to crash up and down, and her arms followed suit. Now Angie looked like she was trying to swim away from him. She was having a goddam seizure.

'Stop it!' he shouted. Then, as she voided herself: 'Stop it! *Stop doing that, you bitch!*'

He dropped on his knees, one on each side of her head, which was now bobbing up and down. Her forehead repeatedly smacked the tile, like one of those camel jockeys saluting Allah.

'Stop it! *Fucking stop it!*'

She began to make a growling noise. It was surprisingly loud. Christ, what if someone heard her? What if he got caught here? This wouldn't be like explaining to his father why he'd left school (a thing Junior had not as yet been able to bring himself to do). This time it would be worse than having his monthly allowance cut by seventy-five percent because of that goddam fight with the cook – the fight *this* useless bitch had instigated. This time Big Jim Rennie wouldn't be able to talk Chief Perkins and the local fuzznuts around. This could be—

A picture of Shawshank State Prison's brooding green walls suddenly popped into his mind. He couldn't go there, he had his whole life ahead of him. But he would. Even if he shut her up now,

he would. Because she'd talk later. And her face – which looked a lot worse than Barbie's had after the fight in the parking lot – would talk for her.

Unless he shut her up completely.

Junior seized her by the hair and helped her wham her head against the tiles. He was hoping it would knock her out so he could finish doing . . . well, whatever . . . but the seizure only intensified. She began beating her feet against the Coldspot, and the rest of the magnets came down in a shower.

He let go of her hair and seized her by the throat. Said, 'I'm sorry, Ange, it wasn't supposed to happen like this.' But he wasn't sorry. He was only scared and in pain and convinced that her struggles in this horribly bright kitchen would never end. His fingers were already getting tired. Who knew it was so hard to choke a person?

Somewhere, far off to the south, there was a boom. As if someone had fired a very large gun. Junior paid no attention. What Junior did was redouble his grip, and at last Angie's struggles began to weaken. Somewhere much closer by – in the house, on this floor – a low chiming began. He looked up, eyes wide, at first sure it was the doorbell. Someone had heard the ruckus and the cops were here. His head was exploding, it felt like he had sprained all his fingers, and it had all been for nothing. A terrible picture flitted through his mind: Junior Rennie being escorted into the Castle County courthouse for arraignment with some cop's sportcoat over his head.

Then he recognized the sound. It was the same chiming his own computer made when the electricity went out and it had to switch over to battery power.

Bing . . . *Bing* . . . *Bing* . . .

Room service, send me up a room, he thought, and went on choking. She was still now but he kept at it for another minute with his head turned to one side, trying to avoid the smell of her shit. How like her to leave such a nasty going-away present! How like them all! Women! Women and their breeding-farms! Nothing but anthills covered with hair! And they said *men* were the problem!

6

He was standing over her bloody, beshitted, and undoubtedly dead body, wondering what to do next, when there was another distant boom from the south. Not a gun; much too big. An explosion. Maybe Chuck Thompson's fancy little airplane had crashed after all. It wasn't impossible; on a day when you set out just to shout at someone –

read them the riot act a little, no more than that — and she ended up making you *kill* her, anything was possible.

A police siren started yowling. Junior was sure it was for him. Someone had looked in the window and seen him choking her. It galvanized him into action. He started down the hall to the front door, got as far as the towel he'd knocked off her hair with that first slap, then stopped. They'd come that way, that was just the way they'd come. Pull up out front, those bright new LED flashers sending arrows of pain into the squalling meat of his poor brain—

He turned around and ran back to the kitchen. He looked down before stepping over Angie's body, he couldn't help it. In first grade, he and Frank had sometimes pulled her braids and she would stick her tongue out at them and cross her eyes. Now her eyes bulged from their sockets like ancient marbles and her mouth was full of blood.

Did I do that? Did I really?

Yes. He had. And even that single fleeting look was enough to explain why. Her fucking teeth. Those humungous choppers.

A second siren joined the first, then a third. But they were going away. Thank Christ, they were going away. They were heading south down Main Street, toward those booming sounds.

Nevertheless, Junior did not slow down. He skulked across the McCains' backyard, unaware that he would have screamed guilt about *something* to anyone who happened to be watching (no one was). Beyond LaDonna's tomato plants was a high board fence and a gate. There was a padlock, but it was hanging open on the hasp. In his years of growing up and sometimes hanging out here, Junior had never seen it closed.

He opened the gate. Beyond were scrub woods and a path leading down to the muted babble of Prestile Stream. Once, when he was thirteen, Junior had spied Frank and Angie standing on that path and kissing, her arms around his neck, his hand cupping her breast, and understood that childhood was almost over.

He leaned down and vomited into the running water. The sun-dapples on the water were malicious, awful. Then his vision cleared enough so he could see the Peace Bridge to his right. The fisherboys were gone, but as he looked, a pair of police cars raced down Town Common Hill.

The town whistle went off. The Town Hall generator had kicked on just as it was supposed to during a power failure, allowing the whistle to broadcast its high-decibel disaster message. Junior moaned and covered his ears.

The Peace Bridge was really just a covered pedestrian walkway, now ramshackle and sagging. Its actual name was the Alvin Chester Pass-Through, but it had become the Peace Bridge in 1969, when some kids (at the time there had been rumors in town about which ones) had painted a big blue peace sign on the side. It was still there, although now faded to a ghost. For the last ten years Peace Bridge had been condemned. Police DO NOT CROSS tape **X**ed both ends, but of course it was still used. Two or three nights a week, members of Chief Perkins's Fuzznuts Brigade would shine their lights in there, always at one end or the other, never both. They didn't want to bust the kids who were drinking and necking, just scare them away. Every year at town meeting, someone would move that Peace Bridge be demolished and someone else would move that it be renovated, and both motions would be tabled. The town had its own secret will, it seemed, and that secret will wanted the Peace Bridge to stay just as it was.

Today, Junior Rennie was glad of that.

He shambled along the Prestile's northern bank until he was beneath the bridge – the police sirens now fading, the town whistle yelling as loud as ever – and climbed up to Strout Lane. He looked both ways, then trotted past the sign reading DEAD END, BRIDGE CLOSED. He ducked under the crisscross of yellow tape, into the shadows. The sun shone through the holey roof, dropping dimes of light on the worn wooden boards underfoot, but after the blaze of that kitchen from hell, it was blessedly dark. Pigeons sweettalked in the roofbeams. Beer cans and Allen's Coffee Flavored Brandy bottles were scattered along the wooden sides.

I will never get away with this. I don't know if I left any of me under her nails, can't remember if she got me or not, but my blood's there. And my fingerprints. I only have two choices, really: run or turn myself in.

No, there was a third. He could kill himself.

He had to get home. Had to draw all the curtains in his room and turn it into a cave. Take another Imitrex, lie down, maybe sleep a little. Then he might be able to think. And if they came for him while he was asleep? Why, that would save him the problem of choosing between Door #1, Door #2, or Door #3.

Junior crossed the town common. When someone – some old guy he only vaguely recognized – grabbed his arm and said, 'What happened, Junior? What's going on?' Junior only shook his head, brushed the old man's hand away, and kept going.

Behind him, the town whistle whooped like the end of the world.

HIGHWAYS AND BYWAYS

1

There was a weekly newspaper in Chester's Mill called the *Democrat*. Which was misinformation, since ownership and management – both hats worn by the formidable Julia Shumway – was Republican to the core. The masthead looked like this:

THE CHESTER'S MILL *DEMOCRAT*
Est. 1890
Serving 'The Little Town That Looks Like A Boot!'

But the motto was misinformation, too. Chester's Mill didn't look like a boot; it looked like a kid's athletic sock so filthy it was able to stand up on its own. Although touched by the much larger and more prosperous Castle Rock to the southwest (the heel of the sock), The Mill was actually surrounded by four towns larger in area but smaller in population: Motton, to the south and southeast; Harlow to the east and northeast; the unicorporated TR-90 to the north; and Tarker's Mills to the west. Chester's and Tarker's were sometimes known as the Twin Mills, and between them – in the days when central and western Maine textile mills were running full bore – had turned Prestile Stream into a polluted and fishless sump that changed color almost daily and according to location. In those days you could start out by canoe in Tarker's running on green water, and be on bright yellow by the time you crossed out of Chester's Mill and into Motton. Plus, if your canoe was made of wood, the paint might be gone below the waterline.

But the last of those profitable pollution factories had closed in 1979. The weird colors had left the Prestile and the fish had returned, although whether or not they were fit for human consumption remained a matter of debate. (The *Democrat* voted 'Aye!')

The town's population was seasonal. Between Memorial Day and Labor Day, it was close to fifteen thousand. The rest of the year it was just a tad over or under two, depending on the balance of births and deaths at Catherine Russell, which was considered to be the best hospital north of Lewiston.

If you asked the summer people how many roads led in and out of The Mill, most would say there were two: Route 117, which led to Norway–South Paris, and Route 119, which went through downtown Castle Rock on its way to Lewiston.

Residents of ten years or so could have named at least eight more, all twolane blacktop, from the Black Ridge and Deep Cut Roads that went into Harlow, to the Pretty Valley Road (yes, just as pretty as its name) that wound north into TR-90.

Residents of thirty years or more, if given time to mull it over (perhaps in the back room of Brownie's Store, where there was still a woodstove), could have named another dozen, with names both sacred (God Creek Road) and profane (Little Bitch Road, noted on local survey maps with nothing but a number).

The oldest resident of Chester's Mill on what came to be known as Dome Day was Clayton Brassey. He was also the oldest resident of Castle County, and thus holder of the *Boston Post* Cane. Unfortunately, he no longer knew what a *Boston Post* Cane was, or even precisely who *he* was. He sometimes mistook his great-great-grand-daughter Nell for his wife, who was forty years dead, and the *Democrat* had stopped doing its yearly 'oldest resident' interview with him three years previous. (On the last occasion, when asked for the secret of his longevity, Clayton had responded, 'Where's my Christing dinner?') Senility had begun to creep up shortly after his hundredth birthday; on this October twenty-first, he was a hundred and five. He had once been a fine finish carpenter specializing in dressers, banisters, and moldings. His specialties in these latter days included eating Jell-O pudding without getting it up his nose and occasionally making it to the toilet before releasing half a dozen blood-streaked pebbles into the commode.

But in his prime — around the age of eighty-five, say — he could have named almost all the roads leading in and out of Chester's Mill, and the total would have been thirty-four. Most were dirt, many were forgotten, and almost all of the forgotten ones wound through deep tangles of second-growth forest owned by Diamond Match, Continental Paper Company, and American Timber.

And shortly before noon on Dome Day, every one of them snapped closed.

2

On most of these roads, there was nothing so spectacular as the explosion of the Seneca V and the ensuing pulp-truck disaster, but there was trouble. Of course there was. If the equivalent of an invisible stone wall suddenly goes up around an entire town, there is bound to be trouble.

At the exact same moment the woodchuck fell in two pieces,

a scarecrow did the same in Eddie Chalmers's pumpkin field, not far from Pretty Valley Road. The scarecrow stood directly on the town line dividing The Mill from TR-90. Its divided stance had always amused Eddie, who called his bird-frightener the Scarecrow Without A Country – Mr SWAC for short. Half of Mr SWAC fell in The Mill; the other half fell 'on the TR,' as the locals would have put it.

Seconds later, a flight of crows bound for Eddie's pumpkins (the crows had never been afraid of Mr SWAC) struck something where nothing had ever been before. Most broke their necks and fell in black clumps on Pretty Valley Road and the fields on both sides. Birds everywhere, on both sides of the Dome, crashed and fell dead; their bodies would be one of the ways the new barrier was eventually delineated.

On God Creek Road, Bob Roux had been digging potatoes. He came in for lunch (more commonly known as 'dinnah' in those parts), sitting astride his old Deere tractor and listening to his brand new iPod, a gift from his wife on what would prove to be his final birthday. His house was only half a mile from the field he'd been digging, but unfortunately for him, the field was in Motton and the house was in Chester's Mill. He struck the barrier at fifteen miles an hour, while listening to James Blunt sing 'You're Beautiful.' He had the loosest of grips on the tractor's steering wheel, because he could see the road all the way to his house and there was nothing on it. So when his tractor came to a smash-halt, the potato-digger rising up behind and then crashing back down, Bob was flung forward over the engine block and directly into the Dome. His iPod exploded in the wide front pocket of his bib overalls, but he never felt it. He broke his neck and fractured his skull on the nothing he collided with and died in the dirt shortly thereafter, by one tall wheel of his tractor, which was still idling. Nothing, you know, runs like a Deere.

3

At no point did the Motton Road actually run through Motton; it ran just inside the Chester's Mill town line. Here were new residential homes, in an area that had been called Eastchester since 1975 or so. The owners were thirty- and fortysomethings who commuted to Lewiston-Auburn, where they worked for good wages, mostly in white-collar jobs. All of these homes were in The Mill, but many of their backyards were in Motton. This was the case with Jack and Myra Evans's home at 379 Motton Road. Myra had a vegetable garden behind their house, and although most of the goodies had

been harvested, there were still a few fat Blue Hubbard squashes beyond the remaining (and badly rotted) pumpkins. She was reaching for one of these when the Dome came down, and although her knees were in Chester's Mill, she happened to be reaching for a Blue Hubbard that was growing a foot or so across the Motton line.

She didn't cry out, because there was no pain – not at first. It was too quick and sharp and clean for that.

Jack Evans was in the kitchen, whipping eggs for a noontime frittata. LCD Soundsystem was playing – 'North American Scum' – and Jack was singing along when a small voice spoke his name from behind him. He didn't at first recognize the voice as belonging to his wife of fourteen years; it sounded like the voice of a child. But when he turned he saw it was indeed Myra. She was standing inside the doorway, holding her right arm across her middle. She had tracked mud onto the floor, which was very unlike her. Usually she took her garden shoes off on the stoop. Her left hand, clad in a filthy gardening glove, was cradling her right hand, and red stuff was running through the muddy fingers. At first he thought *Cranberry juice*, but only for a second. It was blood. Jack dropped the bowl he'd been holding. It shattered on the floor.

Myra said his name again in that same tiny, trembling child-voice.

'What happened? Myra, what happened to you?'

'I had an accident,' she said, and showed him her right hand. Only there was no muddy right gardening glove to match the left one, and no right hand. Only a spouting stump. She gave him a weak smile and said 'Whoops.' Her eyes rolled up to whites. The crotch of her gardening jeans darkened as her urine let go. Then her knees also let go and she went down. The blood gushing from her raw wrist – an anatomy lesson cutaway – mixed with the eggy batter splattered across the floor.

When Jack dropped to his knees beside her, a shard from the bowl jabbed deep into his knee. He hardly noticed, although he would limp on that leg for the rest of his life. He seized her arm and squeezed. The terrible bloodgush from her wrist slowed but didn't stop. He tore his belt free of its loops and noosed it around her lower forearm. That did the job, but he couldn't notch the belt tight; the loop was far beyond the buckle.

'Christ,' he told the empty kitchen. 'Christ.'

It was darker than it had been, he realized. The power had gone out. He could hear the computer in the study chiming its distress call. LCD Soundsystem was okay, because the little boombox on the

counter was battery-powered. Not that Jack cared any longer; he'd lost his taste for techno.

So much blood. So much.

Questions about how she'd lost her hand left his mind. He had more immediate concerns. He couldn't let go of the belt-tourniquet to get to the phone; she'd start to bleed again, and she might already be close to bleeding out. She would have to go with him. He tried pulling her by her shirt, but first it yanked out of her pants and then the collar started to choke her – he heard her breathing turn harsh. So he wrapped a hand in her long brown hair and hauled her to the phone caveman style.

It was a cell, and it worked. He dialed 911 and 911 was busy.

'It can't be!' he shouted to the empty kitchen where the lights were now out (although from the boombox, the band played on). '911 cannot be fucking *busy*!'

He punched redial.

Busy.

He sat in the kitchen with his back propped up against the counter, holding the tourniquet as tightly as he could, staring at the blood and the batter on the floor, periodically hitting redial on the phone, always getting the same stupid *dah-dah-dah*. Something blew up not too far distant, but he barely heard it over the music, which was really cranked (and he never heard the Seneca explosion at all). He wanted to turn the music off, but in order to reach the boombox he would have to lift Myra. Lift her or let go of the belt for two or three seconds. He didn't want to do either one. So he sat there and 'North American Scum' gave way to 'Someone Great' and 'Someone Great' gave way to 'All My Friends,' and after a few more songs, finally the CD, which was called *Sound of Silver*, ended. When it did, when there was silence except for police sirens in the distance and the endlessly chiming computer closer by, Jack realized that his wife was no longer breathing.

But I was going to make lunch, he thought. *A nice lunch, one you wouldn't be ashamed of inviting Martha Stewart to.*

Sitting against the counter, still holding the belt (opening his fingers again would prove exquisitely painful), the lower right leg of his own pants darkening with blood from his lacerated knee, Jack Evans cradled his wife's head against his chest and began to weep.

4

Not too far away, on an abandoned woods road not even old Clay Brassey would have remembered, a deer was foraging tender shoots

at the edge of Prestile Marsh. Her neck happened to be stretched across the Motton town line, and when the Dome dropped, her head tumbled off. It was severed so neatly that the deed might have been done with a guillotine blade.

5

We have toured the sock-shape that is Chester's Mill and arrived back at Route 119. And, thanks to the magic of narration, not an instant has passed since the sixtyish fellow from the Toyota slammed face-first into something invisible but very hard and broke his nose. He's sitting up and staring at Dale Barbara in utter bewilderment. A seagull, probably on its daily commute from the tasty buffet at the Motton town dump to the only slightly less tasty one at the Chester's Mill landfill, drops like a stone and thumps down not three feet from the sixtyish fellow's Sea Dogs baseball cap, which he picks up, brushes off, and puts back on.

Both men look up at where the bird came from and see one more incomprehensible thing in a day that will turn out to be full of them.

6

Barbie's first thought was that he was looking at an afterimage from the exploding plane – the way you sometimes see a big blue floating dot after someone triggers a flash camera close to your face. Only this wasn't a dot, it wasn't blue, and instead of floating along when he looked in a different direction – in this case, at his new acquaintance – the smutch hanging in the air stayed exactly where it was.

Sea Dogs was looking up and rubbing his eyes. He seemed to have forgotten about his broken nose, swelling lips, and bleeding forehead. He got to his feet, almost losing his balance because he was craning his neck so severely.

'What's that?' he said. 'What the hell is that, mister?'

A big black smear – candleflame-shaped, if you really used your imagination – discolored the blue sky.

'Is it . . . a cloud?' Sea Dogs asked. His doubtful tone suggested he already knew it wasn't.

Barbie said, 'I think . . .' He really didn't want to hear himself say this. 'I think it's where the plane hit.'

'Say *what?*' Sea Dogs asked, but before Barbie could reply, a good-sized grackle swooped fifty feet overhead. It struck nothing –

nothing they could see, at any rate – and dropped not far from the gull.

Sea Dogs said, 'Did you *see* that?'

Barbie nodded, then pointed to the patch of burning hay to his left. It and the two or three patches on the right side of the road were sending up thick columns of black smoke to join the smoke rising from the pieces of the dismembered Seneca, but the fire wasn't going far; there had been heavy rain the day before, and the hay was still damp. Lucky thing, or there would have been grassfires racing away in both directions.

'Do you see *that?*' Barbie asked Sea Dogs.

'I'll be dipped in shit,' Sea Dogs said after taking a good long look. The fire had burned a patch of ground about sixty feet square, moving forward until it was almost opposite the place where Barbie and Sea Dogs were facing one another. And there it spread – west to the edge of the highway, east into some small dairy farmer's four acres of grazeland – not raggedly, not the way grassfires normally advance, with the fire a bit ahead in one place and falling a little behind somewhere else – but as if on a straightedge.

Another gull came flying toward them, this one bound for Motton rather than The Mill.

'Look out,' Sea Dogs said. 'Ware that bird.'

'Maybe it'll be okay,' Barbie said, looking up and shading his eyes. 'Maybe whatever it is only stops them if they're coming from the south.'

'Judging by yonder busted plane, I doubt that,' Sea Dogs said. He spoke in the musing tones of a man who is deeply perplexed.

The outbound gull struck the barrier and fell directly into the largest chunk of the burning plane.

'Stops em both ways,' Sea Dogs said. He spoke in the tone of a man who has gotten confirmation of a strongly held but previously unproved conviction. 'It's some kind of force-field, like in a *Star Trick* movie.'

'*Trek*,' Barbie said.

'Huh?'

'Oh shit,' Barbie said. He was looking over Sea Dogs's shoulder.

'Huh?' Sea Dogs looked over his own shoulder. 'Blue *fuck*!'

A pulp-truck was coming. A big one, loaded well past the legal weight limit with huge logs. It was also rolling well above the legal limit. Barbie tried to calculate what the stopping-speed on such a behemoth might be and couldn't even guess.

Sea Dogs sprinted for his Toyota, which he'd left parked askew

on the highway's broken white line. The guy behind the wheel of
the pulper – maybe high on pills, maybe smoked up on meth, maybe
just young, in a big hurry, and feeling immortal – saw him and laid
on his horn. He wasn't slowing.

'*Fuck me sideways!*' Sea Dogs cried as he threw himself behind
the wheel. He keyed the engine and backed the Toyota out of the
road with the driver's door flapping. The little SUV thumped into
the ditch with its square nose canted up to the sky. Sea Dogs was
out the next moment. He stumbled, landed on one knee, and then
took off running into the field.

Barbie, thinking of the plane and the birds – thinking of that
weird black smutch that might have been the plane's point of impact
– also ran into the grazeland, at first sprinting through low, unen-
thusiastic flames and sending up puffs of black ash. He saw a man's
sneaker – it was too big to be a woman's – with the man's foot still
in it.

Pilot, he thought. And then: *I have to stop running around like this.*

'*YOU IDIOT, SLOW DOWN!*' Sea Dogs cried at the pulp-
truck in a thin, panicky voice, but it was too late for such instruc-
tions. Barbie, looking back over his shoulder (helpless not to),
thought the pulp-wrangler might have tried to brake at the last
minute. He probably saw the wreckage of the plane. In any case, it
wasn't enough. He struck the Motton side of the Dome at sixty or
a little more, carrying a log-load of almost forty thousand pounds.
The cab disintegrated as it stopped cold. The overloaded carrier, a
prisoner of physics, continued forward. The fuel tanks were driven
under the logs, shredding and sparking. When they exploded, the load
was already airborne, flipping over where the cab – now a green
metal accordion – had been. The logs sprayed forward and upward,
struck the invisible barrier, and rebounded in all directions. Fire and
black smoke boiled upward in a thick plume. There was a terrific
thud that rolled across the day like a boulder. Then the logs were
raining back down on the Motton side, landing on the road and the
surrounding fields like enormous jackstraws. One struck the roof of
Sea Dogs's SUV and smashed it flat, spilling the windshield onto the
hood in a spray of diamond crumbles. Another landed right in front
of Sea Dogs himself.

Barbie stopped running and only stared.

Sea Dogs got to his feet, fell down, grasped the log that had
almost smashed out his life, and got up again. He stood swaying and
wild-eyed. Barbie started toward him and after twelve steps ran into
something that felt like a brick wall. He staggered backward and felt

warmth cascade from his nose and over his lips. He wiped away a palmload of blood, looked at it unbelievingly, and then smeared it on his shirt.

Now cars were coming from both directions – Motton and Chester's Mill. Three running figures, as yet still small, were cutting across the grazeland from a farmhouse at the other end. Several of the cars were honking their horns, as if that would somehow solve all problems. The first car to arrive on the Motton side pulled over to the shoulder, well back from the burning truck. Two women got out and gawked at the column of smoke and fire, shading their eyes.

7

'Fuck,' Sea Dogs said. He spoke in a small, breathless voice. He approached Barbie through the field, cutting a prudent east-tending diagonal away from the blazing pyre. The trucker might have been overloaded and moving too fast, Barbie thought, but at least he was getting a Viking funeral. 'Did you see where that one log landed? I was almost kilt. Squashed like a bug.'

'Do you have a cell phone?' Barbie had to raise his voice to be heard over the furiously burning pulper.

'In my truck,' Sea Dogs said. 'I'll try for it if you want.'

'No, wait,' Barbie said. He realized with sudden relief that all this could be a dream, the irrational kind where riding your bicycle underwater or talking of your sex life in some language you never studied seems normal.

The first person to arrive on his side of the barrier was a chubby guy driving an old GMC pickup. Barbie recognized him from Sweetbriar Rose: Ernie Calvert, the previous manager of Food City, now retired. Ernie was staring at the burning clutter on the road with wide eyes, but he had his cell phone in his hand and was ratchet-jawing into it. Barbie could hardly hear him over the roar of the burning pulp-truck, but he made out 'Looks like a bad one' and figured Ernie was talking to the police. Or the fire department. If it was the FD, Barbie hoped it was the one in Castle Rock. There were two engines in the tidy little Chester's Mill firebarn, but Barbie had an idea that if they showed up here, the most they'd be able to do was douse a grassfire that was going to putter out on its own before much longer. The burning pulp-truck was close, but Barbie didn't think they'd be able to get to it.

It's a dream, he told himself. *If you keep telling yourself that, you'll be able to operate.*

The two women on the Motton side had been joined by half a dozen men, also shading their eyes. Cars were now parked on both shoulders. More people were getting out and joining the crowd. The same thing was happening on Barbie's side. It was as if a couple of dueling flea markets, both full of juicy bargains, had opened up out here: one on the Motton side of the town line, one on the Chester's Mill side.

The trio from the farm arrived – a farmer and his teenaged sons. The boys were running easily, the farmer redfaced and panting.

'Holy shit!' the older boy said, and his father whapped him backside of the head. The boy didn't seem to notice. His eyes were bugging. The younger boy reached out his hand, and when the older boy took it, the younger boy started to cry.

'What happened here?' the farmer asked Barbie, pausing to whoop in a big deep breath between *happened* and *here*.

Barbie ignored him. He advanced slowly toward Sea Dogs with his right hand held out in a *stop* gesture. Without speaking, Sea Dogs did the same. As Barbie approached the place where he knew the barrier to be – he had only to look at that peculiar straightedge of burnt ground – he slowed down. He had already whammed his face; he didn't want to do it again.

Suddenly he was swept by horripilation. The goosebumps swept up from his ankles all the way to the nape of his neck, where the hairs stirred and tried to lift. His balls tingled like tuning forks, and for a moment there was a sour metallic taste in his mouth.

Five feet away from him – five feet and closing – Sea Dogs's already wide eyes widened some more. 'Did you feel that?'

'Yes,' Barbie said. 'But it's gone now. You?'

'Gone,' Sea Dogs agreed.

Their outstretched hands did not quite meet, and Barbie again thought of a pane of glass; putting your inside hand up against the hand of some outside friend, the fingers together but not touching.

He pulled his hand back. It was the one he'd used to wipe his bloody nose, and he saw the red shapes of his own fingers hanging on thin air. As he watched, the blood began to bead. Just as it would on glass.

'Holy God, what does it mean?' Sea Dogs whispered.

Barbie had no answer. Before he could say anything, Ernie Calvert tapped him on the back. 'I called the cops,' he said. 'They're coming, but no one answers at the Fire Department – I got a recording telling me to call Castle Rock.'

'Okay, do that,' Barbie said. Then another bird dropped about

twenty feet away, falling into the farmer's grazeland and disappearing. Seeing it brought a new idea into Barbie's mind, possibly sparked by the time he'd spent toting a gun on the other side of the world. 'But first, I think you better call the Air National Guard, up in Bangor.'

Ernie gaped at him. 'The *Guard*?'

'They're the only ones who can institute a no-fly zone over Chester's Mill,' Barbie said. 'And I think they better do it right away.'

LOTTA DEAD BIRDS

1

The Mill's Chief of Police heard neither explosion, though he was outside, raking leaves on the lawn of his Morin Street home. The portable radio was sitting on the hood of his wife's Honda, playing sacred music on WCIK (call letters standing for *Christ Is King* and known by the town's younger denizens as Jesus Radio). Also, his hearing wasn't what it once had been. At sixty-seven, was anybody's?

But he heard the first siren when it cut through the day; his ears were attuned to that sound just as a mother's are to the cries of her children. Howard Perkins even knew which car it was, and who was driving. Only Three and Four still had the old warblers, but Johnny Trent had taken Three over to Castle Rock with the FD, to that damned training exercise. A 'controlled burn,' they called it, although what it really amounted to was grown men having fun. So it was car Four, one of their two remaining Dodges, and Henry Morrison would be driving.

He stopped raking and stood, head cocked. The siren started to fade, and he started raking again. Brenda came out on the stoop. Almost everyone in The Mill called him Duke − the nickname a holdover from his high school days, when he had never missed a John Wayne picture down at the Star − but Brenda had quit that soon after they were married in favor of the other nickname. The one he disliked.

'Howie, the power's out. And there were *bangs*.'

Howie. Always Howie. As in *Here's Howie* and *Howie's tricks* and *Howie's life treatin you*. He tried to be a Christian about it − hell, he *was* a Christian about it − but sometimes he wondered if that nickname wasn't at least partially responsible for the little gadget he now carried around in his chest.

'What?'

She rolled her eyes, marched to the radio on the hood of her car, and pushed the power button, cutting off the Norman Luboff Choir in the middle of 'What a Friend We Have in Jesus.'

'How many times have I told you not to stick this thing on the hood of my car? You'll scratch it and the resale value will go down.'

'Sorry, Bren. What did you say?'

'The *power's* out! And something *boomed*. That's probably what Johnny Trent's rolling on.'

'It's Henry,' he said. 'Johnny's over in The Rock with the FD.'

'Well, whoever it is—'

Another siren started up, this one of the newer kind that Duke Perkins thought of as Tweety Birds. That would be Two, Jackie Wettington. Had to be Jackie, while Randolph sat minding the store, rocked back in his chair with his feet cocked up on his desk, reading the *Democrat*. Or sitting in the crapper. Peter Randolph was a fair cop, and he could be just as hard as he needed to be, but Duke didn't like him. Partly because he was so clearly Jim Rennie's man, partly because Randolph was sometimes harder than he needed to be, but mostly because he thought Randolph was lazy, and Duke Perkins could not abide a lazy policeman.

Brenda was looking at him with large eyes. She had been a policeman's wife for forty-three years, and she knew that two booms, two sirens, and a power failure added up to nothing good. If the lawn got raked this weekend — or if Howie got to listen to his beloved Twin Mills Wildcats take on Castle Rock's football team — she would be surprised.

'You better go on in,' she said. 'Something got knocked down. I just hope no one's dead.'

He took his cell phone off his belt. Goddam thing hung there like a leech from morning til night, but he had to admit it was handy. He didn't dial it, just stood looking down at it, waiting for it to ring.

But then another Tweety Bird siren went off: car One. Randolph rolling after all. Which meant something very serious. Duke no longer thought the phone would ring and moved to put it back on his belt, but then it did. It was Stacey Moggin.

'*Stacey?*' He knew he didn't have to bellow into the goddam thing, Brenda had told him so a hundred times, but he couldn't seem to help it. '*What are you doing at the station on Saturday m—*'

'I'm not, I'm at home. Peter called me and said to tell you it's out on 119, and it's bad. He said . . . an airplane and a pulp-truck collided.' She sounded dubious. 'I don't see how that can be, but—'

A plane. Jesus. Five minutes ago, or maybe a little longer, while he'd been raking leaves and singing along with 'How Great Thou Art'—

'Stacey, was it Chuck Thompson? I saw that new Piper of his flying over. Pretty low.'

'I don't know, Chief, I've told you everything Peter told me.'

Brenda, no dummy, was already moving her car so he could back the forest-green Chief's car down the driveway. She had set the portable radio beside his small pile of raked leaves.

'Okay, Stace. Power out on your side of town, too?'

'Yes, and the landlines. I'm on my cell. It's probably bad, isn't it?'

'I hope not. Can you go in and cover? I bet the place is standing there empty and unlocked.'

'I'll be there in five. Reach me on the base unit.'

'Roger that.'

As Brenda came back up the driveway, the town whistle went off, its rise and fall a sound that never failed to make Duke Perkins feel tight in the gut. Nevertheless, he took time to put an arm around Brenda. She never forgot that he took the time to do that. 'Don't let it worry you, Brennie. It's programmed to do that in a general power outage. It'll stop in three minutes. Or four. I forget which.'

'I know, but I still hate it. That idiot Andy Sanders blew it on nine-eleven, do you remember? As if they were going to suicide-bomb *us* next.'

Duke nodded. Andy Sanders *was* an idiot. Unfortunately, he was also First Selectman, the cheery Mortimer Snerd dummy that sat on Big Jim Rennie's lap.

'Honey, I have to go.'

'I know.' But she followed him to the car. 'What is it? Do you know yet?'

'Stacey said a truck and an airplane collided out on 119.'

Brenda smiled tentatively. 'That's a joke, right?'

'Not if the plane had engine trouble and was trying to land on the highway,' Duke said. Her little smile faded and her fisted right hand came to rest just between her breasts, body language he knew well. He climbed behind the wheel, and although the Chief's cruiser was relatively new, he still settled into the shape of his own butt. Duke Perkins was no lightweight.

'On your day off!' she cried. 'Really, it's a shame! And when you could retire on a full P!'

'They'll just have to take me in my Saturday slops,' he said, and grinned at her. It was work, that grin. This felt like it was going to be a long day. 'Just as I am, Lord, just as I am. Stick me a sandwich or two in the fridge, will you?'

'Just one. You're getting too heavy. Even Dr Haskell said so and he never scolds *anybody*.'

'One, then.' He put the shift in reverse . . . then put it back in park. He leaned out the window, and she realized he wanted a kiss. She gave him a good one with the town whistle blowing across the crisp October air, and he caressed the side of her throat while their mouths were together, a thing that always gave her the shivers and he hardly ever did anymore.

His touch there in the sunshine: she never forgot that, either.

As he rolled down the driveway, she called something after him. He caught part of it but not all. He really was going to have to get his ears checked. Let them fit him with a hearing aid if necessary. Although that would probably be the final thing Randolph and Big Jim needed to kick him out on his aging ass.

Duke braked and leaned out again. 'Take care of my *what?*'

'*Your pacemaker!*' she practically screamed. Laughing. Exasperated. Still feeling his hand on her throat, stroking skin that had been smooth and firm – so it seemed to her – only yesterday. Or maybe it had been the day before, when they had listened to KC and the Sunshine Band instead of Jesus Radio.

'Oh, you bet!' he called back, and drove away. The next time she saw him, he was dead.

2

Billy and Wanda Debec never heard the double boom because they were on Route 117, and because they were arguing. The fight had started simply enough, with Wanda observing it was a beautiful day and Billy responding he had a headache and didn't know why they had to go to the Saturday flea market in Oxford Hills, anyway; it would just be the usual pawed-over crap.

Wanda said that he wouldn't have a headache if he hadn't sunk a dozen beers the night before.

Billy asked her if she had counted the cans in the recycling bin (no matter how loaded he got, Billy did his drinking at home and always put the cans in the recycling bin – these things, along with his work as an electrician, were his pride).

She said yes she had, you bet she had. Furthermore—

They got as far as Patel's Market in Castle Rock, having progressed through *You drink too much, Billy* and *You nag too much, Wanda* to *My mother told me not to marry you* and *Why do you have to be such a bitch.* This had become a fairly well-worn call-and-response during the last two years of their four-year marriage, but this morning Billy suddenly felt he had reached his limit. He swung into the market's wide hot-topped parking lot without signaling or slowing, and then back out onto 117 without a single glance into his rearview mirror, let alone over his shoulder. On the road behind him, Nora Robichaud honked. Her best friend, Elsa Andrews, rutted. The two women, both retired nurses, exchanged a glance but not a single word. They had been friends too long for words to be necessary in such situations.

Meanwhile, Wanda asked Billy where he thought he was going.

Billy said back home to take a nap. She could go to the shit-fair on her own.

Wanda observed that he had almost hit those two old ladies (said old ladies now dropping behind fast; Nora Robichaud felt that, lacking some damned good reason, speeds over forty miles an hour were the devil's work).

Billy observed that Wanda both looked and sounded like her mother.

Wanda asked him to elucidate just what he meant by that.

Billy said that both mother and daughter had fat asses and tongues that were hung in the middle and ran on both ends.

Wanda told Billy he was hungover.

Billy told Wanda she was ugly.

It was a full and fair exchange of feelings, and by the time they crossed from Castle Rock into Motton, headed for an invisible barrier that had come into being not long after Wanda had opened this spirited discussion by saying it was a beautiful day, Billy was doing better than sixty, which was almost top end for Wanda's little Chevy shitbox.

'What's that smoke?' Wanda asked suddenly, pointing northeast, toward 119.

'I don't know,' he said. 'Did my mother-in-law fart?' This cracked him up and he started laughing.

Wanda Debec realized she had finally had enough. This clarified the world and her future in a way that was almost magical. She was turning to him, the words *I want a divorce* on the tip of her tongue, when they reached the Motton–Chester's Mill town line and struck the barrier. The Chevy shitbox was equipped with airbags, but Billy's did not deploy and Wanda's didn't pop out completely. The steering wheel collapsed Billy's chest; the steering column smashed his heart; he died almost instantly.

Wanda's head collided with the dashboard, and the sudden, catastrophic relocation of the Chevy's engine block broke one of her legs (the left) and one of her arms (the right). She was not aware of any pain, only that the horn was blaring, the car was suddenly askew in the middle of the road with its front end smashed almost flat, and her vision had come over all red.

When Nora Robichaud and Elsa Andrews rounded the bend just to the south (they had been animatedly discussing the smoke rising to the northeast for several minutes now, and congratulating themselves on having taken the lesser traveled highway this forenoon),

Wanda Debec was dragging herself up the white line on her elbows. Blood gushed down her face, almost obscuring it. She had been half scalped by a piece of the collapsing windshield and a huge flap of skin hung down over her left cheek like a misplaced jowl.

Nora and Elsa looked at each other grimly.

'Shit-my-pajamas,' Nora said, and that was all the talk between them there was. Elsa got out the instant the car stopped and ran to the staggering woman. For an elderly lady (Elsa had just turned seventy), she was remarkably fleet.

Nora left the car idling in park and joined her friend. Together they supported Wanda to Nora's old but perfectly maintained Mercedes. Wanda's jacket had gone from brown to a muddy roan color; her hands looked as if she had dipped them in red paint.

'Whe' Billy?' she asked, and Nora saw that most of the poor woman's teeth had been knocked out. Three of them were stuck to the front of her bloody jacket. 'Whe' Billy, he arri'? Wha' happen?'

'Billy's fine and so are you,' Nora said, then looked a question at Elsa. Elsa nodded and hurried toward the Chevy, now partly obscured by the steam escaping its ruptured radiator. One look through the gaping passenger door, which hung on one hinge, was enough to tell Elsa, who had been a nurse for almost forty years (final employer: Ron Haskell, MD – the MD standing for Medical Doofus), that Billy was not fine at all. The young woman with half her hair hanging upside down beside her head was now a widow.

Elsa returned to the Mercedes and got into the backseat next to the young woman, who had slipped into semiconsciousness. 'He's dead and she will be, too, if you don't get us to Cathy Russell hurry-up-chop-chop,' she told Nora.

'Hang on, then,' Nora said, and floored it. The Mercedes had a big engine, and it leaped forward. Nora swerved smartly around the Debec Chevrolet and crashed into the invisible barrier while still accelerating. For the first time in twenty years Nora had neglected to fasten her seat belt, and she went out through the windshield, where she broke her neck on the invisible barrier just as Bob Roux had. The young woman shot between the Mercedes's front bucket seats, out through the shattered windshield, and landed facedown on the hood with her bloodspattered legs splayed. Her feet were bare. Her loafers (bought at the last Oxford Hills flea market she had attended) had come off in the first crash.

Elsa Andrews hit the back of the driver's seat, then rebounded, dazed but essentially unhurt. Her door stuck at first, but popped open when she put her shoulder against it and rammed. She got out and

looked around at the littered wreckage. The puddles of blood. The smashed-up Chevy shitbox, still gently steaming.

'What happened?' she asked. This had also been Wanda's question, although Elsa didn't remember that. She stood in a strew of chrome and bloody glass, then put the back of her left hand to her forehead, as if checking for a fever. 'What happened? What just happened? Nora? Nora-pie? Where are you, dear?'

Then she saw her friend and uttered a scream of grief and horror. A crow watching from high in a pine tree on The Mill side of the barrier cawed once, a cry that sounded like a contemptuous snort of laughter.

Elsa's legs turned rubbery. She backed until her bottom struck the crumpled nose of the Mercedes. 'Nora-pie,' she said. 'Oh, honey.' Something tickled the back of her neck. She wasn't sure, but thought it was probably a lock of the wounded girl's hair. Only now, of course, she was the dead girl.

And poor sweet Nora, with whom she'd sometimes shared illicit nips of gin or vodka in the laundry room at Cathy Russell, the two of them giggling like girls away at camp. Nora's eyes were open, staring up at the bright midday sun, and her head was cocked at a nasty angle, as if she had died trying to look back over her shoulder and make sure Elsa was all right.

Elsa, who *was* all right – 'just shaken up,' as they'd said of certain lucky survivors back in their ER days – began to cry. She slid down the side of the car (ripping her own coat on a jag of metal) and sat on the asphalt of 117. She was still sitting there and still crying when Barbie and his new friend in the Sea Dogs cap came upon her.

3

Sea Dogs turned out to be Paul Gendron, a car salesman from upstate who had retired to his late parents' farm in Motton two years before. Barbie learned this and a great deal more about Gendron between their departure from the crash scene on 119 and their discovery of another one – not quite so spectacular but still pretty horrific – at the place where Route 117 crossed into The Mill. Barbie would have been more than willing to shake Gendron's hand, but such niceties would have to remain on hold until they found the place where the invisible barrier ended.

Ernie Calvert had gotten through to the Air National Guard in Bangor, but had been put on hold before he had a chance to say

why he was calling. Meanwhile, approaching sirens heralded the imminent arrival of the local law.

'Just don't expect the Fire Department,' said the farmer who'd come running across the field with his sons. His name was Alden Dinsmore, and he was still getting his breath back. 'They're over to Castle Rock, burnin down a house for practice. Could have gotten plenty of practice right h—' Then he saw his younger son approaching the place where Barbie's bloody handprint appeared to be drying on nothing more than sunny air. 'Rory, get away from there!'

Rory, agog with curiosity, ignored him. He reached out and knocked on the air just to the right of Barbie's handprint. But before he did, Barbie saw goosebumps rash out on the kid's arms below the ragged sleeves of his cut-off Wildcats sweatshirt. There was something there, something that kicked in when you got close. The only place Barbie had ever gotten a similar sensation was close to the big power generator in Avon, Florida, where he'd once taken a girl necking.

The sound of the kid's fist was like knuckles on the side of a Pyrex casserole dish. It silenced the little babbling crowd of spectators, who had been staring at the burning remains of the pulp-truck (and in some cases taking pictures of it with their cell phones).

'I'll be dipped in shit,' someone said.

Alden Dinsmore dragged his son away by the ragged collar of his sweatshirt, then whapped him backside of the head as he had the older brother not long before. 'Don't you ever!' Dinsmore cried, shaking the boy. 'Don't you *ever*, when you don't know what it is!'

'Pa, it's like a glass wall! It's—'

Dinsmore shook him some more. He was still panting, and Barbie feared for his heart. 'Don't you *ever*!' he repeated, and pushed the kid at his older brother. 'Hang onto this fool, Ollie.'

'Yessir,' Ollie said, and smirked at his brother.

Barbie looked toward The Mill. He could now see the approaching flashers of a police car, but far ahead of it – as if escorting the cops by virtue of some higher authority – was a large black vehicle that looked like a rolling coffin: Big Jim Rennie's Hummer. Barbie's fading bumps and bruises from the fight in Dipper's parking lot seemed to give a sympathetic throb at the sight.

Rennie Senior hadn't been there, of course, but his son had been the prime instigator, and Big Jim had taken care of Junior. If that meant making life in The Mill tough for a certain itinerant short-order cook – tough enough so the short-order cook in question would decide to just haul stakes and leave town – even better.

Barbie didn't want to be here when Big Jim arrived. Especially

not with the cops. Chief Perkins had treated him okay, but the other one – Randolph – had looked at him as if Dale Barbara were a piece of dogshit on a dress shoe.

Barbie turned to Sea Dogs and said: 'You interested in taking a little hike? You on your side, me on mine? See how far this thing goes?'

'And get away from here before yonder gasbag arrives?' Gendron had also seen the oncoming Hummer. 'My friend, you're on. East or west?'

<p style="text-align:center">4</p>

They went west, toward Route 117, and they didn't find the end of the barrier, but they saw the wonders it had created when it came down. Tree branches had been sheared off, creating pathways to the sky where previously there had been none. Stumps had been cut in half. And there were feathered corpses everywhere.

'Lotta dead birds,' Gendron said. He resettled his cap on his head with hands that trembled slightly. His face was pale. 'Never seen so many.'

'Are you all right?' Barbie asked.

'Physically? Yeah, I think so. Mentally, I feel like I've lost my frickin mind. How about you?'

'Same,' Barbie said.

Two miles west of 119, they came to God Creek Road and the body of Bob Roux, lying beside his still-idling tractor. Barbie moved instinctively toward the downed man and once again bumped the barrier . . . although this time he remembered at the last second and slowed in time to keep from bloodying his nose again.

Gendron knelt and touched the farmer's grotesquely cocked neck. 'Dead.'

'What's that littered all around him? Those white scraps?'

Gendron picked up the largest piece. 'I think it's one of those computer-music doohickies. Musta broke when he hit the . . .' He gestured in front of him. 'The you-know.'

From the direction of town a whooping began, hoarser and louder than the town whistle had been.

Gendron glanced toward it briefly. 'Fire siren,' he said. 'Much good it'll do.'

'FD's coming from Castle Rock,' Barbie said. 'I hear them.'

'Yeah? Your ears are better'n mine, then. Tell me your name again, friend.'

'Dale Barbara. Barbie to my friends.'

'Well, Barbie, what now?'

'Go on, I guess. We can't do anything for this guy.'

'Nope, can't even call anyone,' Gendron said gloomily. 'Not with my cell back there. Guess you don't have one?'

Barbie did, but he had left it behind in his now-vacated apartment, along with some socks, shirts, jeans, and underwear. He'd lit out for the territories with nothing but the clothes on his back, because there was nothing from Chester's Mill he wanted to carry with him. Except a few good memories, and for those he didn't need a suitcase or even a knapsack.

All this was too complicated to explain to a stranger, so he just shook his head.

There was an old blanket draped over the seat of the Deere. Gendron shut the tractor off, took the blanket, and covered the body.

'I hope he was listenin to somethin he liked when it happened,' Gendron said.

'Yeah,' Barbie said.

'Come on. Let's get to the end of this whatever-it-is. I want to shake your hand. Might even break down and give you a hug.'

5

Shortly after discovering Roux's body – they were now very close to the wreck on 117, although neither of them knew it – they came to a little stream. The two men stood there for a moment, each on his own side of the barrier, looking in wonder and silence.

At last Gendron said, 'Holy jumped-up God.'

'What does it look like from your side?' Barbie asked. All he could see on his was the water rising and spreading into the undergrowth. It was as if the stream had encountered an invisible dam.

'I don't know how to describe it. I never seen anything quite like it.' Gendron paused, scratching both cheeks, drawing his already long face down so he looked a little like the screamer in that Edvard Munch painting. 'Yes I have. Once. Sorta. When I brought home a couple of goldfish for my daughter's sixth birthday. Or maybe she was seven that year. I brought em home from the pet store in a plastic bag, and that's what this looks like – water in the bottom of a plastic bag. Only flat instead of saggin down. The water piles up against that . . . thing, then trickles off both ways on your side.'

'Is none going through at all?'

Gendron bent down, his hands on his knees, and squinted. 'Yeah,

some appears to go through. But not very much, just a trickle. And none of the crap the water's carrying. You know, sticks and leaves and such.'

They pushed on, Gendron on his side and Barbie on his. As yet, neither of them were thinking in terms of inside and outside. It didn't occur to them that the barrier might not have an end.

6

Then they came to Route 117, where there had been another nasty accident – two cars and at least two fatals that Barbie could be sure of. There was another, he thought, slumped behind the wheel of an old Chevrolet that had been mostly demolished. Only this time there was also a survivor, sitting beside a smashed-up Mercedes-Benz with her head lowered. Paul Gendron rushed to her, while Barbie could only stand and watch. The woman saw Gendron and struggled to rise.

'No, ma'am, not at all, you don't want to do that,' he said.

'I think I'm fine,' she said. 'Just . . . you know, shaken up.' For some reason this made her laugh, although her face was puffy with tears.

At that moment another car appeared, a slowpoke driven by an old fellow who was leading a parade of three or four other no doubt impatient drivers. He saw the accident and stopped. The cars behind him did, too.

Elsa Andrews was on her feet now, and with-it enough to ask what would become the question of the day: 'What did we hit? It wasn't the other car, Nora went around the other car.'

Gendron answered with complete honesty. 'Dunno, ma'am.'

'Ask her if she has a cell phone,' Barbie said. Then he called to the gathering spectators. 'Hey! Who's got a cell phone?'

'I do, mister,' a woman said, but before she could say more, they all heard an approaching *whup-whup-whup* sound. It was a helicopter.

Barbie and Gendron exchanged a stricken glance.

The copter was blue and white, flying low. It was angling toward the pillar of smoke marking the crashed pulp-truck on 119, but the air was perfectly clear, with that almost magnifying effect that the best days in northern New England seem to have, and Barbie could easily read the big blue **13** on its side. And see the CBS eye logo. It was a news chopper, out of Portland. It must already have been in the area, Barbie thought. And it was a perfect day to get some juicy crash footage for the six o'clock news.

'Oh, no,' Gendron moaned, shading his eyes. Then he shouted: '*Get back, you fools! Get back!*'

Barbie chimed in. '*No! Stop it! Get away!*'

It was useless, of course. Even more useless, he was waving his arms in big go-away gestures.

Elsa looked from Gendron to Barbie, bewildered.

The chopper dipped to treetop level and hovered.

'I think it's gonna be okay,' Gendron breathed. 'The people back there must be waving em off, too. Pilot musta seen—'

But then the chopper swung north, meaning to hook in over Alden Dinsmore's grazeland for a different view, and it struck the barrier. Barbie saw one of the rotors break off. The helicopter dipped, dropped, and swerved, all at the same time. Then it exploded, showering fresh fire down on the road and fields on the other side of the barrier.

Gendron's side.

The outside.

7

Junior Rennie crept like a thief into the house where he had grown up. Or a ghost. It was empty, of course; his father would be out at his giant used car lot on Route 119 – what Junior's friend Frank sometimes called the Holy Tabernacle of No Money Down – and for the last four years Francine Rennie had been hanging out nonstop at Pleasant Ridge Cemetery. The town whistle had quit and the police sirens had faded off to the south somewhere. The house was blessedly quiet.

He took two Imitrex, then dropped his clothes and got into the shower. When he emerged, he saw there was blood on his shirt and pants. He couldn't deal with it now. He kicked the clothes under his bed, drew the shades, crawled into the rack, and drew the covers up over his head, as he had when he was a child afraid of closet-monsters. He lay there shivering, his head gonging like all the bells of hell.

He was dozing when the fire siren went off, jolting him awake. He began to shiver again, but the headache was better. He'd sleep a little, then think about what to do next. Killing himself still seemed by far the best option. Because they'd catch him. He couldn't even go back and clean up; he wouldn't have time before Henry or LaDonna McCain came back from their Saturday errands. He could run – maybe – but not until his head stopped aching. And of course he'd have to put some clothes on. You couldn't begin life as a fugitive buckytail naked.

On the whole, killing himself would probably be best. Except then the fucking short-order cook would win. And when you really considered the matter, all this was the fucking cook's fault.

At some point the fire whistle quit. Junior slept with the covers over his head. When he woke up, it was nine p.m. His headache was gone.

And the house was still empty.

CLUSTERMUG

1

When Big Jim Rennie scrunched to a stop in his H3 Alpha Hummer (color: Black Pearl; accessories: you name it), he was a full three minutes ahead of the town cops, which was just the way he liked it. Keep ahead of the competish, that was Rennie's motto.

Ernie Calvert was still on the phone, but he raised a hand in a half-assed salute. His hair was in disarray and he looked nearly insane with excitement. 'Yo, Big Jim, I got through to em!'

'Through to who?' Rennie asked, not paying much attention. He was looking at the still-burning pyre of the pulp-truck, and at the wreckage of what was clearly a plane. This was a mess, one that could mean a black eye for the town, especially with the two newest firewagons over in The Rock. A training exercise he had approved of . . . but Andy Sanders's signature was the one on the approval form, because Andy was First Selectman. That was good. Rennie was a great believer in what he called the Protectability Quotient, and being Second Selectman was a prime example of the Quotient in action; you got all of the power (at least when the First was a nit like Sanders), but rarely had to take the blame when things went wrong.

And this was what Rennie – who had given his heart to Jesus at age sixteen and did not use foul language – called 'a clustermug.' Steps would have to be taken. Control would have to be imposed. And he couldn't count on that elderly ass Howard Perkins to do the job. Perkins might have been a perfectly adequate police chief twenty years ago, but this was a new century.

Rennie's frown deepened as he surveyed the scene. Too many spectators. Of course there were always too many at things such as this; people loved blood and destruction. And some of these appeared to be playing a bizarre sort of game: seeing how far they could lean over, or something.

Bizarre.

'You people get back from there!' he shouted. He had a good voice for giving orders, big and confident. 'That's an accident site!'

Ernie Calvert – another idiot, the town was full of them, Rennie supposed any town was – tugged at his sleeve. He looked more excited than ever. 'Got through to the ANG, Big Jim, and—'

'The who? The *what*? What are you talking about?'

'The Air National Guard!'

Worse and worse. People playing games, and this fool calling the—

'Ernie, why would you call them, for gosh sakes?'

'Because he said . . . the guy said . . .' But Ernie couldn't remember exactly what Barbie had said, so he moved on. 'Well anyway, the colonel at the ANG listened to what I was telling him, then connected me with Homeland Security in their Portland office. Put me right through!'

Rennie slapped his hands to his cheeks, a thing he did often when he was exasperated. It made him look like a cold-eyed Jack Benny. Like Benny, Big Jim did indeed tell jokes from time to time (always clean ones). He joked because he sold cars, and because he knew politicians were *supposed* to joke, especially when election time came around. So he kept a small rotating stock of what he called 'funnies' (as in 'Do you boys want to hear a funny?'). He memorized these much as a tourist in a foreign land will pick up the phrases for stuff like *Where is the bathroom* or *Is there a hotel with Internet in this village?*

But he didn't joke now. 'Homeland Security! What in the cotton-picking devil *for?*' *Cotton-picking* was by far Rennie's favorite epithet.

'Because the young guy said there's somethin across the road. And there is, Jim! Somethin you can't see! People can lean on it! See? They're doin it now. Or . . . if you throw a stone against it, it bounces back! Look!' Ernie picked up a stone and threw it. Rennie did not trouble looking to see where it went; he reckoned if it had struck one of the rubberneckers, the fellow would have given a yell. 'The truck crashed into it . . . into the whatever-it-is . . . and the plane did, too! And so the guy told me to—'

'Slow down. What guy exactly are we talking about?'

'He's a young guy,' Rory Dinsmore said. 'He cooks at Sweetbriar Rose. If you ask for a hamburg medium, that's how you get it. My dad says you can hardly ever get medium, because nobody knows how to cook it, but this guy does.' His face broke into a smile of extraordinary sweetness. 'I know his name.'

'Shut up, Roar,' his brother warned. Mr Rennie's face had darkened. In Ollie Dinsmore's experience, this was the way teachers looked just before they slapped you with a week's worth of detention.

Rory, however, paid no mind. 'It's a girl's name! It's *Baaarbara.*'

Just when I think I've seen the last of him, that cotton-picker pops up again, Rennie thought. *That darned useless no-account.*

He turned to Ernie Calvert. The police were almost here, but

Rennie thought he had time to put a stop to this latest bit of Barbara-induced lunacy. Not that Rennie saw him around. Nor expected to, not really. How like Barbara to stir up the stew, make a mess, then flee.

'Ernie,' he said, 'you've been misinformed.'

Alden Dinsmore stepped forward. 'Mr Rennie, I don't see how you can say that, when you don't know what the information is.'

Rennie smiled at him. Pulled his lips back, anyway. 'I know Dale Barbara, Alden; I have *that* much information.' He turned back to Ernie Calvert. 'Now, if you'll just—'

'Hush,' Calvert said, holding up a hand. 'I got someone.'

Big Jim Rennie did not like to be hushed, especially by a retired grocery store manager. He plucked the phone from Ernie's hand as though Ernie were an assistant who had been holding it for just that purpose.

A voice from the cell phone said, 'To whom am I speaking?' Less than half a dozen words, but they were enough to tell Rennie that he was dealing with a bureaucratic son-of-a-buck. The Lord knew he'd dealt with enough of them in his three decades as a town official, and the Feds were the worst.

'This is James Rennie, Second Selectman of Chester's Mill. Who are you, sir?'

'Donald Wozniak, Homeland Security. I understand you have some sort of problem out there on Highway 119. An interdiction of some kind.'

Interdiction? *Interdiction?* What kind of Fedspeak was that?

'You have been misinformed, sir,' Rennie said. 'What we have is an airplane – a *civilian* plane, a *local* plane – that tried to land on the road and hit a truck. The situation is completely under control. We do not require the aid of Homeland Security.'

'Mister Rennie,' the farmer said, 'that is *not* what happened.'

Rennie flapped a hand at him and began walking toward the first police cruiser. Hank Morrison was getting out. Big, six-five or so, but basically useless. And behind him, the gal with the big old tiddies. Wettington, her name was, and she was worse than useless: a smart mouth run by a dumb head. But behind *her*, Peter Randolph was pulling up. Randolph was the Assistant Chief, and a man after Rennie's own heart. A man who could get 'er done. If Randolph had been the duty officer on the night Junior got in trouble at that stupid devilpit of a bar, Big Jim doubted if Mr Dale Barbara would still have been in town to cause trouble today. In fact, Mr Barbara might have been behind bars over in The Rock. Which would have suited Rennie fine.

Meanwhile, the man from Homeland Security – did they have the nerve to call themselves agents? – was still jabbering away.

Rennie interrupted him. 'Thank you for your interest, Mr Wozner, but we've got this handled.' He pushed the END button without saying goodbye. Then he tossed the phone back to Ernie Calvert.

'Jim, I don't think that was wise.'

Rennie ignored him and watched Randolph stop behind the Wettington gal's cruiser, bubblegum bars flashing. He thought about walking down to meet Randolph, and rejected the idea before it was fully formed in his mind. Let Randolph come to him. That was how it was supposed to work. And how it *would* work, by God.

2

'Big Jim,' Randolph said. 'What's happened here?'

'I believe that's obvious,' Big Jim said. 'Chuck Thompson's airplane got into a little argument with a pulp-truck. Looks like they fought it to a draw.' Now he could hear sirens coming from Castle Rock. Almost certainly FD responders (Rennie hoped their own two new – and horribly expensive – firewagons were among them; it would play better if no one actually realized the new trucks had been out of town when this clustermug happened). Ambulances and police would be close behind.

'That ain't what happened,' Alden Dinsmore said stubbornly. 'I was out in the side garden, and I saw the plane just—'

'Better move those people back, don't you think?' Rennie asked Randolph, pointing to the lookie-loos. There were quite a few on the pulp-truck side, standing prudently away from the blazing remains, and even more on The Mill side. It was starting to look like a convention.

Randolph addressed Morrison and Wettington. 'Hank,' he said, and pointed at the spectators from The Mill. Some had begun prospecting among the scattered pieces of Thompson's plane. There were cries of horror as more body parts were discovered.

'Yo,' Morrison said, and got moving.

Randolph turned Wettington toward the spectators on the pulp-truck side. 'Jackie, you take . . .' But there Randolph trailed off.

The disaster-groupies on the south side of the accident were standing in the cow pasture on one side of the road and knee-deep in scrubby bushes on the other. Their mouths hung open, giving them a look of stupid interest Rennie was very familiar with; he saw it on individual faces every day, and en masse every March, at town meeting. Only these people weren't looking at the burning truck.

And now Peter Randolph, certainly no dummy (not brilliant, not by a long shot, but at least he knew which side his bread was buttered on), was looking at the same place as the rest of them, and with that same expression of slack-jawed amazement. So was Jackie Wettington.

It was the smoke the rest were looking at. The smoke rising from the burning pulper.

It was dark and oily. The people downwind should have been darned near choking on it, especially with a light breeze out of the south, but they weren't. And Rennie saw the reason why. It was hard to believe, but he saw it, all right. The smoke *did* blow north, at least at first, but then it took an elbow-bend – almost a right angle – and rose straight up in a plume, as if in a chimney. And it left a dark brown residue behind. A long smudge that just seemed to float on the air.

Jim Rennie shook his head to clear the image away, but it was still there when he stopped.

'What is it?' Randolph asked. His voice was soft with wonder.

Dinsmore, the farmer, placed himself in front of Randolph. '*That* guy' – pointing at Ernie Calvert – 'had Homeland Security on the phone, and *this* guy' – pointing at Rennie in a theatrical courtroom gesture Rennie didn't care for in the least – 'took the phone out of his hand and hung up! He shun't'a done that, Pete. Because that was no collision. The plane wasn't anywhere near the ground. I seen it. I was covering plants in case of frost, and I *seen* it.'

'I did, too—' Rory began, and this time it was his brother Ollie who went up the backside of Rory's head. Rory began to whine.

Alden Dinsmore said, 'It *hit* something. Same thing the truck hit. It's there, you can touch it. That young fella – the cook – said there oughta be a no-fly zone out here, and he was right. But Mr Rennie' – again pointing at Rennie like he thought he was a gosh-darn Perry Mason instead of a fellow who earned his daily bread attaching suction cups to cows' tiddies – 'wouldn't even *talk*. Just hung up.'

Rennie did not stoop to rebuttal. 'You're wasting time,' he told Randolph. Moving a little closer and speaking just above a whisper, he added: 'The Chief's coming. My advice would be to look sharp and control this scene before he gets here.' He cast a cold momentary eye on the farmer. 'You can interview the witnesses later.'

But – maddeningly – it was Alden Dinsmore who got the last word. 'That fella Barber was right. He was right and Rennie was wrong.'

Rennie marked Alden Dinsmore for later action. Sooner or later, farmers always came to the Selectmen with their hats in their hands

– wanting an easement, a zoning exception, something – and when Mr Dinsmore next showed up, he would find little comfort, if Rennie had anything to say about it. And he usually did.

'Control this scene!' he told Randolph.

'Jackie, move those people back,' the Assistant Chief said, pointing toward the lookie-loos on the pulp-truck side of the accident. 'Establish a perimeter.'

'Sir, I think those folks are actually in Motton—'

'I don't care, move them back.' Randolph glanced over his shoulder to where Duke Perkins was working his way out of the green Chief's car – a car Randolph longed to see in his own driveway. And would, with Big Jim Rennie's help. In another three years at the very latest. 'Castle Rock PD'll thank you when they get here, believe me.'

'What about . . .' She pointed at the smoke-smudge, which was still spreading. Seen through it, the October-colorful trees looked a uniform dark gray, and the sky was an unhealthy shade of yellowy-blue.

'Stay clear of it,' Randolph said, then went to help Hank Morrison establish the perimeter on the Chester's Mill side. But first he needed to bring Perk up to speed.

Jackie approached the people on the pulp-truck side. The crowd over there was growing all the time as the early arrivers worked their cell phones. Some had stamped out little fires in the bushes, which was good, but now they were just standing around, gawking. She used the same shooing gestures Hank was employing on The Mill side, and chanted the same mantra.

'Get back, folks, it's all over, nothing to see you haven't seen already, clear the road for the firetrucks and the police, get back, clear the area, go home, get ba—'

She hit something. Rennie had no idea what it was, but he could see the result. The brim of her hat collided with it first. It bent, and the hat tumbled off behind her. An instant later those insolent tiddies of hers – a couple of cotton-picking gunshells was what they were – flattened. Then her nose squashed and gave up a jet of blood that splattered against something . . . and began to run down in long drips, like paint on a wall. She went on her well-padded ass with an expression of shock on her face.

The goddarn farmer stuck his oar in then: 'See? What'd I tell you?'

Randolph and Morrison hadn't seen. Neither had Perkins; the three of them were conferring together by the hood of the Chief's

car. Rennie briefly considered going to Wettington, but others were doing that, and besides – she was still a little too close to whatever it was she'd run into. He hurried toward the men instead, set face and big hard belly projecting get-'er-done authority. He spared a glare for Farmer Dinsmore on his way by.

'Chief,' he said, butting in between Morrison and Randolph.

'Big Jim,' Perkins said, nodding. 'You didn't waste any time, I see.'

This was perhaps a gibe, but Rennie, a sly old fish, did not rise to the bait. 'I'm afraid there's more going on here than meets the eye. I think someone had better get in touch with Homeland Security.' He paused, looking suitably grave. 'I don't want to say there's terrorism involved . . . but I won't say there isn't.'

3

Duke Perkins looked past Big Jim. Jackie was being helped to her feet by Ernie Calvert and Johnny Carver, who ran Mill Gas & Grocery. She was dazed and her nose was bleeding, but she appeared all right otherwise. Nevertheless, this whole situation was hinky. Of course, any accident where there were fatalities felt that way to some extent, but there was more wrong here.

For one thing, the plane hadn't been trying to land. There were too many pieces, and they were too widely scattered, for him to believe that. And the spectators. They weren't right, either. Randolph hadn't noticed, but Duke Perkins did. They should have formed into one big spreading clump. It was what they always did, as if for comfort in the face of death. Only these had formed *two* clumps, and the one on the Motton side of the town line marker was awfully close to the still-burning truck. Not in any danger, he judged . . . but why didn't they move over here?

The first firetrucks swept around the curve to the south. Three of them. Duke was glad to see that the second one in line had CHESTER'S MILL FIRE DEPARTMENT PUMPER NO. 2 printed in gold on the side. The crowd shuffled back farther into the scrubby bushes, giving them room. Duke returned his attention to Rennie. 'What happened here? Do you know?'

Rennie opened his mouth to reply, but before he could, Ernie Calvert spoke up. 'There's a barrier across the road. You can't see it, but it's there, Chief. The truck hit it. The plane, too.'

'Damn right!' Dinsmore exclaimed.

'Officer Wettington hit it, too,' Johnny Carver said. 'Lucky for her she was goin slower.' He had placed an arm around Jackie, who

looked dazed. Duke observed her blood on the sleeve of Carver's I GOT GASSED AT MILL DISCOUNT jacket.

On the Motton side, another FD truck had arrived. The first two had blocked the road in a **V**. Firemen were already spilling out and unrolling hoses. Duke could hear the warble of an ambulance from the direction of Castle Rock. *Where's ours?* he wondered. Had it also gone to that stupid damn training exercise? He didn't like to think so. Who in their right mind would order an ambulance to an empty burning house?

'There seems to be an invisible barrier—' Rennie began.

'Yeah, I got that,' Duke said. 'I don't know what it means, but I got it.' He left Rennie and went to his bleeding officer, not seeing the dark red color that suffused the Second Selectman's cheeks at this snub.

'Jackie?' Duke asked, taking her gently by the shoulder. 'All right?'

'Yeah.' She touched her nose, where the blood-flow was slowing. 'Does it look broken? It doesn't *feel* broken.'

'It's not broken, but it's going to swell. Think you'll look all right by the time the Harvest Ball comes around, though.'

She offered a weak smile.

'Chief,' Rennie said, 'I really think we ought to call someone on this. If not Homeland Security – on more mature reflection that seems a little radical – then perhaps the State Police—'

Duke moved him aside. It was gentle but unequivocal. Almost a push. Rennie balled his hands into fists, then unrolled them again. He had built a life in which he was a pusher rather than a pushee, but that didn't alter the fact that fists were for idiots. Witness his own son. All the same, slights needed to be noted and addressed. Usually at some later date . . . but sometimes later was better.

Sweeter.

'Peter!' Duke called to Randolph. 'Give the Health Center a shout and ask where the hell our ambulance is! I want it out here!'

'Morrison can do that,' Randolph said. He had grabbed the camera from his car and was turning to snap pictures of the scene.

'*You* can do it, and right now.'

'Chief, I don't think Jackie's too banged up, and no one else—'

'When I want your opinion I'll ask for it, Peter.'

Randolph started to give him a look, then saw the expression on Duke's face. He tossed the camera back onto the front seat of his shop and grabbed his cell phone.

'What was it, Jackie?' Duke asked.

'I don't know. First there was a buzzy feeling like you get if you accidentally touch the prongs of a plug when you're sticking it into the wall. It passed, but then I hit . . . jeez, I don't know what I hit.'

An *ahhh* sound went up from the spectators. The firemen had trained their hoses on the burning pulp-truck, but beyond it, some of the spray was rebounding. Striking something and splattering back, creating rainbows in the air. Duke had never seen anything like it in his life . . . except maybe when you were in a car wash, watching the high-pressure jets hit your windshield.

Then he saw a rainbow on the Mill side as well: a small one. One of the spectators – Lissa Jamieson, the town librarian – walked toward it.

'Lissa, get away from there!' Duke shouted.

She ignored him. It was as if she were hypnotized. She stood inches from where a jet of high-pressure water was striking thin air and splashing back, her hands spread. He could see drops of mist sparkling on her hair, which was pulled away from her face and bunned at the back. The little rainbow broke up, then re-formed behind her.

'Nothing but mist!' she called, sounding rapturous. 'All that water over there and nothing but mist over here! Like from a humidifier.'

Peter Randolph held up his cell phone and shook his head. 'I get a signal, but I'm not getting through. My guess is that all these spectators' – he swept his arm in a big arc – 'have got everything. jammed up.'

Duke didn't know if that were possible, but it was true that almost everyone he could see was either yakking or taking pictures. Except for Lissa, that was, who was still doing her woodnymph imitation.

'Go get her,' Duke told Randolph. 'Pull her back before she decides to haul out her crystals or something.'

Randolph's face suggested that such errands were far below his pay grade, but he went. Duke uttered a laugh. It was short but genuine.

'What in the goodness sakes do you see that's worth laughing about?' Rennie asked. More Castle County cops were pulling up on the Motton side. If Perkins didn't look out, The Rock would end up taking control of this thing. And getting the gosh-darn credit.

Duke stopped laughing, but he was still smiling. Unabashed. 'It's a clustermug,' he said. 'Isn't that your word, Big Jim? And in my experience, sometimes laughing is the only way to deal with a clustermug.'

'I have no idea what you're talking about!' Rennie almost shouted.

The Dinsmore boys stepped back from him and stood beside their father.

'I know.' Duke spoke gently. 'And that's okay. All you need to understand right now is that I'm the chief law enforcement officer on the scene, at least until the County Sheriff gets here, and you're a town selectman. You have no official standing, so I'd like you to move back.'

Duke raised his voice and pointed to where Officer Henry Morrison was stringing yellow tape, stepping around two largeish pieces of airplane fuselage to do it. 'I'd like *everyone* to move back and let us do our job! Follow Selectman Rennie. He's going to lead you behind the yellow tape.'

'I don't appreciate this, Duke,' Rennie said.

'God bless you, but I don't give a shit,' Duke said. 'Get off my scene, Big Jim. And be sure to go around the tape. No need for Henry to have to string it twice.'

'Chief Perkins, I want you to remember how you spoke to me today. Because I will.'

Rennie stalked toward the tape. The other spectators followed, most looking over their shoulders to watch the water spray off the diesel-smudged barrier and form a line of wetness on the road. A couple of the sharper ones (Ernie Calvert, for instance) had already noticed that this line exactly mimicked the border between Motton and The Mill.

Rennie felt a childish temptation to snap Hank Morrison's carefully strung tape with his chest, but restrained himself. He would not, however, go around and get his Land's End slacks snagged in a mess of burdocks. They had cost him sixty dollars. He shuffled under, holding up the tape with one hand. His belly made serious ducking impossible.

Behind him, Duke walked slowly toward the place where Jackie had suffered her collision. He held one hand outstretched before him like a blind man prospecting his way across an unfamiliar room.

Here was where she had fallen down . . . and *here* . . .

He felt the buzzing she had described, but instead of passing, it deepened to searing pain in the hollow of his left shoulder. He had just enough time to remember the last thing Brenda had said – *Take care of your pacemaker* – and then it exploded in his chest with enough force to blow open his Wildcats sweatshirt, which he'd donned that morning in honor of this afternoon's game. Blood, scraps of cotton, and bits of flesh struck the barrier.

The crowd *aaah*ed.

Duke tried to speak his wife's name and failed, but he saw her face clearly in his mind. She was smiling.

Then, darkness.

4

The kid was Benny Drake, fourteen, and a Razor. The Razors were a small but dedicated skateboarding club, frowned on by the local constabulary but not actually outlawed, in spite of calls from Selectmen Rennie and Sanders for such action (at last March's town meeting, this same dynamic duo had succeeded in tabling a budget item that would have funded a safe-skateboarding area on the town common behind the bandstand).

The adult was Eric 'Rusty' Everett, thirty-seven, a physician's assistant working with Dr Ron Haskell, whom Rusty often thought of as The Wonderful Wizard of Oz. *Because*, Rusty would have explained (if he'd anyone other than his wife he could trust with such disloyalty), *he so often remains behind the curtain while I do the work.*

Now he checked the state of young Master Drake's last tetanus shot. Fall of 2009, very good. Especially considering that young Master Drake had done a Wilson while cement-shooting and torn up his calf pretty good. Not a total jake, but a lot worse than simple roadrash.

'Power's back on, dude,' young Master Drake offered.

'Generator, dude,' Rusty said. 'Handles the hospital *and* the Health Center. Radical, huh?'

'Old-school,' young Master Drake agreed.

For a moment the adult and the adolescent regarded the six-inch gash in Benny Drake's calf without speaking. Cleaned of dirt and blood, it looked ragged but no longer downright awful. The town whistle had quit, but far in the distance, they could hear sirens. Then the fire whistle went off, making them both jump.

Ambulance is gonna roll, Rusty thought. *Sure as shit. Twitch and Everett ride again. Better hurry this up.*

Except the kid's face was pretty white, and Rusty thought there were tears standing in his eyes.

'Scared?' Rusty asked.

'A little,' Benny Drake said. 'Ma's gonna ground me.'

'Is that what you're scared of?' Because he guessed that Benny Drake had been grounded a few times before. Like often, dude.

'Well . . . how much is it gonna hurt?'

Rusty had been hiding the syringe. Now he injected three cc's of Xylocaine and epinephrine – a deadening compound he still called Novocain. He took his time infiltrating the wound, so as not to hurt the kid any more than he had to. 'About that much.'

'Whoa,' Benny said. 'Stat, baby. Code blue.'

Rusty laughed. 'Did you full-pipe before you Wilsoned?' As a long-retired boarder, he was honestly curious.

'Only half, but it was toxic!' Benny said, brightening. 'How many stitches, do you think? Norrie Calvert took twelve when she ledged out in Oxford last summer.'

'Not that many,' Rusty said. He knew Norrie, a mini-goth whose chief aspiration seemed to be killing herself on a skateboard before bearing her first woods colt. He pressed near the wound with the needle end of the syringe. 'Feel that?'

'Yeah, dude, totally. Did you hear, like, a bang out there?' Benny pointed vaguely south as he sat on the examining table in his under-shorts, bleeding onto the paper cover.

'Nope,' Rusty said. He had actually heard two: not bangs but, he was afraid, explosions. Had to make this fast. And where was The Wizard? Doing rounds, according to Ginny. Which probably meant snoozing in the Cathy Russell doctors' lounge. It was where The Wonderful Wiz did most of his rounds these days.

'Feel it now?' Rusty poked again with the needle. 'Don't look, looking is cheating.'

'No, man, nothin. You're goofin wit me.'

'I'm not. You're numb.' *In more ways than one*, Rusty thought. 'Okay, here we go. Lie back, relax, and enjoy flying Cathy Russell Airlines.' He scrubbed the wound with sterile saline, debrided, then trimmed with his trusty no. 10 scalpel. 'Six stitches with my very best four-oh nylon.'

'Awesome,' the kid said. Then: 'I think I may hurl.'

Rusty handed him an emesis basin, in these circumstances known as a puke pan. 'Hurl in this. Faint and you're on your own.'

Benny didn't faint. He didn't hurl, either. Rusty was placing a sterile gauze sponge on the wound when there was a perfunctory knock at the door, followed by Ginny Tomlinson's head. 'Can I speak to you for a minute?'

'Don't worry about me,' Benny said. 'I'm, like, freely radical.' Cheeky little bugger.

'In the hall, Rusty?' Ginny said. She didn't give the kid a glance.

'I'll be right back, Benny. Sit there and take it easy.'

'Chillaxin.'

Rusty followed Ginny out into the hall. 'Ambulance time?' he asked. Beyond Ginny, in the sunny waiting room, Benny's mother was looking grimly down at a paperback with a sweet-savage cover.

Ginny nodded. '119, at the Tarker's town line. There's another accident on the *other* town line – Motton – but I'm hearing everyone involved in that one is DATS.' Dead at the scene. 'Truck-plane collision. The plane was trying to land.'

'Are you *shitting* me?'

Alva Drake looked around, frowning, then went back to her paperback. Or at least to looking at it while she tried to decide if her husband would support her in grounding Benny until he was eighteen.

'This is an authentic no-shit situation,' Ginny said. 'I'm getting reports of other crashes, too—'

'Weird.'

'—but the guy out on the Tarker's town line is still alive. Rolled a delivery truck, I believe. Buzz, cuz. Twitch is waiting.'

'You'll finish the kid?'

'Yes. Go on, go.'

'Dr Rayburn?'

'Had patients in Stephens Memorial.' This was the Norway–South Paris hospital. 'He's on his way, Rusty. Go.'

He paused on his way out to tell Mrs Drake that Benny was fine. Alva did not seem overjoyed at the news, but thanked him. Dougie Twitchell – Twitch – was sitting on the bumper of the out-of-date ambulance Jim Rennie and his fellow selectmen kept not replacing, smoking a cigarette and taking some sun. He was holding a portable CB, and it was lively with talk: voices popping like corn and jumping all over each other.

'Put out that cancer-stick and let's get rolling,' Rusty said. 'You know where we're going, right?'

Twitch flipped the butt away. Despite his nickname, he was the calmest nurse Rusty had ever encountered, and that was saying a lot. 'I know what Gin-Gin told you – Tarker's-Chester's town line, right?'

'Yes. Overturned truck.'

'Yeah, well, plans have changed. We gotta go the other way.' He pointed to the southern horizon, where a thick black pillar of smoke was rising. 'Ever had a desire to see a crashed plane?'

'I have,' Rusty said. 'In the service. Two guys. You could have spread what was left on bread. That was plenty for me, pilgrim. Ginny says they're all dead out there, so why—'

'Maybe so, maybe no,' Twitch said, 'but now Perkins is down, and he might not be.'

'*Chief* Perkins?'

'The very same. I'm thinking the prognosis ain't good if the pacemaker blew right out of his chest – which is what Peter Randolph is claiming – but he *is* the Chief of Police. Fearless Leader.'

'Twitch. Buddy. A pacemaker can't blow like that. It's perfectly unpossible.'

'Then maybe he *is* still alive, and we can do some good,' Twitch said. Halfway around the hood of the ambo, he took out his cigarettes.

'You're not smoking in the ambulance,' Rusty said.

Twitch looked at him sadly.

'Unless you share, that is.'

Twitch sighed and handed him the pack.

'Ah, Marlboros,' Rusty said. 'My very favorite OPs.'

'You slay me,' Twitch said.

5

They blew through the stoplight where Route 117 **T**'d into 119 at the center of town, siren blaring, both of them smoking like fiends (with the windows open, which was SOP), listening to the chatter from the radio. Rusty understood little of it, but he was clear on one thing: he was going to be working long past four o'clock.

'Man, I don't know what happened,' Twitch said, 'but there's this: we're gonna see a genuine aircraft crash site. Post-crash, true, but beggars cannot be choosers.'

'Twitch, you're one sick canine.'

There was a lot of traffic, mostly headed south. A few of these folks might have legitimate errands, but Rusty thought most were human flies being drawn to the smell of blood. Twitch passed a line of four with no problem; the northbound lane of 119 was oddly empty.

'Look!' Twitch said, pointing. 'News chopper! We're gonna be on the six o'clock news, Big Rusty! Heroic paramedics fight to—'

But that was where Dougie Twitchell's flight of fancy ended. Ahead of them – at the accident site, Rusty presumed – the helicopter did a buttonhook. For a moment he could read the number **13** on its side and see the CBS eye. Then it exploded, raining down fire from the cloudless early afternoon sky.

Twitch cried out: '*Jesus, I'm sorry! I didn't mean it!*' And then, childishly, hurting Rusty's heart even in his shock: '*I take it back!*'

6

'I gotta go back,' Gendron said. He took off his Sea Dogs cap and wiped his bloody, grimy, pallid face with it. His nose had swollen until it looked like a giant's thumb. His eyes peered out of dark circles. 'I'm sorry, but my schnozz is hurting like hell, and . . . well, I ain't as young as I used to be. Also . . .' He raised his arms and dropped them. They were facing each other, and Barbie would have taken the guy in his arms and given him a pat on the back, if it were possible.

'Shock to the system, isn't it?' he asked Gendron.

Gendron gave a bark of laughter. 'That copter was the final touch.' And they both looked toward the fresh column of smoke.

Barbie and Gendron had gone on from the accident site on 117 after making sure that the witnesses were getting help for Elsa Andrews, the sole survivor. At least she didn't seem badly hurt, although she was clearly heartbroken over the loss of her friend.

'Go on back, then. Slow. Take your time. Rest when you need to.'

'Pushing on?'

'Yes.'

'Still think you're gonna find the end of it?'

Barbie was silent for a moment. At first he'd been sure, but now—

'I hope so,' he said.

'Well, good luck.' Gendron tipped his cap to Barbie before putting it back on. 'I hope to shake your hand before the day's out.'

'Me, too,' Barbie said. He paused. He had been thinking. 'Can you do something for me, if you can get to your cell phone?'

'Sure.'

'Call the Army base at Fort Benning. Ask for the liaison officer and tell them you need to get in touch with Colonel James O. Cox. Tell them it's urgent, that you're calling for Captain Dale Barbara. Can you remember that?'

'Dale Barbara. That's you. James Cox, that's him. Got it.'

'If you reach him . . . I'm not sure you will, but if . . . tell him what's going on here. Tell him if no one's gotten in touch with Homeland Security, he's the man. Can you do that?'

Gendron nodded. 'If I can, I will. Good luck, soldier.'

Barbie could have done without ever having been called that again, but he touched a finger to his forehead. Then he went on, looking for what he no longer thought he would find.

7

He found a woods road that roughly paralleled the barrier. It was overgrown and disused, but much better than pushing through the puckerbrush. Every now and then he diverted to the west, feeling for the wall between Chester's Mill and the outside world. It was always there.

When Barbie came to where 119 crossed into The Mill's sister town of Tarker's Mills, he stopped. The driver of the overturned delivery truck had been taken away by some good Samaritan on the other side of the barrier, but the truck itself lay blocking the road like a big dead animal. The back doors had sprung open on impact. The tar was littered with Devil Dogs, Ho Hos, Ring Dings, Twinkies, and peanut butter crackers. A young man in a George Strait tee-shirt sat on a stump, eating one of the latter. He had a cell phone in hand. He looked up at Barbie. 'Yo. Did you come from . . .' He pointed vaguely behind Barbie. He looked tired and scared and disillusioned.

'From the other side of town,' Barbie said. 'Right.'

'Invisible wall the whole way? Border closed?'

'Yes.'

The young man nodded and hit a button on his cell. 'Dusty? You there yet?' He listened some more, then said: 'Okay.' He ended the call. 'My friend Dusty and I started east of here. Split up. He went south. We've been staying in touch by phone. When we can get through, that is. He's where the copter crashed now. Says it's getting crowded there.'

Barbie bet it was. 'No break in this thing anywhere on your side?'

The young man shook his head. He didn't say more, and didn't need to. They could have missed breaks, Barbie knew that was possible – holes the size of windows or doors – but he doubted it.

He thought they were cut off.

WE ALL SUPPORT THE TEAM

1

Barbie walked back down Route 119 into the center of town, a distance of about three miles. By the time he got there, it was six o'clock. Main Street was almost deserted, but alive with the roar of generators; dozens of them, by the sound. The traffic light at the intersection of 119 and 117 was dark, but Sweetbriar Rose was lit and loaded. Looking through the big front window, Barbie saw that every table was taken. But when he walked in the door, he heard none of the usual big talk: politics, the Red Sox, the local economy, the Patriots, newly acquired cars and pickemups, the Celtics, the price of gas, the Bruins, newly acquired power tools, the Twin Mills Wildcats. None of the usual laughter, either.

There was a TV over the counter, and everyone was watching it. Barbie observed, with that sense of disbelief and dislocation everyone who actually finds him or herself at the site of a major disaster must feel, that CNN's Anderson Cooper was standing out on Route 119 with the still-smoldering hulk of the wrecked pulp-truck in the background.

Rose herself was waiting table, occasionally darting back to the counter to take an order. Wispy locks of hair were escaping her net and hanging around her face. She looked tired and harried. The counter was supposed to be Angie McCain's territory from four until closing, but Barbie saw no sign of her tonight. Perhaps she'd been out of town when the barrier slammed down. If that were the case, she might not be back behind the counter for a good long while.

Anson Wheeler – whom Rosie usually just called 'the kid,' although the guy had to be at least twenty-five – was cooking, and Barbie dreaded to think what Anse might do to anything more complicated than beans and franks, the traditional Saturday-night special at Sweetbriar Rose. Woe to the fellow or gal who ordered breakfast-for-dinner and had to face Anson's nuclear fried eggs. Still, it was good he was here, because in addition to the missing Angie, there was also no sign of Dodee Sanders. Although *that* particular drip didn't need a disaster to keep her away from work. She wasn't lazy, exactly, but she was easily distracted. And when it came to brain-power . . . jeez, what could you say? Her father – Andy Sanders, The Mill's First Selectman – would never be a Mensa candidate, but Dodee made him look like Albert Einstein.

On the TV, helicopters were landing behind Anderson Cooper, blowing his groovy white hair around and nearly drowning his voice. The copters looked like Pave Lows. Barbie had ridden in his share during his time in Iraq. Now an Army officer walked into the picture, covered Cooper's mike with one gloved hand, and spoke in the reporter's ear.

The assembled diners in Sweetbriar Rose murmured among themselves. Barbie understood their disquiet. He felt it himself. When a man in a uniform covered a famous TV reporter's mike without so much as a by-your-leave, it was surely the End of Days.

The Army guy — a Colonel but not *his* Colonel, seeing Cox would have completed Barbie's sense of mental dislocation — finished what he had to say. His glove made a windy *whroop* sound when he took it off the mike. He walked out of the shot, his face a stolid blank. Barbie recognized the look: Army pod-person.

Cooper was saying, 'The press is being told we have to fall back half a mile, to a place called Raymond's Roadside Store.' The patrons murmured again at this. They all knew Raymond's Roadside in Motton, where the sign in the window said COLD BEER HOT SANDWICHES FRESH BAIT. 'This area, less than a hundred yards from what we're calling the barrier — for want of a better term — has been declared a national security site. We'll resume our coverage as soon as we can, but right now I'm sending it back to you in Washington, Wolf.'

The headline on the red band beneath the location shot read **BREAKING NEWS MAINE TOWN CUT OFF MYSTERY DEEPENS.** And in the upper righthand corner, in red, the word **SEVERE** was blinking like a neon tavern sign. *Drink Severe Beer,* Barbie thought, and nearly chuckled.

Wolf Blitzer took Anderson Cooper's place. Rose had a crush on Blitzer and would not allow the TV to be tuned to anything but *The Situation Room* on weekday afternoons; she called him 'my Wolfie.' This evening Wolfie was wearing a tie, but it was badly knotted and Barbie thought the rest of his clothes looked suspiciously like Saturday grubs.

'Recapping our story,' Rose's Wolfie said, 'this afternoon at roughly one o'clock—'

'Twas earlier than that, and by quite a patch,' someone said.

'Is it true about Myra Evans?' someone else asked. 'Is she really dead?'

'Yes,' Fernald Bowie said. The town's only undertaker, Stewart Bowie, was Fern's older brother. Fern sometimes helped him out

when he was sober, and he looked sober tonight. Shocked sober. 'Now shutcha quack so I can hear this.'

Barbie wanted to hear it, too, because Wolfie was even now addressing the question Barbie cared most about, and saying what Barbie wanted to hear: that the airspace over Chester's Mill had been declared a no-fly zone. In fact, all of western Maine and eastern New Hampshire, from Lewiston-Auburn to North Conway, was a no-fly zone. The President was being briefed. And for the first time in nine years, the color of the National Threat Advisory had exceeded orange.

Julia Shumway, owner and editor of the *Democrat*, shot Barbie a glance as he passed her table. Then the pinched and secretive little smile that was her specialty – almost her trademark – flickered on her face. 'It seems that Chester's Mill doesn't want to let you go, Mr Barbara.'

'So it seems,' Barbie agreed. That she knew he had been leaving – and why – didn't surprise him. He'd spent enough time in The Mill to know Julia Shumway knew everything worth knowing.

Rose saw him as she was serving beans and franks (plus a smoking relic that might once have been a pork chop) to a party of six crammed around a table for four. She froze with a plate in each hand and two more on her arm, eyes wide. Then she smiled. It was one full of undisguised happiness and relief, and it lifted his heart.

This is what home feels like, he thought. *Goddamned if it isn't.*

'Good gravy, I never expected to see *you* again, Dale Barbara!'

'You still got my apron?' Barbie asked. A little shyly. Rose had taken him in, after all – just a drifter with a few scribbled references in his backpack – and given him work. She'd told him she completely understood why he felt he had to blow town, Junior Rennie's dad wasn't a fellow you wanted for an enemy, but Barbie still felt as if he'd left her in the lurch.

Rose put down her load of plates anywhere there was room for them and hurried to Barbie. She was a plump little woman, and she had to stand on tiptoe to hug him, but she managed.

'I'm so goddam glad to see you!' she whispered. Barbie hugged her back and kissed the top of her head.

'Big Jim and Junior won't be,' he said. But at least neither Rennie was here; there was that to be grateful for. Barbie was aware that, for the time being, at least, he had become even more interesting to the assembled Millites than their very own town on national TV.

'Big Jim Rennie can blow me!' she said. Barbie laughed, delighted

by her fierceness but glad for her discretion – she was still whispering. 'I thought you were gone!'

'I almost was, but I got a late start.'

'Did you see . . . it?'

'Yes. Tell you later.' He released her, held her at arm's length, and thought: *If you were ten years younger, Rose . . . or even five . . .*

'So I can have my apron back?'

She wiped the corners of her eyes and nodded. '*Please* take it back. Get Anson out of there before he kills us all.'

Barbie gave her a salute, then hooked around the counter into the kitchen and sent Anson Wheeler to the counter, telling him to take care of orders and cleanup there before helping Rose in the main room. Anson stepped back from the grill with a sigh of relief. Before going to the counter, he shook Barbie's right hand in both of his. 'Thank God, man – I never seen such a rush. I was lost.'

'Don't worry. We're gonna feed the five thousand.'

Anson, no Biblical scholar, looked blank. 'Huh?'

'Never mind.'

The bell sitting in the corner of the pass-through binged. 'Order up!' Rose called.

Barbie grabbed a spatula before taking the slip – the grill was a mess, it always was when Anson was engaged in those cataclysmic heat-induced changes he called cooking – then slipped his apron over his head, tied it in back, and checked the cabinet over the sink. It was full of baseball caps, which served Sweetbriar Rose grill-monkeys as chef's toques. He selected a Sea Dogs cap in honor of Paul Gendron (now in the bosom of his nearest and dearest, Barbie hoped), yanked it on backward, and cracked his knuckles.

Then he grabbed the first slip and went to work.

2

By nine fifteen, more than an hour after their usual Saturday night closing time, Rose ushered the final patrons out. Barbie locked the door and turned the sign from OPEN to CLOSED. He watched those last four or five cross the street to the town common, where there were as many as fifty people gathered and talking among themselves. They were facing south, where a great white light formed a bubble over 119. Not TV lights, Barbie judged; that was the U.S. Army, creating and securing a perimeter. And how did you secure a perimeter at night? Why, by posting sentries and lighting the dead zone, of course.

Dead zone. He didn't like the sound of that.

Main Street, on the other hand, was unnaturally dark. There were electric lights shining in some of the buildings – where there were gennies at work – and battery-powered emergency lights shining in Burpee's Department Store, the Gas & Grocery, Mill New & Used Books, Food City at the foot of Main Street Hill, and half a dozen others, but the streetlights were dark and there were candles shining in the windows of most of Main Street's second-floor windows, where there were apartments.

Rose sat at a table in the middle of the room, smoking a cigarette (illegal in public buildings, but Barbie would never tell). She pulled the net off her head and gave Barbie a wan smile as he sat down across from her. Behind them Anson was swabbing the counter, his own shoulder-length hair now liberated from its Red Sox cap.

'I thought Fourth of July was bad, but this was worse,' Rose said. 'If you hadn't turned up, I'd be curled in the corner, screaming for my mommy.'

'There was a blonde in an F-150,' Barbie said, smiling at the memory. 'She almost gave me a ride. If she had, I might've been out. On the other hand, what happened to Chuck Thompson and the woman in that airplane with him might have happened to me.' Thompson's name had been part of CNN's coverage; the woman hadn't been identified.

But Rose knew. 'It was Claudette Sanders. I'm almost sure it was. Dodee told me yesterday that her mom had a lesson today.'

There was a plate of french fries between them on the table. Barbie had been reaching for one. Now he stopped. All at once he didn't want any more fries. Any more of anything. And the red puddle on the side of the plate looked more like blood than ketchup.

'So that's why Dodee didn't come in.'

Rose shrugged. 'Maybe. I can't say for sure. I haven't heard from her. Didn't really expect to, with the phones out.'

Barbie assumed she meant the landlines, but even from the kitchen he'd heard people complaining about trouble getting through on their cells. Most assumed it was because everyone was trying to use them at the same time, jamming the band. Some thought the influx of TV people – probably hundreds by this time, toting Nokias, Motorolas, iPhones, and BlackBerries – was causing the problem. Barbie had darker suspicions; this was a national security situation, after all, in a time when the whole country was paranoid about terrorism. Some calls were getting through, but fewer and fewer as the evening went on.

'Of course,' Rose said, 'Dodes might also have taken it into that air head of hers to blow off work and go to the Auburn Mall.'

'Does Mr Sanders know it was Claudette in the plane?'

'I can't say for sure, but I'd be awfully surprised if he doesn't by now.' And she sang, in a small but tuneful voice: 'It's a small town, you know what I mean?'

Barbie smiled a little and sang the next line back to her: 'Just a small town, baby, and we all support the team.' It was from an old James McMurtry song that had the previous summer gained a new and mysterious two-month vogue on a couple of western Maine c&w stations. Not WCIK, of course; James McMurtry was not the sort of artist Jesus Radio supported.

Rose pointed to the french fries. 'You going to eat any more of those?'

'Nope. Lost my appetite.'

Barbie had no great love for either the endlessly grinning Andy Sanders or for Dodee the Dim, who had almost certainly helped her good friend Angie spread the rumor that had caused Barbie's trouble at Dipper's, but the idea that those body parts (it was the green-clad leg his mind's eye kept trying to look at) had belonged to Dodee's *mother* . . . the First Selectman's *wife* . . .

'Me too,' Rose said, and put her cigarette out in the ketchup. It made a *pfisss* sound, and for one awful moment Barbie thought he was going to throw up. He turned his head and gazed out the window onto Main Street, although there was nothing to see from in here. From in here it was all dark.

'President's gonna speak at midnight,' Anson announced from the counter. From behind him came the low, constant groan of the dishwasher. It occurred to Barbie that the big old Hobart might be doing its last chore, at least for a while. He would have to convince Rosie of that. She'd be reluctant, but she'd see sense. She was a bright and practical woman.

Dodee Sanders's mother. Jesus. What are the odds?

He realized that the odds were actually not that bad. If it hadn't been Mrs Sanders, it might well have been someone else he knew. *It's a small town, baby, and we all support the team.*

'No President for me tonight,' Rose said. 'He'll have to God-bless-America on his own. Five o'clock comes early.' Sweetbriar Rose didn't open until seven on Sunday mornings, but there was prep. Always prep. And on Sundays, that included cinnamon rolls. 'You boys stay up and watch if you want to. Just make sure we're locked up tight when you leave. Front *and* back.' She started to rise.

'Rose, we need to talk about tomorrow,' Barbie said.

'Fiddle-dee-dee, tomorrow's another day. Let it go for now,

Barbie. All in good time.' But she must have seen something on his face, because she sat back down. 'All right, why the grim look?'

'When's the last time you got propane?'

'Last week. We're almost full. Is that all you're worried about?'

It wasn't, but it was where his worries started. Barbie calculated. Sweetbriar Rose had two tanks hooked together. Each tank had a capacity of either three hundred and twenty-five or three hundred and fifty gallons, he couldn't remember which. He'd check in the morning, but if Rose was right, she had over six hundred gallons on hand. That was good. A bit of luck on a day that had been spectacularly unlucky for the town as a whole. But there was no way of knowing how much bad luck could still be ahead. And six hundred gallons of propane wouldn't last forever.

'What's the burn rate?' he asked her. 'Any idea?'

'Why does that matter?'

'Because right now your generator is running this place. Lights, stoves, fridges, pumps. The furnace, too, if it gets cold enough to kick on tonight. And the gennie is eating propane to do it.'

They were quiet for a moment, listening to the steady roar of the almost-new Honda behind the restaurant.

Anson Wheeler came over and sat down. 'The gennie sucks two gallons of propane an hour at sixty percent utilization,' he said.

'How do you know that?' Barbie asked.

'Read it on the tag. Running everything, like we have since around noon, when the power went out, it probably ate three an hour. Maybe a little more.'

Rose's response was immediate. 'Anse, kill all the lights but the ones in the kitchen. Right now. And turn the furnace thermostat down to fifty.' She considered. 'No, turn it off.'

Barbie smiled and gave her a thumbs-up. She got it. Not everyone in The Mill would. Not everyone in The Mill would *want* to.

'Okay.' But Anson looked doubtful. 'You don't think by tomorrow morning . . . tomorrow afternoon at the latest . . . ?'

'The President of the United States is going to make a TV speech,' Barbie said. 'At midnight. What do *you* think, Anse?'

'I think I better turn off the lights,' he said.

'And the thermostat, don't forget that,' Rose said. As he hurried away, she said to Barbie: 'I'll do the same in my place when I go up.' A widow for ten years or more, she lived over her restaurant.

Barbie nodded. He had turned over one of the paper placemats ('Have You Visited These 20 Maine Landmarks?') and was figuring on the back. Twenty-seven to thirty gallons of propane burned since

the barrier went up. That left five hundred and seventy. If Rose could cut her use back to twenty-five gallons a day, she could theoretically keep going for three weeks. Cut back to twenty gallons a day – which she could probably do by closing between breakfast and lunch and again between lunch and dinner – and she could press on for nearly a month.

Which is fine enough, he thought. *Because if this town isn't open again after a month, there won't be anything here to cook, anyway.*

'What are you thinking?' Rose asked. 'And what's up with those numbers? I have no idea what they mean.'

'Because you're looking at them upside down,' Barbie said, and realized everyone in town was apt to do the same. These were figures no one would want to look at rightside up.

Rose turned Barbie's makeshift scratchpad toward her. She ran the numbers for herself. Then she raised her head and looked at Barbie, shocked. At that moment Anson turned most of the lights out, and the two of them were staring at each other in a gloom that was – to Barbie, at least – horribly persuasive. They could be in real trouble here.

'Twenty-eight days?' she asked. 'You think we need to plan for *four weeks*?'

'I don't know if we do or not, but when I was in Iraq, someone gave me a copy of Chairman Mao's *Little Red Book*. I carried it around in my pocket, read it cover to cover. Most of it makes more sense than our politicians do on their sanest days. One thing that stuck with me was this: *Wish for sunshine, but build dykes*. I think that's what we – you, I mean—'

'We,' she said, and touched his hand. He turned his over and clasped it.

'Okay, we. I think that's what we have to plan for. Which means closing between meals, cutting back on the ovens – no cinnamon rolls, even though I love em as much as anybody – and no dishwasher. It's old and energy inefficient. I know Dodee and Anson won't love the idea of washing dishes by hand . . .'

'I don't think we can count on Dodee coming back soon, maybe not at all. Not with her mother dead.' Rose sighed. 'I almost hope she *did* go to the Auburn Mall. Although I suppose it'll be in the papers tomorrow.'

'Maybe.' Barbie had no idea how much information was going to come out of or into Chester's Mill if this situation didn't resolve quickly, and with some rational explanation. Probably not much. He thought Maxwell Smart's fabled Cone of Silence would descend soon, if it hadn't already.

Anson came back to the table where Barbie and Rose were sitting. He had his jacket on. 'Is it okay for me to go now, Rose?'

'Sure,' she said. 'Six tomorrow?'

'Isn't that a little late?' He grinned and added, 'Not that I'm complaining.'

'We're going to open late.' She hesitated. 'And close between meals.'

'Really? Cool.' His gaze shifted to Barbie. 'You got a place to stay tonight? Because you can stay with me. Sada went to Derry to visit her folks.' Sada was Anson's wife.

Barbie in fact did have a place to go, almost directly across the street.

'Thanks, but I'll go back to my apartment. I'm paid up until the end of the month, so why not? I dropped off the keys with Petra Searles in the drugstore before I left this morning, but I still have a dupe on my key ring.'

'Okay. See you in the morning, Rose. Will you be here, Barbie?'

'Wouldn't miss it.'

Anson's grin widened. 'Excellent.'

When he was gone, Rose rubbed her eyes, then looked at Barbie grimly. 'How long is this going to go on? Best guess.'

'I don't *have* a best guess, because I don't know what happened. Or when it will *stop* happening.'

Very low, Rose said: 'Barbie, you're scaring me.'

'I'm scaring myself. We both need to go to bed. Things will look better in the morning.'

'After this discussion, I'll probably need an Ambien to get to sleep,' she said, 'tired as I am. But thank God you came back.'

Barbie remembered what he'd been thinking about supplies.

'One other thing. If Food City opens tomorrow—'

'It's always open on Sundays. Ten to six.'

'*If* it opens tomorrow, you need to go shopping.'

'But Sysco delivers on—' She broke off and stared at him dismally. 'On Tuesdays, but we can't count on that, can we? Of course not.'

'No,' he said. 'Even if what's wrong suddenly becomes right, the Army's apt to quarantine this burg, at least for a while.'

'What should I buy?'

'Everything, but especially meat. Meat, meat, meat. If the store opens. I'm not sure it will. Jim Rennie may persuade whoever manages it now—'

'Jack Cale. He took over when Ernie Calvert retired last year.'

'Well, Rennie may persuade him to close until further notice. Or get Chief Perkins to *order* the place closed.'

'You don't know?' Rose asked, and at his blank look: 'You don't. Duke Perkins is dead, Barbie. He died out there.' She gestured south.

Barbie stared at her, stunned. Anson had neglected to turn off the television, and behind them, Rose's Wolfie was again telling the world that an unexplained force had cut off a small town in western Maine, the area had been isolated by the armed forces, the Joint Chiefs were meeting in Washington, the President would address the nation at midnight, but in the meantime he was asking the American people to unite their prayers for the people of Chester's Mill with his own.

3

'Dad? *Dad?*'

Junior Rennie stood at the top of the stairs, head cocked, listening. There was no response, and the TV was silent. His dad was *always* home from work and in front of the TV by now. On Saturday nights he forwent CNN and FOX News for either Animal Planet or The History Channel. Not tonight, though. Junior listened to his watch to make sure it was still ticking. It was, and what it said sort of made sense, because it was dark outside.

A terrible thought occurred to him: Big Jim might be with Chief Perkins. The two of them could at this minute be discussing how to arrest Junior with the least possible fuss. And why had they waited so long? So they could spirit him out of town under cover of darkness. Take him to the county jail over in Castle Rock. Then a trial. And then?

Then Shawshank. After a few years there, he'd probably just call it The Shank, like the rest of the murderers, robbers, and sodomites.

'That's stupid,' he whispered, but was it? He'd awakened thinking that killing Angie had just been a dream, must have been, because he would never kill anyone. Beat them up, maybe, but *kill?* Ridiculous. He was . . . was . . . well . . . *a regular person!*

Then he'd looked at the clothes under the bed, seen the blood on them, and it all came back. The towel falling off her hair. Her pussypatch, somehow goading him. The complicated crunching sound from behind her face when he'd gotten her with his knee. The rain of fridge magnets and the way she had thrashed.

But that wasn't me. That was . . .

'It was the headache.' Yes. True. But who'd believe that? He'd have better luck if he said the butler did it.

'*Dad?*'

Nothing. Not here. And not at the police station, conspiring against him, either. Not his dad. He wouldn't. His dad always said family came first.

But *did* family come first? Of course he *said* that – he was a Christian, after all, and half-owner of WCIK – but Junior had an idea that for his dad, Jim Rennie's Used Cars might come before family, and that being the town's First Selectman might come before the Holy Tabernacle of No Money Down.

Junior could be – it was possible – third in line.

He realized (for the first time in his life; it was a genuine flash of insight) that he was only guessing. That he might not really know his father at all.

He went back to his room and turned on the overhead. It cast an odd unsteady light, waxing bright and then dim. For a moment Junior thought something was wrong with his eyes. Then he realized he could hear their generator running out back. And not just theirs, either. The town's power was out. He felt a surge of relief. A big power outage explained everything. It meant his father was likely in the Town Hall conference room, discussing matters with those other two idiots, Sanders and Grinnell. Maybe sticking pins in the big map of the town, making like George Patton. Yelling at Western Maine Power and calling them a bunch of lazy cotton-pickers.

Junior got his bloody clothes, raked the shit out of his jeans – wallet, change, keys, comb, an extra headache pill – and redistributed it in the pockets of his clean pants. He hurried downstairs, stuck the incriminating garments in the washer, set it for hot, then reconsidered, remembering something his mother had told him when he was no more than ten: cold water for bloodstains. As he moved the dial to COLD WASH/COLD RINSE, Junior wondered idly if his dad had started his hobby of secretary-fucking way back then, or if he was still keeping his cotton-picking penis at home.

He started the washer going and thought about what to do next. With the headache gone, he found that he *could* think.

He decided he should go back to Angie's house after all. He didn't want to – God almighty, it was the *last* thing he wanted to do – but he probably should scope out the scene. Walk past and see how many police cars were there. Also whether or not the Castle County forensics van was there. Forensics was key. He knew that from watching *CSI*. He'd seen the big blue-and-white van before, while visiting the county courthouse with his dad. And if it was at the McCains' . . .

I'll run.

Yes. As fast and far as he could. But before he did, he'd come back here and visit the safe in his dad's study. His dad didn't think Junior knew the combo to that safe, but Junior did. Just as he knew the password to his dad's computer, and thus about his dad's penchant for watching what Junior and Frank DeLesseps called Oreo sex: two black chicks, one white guy. There was plenty of money in that safe. Thousands of dollars.

What if you see the van and come back and he's here?

The money first, then. The money right now.

He went into the study and for a moment thought he saw his father sitting in the high-backed chair where he watched the news and nature programs. He'd fallen asleep, or . . . what if he'd had a heart attack? Big Jim had had heart problems off and on for the last three years; mostly arrhythmia. He usually went up to Cathy Russell and either Doc Haskell or Doc Rayburn buzzed him with something, got him back to normal. Haskell would have been content to keep on doing that forever, but Rayburn (whom his father called 'an overeducated cotton-picker') had finally insisted that Big Jim see a cardiologist at CMG in Lewiston. The cardiologist said he needed a procedure to knock out that irregular heartbeat once and for all. Big Jim (who was terrified of hospitals) said he needed to talk to God more, and you called that a *prayer* procedure. Meantime, he took his pills, and for the last few months he'd seemed fine, but now . . . maybe . . .

'Dad?'

No answer. Junior flipped the light switch. The overhead gave that same unsteady glow, but it dispelled the shadow Junior had taken for the back of his father's head. He wouldn't be exactly heartbroken if his dad vaporlocked, but on the whole he was glad it hadn't happened tonight. There was such a thing as too many complications.

Still, he walked to the wall where the safe was with big soft steps of cartoon caution, watching for the splash of headlights across the window that would herald his father's return. He set aside the picture that covered the safe (Jesus giving the Sermon on the Mount), and ran the combination. He had to do it twice before the handle would turn, because his hands were shaking.

The safe was stuffed with cash and stacks of parchment-like sheets with the words **BEARER BONDS** stamped on them. Junior gave a low whistle. The last time he'd opened this – to filch fifty for last year's Fryeburg Fair – there had been plenty of cash, but nowhere near this much. And no **BEARER BONDS.** He thought of the plaque on his father's desk at the car store: WOULD JESUS APPROVE OF THIS DEAL? Even in his distress and fear, Junior found time to

wonder if Jesus would approve of whatever deal his dad had going on the side these days.

'Never mind his business, I gotta run mine,' he said in a low voice. He took five hundred in fifties and twenties, started to close the safe, reconsidered, and took some of the hundreds as well. Given the obscene glut of cash in there, his dad might not even miss it. If he did, it was possible he'd understand why Junior had taken it. And might approve. As Big Jim always said, 'The Lord helps those who help themselves.'

In that spirit, Junior helped himself to another four hundred. Then he closed the safe, spun the combo, and hung Jesus back on the wall. He grabbed a jacket from the front hall closet and went out while the generator roared and the Maytag sudsed Angie's blood from his clothes.

4

There was no one at the McCains' house.

Fucking *no one*.

Junior lurked on the other side of the street, in a moderate shower of maple leaves, wondering if he could trust what he was seeing: the house dark, Henry McCain's 4Runner and LaDonna's Prius still not in evidence. It seemed too good to be true, far too good.

Maybe they were on the town common. A lot of people were tonight. Possibly they were discussing the power failure, although Junior couldn't remember any such gatherings before when the lights went out; people mostly went home and went to bed, sure that – unless there'd been a whopper of a storm – the lights would be back on when they got up for breakfast.

Maybe this power failure had been caused by some spectacular accident, the kind of thing the TV news broke into regular coverage to report. Junior had a vague memory of some geezer asking him what was going on not long after Angie had her own accident. In any case, Junior had taken care to speak to nobody on his way over here. He had walked along Main Street with his head down and his collar turned up (he had, in fact, almost bumped into Anson Wheeler as Anse left Sweetbriar Rose). The streetlights were out, and that helped preserve his anonymity. Another gift from the gods.

And now this. A third gift. A *gigantic* one. Was it really possible that Angie's body hadn't been discovered yet? Or was he looking at a trap?

Junior could picture the Castle County Sheriff or a state police detective saying, *We only have to keep out of sight and wait, boys. The killer always revisits the scene of his crime. It's a well-known fact.*

TV bullshit. Still, as he crossed the street (drawn, it seemed, by a force outside himself), Junior kept expecting spotlights to go on, pinning him like a butterfly on a piece of cardboard; kept expecting someone to shout – probably through a bullhorn: *'Stop where you are and get those hands in the air!'*

Nothing happened.

When he reached the foot of the McCain driveway, heart skittering in his chest and blood thumping in his temples (still no headache, though, and that was good, a good sign), the house remained dark and silent. Not even a generator roaring, although there was one at the Grinnells' next door.

Junior looked over his shoulder and saw a vast white bubble of light rising above the trees. Something at the south end of town, or perhaps over in Motton. The source of the accident that had killed the power? Probably.

He went to the back door. The front door would still be unlocked if no one had returned since Angie's accident, but he didn't want to go in the front. He would if he had to, but maybe he wouldn't. He was, after all, on a roll.

The doorknob turned.

Junior stuck his head into the kitchen and smelled the blood at once – an odor a little like spray starch, only gone stale. He said, 'Hi? Hello? Anybody home?' Almost positive there wasn't, but if someone was, if by some crazy chance Henry or LaDonna had parked over by the common and returned on foot (somehow missing their daughter lying dead on the kitchen floor), he would scream. Yes! Scream and 'discover the body.' That wouldn't do anything about the dreaded forensics van, but it would buy him a little time.

'Hello? Mr McCain? Mrs McCain?' And then, in a flash of inspiration: 'Angie? Are you home?'

Would he call her like that if he'd killed her? Of course not! But then a terrible thought lanced through him: What if she answered? Answered from where she was lying on the floor? Answered through a throatful of blood?

'Get a grip,' he muttered. Yes, he had to, but it was hard. Especially in the dark. Besides, in the Bible stuff like that happened all the time. In the Bible, people sometimes returned to life like the zombies in *Night of the Living Dead.*

'Anybody home?'

Zip. *Nada.*

His eyes had adjusted to the gloom, but not enough. He needed a light. He should've brought a flashlight from the house, but it was

easy to forget stuff like that when you were used to just flipping a switch. Junior crossed the kitchen, stepping over Angie's body, and opened the first of two doors on the far side. It was a pantry. He could just make out the shelves of bottled and canned goods. He tried the other door and had better luck. It was the laundry. And unless he was mistaken about the shape of the thing standing on the shelf just to his right, he was still on a roll.

He wasn't mistaken. It was a flashlight, a nice bright one. He'd have to be careful about shining it around the kitchen – easing down the shades would be an excellent idea – but in the laundry room he could shine it around to his heart's content. In here he was fine.

Soap powder. Bleach. Fabric softener. A bucket and a Swiffer. Good. With no generator there'd only be cold water, but there would probably be enough to fill one bucket from the taps, and then, of course, there were the various toilet tanks. And cold was what he wanted. Cold for blood.

He would clean like the demon housekeeper his mother had once been, mindful of her husband's exhortation: 'Clean house, clean hands, clean heart.' He would clean up the blood. Then he'd wipe everything he could remember touching and everything he might have touched without remembering. But first . . .

The body. He had to do something with the body.

Junior decided the pantry would do for the time being. He dragged her in by the arms, then let them go: *flump*. After that he set to work. He sang under his breath as he first replaced the fridge magnets, then drew the shades. He had filled the bucket almost to the top before the faucet started spitting. Another bonus.

He was still scrubbing, the work well begun but nowhere near done, when the knock came at the front door.

Junior looked up, eyes wide, lips drawn back in a humorless grin of horror.

'Angie?' It was a girl, and she was sobbing. 'Angie, are you there?' More knocking, and then the door opened. His roll, it seemed, was over. 'Angie, *please* be here. I saw your car in the garage . . .'

Shit. The garage! He never checked the fucking garage!

'Angie?' Sobbing again. Someone he knew. Oh God, was it that idiot Dodee Sanders? It was. 'Angie, she said my mom's dead! Mrs Shumway said that she *died*!'

Junior hoped she'd go upstairs first, check Angie's room. But she came down the hall toward the kitchen instead, moving slowly and tentatively in the dark.

'Angie? Are you in the kitchen? I thought I saw a light.'

Junior's head was starting to ache again, and it was this inter-
fering dope-smoking cunt's fault. Whatever happened next . . . that
would be her fault, too.

5

Dodee Sanders was still a little stoned and a little drunk; she was
hungover; her mother was dead; she was fumbling up the hall of her
best friend's house in the dark; she stepped on something that slid
away under her foot and almost went ass over teapot. She grabbed
at the stair railing, bent two of her fingers painfully back, and cried
out. She sort of understood all this was happening to her, but at the
same time it was impossible to believe. She felt as if she'd wandered
into some parallel dimension, like in a science fiction movie.

She bent to see what had nearly spilled her. It looked like a
towel. Some fool had left a towel on the front hall floor. Then she
thought she heard someone moving in the darkness up ahead. In the
kitchen.

'Angie? Is that you?'

Nothing. She still felt someone was there, but maybe not.

'Angie?' She shuffled forward again, holding her throbbing right
hand – her fingers were going to swell, she thought they were swelling
already – against her side. She held her left hand out before her,
feeling the dark air. 'Angie, *please* be there! My mother's dead, it's not
a joke, Mrs Shumway told me and she doesn't joke, I *need* you!'

The day had started so well. She'd been up early (well . . . ten;
early for her) and she'd had no intention of blowing off work. Then
Samantha Bushey had called to say she'd gotten some new Bratz on
eBay and to ask if Dodee wanted to come over and help torture
them. Bratz-torture was something they'd gotten into in high school
– buy them at yard sales, then hang them, pound nails into their
stupid little heads, douse them with lighter fluid and set them on fire
– and Dodee knew they should have grown out of it, they were
adults now, or almost. It was kid-stuff. Also a little creepy, when you
really thought about it. But the thing was, Sammy had her own place
out on the Motton Road – just a trailer, but all hers since her husband
had taken off in the spring – and Little Walter slept practically all
day. Plus Sammy usually had bitchin weed. Dodee guessed she got it
from the guys she partied with. Her trailer was a popular place on
the weekends. But the thing was, Dodee had sworn off weed. Never
again, not since all that trouble with the cook. Never again had lasted
over a week on the day Sammy called.

'You can have Jade and Yasmin,' Sammy coaxed. 'Also, I've got some great you-know.' She always said that, as if someone listening in wouldn't know what she was talking about. 'Also, we can you-know.'

Dodee knew what *that* you-know was, too, and she felt a little tingle Down There (in her you-know), even though that was *also* kid stuff, and they should have left it behind long ago.

'I don't think so, Sam. I have to be at work at two, and—'

'Yasmin awaits,' Sammy said. 'And you know you hate dat bitch.'

Well, that was true. Yasmin was the bitchiest of the Bratz, in Dodee's opinion. And it was almost four hours until two o'clock. Further *and*, if she was a little late, so what? Was Rose going to fire her? Who else would work that shit job?

'Okay. But just for a little while. And only because I hate Yasmin.'

Sammy giggled.

'But I don't you-know anymore. *Either* you-know.'

'Not a problem,' Sammy said. 'Come quick.'

So Dodee had driven out, and of course she discovered Bratz-torture was no fun if you weren't a little high, so she got a little high and so did Sammy. They collaborated on giving Yasmin some drain-cleaner plastic surgery, which was pretty hilarious. Then Sammy wanted to show her this sweet new camisole she'd gotten at Deb, and although Sam was getting a little bit of a potbelly, she still looked good to Dodee, perhaps because they were a little bit stoned – wrecked, in fact – and since Little Walter was still asleep (his father had insisted on naming the kid after some old bluesman, and all that *sleeping*, yow, Dodee had an idea Little Walter was retarded, which would be no surprise given the amount of rope Sam had smoked while carrying him), they ended up getting into Sammy's bed and doing a little of the old you-know. Afterward they'd fallen asleep, and when Dodee woke up Little Walter was blatting – holy shit, call NewsCenter 6 – and it was past five. Really too late to go in to work, and besides, Sam had produced a bottle of Johnnie Walker Black, and they had one-shot two-shot three-shot-four, and Sammy decided she wanted to see what happened to a Baby Bratz in the microwave, only the power was out.

Dodee had crept back to town at roughly sixteen miles an hour, still high and paranoid as hell, constantly checking the rearview mirror for cops, knowing if she did get stopped it would be by that redhaired bitch Jackie Wettington. Or her father would be taking a break from the store and he'd smell the booze on her breath. Or her mother would be home, so tired out from her stupid flying lesson that she had decided to stay home from the Eastern Star Bingo.

Please, God, she prayed. *Please get me through this and I'll never you-know again.* Either *you-know. Never in this life.*

God heard her prayer. Nobody was home. The power was out here too, but in her altered state, Dodee hardly noticed. She crept upstairs to her room, shucked out of her pants and shirt, and lay down on her bed. Just for a few minutes, she told herself. Then she'd put her clothes, which smelled of *ganja,* in the washer, and put herself in the shower. She smelled of Sammy's perfume, which she must buy a gallon at a time down at Burpee's.

Only she couldn't set the alarm with the power out and when the knocking at the door woke her up it was dark. She grabbed her robe and went downstairs, suddenly sure that it would be the redheaded cop with the big boobs, ready to put her under arrest for driving under the influence. Maybe for crack-snacking, too. Dodee didn't think that particular you-know was against the law, but she wasn't entirely sure.

It wasn't Jackie Wettington. It was Julia Shumway, the editor-publisher of the *Democrat.* She had a flashlight in one hand. She shined it in Dodee's face – which was probably puffed with sleep, her eyes surely still red and her hair a haystack – and then lowered it again. Enough light kicked up to show Julia's own face, and Dodee saw a sympathy there that made her feel confused and afraid.

'Poor kid,' Julia said. 'You don't know, do you?'

'Don't know what?' Dodee had asked. It was around then that the parallel universe feeling had started. 'Don't know *what*?'

And Julia Shumway had told her.

6

'Angie? Angie, *please!*'

Fumbling her way up the hall. Hand throbbing. *Head* throbbing.

She could have looked for her father – Mrs Shumway had offered to take her, starting at Bowie Funeral Home – but her blood ran cold at the thought of that place. Besides, it was Angie that she wanted. Angie who would hug her tight with no interest in the you-know. Angie who was her best friend.

A shadow came out of the kitchen and moved swiftly toward her.

'There you are, thank God!' She began to sob harder, and hurried toward the figure with her arms outstretched. 'Oh, it's awful! I'm being punished for being a bad girl, I know I am!'

The dark figure stretched out its own arms, but they did not enfold Dodee in a hug. Instead, the hands at the end of those arms closed around her throat.

THE GOOD OF THE TOWN, THE GOOD OF THE PEOPLE

1

Andy Sanders was indeed at the Bowie Funeral Home. He had walked there, toting a heavy load: bewilderment, grief, a broken heart.

He was sitting in Remembrance Parlor I, his only company in the coffin at the front of the room. Gertrude Evans, eighty-seven (or maybe eighty-eight), had died of congestive heart failure two days before. Andy had sent a condolence note, although God knew who'd eventually receive it; Gert's husband had died a decade ago. It didn't matter. He always sent condolences when one of his constituents died, handwritten on a sheet of cream stationery reading FROM THE DESK OF THE FIRST SELECTMAN. He felt it was part of his duty.

Big Jim couldn't be bothered with such things. Big Jim was too busy running what he called 'our business,' by which he meant Chester's Mill. Ran it like his own private railroad, in point of fact, but Andy had never resented this; he understood that Big Jim was *smart*. Andy understood something else, as well: without Andrew DeLois Sanders, Big Jim probably couldn't have been elected dogcatcher. Big Jim could sell used cars by promising eye-watering deals, low-low financing, and premiums like cheap Korean vacuum cleaners, but when he'd tried to get the Toyota dealership that time, the company had settled on Will Freeman instead. Given his sales figures and location out on 119, Big Jim hadn't been able to under-stand how Toyota could be so stupid.

Andy could. He maybe wasn't the brightest bear in the woods, but he knew Big Jim had no warmth. He was a hard man (some – those who'd come a cropper on all that low-low financing, for instance – would have said hardhearted), and he was persuasive, but he was also chilly. Andy, on the other hand, had warmth to spare. When he went around town at election time, Andy told folks that he and Big Jim were like the Doublemint Twins, or Click and Clack, or peanut butter and jelly, and Chester's Mill wouldn't be the same without both of them in harness (along with whichever third happened to be currently along for the ride – right now Rose Twitchell's sister, Andrea Grinnell). Andy had always enjoyed his partnership with Big Jim. Financially, yes, especially during the last two or three years, but also in his heart. Big Jim knew how to get things done, and why they *should* be done. *We're in this for the long haul*, he'd say. *We're doing*

it for the town. For the people. For their own good. And that was good. Doing good was good.

But now . . . tonight . . .

'I hated those flying lessons from the first,' he said, and began to cry again. Soon he was sobbing noisily, but that was all right, because Brenda Perkins had left in silent tears after viewing the remains of her husband, and the Bowie brothers were downstairs. They had a lot of work to do (Andy understood, in a vague way, that something very bad had happened). Fern Bowie had gone out for a bite at Sweetbriar Rose, and when he came back, Andy was sure Fern would kick him out, but Fern passed down the hall without even looking in at where Andy sat with his hands between his knees and his tie loosened and his hair in disarray.

Fern had descended to what he and his brother Stewart called 'the workroom.' (Horrible; horrible!) Duke Perkins was down there. Also that damned old Chuck Thompson, who maybe hadn't talked his wife into those flying lessons but sure hadn't talked her out of them, either. Maybe others were down there, too.

Claudette for sure.

Andy voiced a watery groan and clasped his hands together more tightly. He couldn't live without her; no way could he live without her. And not just because he'd loved her more than his own life. It was Claudette (along with regular, unreported, and ever larger cash infusions from Jim Rennie) who kept the drugstore going; on his own, Andy would have run it into bankruptcy before the turn of the century. His specialty was people, not accounts and ledgers. His wife was the numbers specialist. Or had been.

As the past perfect clanged in his mind, Andy groaned again.

Claudette and Big Jim had even collaborated on fixing up the town's books that time when the state audited them. It was supposed to be a surprise audit, but Big Jim had gotten advance word. Not much; just enough for them to go to work with the computer program Claudette called MR CLEAN. They called it that because it always produced clean numbers. They'd come out of that audit shiny side up instead of going to jail (which wouldn't have been fair, since most of what they were doing – almost all, in fact – was for the town's own good).

The truth about Claudette Sanders was this: she'd been a prettier Jim Rennie, a *kinder* Jim Rennie, one he could sleep with and tell his secrets to, and life without her was unthinkable.

Andy started to tear up again, and that was when Big Jim himself put a hand on his shoulder and squeezed. Andy hadn't heard him

come in, but he didn't jump. He had almost expected the hand, because its owner always seemed to turn up when Andy needed him the most.

'I thought I'd find you here,' Big Jim said. 'Andy – pal – I'm just so, so sorry.'

Andy lurched to his feet, groped his arms around Big Jim's bulk, and began to sob against Big Jim's jacket. '*I told her those lessons were dangerous! I told her Chuck Thompson was a jackass, just like his father!*'

Big Jim rubbed his back with a soothing palm. 'I know. But she's in a better place now, Andy – she had dinner with Jesus Christ tonight – roast beef, fresh peas, mashed with gravy! How's that for an awesome thought? You hang onto that. Think we should pray?'

'Yes!' Andy sobbed. 'Yes, Big Jim! Pray with me!'

They got on their knees and Big Jim prayed long and hard for the soul of Claudette Sanders. (Below them, in the workroom, Stewart Bowie heard, looked up at the ceiling, and observed: 'That man shits from both ends.')

After four or five minutes of *we see through a glass darkly* and *when I was a child I spake as a child* (Andy didn't quite see the relevance of that one, but didn't care; it was comforting just to be kneebound with Big Jim), Rennie finished up – 'For Jesussakeamen' – and helped Andy to his feet.

Face-to-face and bosom to bosom, Big Jim grasped Andy by the upper arms and looked into his eyes. 'So, partner,' he said. He always called Andy partner when the situation was serious. 'Are you ready to go to work?'

Andy stared at him dumbly.

Big Jim nodded as if Andy had made a reasonable (under the circumstances) protest. 'I know it's hard. Not fair. Inappropriate time to ask you. And you'd be within your rights – God knows you would – if you were to bust me one right in the cotton-picking chops. But sometimes we have to put the welfare of others first – isn't that true?'

'The good of the town,' Andy said. For the first time since getting the news about Claudie, he saw a sliver of light.

Big Jim nodded. His face was solemn, but his eyes were shining. Andy had a strange thought: *He looks ten years younger.* 'Right you are. We're custodians, partner. Custodians of the common good. Not always easy, but never unnecessary. I sent the Wettington woman to hunt up Andrea. Told her to bring Andrea to the conference room. In handcuffs, if that's what it takes.' Big Jim laughed. 'She'll be there. And Pete Randolph's making a list of all the available town cops. Aren't enough. We've got to address that, partner. If this situation goes

on, authority's going to be key. So what do you say? Can you suit up for me?'

Andy nodded. He thought it might take his mind off this. Even if it didn't, he needed to make like a bee and buzz. Looking at Gert Evans's coffin was beginning to give him the willies. The silent tears of the Chief's widow had given him the willies, too. And it wouldn't be hard. All he really needed to do was sit there at the conference table and raise his hand when Big Jim raised his. Andrea Grinnell, who never seemed entirely awake, would do the same. If emergency measures of some sort needed to be implemented, Big Jim would see that they were. Big Jim would take care of everything.

'Let's go,' Andy replied.

Big Jim clapped him on the back, slung an arm over Andy's thin shoulders, and led him out of the Remembrance Parlor. It was a heavy arm. Meaty. But it felt good.

He never even thought of his daughter. In his grief, Andy Sanders had forgotten her entirely.

2

Julia Shumway walked slowly down Commonwealth Street, home of the town's wealthiest residents, toward Main Street. Happily divorced for ten years, she lived over the offices of the *Democrat* with Horace, her elderly Welsh corgi. She had named him after the great Mr Greeley, who was remembered for a single bon mot – 'Go West, young man, go West' – but whose real claim to fame, in Julia's mind, was his work as a newspaper editor. If Julia could do work half as good as Greeley's on the New York *Trib*, she would consider herself a success.

Of course, *her* Horace always considered her a success, which made him the nicest dog on earth, in Julia's book. She would walk him as soon as she got home, then enhance herself further in his eyes by scattering a few pieces of last night's steak on top of his kibble. That would make them both feel good, and she wanted to feel good – about something, anything – because she was troubled.

This was not a new state for her. She had lived in The Mill for all of her forty-three years, and in the last ten she liked what she saw in her hometown less and less. She worried about the inexplicable decay of the town's sewer system and waste treatment plant in spite of all the money that had been poured into them, she worried about the impending closure of Cloud Top, the town's ski resort, she worried that James Rennie was stealing even more from the town till than she suspected (and she suspected he had been stealing a great deal

for decades). And of course she was worried about this new thing, which seemed to her almost too big to comprehend. Every time she tried to get a handle on it, her mind would fix on some part that was small but concrete: her increasing inability to place calls on her cell phone, for instance. And she hadn't *received* a single one, which was very troubling. Never mind concerned friends and relatives outside of town trying to get in touch; she should have been jammed up with calls from other papers: the Lewiston *Sun*, the Portland *Press Herald*, perhaps even the *New York Times*.

Was everyone else in The Mill having the same problems?

She should go out to the Motton town line and see for herself. If she couldn't use her phone to buzz Pete Freeman, her best photographer, she could take some pix herself with what she called her Emergency Nikon. She had heard there was now some sort of quarantine zone in place on the Motton and Tarker's Mills sides of the barrier – probably the other towns, as well – but surely she could get close on this side. They could warn her off, but if the barrier was as impermeable as she was hearing, warning would be the extent of it.

'Sticks and stones will break my bones, but words will never hurt me,' she said. Absolutely true. If words *could* hurt her, Jim Rennie would have had her in ICU after the story she'd written about that joke audit the state had pulled three years ago. Certainly he'd blabbed aplenty-o about suing the paper, but blabbing was all it had been; she had even briefly considered an editorial on the subject, mostly because she had a terrific headline: SUPPOSED SUIT SLIPS FROM SIGHT.

So, yes, she had worries. They came with the job. What she wasn't used to worrying about was her own behavior, and now, standing on the corner of Main and Comm, she was. Instead of turning left on Main, she looked back the way she had come. And spoke in the low murmur she usually reserved for Horace. 'I shouldn't have left that girl alone.'

Julia would not have done, if she'd come in her car. But she'd come on foot, and besides – Dodee had been so *insistent*. There had been a smell about her, too. Pot? Maybe. Not that Julia had any strong objections to that. She had smoked her own share over the years. And maybe it would calm the girl. Take the edge off her grief while it was sharpest and most likely to cut.

'Don't worry about me,' Dodee had said, 'I'll find my dad. But first I have to dress.' And indicated the robe she was wearing.

'I'll wait,' Julia had replied . . . although she didn't *want* to wait.

She had a long night ahead of her, beginning with her duty to her dog. Horace must be close to bursting by now, having missed his five o'clock walk, and he'd be hungry. When those things were taken care of, she really had to go out to what people were calling the barrier. See it for herself. Photograph whatever there was to be photographed.

Even that wouldn't be the end. She'd have to see about putting out some sort of extra edition of the *Democrat*. It was important to her and she thought it might be important to the town. Of course, all this might be over tomorrow, but Julia had a feeling – partly in her head, partly in her heart – that it wouldn't be.

And yet. Dodee Sanders should not have been left alone. She'd seemed to be holding herself together, but that might only have been shock and denial masquerading as calm. And the dope, of course. But she *had* been coherent.

'You don't need to wait. I don't want you to wait.'

'I don't know if being alone right now is wise, dear.'

'I'll go to Angie's,' Dodee said, and seemed to brighten a little at the thought even as the tears continued to roll down her cheeks. 'She'll go with me to find Daddy.' She nodded. 'Angie's the one I want.'

In Julia's opinion, the McCain girl had only marginally more sense than this one, who had inherited her mother's looks but – unfortunately – her father's brains. Angie was a friend, though, and if ever there was a friend in need who needed a friend indeed, it was Dodee Sanders tonight.

'I could go with you . . .' Not wanting to. Knowing that, even in her current state of fresh bereavement, the girl could probably see that.

'No. It's only a few blocks.'

'Well . . .'

'Ms Shumway . . . are you *sure*? Are you sure my mother—?'

Very reluctantly, Julia had nodded. She'd gotten confirmation of the airplane's tail number from Ernie Calvert. She'd gotten something else from him as well, a thing that should more properly have gone to the police. Julia might have insisted that Ernie take it to them, but for the dismaying news that Duke Perkins was dead and that incompetent weasel Randolph was in charge.

What Ernie gave her was Claudette's bloodstained driver's license. It had been in Julia's pocket as she stood on the Sanders stoop, and in her pocket it had stayed. She'd give it either to Andy or to this pale, mussy-haired girl when the right time came . . . but this was not the time.

'Thank you,' Dodee had said in a sadly formal tone of voice. 'Now please go away. I don't mean to be crappy about it, but—' She never finished the thought, only closed the door on it.

And what had Julia Shumway done? Obeyed the command of a grief-stricken twenty-year-old girl who might be too stoned to be fully responsible for herself. But there were other responsibilities tonight, hard as that was. Horace, for one. And the newspaper. People might make fun of Pete Freeman's grainy black-and-white photos and the *Democrat*'s exhaustive coverage of such local fetes as Mill Middle School's Enchanted Night dance; they might claim its only practical use was as a cat-box liner – but they needed it, especially when something bad happened. Julia meant to see that they had it tomorrow, even if she had to stay up all night. Which, with both of her regular reporters out of town for the weekend, she probably would.

Julia found herself actually looking forward to this challenge, and Dodee Sanders's woeful face began to slip from her mind.

3

Horace looked at her reproachfully when she came in, but there were no damp patches on the carpet and no little brown package under the chair in the hall – a magic spot he seemed to believe invisible to human eyes. She snapped his leash on, took him out, and waited patiently while he pissed by his favorite sewer, tottering as he did it; Horace was fifteen, old for a corgi. While he went, she stared at the white bubble of light on the southern horizon. It looked to her like an image out of a Steven Spielberg science fiction movie. It was bigger than ever, and she could hear the *whupapa-whuppa-whuppa* of helicopters, faint but constant. She even saw one in silhouette, speeding across that tall arc of brilliance. How many Christing spotlights had they set up out there, anyway? It was as if North Motton had become an LZ in Iraq.

Horace was now walking in lazy circles, sniffing out the perfect place to finish tonight's ritual of elimination, doing that ever-popular doggie dance, the Poop Walk. Julia took the opportunity to try her cell phone again. As had been the case all too often tonight, she got the normal series of peeping tones . . . and then nothing but silence.

I'll have to Xerox the paper. Which means seven hundred and fifty copies, max.

The *Democrat* hadn't printed its own paper for twenty years. Until 2002, Julia had taken each week's dummy over to View Printing in Castle Rock, and now she didn't even have to do that. She e-mailed

the pages on Tuesday nights, and the finished papers, neatly bound in plastic, were delivered by View Printing before seven o'clock the next morning. To Julia, who'd grown up dealing with penciled corrections and typewritten copy that was 'nailed' when it was finished, this seemed like magic. And, like all magic, slightly untrustworthy.

Tonight, the mistrust was justified. She might still be able to e-mail comps to View Printing, but no one would be able to deliver the finished papers in the morning. She guessed that by the morning, nobody would be able to get within five miles of The Mill's borders. *Any* of its borders. Luckily for her, there was a nice big generator in the former print room, her photocopying machine was a monster, and she had over five hundred reams of paper stacked out back. If she could get Pete Freeman to help her ... or Tony Guay, who covered sports ...

Horace, meanwhile, had finally assumed the position. When he was done, she swung into action with a small green bag labeled Doggie Doo, wondering to herself what Horace Greeley would have thought of a world where picking up dogshit from the gutter was not just socially expected but a legal responsibility. She thought he might have shot himself.

Once the bag was filled and tied off, she tried her phone again. Nothing.

She took Horace back inside and fed him.

4

Her cell rang while she was buttoning her coat to drive out to the barrier. She had her camera over her shoulder and almost dropped it, scrabbling in her pocket. She looked at the number and saw the words PRIVATE CALLER.

'Hello?' she said, and there must have been something in her voice, because Horace – waiting by the door, more than ready for a nighttime expedition now that he was cleaned out and fed – pricked up his ears and looked around at her.

'Mrs Shumway?' A man's voice. Clipped. Official-sounding.

'*Ms* Shumway. To whom am I speaking?'

'Colonel James Cox, Ms Shumway. United States Army.'

'And to what do I owe the honor of this call?' She heard the sarcasm in her voice and didn't like it – it wasn't professional – but she was afraid, and sarcasm had ever been her response to fear.

'I need to get in touch with a man named Dale Barbara. Do you know this man?'

Of course she did. And had been surprised to see him at Sweet-briar earlier tonight. He was crazy to still be in town, and hadn't Rose herself said just yesterday that he had given notice? Dale Barbara's story was one of hundreds Julia knew but hadn't written. When you published a smalltown newspaper, you left the lids on a great many cans of worms. You had to pick your fights. The way she was sure Junior Rennie and his friends picked theirs. And she doubted very much if the rumors about Barbara and Dodee's good friend Angie were true, anyway. For one thing, she thought Barbara had more taste.

'Ms Shumway?' Crisp. Official. An on-the-outside voice. She could resent the owner of the voice just for that. 'Still with me?'

'Still with you. Yes, I know Dale Barbara. He cooks at the restaurant on Main Street. Why?'

'He has no cell phone, it seems, the restaurant doesn't answer—'

'It's closed—'

'—and the landlines don't work, of course.'

'Nothing in this town seems to work very well tonight, Colonel Cox. Cell phones included. But I notice you didn't have any trouble getting through to me, which makes me wonder if you fellows might not be responsible for that.' Her fury – like her sarcasm, born of fear – surprised her. 'What did you *do*? What did you people *do*?'

'Nothing. So far as I know now, nothing.'

She was so surprised she could think of no follow-up. Which was very unlike the Julia Shumway longtime Mill residents knew.

'The cell phones, yes,' he said. 'Calls in and out of Chester's Mill are pretty well shut down now. In the interests of national security. And with all due respect, ma'am, you would have done the same, in our position.'

'I doubt that.'

'Do you?' He sounded interested, not angry. 'In a situation that's unprecedented in the history of the world, and suggestive of tech-nology far beyond what we or anyone else can even understand?'

Once more she found herself stuck for a reply.

'It's quite important that I speak to Captain Barbara,' he said, returning to his original scripture. In a way, Julia was surprised he'd wandered as far off-message as he had.

'*Captain* Barbara?'

'Retired. Can you find him? Take your cell phone. I'll give you a number to call. It'll go through.'

'Why me, Colonel Cox? Why didn't you call the police station? Or one of the town selectmen? I believe all three of them are here.'

'I didn't even try. I grew up in a small town, Ms Shumway—'

'Bully for you.'

'—and in my experience, town politicians know a little, the town cops know a lot, and the local newspaper editor knows everything.'

That made her laugh in spite of herself.

'Why bother with a call when you two can meet face-to-face? With me as your chaperone, of course. I'm going out to my side of the barrier – was leaving when you called, in fact. I'll hunt Barbie up—'

'Still calling himself that, is he?' Cox sounded bemused.

'I'll hunt him up and bring him with me. We can have a mini press conference.'

'I'm not in Maine. I'm in D.C. With the Joint Chiefs.'

'Is that supposed to impress me?' Although it did, a little.

'Ms Shumway, I'm busy, and probably you are, too. So, in the interests of resolving this thing—'

'Is that possible, do you think?'

'Quit it,' he said. 'You were undoubtedly a reporter before you were an editor, and I'm sure asking questions comes naturally to you, but time is a factor here. Can you do as I ask?'

'I can. But if you want him, you get me, too. We'll come out 119 and call you from there.'

'No,' he said.

'That's fine,' she said pleasantly. 'It's been very nice talking to you, Colonel C—'

'Let me finish. Your side of 119 is totally FUBAR. That means—'

'I know the expression, Colonel, I used to be a Tom Clancy reader. What exactly do you mean by it in regard to Route 119?'

'I mean it looks like, pardon the vulgarity, opening night at a free whorehouse out there. Half your town has parked their cars and pickups on both sides of the road and in some dairy farmer's field.'

She put her camera on the floor, took a notepad from her coat pocket, and scrawled *Col. James Cox* and *Like open night at free w'house.* Then she added *Dinsmore farm?* Yes, he was probably thinking about Alden Dinsmore's place.

'All right,' she said, 'what do you suggest?'

'Well, I can't stop you from coming, you're absolutely right about that.' He sighed, the sound seeming to suggest it was an unfair world. 'And I can't stop what you print in your paper, although I don't think it matters, since no one outside of Chester's Mill is going to see it.'

She stopped smiling. 'Would you mind explaining that?'

'I would, actually, and you'll work it out for yourself. My suggestion is that, if you want to see the barrier – although you can't actually

see it, as I'm sure you've been told – you bring Captain Barbara out to where it cuts Town Road Number Three. Do you know Town Road Number Three?'

For a moment she didn't. Then she realized what he was talking about, and laughed.

'Something amusing, Ms Shumway?'

'In The Mill, folks call that one Little Bitch Road. Because in mud season, it's one little bitch.'

'Very colorful.'

'No crowds out on Little Bitch, I take it?'

'No one at all right now.'

'All right.' She put the pad in her pocket and picked up the camera. Hector continued waiting patiently by the door.

'Good. When may I expect your call? Or rather, Barbie's call on your cell?'

She looked at her watch and saw it had just gone ten. How in God's name had it gotten that late so early? 'We'll be out there by ten thirty, assuming I can find him. And I think I can.'

'That's fine. Tell him Ken says hello. That's a—'

'A joke, yes, I get it. Will someone meet us?'

There was a pause. When he spoke again, she sensed reluctance. 'There will be lights, and sentries, and soldiers manning a roadblock, but they have been instructed not to speak to the residents.'

'Not to – *why*? In God's name, *why*?'

'If this situation doesn't resolve, Ms Shumway, all these things will become clear to you. Most you really will figure out on your own – you sound like a very bright lady.'

'Well, fuck you very much, Colonel!' she cried, stung. At the door, Hector pricked up his ears.

Cox laughed, a big unoffended laugh. 'Yes, ma'am, receiving you five-by-five. Ten thirty?'

She was tempted to tell him no, but of course there was no way she could do that.

'Ten thirty. Assuming I can hunt him up. And I call you?'

'Either you or him, but it's him I need to speak with. I'll be waiting with one hand on the phone.'

'Then give me the magic number.' She crooked the phone against her ear and fumbled the pad out again. Of course you always wanted your pad again after you'd put it away; that was a fact of life when you were a reporter, which she now was. Again. The number he gave her to call somehow scared her more than anything else he'd said. The area code was 000.

'One more thing, Ms Shumway: do you have a pacemaker implant? Hearing-aid implants? Anything of that nature?'

'No. Why?'

She thought he might again decline to answer, but he didn't. 'Once you're close to the Dome, there's some kind of interference. It's not harmful to most people, they feel it as nothing more than a low-level electric shock which goes away a second or two after it comes, but it plays hell with electronic devices. Shuts some down – most cell phones, for instance, if they come closer than five feet or so – and explodes others. If you bring a tape recorder out, it'll shut down. Bring an iPod or something sophisticated like a BlackBerry, it's apt to explode.'

'Did Chief Perkins's pacemaker explode? Is that what killed him?'

'Ten thirty. Bring Barbie, and be sure to tell him Ken says hello.'

He broke the connection, leaving Julia standing in silence beside her dog. She tried calling her sister in Lewiston. The numbers peeped . . . then nothing. Blank silence, as before.

The Dome, she thought. *He didn't call it the barrier there at the end; he called it the Dome.*

5

Barbie had taken off his shirt and was sitting on his bed to untie his sneakers when the knock came at the door, which one reached by climbing an outside flight of stairs on the side of Sanders Hometown Drug. The knock wasn't welcome. He had walked most of the day, then put on an apron and cooked for most of the evening. He was beat.

And suppose it was Junior and a few of his friends, ready to throw him a welcome-back party? You could say it was unlikely, even paranoid, but the day had been a festival of unlikely. Besides, Junior and Frank DeLesseps and the rest of their little band were among the few people he hadn't seen at Sweetbriar tonight. He supposed they might be out on 119 or 117, rubbernecking, but maybe somebody had told them he was back in town and they'd been making plans for later tonight. Later like now.

The knock came again. Barbie stood up and put a hand on the portable TV. Not much of a weapon, but it would do some damage if thrown at the first one who tried to cram through the door. There was a wooden closet rod, but all three rooms were small and it was too long to swing effectively. There was also his Swiss Army Knife, but he wasn't going to do any cutting. Not unless he had t—

'Mr Barbara?' It was a woman's voice. 'Barbie? Are you in there?'

He took his hand off the TV and crossed the kitchenette. 'Who is it?' But even as he asked, he recognized the voice.

'Julia Shumway. I have a message from someone who wants to speak to you. He told me to tell you that Ken says hello.'

Barbie opened the door and let her in.

6

In the pine-paneled basement conference room of the Chester's Mill Town Hall, the roar of the generator out back (an elderly Kelvinator) was no more than a dim drone. The table in the center of the room was handsome red maple, polished to a high gleam, twelve feet long. Most of the chairs surrounding it were empty that night. The four attendees of what Big Jim was calling the Emergency Assessment Meeting were clustered at one end. Big Jim himself, although only the Second Selectman, sat at the head of the table. Behind him was a map showing the athletic-sock shape of the town.

Those present were the selectmen and Peter Randolph, the acting Chief of Police. The only one who seemed entirely with it was Rennie. Randolph looked shocked and scared. Andy Sanders was, of course, dazed with grief. And Andrea Grinnell — an overweight, graying version of her younger sister, Rose — just seemed dazed. This was not new.

Four or five years previous, Andrea had slipped in her icy driveway while going to the mailbox one January morning. She had fallen hard enough to crack two discs in her back (being eighty or ninety pounds overweight probably hadn't helped). Dr Haskell had prescribed that new wonder-drug, OxyContin, to ease what had been no doubt excruciating pain. And had been giving it to her ever since. Thanks to his good friend Andy, who ran the local drugstore, Big Jim knew that Andrea had begun at forty milligrams a day and had worked her way up to a giddy four hundred. This was useful information.

Big Jim said, 'Due to Andy's great loss, I'm going to chair this meeting, if no one objects. We're all very sorry, Andy.'

'You bet, sir,' Randolph said.

'Thank you,' Andy said, and when Andrea briefly covered his hand with her own, he began to ooze at the eyes again.

'Now, we all have an idea of what's happened here,' Big Jim said, 'although no one in town understands it yet—'

'I bet no one out of town does, either,' Andrea said.

Big Jim ignored her. '—and the military presence hasn't seen fit to communicate with the town's elected officials.'

'Problems with the phones, sir,' Randolph said. He was on a first-name basis with all of these people – in fact considered Big Jim a friend – but in this room he felt it wise to stick to sir or ma'am. Perkins had done the same, and on that, at least, the old man had probably been right.

Big Jim waved a hand as if swatting at a troublesome fly. 'Someone could have come to the Motton or Tarker's side and sent for me – us – and no one has seen fit to do so.'

'Sir, the situation is still very . . . uh, fluid.'

'I'm sure, I'm sure. And it's very possible that's why no one has put us in the picture just yet. Could be, oh yes, and I pray that's the answer. I hope you've all been praying.'

They nodded dutifully.

'But right now . . .' Big Jim looked around gravely. He *felt* grave. But he also felt excited. And *ready*. He thought it not impossible that his picture would be on the cover of *Time* magazine before the year was out. Disaster – especially the sort triggered by terrorists – was not always a completely bad thing. Look what it had done for Rudy Giuliani. '*Right now*, lady and gentlemen, I think we have to face the very real possibility that we are on our own.'

Andrea put a hand to her mouth. Her eyes shone either with fear or too much dope. Possibly both. 'Surely not, Jim!'

'Hope for the best, prepare for the worst, that's what Claudette always says.' Andy spoke in tones of deep meditation. 'Said, I mean. She made me a nice breakfast this morning. Scrambled eggs and left-over taco cheese. Gosh!'

The tears, which had slowed, began to ooze again. Andrea once more covered his hand. This time Andy gripped it. *Andy and Andrea*, Big Jim thought, and a thin smile creased the lower half of his fleshy face. *The Dumbsey Twins*.

'Hope for the best, plan for the worst,' he said. 'What good advice that is. The worst in this case could entail days cut off from the outside world. Or a week. Possibly even a month.' He didn't actually believe that, but they'd be quicker to do what he wanted if they were frightened.

Andrea repeated: 'Surely not!'

'We just don't know,' Big Jim said. This, at least, was the unvarnished truth. 'How can we?'

'Maybe we ought to close Food City,' Randolph said. 'At least for the time being. If we don't, it's apt to fill up like before a blizzard.'

Rennie was annoyed. He had an agenda, and this was on it, but it wasn't *first* on it.

'Or maybe that's not a good idea,' Randolph said, reading the Second Selectman's face.

'Actually, Pete, I *don't* think it's a good idea,' Big Jim said. 'Same principle as never declaring a bank holiday when currency is tight. You only provoke a run.'

'Are we talking about closing the banks, too?' Andy asked. 'What'll we do about the ATMs? There's one at Brownie's Store . . . Mill Gas and Grocery . . . my drugstore, of course . . .' He looked vague, then brightened. 'I think I even saw one at the Health Center, although I'm not entirely sure about that one . . .'

Rennie wondered briefly if Andrea had been loaning the man some of her pills. 'I was only making a metaphor, Andy.' Keeping his voice low and kind. This was exactly the kind of thing you could expect when people wandered off the agenda. 'In a situation like this, food *is* money, in a manner of speaking. What I'm saying is it should be business as usual. It'll keep people calm.'

'Ah,' Randolph said. This he understood. 'Gotcha.'

'But you'll need to talk to the supermarket manager – what's his name, Cade?'

'Cale,' Randolph said. 'Jack Cale.'

'Also Johnny Carver at the Gas and Grocery, and . . . who in the heck runs Brownie's since Dil Brown died?'

'Velma Winter,' Andrea said. 'She's from Away, but she's very nice.'

Rennie was pleased to see Randolph writing the names down in his pocket notebook. 'Tell those three people that beer and liquor sales are off until further notice.' His face cramped in a rather frightening expression of pleasure. 'And Dipper's is *closed*.'

'A lot of people aren't going to like a *booze* shutdown,' Randolph said. 'People like Sam Verdreaux.' Verdreaux was the town's most notorious tosspot, a perfect example – in Big Jim's opinion – of why the Volstead Act should never have been repealed.

'Sam and the others like him will just have to suffer once their current supplies of beer and coffee brandy are gone. We can't have half the town getting drunk like it was New Year's Eve.'

'Why not?' Andrea asked. 'They'll use up the supplies and that'll be the end of it.'

'And if they riot in the meantime?'

Andrea was silent. She couldn't see what people would have to riot *about* – not if they had food – but arguing with Jim Rennie, she had found, was usually unproductive and always wearying.

'I'll send a couple of the guys out to talk to them,' Randolph said.

'Talk to Tommy and Willow Anderson *personally*.' The Andersons ran Dipper's. 'They can be troublesome.' He lowered his voice. 'Wingnuts.'

Randolph nodded. '*Left*-wingnuts. Got a picture of Uncle Barack over the bar.'

'That's it exactly.' *And*, he didn't need to say, *Duke Perkins let those two hippy cotton-pickers get a foothold with their dancing and loud rock and roll and drinking until one in the morning. Protected them. And look at the trouble it led to for my son and his friends.* He turned to Andy Sanders. 'Also, you've got to put all the prescription drugs under lock and key. Oh, not Nasonex or Lyrica, that sort of thing. You know the stuff I mean.'

'Anything people might use to get high,' Andy said, 'is already under lock and key.' He seemed uneasy at this turn of the conversation. Rennie knew why, but he wasn't concerned about their various sales endeavors just now; they had more pressing business.

'Better take extra precautions, just the same.'

Andrea was looking alarmed. Andy patted her hand. 'Don't worry,' he said, 'we always have enough to take care of those in real need.'

Andrea smiled at him.

'Bottom line is, this town is going to stay sober until the crisis ends,' Big Jim said. 'Are we in agreement? Show of hands.'

The hands went up.

'Now,' Rennie said, 'may I go back to where I wanted to start?' He looked at Randolph, who spread his hands in a gesture that simultaneously conveyed *go ahead* and *sorry*.

'We need to recognize that people are apt to be scared. And when people are scared, they can get up to dickens, booze or no booze.'

Andrea looked at the console to Big Jim's right: switches that controlled the TV, the AM/FM radio, and the built-in taping system, an innovation Big Jim hated. 'Shouldn't that be on?'

'I see no need.'

The darned taping system (shades of Richard Nixon) had been the idea of a meddling medico named Eric Everett, a thirtysomething pain in the buttinsky who was known around town as Rusty. Everett had sprung the taping system idiocy at town meeting two years before, presenting it as a great leap forward. The proposal came as an unwelcome surprise to Rennie, who was seldom surprised, especially by political outsiders.

Big Jim had objected that the cost would be prohibitive. This
tactic usually worked with thrifty Yankees, but not that time; Everett
had presented figures, possibly supplied by Duke Perkins, showing
that the federal government would pay eighty percent. Some Disaster
Assistance Whatever; a leftover from the free-spending Clinton years.
Rennie had found himself outflanked.

It wasn't a thing that happened often, and he didn't like it, but
he had been in politics for many more years than Eric 'Rusty' Everett
had been tickling prostates, and he knew there was a big difference
between losing a battle and losing the war.

'Or at least someone should take notes?' Andrea asked timidly.

'I think it might be best to keep this informal, for the time
being,' Big Jim said. 'Just among the four of us.'

'Well . . . if you think so . . .'

'Two can keep a secret if one of them is dead,' Andy said dreamily.

'That's right, pal,' Rennie said, just as if that made sense. Then
he turned back to Randolph. 'I'd say our prime concern – our prime
responsibility to the town – is maintaining order for the duration of
this crisis. Which means police.'

'Damn straight!' Randolph said smartly.

'Now, I'm sure Chief Perkins is looking down on us from
Above—'

'With my wife,' Andy said. 'With Claudie.' He produced a snot-
clogged honk that Big Jim could have done without. Nonetheless,
he patted Andy's free hand.

'That's right, Andy, the two of them together, bathed in Jesus's
glory. But for us here on earth . . . Pete, what kind of force can you
muster?'

Big Jim knew the answer. He knew the answers to most of his
own questions. Life was easier that way. There were eighteen officers
on the Chester's Mill police payroll, twelve full-timers and six part-
timers (the latter all past sixty, which made their services entrancingly
cheap). Of those eighteen, he was quite sure five of the full-timers
were out of town; they had either gone to that day's high school
football game with their wives and families or to the controlled burn
in Castle Rock. A sixth, Chief Perkins, was dead. And while Rennie
would never speak ill of the dead, he was sure the town was better
off with Perkins in heaven rather than down here, trying to manage
a clustermug that was far beyond his limited abilities.

'I'll tell you what, folks,' Randolph said, 'it's not that good. There's
Henry Morrison and Jackie Wettington, both of whom responded
with me to the initial Code Three. There's also Rupe Libby, Fred

Denton, and George Frederick – although his asthma's so bad I don't know how much use he'll be. He was planning to take early retirement at the end of this year.'

'Poor old George,' Andy said. 'He just about lives on Advair.'

'And as you know, Marty Arsenault and Toby Whelan aren't up to much these days. The only part-timer I'd call really able-bodied is Linda Everett. Between that damned firefighting exercise and the football game, this couldn't have happened at a worse time.'

'Linda Everett?' Andrea asked, a little interested. 'Rusty's wife?'

'Pshaw!' Big Jim often said *pshaw* when he was irritated. 'She's just a jumped-up crossing guard.'

'Yes, sir,' Randolph said, 'but she qualified on the county range over in The Rock last year and she has a sidearm. No reason she can't carry it and go on duty. Maybe not full-time, the Everetts have got a couple of kids, but she can pull her weight. After all, it *is* a crisis.'

'No doubt, no doubt.' But Rennie was damned if he was going to have Everetts popping up like darned old jack-in-the-boxes every time he turned around. Bottom line: he didn't want that cotton-picker's wife on his first team. For one thing, she was still quite young, no more than thirty, and pretty as the devil. He was sure she'd be a bad influence on the other men. Pretty women always were. Wettington and her gunshell tiddies were bad enough.

'So,' Randolph said, 'that's only eight out of eighteen.'

'You forgot to count yourself,' Andrea said.

Randolph hit his forehead with the heel of his hand, as if trying to knock his brains back into gear. 'Oh. Yeah. Right. Nine.'

'Not enough,' Rennie said. 'We need to beef up the force. Just temporarily, you know; until this situation works itself out.'

'Who were you thinking about, sir?' Randolph asked.

'My boy, to begin with.'

'Junior?' Andrea raised her eyebrows. 'He's not even old enough to vote . . . is he?'

Big Jim briefly visualized Andrea's brain: fifteen percent favorite online shopping sites, eighty percent dope receptors, two percent memory, and three percent actual thought process. Still, it was what he had to work with. *And,* he reminded himself, *the stupidity of one's colleagues makes life simpler.*

'He's twenty-one, actually. Twenty-two in November. And either by luck or the grace of God, he's home from school this weekend.'

Peter Randolph knew that Junior Rennie was home from school *permanently* – he'd seen it written on the phone pad in the late Chief's

office earlier in the week, although he had no idea how Duke had gotten the information or why he'd thought it important enough to write down. Something else had been written there, too: *Behavioral issues?*

This was probably not the time to share such information with Big Jim, however.

Rennie was continuing, now in the enthusiastic tones of a gameshow host announcing a particularly juicy prize in the Bonus Round. '*And*, Junior has three friends who would also be suitable: Frank DeLesseps, Melvin Searles, and Carter Thibodeau.'

Andrea was once more looking uneasy. 'Um . . . weren't those the boys . . . the young men . . . involved in that altercation at Dipper's . . . ?'

Big Jim turned a smile of such genial ferocity on her that Andrea shrank back in her seat.

'That business was overblown. *And* sparked by alcohol, as most such trouble is. Plus, the instigator was that fellow Barbara. Which is why no charges were filed. It was a wash. Or am I wrong, Peter?'

'Absolutely not,' Randolph said, although he too looked uneasy. 'These fellows are all at least twenty-one, and I believe Carter Thibodeau might be twenty-three.'

Thibodeau was indeed twenty-three, and had lately been working as a part-time mechanic at Mill Gas & Grocery. He'd been fired from two previous jobs – temper issues, Randolph had heard – but he seemed to have settled down at the Gas & Grocery. Johnny said he'd never had anyone so good with exhaust and electrical systems.

'They've all hunted together, they're good shots—'

'Please God we don't have to put *that* to the test,' Andrea said.

'No one's going to get shot, Andrea, and no one's suggesting we make these young fellows full-time police. What I'm saying is that we need to fill out an extremely depleted roster, and *fast*. So how about it, Chief? They can serve until the crisis is over, and we'll pay them out of the contingency fund.'

Randolph didn't like the idea of Junior toting a gun on the streets of Chester's Mill – Junior with his possible *behavioral issues* – but he also didn't like the idea of bucking Big Jim. And it really might be a good idea to have a few extra widebodies on hand. Even if they were young. He didn't anticipate problems in town, but they could be put on crowd control out where the main roads hit the barrier. If the barrier was still there. And if it wasn't? Problems solved.

He put on a team-player smile. 'You know, I think that's a great idea sir. You send em around to the station tomorrow around ten—'

'Nine might be better, Pete.'

'Nine's fine,' Andy said in his dreamy voice.

'Further discussion?' Rennie asked.

There was none. Andrea looked as if she might have had something to say but couldn't remember what it was.

'Then I call the question,' Rennie said. 'Will the Board ask acting Chief Randolph to take on Junior, Frank DeLesseps, Melvin Searles, and Carter Thibodeau as deputies at base salary? Their period of service to last until this darn crazy business is sorted out? Those in favor signify in the usual manner.'

They all raised their hands.

'The measure is approv—'

He was interrupted by two reports that sounded like gunfire.

They all jumped. Then a third came, and Rennie, who had worked with motors for most of his life, realized what it was.

'Relax, folks. Just a backfire. Generator clearing its throa—'

The elderly gennie backfired a fourth time, then died. The lights went out, leaving them for a moment in stygian blackness. Andrea shrieked.

On his left, Andy Sanders said: 'Oh my gosh, Jim, the propane—'

Rennie reached out with his free hand and grabbed Andy's arm. Andy shut up. As Rennie was relaxing his grip, light crept back into the long pine-paneled room. Not the bright overheads but the emergency box-lights mounted in the four corners. In their weak glow, the faces clustered at the conference table's north end looked yellow and years older. They looked frightened. Even Big Jim Rennie looked frightened.

'No problem,' Randolph said with a cheeriness that sounded manufactured rather than organic. 'Tank just ran dry, that's all. Plenty more in the town supply barn.'

Andy shot Big Jim a look. It was no more than a shifting of the eyes, but Rennie had an idea Andrea saw it. What she might eventually make of it was another question.

She'll forget it after her next dose of Oxy, he told himself. *By morning for sure.*

And in the meantime, the town's supplies of propane – or lack thereof – didn't concern him much. He would take care of that situation when it became necessary.

'Okay, folks, I know you're as anxious to get out of here as I am, so let's move on to our next order of business. I think we should officially confirm Pete here as our Chief of Police pro tem.'

'Yes, why not?' Andy asked. He sounded tired.

'If there's no discussion,' Big Jim said, 'I'll call the question.'
They voted as he wanted them to vote.
They always did.

7

Junior was sitting on the front step of the big Rennie home on Mill Street when the lights of his father's Hummer splashed up the driveway. Junior was at peace. The headache had not returned. Angie and Dodee were stored in the McCain pantry, where they would be fine — at least for a while. The money he'd taken was back in his father's safe. There was a gun in his pocket — the pearl-grip .38 his father had given him for his eighteenth birthday. Now he and his father would speak. Junior would listen very closely to what the King of No Money Down had to say. If he sensed his father knew what he, Junior, had done — he didn't see how that was possible, but his father knew so much — then Junior would kill him. After that he would turn the gun on himself. Because there would be no running away, not tonight. Probably not tomorrow, either. On his way back, he had stopped on the town common and listened to the conversations going on there. What they were saying was insane, but the large bubble of light to the south — and the smaller one to the southwest, where 117 ran toward Castle Rock — suggested that tonight, insanity just happened to be the truth.

The door of the Hummer opened, chunked closed. His father walked toward him, his briefcase banging one thigh. He didn't look suspicious, wary, or angry. He sat down beside Junior on the step without a word. Then, in a gesture that took Junior completely by surprise, he put a hand on the younger man's neck and squeezed gently.

'You heard?' he asked.

'Some,' Junior said. 'I don't understand it, though.'

'None of us do. I think there are going to be some hard days ahead while this gets sorted out. So I have to ask you something.'

'What's that?' Junior's hand closed around the butt of the pistol.

'Will you play your part? You and your friends? Frankie? Carter and the Searles boy?'

Junior was silent, waiting. What was *this* shit?

'Peter Randolph's acting chief now. He's going to need some men to fill out the police roster. Good men. Are you willing to serve as a deputy until this damn clustermug is over?'

Junior felt a wild urge to scream with laughter. Or triumph. Or

both. Big Jim's hand was still on the nape of his neck. Not squeezing. Not pinching. Almost . . . caressing.

Junior took his hand off the gun in his pocket. It occurred to him that he was *still* on a roll — the roll of all rolls.

Today he had killed two girls he'd known since childhood.

Tomorrow he was going to be a town cop.

'Sure, Dad,' he said. 'If you need us, we are *there.*' And for the first time in maybe four years (it could have been longer), he kissed his father's cheek.

PRAYERS

1

Barbie and Julia Shumway didn't talk much; there wasn't much to say. Theirs was, as far as Barbie could see, the only car on the road, but lights streamed from most of the farmhouse windows once they cleared town. Out here, where there were always chores to be done and no one fully trusted Western Maine Power, almost everyone had a gennie. When they passed the WCIK radio tower, the two red lights at the top were flashing as they always did. The electric cross in front of the little studio building was also lit, a gleaming white beacon in the dark. Above it, the stars spilled across the sky in their usual extravagant profusion, a never-ending cataract of energy that needed no generator to power it.

'Used to come fishing out this way,' Barbie said. 'It's peaceful.'

'Any luck?'

'Plenty, but sometimes the air smells like the dirty underwear of the gods. Fertilizer, or something. I never dared to eat what I caught.'

'Not fertilizer – bullshit. Also known as the smell of self-righteousness.'

'I beg your pardon?'

She pointed at a dark steeple-shape blocking out the stars. 'Christ the Holy Redeemer Church,' she said. 'They own WCIK just back the road. Sometimes known as Jesus Radio?'

He shrugged. 'I guess maybe I have seen the steeple. And I know the station. Can't very well miss it if you live around here and own a radio. Fundamentalist?'

'They make the hardshell Baptists look soft. I go to the Congo, myself. Can't stand Lester Coggins, hate all the ha-ha-you're-going-to-hell-and-we're-not stuff. Different strokes for different folks, I guess. Although I *have* often wondered how they afford a fifty-thousand-watt radio station.'

'Love offerings?'

She snorted. 'Maybe I ought to ask Jim Rennie. He's a deacon.'

Julia drove a trim Prius Hybrid, a car Barbie would not have expected of a staunch Republican newspaper owner (although he supposed it did fit a worshipper at the First Congregational). But it was quiet, and the radio worked. The only problem was that out here on the western side of town, CIK's signal was so powerful it wiped

out everything on the FM band. And tonight it was broadcasting some holy accordion shit that hurt Barbie's head. It sounded like polka music played by an orchestra dying of bubonic plague.

'Try the AM band, why don't you?' she said.

He did, and got only nighttime gabble until he hit a sports station near the bottom of the dial. Here he heard that before the Red Sox–Mariners playoff game at Fenway Park, there had been a moment of silence for the victims of what the announcer called 'the western Maine event.'

'Event,' Julia said. 'A sports-radio term if ever I heard one. Might as well turn it off.'

A mile or so past the church, they began to see a glow through the trees. They came around a curve and into the glare of lights almost the size of Hollywood premiere kliegs. Two pointed in their direction; two more were tilted straight up. Every pothole in the road stood out in stark relief. The trunks of the birches looked like narrow ghosts. Barbie felt as if they were driving into a noir movie from the late nineteen forties.

'Stop, stop, stop,' he said. 'This is as close as you want to go. Looks like there's nothing there, but take my word for it, there is. It would likely blow the electronics in your little car, if nothing else.'

She stopped and they got out. For a moment they just stood in front of the car, squinting into the bright light. Julia raised one hand to shield her eyes.

Parked beyond the lights, nose to nose, were two brown canvas-back military trucks. Sawhorses had been placed on the road for good measure, their feet braced with sandbags. Motors roared steadily in the darkness – not one generator but several. Barbie saw thick electrical cables snaking away from the spotlights and into the woods, where other lights glared through the trees.

'They're going to light the perimeter,' he said, and twirled one finger in the air, like an ump signaling a home run. 'Lights around the whole town, shining in and shining up.'

'Why up?'

'The up ones to warn away air traffic. If any gets through, that is. I'd guess it's mostly tonight they're worried about. By tomorrow they'll have the airspace over The Mill sewn up like one of Uncle Scrooge's moneybags.'

On the dark side of the spotlights, but visible in their back-splash, were half a dozen armed soldiers, standing at parade rest with their backs turned. They must have heard the approach of the car, quiet as it was, but not one of them so much as looked around.

Julia called, 'Hello, fellas!'

No one turned. Barbie didn't expect it – on their way out, Julia had told Barbie what Cox had told her – but he had to try. And because he could read their insignia, he knew *what* to try. The Army might be running this show – Cox's involvement suggested that – but these fellows weren't Army.

'Yo, Marines!' he called.

Nothing. Barbie stepped closer. He saw a dark horizontal line hanging on the air above the road, but ignored it for the time being. He was more interested in the men guarding the barrier. Or the Dome. Shumway had said Cox called it the Dome.

'I'm surprised to see you Force Recon boys stateside,' he said, walking a little closer. 'That little Afghanistan problem over, is it?'

Nothing. He walked closer. The grit of the hardpan under his shoes seemed very loud.

'A remarkably high number of pussies in Force Recon, or so I've heard. I'm relieved, actually. If this situation was really bad, they would have sent in the Rangers.'

'Pogeybait,' one of them muttered.

It wasn't much, but Barbie was encouraged. 'Stand easy, fellas; stand easy and let's talk this over.'

More nothing. And he was as close to the barrier (or the Dome) as he wanted to go. His skin didn't rash out in goosebumps and the hair on his neck didn't try to stand up, but he knew the thing was there. He sensed it.

And could see it: that stripe hanging on the air. He didn't know what color it would be in daylight, but he was guessing red, the color of danger. It was spray paint, and he would have bet the entire contents of his bank account (currently just over five thousand dollars) that it went all the way around the barrier.

Like a stripe on a shirtsleeve, he thought.

He balled a fist and rapped on his side of the stripe, once more producing that knuckles-on-glass sound. One of the Marines jumped.

Julia began: 'I'm not sure that's a good—'

Barbie ignored her. He was starting to be angry. Part of him had been waiting to be angry all day, and here was his chance. He knew it would do no good to go off on these guys – they were only spear-carriers – but it was hard to bite back. 'Yo, Marines! Help a brother out.'

'Quit it, pal.' Although the speaker didn't turn around, Barbie knew it was the CO of this happy little band. He recognized the tone, had used it himself. Many times. 'We've got our orders, so *you* help a

brother out. Another time, another place, I'd be happy to buy you a beer or kick your ass. But not here, not tonight. So what do you say?'

'I say okay,' Barbie said. 'But seeing as how we're all on the same side, I don't have to like it.' He turned to Julia. 'Got your phone?'

She held it up. 'You should get one. They're the coming thing.'

'I have one,' Barbie said. 'A disposable Best Buy special. Hardly ever use it. Left it in a drawer when I tried to blow town. Saw no reason not to leave it there tonight.'

She handed him hers. 'You'll have to punch the number, I'm afraid. I've got work to do.' She raised her voice so the soldiers standing beyond the glaring lights could hear her. 'I'm the editor of the local newspaper, after all, and I want to get some pix.' She raised her voice a little more. 'Especially a few of soldiers standing with their backs turned on a town that's in trouble.'

'Ma'am, I kind of wish you wouldn't do that,' the CO said. He was a blocky fellow with a broad back.

'Stop me,' she invited.

'I think you know we can't do that,' he said. 'As far as our backs being turned, those are our orders.'

'Marine,' she said, 'you take your orders, roll em tight, bend over, and stick em where the air quality is questionable.' In the brilliant light, Barbie saw a remarkable thing: her mouth set in a harsh, unforgiving line and her eyes streaming tears.

While Barbie dialed the number with the weird area code, she got her camera and began snapping. The flash wasn't very bright compared to the big generator-driven spotlights, but Barbie saw the soldiers flinch every time it went off. *Probably hoping their fucking insignia doesn't show*, he thought.

2

United States Army Colonel James O. Cox had said he'd be sitting with a hand on the phone at ten thirty. Barbie and Julia Shumway had run a little late and Barbie didn't place the call until twenty of eleven, but Cox's hand must have stayed right there, because the phone only managed half a ring before Barbie's old boss said, 'Hello, this is Ken.'

Barbie was still mad, but laughed just the same. 'Yes, sir. And I continue to be the bitch who gets all the good shit.'

Cox also laughed, no doubt thinking they were off to a good start. 'How are you, Captain Barbara?'

'Sir, I'm fine, sir. But with respect, it's just Dale Barbara now. The only things I captain these days are the grills and Fry-O-Lators in the local restaurant, and I'm in no mood for small talk. I am perplexed, sir, and since I'm looking at the backs of a bunch of pogey-bait Marines who won't turn around and look me in the eye, I'm also pretty goddam pissed off.'

'Understood. And *you* need to understand something from my end. If there was anything at all those men could do to aid or end this situation, you would be looking at their faces instead of their asses. Do you believe that?'

'I'm hearing you, sir.' Which wasn't exactly an answer.

Julia was still snapping. Barbie shifted to the edge of the road. From his new position he could see a bivouac tent beyond the trucks. Also what might have been a small mess tent, plus a parking area filled with more trucks. The Marines were building a camp here, and probably bigger ones where Routes 119 and 117 left town. That suggested permanence. His heart sank.

'Is the newspaper woman there?' Cox asked.

'She's here. Taking pictures. And sir, full disclosure, whatever you tell me, I tell her. I'm on this side now.'

Julia stopped what she was doing long enough to flash Barbie a smile.

'Understood, Captain.'

'Sir, calling me that earns you no points.'

'All right, just Barbie. Is that better?'

'Yes, sir.'

'As to how much the lady decides to publish . . . for the sake of the people in that little town of yours, I hope she's got sense enough to pick and choose.'

'My guess is she does.'

'And if she e-mails pictures to anyone on the outside – one of the newsmagazines or the *New York Times*, for instance – you may find your Internet goes the way of your landlines.'

'Sir, that's some dirty sh—'

'The decision would be made above my pay grade. I'm just saying.'

Barbie sighed. 'I'll tell her.'

'Tell me what?' Julia asked.

'That if you try to transmit those pictures, they may take it out on the town by shutting down Internet access.'

Julia made a hand gesture Barbie did not ordinarily associate with pretty Republican ladies. He returned his attention to the phone.

'How much can you tell me?'

'Everything I know,' Cox said.

'Thank you, sir.' Although Barbie doubted Cox would actually spill everything. The Army never told everything it knew. Or thought it knew.

'We're calling it the Dome,' Cox said, 'but it's not a Dome. At least, we don't think it is. We think it's a capsule whose edges conform exactly to the borders of the town. And I do mean exactly.'

'Do you know how high it goes?'

'It appears to top out at forty-seven thousand and change. We don't know if the top is flat or rounded. At least not yet.'

Barbie said nothing. He was flabbergasted.

'As to how deep . . . who knows. All we can say now is more than a hundred feet. That's the current depth of an excavation we're making on the border between Chester's Mill and the unincorporated township to the north.'

'TR-90.' To Barbie's ears, his voice sounded dull and listless.

'Whatever. We started in a gravel pit that was already dug down to forty feet or so. I've seen spectrographic images that blow my mind. Long sheets of metamorphic rock that have been sheared in two. There's no gap, but you can see a shift where the northern part of the sheet dropped a little. We've checked seismographic reports from the Portland meteorological station, and bingo. There was a bump at eleven forty-four A.M. Two point one on the Richter. So that's when it happened.'

'Great,' Barbie said. He supposed he was being sarcastic, but he was too amazed and perplexed to be sure.

'None of this is conclusive, but it's persuasive. Of course the exploring has just started, but right now it does look as if the thing is down as well as up. And if it goes *up* five miles . . .'

'How do you know that? Radar?'

'Negative, this thing doesn't show on radar. There's no way of telling it's there until you hit it, or until you're so close you can't stop. The human toll when the thing went up was remarkably low, but you've got one hell of a bird-kill around the edges. Inside *and* outside.'

'I know. I've seen them.' Julia was done with her pictures now. She was standing next to him, listening to Barbie's end of the conversation. 'So how do you know how high it is? Lasers?'

'No, they also shoot right through. We've been using missiles with dummy warheads. We've been flying F-15A sorties out of Bangor since four this afternoon. Surprised you didn't hear them.'

'I might have heard something,' Barbie said. 'But my mind was occupied with other things.' Like the airplane. And the pulp-truck. The dead people out on Route 117. Part of the remarkably low human toll.

'They kept bouncing off . . . and then, at forty-seven thousand plus, just zippity-zoom, up, up and away. Between you and me, I'm surprised we didn't lose any of those fighter-jocks.'

'Have you actually overflown it yet?'

'Less than two hours ago. Mission successful.'

'Who did it, Colonel?'

'We don't know.'

'Was it us? Is this an experiment that went wrong? Or, God help us, some kind of test? You owe me the truth. You owe this town the truth. These people are goddam terrified.'

'Understood. But it wasn't us.'

'Would you know if it was?'

Cox hesitated. When he next spoke, his voice was lower. 'We have good sources in my department. When they fart in the NSA, we hear it. The same is true about Group Nine at Langley and a couple of other little deals you never heard of.'

It was possible that Cox was telling the truth. And it was possible he wasn't. He was a creature of his calling, after all; if he had been drawing sentry duty out here in the chilly autumn dark with the rest of the pogeybait Marines, Cox too would have been standing with his back turned. He wouldn't have liked it, but orders were orders.

'Any chance it's some sort of natural phenomenon?' Barbie asked.

'One that conforms exactly to the man-made borders of a whole town? Every nook and fucking cranny? What do you think?'

'I had to ask. Is it permeable? Do you know?'

'Water goes through,' Cox said. 'A little, anyway.'

'How is that possible?' Although he'd seen for himself the weird way water behaved; both he and Gendron had seen it.

'We don't know, how could we?' Cox sounded exasperated. 'We've been working on this less than twelve hours. People here are slapping themselves on the back just for figuring out how high it goes. We may figure it out, but for now we just don't know.'

'Air?'

'Air goes through to a greater degree. We've set up a monitoring station where your town borders on . . . mmm . . .' Faintly, Barbie heard paper rustle. 'Harlow. They've done what they call "puff tests." I guess that must measure outgoing air pressure against what bounces

back. Anyway, air goes through, and a lot more freely than water does, but the scientists say still not completely. This is going to severely fuck up your weather, pal, but nobody can say how much or how bad. Hell, maybe it'll turn Chester's Mill into Palm Springs.' He laughed, rather feebly.

'Particulates?' Barbie thought he knew the answer to that one.

'Nope,' Cox said. 'Particulate matter doesn't go through. At least we don't think so. And you want to be aware that works both ways. If particulate matter doesn't get in, it won't get out. That means auto emissions—'

'Nobody's got that far to drive. Chester's Mill is maybe four miles across at its widest. Along a diagonal—' He looked at Julia.

'Seven, tops,' she said.

Cox said, 'We don't think oil-heat pollutants are going to be a big deal, either. I'm sure everybody in town has a nice expensive oil furnace – in Saudi Arabia they have bumper stickers on their cars these days saying I Heat New England – but modern oil furnaces need electricity to provide a constant spark. Your oil reserves are probably good, considering the home-heating season hasn't started yet, but we don't think it's going to be very useful to you. In the long run, that may be a good thing, from the pollution standpoint.'

'You think so? Come on up here when it's thirty below zero and the wind's blowing at—' He stopped for a moment. '*Will* the wind blow?'

'We don't know,' Cox said. 'Ask me tomorrow and I may at least have a theory.'

'We can burn wood,' Julia said. 'Tell him that.'

'Ms Shumway says we can burn wood.'

'People have to be careful about that, Captain Barbara – Barbie. Sure, you've got plenty of wood up there and you don't need electricity to ignite it and keep it going, but wood produces ash. Hell, it produces carcinogens.'

'Heating season here starts . . .' Barbie looked at Julia.

'November fifteenth,' she said. 'Or thereabouts.'

'Ms Shumway says mid-November. So tell me you're going to have this worked out by then.'

'All I can say is that we intend to try like hell. Which brings me to the point of this conversation. The smart boys – the ones we've been able to convene so far – all agree that we're dealing with a force field—'

'Just like on *Star Trick*,' Barbie said. 'Beam me up, Snotty.'

'Beg your pardon?'

'Doesn't matter. Go on, sir.'

'They all agree that a force field doesn't just happen. Something either close to the field of effect or in the center of it has to generate it. Our guys think the center is most likely. "Like the handle of an umbrella," one of them said.'

'You think this is an inside job?'

'We think it's a *possibility*. And we just happen to have a decorated soldier in town—'

Ex-soldier, Barbie thought. *And the decorations went into the Gulf of Mexico eighteen months ago.* But he had an idea his term of service had just been extended, like it or not. Held over by popular demand, as the saying went.

'—whose specialty in Iraq was hunting down Al Qaeda bomb factories. Hunting them down and shutting them down.'

So. Basically just another gennie. He thought of all those he and Julia Shumway had passed on the way out here, roaring away in the dark, providing heat and light. Eating propane to do it. He realized that propane and storage batteries, even more than food, had become the new gold standard in Chester's Mill. One thing he knew: people *would* burn wood. If it got cold and the propane was gone, they'd burn plenty. Hardwood, softwood, trashwood. And fuck the carcinogens.

'It won't be like the generators working away in your part of the world tonight,' Cox said. 'A thing that could do this . . . we don't know *what* it would be like, or who could build such a thing.'

'But Uncle Sammy wants it,' Barbie said. He was gripping the phone almost tightly enough to crack it. 'That's actually the priority, isn't it? Sir? Because a thing like that could change the world. The people of this town are strictly secondary. Collateral damage, in fact.'

'Oh, let's not be melodramatic,' Cox said. 'In this matter our interests coincide. Find the generator, if it's there to be found. Find it the way you found those bomb factories, and then shut it down. Problem solved.'

'If it's there.'

'If it's there, roger that. Will you try?'

'Do I have a choice?'

'Not that I can see, but I'm career military. For us, free will isn't an option.'

'Ken, this is one fucked-up fire drill.'

Cox was slow to reply. Although there was silence on the line (except for a faint high hum that might mean the proceedings were

being recorded), Barbie could almost hear him reflecting. Then he said: 'That's true, but you still get all the good shit, you bitch.'

Barbie laughed. He couldn't help it.

3

On the way back, passing the dark shape that was Christ the Holy Redeemer Church, he turned to Julia. In the glow of the dashboard lights, her face looked tired and solemn.

'I won't tell you to keep quiet about any of this,' he said, 'but I think you should hold one thing back.'

'The generator that may or may not be in town.' She took a hand off the wheel, reached back, and stroked Horace's head, as if for comfort and reassurance.

'Yes.'

'Because if there's a generator spinning the field – creating your Colonel's Dome – then somebody must be running it. Somebody here.'

'Cox didn't say that, but I'm sure it's what he thinks.'

'I'll withhold that. And I won't e-mail any pictures.'

'Good.'

'They should run first in the *Democrat* anyway, dammit.' Julia continued stroking the dog. People who drove one-handed usually made Barbie nervous, but not tonight. They had both Little Bitch and 119 to themselves. 'Also, I understand that sometimes the greater good is more important than a great story. Unlike the *New York Times*.'

'Zing,' Barbie said.

'And if you find the generator, I won't have to spend too many days shopping at Food City. I hate that place.' She looked startled. 'Do you think it'll even be open tomorrow?'

'I'd say yes. People can be slow to catch up with the new deal when the old deal changes.'

'I think I better do a little Sunday shopping,' she said thought-fully.

'When you do, say hello to Rose Twitchell. She'll probably have the faithful Anson Wheeler with her.' Remembering his earlier advice to Rose, he laughed and said: 'Meat, meat, meat.'

'Beg your pardon?'

'If you have a generator at your house—'

'Of course I do, I live over the newspaper. Not a house; a very nice apartment. The generator was a tax deduction.' She said this proudly.

'Then buy meat. Meat and canned goods, canned goods and meat.'

She thought about it. Downtown was just ahead now. There were far fewer lights than usual, but still plenty. *For how long?* Barbie wondered. Then Julia asked, 'Did your Colonel give you any ideas about how to find this generator?'

'Nope,' Barbie said. 'Finding shit used to be my job. He knows that.' He paused, then asked: 'Do you think there might be a Geiger counter in town?'

'I know there is. In the basement of the Town Hall. Actually the subbasement, I guess you'd say. There's a fallout shelter there.'

'You're shittin me!'

She laughed. 'No shit, Sherlock. I did a feature story on it three years ago. Pete Freeman took the pictures. In the basement there's a big conference room and a little kitchen. The shelter's half a flight of stairs down from the kitchen. Pretty good-sized. It was built in the fifties, when the smart money was on us blowing ourselves to hell.'

'*On the Beach*,' Barbie said.

'Yep, see you that and raise you *Alas, Babylon*. It's a pretty depressing place. Pete's pictures reminded me of the *Führerbunker*, just before the end. There's a kind of pantry — shelves and shelves of canned goods — and half a dozen cots. Also some equipment supplied by the government. Including a Geiger counter.'

'The canned stuff must be extremely tasty after fifty years.'

'Actually, they rotate in new goods every so often. There's even a small generator that went in after nine-eleven. Check the Town Report and you'll see an appropriation item for the shelter every four years or so. Used to be three hundred dollars. Now it's six hundred. You've got your Geiger counter.' She shifted her eyes to him briefly. 'Of course, James Rennie sees all things Town Hall, from the attic to the fallout shelter, as his personal property, so he'll want to know why you want it.'

'Big Jim Rennie isn't going to know,' he said.

She accepted this without comment. 'Would you like to come back to the office with me? Watch the President's speech while I start comping the paper? It'll be a quick and dirty job, I can tell you that. One story, half a dozen pictures for local consumption, no Burpee's Autumn Sales Days circular.'

Barbie considered it. He was going to be busy tomorrow, not just cooking but asking questions. Starting the old job all over again, in the old way. On the other hand, if he went back to his place over the drugstore, would he be able to sleep?

'Okay. And I probably shouldn't be telling you this, but I have excellent office-boy skills. I also make a mean cup of coffee.'

'Mister, you are on.' She raised her right hand off the wheel and Barbie slapped her five.

'Can I ask you one more question? Strictly not for publication?'

'Sure,' he said.

'This sci-fi generator. Do you think you'll find it?'

Barbie thought it over as she pulled in beside the storefront that housed the *Democrat*'s offices.

'No,' he said at last. 'That would be too easy.'

She sighed and nodded. Then she grasped his fingers. 'Would it help, do you think, if I prayed for your success?'

'Couldn't hurt,' Barbie said.

4

There were only two churches in Chester's Mill on Dome Day; both purveyed the Protestant brand of goods (although in very different ways). Catholics went to Our Lady of Serene Waters in Motton, and the town's dozen or so Jews attended Congregation Beth Shalom in Castle Rock when they felt in need of spiritual consolation. Once there had been a Unitarian church, but it had died of neglect in the late eighties. Everyone agreed it had been sort of hippy-dippy, anyway. The building now housed Mill New & Used Books.

Both Chester's Mill pastors were what Big Jim Rennie liked to call 'kneebound' that night, but their modes of address, states of mind, and expectations were very different.

The Reverend Piper Libby, who ministered to her flock from the pulpit of the First Congregational Church, no longer believed in God, although this was a fact she had not shared with her congregants. Lester Coggins, on the other hand, believed to the point of martyrdom or madness (both words for the same thing, perhaps).

The Rev. Libby, still wearing her Saturday grubs – and still pretty enough, even at forty-five, to look good in them – knelt in front of the altar in almost total darkness (the Congo had no generator), with Clover, her German shepherd, lying behind her with his nose on his paws and his eyes at half-mast.

'Hello, Not-There,' Piper said. Not-There was her private name for God just lately. Earlier in the fall it had been The Great Maybe. During the summer, it had been The Omnipotent Could-Be. She'd liked that one; it had a certain ring. 'You know the situation I've been in – You should, I've bent Your ear about it enough – but that's

not what I'm here to talk about tonight. Which is probably a relief to You.'

She sighed.

'We're in a mess here, my Friend. I hope You understand it, because I sure don't. But we both know this place is going to be full of people tomorrow, looking for heavenly disaster assistance.'

It was quiet inside the church, and quiet outside. 'Too quiet,' as they said in the old movies. Had she ever heard The Mill this quiet on a Saturday night? There was no traffic, and the bass thump of whatever weekend band happened to be playing at Dipper's (always advertised as being **DIRECT FROM BOSTON!**) was absent.

'I'm not going to ask that You show me Your will, because I'm no longer convinced You actually *have* a will. But on the off chance that You are there after all – always a possibility, I'm more than happy to admit that – please help me to say something helpful. Hope not in heaven, but right here on earth. Because . . .' She was not surprised to find that she had started to cry. She bawled so often now, although always in private. New Englanders strongly disapproved of public tears from ministers and politicians.

Clover, sensing her distress, whined. Piper told him to hush, then turned back to the altar. She often thought of the cross there as the religious version of the Chevrolet Bowtie, a logo that had come into being for no other reason than because some guy saw it on the wallpaper of a Paris hotel room a hundred years ago and liked it. If you saw such symbols as divine, you were probably a lunatic.

Nevertheless, she persevered.

'Because, as I'm sure You know, Earth is what we have. What we're sure of. I want to help my people. That's my job, and I still want to do it. Assuming You're there, and that You care – shaky assumptions, I admit – then please help me. Amen.'

She stood up. She had no flashlight, but anticipated no trouble finding her way outside with unbarked shins. She knew this place step for step and obstacle for obstacle. Loved it, too. She didn't fool herself about either her lack of faith or her stubborn love of the idea itself.

'Come on, Clove,' she said. 'President in half an hour. The other Great Not-There. We can listen on the car radio.'

Clover followed placidly, untroubled by questions of faith.

5

Out on Little Bitch Road (always referred to as Number Three by Holy Redeemer worshippers), a far more dynamic scene was taking

place, and under bright electric lights. Lester Coggins's house of worship possessed a generator new enough for the shipping tags still to be pasted on its bright orange side. It had its own shed, also painted orange, next to the storage barn behind the church.

Lester was a man of fifty so well maintained – by genetics as well as his own strenuous efforts to take care of the temple of his body – that he looked no more than thirty-five (judicious applications of Just For Men helped in this regard). He wore nothing tonight but a pair of gym shorts with ORAL ROBERTS GOLDEN EAGLES printed on the right leg, and almost every muscle on his body stood out.

During services (of which there were five each week), Lester prayed in an ecstatic televangelist tremolo, turning the Big Fellow's name into something that sounded as if it could have come from an overamped wah-wah pedal: not *God* but *GUH*-UH-UH-ODD*!* In his private prayers, he sometimes fell into these same cadences without realizing it. But when he was deeply troubled, when he really needed to take counsel with the God of Moses and Abraham, He who traveled as a pillar of smoke by day and a pillar of fire by night, Lester held up his end of the conversation in a deep growl that made him sound like a dog on the verge of attacking an intruder. He wasn't aware of this because there was no one in his life to hear him pray. Piper Libby was a widow who had lost her husband and both young sons in an accident three years before; Lester Coggins was a lifelong bachelor who as an adolescent had suffered nightmares of masturbating and looking up to see Mary Magdalene standing in his bedroom doorway.

The church was almost as new as the generator, and constructed of expensive red maple. It was also plain to the point of starkness. Behind Lester's bare back stretched a triple rank of pews beneath a beamed ceiling. Ahead of him was the pulpit: nothing but a lectern with a Bible on it and a large redwood cross hanging on a drape of royal purple. The choir loft was above and to the right, with musical instruments – including the Stratocaster Lester himself sometimes played – clustered at one end.

'God hear my prayer,' Lester said in his growly I'm-really-praying voice. In one hand he held a heavy length of rope that had been knotted twelve times, one knot for each disciple. The ninth knot – the one signifying Judas – had been painted black. 'God hear my prayer, I ask it in the name of the crucified and risen Jesus.'

He began to whip himself across the back with the rope, first over the left shoulder and then over the right, his arm rising and

flexing smoothly. His not inconsiderable biceps and delts began to pop a sweat. When it struck his already well-scarred skin, the knotted rope made a carpet-beater sound. He had done this many times before, but never with such force.

'God hear my *prayer*! God hear *my* prayer! God *hear* my prayer! *God* hear my prayer!'

Whack and *whack* and *whack* and *whack*. The sting like fire, like nettles. Sinking in along the turnpikes and byroads of his miserable human nerves. Both terrible and terribly satisfying.

'Lord, we have sinned in this town, and I am chief among sinners. I listened to Jim Rennie and believed his lies. Yea, I believed, and here is the price, and it is now as it was of old. It's not just the one that pays for the sin of one, but the many. You are slow to anger, but when it comes, Your anger is like the storms that sweep a field of wheat, laying low not just one stalk or a score but every one. I have sowed the wind and reaped the whirlwind, not just for one but for many.'

There were other sins and other sinners in The Mill – he knew that, he was not naïve, they swore and danced and sexed and took drugs he knew far too much about – and they no doubt deserved to be punished, to be *scourged*, but that was true of *every* town, surely, and this was the only one that had been singled out for this terrible act of God.

And yet . . . and yet . . . was it possible that this strange curse was not because of *his* sin? Yes. Possible. Although not likely.

'Lord, I need to know what to do. I'm at the crossroads. If it's Your will that I should stand in this pulpit tomorrow morning and confess to what that man talked me into – the sins we participated in together, the sins I have participated in alone – then I will do so. But that would mean the end of my ministry, and it's hard for me to believe that's Your will at such a crucial time. If it's Your will that I should wait . . . wait and see what happens next . . . wait and pray with my flock that this burden should be lifted . . . then I'll do that. Your will be done, Lord. Now and always.'

He paused in his scourging (he could feel warm and comforting trickles running down his bare back; several of the rope knots had begun to turn red) and turned his tearstained face up toward the beamed roof.

'Because these folks need me, Lord. You *know* they do, now more than ever. So . . . if it's Your will that this cup should be removed from my lips . . . please give me a sign.'

He waited. And behold, the Lord God said unto Lester Coggins,

'I will shew you a sign. Goest thou to thy Bible, even as you did as a child after those nasty dreams of yours.'

'This minute,' Lester said. 'This *second.*'

He hung the knotted rope around his neck, where it printed a blood horseshoe on his chest and shoulders, then mounted to the pulpit with more blood trickling down the hollow of his spine and dampening the elastic waistband of his shorts.

He stood at the pulpit as if to preach (although never in his worst nightmares had he dreamed of preaching in such scant garb), closed the Bible lying open there, then shut his eyes. 'Lord, Thy will be done – I ask in the name of Your Son, crucified in shame and risen in glory.'

And the Lord said, 'Open My Book, and see what you see.'

Lester did as instructed (taking care not to open the big Bible too close to the middle – this was an Old Testament job if ever there had been one). He plunged his finger down to the unseen page, then opened his eyes and bent to look. It was the second chapter of Deuteronomy, the twenty-eighth verse. He read:

'*The Lord shalt smite thee with madness and blindness and astonishment of the heart.*'

Astonishment of the heart was probably good, but on the whole this wasn't encouraging. Or clear. Then the Lord spake again, saying: 'Don't stop there, Lester.'

He read the twenty-ninth verse.

'*And thou shalt grope at noonday—*'

'Yes, Lord, yes,' he breathed, and read on.

'*—as the blind gropeth in darkness, and thou shalt not prosper in thy ways: and thou shalt be only oppressed and spoiled evermore, and no man shall save thee.*'

'Will I be struck blind?' Lester asked, his growly prayer-voice rising slightly. 'Oh God, please don't do that – although, if it is Thy will—'

The Lord spake unto him again, saying, 'Did you get up on the stupid side of the bed today, Lester?'

His eyes flew wide. God's voice, but one of his mother's favorite sayings. A true miracle. 'No, Lord, no.'

'Then look again. What am I shewing you?'

'It's something about madness. Or blindness.'

'Which of the two dost thou thinkest most likely?'

Lester scored the verses. The only word repeated was *blind*.

'Is that . . . Lord, is that my sign?'

The Lord answered, saying, 'Yea, verily, but not thine own blindness; for now thine eyes see more clearly. Lookest thou for the blinded

one who has gone mad. When you see him, you must tell your congregation what Rennie has been up to out here, and your part in it. You both must tell. We'll talk about this more, but for now, Lester, go to bed. You're dripping on the floor.'

Lester did, but first he cleaned up the little splatters of blood on the hardwood behind the pulpit. He did it on his knees. He didn't pray as he worked, but he meditated on the verses. He felt much better.

For the time being, he would speak only generally of the sins which might have brought this unknown barrier down between The Mill and the outside world; but he would look for the sign. For a blind man or woman who had gone crazy, yea, verily.

6

Brenda Perkins listened to WCIK because her husband liked it (*had* liked it), but she would never have set foot inside the Holy Redeemer Church. She was Congo to the core, and she made sure her husband went with her.

Had made sure. Howie would only be in the Congo church once more. Would lie there, unknowing, while Piper Libby preached his eulogy.

This realization – so stark and immutable – struck home. For the first time since she'd gotten the news, Brenda let loose and wailed. Perhaps because now she could. Now she was alone.

On the television, the President – looking solemn and frighteningly old – was saying, 'My fellow Americans, you want answers. And I pledge to give them to you as soon as I have them. There will be no secrecy on this issue. My window on events will be your window. That is my solemn promise—'

'Yeah, and you've got a bridge you want to sell me,' Brenda said, and that made her cry harder, because it was one of Howie's faves. She snapped off the TV, then dropped the remote on the floor. She felt like stepping on it and breaking it but didn't, mostly because she could see Howie shaking his head and telling her not to be silly.

She went into his little study instead, wanting to touch him somehow while his presence here was still fresh. *Needing* to touch him. Out back, their generator purred. *Fat n happy*, Howie would have said. She'd hated the expense of that thing when Howie ordered it after nine-eleven (*Just to be on the safe side*, he'd told her), but now she regretted every sniping word she'd said about it. Missing him in the dark would have been even more terrible, more lonely.

His desk was bare except for his laptop, which was standing

open. His screen saver was a picture from a long-ago Little League game. Both Howie and Chip, then eleven or twelve, were wearing the green jerseys of the Sanders Hometown Drug Monarchs; the picture had been taken the year Howie and Rusty Everett had taken the Sanders team to the state finals. Chip had his arms around his father and Brenda had her arms around both of them. A good day. But fragile. As fragile as a crystal goblet. Who knew such things at the time, when it still might be possible to hold on a little?

She hadn't been able to get hold of Chip yet, and the thought of that call – supposing she could make it – undid her completely. Sobbing, she got down on her knees beside her husband's desk. She didn't fold her hands but put them together palm to palm, as she had as a child, kneeling in flannel pajamas beside her bed and reciting the mantra of *God bless Mom, God bless Dad, God bless my goldfish who doesn't have a name yet.*

'God, this is Brenda. I don't want him back . . . well, I do, but I know You can't do that. Only give me the strength to bear this, okay? And I wonder if maybe . . . I don't know if this is blasphemy or not, probably it is, but I wonder if You could let him talk to me one more time. Maybe let him touch me one more time, like he did this morning.'

At the thought of it – his fingers on her skin in the sunshine – she cried even harder.

'I know You don't deal in ghosts – except of course for the Holy one – but maybe in a dream? I know it's a lot to ask, but . . . oh God, there's such a hole in me tonight. I didn't know there could *be* such holes in a person, and I'm afraid I'll fall in. If You do this for me, I'll do something for You. All You have to do is ask. Please, God, just a touch. Or a word. Even if it's in a dream.' She took a deep, wet breath. 'Thank you. Thy will be done, of course. Whether I like it or not.' She laughed weakly. 'Amen.'

She opened her eyes and got up, holding the desk for support. One hand nudged the computer, and the screen brightened at once. He was always forgetting to turn it off, but at least he kept it plugged in so the battery wouldn't run down. And he kept his electronic desktop far neater than she did; hers was always cluttered with downloads and electronic sticky-notes. On Howie's desktop, always just three files stacked neatly below the hard-disc icon: CURRENT, where he kept reports of ongoing investigations; COURT, where he kept a list of who (including himself) was down to testify, and where, and why. The third file was MORIN ST. MANSE, where he kept everything having to do with the

house. It occurred to her that if she opened that one she might find something about the generator, and she needed to know about that so she could keep it running as long as possible. Henry Morrison from the PD would probably be happy to change the current propane canister, but what if there were no spares? If that were the case, she should buy more at Burpee's or the Gas & Grocery before they were all gone.

She put her fingertip on the mousepad, then paused. There was a fourth file on the screen, lurking way down in the lefthand corner. She had never seen it before. Brenda tried to remember the last time she'd happened to look at the desktop of this computer, and couldn't.

VADER, the filename read.

Well, there was only one person in town Howie referred to as Vader, as in Darth: Big Jim Rennie.

Curious, she moved the cursor to the file and double-clicked it, wondering if it was password protected.

It was. She tried WILDCATS, which opened his CURRENT file (he hadn't bothered to protect COURT), and it worked. In the file were two documents. One was labeled ONGOING INVESTI-GATION. The other was a PDF doc titled LETTER FROM SMAG. In Howie-speak, that stood for State of Maine Attorney General. She clicked on it.

Brenda scanned the AG's letter with growing amazement as the tears dried on her cheeks. The first thing her eye happened on was the salutation: not *Dear Chief Perkins* but *Dear Duke*.

Although the letter was couched in lawyer-speak rather than Howie-speak, certain phrases leaped out at her as if in boldface type. **Misappropriation of town goods and services** was the first. **Selectman Sanders's involvement seems all but certain** was the next. Then **This malfeasance is wider and deeper than we could have imagined three months ago.**

And near the bottom, seeming not just in boldface but in capital letters: **MANUFACTURE AND SALE OF ILLEGAL DRUGS.**

It appeared that her prayer had been answered, and in a completely unexpected way. Brenda sat down in Howie's chair, clicked ONGOING INVESTIGATION in the VADER file, and let her late husband talk to her.

7

The President's speech – long on comfort, short on information – wrapped up at 12:21 a.m. Rusty Everett watched it in the third-floor

lounge of the hospital, made a final check of the charts, and went home. He had ended days more tired than this during his medical career, but he had never been more disheartened or worried about the future.

The house was dark. He and Linda had discussed buying a generator last year (and the year before), because Chester's Mill always lost its power four or five days each winter, and usually a couple of times in the summer as well; Western Maine Power was not the most reliable of service providers. The bottom line had been that they just couldn't afford it. Perhaps if Lin went full-time with the cops, but neither of them wanted that with the girls still small.

At least we've got a good stove and a helluva woodpile. If we need it.

There was a flashlight in the glove compartment, but when he turned it on it emitted a weak beam for five seconds and then died. Rusty muttered an obscenity and reminded himself to stock up on batteries tomorrow – later today, now. Assuming the stores were open.

If I can't find my way around here after twelve years, I'm a monkey.

Yes, well. He *felt* a little like a monkey tonight – one fresh-caught and slammed into a zoo cage. And he definitely smelled like one. Maybe a shower before bed—

But nope. No power, no shower.

It was a clear night, and although there was no moon, there were a billion stars above the house, and they looked the same as ever. Maybe the barrier didn't exist overhead. The President hadn't spoken to that issue, so perhaps the people in charge of investigating didn't know yet. If The Mill were at the bottom of a newly created well instead of caught underneath some weird bell jar, then things might still work out. The government could airdrop supplies. Surely if the country could spend hundreds of billions for corporate bailouts, then it could afford to parachute in extra Pop-Tarts and a few lousy generators.

He mounted the porch steps, taking out his housekey, but when he got to the door, he saw something hanging over the lockplate. He bent closer, squinting, and smiled. It was a mini-flashlight. At Burpee's End of Summer Blowout Sale, Linda had bought six for five bucks. At the time he'd thought it a foolish expenditure, even remembered thinking, *Women buy stuff at sales for the same reason men climb mountains – because they're there.*

A small metal loop stuck out on the bottom of the light. Threaded through it was a lace from one of his old tennis shoes. A note had been taped to the lace. He took it off and trained the light on it.

Hello sweet man. Hope you're OK. The 2 Js are finally down for the night. Both worried & upset, but finally corked off. I have the duty all day tomorrow & I do mean <u>all day</u>, from 7 to 7, Peter Randolph says (our new Chie— GROAN). Marta Edmunds said she'd take the girls, so God bless Marta. Try not to wake me. (Altho I may not be asleep.) We are in for hard days I fear, but we'll get thru this. Plenty to eat in pantry, thank God.

Sweetie, I know you're tired, but will you walk Audrey? She's still doing that weird Whining Thing of hers. Is it possible she knew this was coming? They say dogs can sense earthquakes, so maybe . . . ?

Judy & Jannie say they love their Daddy. So do I.

We'll find time to talk tomorrow, won't we? Talk and take stock.

I'm a little scared.

Lin

He was scared, too, and not crazy about his wife working a twelve tomorrow when he was likely to be working a sixteen or even longer. Also not crazy about Judy and Janelle spending a whole day with Marta when *they* were undoubtedly scared, too.

But the thing he was least crazy about was having to walk their golden retriever at nearly one in the morning. He thought it was possible she *had* sensed the advent of the barrier; he knew that dogs were sensitive to many impending phenomena, not just earthquakes. Only if that were the case, what he and Linda called the Whining Thing should have stopped, right? The rest of the dogs in town had been grave-quiet on his way back tonight. No barking, no howling. Nor had he heard other reports of dogs doing the Whining Thing.

Maybe she'll be asleep on her bed beside the stove, he thought as he unlocked the kitchen door.

Audrey wasn't asleep. She came to him at once, not bounding joyfully as she usually did – *You're home! You're home! Oh, thank God, you're home!* – but sidling, almost *slinking*, with her tail tucked down over her withers, as if expecting a blow (which she had never received) instead of a pat on the head. And yes, she was once more doing the Whining Thing. It had actually been going on since before the barrier. She'd stop for a couple of weeks, and Rusty would begin to hope it was over, and then it would start again, sometimes soft, sometimes loud. Tonight it was loud – or maybe it only seemed that way in the dark kitchen where the digital readouts on the stove and the microwave

were out and the usual light Linda left on for him over the sink was dark.

'Stop it, girl,' he said. 'You'll wake the house.'

But Audrey wouldn't. She butted her head softly against his knee and looked up at him in the bright, narrow beam of light he held in his right hand. He would have sworn that was a pleading look.

'All right,' he said. 'All right, all right. Walkies.'

Her leash dangled from a peg beside the pantry door. As he went to get it (dropping the light around his neck to hang by the shoelace as he did), she skittered in front of him, more like a cat than a dog. If not for the flashlight, she might have tripped him up. That would have finished this whore of a day in grand fashion.

'Just a minute, just a minute, hold on.'

But she barked at him and backed away.

'Hush! Audrey, hush!'

Instead of hushing she barked again, the sound shockingly loud in the sleeping house. He jerked in surprise. Audrey darted forward and seized the leg of his pants in her teeth and began to back toward the hall, trying to pull him along.

Now intrigued, Rusty allowed himself to be led. When she saw he was coming, Audrey let go and ran to the stairs. She went up two, looked back, and barked again.

A light went on upstairs, in their bedroom. 'Rusty?' It was Lin, her voice muzzy.

'Yeah, it's me,' he called, keeping it as low as he could. 'Actually it's Audrey.'

He followed the dog up the stairs. Instead of taking them at her usual all-out lope, Audrey kept pausing to look back. To dog-people, their animals' expressions are often perfectly readable, and what Rusty was seeing now was anxiety. Audrey's ears were laid flat, her tail still tucked. If this was the Whining Thing, it had been raised to a new level. Rusty suddenly wondered if there was a prowler in the house. The kitchen door had been locked, Lin was usually good about locking all the doors when she was alone with the girls, but—

Linda came to the head of the stairs, belting a white terry-cloth robe. Audrey saw her and barked again. A get-out-of-my-way bark.

'Audi, *stop* that!' she said, but Audrey ran past her, striking against Lin's right leg hard enough to knock her back against the wall. Then the golden ran down the hall toward the girls' room, where all was still quiet.

Lin fished her own mini-flashlight from a pocket of her robe. 'What in the name of *heaven*—'

'I think you better go back to the bedroom,' Rusty said.

'Like hell I will!' She ran down the hall ahead of him, the bright beam of the little light bouncing.

The girls were seven and five, and had recently entered what Lin called 'the feminine privacy phase.' Audrey reached their door, rose up, and began scratching on it with her front paws.

Rusty caught up with Lin just as she opened the door. Audrey bounded in, not even giving Judy's bed a look. Their five-year-old was fast asleep, anyway.

Janelle wasn't asleep. Nor was she awake. Rusty understood everything the moment the two flashlight beams converged on her, and cursed himself for not realizing earlier what was happening, what must have been happening since August or maybe even July. Because the behavior Audrey had been exhibiting – the Whining Thing – was well documented. He just hadn't seen the truth when it was staring him in the face.

Janelle, eyes open but showing only whites, wasn't convulsing – thank God for that – but she was trembling all over. She had pushed the covers down with her feet, probably at onset, and in the double flashlight beams he could see a damp patch on her pajama bottoms. Her fingertips wiggled, as if she were loosening up to play the piano.

Audrey sat by the bed, looking up at her little mistress with rapt attention.

'*What's happening to her?*' Linda screamed.

In the other bed Judy stirred and spoke. 'Mumma? Is it brefkus? Did I miss the bus?'

'She's having a seizure,' Rusty said.

'*Well, help her!*' Linda cried. '*Do something! Is she dying?*'

'No,' Rusty said. The part of his brain that remained analytical knew this was almost certainly just petit mal – as the others must have been, or they would have known about this already. But it was different when it was one of your own.

Judy sat bolt upright in bed, spilling stuffed animals everywhere. Her eyes were wide and terrified, nor was she much comforted when Linda tore the child out of bed and clasped her in her arms.

'*Make her stop! Make her stop, Rusty!*'

If it was petit mal, it would stop on its own.

Please God let it stop on its own, he thought.

He placed his palms on the sides of Jan's trembling, thrumming head and tried to rotate it upward, wanting to make sure her airway remained clear. At first he wasn't able to – the goddam foam pillow was fighting him. He tossed it on the floor. It struck Audrey on the

way down, but she didn't so much as flinch, only maintained her rapt gaze.

Rusty was now able to cock Jannie's head back a little, and he could hear her breathing. It wasn't rapid; there was no harsh tearing for oxygen, either.

'Mommy, what's the matter with Jan-Jan?' Judy asked, beginning to cry. 'Is she mad? Is she sick?'

'Not mad and only a little sick.' Rusty was astounded at how calm he sounded. 'Why don't you let Mommy take you down to our—'

'*No!*' they cried together, in perfect two-part harmony.

'Okay,' he said, 'but you have to be quiet. Don't scare her when she wakes up, because she's apt to be scared already.

'A *little* scared,' he amended. 'Audi, good girl. That's a very *very* good girl.'

Such compliments usually sent Audrey into paroxysms of joy, but not tonight. She didn't even wag her tail. Then, suddenly, the golden gave a small woof and lay down, dropping her muzzle onto one paw. Seconds later, Jan's trembling ceased and her eyes closed.

'I'll be damned,' Rusty said.

'What?' Linda was now sitting on the edge of Judy's bed with Judy on her lap. '*What?*'

'It's over,' Rusty said.

But it wasn't. Not quite. When Jannie opened her eyes again, they were back where they belonged, but they weren't seeing him.

'The Great Pumpkin!' Janelle cried. 'It's the Great Pumpkin's fault! You have to stop the Great Pumpkin!'

Rusty gave her a gentle shake. 'You were having a dream, Jannie. A bad one, I guess. But it's over and you're all right.'

For a moment she still wasn't completely there, although her eyes shifted and he knew she was seeing and hearing him now. 'Stop Halloween, Daddy! You have to stop Halloween!'

'Okay, honey, I will. Halloween's off. Completely.'

She blinked, then raised one hand to brush her clumped and sweaty hair off her forehead. 'What? *Why?* I was going to be Princess Leia! Does everything have to go wrong with my life?' She began to cry.

Linda came over – Judy scurrying behind and holding onto the skirt of her mother's robe – and took Janelle in her arms. 'You can still be Princess Leia, honeylove, I promise.'

Jan was looking at her parents with puzzlement, suspicion, and growing fright. 'What are you *doing* in here? And why is *she* up?' Pointing to Judy.

'You peed in your bed,' Judy said smugly, and when Jan realized
– realized and started to cry harder – Rusty felt like smacking Judy
a good one. He usually felt like a pretty enlightened parent (espe-
cially compared to those he sometimes saw creeping into the Health
Center with their arm-broke or eye-blackened children), but not
tonight.

'It doesn't matter,' Rusty said, hugging Jan close. 'It wasn't your
fault. You had a little problem, but it's over now.'

'Does she have to go to the hospital?' Linda asked.

'Only to the Health Center, and not tonight. Tomorrow morning.
I'll get her fixed up with the right medicine then.'

'*NO SHOTS!*' Jannie screamed, and began to cry harder than
ever. Rusty loved the sound of it. It was a healthy sound. Strong.

'No shots, sweetheart. Pills.'

'Are you sure?' Lin asked.

Rusty looked at their dog, now lying peacefully with her snout
on her paw, oblivious of all the drama.

'*Audrey's* sure,' he said. 'But she ought to sleep in here with the
girls for tonight.'

'Yay!' Judy cried. She fell to her knees and hugged Audi extrava-
gantly.

Rusty put an arm around his wife. She laid her head on his
shoulder as if too weary to hold it up any longer.

'Why now?' she asked. 'Why *now?*'

'I don't know. Just be grateful it was only petit mal.'

On that score, his prayer had been answered.

MADNESS, BLINDNESS, ASTONISHMENT OF THE HEART

1

Scarecrow Joe wasn't up early; he was up late. All night, in fact.

This would be Joseph McClatchey, age thirteen, also known as King of the Geeks and Skeletor, residing at 19 Mill Street. Standing six-two and weighing one-fifty, he was indeed skeletal. And he was a bona fide brain. Joe remained in the eighth grade only because his parents were adamantly opposed to the practice of 'skipping forward.'

Joe didn't mind. His friends (he had a surprising number for a scrawny thirteen-year-old genius) were there. Also, the work was a tit and there were plenty of computers to goof with; in Maine, every middle school kid got one. Some of the better websites were blocked, of course, but it hadn't taken Joe long to conquer such minor annoyances. He was happy to share the information with his homies, two of whom were those dauntless board-benders Norrie Calvert and Benny Drake. (Benny particularly enjoyed surfing the Blondes in White Panties site during his daily library period.) This sharing no doubt explained some of Joe's popularity, but not all; kids just thought he was cool. The bumper sticker plastered on his backpack probably came closest to explaining why. It read **FIGHT THE POWERS THAT BE.**

Joe was a straight-A student, a dependable and sometimes brilliant basketball center on the middle school team (varsity as a seventh-grader!), and a foxy-good soccer player. He could tickle the piano keys, and two years previous had won second prize in the annual Town Christmas Talent Competition with a hilariously laid-back dance routine to Gretchen Wilson's 'Redneck Woman.' It had the adults in attendance applauding and screaming with laughter. Lissa Jamieson, the town's head librarian, said he could make a living doing that if he wanted to, but growing up to be Napoleon Dynamite was not Joe's ambition.

'The fix was in,' Sam McClatchey had said, gloomily fingering his son's second-place medal. It was probably true; the winner that year had been Dougie Twitchell, who happened to be the Third Selectman's brother. Twitch had juggled half a dozen Indian clubs while singing 'Moon River.'

Joe didn't care if the fix was in or not. He had lost interest in dancing the way he lost interest in most things once he had to some degree mastered them. Even his love of basketball, which as a fifth-grader he had assumed to be eternal, was fading.

Only his passion for the Internet, that electronic galaxy of endless possibilities, did not seem to pall for him.

His ambition, unexpressed even to his parents, was to become President of the United States. *Maybe*, he sometimes thought, *I'll do the* Napoleon Dynamite *thing at my inaugural. That shit would be on YouTube for eternity.*

Joe spent the entire first night the Dome was in place on the Internet. The McClatcheys had no generator, but Joe's laptop was juiced and ready to go. Also, he had half a dozen spare batteries. He had urged the other seven or eight kids in his informal computer club to also keep spares on hand, and he knew where there were more if they were needed. They might not be; the school had a kickass generator, and he thought he could recharge there with no trouble. Even if Mill Middle went into lockdown, Mr Allnut, the janitor, would no doubt hook him up; Mr Allnut was also a fan of blondesinwhitepanties.com. Not to mention country music downloads, which Scarecrow Joe saw he got for free.

Joe all but wore out his Wi-Fi connection that first night, going from blog to blog with the jitter-jive agility of a toad hopping on hot rocks. Each blog was more dire than the last. The facts were thin, the conspiracy theories lush. Joe agreed with his dad and mom, who called the weirder conspiracy theorists who lived on (and for) the Internet 'the tinfoil-hat folks,' but he was also a believer in the idea that, if you were seeing a lot of horseshit, there had to be a pony in the vicinity.

As Dome Day became Day Two, all the blogs were suggesting the same thing: the pony in this case was not terrorists, invaders from space, or Great Cthulhu, but the good old military-industrial complex. The specifics varied from site to site, but three basic theories ran through all of them. One was that the Dome was some sort of heartless experiment, with the people of Chester's Mill serving as guinea pigs. Another was that it was an experiment that had gone wrong and out of control ('Exactly like in that movie *The Mist*,' one blogger wrote). A third was that it wasn't an experiment at all, but a coldly created pretext to justify war with America's stated enemies. 'And WE'LL WIN!' ToldjaSo87 wrote. 'Because with this new weapon, WHO CAN STAND AGAINST US? My friends, WE HAVE BECOME THE NEW ENGLAND PATRIOTS OF NATIONS!!!!'

Joe didn't know which if any of these theories was the truth. He didn't really care. What he cared about was the expressed common denominator, which was the government.

It was time for a demonstration, which he of course would lead.

Not in town, either, but out on Route 119, where they could stick it directly to The Man. It might only be Joe's guys at first, but it would grow. He had no doubt of that. The Man was probably still keeping the press corps away, but even at thirteen, Joe was wise enough to know that didn't necessarily matter. Because there were *people* inside those uniforms, and thinking brains behind at least some of those expressionless faces. The military presence as a whole might constitute The Man, but there would be individuals hiding in the whole, and some of them would be secret bloggers. They'd get the word out, and some would probably accompany their reports with camera-phone pictures: Joe McClatchey and his friends carrying signs reading END THE SECRECY, STOP THE EXPERIMENT, FREE CHESTER'S MILL, etc., etc.

'Need to post signs around town, too,' he murmured. But that would be no problem. All of his guys had printers. And bikes.

Scarecrow Joe began sending e-mails by the dawn's early light. Soon he'd make the rounds on his own bike, and enlist Benny Drake to help him. Maybe Norrie Calvert, too. Ordinarily the members of Joe's posse were late weekend risers, but Joe thought everyone in town would be up early this morning. No doubt The Man would shut down the Internet soon, as He had the phones, but for now it was Joe's weapon, the weapon of the people.

It was time to fight the power.

2

'Fellas, raise your hands,' Peter Randolph said. He was tired and baggy-eyed as he stood in front of his new recruits, but he also felt a certain grim happiness. The green Chief's car was parked in the motor pool parking lot, freshly gassed and ready to go. It was his now.

The new recruits – Randolph intended to call them Special Deputies in his formal report to the Selectmen – obediently raised their hands. There were actually five of them, and one was not a fella but a stocky young woman named Georgia Roux. She was an unemployed hairdresser and Carter Thibodeau's girlfriend. Junior had suggested to his father that they probably ought to add a female just to keep everybody happy, and Big Jim had concurred at once. Randolph initially resisted the idea, but when Big Jim favored the new Chief with his fiercest smile, Randolph had given in.

And, he had to admit as he administered the oath (with some of his regular force looking on), they certainly looked tough enough. Junior had lost some pounds over the previous summer and was

nowhere near his weight as a high school offensive linemen, but he still had to go one-ninety, and the others, even the girl, were authentic bruisers.

They stood repeating the words after him, phrase for phrase: Junior on the far left, next to his friend Frankie DeLesseps; then Thibodeau and the Roux girl; Melvin Searles on the end. Searles was wearing a vacant going-to-the-county-fair grin. Randolph would have wiped *that* shit off his face in a hurry if he'd had three weeks to train these kids (hell, even one), but he didn't.

The only thing on which he *hadn't* caved to Big Jim was the issue of sidearms. Rennie had argued for them, insisting that these were 'levelheaded, Godfearing young people,' and saying he'd be glad to provide them himself, if necessary.

Randolph had shaken his head. 'The situation's too volatile. Let's see how they do first.'

'If one of them gets hurt while you're seeing how they do—'

'Nobody's gonna get hurt, Big Jim,' Randolph said, hoping he was right. 'This is Chester's Mill. If it was New York City, things might be different.'

3

Now Randolph said, '"And I will, to the best of my ability, protect and serve the people of this town."'

They gave it back as sweetly as a Sunday School class on Parents' Day. Even the vacantly grinning Searles got it right. And they looked good. No guns – yet – but at least they had walkie-talkies. Night-sticks, too. Stacey Moggin (who would be pulling a street shift herself) had found uniform shirts for everyone but Carter Thibodeau. They had nothing to fit him because he was too broad in the shoulders, but the plain blue workshirt he'd fetched from home looked okay. Not reg, but it was clean. And the silver badge pinned over the left pocket sent the message that needed sending.

Maybe this was going to work.

'So help me God,' Randolph said.

'So help me God,' they repeated.

From the corner of his eye, Randolph saw the door open. It was Big Jim. He joined Henry Morrison, wheezy George Frederick, Fred Denton, and a dubious-looking Jackie Wettington at the back of the room. Rennie was here to see his son sworn in, Randolph knew. And because he was still uneasy about refusing the new men sidearms (refusing Big Jim anything ran counter to Randolph's

politically attuned nature), the new Chief now extemporized, mostly for the Second Selectman's benefit.

'And I will take no shit from anybody.'

'And I will take no shit from anybody!' they repeated. With enthusiasm. All smiling now. Eager. Ready to hit the streets.

Big Jim was nodding and giving him a thumbs-up in spite of the cussword. Randolph felt himself expand, unaware the words would come back to haunt him: *I will take no shit from anybody.*

4

When Julia Shumway came into Sweetbriar Rose that morning, most of the breakfast crowd had departed either for church or impromptu forums on the common. It was nine o'clock. Barbie was on his own; neither Dodee Sanders nor Angie McCain had shown up, which surprised no one. Rose had gone to Food City. Anson went with her. Hopefully they'd come back loaded with groceries, but Barbie wouldn't let himself believe it until he actually saw the goodies.

'We're closed until lunch,' he said, 'but there's coffee.'

'And a cinnamon roll?' Julia asked hopefully.

Barbie shook her head. 'Rose didn't make them. Trying to conserve the gennie as much as possible.'

'Makes sense,' she said. 'Just coffee, then.'

He had carried the pot with him, and poured. 'You look tired.'

'Barbie, *everyone* looks tired this morning. And scared to death.'

'How's that paper coming?'

'I was hoping to have it out by ten, but it's looking more like three this afternoon. The first *Democrat* extra since the Prestile flooded in oh-three.'

'Production problems?'

'Not as long as my generator stays online. I just want to go down to the grocery store and see if a mob shows up. Get that part of the story, if one does. Pete Freeman's already there to take pictures.'

Barbie didn't like that word *mob*. 'Christ, I hope they behave.'

'They will; this is The Mill, after all, not New York City.'

Barbie wasn't sure there was that much difference between city mice and country mice when they were under stress, but he kept his mouth shut. She knew the locals better than he did.

And Julia, as if reading his mind: 'Of course I could be wrong. That's why I sent Pete.' She looked around. There were still a few people at the counter up front, finishing eggs and coffee, and of course the big table at the back – the 'bullshit table' in Yankee parlance –

was full of old men chewing over what had happened and discussing what might happen next. The center of the restaurant, however, she and Barbie had to themselves.

'Couple of things to tell you,' she said in a lower voice. 'Stop hovering like Willie the Waiter and sit down.'

Barbie did so, and poured his own cup of coffee. It was the bottom of the pot and tasted like diesel . . . but of course the bottom of the pot was where the caffeine motherlode was.

Julia reached into the pocket of her dress, brought out her cell, and slid it across to him. 'Your man Cox called again at seven this morning. Guess he didn't get much sleep last night, either. Asked me to give you this. Doesn't know you have one of your own.'

Barbie let the phone stay where it was. 'If he expects a report already, he's seriously overestimated my abilities.'

'He didn't say that. He said that if he needed to talk to you, he wanted to be able to reach out.'

That decided Barbie. He pushed the cell phone back to her. She took it, not looking surprised. 'He also said that if you didn't hear from him by five this afternoon, you should call him. He'll have an update. Want the number with the funny area code?'

He sighed. 'Sure.'

She wrote it on a napkin: small neat numbers. 'I think they're going to try something.'

'What?'

'He didn't say; it was just a sense I got that a number of options are on the table.'

'I'll bet there are. What else is on your mind?'

'Who says there's anything?'

'It's just a sense I get,' he said, grinning.

'Okay, the Geiger counter.'

'I was thinking I'd speak to Al Timmons about that.' Al was the Town Hall janitor, and a regular at Sweetbriar Rose. Barbie got on well with him.

Julia shook her head.

'No? Why no?'

'Want to guess who gave Al a personal no-interest loan to send Al's youngest son to Heritage Christian in Alabama?'

'Would that be Jim Rennie?'

'Right. Now let's go on to Double Jeopardy, where the scores can really change. Guess who holds the paper on Al's Fisher plow.'

'I'm thinking that would also be Jim Rennie.'

'Correct. And since you're the dogshit Selectman Rennie can't

quite scrape off his shoe, reaching out to people who owe him might not be a good idea.' She leaned forward. 'But it so happens that I know who had a complete set of the keys to the kingdom: Town Hall, hospital, Health Center, schools, you name it.'

'Who?'

'Our late police chief. And I happen to know his wife – widow – very well. She has no love for James Rennie. Plus, she can keep a secret if someone convinces her it needs keeping.'

'Julia, her husband isn't even cold yet.'

Julia thought of the grim little Bowie funeral parlor and made a grimace of sorrow and distaste. 'Maybe not, but he's probably down to room temperature. I take your point, though, and applaud your compassion. But . . .' She grasped his hand. This surprised Barbie but didn't displease him. 'These aren't ordinary circumstances. And no matter how brokenhearted she is, Brenda Perkins will know that. You have a job to do. I can convince her of that. You're the inside man.'

'The inside man,' Barbie said, and was suddenly visited by a pair of unwelcome memories: a gymnasium in Fallujah and a weeping Iraqi man, naked save for his unraveling *hijab*. After that day and that gym, he had stopped wanting to be an inside man. And yet here he was.

'So shall I—'

It was a warm morning for October, and although the door was now locked (people could leave but not reenter), the windows were open. Through those facing Main Street, there now came a hollow metallic bang and a yelp of pain. It was followed by cries of protest.

Barbie and Julia looked at each other across their coffee cups with identical expressions of surprise and apprehension.

It begins right now, Barbie thought. He knew that wasn't true – it had begun yesterday, when the Dome came down – but at the same time he felt sure it *was* true.

The people at the counter were running to the door. Barbie got up to join them, and Julia followed.

Down the street, at the north end of the town common, the bell in the steeple of the First Congregational Church began to ring, summoning the faithful to worship.

5

Junior Rennie felt great. He had not so much as a shadow of a headache this morning, and breakfast was sitting easy in his stomach. He thought he might even be able to eat lunch. That was good. He hadn't had much use for food lately; half the time just looking at it

made him feel throw-uppy. Not this morning, though. Flapjacks and bacon, baby.

If this is the apocalypse, he thought, *it should have come sooner.*

Each Special Deputy had been partnered with a regular full-time officer. Junior drew Freddy Denton, and that was also good. Denton, balding but still trim at fifty, was known as a serious hardass . . . but there were exceptions. He had been president of the Wildcat Boosters Club during Junior's high school football years, and it was rumored he had never given a varsity football player a ticket. Junior couldn't speak for all of them, but he knew that Frankie DeLesseps had been let off by Freddy once, and Junior himself had been given the old 'I'm not going to write you up this time but slow down' routine twice. Junior could have been partnered with Wettington, who probably thought a first down was finally letting some guy into her pants. She had a great rack, but can you say *loser*? Nor had he cared for the cold-eyed look she gave him after the swearing-in, as he and Freddy passed her on their way to the street.

Got a little leftover pantry space for you, if you fuck with me, Jackie, he thought, and laughed. God, the heat and light on his face felt good! How long since it had felt so good?

Freddy looked over. 'Something funny, Junes?'

'Nothing in particular,' Junior said. 'I'm just on a roll, that's all.'

Their job – this morning, at least – was to foot-patrol Main Street ('To announce our presence,' Randolph had said), first up one side and down the other. Pleasant enough duty in the warm October sunshine.

They were passing Mill Gas & Grocery when they heard raised voices from inside. One belonged to Johnny Carver, the manager and part owner. The other was too slurry for Junior to make out, but Freddy Denton rolled his eyes.

'Sloppy Sam Verdreaux, as I live and breathe,' he said. 'Shit! And not even nine-thirty.'

'Who's Sam Verdreaux?' Junior asked.

Freddy's mouth tightened down to a white line Junior recognized from his football days. It was Freddy's *Ah fuck, we're behind* look. Also his *Ah fuck, that was a bad call* look. 'You've been missing the better class of Mill society, Junes. But you're about to get introduced.'

Carver was saying, 'I *know* it's past nine, Sammy, and I see you've got money, but I still can't sell you any wine. Not this morning, not this afternoon, not tonight. Probably not tomorrow either, unless this mess clears itself up. That's from Randolph himself. He's the new Chief.'

'Like fuck he is!' the other voice responded, but it was so slurry it came to Junior's ears sounding as *Li-fuh bizz*. 'Pete Randolph ain't but shitlint on Duke Perkins's asshole.'

'Duke's dead and Randolph says no booze sales. I'm sorry, Sam.'

'Just one bottle of T-Bird,' Sam whined. *Juz one barf T-Burr.* 'I need it. *Annd*, I can pay for it. Come on. How long I been tradin here?'

'Well, shit.' Although he sounded disgusted with himself, Johnny was turning to look at the wall-long case of beer and vino as Junior and Freddy came up the aisle. He had probably decided a single bottle of Bird would be a small price to get the old rumpot out of his store, especially since a number of shoppers were watching and avidly awaiting further developments.

The hand-printed sign on the case said ABSOLUTELY NO ALCOHOL SALES UNTIL FURTHER NOTICE, but the wussy was reaching for the booze just the same, the stuff in the middle. That was where the cheapass popskull lived. Junior had been on the force less than two hours, but he knew *that* was a bad idea. If Carver caved in to the straggle-haired wino, other, less disgusting, customers would demand the same privilege.

Freddy Denton apparently agreed. 'Don't do that,' he told Johnny Carver. And to Verdreaux, who was looking at him with the red eyes of a mole caught in a brushfire: 'I don't know if you have enough working brain cells left to read the sign, but I know you heard the man: no alcohol today. So get in the breeze. Quit smelling up the place.'

'You can't do that, Officer,' Sam said, drawing himself up to his full five and a half feet. He was wearing filthy chinos, a Led Zeppelin tee-shirt, and old slippers with busted backs. His hair looked as if it had last been cut while Bush II was riding high in the polls. 'I got my rights. Free country. Says so right in the Constitution of Independence.'

'The Constitution's been canceled in The Mill,' Junior said, with absolutely no idea that he was speaking prophecy. 'So put an egg in your shoe and beat it.' God, how fine he felt! In barely a day he had gone from doom and gloom to boom and zoom!

'But . . .'

Sam stood there for a moment with his lower lip trembling, trying to muster more arguments. Junior observed with disgust and fascination that the old fuck's eyes were getting wet. Sam held out his hands, which were trembling far worse than his loose mouth. He only had one more argument to make, but it was a hard one to bring out in front of an audience. Because he had to, he did.

'I really need it, Johnny. No joke. Just a little, to stop the shakes. I'll make it last. And I won't get up to no dickens. Swear on my mother's name. I'll just go home.' Home for Sloppy Sam was a shack sitting in a gruesomely bald dooryard dotted with old auto parts.

'Maybe I ought to—' Johnny Carver began.

Freddy ignored him. 'Sloppy, you never made a bottle last in your life.'

'Don't you call me that!' Sam Verdreaux cried. The tears over-spilled his eyes and slid down his cheeks.

'Your fly's unzipped, oldtimer,' Junior said, and when Sam looked down at the crotch of his grimy chinos, Junior stroked a finger up the flabby underside of the old man's chin and then tweaked his beak. A grammar school trick, sure, but it hadn't lost its charm. Junior even said what they'd said back then: 'Dirty clothes, gotcha nose!'

Freddy Denton laughed. So did a couple of other people. Even Johnny Carver smiled, although he didn't look as if he really wanted to.

'Get outta here, Sloppy,' Freddy said. 'It's a nice day. You don't want to spend it in a cell.'

But something – maybe being called Sloppy, maybe having his nose tweaked, maybe both – had relit some of the rage that had awed and frightened Sam's mates when he'd been a lumber-jockey on the Canadian side of the Merimachee forty years before. The tremble disappeared from his lips and hands, at least temporarily. His eyes lighted on Junior, and he made a phlegmy but undeniably contemp-tuous throat-clearing sound. When he spoke, the slur had left his voice.

'Fuck you, kid. You ain't no cop, and you was never much of a football player. Couldn't even make the college B-team is what I heard.'

His gaze switched to Officer Denton.

'And you, Deputy Dawg. Sunday sales legal after nine o'clock. Has been since the seventies, and that's the end of *that* tale.'

Now it was Johnny Carver he was looking at. Johnny's smile was gone, and the watching customers had grown very silent. One woman had a hand to her throat.

'I got money, coin of the realm, and I'm takin what's mine.'

He started around the counter. Junior grabbed him by the back of the shirt and the seat of the pants, whirled him around, and ran him toward the front of the store.

'*Hey!*' Sam shouted as his feet bicycled above the old oiled boards. '*Take your hands off me! Take your fucking hands—*'

Out through the door and down the steps, Junior holding the old man out in front of him. He was light as a bag of feathers. And Christ, he was *farting*! Pow-pow-pow, like a damn machine gun!

Stubby Norman's panel truck was parked at the curb, the one with FURNITURE BOUGHT & SOLD and TOP PRICES FOR ANTIQUES on the side. Stubby himself stood beside it with his mouth open. Junior didn't hesitate. He ran the blabbering old drunk headfirst into the side of the truck. The thin metal gave out a mellow *BONNG!*

It didn't occur to Junior that he might have killed the smelly fuck until Sloppy Sam dropped like a rock, half on the sidewalk and half in the gutter. But it took more than a smack against the side of an old truck to kill Sam Verdreaux. Or silence him. He cried out, then just began to cry. He got to his knees. Scarlet was pouring down his face from his scalp, where the skin had split. He wiped some away, looked at it with disbelief, then held out his dripping fingers.

Foot traffic on the sidewalk had halted so completely that someone might have called a game of Statues. Pedestrians stared with wide eyes at the kneeling man holding out a palmful of blood.

'*I'll sue this whole fuckin town for police brutality!*' Sam bawled. '*AND I'LL WIN!*'

Freddy came down the store's steps and stood beside Junior.

'Go ahead, say it,' Junior told him.

'Say what?'

'I overreacted.'

'The fuck you did. You heard what Pete said: Take no shit from anybody. Partner, that deal starts here and now.'

Partner! Junior's heart lifted at the word.

'*You can't throw me out when I got money!*' Sam raved. '*You can't beat me up! I'm an American citizen! I'll see you in court!*'

'Good luck on that one,' Freddy said. 'The courthouse is in Castle Rock, and from what I hear, the road going there is closed.'

He hauled the old man to his feet. Sam's nose was also bleeding, and the flow had turned his shirt into a red bib. Freddy reached around to the small of his back for a set of his plastic cuffs (*Gotta get me some of those,* Junior thought admiringly). A moment later they were on Sam's wrists.

Freddy looked around at the witnesses — those on the street, those crowding the doorway of the Gas & Grocery. 'This man is being arrested for public disturbance, interfering with police officers, and attempted assault!' he said in a bugling voice Junior remembered

well from his days on the football field. Hectoring from the sidelines, it had never failed to irritate him. Now it sounded delightful.

Guess I'm growing up, Junior thought.

'He is also being arrested for violating the new no-alcohol rule, instituted by Chief Randolph. Take a good look!' Freddy shook Sam. Blood flew from Sam's face and filthy hair. 'We've got a crisis situation here, folks, but there's a new sheriff in town, and he intends to handle it. Get used to it, deal with it, learn to love it. That's my advice. Follow it, and I'm sure we'll get through this situation just fine. Go against it, and . . .' He pointed to Sam's hands, plasticuffed behind him.

A couple of people actually applauded. For Junior Rennie, the sound was like cold water on a hot day. Then, as Freddy began to frog-march the bleeding old man up the street, Junior felt eyes on him. The sensation so clear it might have been fingers poking the nape of his neck. He turned, and there was Dale Barbara. Standing with the newspaper editor and looking at him with flat eyes. Barbara, who had beaten him up pretty good that night in the parking lot. Who'd marked all three of them, before sheer weight of numbers had finally begun to turn things around.

Junior's good feelings began to depart. He could almost feel them flying up through the top of his head like birds. Or bats from a belfry.

'What are *you* doing here?' he asked Barbara.

'I've a better question,' Julia Shumway said. She was wearing her tight little smile. 'What are *you* doing, brutalizing a man who's a quarter your weight and three times your age?'

Junior could think of nothing to say. He felt blood rush into his face and fan out on his cheeks. He suddenly saw the newspaper bitch in the McCain pantry, keeping Angie and Dodee company. Barbara, too. Maybe lying on top of the newspaper bitch, as if he were enjoying a little of the old sumpin-sumpin.

Freddy came to Junior's rescue. He spoke calmly. He wore the stolid policeman's face known the world over. 'Any questions about police policy should go to the new Chief, ma'am. In the meantime, you'd do well to remember that, for the time being, we're on our own. Sometimes when people are on their own, examples have to be made.'

'Sometimes when people are on their own, they do things they regret later,' Julia replied. 'Usually when the investigations start.'

The corners of Freddy's mouth turned down. Then he hauled Sam down the sidewalk.

Junior looked at Barbie a moment longer, then said: 'You want to watch your mouth around me. And your step.' He touched a thumb deliberately to his shiny new badge. 'Perkins is dead and I'm the law.'

'Junior,' Barbie said, 'you don't look so good. Are you sick?'

Junior looked at him from eyes that were a little too wide. Then he turned and went after his new partner. His fists were clenched.

6

In times of crisis, folks are apt to fall back on the familiar for comfort. That is as true for the religious as it is for the heathen. There were no surprises for the faithful in Chester's Mill that morning; Piper Libby preached hope at the Congo, and Lester Coggins preached hellfire at Christ the Holy Redeemer. Both churches were packed.

Piper's scripture was from the book of John: *A new commandment I give unto you, That ye love one another, as I have loved you, that ye also love one another.* She told those who filled the pews of the Congo church that prayer was important in times of crisis – the comfort of prayer, the power of prayer – but it was also important to help one another, depend on one another, and love one another.

'God tests us with things we don't understand,' she said. 'Sometimes it's sickness. Sometimes it's the unexpected death of a loved one.' She looked sympathetically at Brenda Perkins, who sat with her head bowed and her hands clasped in the lap of a black dress. 'And now it's some inexplicable barrier that has cut us off from the outside world. We don't understand it, but we don't understand sickness or pain or the unexpected deaths of good people, either. We ask God why, and in the Old Testament, the answer is the one He gave to Job: "Were you there when I made the world?" In the New – and more enlightened – Testament, it's the answer Jesus gave to his disciples: "Love one another, as I have loved you." That's what we have to do today and every day until this thing is over: love one another. Help one another. And wait for the test to end, as God's tests always do.'

Lester Coggins's scripture came from Numbers (a section of the Bible not known for optimism): *Behold, ye have sinned against the LORD, and be sure your sin will find you out.*

Like Piper, Lester mentioned the testing concept – an ecclesiastical hit during all the great clustermugs of history – but his major theme had to do with the infection of sin, and how God dealt with such infections, which seemed to be squeezing them with His Fingers

the way a man might squeeze a troublesome pimple until the pus squirted out like holy Colgate.

And because, even in the clear light of a beautiful October morning, he was still more than half convinced that the sin for which the town was being punished was his own, Lester was particularly eloquent. There were tears in many eyes, and cries of 'Yes, Lord!' rang from one amen corner to the other. When he was this inspired, great new ideas sometimes occurred to Lester even as he was preaching. One occurred to him this day, and he articulated it at once, without so much as a pause for thought. It needed no thought. Some things are just too bright, too glowing, not to be right.

'This afternoon I'm going out to where Route 119 strikes God's mysterious Gate,' he said.

'Yes, Jesus!' a weeping woman cried. Others clapped their hands or raised them in testimony.

'I reckon two o'clock. I'm going to get on my knees out there in that dairy field, yea, and I'm going to pray to God to lift this affliction.'

This time the cries of Yes Lord and Yes Jesus and God knows it were louder.

'But first—' Lester raised the hand with which he had whipped his bare back in the dark of night. 'First, I'm going to pray about the SIN that has caused this PAIN and this SORROW and this AFFLIC-TION! If I am alone, God may not hear me. If I am with two or three or even five, God STILL may not hear me, can you say amen.'

They could. They did. All of them were holding up their hands now, and swaying from side to side, caught up in that good-God fever.

'But if YOU ALL were to come out – if we were to pray in a circle right there in God's grass, under God's blue sky . . . within sight of the soldiers they say are guarding the work of God's right-eous Hand . . . if YOU ALL were to come out, if WE ALL were to pray together, then we might be able to get to the bottom of this sin, and drag it out into the light to die, and work a God-almighty miracle! WILL YOU COME? WILL YOU GET KNEEBOUND WITH ME?'

Of course they would come. Of course they would get knee-bound. People enjoy an honest-to-God prayer meeting in good times and bad. And when the band swung into 'Whate'er My God Ordains is Right' (key of G, Lester on lead guitar), they sang fit to raise the roof.

Jim Rennie was there, of course; it was Big Jim who made the car-pool arrangements.

7

**END THE SECRECY!
FREE CHESTER'S MILL!
DEMONSTRATE!!!!**

WHERE? The Dinsmore Dairy Farm on Route 119
(Just look for the WRECKED TRUCK and the MILITARY
AGENTS OF OPPRESSION)!

WHEN? 2 pm, eot (Eastern Oppression Time)!

WHO? YOU, and every Friend you can bring! Tell
them WE WANT TO TELL OUR STORY TO THE MEDIA!
Tell them WE WANT TO KNOW WHO DID THIS TO US!
AND WHY!
Most of all, tell them **WE WANT OUT!!!**

This is OUR TOWN! We need to fight for it!
WE NEED TO TAKE IT BACK!!!

Some signs available, but be sure & bring your own
(and remember that Profanity is counterproductive).

**FIGHT THE POWER!
STICK IT TO THE MAN!**

The Committee to Free Chester's Mill

8

If there was one man in town who could take that old Nietzschean saying 'Whatever does not kill me makes me stronger' as his personal motto, that man was Romeo Burpee, a hustler with a daddy-cool Elvis pomp and pointed boots with elastic sides. He owed his first name to a romantic Franco-American mother; his last to a hardass Yankee father who was practical to his dry pinchpenny core. Romeo had survived a childhood of merciless taunts – plus the occasional beating – to become the richest man in town. (Well . . . no. Big Jim was the richest man in town, but much of his wealth was of

necessity hidden.) Rommie owned the largest and most profitable indie department store in the entire state. Back in the eighties, his potential backers in the venture had told him he was mad to go with such a frankly ugly name as Burpee's. Rommie's response had been that if the name hadn't hurt Burpee Seeds, it wouldn't hurt him. And now their biggest summer sellers were tee-shirts reading MEET ME FOR SLURPEES AT BURPEES. Take *that*, you imagination-challenged bankers!

He had succeeded, in large measure, by recognizing the main chance and pursuing it ruthlessly. Around ten that Sunday morning – not long after he'd watched Sloppy Sam hauled off to the cop-shop – another main chance rolled around. As they always did, if you watched for them.

Romeo observed children putting up posters. Computer-generated and very professional-looking. The kids – most on bikes, a couple on skateboards – were doing a good job of covering Main Street. A protest demonstration out on 119. Romeo wondered whose idea *that* had been.

He caught up with one and asked.

'It was my idea,' Joe McClatchey said.

'No shit?'

'No shit whatsoever,' Joe said.

Rommie tipped the kid five, ignoring his protests and tucking it deep into his back pocket. Information was worth paying for. Rommie thought people would go to the kid's demonstration. They were crazy to express their fear, frustration, and righteous anger.

Shortly after sending Scarecrow Joe on his way, Romeo began to hear people talking about an afternoon prayer meeting, to be held by Pastor Coggins. Same by-God time, same by-God place.

Surely a sign. One reading SALES OPPORTUNITY HERE.

Romeo went into his store, where business was lackadaisical. The people Sunday-shopping today were either doing it at Food City or Mill Gas & Grocery. And they were the minority. Most were either at church or at home watching the news. Toby Manning was behind the cash register, watching CNN on a little battery-powered TV.

'Shut off that quack and close down your register,' Romeo said.

'Really, Mr Burpee?'

'Yes. Drag the big tent out of storage. Get Lily to help you.'

'The Summer Blowout Sale tent?'

'That's the baby,' Romeo said. 'We're gonna pitch it in that cowgrass where Chuck Thompson's plane crashed.'

'Alden Dinsmore's field? What if he wants money to use it?'

'Then we'll pay him.' Romeo was calculating. The store sold everything, including discount grocery items, and he currently had roughly a thousand packs of discount Happy Boy franks in the industrial freezer behind the store. He'd bought them from Happy Boy HQ in Rhode Island (company now defunct, little microbe problem, thank God not *E. coli*), expecting to sell them to tourists and locals planning Fourth of July cookouts. Hadn't done as well as he'd expected, thanks to the goddam recession, but had held onto them anyway, as stubbornly as a monkey holding onto a nut. And now maybe . . .

Serve them on those little garden-sticks from Taiwan, he thought. *I've still got a billion of those bastards. Call them something cute, like Frank-A-Ma-Bobs.* Plus they had maybe a hundred cartons of Yummy Tummy Lemonade and Limeade powder, another discount item on which he'd expected to take a loss.

'We're going to want to pack up all the Blue Rhino, too.' Now his mind was clicking away like an adding machine, which was just the way Romeo liked it to click.

Toby was starting to look excited. 'Whatcha got in mind, Mr Burpee?'

Rommie went on inventorying stuff he'd expected to record on his books as a dead loss. Those cheapshit pinwheels . . . leftover Fourth of July sparklers . . . the stale candy he'd been saving for Halloween . . .

'Toby,' he said, 'we're going to throw the biggest damn cookout and field day this town has ever seen. Get moving. We've got a lot to do.'

9

Rusty was making hospital rounds with Dr Haskell when the walkie-talkie Linda had insisted he carry buzzed in his pocket.

Her voice was tinny but clear. 'Rusty, I have to go in after all. Randolph says it looks like half the town is going to be out at the barrier on 119 this afternoon – some for a prayer meeting, some for a demonstration. Romeo Burpee is going to pitch a tent and sell hotdogs, so expect an influx of gastroenteritis patients this evening.'

Rusty groaned.

'I'll have to leave the girls with Marta after all.' Linda sounded defensive and worried, a woman who knew there was suddenly not enough of her to go around. 'I'll fill her in on Jannie's problem.'

'Okay.' He knew if he told her to stay home, she would . . . and all he'd accomplish would be to worry her just when her worries

were starting to settle a bit. And if a crowd *did* show up out there, she'd be needed.

'Thank you,' she said. 'Thank you for understanding.'

'Just remember to send the dog to Marta's with the girls,' Rusty said. 'You know what Haskell said.'

Dr Ron Haskell – The Wiz – had come up big for the Everett family this morning. Had come up big ever since the onset of the crisis, really. Rusty never would have expected it, but he appreciated it. And he could see by the old guy's pouched eyes and drooping mouth that Haskell was paying the price. The Wiz was too old for medical crises; snoozing in the third floor lounge was more his speed these days. But, other than Ginny Tomlinson and Twitch, it was now just Rusty and The Wiz holding the fort. It was bad luck all around that the Dome had crashed down on a beautiful weekend morning when anyone who could get out of town had done so.

Haskell, although pushing seventy, had stayed at the hospital with Rusty last night until eleven, when Rusty had literally forced him out the door, and he'd been back by seven this morning, when Rusty and Linda arrived with daughters in tow. Also with Audrey, who seemed to take the new environment of Cathy Russell calmly enough. Judy and Janelle had walked on either side of the big golden, touching her for comfort. Janelle had looked scared to death.

'What's with the dog?' Haskell asked, and when Rusty filled him in, Haskell had nodded and said to Janelle: 'Let's check you out, hon.'

'Will it hurt?' Janelle had asked apprehensively.

'Not unless getting a piece of candy after I look in your eyes hurts.'

When the exam was over, the adults left the two girls and the dog in the examining room and went into the hall. Haskell's shoulders were slumped. His hair seemed to have whitened overnight.

'What's your diagnosis, Rusty?' Haskell had asked.

'Petit mal. I'd think brought on by excitement and worry, but Audi's been doing that Whining Thing of hers for months.'

'Right. We'll start her on Zarontin. You agree?'

'Yes.' Rusty had been touched to be asked. He was beginning to regret some of the mean things he'd said and thought about Haskell.

'And keep the dog with her, yes?'

'Absolutely.'

'Will she be all right, Ron?' Linda asked. She'd had no plans to work then; her plan then had been to spend the day in quiet activities with the girls.

'She *is* all right,' Haskell said. 'Many children suffer petit mal

seizures. Most have only one or two. Others have more, over a course of years, and then stop. There's rarely any lasting damage.'

Linda looked relieved. Rusty hoped she would never have to know what Haskell wasn't telling her: that instead of finding their way out of the neurological thicket, some unlucky kids went in deeper, progressing to grand mal. And grand mal seizures *could* do damage. They could kill.

Now, after finishing morning rounds (only half a dozen patients, one a new mom with no complications) and hoping for a cup of coffee before jetting over to the Health Center, this call from Linda.

'I'm sure Marta will be fine with having Audi,' she said.

'Good. You'll have your cop walkie while you're on duty, right?'

'Yes. Of course.'

'Then give your personal walkie to Marta. Agree on a com channel. If something should go wrong with Janelle, I'll come on the run.'

'All right. Thanks, honeybunch. Is there any chance you could get out there this afternoon?'

As Rusty considered that, he saw Dougie Twitchell coming down the hall. He had a cigarette tucked behind his ear and was walking in his usual don't-give-a-shit amble, but Rusty saw concern on his face.

'I might be able to play hookey for an hour. No promises.'

'I understand, but it would be so great to see you.'

'You too. Be careful out there. And tell folks not to eat the hotdogs. Burpee's probably had them in cold storage for ten thousand years.'

'Those are his mastadon steaks,' Linda said. 'Over and out, sweet man. I'll look for you.'

Rusty stuck the walkie in the pocket of his white coat and turned to Twitch. 'What's up? And get that cigarette out from behind your ear. This is a hospital.'

Twitch plucked the cigarette from its resting place and looked at it. 'I was going to smoke it out by the storage shed.'

'Not a good idea,' Rusty said. 'That's where the extra propane's stored.'

'That's what I came to tell you. Most of the tanks are gone.'

'Bullshit. Those things are *huge*. I can't remember if they hold three thousand gallons each or five thousand.'

'So what are you saying? I forgot to look behind the door?'

Rusty began to rub his temples. 'If it takes them — whoever *they* are — more than three or four days to short out that forcefield, we're going to need mucho LP.'

'Tell me something I don't know,' Twitch said. 'According to the inventory card on the door, there's supposed to be seven of those puppies, but there are only two.' He stowed the cigarette in the pocket of his own white coat. 'I checked the other shed just to make sure, thought somebody might have moved the tanks—'

'Why would anyone do that?'

'I dunno, O Great One. Anyway, the other shed's for the really important hospital supplies: gardening and landscaping shit. In that one the tools are present and accounted for, but the fucking fertilizer's gone.'

Rusty didn't care about the fertilizer; he cared about the propane. 'Well — if push comes to shove, we'll get some from the town supplies.'

'You'll get a fight from Rennie.'

'When Cathy Russell might be his only option if that ticker of his vapor-locks? I doubt it. You think there's any chance I can get away for a while this afternoon?'

'That'd be up to The Wiz. He now appears to be the ranking officer.'

'Where is he?'

'Sleeping in the lounge. Snores like a mad bastard, too. You want to wake him up?'

'No,' Rusty said. 'Let him sleep. And I'm not going to call him The Wiz anymore. Given how hard he's worked since this shit came down, I think he deserves better.'

'Ah so, sensei. You have reached a new level of enlightenment.'

'Blow me, grasshopper,' Rusty said.

10

Now see this; see it very well.

It's two forty p.m. on another eye-bustingly gorgeous autumn day in Chester's Mill. If the press were not being kept away they'd be in photo-op heaven — and not just because the trees are in full flame. The imprisoned people of the town have migrated to Alden Dinsmore's dairy field en masse. Alden has struck a use-fee deal with Romeo Burpee: six hundred dollars. Both men are happy, the farmer because he jacked the businessman up considerable from Burpee's starting offer of two hundred, Romeo because he would have gone to a thousand, if pressed.

From the protestors and Jesus-shouters Alden collected not a single crying dime. That doesn't mean he isn't charging them, however; Farmer Dinsmore was born at night, but not last night. When this

opportunity came along, he marked out a large parking area just
north of the place where the fragments of Chuck Thompson's plane
came to rest the day before, and there he has stationed his wife
(Shelley), his older son (Ollie; you remember Ollie), and his hired
man (Manuel Ortega, a no-greencard Yankee who can ayuh with the
best of them). Alden's knocking down five dollars a car, a fortune for
a shirttail dairyman who for the last two years has been keeping his
farm out of Keyhole Bank's hands by the skin of his teeth. There are
complaints about the fee, but not many; they charge more to park
at the Fryeburg Fair, and unless folks want to park by the side of the
road — which has already been lined on both sides by early arrivals
— and then walk half a mile to where all the excitement is, they have
no choice.

And what a strange and varied scene! A three-ring circus for
sure, with the ordinary citizens of The Mill in all the starring roles.
When Barbie arrives with Rose and Anse Wheeler (the restaurant is
closed again, will reopen for supper — just cold sandwiches, no grill
orders), they stare in openmouthed silence. Both Julia Shumway and
Pete Freeman are taking pictures. Julia stops long enough to give
Barbie her attractive but somehow inward-turning smile.

'Some show, wouldn't you say?'

Barbie grins. 'Yessum.'

In the first ring of this circus, we have the townsfolk who have
responded to the posters put up by Scarecrow Joe and his cadre. The
protest turnout has been quite satisfying, almost two hundred, and
the sixty signs the kids made (the most popular: **LET US OUT,
DAMN IT!!**) were gone in no time. Luckily, many people *did*
bring their own signs. Joe's favorite is the one with prison bars inked
over a map of The Mill. Lissa Jamieson is not just holding it but pumping
it aggressively up and down. Jack Evans is there, looking pale and
grim. His sign is a collage of photographs featuring the woman who
bled to death the day before. **WHO KILLED MY WIFE?** it
screams. Scarecrow Joe feels sorry for him . . . but what an awesome
sign! If the press could see that one, they'd fill their collective pants
with joyshit.

Joe organized the protestors into a big circle that rotates just in
front of the Dome, which is marked by a line of dead birds on the
Chester's Mill side (those on the Motton side have been removed by
the military personnel). The circle gives all of Joe's people — for so
he thinks of them — a chance to wave their signs at the posted guards,
who stand with their backs resolutely (and maddeningly) turned. Joe
also gave out printed 'chant-sheets.' He wrote these with Benny

Drake's skateboarding idol, Norrie Calvert. Besides being balls-to-the-wall on her Blitz deck, Norrie's rhymes are simple but tight, yo? One chant goes, *Ha-ha-ha! Hee-hee-hee! Chester's Mill must be set free!* Another: *You did it! You did it! Come on out and just admit it!* Joe has – with real reluctance – vetoed another Norrie masterpiece that goes *Take off the gags! Take off the gags! Let us talk to the press, you fags!* 'We have to be politically correct about this,' he told her. What he's wondering just now is if Norrie Calvert is too young to kiss. And if she would slip him any tongue if he did. He has never kissed a girl, but if they're all going to die like starving bugs trapped under a Tupperware bowl, he probably should kiss this one while there's still time.

In the second ring is Pastor Coggins's prayer circle. They are really getting God-sent. And, in a fine show of ecclesiastical détente, the Holy Redeemer choir has been joined by a dozen men and women from the Congo church choir. They're singing 'A Mighty Fortress Is Our God,' and a good number of unaffiliated townsfolk who know the words have joined in. Their voices rise to the blameless blue sky, with Lester's shrill exhortations and the prayer circle's supporting cries of *amen* and *hallelujah* weaving in and out of the singing in perfect counterpoint (although not harmony – that would be going too far). The prayer circle keeps growing as other townsfolk drop to their knees and join in, laying their signs temporarily aside so they can raise their clasped hands in supplication. The soldiers have turned their backs; perhaps God has not.

But the center ring of this circus is the biggest and most bodacious. Romeo Burpee pitched the End of Summer Blowout Sale tent well back from the Dome and sixty yards east of the prayer circle, calculating the location by testing the faint gasp of breeze that's blowing. He wants to make sure that the smoke from his rank of Hibachis reaches both those praying and those protesting. His only concession to the afternoon's religious aspect is to make Toby Manning turn off his boombox, which was blaring that James McMurtry song about living in a small town; it didn't mix well with 'How Great Thou Art' and 'Won't You Come to Jesus.' Business is good and will only get better. Of this Romeo is sure. The hotdogs – thawing even as they cook – may gripe some bellies later, but they smell *perfect* in the warm afternoon sun; like a county fair instead of chowtime in prison. Kids race around waving pinwheels and threatening to set Dinsmore's grass on fire with leftover Fourth of July sparklers. Empty paper cups that held either citrus-powder drinks (foul) or hastily brewed coffee (fouler still) are littered everywhere. Later on, Romeo

will have Toby Manning pay some kid, maybe Dinsmore's, ten bucks to pick up the litter. Community relations, always important. Right now, though, Romeo's totally focused on his jackleg cash register, a carton that once contained Charmin toilet paper. He takes in long green and returns short silver: it's the way America does business, honeybunch. He's charging four bucks per dog, and he's goddamned if people aren't paying it. He expects to clear at least 3K by sundown, maybe a lot more.

And look! Here's Rusty Everett! He got away after all! Good for him! He almost wishes he'd stopped to get the girls – they would surely enjoy this, and it might allay their fears to see so many people having a good time – but it might be a little too much excitement for Jannie.

He spots Linda at the same time she spots him and starts waving frantically, practically jumping up and down. With her hair done in the stubby Fearless Police Girl braids she almost always wears when she's working, Lin looks like a junior high school cheerleader. She's standing with Twitch's sister Rose and the young man who short-orders at the restaurant. Rusty's a little surprised; he thought Barbara had left town. Got on Big Jim Rennie's bad side. A bar fight is what Rusty heard, although he wasn't on duty when the participants came in to get patched up. Fine by Rusty. He's patched up his share of Dipper's customers.

He hugs his wife, kisses her mouth, then plants a kiss on Rose's cheek. Shakes hands with the cook, and gets reintroduced.

'Look at those hotdogs,' Rusty mourns. 'Oh dear.'

'Better line up the bedpans, Doc,' Barbie says, and they all laugh. It's amazing to be laughing under these circumstances, but they aren't the only ones ... and good God, why not? If you can't laugh when things go bad – laugh and put on a little carnival – then you're either dead or wishing you were.

'This is fun,' Rose says, unaware of how soon the fun is going to end. A Frisbee floats past. She plucks it out of the air and wings it back to Benny Drake, who leaps to catch it and then spins to throw it on to Norrie Calvert, who catches it behind her back – show-off! The prayer circle prays. The mixed choir, really finding its voice now, has moved on to that all-time chart topper 'Onward, Christian Soldiers.' A child no more than Judy's age bops past, skirt flapping around her chubby knees, a sparkler clutched in one hand and a cup of the awful limeade in the other. The protestors turn and turn in a widening gyre, chanting *Ha-ha-ha! Hee-hee-hee! Chester's Mill must be set free!* Overhead, puffy clouds with shady bottoms float northward from

Motton . . . and then divide as they near the soldiers, skirting around the Dome. The sky directly overhead is a cloudless, flawless blue. There are those in Dinsmore's field who study those clouds and wonder about the future of rain in Chester's Mill, but nobody speaks of this aloud.

'I wonder if we'll still be having fun next Sunday,' Barbie says.

Linda Everett looks at him. It's not a friendly look. 'Surely you think before then—'

Rose interrupts her. 'Look over there. That kid shouldn't be driving that damn rig so fast – he'll tip it over. I *hate* those ATVs.'

They all look at the little vehicle with the fat balloon tires, and watch as it cuts a diagonal through the October-white hay. Not toward them, exactly, but certainly toward the Dome. It's going too fast. A couple of the soldiers hear the approaching engine and finally turn around.

'Oh Christ, don't let him crash,' Linda Everett moaned.

Rory Dinsmore doesn't crash. It would have been better if he had.

11

An idea is like a cold germ: sooner or later someone always catches it. The Joint Chiefs had already caught this one; it had been kicked around at several of the meetings attended by Barbie's old boss, Colonel James O. Cox. Sooner or later someone in The Mill was bound to be infected by the same idea, and it wasn't entirely surprising that the someone should turn out to be Rory Dinsmore, who was by far the sharpest tool in the Dinsmore family box ('I don't know *where* he gets it from,' Shelley Dinsmore said when Rory brought home his first all-As rank card . . . and she said it in a voice more worried than proud). If he'd lived in town – and if he'd had a computer, which he did not – Rory would undoubtedly have been a part of Scarecrow Joe McClatchey's posse.

Rory had been forbidden to attend the carnival/prayer meeting/demonstration; instead of eating weird hotdogs and helping with the car-park operation, he was ordered by his father to stay at home and feed the cows. When that was done, he was to grease their udders with Bag Balm, a job he hated. 'And once you got those teats nice and shiny,' his father said, 'you can sweep the barns and bust up some haybales.'

He was being punished for approaching the Dome yesterday after his father had expressly forbidden it. And actually *knocking* on it, for God's sake. Appealing to his mother, which often worked, did

no good this time. 'You could have been killed,' Shelley said. 'Also, your dad says you mouthed off.'

'Just told em the cook's name!' Rory protested, and for that his father once more had gone upside his head while Ollie looked on with smug and silent approval.

'You're too smart for your own good,' Alden said.

Safely behind his father's back, Ollie had stuck out his tongue. Shelley saw, however . . . and went upside *Ollie's* head. She did not, however, forbid him the pleasures and excitements of that afternoon's makeshift fair.

'And you leave that goddam go-cart alone,' Alden said, pointing to the ATV parked in the shade between dairy barns 1 and 2. 'You need to move hay, you carry it. It'll build you up a little.' Shortly thereafter, the dim Dinsmores went off together, walking across the field toward Romeo's tent. The bright one was left behind with a hayfork and a jar of Bag Balm as big as a flowerpot.

Rory went about his chores glumly but thoroughly; his racing mind sometimes got him in trouble, but he was a good son for all that, and the idea of ditching punishment-chores never crossed his mind. At first *nothing* crossed his mind. He was in that mostly empty-headed state of grace which is sometimes such fertile soil; it's the ground from which our brightest dreams and biggest ideas (both the good and the spectacularly bad) suddenly burst forth, often full-blown. Yet there is always a chain of association.

As Rory began sweeping barn 1's main aisle (he would save the hateful udder-greasing for last, he reckoned), he heard a rapid *pop-pow-pam* that could only be a string of firecrackers. They sounded a little like gunshots. This made him think of his father's .30–.30 rifle, which was propped in the front closet. The boys were forbidden to touch it except under strict supervision – while shooting at targets, or in hunting season – but it wasn't locked up and the ammo was on the shelf above it.

And the idea came. Rory thought: *I could blow a hole in that thing. Maybe pop it.* He had an image, bright and clear, of touching a match to the side of a balloon.

He dropped the broom and ran for the house. Like many bright people (especially bright children), inspiration rather than consideration was his strong suit. If his older brother had had such an idea (unlikely), Ollie would have thought: *If a plane couldn't bust through it, or a pulp-truck going full tilt, what chance does a bullet have?* He might also have reasoned: *I'm in dutch already for disobeying, and this is disobedience raised to the ninth power.*

Well . . . no, Ollie probably wouldn't have thought that. Ollie's mathematical abilities had topped out at simple multiplication.

Rory, however, was already taking college-track algebra, and knocking it dead. If asked how a bullet could accomplish what a truck or an airplane hadn't, he would have said the impact effect of a Winchester Elite XP^3 would be far greater than either. It stood to reason. For one thing, the velocity would be greater. For another, the impact itself would be concentrated upon the point of a 180-grain bullet. He was sure it would work. It had the unquestionable elegance of an algebraic equation.

Rory saw his smiling (but of course modest) face on the front page of *USA Today*; being interviewed on *Nightly News with Brian Williams*; sitting on a flower-bedecked float in a parade in his honor, with Prom Queen-type girls surrounding him (probably in strapless gowns, but possibly in bathing suits) as he waved to the crowd and confetti floated down in drifts. He would be THE BOY WHO SAVED CHESTER'S MILL!

He snatched the rifle from the closet, got the step stool, and pawed a box of XP^3s down from the shelf. He stuffed two cartridges into the breech (one for a backup), then raced back outside with the rifle held above his head like a conquering *rebelista* (but – give him this – he engaged the safety without even thinking about it). The key to the Yamaha ATV he had been forbidden to ride was hanging on the pegboard in barn 1. He held the key fob between his teeth while he strapped the rifle to the back of the ATV with a couple of bungee cords. He wondered if there would be a sound when the Dome popped. He probably should have taken the shooter's plugs from the top shelf of the closet, but going back for them was unthinkable; he had to do this *now*.

That's how it is with big ideas.

He drove the ATV around barn 2, pausing just long enough to size up the crowd in the field. Excited as he was, he knew better than to head for where the Dome crossed the road (and where the smudges of yesterday's collisions still hung like dirt on an unwashed windowpane). Someone might stop him before he could pop the Dome. Then, instead of being THE BOY WHO SAVED CHESTER'S MILL, he'd likely wind up as THE BOY WHO GREASED COW TITS FOR A YEAR. Yes, and for the first week he'd be doing it in a crouch, his ass too sore to sit down. Someone else would end up getting the credit for *his* big idea.

So he drove on a diagonal that would bring him to the Dome five hundred yards or so from the tent, marking the place to stop by

the crushed spots in the hay. Those, he knew, had been made by falling birds. He saw the soldiers stationed in that area turn toward the oncoming blat of the ATV. He heard shouts of alarm from the fair-and-prayer folks. The hymn-singing came to a discordant halt.

Worst of all, he saw his father waving his dirty John Deere cap at him and bawling, '*RORY OH GODDAMMIT YOU STOP!*'

Rory was in too deep to stop, and – good son or not – he didn't *want* to stop. The ATV struck a hummock and he bounced clear of the seat, holding on with his hands and laughing like a loon. His own Deere cap was spun around backward and he didn't even remember doing it. The ATV tilted, then decided to stay up. Almost there, now, and one of the fatigues-clad soldiers was also shouting at him to stop.

Rory did, and so suddenly he almost somersaulted over the Yamaha's handlebars. He forgot to put the darned thing in neutral and it lurched forward, actually striking the Dome before stalling out. Rory heard the crimp of metal and the tinkle of the headlight as it shattered.

The soldiers, afraid of being hit by the ATV (the eye which sees nothing to block an oncoming object triggers powerful instincts), fell off to either side, leaving a nice big hole and sparing Rory the need of telling them to move away from a possible explosive blowout. He wanted to be a hero, but didn't want to hurt or kill anybody to do it.

He had to hurry. The people closest to his stopping point were the ones in the parking lot and clustered around the Summer Blowout Sale tent, and they were running like hell. His father and brother were among them, both screaming at him to not do whatever he was planning to do.

Rory yanked the rifle free of the bungee cords, socked the butt-plate into his shoulder, and aimed at the invisible barrier five feet above a trio of dead sparrows.

'*No, kid, bad idea!*' one of the soldiers shouted.

Rory paid him no mind, because it was a *good* idea. The people from the tent and the parking lot were close, now. Someone – it was Lester Coggins, who ran a lot better than he played guitar – shouted: '*In the name of God, son, don't do that!*'

Rory pulled the trigger. No; only tried to. The safety was still on. He looked over his shoulder and saw the tall, thin preacher from the holy-roller church blow past his puffing, red-faced father. Lester's shirttail was out and flying. His eyes were wide. The cook from Sweetbriar Rose was right behind him. They were no more than sixty yards away now, and the Reverend looked like he was just getting into fourth gear.

Rory thumbed off the safety.

'*No, kid, no!*' the soldier cried again, simultaneously crouching on his side of the Dome and holding out his splayed hands.

Rory paid no attention. It's that way with big ideas. He fired.

It was, unfortunately for Rory, a perfect shot. The hi-impact slug struck the Dome dead on, ricocheted, and came back like a rubber ball on a string. Rory felt no immediate pain, but a vast sheet of white light filled his head as the smaller of the slug's two fragments thumbed out his left eye and lodged in his brain. Blood flew in a spray, then ran through his fingers as he dropped to his knees, clutching his face.

12

'I'm blind! I'm blind!' the boy was screaming, and Lester immediately thought of the scripture upon which his finger had landed: *Madness and blindness and astonishment of the heart.*

'I'm blind! I'm blind!'

Lester pried away the boy's hands and saw the red, welling socket. The remains of the eye itself were dangling on Rory's cheek. As he turned his head up to Lester, the splattered remains plopped into the grass.

Lester had a moment to cradle the child in his arms before the father arrived and tore him away. That was all right. That was as it should be. Lester had sinned and begged guidance from the Lord. Guidance had been given, an answer provided. He knew now what he was to do about the sins he'd been led into by James Rennie.

A blind child had shown him the way.

THIS IS *NOT*
AS BAD AS IT GETS

1

What Rusty Everett would recall later was confusion. The only image that stuck out with complete clarity was Pastor Coggins's naked upper body: fishbelly-white skin and stacked ribs.

Barbie, however – perhaps because he'd been tasked by Colonel Cox to put on his investigator's hat again – saw everything. And his clearest memory wasn't of Coggins with his shirt off; it was of Melvin Searles pointing a finger at him and then tilting his head slightly – sign language any man recognizes as meaning *We ain't done yet, Sunshine.*

What everyone else remembered – what brought the town's situation home to them as perhaps nothing else could – were the father's cries as he held his wretched, bleeding boy in his arms, and the mother screaming '*Is he all right, Alden? IS HE ALL RIGHT?*' as she labored her sixty-pounds-overweight bulk toward the scene.

Barbie saw Rusty Everett push through the circle gathering around the boy and join the two kneeling men – Alden and Lester. Alden was cradling his son in his arms as Pastor Coggins stared with his mouth sagging like a gate with a busted hinge. Rusty's wife was right behind him. Rusty fell on his knees between Alden and Lester and tried to pull the boy's hands away from his face. Alden – not surprisingly, in Barbie's opinion – promptly socked him one. Rusty's nose started to bleed.

'No! Let him help!' the PA's wife yelled.

Linda, Barbie thought. *Her name is Linda, and she's a cop.*

'No, Alden! No!' Linda put her hand on the farmer's shoulder and he turned, apparently ready to sock *her.* All sense had departed his face; he was an animal protecting a cub. Barbie moved forward to catch his fist if the farmer let it fly, then had a better idea.

'Medic here!' he shouted, bending into Alden's face and trying to block Linda from his field of vision. 'Medic! Medic, med—'

Barbie was yanked backward by the collar of his shirt and spun around. He had just time enough to register Mel Searles – one of Junior's buddies – and to realize that Searles was wearing a blue uniform shirt and a badge. *This is as bad as it gets,* Barbie thought, but as if to prove him wrong, Searles socked *him* in the face, just as he had that night in Dipper's parking lot. He missed Barbie's nose, which had probably been his target, but mashed Barbie's lips back against his teeth.

Searles drew back his fist to do it again, but Jackie Wettington
– Mel's unwilling partner that day – grabbed his arm before he could.
'Don't do it!' she shouted. 'Officer, *don't do it!*'

For a moment the issue was in doubt. Then Ollie Dinsmore,
closely followed by his sobbing, gasping mother, passed between them,
knocking Searles back a step.

Searles lowered his fist. 'Okay,' he said. 'But you're on a crime
scene, asshole. Police investigation scene. Whatever.'

Barbie wiped his bleeding mouth with the heel of his hand and
thought, *This is* not *as bad as it gets. That's the hell of it – it's not.*

2

The only part of this Rusty heard was Barbie shouting *medic*. Now
he said it himself. 'Medic, Mr Dinsmore. Rusty Everett. You know
me. Let me look at your boy.'

'Let him, Alden!' Shelley cried. 'Let him take care of Rory!'

Alden relaxed his grip on the kid, who was swaying back and
forth on his knees, his bluejeans soaked with blood. Rory had covered
his face with his hands again. Rusty took hold of them – gently,
gently does it – and pulled them down. He had hoped it wouldn't
be as bad as he feared, but the socket was raw and empty, pouring
blood. And the brain behind that socket was hurt plenty. The news
was in how the remaining eye cocked senselessly skyward, bulging at
nothing.

Rusty started to pull his shirt off, but the preacher was already
holding out his own. Coggins's upper body, thin and white in front,
striped with crisscrossing red welts in back, was running with sweat.
He held the shirt out.

'No,' Rusty said. 'Rip it, rip it.'

For a moment Lester didn't get it. Then he tore the shirt down
the middle. The rest of the police contingent was arriving now, and
some of the regular cops – Henry Morrison, George Frederick, Jackie
Wettington, Freddy Denton – were yelling at the new Special Deputies
to help move the crowd back, make some space. The new hires did
so, and enthusiastically. Some of the rubberneckers were knocked
down, including that famous Bratz-torturer Samantha Bushey. Sammy
had Little Walter in a Papoose carrier, and when she went on her
ass, both of them began to squall. Junior Rennie stepped over her
without so much as a look and grabbed Rory's mom, almost pulling
the wounded boy's mother off her feet before Freddy Denton stopped
him.

'No, Junior, no! It's the kid's mother! Let her loose!'

'*Police brutality!*' Sammy Bushey yelled from where she lay in the grass. '*Police brutal—*'

Georgia Roux, the newest hire in what had become Peter Randolph's police department, arrived with Carter Thibodeau (holding his hand, actually). Georgia pressed her boot against one of Sammy's breasts − it wasn't quite a kick − and said, 'Yo, dyke, shut up.'

Junior let go of Rory's mother and went to stand with Mel, Carter, and Georgia. They were staring at Barbie. Junior added his eyes to theirs, thinking that the cook was like a bad goddamned penny that kept turning up. He thought *Baarbie* would look awfully good in a cell right next to Sloppy Sam's. Junior also thought that being a cop had been his destiny all along; it had certainly helped with his headaches.

Rusty took half of Lester's torn shirt and ripped it again. He folded a piece, started to put it over the gaping wound in the boy's face, then changed his mind and gave it to the father. 'Hold it to the—'

The words barely came out; his throat was full of blood from his mashed nose. Rusty hawked it back, turned his head, spat a half-clotted loogie into the grass, and tried again. 'Hold it to the wound, Dad. Apply pressure. Hand to the back of his neck and *squeeze.*'

Dazed but willing, Alden Dinsmore did as he was told. The makeshift pad immediately turned red, but the man seemed calmer nonetheless. Having something to do helped. It usually did.

Rusty flung the remaining piece of shirt at Lester. 'More!' he said, and Lester began ripping the shirt into smaller pieces. Rusty lifted Dinsmore's hand and removed the first pad, which was now soaked and useless. Shelley Dinsmore shrieked when she saw the empty socket. 'Oh, my boy! *My boy!*'

Peter Randolph arrived at a jog, huffing and puffing. Still, he was far ahead of Big Jim, who − mindful of his substandard ticker − was plodding down the slope of the field on grass the rest of the crowd had trampled into a broad path. He was thinking of what a clustermug this had turned out to be. Town gatherings would have to be by permit only in the future. And if he had anything to do with it (he would; he always did), permits would be hard to come by.

'Move these people back further!' Randolph snarled at Officer Morrison. And, as Henry turned to do so: '*Move it back, folks! Give em some air!*'

Morrison bawled: '*Officers, form a line! Push em back! Anyone who resists, put em in cuffs!*'

The crowd began a slow reverse shuffle. Barbie lingered. 'Mr Everett . . . Rusty . . . do you need any help? Are you okay?'

'Fine,' Rusty said, and his face told Barbie everything he needed to know: the PA was all right, just a bloody nose. The kid wasn't and never would be again, even if he lived. Rusty applied a fresh pad to the kid's bleeding eyesocket and put the father's hand over it again. 'Nape of the neck,' he said. 'Press hard. *Hard.*'

Barbie started to step back, but then the kid spoke.

3

'It's Halloween. You can't . . . *we* can't . . .'

Rusty froze in the act of folding another piece of shirt into a compression pad. Suddenly he was back in his daughters' bedroom, listening to Janelle scream, *It's the Great Pumpkin's fault!*

He looked up at Linda. She had heard, too. Her eyes were big, the color fleeing her previously flushed cheeks.

'Linda!' Rusty snapped at her. 'Get on your walkie! Call the hospital! Tell Twitch to get the ambulance—'

'*The fire!*' Rory Dinsmore screamed in a high, trembling voice. Lester was staring at him as Moses might have stared at the burning bush. '*The fire! The bus is in the fire! Everyone's screaming! Watch out for Halloween!*'

The crowd was silent now, listening to the child rant. Even Jim Rennie heard as he reached the back of the mob and began to elbow his way through.

'Linda!' Rusty shouted. 'Get on your walkie! *We need the ambulance!*'

She started visibly, as if someone had just clapped his hands in front of her face. She pulled the walkie-talkie off her belt.

Rory tumbled forward into the flattened grass and began to seize.

'*What's happening?*' That was the father.

'*Oh dear-to-Jesus, he's dying!*' That was the mother.

Rusty turned the trembling, bucking child over (trying not to think of Jannie as he did it, but that, of course, was impossible) and tilted his chin up to create an airway.

'Come on, Dad,' he told Alden. 'Don't quit on me now. Squeeze the neck. Compression on the wound. Let's stop the bleeding.'

Compression might drive the fragment that had taken the kid's eye deeper in, but Rusty would worry about that later. If, that was, the kid didn't die right out here on the grass.

From nearby – but oh so far – one of the soldiers finally spoke up. Barely out of his teens, he looked terrified and sorry. 'We tried to stop him. Boy didn't listen. There wasn't nothing we could do.'

Pete Freeman, his Nikon dangling by his knee on its strap, favored this young warrior with a smile of singular bitterness. 'I think we know that. If we didn't before, we sure do now.'

<div align="center">

4

</div>

Before Barbie could melt into the crowd, Mel Searles grabbed him by the arm.

'Take your hand off me,' Barbie said mildly.

Searles showed his teeth in his version of a grin. 'In your dreams, Fucko.' Then he raised his voice. 'Chief! Hey, Chief!'

Peter Randolph turned toward him impatiently, frowning.

'This guy interfered with me while I was trying to secure the scene. Can I arrest him?'

Randolph opened his mouth, possibly to say *Don't waste my time.* Then he looked around. Jim Rennie had finally joined the little group watching Everett work on the boy. Rennie gave Barbie the flat stare of a reptile on a rock, then looked back at Randolph and nodded slightly.

Mel saw it. His grin widened. 'Jackie? Officer Wettington, I mean? Can I borrow a pair of your cuffs?'

Junior and the rest of his crew were also grinning. This was better than watching some bleeding kid, and a *lot* better than policing a bunch of holy rollers and dumbbells with signs. 'Payback's a bitch, *Baaaar*-bie,' Junior said.

Jackie looked dubious. 'Pete – Chief, I mean – I think the guy was only trying to h—'

'Cuff him up,' Randolph said. 'We'll sort out what he was or wasn't trying to do later. In the meantime, I want this mess shut down.' He raised his voice. 'It's over, folks! You've had your fun, and see what it's come to! *Now go home!*'

Jackie was removing a set of plasticuffs from her belt (she had no intention of handing them to Mel Searles, would put them on herself) when Julia Shumway spoke up. She was standing just behind Randolph and Big Jim (in fact, Big Jim had elbowed her aside on his way to where the action was).

'I wouldn't do that, Chief Randolph, unless you want the PD embarrassed on the front page of the *Democrat.*' She was smiling her Mona Lisa smile. 'With you so new to the job and all.'

'What are you talking about?' Randolph asked. His frown was deeper now, turning his face into a series of unlovely crevices.

Julia held up her camera – a slightly older version of Pete Freeman's. 'I have quite a few pictures of Mr Barbara assisting Rusty Everett with that wounded child, a couple of Officer Searles hauling Mr Barbara off for no discernible reason . . . and one of Officer Searles punching Mr Barbara in the mouth. Also for no discernible reason. I'm not much of a photographer, but that one is really quite good. Would you like to see it, Chief Randolph? You can; the camera's digital.'

Barbie's admiration for her deepened, because he thought she was running a bluff. If she'd been taking pictures, why was she holding the lenscap in her left hand, as if she'd just taken it off?

'It's a lie, Chief,' Mel said. 'He tried to take a swing at me. Ask Junior.'

'I think my pictures will show that young Mr Rennie was involved in crowd control and had his back turned when the punch landed,' Julia said.

Randolph was glowering at her. 'I could take your camera away,' he said. 'Evidence.'

'You certainly could,' she agreed cheerily, 'and Pete Freeman would take a picture of you doing it. Then you could take *Pete's* camera . . . but everyone here would see you do it.'

'Whose side are you on here, Julia?' Big Jim asked. He was smiling his fierce smile – the smile of a shark about to take a bite out of some plump swimmer's ass.

Julia turned her own smile on him, the eyes above it as innocent and enquiring as a child's. '*Are* there sides, James? Other than over there' – she pointed at the watching soldiers – 'and in here?'

Big Jim considered her, his lips now bending the other way, a smile in reverse. Then he flapped one disgusted hand at Randolph.

'I guess we'll let it slide, Mr Barbara,' Randolph said. 'Heat of the moment.'

'Thanks,' Barbie said.

Jackie took her glowering young partner's arm. 'Come on, Officer Searles. This part's over. Let's move these people back.'

Searles went with her, but not before turning to Barbie and making the gesture: finger pointing, head cocked slightly. *We ain't done yet, Sunshine.*

Rommie's assistant Toby Manning and Jack Evans appeared, carrying a makeshift stretcher made out of canvas and tent poles. Rommie opened his mouth to ask what the hell they thought they

were doing, then closed it again. The field day had been canceled anyway, so what the hell.

5

Those with cars got into them. Then they all tried to drive away at the same time.

Predictable, Joe McClatchey thought. *Totally predictable.*

Most of the cops worked to unclog the resulting traffic jam, although even a bunch of kids (Joe was standing with Benny Drake and Norrie Calvert) could tell that the new and improved Five-O had no idea what it was doing. The sound of po-po curses came clear on the summery air (*'Can't you back that sonofawhore UP!'*). In spite of the mess, nobody seemed to be laying on their horns. Most folks were probably too bummed to beep.

Benny said, 'Look at those idiots. How many gallons of gas do you think they're blowing out their tailpipes? Like they think the supply's endless.'

'Word,' Norrie said. She was a tough kid, a smalltown riot grrrl with a modified Tennessee Tophat mullet 'do, but now she only looked pale and sad and scared. She took Benny's hand. Scarecrow Joe's heart broke, then remended itself in an instant when she took his as well.

'There goes the guy who almost got arrested,' Benny said, pointing with his free hand. Barbie and the newspaper lady were trudging across the field toward the makeshift parking lot with sixty or eighty other people, some dragging their protest signs dispiritedly behind them.

'Nancy Newspaper wasn't taking pictures at all, y'know,' Scarecrow Joe said. 'I was standing right behind her. Pretty foxy.'

'Yeah,' Benny said, 'but I still wouldn't want to be him. Until this shit ends, the cops can do pretty much what they want.'

That was true, Joe reflected. And the new cops weren't particularly nice guys. Junior Rennie, for example. The story of Sloppy Sam's arrest was already making the rounds.

'What are you saying?' Norrie asked Benny.

'Nothing right now. It's still cool right now.' He considered. '*Fairly* cool. But if this goes on . . . remember *Lord of the Flies?*' They had read it for honors English.

Benny intoned: '"Kill the pig. Cut her throat. Bash her in." People call cops pigs, but I'll tell you what *I* think, I think cops *find* pigs when the shit gets deep. Maybe because they get scared, too.'

Norrie Calvert burst into tears. Scarecrow Joe put an arm around

her. He did it carefully, as if he thought doing such a thing might
cause them both to explode, but she turned her face against his shirt
and hugged him. It was a one-armed hug, because she was still holding
onto Benny with her other hand. Joe thought he had felt nothing
in his whole life as weirdly thrilling as her tears dampening his shirt.
Over the top of her head, he looked at Benny reproachfully.

'Sorry, dude,' Benny said, and patted her back. 'No fear.'

'*His eye was gone!*' she cried. The words were muffled against
Joe's chest. Then she let go of him. 'This isn't fun anymore. This is
not fun.'

'No.' Joe spoke as if discovering a great truth. 'It isn't.'

'Look,' Benny said. It was the ambulance. Twitch was bumping
across Dinsmore's field with the red roof lights flashing. His sister, the
woman who owned Sweetbriar Rose, was walking ahead of him,
guiding him around the worst potholes. An ambulance in a hayfield,
under a bright afternoon sky in October: it was the final touch.

Suddenly, Scarecrow Joe no longer wanted to protest. Nor did
he exactly want to go home.

At that moment, the only thing in the world he wanted was to
get out of town.

6

Julia slid behind the wheel of her car but didn't start it; they were
going to be here awhile, and there was no sense in wasting gas. She
leaned past Barbie, opened the glove compartment, and brought out
an old pack of American Spirits. 'Emergency supplies,' she told him
apologetically. 'Do you want one?'

He shook his head.

'Do you mind? Because I can wait.'

He shook his head again. She lit up, then blew smoke out her
open window. It was still warm – a real Indian summer day for sure
– but it wouldn't stay that way. Another week or so and the weather
would turn wrong, as the oldtimers said. *Or maybe not*, she thought.
Who in the hell knows? If the Dome stayed in place, she had no doubt
that plenty of meteorologists would weigh in on the subject of the
weather inside, but so what? The Weather Channel Yodas couldn't
even predict which way a snowstorm would turn, and in Julia's opinion
they deserved no more credence than the political geniuses who
blabbed their days away at the Sweetbriar Rose bullshit table.

'Thanks for speaking up back there,' he said. 'You saved my
bacon.'

'Here's a newsflash, honey – your bacon's still hanging in the smokehouse. What are you going to do next time? Have your friend Cox call the ACLU? They might be interested, but I don't think anyone from the Portland office is going to be visiting Chester's Mill soon.'

'Don't be so pessimistic. The Dome might blow out to sea tonight. Or just dissipate. We don't know.'

'Fat chance. This is a government job – *some* government's – and I'll bet your Colonel Cox knows it.'

Barbie was silent. He had believed Cox when Cox said the U.S. hadn't been responsible for the Dome. Not because Cox was necessarily trustworthy, but because Barbie just didn't think America had the technology. Or any other country, for that matter. But what did he know? His last service job had been threatening scared Iraqis. Sometimes with a gun to their heads.

Junior's friend Frankie DeLesseps was out on Route 119, helping to direct traffic. He was wearing a blue uniform shirt over jeans – there probably hadn't been any uniform pants in his size at the station. He was a tall sonofabitch. And, Julia saw with misgivings, he was wearing a gun on his hip. Smaller than the Glocks the regular Mill police carried, probably his own property, but it was a gun, all right.

'What will you do if the Hitler Youth comes after you?' she asked, lifting her chin in Frankie's direction. 'Good luck hollering police brutality if they jug you and decide to finish what they started. There's only two lawyers in town. One's senile and the other drives a Boxster Jim Rennie got him at discount. Or so I've heard.'

'I can take care of myself.'

'Oooh, macho.'

'What's up with your paper? It looked ready when I left last night.'

'Technically speaking, you left this morning. And yes, it's ready. Pete and I and a few friends will make sure it gets distributed. I just didn't see any point in starting while the town was three-quarters empty. Want to be a volunteer newsboy?'

'I would, but I've got a zillion sandwiches to make. Strictly cold food at the restaurant tonight.'

'Maybe I'll drop by.' She tossed her cigarette, only half-smoked, from the window. Then, after a moment's consideration, she got out and stepped on it. Starting a grassfire out here would not be cool, not with the town's new firetrucks stranded in Castle Rock.

'I swung by Chief Perkins's house earlier,' she said as she got back behind the wheel. 'Except of course it's just Brenda's now.'

'How is she?'

'Terrible. But when I said you wanted to see her, and that it was important – although I didn't say what it was about – she agreed. After dark might be best. I suppose your friend will be impatient—'

'Stop calling Cox my friend. He's not my friend.'

They watched silently as the wounded boy was loaded into the back of the ambulance. The soldiers were still watching, too. Probably against orders, and that made Julia feel a little better about them. The ambulance began to buck its way back across the field, lights flashing.

'This is terrible,' she said in a thin voice.

Barbie put an arm around her shoulders. She tensed for a moment, then relaxed. Looking straight ahead – at the ambulance, which was now turning into a cleared lane in the middle of Route 119 – she said: 'What if they shut me down, my friend? What if Rennie and his pet police decide to shut my little newspaper down?'

'That's not going to happen,' Barbie said. But he wondered. If this went on long enough, he supposed every day in Chester's Mill would become Anything Can Happen Day.

'She had something else on her mind,' Julia Shumway said.

'Mrs Perkins?'

'Yes. It was in many ways a very strange conversation.'

'She's grieving for her husband,' Barbie said. 'Grief makes people strange. I said hello to Jack Evans – his wife died yesterday when the Dome came down – and he looked at me as if he didn't know me, although I've been serving him my famous Wednesday meatloaf since last spring.'

'I've known Brenda Perkins since she was Brenda Morse,' Julia said. 'Almost forty years. I thought she might tell me what was troubling her . . . but she didn't.'

Barbie pointed at the road. 'I think you can go now.'

As Julia started the engine, her cell phone trilled. She almost dropped her bag in her hurry to dig it out. She listened, then handed it to Barbie with her ironic smile. 'It's for you, boss.'

It was Cox, and Cox had something to say. Quite a lot, actually. Barbie interrupted long enough to tell Cox what had happened to the boy now headed to Cathy Russell, but Cox either didn't relate Rory Dinsmore's story to what he was saying, or didn't want to. He listened politely enough, then went on. When he finished, he asked Barbie a question that would have been an order, had Barbie still been in uniform and under his command.

'Sir, I understand what you're asking, but you don't understand

the . . . I guess you'd call it the political situation here. And my little part in it. I had some trouble before this Dome thing, and—'

'We know all about that,' Cox said. 'An altercation with the Second Selectman's son and some of his friends. You were almost arrested, according to what I've got in my folder.'

A folder. Now he's got a folder. God help me.

'That's fine intel as far as it goes,' Barbie said, 'but let me give you a little more. One, the Police Chief who *kept* me from being arrested died out on 119, not far from where I'm talking to you, in fact—'

Faintly, in a world he could not now visit, Barbie heard paper rattle. He suddenly felt he would like to kill Colonel James O. Cox with his bare hands, simply because Colonel James O. Cox could go out for Mickey-D's any time he wanted, and he, Dale Barbara, could not.

'We know about that, too,' Cox said. 'A pacemaker problem.'

'Two,' Barbie went on, 'the new Chief, who is asshole buddies with the only powerful member of this town's Board of Selectmen, has hired some new deputies. They're the guys who tried to beat my head off my shoulders in the parking lot of the local nightclub.'

'You'll have to rise above that, won't you? Colonel?'

'Why are you calling me Colonel? *You're* the Colonel.'

'Congratulations,' Cox said. 'Not only have you reenlisted in your country's service, you've gotten an absolutely *dizzying* promotion.'

'No!' Barbie shouted. Julia was looking at him with concern, but he was hardly aware of it. 'No, I don't want it!'

'Yeah, but you've got it,' Cox said calmly. 'I'm going to e-mail a copy of the essential paperwork to your editor friend before we shut down your unfortunate little town's Internet capacity.'

'Shut it *down*? You can't shut it down!'

'The paperwork is signed by the President himself. Are you going to say no to him? I understand he can be a tad grumpy when he's crossed.'

Barbie didn't reply. His mind was whirling.

'You need to visit the Selectmen and the Police Chief,' Cox said. 'You need to tell them the President has invoked martial law in Chester's Mill, and you're the officer in charge. I'm sure you'll encounter some initial resistance, but the information I've just given you should help establish you as the town's conduit to the outside world. And I know your powers of persuasion. Saw them firsthand in Iraq.'

'Sir,' he said. 'You have *so* misread the situation here.' He ran a hand through his hair. His ear was throbbing from the goddamned cell phone. 'It's as if you can comprehend the idea of the Dome, but not what's happening in this town as a result of it. And it's been less than thirty hours.'

'Help me understand, then.'

'You say the President wants me to do this. Suppose I were to call him up and tell him he can kiss my rosy red ass?'

Julia was looking at him, horrified, and this actually inspired him.

'Suppose, in fact, I said I was a sleeper Al Qaeda agent, and I was planning to kill him − pow, one to the head. How about that?'

'Lieutenant Barbara − *Colonel* Barbara, I mean − you've said enough.'

Barbie did not feel this was so. 'Could he send the FBI to come and grab me? The Secret Service? The goddam Red Army? No, sir. He could not.'

'We have plans to change that, as I have just explained.' Cox no longer sounded loose and good-humored, jest one ole grunt talkin to another.

'And if it works, feel free to have the federal agency of your choice come and arrest me. But if we stay cut off, who in here's going to listen to me? Get it through your head: *this town has seceded.* Not just from America but from the whole world. There's nothing we can do about it, and nothing you can do about it either.'

Quietly, Cox said: 'We're trying to help you guys.'

'You say that and I almost believe you. Will anybody else around here? When they look to see what kind of help their taxes are buying them, they see soldiers standing guard with their backs turned. That sends a hell of a message.'

'You're talking a whole lot for someone who's saying no.'

'I'm *not* saying no. But I'm only about nine feet from being arrested, and proclaiming myself the commandant pro tem won't help.'

'Suppose I were to call the First Selectman . . . what's his name . . . Sanders . . . and tell him . . .'

'That's what I mean about how little you know. It's like Iraq all over again, only this time you're in Washington instead of boots on the ground, and you seem as clueless as the rest of the desk soldiers. Read my lips, sir: *some* intelligence is worse than no intelligence at all.'

'A little learning is a dangerous thing,' Julia said dreamily.

'If not Sanders, then who?'

'James Rennie. The *Second* Selectman. He's the Boss Hog around here.'

There was a pause. Then Cox said, 'Maybe we can give you the Internet. Some of us are of the opinion that cutting it off's just a knee-jerk reaction, anyway.'

'Why would you think that?' Barbie asked. 'Don't you guys know that if you let us stay on the Net, Aunt Sarah's cranberry bread recipe is sure to get out sooner or later?'

Julia sat up straight and mouthed, *They're trying to cut the Internet?* Barbie raised one finger toward her – *Wait.*

'Just hear me out, Barbie. Suppose we call this Rennie and tell him the Internet's got to go, so sorry, crisis situation, extreme measures, et cetera, et cetera. Then you can convince him of your usefulness by changing our minds.'

Barbie considered. It might work. For a while, anyway. Or it might not.

'Plus,' Cox said brightly, 'you'll be giving them this other information. Maybe saving some lives, but saving people the scare of their lives, for sure.'

Barbie said, 'Phones stay up as well as Internet.'

'That's hard. I might be able to keep the Net for you, but . . . listen, man. There are at least five Curtis LeMay types sitting on the committee presiding over this mess, and as far as they're concerned, everyone in Chester's Mill is a terrorist until proved otherwise.'

'What can these hypothetical terrorists do to harm America? Suicidebomb the Congo Church?'

'Barbie, you're preaching to the choir.'

Of course that was probably the truth.

'Will you do it?'

'I'll have to get back to you on that. Wait for my call before you do anything. I have to talk to the late Police Chief's widow first.'

Cox persisted. 'Will you keep the horse-trading part of this conversation to yourself?'

Again, Barbie was struck by how little even Cox – a freethinker, by military standards – understood about the changes the Dome had already wrought. In here, the Cox brand of secrecy no longer mattered.

Us against them, Barbie thought. *Now it's us against them. Unless their crazy idea works, that is.*

'Sir, I really will have to get back to you on that; this phone is suffering a bad case of low battery.' A lie he told with no remorse.

'And you need to wait to hear from me before you talk to anybody else.'

'Just remember, the big bang's scheduled for thirteen hundred tomorrow. If you want to maintain viability on this, you better stay out front.'

Maintain viability. Another meaningless phrase under the Dome. Unless it applied to keeping your gennie supplied with propane.

'We'll talk,' Barbie said. He closed the phone before Cox could say more. 119 was almost clear now, although DeLesseps was still there, leaning against his vintage muscle car with his arms folded. As Julia drove past the Nova, Barbie noted a sticker reading ASS, GAS, OR GRASS – NOBODY RIDES FOR FREE. Also a police bubblegum light on the dash. He thought the contrast summed up everything that was now wrong in Chester's Mill.

As they rode, Barbie told her everything Cox had said.

'What they're planning is really no different than what that kid just tried,' she said, sounding appalled.

'Well, a *little* different,' Barbie said. 'The kid tried it with a rifle. They've got a Cruise missile lined up. Call it the Big Bang theory.'

She smiled. It wasn't her usual one; wan and bewildered, it made her look sixty instead of forty-three. 'I think I'm going to be putting out another paper sooner than I thought.'

Barbie nodded. 'Extra, extra, read all about it.'

7

'Hello, Sammy,' someone said. 'How are you?'

Samantha Bushey didn't recognize the voice and turned toward it warily, hitching up the Papoose carrier as she did. Little Walter was asleep and he weighed a ton. Her butt hurt from falling on it, and her feelings were hurt, too – that damn Georgia Roux, calling her a dyke. Georgia Roux, who had come whining around Sammy's trailer more than once, looking to score an eightball for her and the musclebound freak she went around with.

It was Dodee's father. Sammy had spoken with him thousands of times, but she hadn't recognized his voice; she hardly recognized *him.* He looked old and sad – broken, somehow. He didn't even scope out her boobs, which was a first.

'Hi, Mr Sanders. Gee, I didn't even see you at the—' She flapped her hand back toward the flattened-down field and the big tent, now half collapsed and looking forlorn. Although not as forlorn as Mr Sanders.

'I was sitting in the shade.' That same hesitant voice, coming through an apologetic, hurting smile that was hard to look at. 'I had something to drink, though. Wasn't it warm for October? Golly, yes. I thought it was a good afternoon – a real *town* afternoon – until that boy ...'

Oh, crispy crackers, he was crying.

'I'm awful sorry about your wife, Mr Sanders.'

'Thank you, Sammy. That's very kind. Can I carry your baby back to your car for you? I think you can go now – the road's almost clear.'

That was an offer Sammy couldn't refuse even if he *was* crying. She scooped Little Walter out of the Papoose – it was like picking up a big clump of warm bread dough – and handed him over. Little Walter opened his eyes, smiled glassily, belched, then went back to sleep.

'I think he might have a package in his diaper,' Mr Sanders said.

'Yeah, he's a regular shit machine. Good old Little Walter.'

'Walter's a very nice old-fashioned name.'

'Thanks.' Telling him that her baby's first name was actually Little didn't seem worth the trouble ... and she was sure she'd had that conversation with him before, anyway. He just didn't remember. Walking with him like this – even though he was carrying the baby – was the perfect bummer end to a perfect bummer afternoon. At least he was right about the traffic; the automotive mosh pit had finally cleared out. Sammy wondered how long it would be before the whole town was riding bicycles again.

'I never liked the idea of her in that plane,' Mr Sanders said. He seemed to be picking up the thread of some interior conversation. 'Sometimes I even wondered if Claudie was sleeping with that guy.'

Dodee's Mom sleeping with Chuck Thompson? Sammy was both shocked and intrigued.

'Probably not,' he said, and sighed. 'In any case, it doesn't matter now. Have you seen Dodee? She didn't come home last night.'

Sammy almost said *Sure, yesterday afternoon*. But if the Dodester hadn't slept at home last night, saying that would only worry the Dodester's dadster. And let Sammy in for a long conversation with a guy who had tears streaming down his face and a snotrunner hanging from one nostril. That would not be cool.

They had reached her car, an old Chevrolet with cancer of the rocker panels. She took Little Walter and grimaced at the smell. That wasn't just mail in his diaper, that was UPS and Federal Express combined.

'No, Mr Sanders, haven't seen her.'

He nodded, then wiped his nose with the back of his hand. The snotrunner disappeared, or at least went somewhere else. That was a relief. 'She probably went to the mall with Angie McCain, then to her aunt Peg's in Sabattus when she couldn't get back into town.'

'Yeah, that's probably it.' And when Dodee turned up right here in The Mill, he'd have a pleasant surprise. God knew he deserved one. Sammy opened the car door and laid Little Walter on the passenger side. She'd given up on the child-restraint seat months ago. Too much of a pain in the ass. And besides, she was a very safe driver.

'Good to see you, Sammy.' A pause. 'Will you pray for my wife?'

'Uhhh . . . sure, Mr Sanders, no prob.'

She started to get in the car, then remembered two things: that Georgia Roux had shoved her tit with her goddam motorcycle boot − probably hard enough to leave a bruise − and that Andy Sanders, brokenhearted or not, was the town's First Selectman.

'Mr Sanders?'

'Yes, Sammy?'

'Some of those cops were kinda rough out there. You might want to do something about that. Before it, you know, gets out of hand.'

His unhappy smile didn't change. 'Well, Sammy, I understand how you young people feel about police − I was young myself once − but we've got a pretty bad situation here. And the quicker we establish a little authority, the better off everyone will be. You understand that, don't you?'

'Sure,' Sammy said. What she understood was that grief, no matter how genuine, did not seem to impede a politician's flow of bullshit. 'Well, I'll see you.'

'They're a good team,' Andy said vaguely. 'Pete Randolph will see they all pull together. Wear the same hat. Do . . . uh . . . the same dance. Protect and serve, you know.'

'Sure,' Samantha said. The protect-and-serve dance, with the occasional tit-kick thrown in. She pulled away with Little Walter once more snoring on the seat. The smell of babyshit was terrific. She unrolled the windows, then looked in the rearview mirror. Mr Sanders was still standing in the makeshift parking lot, which was now almost entirely deserted. He raised a hand to her.

Sammy raised her own in turn, wondering just where Dodee *had* stayed last night if she hadn't gone home. Then she dismissed it

– it was really none of her concern – and flipped on the radio. The only thing she could get clearly was Jesus Radio, and she turned it off again.

When she looked up, Frankie DeLesseps was standing in the road in front of her with his hand up, just like a real cop. She had to stomp the brake to keep from hitting him, then put her hand on the baby to keep him from falling. Little Walter awoke and began to blat.

'Look what you did!' she yelled at Frankie (with whom she'd once had a two-day fling back in high school, when Angie was at band camp). 'The baby almost went on the floor!'

'Where's his seat?' Frankie leaned in her window, biceps bulging. Big muscles, little dick, that was Frankie DeLesseps. As far as Sammy was concerned, Angie could have him.

'None of your beeswax.'

A real cop might have written her up – for the lip as much as the child-restraint law – but Frankie only smirked. 'You seen Angie?'

'No.' This time it was the truth. 'She probably got caught out of town.' Although it seemed to Sammy that the ones *in* town were the ones who'd gotten caught.

'What about Dodee?'

Sammy once again said no. She practically had to, because Frankie might talk to Mr Sanders.

'Angie's car is at her house,' Frankie said. 'I looked in the garage.'

'Big whoop. They probably went off somewhere in Dodee's Kia.'

He seemed to consider this. They were almost alone now. The traffic jam was just a memory. Then he said, 'Did Georgia hurt your booby, baby?' And before she could answer, he reached in and grabbed it. Not gently, either. 'Want me to kiss it all better?'

She slapped his hand. On her right, Little Walter blatted and blatted. Sometimes she wondered why God had made men in the first place, she really did. Always blatting or grabbing, grabbing or blatting.

Frankie wasn't smiling now. 'You want to watch that shit,' he said. 'Things are different now.'

'What are you going to do? Arrest me?'

'I'd think of something better than that,' he said. 'Go on, get out of here. And if you *do* see Angie, tell her I want to see her.'

She drove away, mad and – she didn't like to admit this to herself, but it was true – a little frightened. Half a mile down the road she

pulled over and changed Little Walter's diaper. There was a used diaper bag in back, but she was too mad to bother. She threw the shitty Pamper onto the shoulder of the road instead, not far from the big sign reading:

JIM RENNIE'S USED CARS
FOREIGN & DOMESTIC
A$K U$ 4 CREDIT!
YOU'LL BE WHEELIN' BECAUSE BIG JIM
IS DEALIN'!

She passed some kids on bikes and wondered again how long it would be before everyone was riding them. Except it wouldn't come to that. Someone would figure things out before it did, just like in one of those disaster movies she enjoyed watching on TV while she was stoned: volcanoes erupting in LA, zombies in New York. And when things went back to normal, Frankie and Carter Thibodeau would revert to what they'd been before: smalltown losers with little or no jingle in their pockets. In the meantime, though, she might do well to keep a low profile.

All in all, she was glad she'd kept her mouth shut about Dodee.

8

Rusty listened to the blood-pressure monitor begin its urgent beeping and knew they were losing the boy. Actually they'd been losing him ever since the ambulance – hell, from the moment the ricochet struck him – but the sound of the monitor turned the truth into a headline. Rory should have been Life-Flighted to CMG immediately, right from where he'd been so grievously wounded. Instead he was in an under-equipped operating room that was too warm (the airconditioning had been turned off to conserve the generator), being operated on by a doctor who should have retired years ago, a physician's assistant who had never assisted in a neurosurgery case, and a single exhausted nurse who spoke up now.

'V-fib, Dr Haskell.'

The heart monitor had joined in. Now it was a chorus.

'I know, Ginny. I'm not death.' He paused. '*Deaf*, I mean. Christ.'

For a moment he and Rusty looked at each other over the boy's sheet-swaddled form. Haskell's eyes were clear and with-it – this was not the same stethoscope-equipped time-server who had been plodding through the rooms and corridors of Cathy Russell for

the last couple of years like a dull ghost – but he looked terribly old and frail.

'We tried,' Rusty said.

In truth, Haskell had done more than try; he'd reminded Rusty of one of those sports novels he'd loved as a kid, where the aging pitcher comes out of the bullpen for one more shot at glory in the seventh game of the World Series. But only Rusty and Ginny Tomlinson had been in the stands for this performance, and this time there would be no happy ending for the old warhorse.

Rusty had started the saline drip, adding mannitol to reduce brain swelling. Haskell had left the OR at an actual run to do the bloodwork in the lab down the hall, a complete CBC. It had to be Haskell; Rusty was unqualified and there were no lab techs. Catherine Russell was now hideously understaffed. Rusty thought the Dinsmore boy might be only a down payment on the price the town would eventually have to pay for that lack of personnel.

It got worse. The boy was A-negative, and they had none in their small blood supply. They did, however, have O-negative – the universal donor – and had given Rory four units, which left exactly nine more in supply. Giving it to the boy had probably been tantamount to pouring it down the scrub-room drain, but none of them had said so. While the blood ran into him, Haskell sent Ginny down to the closet-sized cubicle that served as the hospital's library. She came back with a tattered copy of *On Neurosurgery: A Brief Overview*. Haskell operated with the book beside him, an otiscope laid across the pages to hold them down. Rusty thought he would never forget the whine of the saw, the smell of the bone dust in the unnaturally warm air, or the clot of jellied blood that oozed out after Haskell removed the bone plug.

For a few minutes, Rusty had actually allowed himself to hope. With the pressure of the hematoma relieved by the burr-hole, Rory's vital signs had stabilized – or tried to. Then, while Haskell was attempting to determine if the bullet fragment was within his reach, everything had started going downhill again, and fast.

Rusty thought of the parents, waiting and hoping against hope. Now, instead of wheeling Rory to the left outside the OR – toward Cathy Russell's ICU, where his folks might be allowed to creep in and see him – it looked like Rory would be taking a right, toward the morgue.

'If this were an ordinary situation, I'd maintain life support and ask the parents about organ donation,' Haskell said. 'But of course, if this were an ordinary situation, he wouldn't be here. And even if

he was, I wouldn't be trying to operate on him using a . . . a goddam *Toyota* manual.' He picked up the otiscope and threw it across the OR. It struck the green tiles, chipped one, and fell to the floor.

'Do you want to administer epi, Doctor?' Ginny asked. Calm, cool, and collected . . . but she looked tired enough to drop in her tracks.

'Was I not clear? I won't prolong this boy's agony.' Haskell reached toward the red switch on the back of the respirator. Some wit – Twitch, perhaps – had put a small sticker there that read BOOYA! 'Do you want to express a contrary opinion, Rusty?'

Rusty considered the question, then slowly shook his head. The Babinski test had been positive, indicating major brain damage, but the main thing was that there was just no chance. Never had been, really.

Haskell flipped the switch. Rory Dinsmore took one labored breath on his own, appeared to try for a second one, and then gave up.

'I make it . . .' Haskell looked at the big clock on the wall. 'Five fifteen p.m. Will you note that as the TOD, Ginny?'

'Yes, Doctor.'

Haskell pulled down his mask, and Rusty noted with concern that the old man's lips were blue. 'Let's get out of here,' he said. 'The heat is killing me.'

But it wasn't the heat; his heart was doing that. He collapsed halfway down the corridor, on his way to give Alden and Shelley Dinsmore the bad news. Rusty got to administer epi after all, but it did no good. Neither did closed-chest massage. Or the paddles.

Time of death, five forty-nine p.m. Ron Haskell outlived his last patient by exactly thirty-four minutes. Rusty sat down on the floor, his back against the wall. Ginny had given Rory's parents the news; from where he sat with his face in his hands, Rusty could hear the mother's shrieks of grief and sorrow. They carried well in the nearly empty hospital. She sounded as if she would never stop.

9

Barbie thought that the Chief's widow must once have been an extremely beautiful woman. Even now, with dark circles under her eyes and an indifferent choice of clothes (faded jeans and what he was pretty sure was a pajama top), Brenda Perkins was striking. He thought maybe smart people rarely lost their good looks – if they had good ones to begin with, that was – and he saw the clear light

of intelligence in her eyes. Something else, too. She might be in mourning, but it hadn't killed her curiosity. And right now, the object of her curiosity was him.

She looked over his shoulder at Julia's car, backing down the driveway, and raised her hands to it: *Where you going?*

Julia leaned out the window and called, 'I have to make sure the paper gets out! I also have to go by Sweetbriar Rose and give Anson Wheeler the bad news – he's on sandwich detail tonight! Don't worry, Bren, Barbie's safe!' And before Brenda could reply or remonstrate, Julia was off down Morin Street, a woman on a mission. Barbie wished he were with her, his only objective the creation of forty ham-and-cheese and forty tuna sandwiches.

With Julia gone, Brenda resumed her inspection. They were on opposite sides of the screen door. Barbie felt like a job applicant facing a tough interview.

'Are you?' Brenda asked.

'Beg your pardon, ma'am?'

'Are you safe?'

Barbie considered it. Two days ago he would have said yes, of course he was, but on this afternoon he felt more like the soldier of Fallujah than the cook of Chester's Mill. He settled for saying he was housebroken, which made her smile.

'Well, I'll have to make my own judgment on that,' she said. 'Even though right now my judgment isn't the best. I've suffered a loss.'

'I know, ma'am. I'm very sorry.'

'Thank you. He's being buried tomorrow. Out of that cheesy little Bowie Funeral Home that continues to stagger along somehow, even though almost everyone in town uses Crosman's in Castle Rock. Folks call Stewart Bowie's establishment Bowie's Buryin Barn. Stewart's an idiot and his brother Fernald's worse, but now they're all we have. All *I* have.' She sighed like a woman confronting some vast chore. *And why not?* Barbie thought. *The death of a loved one may be many things, but work is certainly one of them.*

She surprised him by stepping out onto the stoop with him. 'Walk around back with me, Mr Barbara. I may invite you in later on, but not until I'm sure of you. Ordinarily I'd take a character reference from Julia like a shot, but these are not ordinary times.' She was leading him along the side of the house, over nicely clipped grass raked clear of autumn leaves. On the right was a board fence separating the Perkins home from its next-door neighbor; on the left were nicely kept flowerbeds.

'The flowers were my husband's bailiwick. I suppose you think that's a strange hobby for a law enforcement officer.'

'Actually, I don't.'

'I never did, either. Which makes us in the minority. Small towns harbor small imaginations. Grace Metalious and Sherwood Anderson were right about that.

'Also,' she said as they rounded the rear corner of the house and entered a commodious backyard, 'it will stay light out here longer. I have a generator, but it died this morning. Out of fuel, I believe. There's a spare tank, but I don't know how to change it. I used to nag Howie about the generator. He wanted to teach me how to maintain it. I refused to learn. Mostly out of spite.' A tear overspilled one eye and trickled down her cheek. She wiped it away absently. 'I'd apologize to him now if I could. Admit he was right. But I can't do that, can I?'

Barbie knew a rhetorical question when he heard one. 'If it's just the canister,' he said, 'I can change it out.'

'Thank you,' she said, leading him to a patio table with an Igloo cooler sitting beside it. 'I was going to ask Henry Morrison to do it, and I was going to get more canisters at Burpee's, too, but by the time I got down to the high street this afternoon, Burpee's was closed and Henry was out at Dinsmore's field, along with everyone else. Do you think I'll be able to get extra canisters tomorrow?'

'Maybe,' Barbie said. In truth, he doubted it.

'I heard about the little boy,' she said. 'Gina Buffalino from next door came over and told me. I'm terribly sorry. Will he live?'

'I don't know.' And, because intuition told him honesty would be the most direct route to this woman's trust (provisional though that might be), he added, 'I don't think so.'

'No.' She sighed and wiped at her eyes again. 'No, it sounded very bad.' She opened the Igloo. 'I have water and Diet Coke. That was the only soft drink I allowed Howie to have. Which do you prefer?'

'Water, ma'am.'

She opened two bottles of Poland Spring and they drank. She looked at him with her sadly curious eyes. 'Julia told me you want a key to the Town Hall. I understand why you want it. I also understand why you don't want Jim Rennie to know—'

'He may have to. The situation's changed. You see—'

She held up her hand and shook her head. Barbie ceased.

'Before you tell me that, I want you to tell me about the trouble you had with Junior and his friends.'

'Ma'am, didn't your husband—?'

'Howie rarely talked about his cases, but this one he *did* talk about. It troubled him, I think. I want to see if your story matches his. If it does, we can talk about other matters. If it doesn't, I'll invite you to leave, although you may take your bottle of water with you.'

Barbie pointed to the little red shed by the left corner of the house. 'That your gennie?'

'Yes.'

'If I change out the canister while we talk, will you be able to hear me?'

'Yes.'

'And you want the whole deal, right?'

'Yes indeed. And if you call me ma'am again, I may have to brain you.'

The door of the little generator shed was held shut with a hook-and-eye of shiny brass. The man who had lived here until yesterday had taken care of his things . . . although it was a shame about that lone canister. Barbie decided that, no matter how this conversation went, he would take it upon himself to try and get her a few more tomorrow.

In the meantime, he told himself, *tell her everything she wants to know about that night.* But it would be easier to tell with his back turned; he didn't like saying the trouble had happened because Angie McCain had seen him as a slightly overage boy-toy.

Sunshine Rule, he reminded himself, and told his tale.

10

What he remembered most clearly about last summer was the James McMurtry song that seemed to be playing everywhere – 'Talkin' at the Texaco,' it was called. And the line he remembered most clearly was the one about how in a small town 'we all must know our place.' When Angie started standing too close to him while he was cooking, or pressing a breast against his arm while she reached for something he could have gotten for her, the line recurred. He knew who her boyfriend was, and he knew that Frankie DeLesseps was part of the town's power structure, if only by virtue of his friendship with Big Jim Rennie's son. Dale Barbara, on the other hand, was little more than a drifter. In the Chester's Mill scheme of things, he *had* no place.

One evening she had reached around his hip and given his crotch a light squeeze. He reacted, and he saw by her mischievous grin that she'd felt him react.

'You can have one back, if you want,' she said. They'd been in

the kitchen, and she'd twitched the hem of her skirt, a short one, up a little, giving him a quick glimpse of frilly pink underwear. 'Fair's fair.'

'I'll pass,' he said, and she stuck her tongue out at him.

He'd seen similar hijinks in half a dozen restaurant kitchens, had even played along from time to time. It might have amounted to no more than a young girl's passing letch for an older and moderately good-looking co-worker. But then Angie and Frankie broke up, and one night when Barbie was dumping the swill in the Dumpster out back after closing, she'd put a serious move on him.

He turned around and she was there, slipping her arms around his shoulders and kissing him. At first he kissed her back. Angie unlocked one arm long enough to take his hand and put it on her left breast. That woke his brain up. It was good breast, young and firm. It was also trouble. *She* was trouble. He tried to pull back, and when she hung on one-handed (her nails now biting into the nape of his neck) and tried to thrust her hips against him, he pushed her away with a little more force than he had intended. She stumbled against the Dumpster, glared at him, touched the seat of her jeans, and glared harder.

'Thanks! Now I've got crap all over my pants!'

'You should know when to let go,' he said mildly.

'You liked it!'

'Maybe,' he said, 'but I don't like you.' And when he saw the hurt and anger deepen on her face, he added: 'I mean I do, just not that way.' But of course people have a way of saying what they really mean when they're shaken up.

Four nights later, in Dipper's, someone poured a glass of beer down the back of his shirt. He turned and saw Frankie DeLesseps.

'Did you like that, *Baaarbie?* If you did, I can do it again – it's two-buck pitcher night. Of course, if you didn't, we can take it outside.'

'I don't know what she told you, but it's wrong,' Barbie said. The jukebox had been playing – not the McMurtry song, but that was what he heard in his head: *We all must know our place.*

'What she *told* me is she said no and you went ahead and fucked her anyway. What do you outweigh her by? Hunnert pounds? That sounds like rape to me.'

'I didn't.' Knowing it was probably hopeless.

'You want to go outside, motherfuck, or are you too chicken?'

'Too chicken,' Barbie said, and to his surprise, Frankie went away. Barbie decided he'd had enough beer and music for one night and

was getting up to go when Frankie returned, this time not with a glass but a pitcher.

'Don't do that,' Barbie said, but of course Frankie paid no attention. Splash, in the face. A Bud Light shower. Several people laughed and applauded drunkenly.

'You can come out now and settle this,' Frankie said, 'or I can wait. Last call's comin, *Baaarbie.*'

Barbie went, realizing it was then or later, and believing that if he decked Frankie fast, before a lot of people could see, that would end it. He could even apologize and repeat that he'd never been with Angie. He wouldn't add that Angie had been coming on to him, although he supposed a lot of people knew it (certainly Rose and Anson did). Maybe, with a bloody nose to wake him up, Frankie would see what seemed so obvious to Barbie: this was the little twit's idea of payback.

At first it seemed that it might work out that way. Frankie stood flat-footed on the gravel, his shadow cast two different ways by the glare of the sodium lights at either end of the parking lot, his fists held up like John L. Sullivan. Mean, strong, and stupid: just one more smalltown brawler. Used to putting his opponents down with one big blow, then picking them up and hitting them a bunch of little ones until they cried uncle.

He shuffled forward and uncorked his not-so-secret weapon: an uppercut Barbie avoided by the simple expedient of cocking his head slightly to one side. Barbie countered with a straight jab to the solar plexus. Frankie went down with a stunned expression on his face.

'We don't have to—' Barbie began, and that was when Junior Rennie hit him from behind, in the kidneys, probably with his hands laced together to make one big fist. Barbie stumbled forward. Carter Thibodeau was there to meet him, stepping from between two parked cars and throwing a roundhouse. It might have broken Barbie's jaw if it had connected, but Barbie got his arm up in time. That accounted for the worst of his bruises, still an unlovely yellow when he tried to leave town on Dome Day.

He twisted to one side, understanding this had been a planned ambush, knowing he had to get out before someone was really hurt. Not necessarily him. He was willing to run; he wasn't proud. He got three steps before Melvin Searles tripped him up. Barbie sprawled in the gravel on his belly and the kicking started. He covered his head, but a squall of bootleather pounded his legs, ass, and arms. One caught him high in the rib cage just before he managed to knee-scramble behind Stubby Norman's used-furniture panel truck.

His good sense left him then, and he stopped thinking about running away. He got up, faced them, then held out his hands to them, palms up and fingers wiggling. Beckoning. The slot he was standing in was narrow. They'd have to come one by one.

Junior tried first; his enthusiasm was rewarded with a kick in the belly. Barbie was wearing Nikes rather than boots, but it was a hard kick and Junior folded up beside the panel truck, woofing for breath. Frankie scrambled over him and Barbie popped him twice in the face – stinging shots, but not quite hard enough to break anything. Good sense had begun to reassert itself.

Gravel crunched. He turned in time to catch incoming from Thibodeau, who had cut behind him. The blow connected with his temple. Barbie saw stars. ('Or maybe one was a comet,' he told Brenda, opening the valve on the new gas canister.) Thibodeau moved in. Barbie pistoned a hard kick to his ankle, and Thibodeau's grin turned to a grimace. He dropped to one knee, looking like a football player holding the ball for a field goal attempt. Except ball-holders usually don't clutch their ankles.

Absurdly, Carter Thibodeau cried: 'Fuckin dirty-fighter!'

'Look who's ta—' Barbie got that far before Melvin Searles locked an elbow around his throat. Barbie drove his own elbow back into Searles's midsection and heard the grunt of escaping air. Smelled it, too: beer, cigarettes, Slim Jims. He was turning, knowing that Thibodeau would probably be on him again before he could fight his way entirely clear of the aisle between vehicles into which he had retreated, no longer caring. His face was throbbing, his ribs were throbbing, and he suddenly decided – it seemed quite reasonable – that he was going to put all four of them in the hospital. They could discuss what constituted dirty fighting and what did not as they signed each other's casts.

That was when Chief Perkins – called by either Tommy or Willow Anderson, the roadhouse proprietors – drove into the parking lot with his jackpots lit and his headlights winking back and forth. The combatants were illuminated like actors on a stage.

Perkins hit the siren once; it blipped half a whoop and died. Then he got out, hitching his belt up over his considerable girth.

'Little early in the week for this, isn't it, fellas?'

To which Junior Rennie replied

11

Brenda didn't need Barbie to tell her that; she'd heard it from Howie, and hadn't been surprised. Even as a child, Big Jim's boy

had been a fluent confabulator, especially when his self-interest was
at stake.

'To which he replied, "The cook started it." Am I right?'

'Yep.' Barbie pushed the gennie's start button and it roared into
life. He smiled at her, although he could feel a flush warming his
cheeks. What he'd just told was not his favorite story. Although he
supposed he'd pick it over the one of the gym in Fallujah any day.
'There you go – lights, camera, action.'

'Thank you. How long will it last?'

'Only a couple of days, but this may be over by then.'

'Or not. I suppose you know what saved you from a trip to the
county lockup that night?'

'Sure,' Barbie said. 'Your husband saw it happening. Four-on-one.
It was kind of hard to miss.'

'Any other cop might *not* have seen it, even if it was right in
front of his eyes. And it was just luck Howie was on that night;
George Frederick was supposed to have the duty, but he called in
with stomach flu.' She paused. 'You might call it providence instead
of luck.'

'So I might,' Barbie agreed.

'Would you like to come inside, Mr Barbara?'

'Why don't we sit out here? If you don't mind. It's pleasant.'

'Fine by me. The weather will turn cold soon enough. Or
will it?'

Barbie said he didn't know.

'When Howie got you all to the station, DeLesseps told Howie
that you raped Angie McCain. Isn't that how it went?'

'That was his first story. Then he said maybe it wasn't quite rape,
but when she got scared and told me to stop, I wouldn't. That would
make it rape in the second degree, I guess.'

She smiled briefly. 'Don't let any feminists hear you say there
are degrees of rape.'

'I guess I better not. Anyway, your husband put me in the inter-
rogation room – which seems to be a broom closet when it's doing
its day job—'

Brenda actually laughed.

'—then hauled Angie in. Sat her where she had to look me in the
eye. Hell, we were almost rubbing elbows. It takes mental prepar-
ation to lie about something big, especially for a young person. I
found that out in the Army. Your husband knew it, too. Told her it
would go to court. Explained the penalties for perjury. Long story
short, she recanted. Said there'd been no intercourse, let alone rape.'

'Howie had a motto: "Reason before law." It was the basis for the way he handled things. It will *not* be the way Peter Randolph handles things, partially because he's a foggy thinker but mostly because he won't be able to handle Rennie. My husband could. Howie said that when news of your . . . altercation . . . got back to Mr Rennie, he insisted that you be tried for *something*. He was furious. Did you know that?'

'No.' But he wasn't surprised.

'Howie told Mr Rennie that if any of it made it into court, he'd see that *all* of it made it into court, including the four-on-one in the parking lot. He added that a good defense attorney might even be able to get some of Frankie and Junior's high school escapades into the record. There were several, although nothing quite like what happened to you.'

She shook her head.

'Junior Rennie was never a *great* kid, but he used to be relatively harmless. Over the last year or so, he's changed. Howie saw it, and was troubled by it. I've discovered that Howie knew things about both the son *and* the father . . .' She trailed off. Barbie could see her debating whether or not to go on and deciding not to. She had learned discretion as the wife of a small-town police official, and it was a hard habit to unlearn.

'Howie advised you to leave town before Rennie found some other way to make trouble for you, didn't he? I imagine you got caught by this Dome thing before you could do it.'

'Yes to both. Can I have that Diet Coke now, Mrs Perkins?'

'Call me Brenda. And I'll call you Barbie, if that's what you go by. Please help yourself to a soft drink.'

Barbie did.

'You want a key to the fallout shelter so you can get the Geiger counter. I can and will help you there. But it sounded like you were saying Jim Rennie has to know, and with that idea I have trouble. Maybe it's grief clouding my mind, but I don't understand why you'd want to get into any kind of head-butting contest with him. Big Jim freaks out when *anybody* challenges his authority, and you he doesn't like to begin with. Nor does he owe you any favors. If my husband were still Chief, maybe the two of you could go see Rennie together. I would rather have enjoyed that, I think.' She leaned forward, looking at him earnestly from her dark-circled eyes. 'But Howie's gone and you're apt to wind up in a cell instead of looking around for some mystery generator.'

'I know all that, but something new has been added. The Air

Force is going to shoot a Cruise missile at the Dome tomorrow at thirteen hundred hours.'

'Oh-my-Jesus.'

'They've shot other missiles at it, but only to determine how high the barrier goes. Radar doesn't work. Those had dummy warheads. This one will have a very live one. A bunker-buster.'

She paled visibly.

'What part of our town are they going to shoot it at?'

'Point of impact will be where the Dome cuts Little Bitch Road. Julia and I were out there just last night. It'll explode about five feet off the ground.'

Her mouth dropped open in an unladylike gape. 'Not possible!'

'I'm afraid it is. They'll release in from a B-52, and it'll fly a preprogrammed course. I mean *really* programmed. Down to every ridge and dip, once it descends to target height. Those things are *eerie*. If it explodes and doesn't break through, it means everyone in town just gets a bad scare – it's going to sound like Armageddon. If it *does* break through, though—'

Her hand had gone to her throat. 'How much damage? Barbie, we have no firetrucks!'

'I'm sure they'll have fire equipment standing by. As to how much damage?' He shrugged. 'The whole area will have to be evacuated, that's for sure.'

'Is it wise? Is what they're planning wise?'

'It's a moot question, Mrs – Brenda. They've made their decision. But it gets worse, I'm afraid.' And, seeing her expression: 'For me, not the town. I've been promoted to Colonel. By Presidential order.'

She rolled her eyes. 'How nice for you.'

'I'm supposed to declare martial law and basically take over Chester's Mill. Won't Jim Rennie enjoy hearing that?'

She surprised him by bursting into laughter. And Barbie surprised himself by joining her.

'You see my problem? The town doesn't have to know about me borrowing an old Geiger counter, but they *do* need to know about the bunker-buster coming their way. Julia Shumway will spread the news if I don't, but the town fathers ought to hear it from me. Because—'

'I know why.' Thanks to the reddening sun, Brenda's face had lost its pallor. But she was rubbing her arms absently. 'If you're to establish any authority here . . . which is what your superior wants you to do . . .'

'I guess Cox is more like my colleague now,' Barbie said.

She sighed. 'Andrea Grinnell. We'll take this to her. Then we'll talk to Rennie and Andy Sanders together. At least we'll outnumber them, three to two.'

'Rose's sister? Why?'

'You don't know she's the town's Third Selectman?' And when he shook his head: 'Don't look so chagrined. Many don't, although she's held the job for several years. She's usually little more than a rubber-stamp for the two men – which means for Rennie, since Andy Sanders is a rubber-stamp himself – and she has . . . problems . . . but there's a core of toughness there. Or was.'

'What problems?'

He thought she might keep that to herself too, but she didn't. 'Drug dependency. Pain pills. I don't know how bad it is.'

'And I suppose she gets her scrips filled at Sanders's pharmacy.'

'Yes. I know it's not a perfect solution, and you'll have to be very careful, but . . . Jim Rennie may be forced by simple expediency to accept your input for a while. Your actual leadership?' She shook her head. 'He'll wipe his bottom with any declaration of martial law, whether it's signed by the President or not. I—'

She ceased. Her eyes were looking past him, and widening.

'Mrs Perkins? Brenda? What is it?'

'Oh,' she said. 'Oh, my *God.*'

Barbie turned to look, and was stunned to silence himself. The sun was going down red as it often did after warm, fair days unsullied by late showers. But never in his life had he seen a sunset like this one. He had an idea the only people who ever had were those in the vicinity of violent volcanic eruptions.

No, he thought. *Not even them. This is brand new.*

The declining sun wasn't a ball. It was a huge red bowtie shape with a burning circular center. The western sky was smeared as if with a thin film of blood that shaded to orange as it climbed. The horizon was almost invisible through that blurry glare.

'Good Christ, it's like trying to look through a dirty windshield when you're driving into the sun,' she said.

And of course that was it, only the Dome was the windshield. It had begun to collect dust and pollen. Pollutants as well. And it would get worse.

We'll have to wash it, he thought, and visualized lines of volunteers with buckets and rags. Absurd. How were they going to wash it forty feet up? Or a hundred and forty? Or a thousand?

'This has to end,' she whispered. 'Call them and tell them to

shoot the biggest missile they can, and damn the consequences. Because this has to end.'

Barbie said nothing. Wasn't sure he could have spoken even if he had something to say. That vast, dusty glare had stolen his words. It was like looking through a porthole into hell.

NYUCK-NYUCK-NYUCK

1

Jim Rennie and Andy Sanders watched the weird sunset from the steps of the Bowie Funeral Home. They were due at the Town Hall for another 'Emergency Assessment Meeting' at seven o'clock, and Big Jim wanted to be there early to prepare, but for now they stood where they were, watching the day die its strange, smeary death.

'It's like the end of the world.' Andy spoke in a low, awestruck voice.

'Bull-pucky!' Big Jim said, and if his voice was harsh – even for him – it was because a similar thought had been going through his own mind. For the first time since the Dome had come down, it had occurred to him that the situation might be beyond their ability to manage – *his* ability to manage – and he rejected the idea furiously. 'Do you see Christ the Lord coming down from the sky?'

'No,' Andy admitted. What he saw were townspeople he'd known all his life standing in clumps along Main Street, not talking, only watching that strange sunset with their hands shading their eyes.

'Do you see *me*?' Big Jim persisted.

Andy turned to him. 'Sure I do,' he said. Sounding perplexed. 'Sure I do, Big Jim.'

'Which means I haven't been Raptured,' Big Jim said. 'I gave my heart to Jesus years ago, and if it was End Times, I wouldn't be here. Neither would you, right?'

'Guess not,' Andy said, but he felt doubtful. If they were Saved – washed in the Blood of the Lamb – why had they just been talking to Stewart Bowie about shutting down what Big Jim called 'our little business'? And how had they gotten into such a business to start with? What did running a meth factory have to do with being Saved?

If he asked Big Jim, Andy knew what the answer would be: the ends sometimes justify the means. The ends in this case had seemed admirable, once upon a time: the new Holy Redeemer Church (the old one had been little more than a clapboard shack with a wooden cross on top); the radio station that had saved only God knew how many souls; the ten percent they tithed – prudently, the contribution checks issued from a bank in the Cayman Islands – to the Lord Jesus Missionary Society, to help what Pastor Coggins liked to call 'the little brown brothers.'

But looking at that huge blurry sunset that seemed to suggest

all human affairs were tiny and unimportant, Andy had to admit those things were no more than justifications. Without the cash income from the meth, his drugstore would have gone under six years ago. The same with the funeral home. The same – probably, although the man beside him would never admit it – with Jim Rennie's Used Cars.

'I know what you're thinking, pal,' Big Jim said.

Andy looked up at him timidly. Big Jim was smiling . . . but not the fierce one. This one was gentle, understanding. Andy smiled back, or tried to. He owed Big Jim a lot. Only now things like the drugstore and Claudie's BMW seemed a lot less important. What good was a BMW, even one with self-parking and a voice-activated sound system, to a dead wife?

When this is over and Dodee comes back, I'll give the Beemer to her, Andy decided. *It's what Claudie would have wanted.*

Big Jim raised a blunt-fingered hand to the declining sun that seemed to be spreading across the western sky like a great poisoned egg. 'You think all this is our fault, somehow. That God is punishing us for propping up the town when times were hard. That's just not true, pal. This isn't God's work. If you wanted to say getting beat in Vietnam was God's work – God's warning that America was losing her spiritual way – I'd have to agree with you. If you were to say that nine-eleven was the Supreme Being's response to our Supreme Court telling little children they could no longer start their day with a prayer to the God who made them, I'd have to go along. But God punishing Chester's Mill because we didn't want to end up just another moribund wide spot in the road, like Jay or Millinocket?' He shook his head. 'Nosir. No.'

'We also put some pretty good change in our own pockets,' Andy said timidly.

This was true. They had done more than prop up their own businesses and extend a helping hand to the little brown brothers; Andy had his own account in the Cayman Islands. And for every dollar Andy had – or the Bowies, for that matter – he was willing to bet that Big Jim had put away three. Maybe even four.

'"The workman is worthy of his hire,"' Big Jim said in a pedantic but kindly tone. 'Matthew ten-ten.' He neglected to cite the previous verse: *Provide neither gold, nor silver, nor brass in your purses.*

He looked at his watch. 'Speaking of work, pal, we better get moving. Got a lot to decide.' He started walking. Andy followed, not taking his eyes off the sunset, which was still bright enough to make him think of infected flesh. Then Big Jim stopped again.

'Anyway, you heard Stewart – we're shut down out there. "All done and buttoned up," as the little boy said after he made his first wee. He told the Chef himself.'

'*That* guy,' Andy said dourly.

Big Jim chuckled. 'Don't you worry about Phil. We're shut down and we're going to *stay* shut down until the crisis is over. In fact, this might be a sign that we're supposed to close up shop forever. A sign from the Almighty.'

'That would be good,' Andy said. But he had a depressing insight: if the Dome disappeared, Big Jim would change his mind, and when he did, Andy would go along. Stewart Bowie and his brother Fernald would, too. Eagerly. Partly because the money was so unbelievable – not to mention tax-free – and partly because they were in too deep. He remembered something some long-ago movie star had said: 'By the time I discovered I didn't like acting, I was too rich to quit.'

'Don't worry so much,' Big Jim said. 'We'll start moving the propane back into town in a couple of weeks, whether this Dome situation resolves itself or not. We'll use the town sand-trucks. You can drive a standard shift, can't you?'

'Yes,' Andy said glumly.

'And' – Big Jim brightened as an idea struck him – 'we can use Stewie's hearse! Then we can move some of the canisters even sooner!'

Andy said nothing. He hated the idea that they had appropriated (that was Big Jim's word for it) so much propane from various town sources, but it had seemed the safest way. They were manufacturing on a large scale, and that meant a lot of cooking and a lot of venting the bad gasses. Big Jim had pointed out that buying propane in large amounts could raise questions. Just as buying large amounts of the various over-the-counter drugs that went into the crap might be noticed and cause trouble.

Owning a drugstore had helped with that, although the size of his orders for stuff like Robitussin and Sudafed had made Andy horribly nervous. He'd thought *that* would be their downfall, if their downfall came. He had never considered the huge cache of propane tanks behind the WCIK studio building until now.

'By the way, we'll have plenty of electricity in the Town Hall tonight.' Big Jim spoke with the air of one springing a pleasant surprise. 'I had Randolph send my boy and his friend Frankie over to the hospital to grab one of their tanks for our gennie.'

Andy looked alarmed. 'But we already took—'

'I know,' Rennie said soothingly. 'I know we did. Don't you worry about Cathy Russell, they've got enough for the time being.'

'You could have gotten one from the radio station . . . there's so much out there . . .'

'This was closer,' Big Jim said. 'And safer. Pete Randolph's our guy, but that doesn't mean I want him to know about our little business. Now or ever.'

This made Andy even more certain that Big Jim didn't really want to give up the factory.

'Jim, if we start sneaking LP back into town, where will we say it was? Are we going to tell folks the Gas Fairy took it, then changed his mind and gave it back?'

Rennie frowned. 'Do you think this is funny, pal?'

'No! I think it's *scary!*'

'I've got a plan. We'll announce a town fuel supply depot, and ration propane from it as needed. Heating oil too, if we can figure out how to use it with the power out. I hate the idea of rationing – it's un-American to the core – but this is like the story of the grasshopper and the ant, you know. There are cotton-pickers in town who'd use up everything in a month, then yell at *us* to take care of em at the first sign of a cold snap!'

'You don't really think this will go on for a *month*, do you?'

'Of course not, but you know what the oldtimers say: hope for the best, prepare for the worst.'

Andy thought of pointing out that they'd already used a fair amount of the town's supplies to make crystal meth, but he knew what Big Jim would say: *How could we possibly have known?*

They couldn't have, of course. Who in their right mind would ever have expected this sudden contraction of all resources? You planned for *more than enough.* It was the American way. *Not nearly enough* was an insult to the mind and the spirit.

Andy said, 'You're not the only one who won't like the idea of rationing.'

'That's why we have a police force. I know we all mourn Howie Perkins's passing, but he's with Jesus now and we've got Pete Randolph. Who's going to be better for the town in this situation. Because he *listens.*' He pointed a finger at Andy. 'The people in a town like this – people everywhere, really – aren't much more than children when it comes to their own self-interest. How many times have I said that?'

'Lots,' Andy said, and sighed.

'And what do you have to make children do?'

'Eat their vegetables if they want their dessert.'

'Yes! And sometimes that means cracking the whip.'

'That reminds me of something else,' Andy said. 'I was talking

to Sammy Bushey out at Dinsmore's field – one of Dodee's friends? She said some of the cops were pretty rough out there. *Darn* rough. We might want to talk to Chief Randolph about that.'

Jim frowned at him. 'What did you expect, pal? Kid gloves? There was darn near a riot out there. We almost had a cotton-picking *riot* right here in Chester's *Mill*!'

'I know, you're right, it's just that—'

'I know the Bushey girl. Knew her whole family. Drug users, car thieves, scofflaws, loan-dodgers and tax-dodgers. What we used to call poor white trash, before it became politically incorrect. Those are the people we have to watch out for right now. *The very people.* They're the ones who'll tear this town apart, given half a chance. Is that what you want?'

'No, course not—'

But Big Jim was in full flight. 'Every town has its ants – which is good – and its grasshoppers, which aren't so good but we can live with them because we understand them and can make them do what's in their own best interests, even if we have to squeeze em a little. But every town also has its locusts, just like in the Bible, and that's what people like the Busheys are. On them we've got to bring the hammer down. You might not like it and I might not like it, but personal freedom's going to have to take a hike until this is over. And we'll sacrifice, too. Aren't we going to shut down our little business?'

Andy didn't want to point out that they really had no choice, since they had no way of shipping the stuff out of town anyway, but settled for a simple yes. He didn't want to discuss things any further, and he dreaded the upcoming meeting, which might drag on until midnight. All he wanted was to go home to his empty house and have a stiff drink and then lie down and think about Claudie and cry himself to sleep.

'What matters right now, pal, is keeping things on an even keel. That means law and order and oversight. *Our* oversight, because we're not grasshoppers. We're ants. *Soldier* ants.'

Big Jim considered. When he spoke again, his tone was all business. 'I'm rethinking our decision to let Food City continue on a business-as-usual basis. I'm not saying we're going to shut it down – at least not yet – but we'll have to watch it pretty closely over the next couple of days. Like a cotton-picking *hawk*. Same with the Gas and Grocery. And it might not be a bad idea if we were to appropriate some of the more perishable food for our own personal—'

He stopped, squinting at the Town Hall steps. He didn't believe what he saw and raised a hand to block the sunset. It was still there:

Brenda Perkins and that gosh-darned troublemaker Dale Barbara. Not side by side, either. Sitting between them, and talking animatedly to Chief Perkins's widow, was Andrea Grinnell, the Third Selectman. They appeared to be passing sheets of paper from hand to hand.

Big Jim did not like this.

At all.

2

He started forward, meaning to put a stop to the conversation no matter the subject. Before he could get half a dozen steps, a kid ran up to him. It was one of the Killian boys. There were about a dozen Killians living on a ramshackle chicken farm out by the Tarker's Mills town line. None of the kids was very bright – which they came by honestly, considering the parents from whose shabby loins they had sprung – but all were members in good standing at Holy Redeemer; all Saved, in other words. This one was Ronnie . . . at least Rennie thought so, but it was hard to be sure. They all had the same bullet heads, bulging brows, and beaky noses.

The boy was wearing a tattered WCIK tee-shirt and carrying a note. 'Hey, Mr Rennie!' he said. 'Gorry, I been lookin all over town for you!'

'I'm afraid I don't have time to talk right now, Ronnie,' Big Jim said. He was still looking at the trio sitting on the Town Hall steps. The Three Gosh-Darn Stooges. 'Maybe tomor—'

'It's Richie, Mr Rennie. Ronnie's my brother.'

'Richie. Of course. Now if you'll excuse me.' Big Jim strode on.

Andy took the note from the boy and caught up to Rennie before he could get to the trio sitting on the steps. 'You better look at this.'

What Big Jim looked at first was Andy's face, more pinched and worried than ever. Then he took the note.

> *James—*
>
> *I must see you tonight. God has spoken to me. Now I must speak to you before I speak to the town. Please reply. Richie Killian will carry your message to me.*
>
> *Reverend Lester Coggins*

Not Les; not even Lester. No. *Reverend Lester Coggins.* This was not good. Why oh why did everything have to happen at the same time?

The boy was standing in front of the bookstore, looking in his

faded shirt and baggy, slipping-down jeans like a gosh-darn orphan. Big Jim beckoned to him. The kid raced forward eagerly. Big Jim took his pen from his pocket (written in gold down the barrel: YOU'LL LUV THE FEELIN' WHEN BIG JIM'S DEALIN') and scribbled a three-word reply: *Midnight. My house.* He folded it over and handed it to the boy.

'Take that back to him. And *don't* read it.'

'I won't! No way! God bless you, Mr Rennie.'

'You too, son.' He watched the boy speed off.

'What's *that* about?' Andy asked. And before Big Jim could answer: 'The factory? Is it the meth—'

'Shut up.'

Andy fell back a step, shocked. Big Jim had never told him to shut up before. This could be bad.

'One thing at a time,' Big Jim said, and marched forward toward the next problem.

3

Watching Rennie come, Barbie's first thought was *He walks like a man who's sick and doesn't know it.* He also walked like a man who has spent his life kicking ass. He was wearing his most carnivorously sociable smile as he took Brenda's hands and gave them a squeeze. She allowed this with calm good grace.

'Brenda,' he said. 'My deepest condolences. I would have been over to see you before now . . . and of course I'll be at the funeral . . . but I've been a little busy. We all have.'

'I understand,' she said.

'We miss Duke so much,' Big Jim said.

'That's right,' Andy put in, pulling up behind Big Jim: a tugboat in the wake of an ocean liner. 'We sure do.'

'Thank you both so much.'

'And while I'd love to discuss your concerns . . . I can see that you have them . . .' Big Jim's smile widened, although it did not come within hailing distance of his eyes. 'We have a very important meeting. Andrea, I wonder if you'd like to run on ahead and set out those files.'

Although pushing fifty, Andrea at that moment looked like a child who has been caught sneaking hot tarts off a windowsill. She started to get up (wincing at the pain in her back as she did so), but Brenda took her arm, and firmly. Andrea sat back down.

Barbie realized that both Grinnell and Sanders looked frightened

to death. It wasn't the Dome, at least not at this moment; it was Rennie. Again he thought: *This is* not *as bad as it gets.*

'I think you'd better make time for us, James,' Brenda said pleasantly. 'Surely you understand that if this wasn't important – *very* – I'd be at home, mourning my husband.'

Big Jim was at a rare loss for words. The people on the street who'd been watching the sunset were now watching this impromptu meeting instead. Perhaps elevating Barbara to an importance he did not deserve simply because he was sitting in close proximity to the town's Third Selectman and the late Police Chief's widow. Passing some piece of paper among themselves as if it were a letter from the Grand High Pope of Rome. Whose idea had this public display been? The Perkins woman's, of course. Andrea wasn't smart enough. Nor brave enough to cross him in such a public way.

'Well, maybe we can spare you a few minutes. Eh, Andy?'

'Sure,' Andy said. 'Always a few minutes for you, Mrs Perkins. I'm really sorry about Duke.'

'And I'm sorry about your wife,' she said gravely.

Their eyes met. It was a genuine Tender Moment, and it made Big Jim feel like tearing his hair out. He knew he wasn't supposed to let such feelings grip him – it was bad for his blood pressure, and what was bad for his blood pressure was bad for his heart – but it was hard, sometimes. Especially when you'd just been handed a note from a fellow who knew far too much and now believed God wanted him to speak to the town. If Big Jim was right about what had gotten into Coggins's head, this current business was piddling by comparison.

Only it might *not* be piddling. Because Brenda Perkins had never liked him, and Brenda Perkins was the widow of a man who was now perceived in town – for absolutely no good reason – as a hero. The first thing he had to do—

'Come on inside,' he said. 'We'll talk in the conference room.' His eyes flicked to Barbie. 'Are you a part of this, Mr Barbara? Because I can't for the life of me understand why.'

'This may help,' Barbie said, holding out the sheets of paper they'd been passing around. 'I used to be in the Army. I was a lieutenant. It seems that I've had my term of service extended. I've also been given a promotion.'

Rennie took the sheets, holding them by the corner as if they might be hot. The letter was considerably more elegant than the grubby note Richie Killian had handed him, and from a rather more well-known correspondent. The heading read simply: **FROM THE WHITE HOUSE.** It bore today's date.

Rennie felt the paper. A deep vertical crease had formed between his bushy eyebrows. 'This isn't White House stationery.'

Of course it is, you silly man, Barbie was tempted to say. *It was delivered an hour ago by a member of the FedEx Elf Squad. Crazy little fucker just teleported through the Dome, no problem.*

'No, it's not.' Barbie tried to keep his voice pleasant. 'It came by way of the Internet, as a PDF file. Ms Shumway downloaded it and printed it out.'

Julia Shumway. Another troublemaker.

'Read it, James,' Brenda said quietly. 'It's important.'

Big Jim read it.

4

Benny Drake, Norrie Calvert, and Scarecrow Joe McClatchey stood outside the offices of the Chester's Mill *Democrat*. Each had a flashlight. Benny and Joe held theirs in their hands; Norrie's was tucked into the wide front pocket of her hoodie. They were looking up the street at the Town Hall, where several people – including all three selectmen and the cook from Sweetbriar Rose – appeared to be having a conference.

'I wonder what's that's about,' Norrie said.

'Grownup shit,' Benny said, with a supreme lack of interest, and knocked on the door of the newspaper office. When there was no response, Joe pushed past him and tried the knob. The door opened. He knew at once why Miz Shumway hadn't heard them; her copier was going full blast while she talked with the paper's sports reporter and the guy who had been taking pictures out at the field day.

She saw the kids and waved them in. Single sheets were shooting rapidly in the copier's tray. Pete Freeman and Tony Guay were taking turns pulling them out and stacking them up.

'There you are,' Julia said. 'I was afraid you kids weren't coming. We're almost ready. If the damn copier doesn't shit the bed, that is.'

Joe, Benny, and Norrie received this enchanting bon mot with silent appreciation, each resolving to put it to use as soon as possible.

'Did you get permission from your folks?' Julia asked. 'I don't want a bunch of angry parents on my neck.'

'Yes, ma'am,' Norrie said. 'All of us did.'

Freeman was tying up a bundle of sheets with twine. Doing a bad job of it, too, Norrie observed. She herself could tie five different knots. Also fishing flies. Her father had shown her. She in turn had shown him how to do nosies on her rail, and when he fell off the

first time he'd laughed until tears rolled down his face. She thought she had the best dad in the universe.

'Want me to do that?' Norrie asked.

'If you can do a better job, sure.' Pete stood aside.

She started forward, Joe and Benny crowding close behind her. Then she saw the big black headline on the one-sheet extra, and stopped. 'Holy shit!'

As soon as the words were out she clapped her hands to her mouth, but Julia only nodded. 'It's an authentic holy shit, all right. I hope you all brought bikes, and I hope they all have baskets. You can't haul these around town on skateboards.'

'That's what you said, that's what we brought,' Joe replied. 'Mine doesn't have a basket, but it's got a carrier.'

'And I'll tie his load on for him,' Norrie said.

Pete Freeman, who was watching with admiration as the girl quickly tied up the bundles (with what looked like a sliding butterfly), said, 'I bet you will. Those are good.'

'Yeah, I rock,' Norrie said matter-of-factly.

'Got flashlights?' Julia asked.

'Yes,' they all said together.

'Good. The *Democrat* hasn't used newsboys in thirty years, and I don't want to celebrate the reintroduction of the practice with one of you getting hit on the corner of Main or Prestile.'

'That would be a bummer, all right,' Joe agreed.

'Every house and business on those two streets gets one, right? Plus Morin and St Anne Avenue. After that, spread out. Do what you can, but when it gets to be nine o'clock, go on home. Drop any left-over papers on streetcorners. Put a rock on them to hold them down.'

Benny looked at the headline again:

CHESTER'S MILL, ATTENTION!
EXPLOSIVES TO BE FIRED AT BARRIER!
CRUISE MISSILE DELIVERY SYSTEM
WESTERN BORDER EVACUATION RECOMMENDED

'I bet this won't work,' Joe said darkly, examining the map, obviously hand-drawn, at the bottom of the sheet. The border between Chester's Mill and Tarker's Mills had been highlighted in red. There was a black **X** where Little Bitch Road cut across the town line. The **X** had been labeled **Point of Impact.**

'Bite your tongue, kiddo,' Tony Guay said.

5

FROM THE WHITE HOUSE

Greetings and salutations
to the CHESTER'S MILL BOARD OF SELECTMEN:
 Andrew Sanders
 James P. Rennie
 Andrea Grinnell

Dear Sirs and Madam:

First and foremost, I send you greetings, and want to express our nation's deep concern and good wishes. I have designated tomorrow as a national Day of Prayer; across America, churches will be open as people of all faiths pray for you and for those working to understand and reverse what has happened at the borders of your town. Let me assure you that we will not rest until the people of Chester's Mill are freed and those responsible for your imprisonment are punished. That this situation *will* be resolved – and soon – is my promise to you and to the people of Chester's Mill. I speak with all the solemn weight of my office, as your Commander in Chief.

Second, this letter will introduce Colonel Dale Barbara, of the U.S. Army. Col. Barbara served in Iraq, where he was awarded the Bronze Star, a Merit Service Medal, and two Purple Hearts. He has been recalled to duty and promoted so that he may serve as your conduit to us, and ours to you. I know that, as loyal Americans, you will afford him every assistance. As you aid him, so will we aid you.

My original intent, in accordance with the advice given me by the Joint Chiefs and the Secretaries of Defense and Homeland Security, was to invoke martial law in Chester's Mill and appoint Col. Barbara as interim military governor. Col. Barbara has assured me, however, that this will not be necessary. He tells me he expects full cooperation from Selectmen and local police. He believes his position should be one of 'advise and consent.' I have agreed to his judgment, subject to review.

Third, I know you are worried about your inability to call friends and loved ones. We understand your concern, but it

is imperative that we maintain this 'telephonic blackout' to lower the risk of classified information passing into and out of Chester's Mill. You may think this a specious concern; I assure you it is not. It may very well be that someone in Chester's Mill has information regarding the barrier surrounding your town. 'In-town' calls should go through.

Fourth, we will continue to maintain a press blackout for the time being, although this matter will remain subject to review. There may come a time when it would be beneficial for town officials and Col. Barbara to hold a press conference, but at present our belief is that a speedy end to this crisis will render such a meeting with the press moot.

My fifth point concerns Internet communications. The Joint Chiefs are strongly in favor of a temporary blackout on e-mail communications, and I was inclined to agree. Col. Barbara, however, has argued strongly in favor of allowing the citizens of Chester's Mill continued Internet access. He points out that e-mail traffic can be legally monitored by the NSA, and as a practical matter such communications can be vetted more easily than cell transmissions. Since he is our 'man on the spot,' I have agreed to this point, partly on humanitarian grounds. This decision, however, will also be subject to review; changes in policy may occur. Col. Barbara will be a full participant in such reviews, and we look forward to a smooth working relationship between him and all town officials.

Sixth, I offer you the strong possibility that your ordeal may end as early as tomorrow, at 1 p.m, EDT. Col. Barbara will explain the military operation that will occur at that time, and he assures me that between the good offices of yourselves and Ms Julia Shumway, who owns and operates the local newspaper, you will be able to inform the citizens of Chester's Mill what to expect.

And last: you are citizens of the United States of America, and we will never abandon you. Our firmest promise, based on our finest ideals, is simple: No man, woman, or child left behind. Every resource we need to employ in order to end your confinement will be employed. Every dollar we need to spend will be spent. What we expect from you in return is faith and cooperation. Please give us both.

<div style="text-align: center">With every prayer and every good wish,
I remain most sincerely yours,</div>

6

Whatever scribble-dee-dee dogsbody might have written it, the bastard had signed it himself, and using all three of his names, including the terrorist one in the middle. Big Jim hadn't voted for him, and at this moment, had he teleported into existence in front of him, Rennie felt he could cheerfully have strangled him.

And Barbara.

Big Jim's fondest wish was that he could whistle up Pete Randolph and have Colonel Fry Cook slammed into a cell. Tell him he could run his gosh-darned martial law command from the basement of the cop-shop with Sam Verdreaux serving as his aide-de-camp. Maybe Sloppy Sam could even hold the DTs at bay long enough to salute without sticking his thumb in his eye.

But not now. Not yet. Certain phrases from the Blackguard in Chief's letter stood out:

> *As you aid him, so will we aid you.*
> *A smooth working relationship with all town officials.*
> *This decision will be subject to review.*
> *What we expect is faith and cooperation.*

That last one was the most telling. Big Jim was sure the pro-abortion son-of-a-buck knew nothing about faith – to him it was just a buzzword – but when he spoke of cooperation, he knew *exactly* what he was saying, and so did Jim Rennie: *It's a velvet glove, but don't forget the iron fist inside it.*

The President offered sympathy and support (he saw the drug-addled Grinnell woman actually tear up as she read the letter), but if you looked between the lines, you saw the truth. It was a threat letter, pure and simple. Cooperate or you lose your Internet. Cooperate because we'll be making a list of who's naughty and who's nice, and you don't want to be on the naughty side of the ledger when we break through. Because we *will* remember.

Cooperate, pal. Or else.

Rennie thought: *I will never turn my town over to a short-order cook who dared to lay a hand on my son and then dared to challenge my authority. That will never happen, you monkey. Never.*

He also thought: *Softly, calmly.*

Let Colonel Fry Cook explain the military's big plan. If it worked,

fine. If it didn't, the U.S. Army's newest colonel was going to discover whole new meanings to the phrase *deep in enemy territory.*

Big Jim smiled and said, 'Let's go inside, shall we? Seems we have a lot to talk about.'

<div align="center">7</div>

Junior sat in the dark with his girlfriends.

It was strange, even *he* thought so, but it was also soothing.

When he and the other new deputies had gotten back to the police station after the colossal fuckup in Dinsmore's field, Stacey Moggin (still in uniform herself, and looking tired) had told them they could have another four duty-hours if they wanted. There was going to be plenty of overtime on offer, at least for a while, and when it came time for the town to pay, Stacey said she was sure there'd be bonuses, as well . . . probably provided by a grateful United States government.

Carter, Mel, Georgia Roux, and Frank DeLesseps had all agreed to work the extra hours. It wasn't really the money; they were getting off on the job. Junior was too, but he'd also been hatching another of his headaches. This was depressing after feeling absolutely tip-top all day.

He told Stacey he'd pass, if that was all right. She assured him it was, but reminded him he was scheduled back on duty tomorrow at seven o'clock. 'There'll be plenty to do,' she said.

On the steps, Frankie hitched up his belt and said, 'I think I'll swing by Angie's house. She probably went someplace with Dodee, but I'd hate to think she slipped in the shower – that she's lying there all paralyzed, or something.'

Junior felt a throb go through his head. A small white spot began to dance in front of his left eye. It seemed to be jigging and jagging with his heartbeat, which had just speeded up.

'I'll go by, if you want,' he told Frankie. 'It's on my way.'

'Really? You don't mind?'

Junior shook his head. The white spot in front of his eye darted crazily, sickeningly, when he did. Then it settled again.

Frankie lowered his voice. 'Sammy Bushey gave me some lip out at the field day.'

'*That* hole,' Junior said.

'No doubt. She goes, "What are you going to do, arrest me?"' Frankie raised his voice to a snarky falsetto that scraped Junior's nerves. The dancing white spot actually seemed to turn red, and for a moment

he considered putting his hands around his old friend's neck and choking the life out of him so that he, Junior, would never have to be subjected to that falsetto again.

'What I'm thinking,' Frankie continued, 'is I might go out there after I'm off. Teach her a lesson. You know, Respect Your Local Police.'

'She's a skank. Also a lesboreenie.'

'That might make it even better.' Frankie had paused, looking toward the weird sunset. 'This Dome thing could have an upside. We can do pretty much whatever we want. For the time being, anyway. Consider it, chum.' Frankie squeezed his crotch.

'Sure,' Junior had replied, 'but I'm not particularly horny.'

Except now he *was*. Well, sort of. It wasn't like he was going to *fuck* them or anything but—

'But you're still my girlfriends,' Junior said in the darkness of the pantry. He'd used a flashlight at first, but then had turned it off. The dark was better. 'Aren't you?'

They didn't reply. *If they did,* Junior thought, *I'd have a major miracle to report to my dad and Reverend Coggins.*

He was sitting against a wall lined with shelves of canned goods. He had propped Angie on his right and Dodee on his left. *Menagerie a trios,* as they said in the *Penthouse* Forum. His girls hadn't looked too good with the flashlight on, their swollen faces and bulging eyes only partially obscured by their hanging hair, but once he turned it off . . . hey! They could have been a couple of live chicks!

Except for the smell, that was. A mixture of old shit and decay just starting to happen. But it wasn't too bad, because there were other, more pleasant smells in here: coffee, chocolate, molasses, dried fruit, and – maybe – brown sugar.

Also a faint aroma of perfume. Dodee's? Angie's? He didn't know. What he knew was that his headache was better again and that disturbing white spot had gone away. He slid his hand down and cupped Angie's breast.

'You don't mind me doing that, do you, Ange? I mean, I know you're Frankie's girlfriend, but you guys sort of broke up and hey, it's only copping a feel. Also – I hate to tell you this, but I think he's got cheating on his mind tonight.'

He groped with his free hand, found one of Dodee's. It was chilly, but he put it on his crotch anyway. 'Oh my, Dodes,' he said. 'That's pretty bold. But you do what you feel, girl; get down with your bad self.'

He'd have to bury them, of course. Soon. The Dome was apt to pop like a soap bubble, or the scientists would find a way to

dissolve it. When that happened, the town would be flooded with investigators. And if the Dome stayed in place, there would likely be some sort of food-finding committee going house to house, looking for supplies.

Soon. But not right now. Because this was soothing.

Also sort of exciting. People wouldn't understand, of course, but they wouldn't *have* to understand. Because—

'This is our secret,' Junior whispered in the dark. 'Isn't it, girls?'

They did not reply (although they would, in time).

Junior sat with his arms around the girls he had murdered, and at some point he drifted off to sleep.

8

When Barbie and Brenda Perkins left the Town Hall at eleven, the meeting was still going on. The two of them walked down Main to Morin without speaking much at first. There was still a small stack of the *Democrat* one-page extras on the corner of Main and Maple. Barbie slid one out from beneath the rock anchoring the pile. Brenda had a Penlite in her purse and shone the beam on the headline.

'Seeing it in print should make it easier to believe, but it doesn't,' she said.

'No,' he agreed.

'You and Julia collaborated on this to make sure James couldn't cover it up,' she said. 'Isn't that so?'

Barbie shook his head. 'He wouldn't try, because it can't be done. When that missile hits, it's going to make one hell of a bang. Julia just wanted to make sure Rennie doesn't get to spin the news his way, whatever way that might be.' He tapped the one-sheet. 'To be perfectly blunt, I see this as insurance. Selectman Rennie's got to be thinking, "If he was ahead of me on this, what other information is he ahead of me on?"'

'James Rennie can be a very dangerous adversary, my friend.' They began walking again. Brenda folded the paper and tucked it under her arm. 'My husband was investigating him.'

'For what?'

'I don't know how much to tell you,' she said. 'The choices seem to come down to all or nothing. And Howie had no absolute proof – that's one thing I *do* know. Although he was close.'

'This isn't about proof,' Barbie said. 'It's about me staying out of jail if tomorrow doesn't go well. If what you know might help me with that—'

'If staying out of jail is the only thing you're worried about, I'm disappointed in you.'

It wasn't all, and Barbie guessed the widow Perkins knew it. He had listened carefully at the meeting, and although Rennie had taken pains to be at his most ingratiating and sweetly reasonable, Barbie had still been appalled. He thought that, beneath the goshes and gollies and doggone-its, the man was a raptor. He would exert control until it was wrested from him; he would take what he needed until he was stopped. That made him dangerous for everybody, not just for Dale Barbara.

'Mrs Perkins—'

'Brenda, remember?'

'Brenda, right. Put it this way, Brenda: if the Dome stays in place, this town is going to need help from someone other than a used-car salesman with delusions of grandeur. I can't help anybody if I'm in the calabozo.'

'What my husband believed is that Big Jim was helping himself.'

'How? To what? And how much?'

She said, 'Let's see what happens with the missile. If it doesn't work, I'll tell you everything. If it does, I'll sit down with the County Attorney when the dust settles . . . and, in the words of Ricky Ricardo, James Rennie will have some splainin to do.'

'You're not the only one waiting to see what happens with the missile. Tonight, butter wouldn't melt in Rennie's mouth. If the Cruise bounces off instead of punching through, I think we may see his other side.'

She snapped off the Penlite and looked up. 'See the stars,' she said. 'So bright. There's the Dipper . . . Cassiopeia . . . the Great Bear. All just the same. I find that comforting. Do you?'

'Yes.'

They said nothing for a little while, only looked up at the glimmering sprawl of the Milky Way. 'But they always make me feel very small and very . . . very brief.' She laughed, then said – rather timidly: 'Would you mind if I took your arm, Barbie?'

'Not at all.'

She grasped his elbow. He put his hand over hers. Then he walked her home.

9

Big Jim adjourned the meeting at eleven twenty. Peter Randolph bade them all good night and left. He planned to start the evacuation

on the west side of town at seven a.m. sharp, and hoped to have the entire area around Little Bitch Road clear by noon. Andrea followed, walking slowly, with her hands planted in the small of her back. It was a posture with which they had all become familiar.

Although his meeting with Lester Coggins was very much on his mind (and sleep; he wouldn't mind getting a little damned sleep), Big Jim asked her if she could stay behind a moment or two.

She looked at him questioningly. Behind him, Andy Sanders was ostentatiously stacking files and putting them back in the gray steel cabinet.

'And close the door,' Big Jim said pleasantly.

Now looking worried, she did as he asked. Andy went on doing the end-of-meeting housework, but his shoulders were hunched, as if against a blow. Whatever it was Jim wanted to talk to her about, Andy knew already. And judging by his posture, it wasn't good.

'What's on your mind, Jim?' she asked.

'Nothing serious.' Which meant it was. 'But it *did* seem to me, Andrea, that you were getting pretty chummy with that Barbara fellow before the meeting. With Brenda, too, for that matter.'

'Brenda? That's just . . .' She started to say *ridiculous*, but that seemed a little strong. 'Just silly. I've known Brenda for thirty yea—'

'And Mr Barbara for three months. If, that is, eating a man's waffles and bacon is a basis for knowing him.'

'I think he's Colonel Barbara now.'

Big Jim smiled. 'Hard to take that seriously when the closest thing he can get to a uniform is a pair of bluejeans and a tee-shirt.'

'You saw the President's letter.'

'I saw something Julia Shumway could have composed on her own gosh-darn computer. Isn't that right, Andy?'

'Right,' Andy said without turning around. He was still filing. And then refiling what he'd already filed, from the look of it.

'And suppose it *was* from the President?' Big Jim said. The smile she hated was spreading on his broad, jowly face. Andrea observed with some fascination that she could see stubble on those jowls, maybe for the first time, and she understood why Jim was always so careful to shave. The stubble gave him a sinister Nixonian look.

'Well . . .' Worry was now edging into fright. She wanted to tell Jim she'd only been being polite, but it had actually been a little more, and she guessed Jim had seen that. He saw a great deal. 'Well, he *is* the Commander in Chief, you know.'

Big Jim made a *pshaw* gesture. 'Do you know what a commander is, Andrea? I'll tell you. Someone who merits loyalty and obedience

because he can provide the resources to help those in need. It's supposed to be a fair trade.'

'Yes!' she said eagerly. 'Resources like that Cruiser missile thing!'

'And if it works, that's all very fine.'

'How could it not? He said it might have a thousand-pound warhead!'

'Considering how little we know about the Dome, how can you or any of us be sure? How can we be sure it won't blow the Dome up and leave nothing but a mile-deep crater where Chester's Mill used to be?'

She looked at him in dismay. Hands in the small of her back, rubbing and kneading at the place where the pain lived.

'Well, that's in God's hands,' he said. 'And you're right, Andrea – it may work. But if it doesn't, we're on our own, and a commander in chief who can't help his citizens isn't worth a squirt of warm pee in a cold chamberpot, as far as I'm concerned. If it doesn't work, and if they don't blow all of us to Glory, somebody is going to have to take hold in this town. Is it going to be some drifter the President taps with his magic wand, or is it going to be the elected officials already in place? Do you see where I'm going with this?'

'Colonel Barbara seemed very capable to me,' she whispered.

'*Stop calling him that!*' Big Jim shouted. Andy dropped a file, and Andrea took a step backward, uttering a squeak of fear as she did so.

Then she straightened, momentarily recovering some of the Yankee steel that had given her the courage to run for Selectman in the first place. 'Don't you yell at me, Jim Rennie. I've known you since you were cutting out Sears catalogue pictures in the first grade and pasting them on construction paper, so don't you yell.'

'Oh gosh, she's *offended*.' The fierce smile now spread from ear to ear, lifting his upper face into an unsettling mask of jollity. 'Isn't that too cotton-picking bad. But it's late and I'm tired and I've handed out about all the sweet syrup I can manage for one day. So you listen to me now, and don't make me repeat myself.' He glanced at his watch. 'It's eleven thirty-five, and I want to be home by midnight.'

'*I don't understand what you want of me!*'

He rolled his eyes as if he couldn't believe her stupidity. 'In a nutshell? I want to know you're going to be on my side – mine and Andy's – if this harebrained missile idea doesn't work. Not with some dishwashing johnny-come-lately.'

She squared up her shoulders and let go of her back. She managed to meet his eyes, but her lips were trembling. 'And if I think Colonel

Barbara – *Mr* Barbara, if you prefer – is better qualified to manage things in a crisis situation?'

'Well, I have to go with Jiminey Cricket on that one,' Big Jim said. 'Let your conscience be your guide.' His voice had dropped to a murmur that was more frightening than his shout had been. 'But there's those pills you take. Those OxyContins.'

Andrea felt her skin go cold. 'What about them?'

'Andy's got a pretty good supply put aside for you, but if you were to back the wrong horse in this-here race, those pills just might disappear. Isn't that right, Andy?'

Andy had begun washing out the coffeemaker. He looked unhappy and he wouldn't meet Andrea's brimming eyes, but there was no hesitation in his reply. 'Yes,' he said. 'In a case like that, I might have to turn them down the pharmacist's toilet. Dangerous to have drugs like that around with the town cut off and all.'

'You can't do that!' she cried. 'I have a prescription!'

Big Jim said kindly, 'The only prescription you need is sticking with the people who know this town best, Andrea. For the present, it's the only kind of prescription that will do you any good.'

'Jim, I need my pills.' She heard the whine in her voice – so much like her mother's during the last bad years when she'd been bedridden – and hated it. 'I *need* them!'

'I know,' Big Jim said. 'God has burdened you with a great deal of pain.' *Not to mention a big old monkey on your back*, he thought.

'Just do the right thing,' Andy said. His dark-circled eyes were sad and earnest. 'Jim knows what's best for the town; always has. We don't need some outsider telling us our business.'

'If I do, will I keep getting my pain pills?'

Andy's face lit in a smile. 'You betcha! I might even take it on myself to up the dosage a little. Say a hundred milligrams more a day? Couldn't you use it? You look awfully uncomfortable.'

'I suppose I could use a little more,' Andrea said dully. She lowered her head. She hadn't taken a drink, not even a glass of wine, since the night of the Senior Prom when she'd gotten so sick, had never smoked a joint, had never even seen cocaine except on TV. She was a good person. A *very* good person. So how had she gotten into a box like this? By falling while she was going to get the mail? Was that all it took to turn someone into a drug addict? If so, how unfair. How horrible. 'But only forty milligrams. Forty more would be enough, I think.'

'Are you sure?' Big Jim asked.

She didn't feel sure at all. That was the devil of it.

'Maybe eighty,' she said, and wiped the tears from her face. And, in a whisper: 'You're blackmailing me.'

The whisper was low, but Big Jim heard it. He reached for her. Andrea flinched, but Big Jim only took her hand. Gently.

'No,' he said. 'That would be a sin. We're helping you. And all we want in return is for you to help us.'

10

There was a *thud*.

It brought Sammy wide awake in bed even though she'd smoked half a doob and drunk three of Phil's beers before falling out at ten o'clock. She always kept a couple of sixes in the fridge and still thought of them as 'Phil's beers,' although he'd been gone since April. She'd heard rumors that he was still in town, but discounted them. Surely if he was still around, she would have seen him *sometime* during the last six months, wouldn't she? It was a small town, just like that song said.

Thud!

That got her bolt upright, and listening for Little Walter's wail. It didn't come and she thought, *Oh God, that damn crib fell apart! And if he can't even cry—*

She threw the covers back and ran for the door. She smacked into the wall to the left of it, instead. Almost fell down. Damn dark! Damn power company! Damn Phil, going off and leaving her like this, with no one to stick up for her when guys like Frank DeLesseps were mean to her and scared her and—

Thud!

She felt along the top of the dresser and found the flashlight. She turned it on and hurried out the door. She started to turn left, into the bedroom where Little Walter slept, but the thud came again. Not from the left, but from straight ahead, across the cluttered living room. Someone was at the trailer's front door. And now there came muffled laughter. Whoever it was sounded like they had their drink on.

She strode across the room, the tee-shirt she slept in rippling around her chubby thighs (she'd put on a little weight since Phil left, about fifty pounds, but when this Dome shit was over she intended to get on NutriSystem, return to her high school weight) and threw open the door.

Flashlights – four of them, and high-powered – hit her in the face. From behind them came more laughter. One of those laughs was more of *a nyuck-nyuck-nyuck*, like Curly in the Three Stooges. She recognized *that* one, having heard it all through high school: Mel Searles.

'Look at you!' Mel said. 'All dressed up and no one to blow.'

More laughter. Sammy raised an arm to shield her eyes, but it did no good; the people behind the flashlights were just shapes. But one of the laughters sounded female. That was probably good.

'Turn off those lights before I go blind! And shut up, you'll wake the baby!'

More laughter, louder than ever, but three of the four lights went out. She trained her own flashlight out the door, and wasn't comforted by what she saw: Frankie DeLesseps and Mel Searles flanking Carter Thibodeau and Georgia Roux. Georgia, the girl who'd put her foot on Sammy's tit that afternoon and called her a dyke. A female, but not a *safe* female.

They were wearing their badges. And they were indeed drunk.

'What do you want? It's late.'

'Want some dope,' Georgia said. 'You sell it, so sell some to us.'

'I want to get high as apple pie in a red dirt sky,' Mel said, and then laughed: *Nyuck-nyuck-nyuck.*

'I don't have any,' Sammy said.

'Bullshit, the place reeks of it,' Carter said. 'Sell us some. Don't be a bitch.'

'Yeah,' Georgia said. In the light of Sammy's flash, her eyes had a silvery glitter. 'Never mind that we're cops.'

They all roared at this. They would wake the baby for sure.

'No!' Sammy tried to shut the door. Thibodeau pushed it open again. He did it with just the flat of his hand – easy as could be – but Sammy went stumbling backward. She tripped over Little Walter's goddam choo-choo and went down on her ass for the second time that day. Her tee-shirt flew up.

'Ooo, pink underwear, are you expecting one of your girlfriends?' Georgia asked, and they all roared again. The flashlights that had gone out now came back on, spotlighting her.

Sammy yanked the tee-shirt down almost hard enough to rip the neck. Then she got unsteadily to her feet, the flashlight beams dancing up and down her body.

'Be a good hostess and invite us in,' Frankie said, barging through the door. 'Thank you very much.' His light flashed around the living room. 'What a pigsty.'

'Pigsty for a pig!' Georgia bellowed, and they all broke up again. 'If I was Phil, I might come back out of the woods just long enough to kick your fuckin ass!' She raised her fist; Carter Thibodeau knuckle-dapped her.

'He still hidin out at the radio station?' Mel asked. 'Tweekin the rock? Gettin all paranoid for Jesus?'

'I don't know what you ...' She wasn't mad anymore, only afraid. This was the disconnected way people talked in the nightmares that came if you smoked weed dusted with PCP. 'Phil's gone!'

Her four visitors looked at each other, then laughed. Searles's idiotic *nyuck-nyuck-nyuck* rode above the others.

'Gone! Bugged out!' Frankie crowed.

'Fuckin as *if!*' Carter replied, and then *they* bumped knucks.

Georgia grabbed a bunch of Sammy's paperbacks off the top shelf of the bookcase and looked through them. 'Nora Roberts? Sandra Brown? Stephenie Meyer? You read this stuff? Don't you know fuckin Harry Potter rules?' She held the books out, then opened her hands and dropped them on the floor.

The baby still hadn't awakened. It was a miracle. 'If I sell you some dope, will you go?' Sammy asked.

'Sure,' Frankie said.

'And hurry up,' Carter said. 'We got an early call tomorrow. Eee-*vack*-u-ation detail. So shag that fat ass of yours.'

'Wait here.'

She went into the kitchenette and opened the freezer – warm now, everything would be thawed, for some reason that made her feel like crying – and took out one of the gallon Baggies of dope she kept in there. There were three others.

She started to turn around, but someone grabbed her before she could, and someone else plucked the Baggie from her hand. 'I want to check out that pink underwear again,' Mel said in her ear. 'See if you got SUNDAY on your ass.' He yanked her shirt up to her waist. 'Nope, guess not.'

'Stop it! *Quit* it!'

Mel laughed: *Nyuck-nyuck-nyuck.*

A flashlight stabbed her in the eyes, but she recognized the narrow head behind it: Frankie DeLesseps. 'You gave me lip today,' he said. 'Plus, you slapped me and hurt my little hannie. And all I did was this.' He reached out and grabbed her breast again.

She tried to jerk away. The beam of light that had been trained on her face tilted momentarily up to the ceiling. Then it came down again, fast. Pain exploded in her head. He had hit her with his flashlight.

'*Ow! Ow, that hurts! STOP it!*'

'Shit, that didn't hurt. You're just lucky I don't arrest you for pushing dope. Stand still if you don't want another one.'

'This dope smells skanky,' Mel said in a matter-of-fact voice. He was behind her, still holding up her shirt.

'So does she,' Georgia said.

'Gotta confiscate the weed, bee-yatch,' Carter said. 'Sorry.'

Frankie had glommed onto her breast again. 'Stand still.' He pinched the nipple. 'Just stand still.' His voice, roughening. His breathing, quickening. She knew where this was going. She closed her eyes. *Just as long as the baby doesn't wake up*, she thought. *And as long as they don't do more. Do worse.*

'Go on,' Georgia said. 'Show her what she's been missing since Phil left.'

Frankie gestured into the living room with his flashlight. 'Get on the couch. And spread em.'

'Don't you want to read her her rights, first?' Mel asked, and laughed: *Nyuck-nyuck-nyuck*. Sammy thought if she had to hear that laugh one more time, her head would split wide open. But she started for the couch, head down, shoulders slumped.

Carter grabbed her on the way by, turned her, and sprayed the beam of his flashlight up his own face, turning it into a goblin-mask. 'Are you going to talk about this, Sammy?'

'N-N-No.'

The goblin-mask nodded. 'You hold that thought. Because no one would believe you, anyway. Except for us, of course, and then we'd have to come back and *really* fuck you up.'

Frankie pushed her onto the couch.

'Do her,' Georgia said excitedly, training her light on Sammy. '*Do* that bitch!'

All three of the young men did her. Frankie went first, whispering 'You gotta learn to keep your mouth shut except for when you're on your knees' as he pushed into her.

Carter was next. While he was riding her, Little Walter awoke and began to cry.

'Shut up, kid, or I'll hafta readja your rights!' Mel Searles hollered, and then laughed.

Nyuck-nyuck-nyuck.

11

It was almost midnight.

Linda Everett lay fast asleep in her half of the bed; she'd had an exhausting day, she had an early call tomorrow (eee-*vack*-u-ation detail), and not even her worries about Janelle could keep her awake.

She didn't snore, exactly, but a soft *queep-queep-queep* sound came from her half of the bed.

Rusty had had an equally exhausting day, but he couldn't sleep, and it wasn't Jan he was worried about. He thought she was going to be all right, at least for a while. He could keep her seizures at bay if they didn't get any worse. If he ran out of Zarontin at the hospital dispensary, he could get more from Sanders Drug.

It was Dr Haskell he kept thinking about. And Rory Dinsmore, of course. Rusty kept seeing the torn and bloody socket where the boy's eye had been. Kept hearing Ron Haskell telling Ginny, *I'm not death. Deaf, I mean.*

Except he *had* been death.

He rolled over in bed, trying to leave these memories behind, and what came in their place was Rory muttering *It's Halloween.* Overlapping that, his own daughter's voice: *It's the Great Pumpkin's fault! You have to stop the Great Pumpkin!*

His daughter had been having a seizure. The Dinsmore kid had taken a ricochet to the eye and a bullet fragment to the brain. What did that tell him?

It tells me nothing. What did the Scottish guy say on Lost? *'Don't mistake coincidence for fate?'*

Maybe that had been it. Maybe it had. But *Lost* had been a long time ago. The Scottish guy could have said *Don't mistake fate for coincidence.*

He rolled over the other way and this time saw the black head-line of that night's *Democrat* one-sheet: **EXPLOSIVES TO BE FIRED AT BARRIER!**

It was hopeless. Sleep was out of the question for now, and the worst thing you could do in a situation like that was try to flog your way into dreamland.

There was half a loaf of Linda's famous cranberry-orange bread downstairs; he'd seen it on the counter when he came in. Rusty decided he'd have a piece of it at the kitchen table and thumb through the latest issue of *American Family Physician.* If an article on whooping cough wouldn't put him to sleep, nothing would.

He got up, a big man dressed in the blue scrubs that were his usual nightwear, and left quietly, so as not to wake Linda.

Halfway to the stairs, he paused and cocked his head.

Audrey was whining, very soft and low. From the girls' room. Rusty went down there and eased the door open. The golden retriever, just a dim shape between the girls' beds, turned to look at him and voiced another of those low whines.

Judy was lying on her side with one hand tucked under her cheek, breathing long and slow. Jannie was a different story. She rolled restlessly from one side to the other, kicking at the bedclothes and muttering. Rusty stepped over the dog and sat down on her bed, under Jannie's latest boy-band poster.

She was dreaming. Not a good dream, by her troubled expression. And that muttering sounded like protests. Rusty tried to make out the words, but before he could, she ceased.

Audrey whined again.

Jan's nightdress was all twisted. Rusty straightened it, pulled up the covers, and brushed Jannie's hair off her forehead. Her eyes were moving rapidly back and forth beneath her closed lids, but he observed no trembling of the limbs, no fluttering fingers, no characteristic smacking of the lips. REM sleep rather than seizure, almost certainly. Which raised an interesting question: could dogs also smell bad dreams?

He bent and kissed Jan's cheek. When he did, her eyes opened, but he wasn't entirely sure she was seeing him. This could have been a petit mal symptom, but Rusty just didn't believe it. Audi would have been barking, he felt sure.

'Go back to sleep, honey,' he said.

'He has a golden baseball, Daddy.'

'I know he does, honey, go back to sleep.'

'It's a *bad* baseball.'

'No. It's good. Baseballs are good, especially golden ones.'

'Oh,' she said.

'Go back to sleep.'

'Okay, Daddy.' She rolled over and closed her eyes. There was a moment of settling beneath the covers, and then she was still. Audrey, who had been lying on the floor with her head up, watching them, now put her muzzle on her paw and went to sleep herself.

Rusty sat there awhile, listening to his daughters breathe, telling himself there was really nothing to be frightened of, people talked their way in and out of dreams all the time. He told himself that everything was fine – he only had to look at the sleeping dog on the floor if he doubted – but in the middle of the night it was hard to be an optimist. When dawn was still long hours away, bad thoughts took on flesh and began to walk. In the middle of the night thoughts became zombies.

He decided he didn't want the cranberry-orange bread after all. What he wanted was to snuggle against his bedwarm sleeping wife. But before leaving the room, he stroked Audrey's silky head. 'Pay attention,

girl,' he whispered. Audi briefly opened her eyes and looked at him.

He thought, *Golden retriever*. And, following that – the perfect connection: *Golden baseball. A* bad *baseball.*

That night, despite the girls' newly discovered feminine privacy, Rusty left their door open.

12

Lester Coggins was sitting on Rennie's stoop when Big Jim got back. Coggins was reading his Bible by flashlight. This did not inspire Big Jim with the Reverend's devotion but only worsened a mood that was already bad.

'God bless you, Jim,' Coggins said, standing up. When Big Jim offered his hand, Coggins seized it in a fervent fist and pumped it.

'Bless you too,' Big Jim said gamely.

Coggins gave his hand a final hard shake and let go. 'Jim, I'm here because I've had a revelation. I asked for one last night – yea, for I was sorely troubled – and this afternoon it came. God has spoken to me, both through scripture and through that young boy.'

'The Dinsmore kid?'

Coggins kissed his clasped hands with a loud smack and then held them skyward. 'The very same. Rory Dinsmore. May God keep him for all eternity.'

'He's eating dinner with Jesus right this minute,' Big Jim said automatically. He was examining the Reverend in the beam of his own flashlight, and what he was seeing wasn't good. Although the night was cooling rapidly, sweat shone on Coggins's skin. His eyes were wide, showing too much of the whites. His hair stood out in wild curls and bumbershoots. All in all, he looked like a fellow whose gears were slipping and might soon be stripping.

Big Jim thought, *This is not good.*

'Yes,' Coggins said, 'I'm sure. Eating the great feast . . . wrapped in the everlasting arms . . .'

Big Jim thought it would be hard to do both things at the same time, but kept silent on that score.

'And yet his death was for a purpose, Jim. That's what I've come to tell you.'

'Tell me inside,' Big Jim said, and before the minister could reply: 'Have you seen my son?'

'Junior? No.'

'How long have you been here?' Big Jim flicked on the hall light, blessing the generator as he did so.

'An hour. Maybe a little less. Sitting on the steps . . . reading . . . praying . . . meditating.'

Rennie wondered if anyone had seen him, but did not ask. Coggins was upset already, and a question like that might upset him more.

'Let's go in my study,' he said, and led the way, head down, lumbering slowly along in his big flat strides. Seen from behind, he looked a bit like a bear dressed in human clothes, one who was old and slow but still dangerous.

13

In addition to the picture of the Sermon on the Mount with his safe behind it, there were a great many plaques on the walls of Big Jim's study, commending him for various acts of community service. There was also a framed picture of Big Jim shaking hands with Sarah Palin and another of him shaking with the Big Number 3, Dale Earnhardt, when Earnhardt had done a fundraiser for some children's charity at the annual Oxford Plains Crash-A-Rama. There was even a picture of Big Jim shaking hands with Tiger Woods, who had seemed like a very nice Negro.

The only piece of memorabilia on his desk was a gold-plated baseball in a Lucite cradle. Below it (also in Lucite) was an autograph reading: *To Jim Rennie, with thanks for your help in putting on the Western Maine Charity Softball Tournament of 2007!* It was signed *Bill 'Spaceman' Lee*.

As he sat behind his desk in his high-backed chair, Big Jim took the ball from its cradle and began tossing it from hand to hand. It was a fine thing to toss, especially when you were a little upset: nice and heavy, the golden seams smacking comfortably against your palms. Big Jim sometimes wondered what it would be like to have a *solid* gold ball. Perhaps he would look into that when this Dome business was over.

Coggins seated himself on the other side of the desk, in the client's chair. The supplicant's chair. Which was where Big Jim wanted him. The Reverend's eyes went back and forth like the eyes of a man watching a tennis match. Or maybe a hypnotist's crystal.

'Now what's this all about, Lester? Fill me in. But let's keep it short, shall we? I need to get some sleep. Got a lot to do tomorrow.'

'Will you pray with me first, Jim?'

Big Jim smiled. It was the fierce one, although not turned up to maximum chill. At least not yet. 'Why don't you fill me in before

we do that? I like to know what I'm praying about before I get kneebound.'

Lester did not keep it short, but Big Jim hardly noticed. He listened with growing dismay that was close to horror. The Reverend's narrative was disjointed and peppered with Biblical quotations, but the gist was clear: he had decided that their little business had displeased the Lord enough for Him to clap a big glass bowl over the whole town. Lester had prayed on what to do about this, scourging himself as he did so (the scourging might have been metaphorical – Big Jim certainly hoped so), and the Lord had led him to some Bible verse about madness, blindness, smiting, etc., etc.

'The Lord said he would shew me a sign, and—'

'Shoe?' Big Jim raised his tufted eyebrows.

Lester ignored him and plunged on, sweating like a man with malaria, his eyes still following the golden ball. Back . . . and forth.

'It was like when I was a teenager and I used to come in my bed.'

'Les, that's . . . a little too much information.' Tossing the ball from hand to hand.

'God said He would shew me blindness, but not *my* blindness. And this afternoon, out in that field, He did! Didn't he?'

'Well, I guess that's one interpretation—'

'*No!*' Coggins leaped to his feet. He began to walk in a circle on the rug, his Bible in one hand. With the other he tugged at his hair. 'God said that when I saw that sign, I had to tell my congregation exactly what you'd been up to—'

'Just me?' Big Jim asked. He did so in a meditative voice. He was tossing the ball from hand to hand a little faster now. *Smack. Smack. Smack.* Back and forth against palms that were fleshy but still hard.

'No,' Lester said in a kind of groan. He paced faster now, no longer looking at the ball. He was waving the Bible with the hand not busy trying to tear his hair out by the roots. He did the same thing in the pulpit sometimes, when he really got going. That stuff was all right in church, but here it was just plain infuriating. 'It was you and me and Roger Killian, the Bowie brothers and . . .' He lowered his voice. 'And that other one. The Chef. I think that man's crazy. If he wasn't when he started last spring, he sure is now.'

Look who's talking, little buddy, Big Jim thought.

'We're all involved, but it's you and I who have to confess, Jim. That's what the Lord told me. That's what the boy's blindness meant; it's what he *died* for. We'll confess, and we'll burn that Barn of Satan behind the church. Then God will let us go.'

'You'll go, all right, Lester. Straight to Shawshank State Prison.'

'I will take the punishment God metes out. And gladly.'

'And me? Andy Sanders? The Bowie brothers? And Roger Killian! He's got I think nine kids to support! What if we're not so glad, Lester?'

'I can't help that.' Now Lester began to whack himself on the shoulders with his Bible. Back and forth; first one side and then the other. Big Jim found himself synchronizing his tosses of the golden baseball to the preacher's blows. *Whack* . . . and *smack*. *Whack* . . . and *smack*. *Whack* . . . and *smack*. 'It's sad about the Killian children, of course, but . . . Exodus twenty, verse five: "For I the Lord thy God am a jealous God, visiting the iniquity of the fathers upon the children unto the third and fourth generation." We have to bow to that. We have to clean out this chancre however much it may hurt; make right what we have made wrong. That means confession and purification. Purification by fire.'

Big Jim raised the hand not currently holding the gold baseball. 'Whoa, whoa, *whoa*. Think about what you're saying. This town depends on me – and you, of course – in ordinary times, but in times of crisis, it *needs* us.' He stood up, pushing his chair back. This had been a long and terrible day, he was tired, and now this. It made a man angry.

'We have sinned.' Coggins spoke stubbornly, still whacking himself with his Bible. As if he thought treating God's Holy Book like that was perfectly okay.

'What we did, Les, was keep thousands of kids from starving in Africa. We even paid to treat their hellish diseases. We also built you a new church and the most powerful Christian radio station in the northeast.'

'And lined our own pockets, don't forget that!' Coggins shrilled. This time he smacked himself full in the face with the Good Book. A thread of blood seeped from one nostril. 'Lined em with filthy dope-money!' He smacked himself again. 'And Jesus's radio station is being run by a lunatic who cooks the poison that children put into their veins!'

'Actually, I think most of them smoke it.'

'Is that supposed to be *funny*?'

Big Jim came around the desk. His temples were throbbing and a bricklike flush was rising in his cheeks. Yet he tried once more, speaking softly, as if to a child doing a tantrum. 'Lester, the town needs my leadership. If you go opening your gob, I won't be able to provide that leadership. Not that anyone will believe you—'

'They'll *all* believe!' Coggins cried. 'When they see the devil's workshop I've let you run behind my church, they'll *all* believe! And Jim – don't you see – once the sin is out . . . once the sore's been cleansed . . . God will remove His barrier! The crisis will end! They won't *need* your leadership!'

That was when James P. Rennie snapped. '*They'll always need it!*' he roared, and swung the baseball in his closed fist.

It split the skin of Lester's left temple as Lester was turning to face him. Blood poured down the side of Lester's face. His left eye glared out of the gore. He lurched forward with his hands out. The Bible flapped at Big Jim like a blabbery mouth. Blood pattered down onto the carpet. The left shoulder of Lester's sweater was already soaked. '*No, this is not the will of the Lor—*'

'It's *my* will, you troublesome fly.' Big Jim swung again, and this time connected with the Reverend's forehead, dead center. Big Jim felt the shock travel all the way up to his shoulder. Yet Lester staggered forward, wagging his Bible. It seemed to be trying to talk.

Big Jim dropped the ball to his side. His shoulder was throbbing. Now blood was *pouring* onto the carpet, and still the son-of-a-buck wouldn't go down; still he came forward, trying to talk and spitting scarlet in a fine spray.

Coggins bumped into the front of the desk – blood splattered across the previously unmarked blotter – and then began to sidle along it. Big Jim tried to raise the ball again and couldn't.

I knew all that high school shotputting would catch up with me someday, he thought.

He switched the ball to his left hand and swung it sideways and upward. It connected with Lester's jaw, knocking his lower face out of true and spraying more blood into the not-quite-steady light of the overhead fixture. A few drops struck the milky glass.

'*Guh!*' Lester cried. He was still trying to sidle around the desk. Big Jim retreated into the kneehole.

'Dad?'

Junior was standing in the doorway, eyes wide, mouth open.

'*Guh!*' Lester said, and began to flounder around toward the new voice. He held out the Bible. '*Guh . . . Guh . . . Guh-uh-ODD—*'

'*Don't just stand there, help me!*' Big Jim roared at his son.

Lester began to stagger toward Junior, flapping the Bible extravagantly up and down. His sweater was sodden; his pants had turned a muddy maroon; his face was gone, buried in blood.

Junior hurried to meet him. When Lester started to collapse,

Junior grabbed him and held him up. 'I gotcha, Reverend Coggins – I gotcha, don't worry.'

Then Junior clamped his hands around Lester's blood-sticky throat and began to squeeze.

14

Five interminable minutes later.

Big Jim sat in his office chair – *sprawled* in his office chair – with his tie, put on special for the meeting, pulled down and his shirt unbuttoned. He was massaging his hefty left breast. Beneath it, his heart was still galloping and throwing off arrhythmias, but showed no signs of actually going into cardiac arrest.

Junior left. Rennie thought at first he was going to get Randolph, which would have been a mistake, but he was too breathless to call the boy back. Then he came back on his own, carrying the tarp from the back of the camper. He watched Junior shake it out on the floor – oddly businesslike, as if he had done this a thousand times before. *It's all those R-rated movies they watch now*, Big Jim thought. Rubbing the flabby flesh that had once been so firm and so hard.

'I'll . . . help,' he wheezed, knowing he could not.

'You'll sit right there and get your breath.' His son, on his knees, gave him a dark and unreadable look. There might have been love in it – Big Jim certainly hoped there was – but there were other things, too.

Gotcha now? Was *Gotcha now* part of that look?

Junior rolled Lester onto the tarp. The tarp crackled. Junior studied the body, rolled it a little farther, then flipped the end of the tarp over it. The tarp was green. Big Jim had bought it at Burpee's. Bought it on sale. He remembered Toby Manning saying, *You're getting a heckuva good deal on that one, Mr Rennie.*

'Bible,' Big Jim said. He was still wheezing, but he felt a little better. Heartbeat slowing, thank God. Who knew the climb would get so steep after fifty? He thought: *I have to start working out. Get back in shape. God only gives you one body.*

'Right, yeah, good call,' Junior murmured. He grabbed the bloody Bible, wedged it between Coggins's thighs, and began rolling up the body.

'He broke in, Son. He was crazy.'

'Sure.' Junior did not seem interested in that. What he seemed interested in was rolling the body up . . . just so.

'It was him or me. You'll have to—' Another little taradiddle in

his chest. Jim gasped, coughed, pounded his breast. His heart settled again. 'You'll have to take him out to Holy Redeemer. When he's found, there's a guy . . . maybe . . .' It was the Chef he was thinking of, but maybe arranging for Chef to carry the can for this was a bad idea. Chef Bushey knew stuff. Of course, he'd probably resist arrest. In which case he might not be taken alive.

'I've got a better place,' Junior said. He sounded serene. 'And if you're talking about hanging it on someone, I've got a better *idea*.'

'Who?'

'Dale Fucking Barbara.'

'You know I don't approve of that language—'

Looking at him over the tarp, eyes glittering, Junior said it again. '*Dale . . . Fucking . . . Barbara*.'

'How?'

'I don't know yet. But you better wash off that damn gold ball if you mean to keep it. And get rid of the blotter.'

Big Jim got to his feet. He was feeling better now. 'You're a good boy to help your old dad this way, Junior.'

'If you say so,' Junior replied. There was now a big green burrito on the rug. With feet sticking out the end. Junior tucked the tarp over them, but it wouldn't stay. 'I'll need some duct tape.'

'If you're not going to take him to the church, then where—'

'Never mind,' Junior said. 'It's safe. The Rev'll keep until we figure out how to put Barbara in the frame.'

'Got to see what happens tomorrow before we do anything.'

Junior looked at him with an expression of distant contempt Big Jim had never seen before. It came to him that his son now had a great deal of power over him. But surely his own *son* . . .

'We'll have to bury your rug. Thank God it's not the wall-to-wall carpet you used to have in here. And the upside is it caught most of the mess.' Then he lifted the big burrito and bore it down the hall. A few minutes later Rennie heard the camper start up.

Big Jim considered the golden baseball. *I should get rid of that, too*, he thought, and knew he wouldn't. It was practically a family heirloom. And besides, what harm? What harm, if it was clean?

When Junior returned an hour later, the golden baseball was once again gleaming in its Lucite cradle.

MISSILE STRIKE IMMINENT

1

'ATTENTION! THIS IS THE CHESTER'S MILL POLICE! THE AREA IS BEING EVACUATED! IF YOU HEAR ME, COME TO THE SOUND OF MY VOICE! THE AREA IS BEING EVACUATED!'

Thurston Marshall and Carolyn Sturges sat up in bed, listening to this weird blare and looking at each other with wide eyes. They were teachers at Emerson College, in Boston – Thurston a full professor of English (and guest editor for the current issue of *Ploughshares*), Carolyn a graduate assistant in the same department. They had been lovers for the last six months, and the bloom was far from off the rose. They were in Thurston's little cabin on Chester Pond, which lay between Little Bitch Road and Prestile Stream. They had come here for a long 'fall foliage' weekend, but most of the foliage they had admired since Friday afternoon had been of the pubic variety. There was no TV in the cabin; Thurston Marshall abominated TV. There was a radio, but they hadn't turned it on. It was eight thirty in the morning on Monday, October twenty-third. Neither of them had any idea anything was wrong until that blaring voice startled them awake.

'ATTENTION! THIS IS THE CHESTER'S MILL POLICE! THE AREA—' Closer. Moving in.

'Thurston! The dope! Where did you leave the dope?'

'Don't worry,' he said, but the quaver in his voice suggested he was incapable of taking his own advice. He was a tall, reedy man with a lot of graying hair that he usually tied back in a ponytail. Now it lay loose, almost to his shoulders. He was sixty; Carolyn was twenty-three. 'All these little camps are deserted at this time of year, they'll just drive past and back to the Little Bitch R—'

She pounded him on the shoulder – a first. 'The car is in the driveway! They'll see the car!'

An *oh shit* look dawned on his face.

'—EVACUATED! IF YOU HEAR ME, COME TO THE SOUND OF MY VOICE! ATTENTION! ATTENTION!' Very close now. Thurston could hear other amplified voices, as well – people using loudhailers, *cops* using loudhailers – but this one was almost on top of them. 'THE AREA IS BEING EVAC—' There was a moment of silence. Then: 'HELLO, CABIN! COME OUT HERE! MOVE IT!'

Oh, this was a nightmare.

'*Where did you leave the dope?*' She pounded him again.

The dope was in the other room. In a Baggie that was now half empty, sitting beside a platter of last night's cheese and crackers. If someone came in, it would be the first goddam thing they saw.

'THIS IS THE POLICE! WE ARE NOT SCREWING AROUND HERE! THE AREA IS BEING EVACUATED! IF YOU'RE IN THERE, COME OUT BEFORE WE HAVE TO DRAG YOU OUT!'

Pigs, he thought. *Smalltown pigs with smalltown piggy minds.*

Thurston sprang from the bed and ran across the room, hair flying, skinny buttocks flexing.

His grandfather had built the cabin after World War II, and it had only two rooms: a big bedroom facing the pond and the living room/kitchen. Power was provided by an old Henske generator, which Thurston had turned off before they had retired; its ragged blat was not exactly romantic. The embers of last night's fire – not really necessary, but *très* romantic – still winked sleepily in the fireplace.

Maybe I was wrong, maybe I put the dope back in my attaché—

Unfortunately, no. The dope was there, right next to the remains of the Brie they had gorged on before commencing last night's fuckathon.

He ran to it, and there was a knock on the door. No, a *hammering* on the door.

'Just a minute!' Thurston cried, madly merry. Carolyn was standing in the bedroom doorway, wrapped in a sheet, but he hardly noticed her. Thurston's mind – still suffering residual paranoia from the previous evening's indulgences – tumbled with unconnected thoughts: revoked tenure, *1984* thought-police, revoked tenure, the disgusted reaction of his three children (by two previous wives), and, of course, revoked tenure. 'Just a minute, just a sec, let me get dressed—'

But the door burst open, and – in direct violation of about nine different Constitutional guarantees – two young men strode in. One held a bullhorn. Both were dressed in jeans and blue shirts. The jeans were almost comforting, but the shirts bore shoulder-patches and badges.

We don't need no stinkin badges, Thurston thought numbly.

Carolyn shrieked, '*Get out of here!*'

'Check it out, Junes,' Frankie DeLesseps said. 'It's *When Horny Met Slutty.*'

Thurston snatched up the Baggie, held it behind his back, and dropped it into the sink.

Junior was eyeing the equipment this move revealed. 'That's about the longest and skinniest dorkola I've ever seen,' he said. He looked tired, and came by the look honestly – he'd had only two hours' sleep – but he was feeling fine, absolutely ripping, old bean. Not a trace of a headache.

This work suited him.

'*Get OUT!*' Carolyn shouted.

Frankie said, 'You want to shut your mouth, sweetheart, and put on some clothes. Everyone on this side of town's being evacuated.'

'*This is our place! GET THE FUCK OUT!*'

Frankie had been smiling. Now he stopped. He strode past the skinny naked man standing by the sink (*quailing* by the sink might have been more accurate) and grabbed Carolyn by the shoulders. He gave her a brisk shake. 'Don't give me lip, sweetheart. I'm trying to keep you from getting your ass fried. You and your boyfr—'

'*Get your hands off me! You'll go to jail for this! My father's a lawyer!*' She tried to slap him. Frankie – not a morning person, never had been – seized her hand and bent it back. Not really hard, but Carolyn screamed. The sheet dropped to the floor.

'Whoa! That's a serious rack,' Junior confided to the gaping Thurston Marshall. 'Can you keep up with that, old fella?'

'Get your clothes on, both of you,' Frankie said. 'I don't know how dumb you are, but pretty dumb would be my guess, since you're still here. Don't you know—' He stopped. Looked from the woman's face to the man's. Both equally terrified. Equally mystified.

'Junior!' he said.

'What?'

'Titsy McGee and wrinkle-boy don't know what's going on.'

'*Don't you dare call me any of your sexist—*'

Junior held up his hands. 'Ma'am, get dressed. You have to get out of here. The U.S. Air Force is going to fire a Cruise missile at this part of town in' – he looked at his watch – 'a little less than five hours.'

'*ARE YOU INSANE?*' Carolyn screamed.

Junior heaved a sigh and then pushed ahead. He guessed he understood the whole cop thing a little better now. It was a great job, but people could be so *stupid*. 'If it bounces off, you'd just hear a big bang. Might cause you to shit your pants – if you were wearing any – but it wouldn't hurt you. If it punches through, though, you'd most likely get charbroiled, since it's gonna be really big and you're less than two miles from what they say is gonna be the point of impact.'

'Bounces off *what*, you dimwit?' Thurston demanded. With the

dope in the sink, he now used one hand to cover his privates . . . or at least tried to; his love-machine was indeed extremely long and skinny.

'The Dome,' Frankie said. 'And I don't appreciate your mouth.' He took a long step forward and punched the current guest editor of *Ploughshares* in the gut. Thurston made a hoarse whoofing sound, doubled over, staggered, almost kept his feet, went to his knees, and vomited up about a teacup's worth of thin white gruel that still smelled of Brie.

Carolyn held her swelling wrist. 'You'll go to jail for this,' she promised Junior in a low, trembling voice. 'Bush and Cheney are long gone. This isn't the United States of North Korea anymore.'

'I know that,' Junior said, with admirable patience for one who was thinking he wouldn't mind doing a little more choking; there was a small dark Gila monster in his brain that thought a little more choking would be just the way to start the day off right.

But no. No. He had to do his part in completing the evacuation. He had taken the Oath of Duty, or whatever the fuck it was.

'I *do* know it,' he repeated. 'But what you two Massholes don't get is that you aren't in the United States of *America* anymore, either. You're in the Kingdom of Chester now, and if you don't behave, you're going to end up in the *Dungeons* of Chester. I promise. No phone call, no lawyer, no due process. We're trying to save your lives here. Are you too fuck-dumb to understand that?'

She was staring at him, stunned. Thurston tried to get up, couldn't manage it, and crawled toward her. Frankie helped him along with a boot to the butt. Thurston cried out in shock and pain. 'That's for holding us up, Grampa,' Frankie said. 'I admire your taste in chicks, but we've got a lot to do.'

Junior looked at the young woman. Great mouth. Angelina lips. He bet she could, as the saying went, suck the chrome off a trailer hitch. 'If he can't get dressed by himself, you help him. We've got four more cabins to check out, and when we get back here, you want to be in that Volvo of yours and on your way into town.'

'*I don't understand any of this!*' Carolyn wailed.

'Not surprised,' Frankie said, and plucked the Baggie of dope out of the sink. 'Didn't you know this stuff makes you stupid?'

She began to cry.

'Don't worry,' Frankie said. 'I'm confisticating it, and in a couple of days, booya, you'll smarten up all on your own.'

'You didn't read us our rights,' she wept.

Junior looked astonished. Then he laughed. 'You have the right to

get the fuck out of here and shut the fuck up, okay? In this situation those are the only rights you have. Do you understand that?'

Frankie was examining the confisticated dope. 'Junior,' he said, 'there's hardly any seeds in this. This is fucking *primo*.'

Thurston had reached Carolyn. He got to his feet, farting quite loudly as he did so. Junior and Frankie looked at each other. They tried to hold it in — they were officers of the law, after all — and couldn't. They burst out laughing simultaneously.

'*Trombone Charlie is back in town!*' Frankie yelled, and they gave each other a high five.

Thurston and Carolyn stood in the bedroom doorway, covering their mutual nakedness in an embrace, staring at the cackling intruders. In the background, like voices in a bad dream, loudhailers continued to announce that the area was being evacuated. Most of the amplified voices were now retreating toward Little Bitch.

'I want that car gone when we get back,' Junior said. 'Or I *will* fuck you up.'

They left. Carolyn dressed herself, then helped Thurston — his stomach hurt too much for him to bend over and put on his own shoes. By the time they were finished, both of them were crying. In the car, on their way back down the camp lane that led to Little Bitch Road, Carolyn tried to reach her father on her cell. She got nothing but silence.

At the intersection of Little Bitch and Route 119, a town police car was pulled across the road. A stocky female cop with red hair pointed at the soft shoulder, then waved at them to use it. Carolyn pulled over instead, and got out. She held up her puffy wrist.

'We were assaulted! By two guys calling themselves cops! One named Junior and one named Frankie! They—'

'Get your ass gone or I'll assault you myself,' Georgia Roux said. 'I ain't shittin, honeypie.'

Carolyn stared at her, stunned. The whole world had turned sideways and slipped into a *Twilight Zone* episode while she was asleep. That had to be it; no other explanation made even marginal sense. They'd hear the Rod Serling voice-over anytime now.

She got back into the Volvo (the sticker on the bumper, faded but still readable: OBAMA '12! YES WE **STILL** CAN) and detoured around the police car. Another, older cop was sitting inside it, going over a checklist on a clipboard. She thought of appealing to him, then thought better of it.

'Try the radio,' she said. 'Let's find out if something really *is* going on.'

Thurston turned it on and got nothing but Elvis Presley and the Jordanaires, trudging through 'How Great Thou Art.'

Carolyn snapped it off, thought of saying *The nightmare is officially complete*, and didn't. All she wanted was to get out of Weirdsville as soon as possible.

2

On the map, the Chester Pond camp road was a thin hooklike thread, almost not there. After leaving the Marshall cabin, Junior and Frankie sat for a moment in Frankie's car, studying this.

'Can't be anybody else down there,' Frankie said. 'Not at this time of the year. What do you think? Say fuck it and go back to town?' He cocked a thumb at the cabin. 'They'll be along, and if they're not, who really gives a shit?'

Junior considered it for a moment, then shook his head. They had taken the Oath of Duty. Besides, he wasn't anxious to get back and face his father's pestering about what he'd done with the Reverend's body. Coggins was now keeping his girlfriends company in the McCain pantry, but there was no need for his dad to know that. At least not until the big man figured out how to nail Barbara with it. And Junior believed his father *would* figure it out. If there was one thing Big Jim Rennie was good at, it was nailing people.

Now it doesn't even matter if he finds out I left school, Junior thought, *because I know worse about him. Way worse.*

Not that dropping out seemed very important now; it was chump change compared to what was going on in The Mill. But he'd have to be careful, just the same. Junior wouldn't put it past his father to nail *him*, if the situation seemed to call for it.

'Junior? Earth to Junior.'

'I'm here,' he said, a little irritated.

'Back to town?'

'Let's check out the other cabins. It's only a quarter of a mile, and if we go back to town, Randolph'll find something else for us to do.'

'Wouldn't mind a little chow, though.'

'Where? At Sweetbriar? Want some rat poison in your scrambled eggs, courtesy of Dale Barbara?'

'He wouldn't dare.'

'You positive?'

'Okay, okay.' Frankie started the car and backed down the little stub of driveway. The brightly colored leaves hung moveless on the

trees, and the air felt sultry. More like July than October. 'But the Massholes better be gone when we come back, or I just might have to introduce Titsy McGee to my helmeted avenger.'

'I'll be happy to hold her down,' Junior said. 'Yippee-ki-yi-yay, motherfucker.'

3

The first three cabins were clearly empty; they didn't even bother getting out of the car. By now the camp road was down to a pair of wheelruts with a grassy hump between them. Trees overhung it on both sides, some of the lower branches almost close enough to scrape the roof.

'I think the last one's just around this curve,' Frankie said. 'The road ends at this shitpot little boat land—'

'*Look out!*' Junior shouted.

They came out of the blind curve and two kids, a boy and a girl, were standing in the road. They made no effort to get out of the way. Their faces were shocked and blank. If Frankie hadn't been afraid of tearing the Toyota's exhaust system out on the camp road's center hump – if he'd been making any kind of speed at all – he would have hit them. Instead he stood on the brake, and the car stopped two feet short.

'Oh my God, that was close,' he said. 'I think I'm having a heart attack.'

'If my father didn't, you won't,' Junior said.

'Huh?'

'Never mind.' Junior got out. The kids were still standing there. The girl was taller and older. Maybe nine. The boy looked about five. Their faces were pale and dirty. She was holding his hand. She looked up at Junior, but the boy looked straight ahead, as if examining something of interest in the Toyota's driver's side headlamp.

Junior saw the terror on her face and dropped to one knee in front of her. 'Honey, are you okay?'

It was the boy who answered. He spoke while still examining the headlamp. 'I want my mother. And I want my breffus.'

Frankie joined him. 'Are they real?' Speaking in a voice that said *I'm joking, but not really*. He reached out and touched the girl's arm.

She jumped a little, and looked at him. 'Mumma didn't come back.' She spoke in a low voice.

'What's your name, hon?' Junior asked. 'And who's your mommy?'

'I'm Alice Rachel Appleton,' she said. 'This is Aidan Patrick Appleton. Our mother is Vera Appleton. Our father is Edward Appleton, but he and Mommy got a divorce last year and now he lives in Plano, Texas. We live in Weston, Massachusetts, at Sixteen Oak Way. Our telephone number is—' She recited it with the toneless accuracy of a directory assistance recording.

Junior thought, *Oh boy. More Massholes.* But it made sense; who else would burn expensive gasoline just to watch the fucking leaves fall off the fucking trees?

Frankie was also kneeling now. 'Alice,' he said, 'listen to me, sweetheart. Where is your mother now?'

'Don't know.' Tears – big clear globes – began to roll down her cheeks. 'We came to see the leaves. Also, we were going to go in the kayak. We like the kayak, don't we, Aide?'

'I'm hungry,' Aidan said mournfully, and then he too began to cry.

Seeing them like that made Junior feel like crying himself. He reminded himself he was a cop. Cops didn't cry, at least not on duty. He asked the girl again where her mother was, but it was the little boy who answered.

'She went to get Woops.'

'He means Whoopie Pies,' Alice said. 'But she went to get other stuff, too. Because Mr Killian didn't caretake the cabin like he was supposed to. Mommy said I could take care of Aidan because I'm a big girl now and she'd be right back, she was only going to Yoder's. She just said don't let Aide go near the pond.'

Junior was starting to get the picture. Apparently the woman had expected to find the cabin stocked with food – a few staples, at least – but if she'd known Roger Killian well, she would have known better than to depend on him. The man was a class-A dumbbell, and had passed his less-than-sterling intellect on to his entire brood. Yoder's was a nasty little store just across the Tarker's Mills town line specializing in beer, coffee brandy, and canned spaghetti. Ordinarily it would have been a twenty-minute run there and another twenty back. Only she hadn't come back, and Junior knew why.

'Did she go Saturday morning?' he asked. 'She did, didn't she?'

'I *want* her!' Aidan cried. 'And I want my *breffus*! My belly hurts!'

'Yes,' the girl said. 'Saturday morning. We were watching cartoons, only now we can't watch anything, because the electricity's broke.'

Junior and Frankie looked at each other. Two nights alone in the dark. The girl maybe nine, the boy about five. Junior didn't like to think about that.

'Did you have anything to eat?' Frankie asked Alice Appleton. 'Sweetheart? Anything at all?'

'There was a onion in the vegetable draw,' she whispered. 'We each had half. With sugar.'

'Oh, fuck,' Frankie said. Then: 'I didn't say that. You didn't hear me say that. Just a second.' He went back to the car, opened the passenger door, and began to rummage in the glove compartment.

'Where were you going, Alice?' Junior asked.

'To town. To look for Mommy and to find something to eat. We were going to walk past the next camp and then cut through the woods.' She pointed vaguely north. 'I thought that would be quicker.'

Junior smiled, but he was cold inside. She wasn't pointing toward Chester's Mill; she was pointing in the direction of TR-90. At nothing but miles of tangled second-growth and boggy sumps. Plus the Dome, of course. Out there, Alice and Aidan would almost certainly have died of starvation; Hansel and Gretel minus the happy ending.

And we came so close to turning around. Jesus.

Frankie returned. He had a Milky Way. It looked old and squashed, but it was still in the wrapper. The way the children fixed their eyes on it made Junior think of the kids you saw on the news sometimes. That look on American faces was unreal, horrible.

'It's all I could find,' Frankie said, stripping off the wrapper. 'We'll get you something better in town.'

He broke the Milky Way in two and gave a piece to each child. The candy was gone in five seconds. When he had finished his piece, the boy stuck his fingers knuckle-deep into his mouth. His cheeks hollowed rhythmically in and out as he sucked them.

Like a dog licking grease off a stick, Junior thought.

He turned to Frankie. 'Never mind waiting until we get back to town. We're gonna stop at the cabin where the old man and the chick were. And whatever they got, these kids are going to get it.'

Frankie nodded and picked up the boy. Junior picked up the little girl. He could smell her sweat, her fear. He stroked her hair as if he could stroke that oily reek away.

'You're all right, honey,' he said. 'You and your brother both. You're all right. You're safe.'

'Do you promise?'

'Yes.'

Her arms tightened around his neck. It was one of the best things Junior had ever felt in his life.

4

The western side of Chester's Mill was the least populated part of town, and by quarter of nine that morning it was almost entirely clear. The only police car left on Little Bitch was Unit 2. Jackie Wettington was driving and Linda Everett was riding shotgun. Chief Perkins, a smalltown cop of the old school, would never have sent two women out together, but of course Chief Perkins was no longer in charge, and the women themselves enjoyed the novelty. Men, especially male cops with their endless yee-haw banter, could be tiring.

'Ready to go back?' Jackie asked. 'Sweetbriar'll be closed, but we might be able to beg a cup of coffee.'

Linda didn't reply. She was thinking about where the Dome cut across Little Bitch. Going out there had been unsettling, and not just because the sentries were still standing with their backs turned, and hadn't budged when she gave them a good morning through the car's roof speaker. It was unsettling because there was now a great big red **X** spray-painted on the Dome, hanging in midair like a sci-fi hologram. That was the projected point of impact. It seemed impossible that a missile fired from two or three hundred miles away could hit such a small spot, but Rusty had assured her that it could.

'Lin?'

She came back to the here and now. 'Sure, I'm ready if you are.'

The radio crackled. 'Unit Two, Unit Two, do you read, over?'

Linda unracked the mike. 'Base, this is Two. We hear you, Stacey, but reception out here isn't very good, over?'

'Everybody says the same,' Stacey Moggin replied. 'It's worse near the Dome, better as you get closer to town. But you're still on Little Bitch, right? Over.'

'Yes,' Linda said. 'Just checked the Killians and the Bouchers. Both gone. If that missile busts through, Roger Killian's going to have a lot of roast chickens, over.'

'We'll have a picnic. Pete wants to talk to you. Chief Randolph, I mean. Over.'

Jackie pulled the cruiser to the side of the road. There was a pause with static crackling in it, then Randolph came on. He didn't bother with any *overs*, never had.

'Did you check the church, Unit Two?'

'Holy Redeemer?' Linda asked. 'Over.'

'That's the only one I know out there, Officer Everett. Unless a Hindu mosque grew overnight.'

Linda didn't think Hindus were the ones who worshipped in mosques, but this didn't seem like the right time for corrections. Randolph sounded tired and grouchy. 'Holy Redeemer wasn't in our sector,' she said. 'That one belonged to a couple of the new cops. Thibodeau and Searles, I think. Over.'

'Check it again,' Randolph said, sounding more irritable than ever. 'No one's seen Coggins, and a couple of his parishioners want to canoodle with him, or whatever they call it.'

Jackie put a finger to her temple and mimed shooting herself. Linda, who wanted to get back and check on her kids at Marta Edmunds's house, nodded.

'Roger that, Chief,' Linda said. 'Will do. Over.'

'Check the parsonage, too.' There was a pause. 'Also the radio station. The damn thing keeps bellowing away, so there must be someone there.'

'Will do.' She started to say *over and out*, then thought of something else. 'Chief, is there anything new on the TV? Has the President said anything? Over?'

'I don't have time to listen to every word that guy drops out of his silly mouth. Just go on and hunt up the padre and tell him to get his butt back here. And get your butts back, too. Out.'

Linda racked the mike and looked at Jackie.

'Get our butts back there?' Jackie said. 'Our *butts*?'

'*He's* a butt,' Linda said.

The remark was supposed to be funny, but it fell flat. For a moment they just sat in the idling car, not talking. Then Jackie spoke in a voice that was almost too low to be heard. 'This is so bad.'

'Randolph instead of Perkins, you mean?'

'That, and the new cops.' She gave the last word verbal quotation marks. 'Those *kids*. You know what? When I was punching in, Henry Morrison told me Randolph hired two more this morning. They came in off the street with Carter Thibodeau and Pete just signed em up, no questions asked.'

Linda knew the sort of guys who hung out with Carter, either at Dipper's or at the Gas & Grocery, where they used the garage to tune up their finance-company motorcycles. 'Two *more*? *Why*?'

'Pete told Henry we might need em if that missile doesn't work. "To make sure the situation doesn't get out of hand," he said. And you know who put *that* idea in his head.'

Linda knew, all right. 'At least they're not carrying guns.'

'A couple are. Not department issue; their personals. By tomorrow – if this doesn't end today, that is – they all will be. And as of this

morning Pete's letting them ride together instead of pairing them with real cops. Some training period, huh? Twenty-four hours, give or take. Do you realize those kids now outnumber us?'

Linda considered this silently.

'Hitler Youth,' Jackie said. 'That's what I keep thinking. Probably overreacting, but I hope to God this thing ends today and I don't have to find out.'

'I can't quite see Peter Randolph as Hitler.'

'Me, either. I see him more as Hermann Goering. It's Rennie I think of when I think of Hitler.' She put the cruiser in gear, made a K-turn, and headed them back toward Christ the Holy Redeemer Church.

<div style="text-align:center">

5

</div>

The church was unlocked and empty, the generator off. The parsonage was silent, but Reverend Coggins's Chevrolet was parked in the little garage. Peering in, Linda could read two stickers on the bumper. The one on the right: IF THE RAPTURE'S TODAY, SOMEBODY GRAB MY STEERING WHEEL! The one on the left boasted MY OTHER CAR IS A 10-SPEED.

Linda called the second one to Jackie's attention. 'He does have a bike – I've seen him riding it. But I don't see it in the garage, so maybe he rode it into town. Saving gas.'

'Maybe,' Jackie said. 'And maybe we ought to check the house to make sure he didn't slip in the shower and break his neck.'

'Does that mean we might have to look at him naked?'

'No one said police work was pretty,' Jackie said. 'Come on.'

The house was locked, but in towns where seasonal residents form a large part of the population, the police are adept at gaining entry. They checked the usual places for a spare key. Jackie was the one who found it, hanging on a hook behind a kitchen shutter. It opened the back door.

'Reverend Coggins?' Linda called, sticking her head in. 'It's the police, Reverend Coggins, are you here?'

No answer. They went in. The lower floor was neat and orderly, but it gave Linda an uncomfortable feeling. She told herself it was just being in someone else's house. A *religious* person's house, and uninvited.

Jackie went upstairs. 'Reverend Coggins? Police. If you're here, please make yourself known.'

Linda stood at the foot of the stairs, looking up. The house felt

wrong, somehow. That made her think of Janelle, shaking in the grip of her seizure. That had been wrong, too. A queer certainty stole into her mind: if Janelle were here right now, she would have another seizure. Yes, and start talking about queer things. Halloween and the Great Pumpkin, maybe.

It was a perfectly ordinary flight of stairs, but she didn't want to go up there, just wanted Jackie to report the place was empty so they could go on to the radio station. But when her partner called for her to come up, Linda did.

6

Jackie was standing in the middle of Coggins's bedroom. There was a plain wooden cross on one wall and a plaque on another. The plaque read HIS EYE IS ON THE SPARROW. The coverlet of the bed was turned back. There were traces of blood on the sheet beneath.

'And this,' Jackie said. 'Come around here.'

Reluctantly, Linda did. Lying on the polished wood floor between the bed and the wall was a knotted length of rope. The knots were bloody.

'Looks like somebody beat him,' Jackie said grimly. 'Hard enough to knock him out, maybe. Then they laid him on the . . .' She looked at the other woman. 'No?'

'I take it you didn't grow up in a religious home,' Linda said.

'I did so. We worshipped the Holy Trinity: Santa Claus, the Easter Bunny, and the Tooth Fairy. What about you?'

'Plain old tapwater Baptist, but I heard about things like this. I think he was flagellating himself.'

'Yug! People did that for sins, right?'

'Yes. And I don't think it ever went entirely out of style.'

'Then this makes sense. Sort of. Go in the bathroom and look on the toilet tank.'

Linda made no move to do so. The knotted rope was bad enough, the feel of the house – too empty, somehow – was worse.

'Go on. It's nothing that'll bite you, and I'll bet you a dollar to a dime that you've seen worse.'

Linda went into the bathroom. Two magazines were lying on top of the toilet tank. One was a devotional, *The Upper Room*. The other was called *Young Oriental Slits*. Linda doubted if that one was sold in many religious bookshops.

'So,' Jackie said. 'Are we getting a picture here? He sits on the john, tosses the truffle—'

'Tosses the *truffle*?' Linda giggled in spite of her nerves. Or because of them.

'It's what my mother used to call it,' Jackie said. 'Anyway, after he's done with that, he opens a medium-sized can of whoop-ass to expiate his sins, then goes to bed and has happy Asian dreams. This morning he gets up, refreshed and sin-free, does his morning devotionals, then rides into town on his bike. Make sense?'

It did. It just didn't explain why the house felt so wrong to her. 'Let's check the radio station,' she said. 'Then we'll head into town ourselves and get coffee. I'm buying.'

'Good,' Jackie said. 'I want mine black. Preferably in a hypo.'

7

The low-slung, mostly glass WCIK studio was also locked, but speakers mounted beneath the eaves were playing 'Good Night, Sweet Jesus' as interpreted by that noted soul singer Perry Como. Behind the studio the broadcast tower loomed, the flashing red lights at the top barely visible in the strong morning light. Near the tower was a long barnlike structure which Linda assumed must hold the station's generator and whatever other supplies it needed to keep beaming the miracle of God's love to western Maine, eastern New Hampshire, and possibly the inner planets of the solar system.

Jackie knocked, then hammered.

'I don't think anybody's here,' Linda said . . . but this place seemed wrong, too. And the air had a funny smell, stale and sallow. It reminded her of the way her mother's kitchen smelled, even after a good airing. Because her mother smoked like a chimney and believed the only things worth eating were those fried in a hot skillet greased with plenty of lard.

Jackie shook her head. 'We heard someone, didn't we?'

Linda had no answer for that, because it was true. They had been listening to the station on their drive from the parsonage, and had heard a smooth deejay announcing the next record as 'Another message of God's love in song.'

This time the hunt for the key was longer, but Jackie finally found it in an envelope taped beneath the mailbox. With it was a scrap of paper on which someone had scrawled **1 6 9 3.**

The key was a dupe, and a little sticky, but after some chivvying, it worked. As soon as they were in, they heard the steady beep of the security system. The keypad was on the wall. When Jackie punched in the numbers, the beeping quit. Now there was only the music.

Perry Como had given way to something instrumental; Linda thought it sounded suspiciously like the organ solo from 'In-A-Gadda-Da-Vida.' The speakers in here were a thousand times better than the ones outside and the music was louder, almost like a living thing.

Did people work in this holier-than-thou racket? Linda wondered. *Answer the phones? Do business? How could they?*

There was something wrong in here, too. Linda was sure of it. The place felt more than creepy to her; it felt outright dangerous. When she saw that Jackie had unsnapped the strap on her service automatic, Linda did the same. The feel of the gun-butt under her hand was good. *Thy rod and thy gun-butt, they comfort me,* she thought.

'Hello?' Jackie called. 'Reverend Coggins? Anybody?'

There was no answer. The reception desk was empty. To the left of it were two closed doors. Straight ahead was a window running the entire length of the main room. Linda could see blinking lights inside it. The broadcast studio, she assumed.

Jackie pushed the closed doors open with her foot, standing well back. Behind one was an office. Behind the other was a conference room of surprising luxury, dominated by a giant flat-screen TV. It was on, but muted. Anderson Cooper, almost life-sized, looked like he was doing his standup on Castle Rock's Main Street. The buildings were draped with flags and yellow ribbons. Linda saw a sign on the hardware store that read: SET THEM FREE. That made Linda feel even eerier. The super running across the bottom of the screen read DEFENSE DEPARTMENT SOURCES CLAIM MISSILE STRIKE IS IMMINENT.

'Why is the TV on?' Jackie asked.

'Because whoever was minding the store left it that way when—'

A booming voice interrupted her. 'That was Raymond Howell's version of "Christ My Lord and Leader."'

Both women jumped.

'And this is Norman Drake, reminding you of three important facts: you're listening to the Revival Time Hour on WCIK, God loves you, and He sent his Son to die for you on Calvary's cross. It's nine twenty-five a.m., and as we always like to remind you, time is short. Have you given *your* heart to the Lord? Back after this.'

Norman Drake gave way to a silver-tongued devil selling the entire Bible on DVDs, and the best thing about it was you could pay in monthly installments and return the whole deal if you weren't just as happy as a pig in shit. Linda and Jackie went to the broadcast studio window and looked in. Neither Norman Drake nor the silver-tongued devil was there, but when the commercial ended and the

deejay came back to announce the next song of praise, a green light turned red and a red light turned green. When the music started up, another red light went green.

'It's automated!' Jackie said. 'The whole freaking thing!'

'Then why do we feel like someone's here? And don't say you don't.'

Jackie didn't. 'Because it's weird. The jock even does time-checks. Honey, this setup must have cost a fortune! Talk about the ghost in the machine – how long do you think it will run?'

'Probably till the propane runs out and the generator stops.' Linda spotted another closed door and opened it with her foot, as Jackie had . . . only, unlike Jackie, she drew her gun and held it, safety on and muzzle down, beside her leg.

It was a bathroom, and it was empty. There was, however, a picture of a very Caucasian Jesus on the wall.

'I'm not religious,' Jackie said, 'so you'll have to explain to me why people would want Jesus watching them poop.'

Linda shook her head. 'Let's get out of here before I lose it,' she said. 'This place is the Radioland version of the *Mary Celeste.*'

Jackie looked around uneasily. 'Well, the vibe is spooky, I'll give you that.' She suddenly raised her voice in a harsh shout that made Linda jump. She wanted to tell Jackie not to yell like that. Because someone might hear her and come. Or some*thing.*

'*Hey! Yo! Anybody here? Last chance!*'

Nothing. No one.

Outside, Linda took a deep breath. 'Once, when I was a teenager, some friends and I went to Bar Harbor, and we stopped for a picnic at this scenic turnout. There were half a dozen of us. The day was clear, and you could see practically all the way to Ireland. When we were done eating, I said I wanted to take a picture. My friends were all horsing around and grabassing, and I kept backing up, trying to get everyone in the frame. Then this one girl – Arabella, my best friend back then – stopped trying to give this other girl a wedgie and shouted, "Stop, Linda, *stop!*" I stopped and looked around. Know what I saw?'

Jackie shook her head.

'The Atlantic Ocean. I'd backed up all the way to the drop-off at the edge of the picnic area. There was a warning sign, but no fence or guardrail. One more step and I would have gone down. And how I felt then is how I felt in there.'

'Lin, it was *empty.*'

'I don't think so. And I don't think you do, either.'

'It was spooky, sure. But we checked the rooms—'

'Not the studio. Plus the TV was on and the music was too loud. You don't think they turn it up that loud ordinarily, do you?'

'How do I know what holy rollers do?' Jackie asked. 'Maybe they were expecting the Apocolick.'

'*Lypse.*'

'Whatever. Do you want to check the storage barn?'

'Absolutely not,' Linda said, and that made Jackie snort laughter.

'Okay. Our report is no sign of the Rev, correct?'

'Correct.'

'Then we're off to town. And coffee.'

Before getting into unit Two's shotgun seat, Linda took one more look at the studio building, sitting there wreathed in white-bread audio joy. There was no other sound; she realized she didn't hear a single bird singing, and wondered if they had all killed themselves smashing into the Dome. Surely that wasn't possible. Was it?

Jackie pointed at the mike. 'Want me to give the place a shout through the loudspeaker? Say if anyone's hiding in there they should beat feet into town? Because – I just thought of this – maybe they were scared of us.'

'What I want is for you to stop screwing around and get out of here.'

Jackie didn't argue. She reversed down the short driveway to Little Bitch Road, and turned the cruiser toward The Mill.

8

Time passed. Religious music played. Norman Drake returned and announced that it was nine thirty-four, Eastern Daylight God Loves You Time. This was followed by an ad for Jim Rennie's Used Cars, delivered by the Second Selectman himself. 'It's our annual Fall Sales Spectacular, and boy, did we overstock!' Big Jim said in a rueful the-joke's-on-me voice. 'We've got Fords, Chevvies, Plymouths! We've got the hard-to-get Dodge Ram and even the harder-to-get Mustang! Folks, I'm sitting on not one or two but *three* Mustangs that are like new, one the famous V6 convertible, and each comes with the famous Jim Rennie Christian Guarantee. We service what we sell, we finance, and we do it all at low low prices. And right now' – he chuckled more ruefully than ever – 'we've just *GOT* to clear this *LOT*! So come on down! The coffeepot's always on, neighbor, and you'll love the feelin when Big Jim's dealin!'

A door neither woman had noticed eased open at the back of the studio. Inside were more blinking lights – a galaxy of them. The

room was little more than a cubby choked with wires, splitters, routers, and electronic boxes. You would have said there was no room for a man. But The Chef was beyond skinny; he was emaciated. His eyes were only glitters sunk deep in his skull. His skin was pale and blotchy. His lips folded loosely inward over gums that had lost most of their teeth. His shirt and pants were filthy, and his hips were naked wings; Chef's underwear days were now just a memory. It is doubtful that Sammy Bushey would have recognized her missing husband. He had a peanut butter and jelly sandwich in one hand (he could only eat soft things now) and a Glock 9 in the other.

He went to the window overlooking the parking lot, thinking he'd rush out and kill the intruders if they were still there; he had almost done it while they were inside. Only he'd been afraid. Because demons couldn't actually be killed. When their human bodies died, they just flew into another host. When they were between bodies, the demons looked like blackbirds. Chef had seen this in vivid dreams that came on the increasingly rare occasions when he slept.

They were gone, however. His *atman* had been too strong for them.

Rennie had told him he had to shut down out back, and Chef Bushey had, but he might have to start up some of the cookers again, because there had been a big shipment to Boston a week ago and he was almost out of product. He needed smoke. It was what his *atman* fed on these days.

But for now he had enough. He had given up on the blues music that had been so important to him in his Phil Bushey stage of life – B. B. King, Koko and Hound Dog Taylor, Muddy and Howlin' Wolf, even the immortal Little Walter – and he had given up on fucking; he had even pretty much given up on moving his bowels, had been constipated since July. But that was okay. What humiliated the body fed the *atman*.

He checked the parking lot and the road beyond once more to make sure the demons weren't lurking, then tucked the automatic into his belt at the small of his back and headed for the storage shed, which was actually more of a factory these days. A factory that was shut down, but he could and would fix that if necessary.

Chef went to get his pipe.

9

Rusty Everett stood looking into the storage shed behind the hospital. He was using a flashlight, because he and Ginny Tomlinson – now

the administrative head of medical services in Chester's Mill, crazy as that was – had decided to kill the power to every part of the plant that didn't absolutely need it. From his left, in its own shed, he could hear the big generator roaring away, eating ever deeper into the current long tank of propane.

Most of the tanks are gone, Twitch had said, and by God, they were. *According to the card on the door, there's supposed to be seven, but there's only two.* On that, Twitch was wrong. There was only one. Rusty ran the beam of his flashlight over the blue **CR HOSP** stenciled on the tank's silver side below the supply company's Dead River logo.

'Told you,' Twitch said from behind him, making Rusty jump.

'You told me wrong. There's only one.'

'Bullshit!' Twitch stepped into the doorway. Looked while Rusty shone the beam around, highlighting boxes of supplies surrounding a large – and largely empty – center area. Said: 'It's *not* bullshit.'

'No.'

'Fearless leader, someone is stealing our propane.'

Rusty didn't want to believe this, but saw no way around it.

Twitch squatted down. 'Look here.'

Rusty dropped to one knee. The quarter-acre behind the hospital had been asphalted the previous summer, and without any cold weather to crack or buckle it – not yet, anyway – the area was a smooth black sheet. It made it easy to see the tire tracks in front of the shed's sliding doors.

'That looks like it could have been a town truck,' Twitch remarked.

'Or any other big truck.'

'Nevertheless, you might want to check the storage shed behind the town hall. Twitch no trust-um Big Chief Rennie. Him bad medicine.'

'Why would he take our propane? The Selectmen have plenty of their own.'

They walked to the door leading into the hospital's laundry – also shut down, at least for the time being. There was a bench beside the door. A sign posted on the bricks read SMOKING HERE WILL BE BANNED AS OF JANUARY 1ST. QUIT NOW AND AVOID THE RUSH!

Twitch took out his Marlboros and offered them to Rusty. Rusty waved them away, then reconsidered and took one. Twitch lit them up. 'How do you know?' he asked.

'How do I know what?'

'That they've got plenty of their own. Have you checked?'

'No,' Rusty said. 'But if they *were* going to poach, why from us? Not only is stealing from the local hospital usually considered bad form by the better class of people, the post office is practically right next door. They must have some.'

'Maybe Rennie and his friends already snatched the post office's gas. How much would they have, anyway? One tank? Two? Peanuts.'

'I don't understand why they'd need *any*. It makes no sense.'

'Nothing about any of this makes sense,' Twitch said, and yawned so hugely that Rusty could hear his jaws creak.

'You finished rounds, I take it?' Rusty had a moment to consider the surreal quality of that question. Since Haskell's death, Rusty had become the hospital's head doc, and Twitch – a nurse just three days ago – was now what Rusty had been: a physician's assistant.

'Yep.' Twitch sighed. 'Mr Carty isn't going to live out the day.'

Rusty had thought the same thing about Ed Carty, who was suffering from end-stage stomach cancer, a week ago, and the man was still hanging in. 'Comatose?'

'Roger that, sensei.'

Twitch was able to count their other patients off on the digits of one hand – which, Rusty knew, was extraordinarily lucky. He thought he might even have felt lucky, if he hadn't been so tired and worried.

'George Werner I'd call stable.'

Werner, an Eastchester resident, sixty years old and obese, had suffered a myocardial infarction on Dome Day. Rusty thought he would pull through . . . this time.

'As for Emily Whitehouse . . .' Twitch shrugged. 'It ain't good, sensei.'

Emmy Whitehouse, forty years old and not even an ounce over-weight, had suffered her own MI an hour or so after Rory Dins-more's accident. It had been much worse than George Werner's because she'd been an exercise freak and had suffered what Doc Haskell had called 'a health-club blowout.'

'The Freeman girl is getting better, Jimmy Sirois is holding up, and Nora Coveland is totally cool. Out after lunch. On the whole, not so bad.'

'No,' Rusty said, 'but it'll get worse. I guarantee you. And . . . if you suffered a catastrophic head injury, would you want me to operate on you?'

'Not really,' Twitch said. 'I keep hoping Gregory House will show up.'

Rusty butted his cigarette in the can and looked at the nearly empty supply shed. Maybe he *should* have a peek into the storage facility behind the Town Hall – what could it hurt?

This time he was the one who yawned.

'How long can you keep this up?' Twitch asked. All the banter had gone out of his voice. 'I only ask because right now you're what this town's got.'

'As long as I have to. What worries me is getting so tired I screw something up. And of facing stuff that's way beyond my skill set.' He thought of Rory Dinsmore . . . and Jimmy Sirois. Thinking of Jimmy was worse, because Rory was now beyond the possibility of medical mistakes. Jimmy, on the other hand . . .

Rusty saw himself back in the operating room, listening to the soft bleep of the equipment. Saw himself looking down at Jimmy's pale bare leg, with a black line drawn on it where the cut would have to be made. Thought of Dougie Twitchell trying out his anesthesiologist skills. Felt Ginny Tomlinson slapping a scalpel into his gloved hand and then looking at him over the top of her mask with her cool blue eyes.

God spare me from that, he thought.

Twitch put a hand on Rusty's arm. 'Take it easy,' he said. 'One day at a time.'

'Fuck that, one *hour* at a time,' Rusty said, and got up. 'I have to go over to the Health Center, see what's shaking there. Thank *Christ* this didn't happen in the summer; we would've had three thousand tourists and seven hundred summer-camp kids on our hands.'

'Want me to come?'

Rusty shook his head. 'Check on Ed Carty again, why don't you? See if he's still in the land of the living.'

Rusty took one more look at the supply shed, then plodded around the corner of the building and on a diagonal toward the Health Center on the far side of Catherine Russell Drive.

10

Ginny was at the hospital, of course; she would give Mrs Coveland's new bundle of joy a final weigh-in before sending them home. The receptionist on duty at the Health Center was seventeen-year-old Gina Buffalino, who had exactly six weeks' worth of medical experience. As a candy striper. She gave Rusty a deer-in-the-headlights look when he came in that made his heart sink, but the waiting room

was empty, and that was a good thing. A *very* good thing.

'Any call-ins?' Rusty asked.

'One. Mrs Venziano, out on the Black Ridge Road. Her baby got his head caught between the bars of his playpen. She wanted an ambulance. I . . . I told her to grease the kid's head up with olive oil and see if she could get him out that way. It worked.'

Rusty grinned. Maybe there was hope for this kid yet. Gina, looking divinely relieved, grinned back.

'Place is empty, at least,' Rusty said. 'Which is great.'

'Not quite. Ms Grinnell is here – Andrea? I put her in three.' Gina hesitated. 'She seemed pretty upset.'

Rusty's heart, which had begun to rise, sank back down again. Andrea Grinnell. And upset. Which meant she wanted a bump on her OxyContin prescription. Which he, in all good conscience, could not give, even supposing Andy Sanders had enough stock to fill it.

'Okay.' He started down the hall to exam room three, then stopped and looked back. 'You didn't page me.'

Gina flushed. 'She asked me specifically not to.'

This puzzled Rusty, but only for a second. Andrea might have a pill problem, but she was no dummy. She'd known that if Rusty was over at the hospital, he was probably with Twitch. And Dougie Twitchell happened to be her baby brother, who even at the age of thirty-nine must be protected from the evil facts of life.

Rusty stood at the door with the black **3** decaled on it, trying to gather himself. This was going to be hard. Andrea wasn't one of the defiant boozers he saw who claimed that alcohol formed absolutely no part of their problems; nor was she one of the meth-heads who had been showing up with increasing frequency over the last year or so. Andrea's responsibility for her problem was more difficult to pinpoint, and that complicated the treatment. Certainly she'd been in agony after her fall. Oxy had been the best thing for her, allowing her to cope with the pain so she could sleep and begin therapy. It wasn't her fault that the drug which allowed her to do those things was the one doctors sometimes called hillbilly heroin.

He opened the door and went in, rehearsing his refusal. *Kind but firm*, he told himself. *Kind but firm.*

She was sitting in the corner chair under the cholesterol poster, knees together, head bowed over the purse in her lap. She was a big woman who now looked small. Diminished, somehow. When she raised her head to look at him and he saw how haggard her face was – the lines bracketing her mouth deep, the skin under her eyes almost black – he changed his mind and decided to write the scrip on one

of Dr Haskell's pink pads after all. Maybe after the Dome crisis was over, he'd try to get her into a detox program; threaten to tattle to her brother, if that was what it took. Now, however, he would give her what she needed. Because he had rarely seen need so stark.

'Eric . . . Rusty . . . I'm in trouble.'

'I know. I can see it. I'll write you a—'

'No!' She was looking at him with something like horror. 'Not even if I beg! I'm a drug addict and I have to get off! I'm just a darn old *junkie!*' Her face folded in on itself. She tried to will it straight again and couldn't. She put her hands over it instead. Big wrenching sobs that were hard to listen to came through her fingers.

Rusty went to her, going down on one knee and putting an arm around her. 'Andrea, it's good that you want to stop – excellent – but this might not be the best time—'

She looked at him with streaming, reddened eyes. 'You're right about that, it's the *worst* time, but it has to be now! And you mustn't tell Dougie or Rose. Can you help me? Can it even be done? Because I haven't been able to, not on my own. Those hateful pink pills! I put them in the medicine cabinet and say "No more today," and an hour later I'm taking them down again! I've never been in a mess like this, not in my whole life.'

She dropped her voice as if confiding a great secret.

'I don't think it's my back anymore, I think it's my *brain* telling my back to hurt so I can go on taking those damn pills.'

'Why now, Andrea?'

She only shook her head. 'Can you help me or not?'

'Yes, but if you're thinking about going cold turkey, don't. For one thing, you're apt to . . .' For a brief moment he saw Jannie, shaking in her bed, muttering about the Great Pumpkin. 'You're apt to have seizures.'

She either didn't register that or set it aside. 'How long?'

'To get past the physical part? Two weeks. Maybe three.' *And that's putting you on the fast track*, he thought but didn't say.

She gripped his arm. Her hand was very cold. 'Too slow.'

An exceedingly unpleasant idea surfaced in Rusty's mind. Probably just transient paranoia brought on by stress, but persuasive. 'Andrea, is someone blackmailing you?'

'Are you kidding? Everyone knows I take those pills, it's a small town.' Which did not, in Rusty's opinion, actually answer the question. 'What's the absolute shortest it can take?'

'With B_{12} shots – plus thiamine and vitamins – you might manage it in ten days. But you'd be miserable. You wouldn't be able

to sleep much, and you'll have restless leg syndrome. Not mild, either, they don't call it kicking the habit for nothing. And you'd have to have someone administer the step-down dosage – someone who can hold the pills and won't give them to you when you ask. Because you will.'

'Ten days?' She looked hopeful. 'And this might be over by then anyway, yes? This Dome thing?'

'Maybe this afternoon. That's what we all hope.'

'Ten days,' she said.

'Ten days.'

And, he thought, *you'll want those goddam things for the rest of your life*. But this he didn't say aloud either.

11

Sweetbriar Rose had been extraordinarily busy for a Monday morning . . . but of course there had never been a Monday morning like this in the town's history. Still, the patrons had left willingly enough when Rose announced the grill was closed, and wouldn't reopen until five that afternoon. 'And by then, maybe you can all go over to Moxie's in Castle Rock and eat there!' she finished. That had brought spontaneous applause, even though Moxie's was a famously filthy greasepit.

'No lunch?' Ernie Calvert asked.

Rose looked at Barbie, who raised his hands to his shoulders. Don't ask me.

'Sandwiches,' Rose said. 'Until they're gone.'

This had brought more applause. People seemed surprisingly upbeat this morning; there had been laughter and raillery. Perhaps the best sign of the town's improved mental health was at the rear of the restaurant, where the bullshit table was back in session.

The TV over the counter – now locked on CNN – was a big part of the reason. The talking heads had little more to broadcast than rumors, but most were hopeful. Several scientists who'd been interviewed said the Cruise had a good chance of smashing through and ending the crisis. One estimated the chances of success as 'better than eighty percent.' *But of course he's at MIT in Cambridge*, Barbie thought. *He can afford optimism.*

Now, as he scraped the grill, a knock came at the door. Barbie looked around and saw Julia Shumway, with three children clustered around her. They made her look like a junior high school teacher on a field trip. Barbie went to the door, wiping his hands on his apron.

'If we let everyone in who wants to eat, we'll be out of food in no time,' Anson said irritably from where he was swabbing down tables. Rose had gone back to Food City to try and purchase more meat.

'I don't think she wants to eat,' Barbie said, and he was right about that.

'Good morning, Colonel Barbara,' Julia said with her little Mona Lisa smile. 'I keep wanting to call you Major Barbara. Like the—'

'The play, I know.' Barbie had heard this one a few times before. Like ten thousand. 'Is this your posse?'

One of the children was an extremely tall, extremely skinny boy with a mop of dark brown hair; one was a stocky young fellow wearing baggy shorts and a faded 50 Cent tee-shirt; the third was a pretty little girl with a lightning bolt on her cheek. A decal rather than a tattoo, but it still gave her a certain savoir faire. He realized if he told her she looked like the middle-school version of Joan Jett, she wouldn't know who he was talking about.

'Norrie Calvert,' Julia said, touching the riot grrl's shoulder. 'Benny Drake. And this tall drink of water is Joseph McClatchey. Yesterday's protest demonstration was his idea.'

'But I never meant anyone to get hurt,' Joe said.

'And it wasn't your fault they did,' Barbie told him. 'So rest easy on that.'

'Are you really the bull goose?' Benny asked, looking him over.

Barbie laughed. 'No,' he said. 'I'm not even going to *try* and be the bull goose unless I absolutely have to.'

'But you know the soldiers out there, right?' Norrie asked.

'Well, not personally. For one thing, they're Marines. I was Army.'

'You're still Army, according to Colonel Cox,' Julia said. She was wearing her cool little smile, but her eyes were dancing with excitement. 'Can we talk to you? Young Mr McClatchey has had an idea, and I think it's brilliant. If it works.'

'It'll work,' Joe said. 'When it comes to computer shi— stuff, *I'm* the bull goose.'

'Step into my office,' Barbie said, and escorted them toward the counter.

12

It was brilliant, all right, but it was already going on ten thirty, and if they were really going to make this thing happen, they would have to move fast. He turned to Julia. 'Do you have your cell ph—'

Julia slapped it smartly into his palm before he could finish. 'Cox's number is in memory.'

'Great. Now if I knew how to access the memory.'

Joe took the phone. 'What are you, from the Dark Ages?'

'Yes!' Barbie said. 'When knights were bold and ladies fair went without their underwear.'

Norrie laughed hard at that, and when she raised her fist, Barbie tapped her small fist with his big one.

Joe pushed a couple of buttons on the minuscule keypad. He listened, then handed the cell to Barbie.

Cox must still have been sitting with one hand on the phone, because he was already on when Barbie put Julia's cell to his ear.

'How's it going, Colonel?' Cox asked.

'We're basically okay.'

'And that's a start.'

Easy for you to say, Barbie thought. 'I imagine things will remain basically okay until the missile either bounces off or punches through and does gross damage to the woods and farms on our side. Which the citizens of Chester's Mill would welcome. What are your guys saying?'

'Not much. No one is making any predictions.'

'That's not what we're hearing on the TV.'

'I don't have time to keep up with the talking heads.' Barbie could hear the shrug in Cox's voice. 'We're hopeful. We think we've got a shot. To coin a phrase.'

Julia was opening and closing her hands in a *What gives?* gesture.

'Colonel Cox, I'm sitting here with four friends. One of them is a young man named Joe McClatchey, who's had a pretty cool idea. I'm going to put him on the phone with you right now—'

Joe was shaking his head hard enough to make his hair fly. Barbie paid no attention.

'—to explain it.'

And he handed Joe the cell. 'Talk,' he said.

'But—'

'Don't argue with the bull goose, son. Talk.'

Joe did so, diffidently at first, with a lot of *ahs* and *erms* and *y'knows*, but as his idea took hold of him again he sped up, became articulate. Then he listened. After a little while he started to grin. A few moments later he said, 'Yessir! Thank you, sir!' and handed the phone back to Barbie. 'Check it out, they're gonna try to augment our Wi-Fi before they shoot the missile! Jesus, this is *hot*!' Julia grabbed his arm and Joe said, 'I'm sorry, Miz Shumway, I mean *jeepers*.'

'Never mind that, can you really work this thing?'

'You kidding? No prob.'

'Colonel Cox?' Barbie asked. 'Is this true about the Wi-Fi?'

'We can't stop anything you folks want to try to do,' Cox said. 'I think you were the one who originally pointed that out to me. So we might as well help. You'll have the fastest Internet in the world, at least for today. That's some bright kid you got there, by the way.'

'Yes, sir, that was my impression,' Barbie said, and gave Joe a thumbs-up. The kid was glowing.

Cox said, 'If the boy's idea works and you record it, make sure we get a copy. We'll be making our own, of course, but the scientists in charge of this thing will want to see what the hit looks like from your side of the Dome.'

'I think we can do better than that,' Bárbie said. 'If Joe here can put this together, I think most of the town will be able to watch it live.'

This time Julia raised her fist. Grinning, Barbie bumped it.

13

'Holee shit,' Joe said. The awe on his face made him look eight instead of thirteen. The whipcrack confidence was gone from his voice. He and Barbie were standing about thirty yards from where Little Bitch Road ran up against the Dome. It wasn't the soldiers he was looking at, although they had turned around to observe; it was the warning band and the big red **X** sprayed on the Dome that had fascinated him.

'They're moving their bivouac point, or whatever you call it,' Julia said. 'The tents are gone.'

'Sure. In about' – Barbie looked at his watch – 'ninety minutes, it's going to get very hot over there. Son, you better get to it.' But now that they were actually out here on the deserted road, Barbie began to wonder if Joe could do what he had promised.

'Yeah, but . . . do you see the *trees*?'

Barbie didn't understand at first. He looked at Julia, who shrugged. Then Joe pointed, and he saw. The trees on the Tarker's side of the Dome were dancing in a moderate fall wind, shedding leaves in colorful bursts that fluttered down around the watching Marine sentries. On The Mill side, the branches were barely moving and most of the trees were still fully dressed. Barbie was pretty sure air was coming through the barrier, but not with any force. The Dome was damping the wind. He thought of how he and Paul Gendron, the

guy in the Sea Dogs cap, had come to the little stream and had seen
the water piling up.

Julia said, 'The leaves over here look . . . I don't know . . .
listless, somehow. Limp.'

'It's just because they've got a wind on their side and we've only
got a puff of breeze,' Barbie said, then wondered if that was really it.
Or *all* of it. But what good did it do to speculate about the current
air quality in Chester's Mill, when there was nothing they could do
about it? 'Go on, Joe. Do your thing.'

They had swung by the McClatchey house in Julia's Prius to
get Joe's PowerBook. (Mrs McClatchey had made Barbie swear he
would keep her son safe, and Barbie had so sworn.) Now Joe pointed
at the road. 'Here?'

Barbie raised his hands to the sides of his face and sighted at
the red **X**. 'Little to the left. Can you try it? See how it looks?'

'Yeah.' Joe opened the PowerBook and turned it on. The Mac
power-up chime sounded as pretty as ever, but Barbie thought he
had never seen anything quite so surreal as the silver computer sitting
on the patched asphalt of Little Bitch Road with its screen up. It
seemed to summarize the last three days perfectly.

'Battery's fresh, so it should run for at least six hours,' Joe said.

'Won't it go to sleep?' Julia asked.

Joe gave her an indulgent *Mother, please* look. Then he turned
back to Barbie. 'If the missile roasts my Pro, do you promise to buy
me another one?'

'Uncle Sam will buy you another one,' Barbie promised. 'I'll put
in the requisition myself.'

'Sweet.'

Joe bent over the PowerBook. There was a little silver barrel
mounted atop the screen. This, Joe had told them, was some current
compu-miracle called iSight. He ran his finger over the computer's
touchpad, hit ENTER, and suddenly the screen filled with a bril-
liant image of Little Bitch Road. From ground level, each little bump
and irregularity in the tar looked like a mountain. At mid-range,
Barbie could see the Marine sentries up to their knees.

'Sir, does he have a picture, sir?' one of them asked.

Barbie looked up. 'Let's put it this way, Marine — if I was
doing inspection, you'd be doing push-ups with my foot in your
ass. There's a scuff on your left boot. Unacceptable on a noncombat
assignment.'

The Marine looked down at his boot, which was indeed scuffed.
Julia laughed. Joe did not. He was absorbed. 'It's too low. Miz Shumway,

have you got something in the car we can use to—?' He raised his hand about three feet off the road.

'I do,' she said.

'And get me my little gym bag, please.' He fiddled some more with the PowerBook, then held out his hand. 'Cell?'

Barbie handed it to him. Joe hit the tiny buttons with blinding speed. Then: 'Benny? Oh, Norrie, okay. You guys there? . . . Good. Never been in a beerjoint before, I bet. You ready? . . . *Excellent*. Stand by.' He listened, then grinned. 'Are you kidding? Dude, according to what I'm getting, the jack is *awesome*. They're *blasting* the Wi-Fi. Gotta jet.' He snapped the phone closed and handed it back to Barbie.

Julia came back with Joe's gym bag and a carton containing undistributed sheets of the *Democrat*'s Sunday extra edition. Joe set the PowerBook on the carton (the sudden rise in the image from ground level made Barbie a bit dizzy), then checked it and pronounced it totally rad. He rummaged in the gym bag, brought out a black box with an antenna, and plugged it into the computer. The soldiers were clustered on their side of the Dome, watching with interest. *Now I know how a fish feels in an aquarium*, Barbie thought.

'Looks okay,' Joe murmured. 'I got a green bulb.'

'Shouldn't you call your—'

'If it's working, they'll call me,' Joe said. Then: 'Uh-oh, this could be trouble.'

Barbie thought he was referring to the computer, but the boy wasn't even looking at it. Barbie followed his gaze and saw the green Chief of Police car. It wasn't moving fast, but the bubblegums were pulsing. Pete Randolph got out from behind the wheel. Emerging from the passenger side (the cruiser rocked a little when his weight left the springs) came Big Jim Rennie.

'Just what in the heck do you think you're doing?' he asked.

The phone in Barbie's hand buzzed. He handed it to Joe without taking his eyes from the approaching Selectman and Chief of Police.

14

The sign over the door of Dipper's said WELCOME TO THE BIGGEST DANCE FLOOR IN MAINE!, and for the first time in the roadhouse's history, that floor was crowded at eleven forty-five in the morning. Tommy and Willow Anderson greeted people at the door as they arrived, a little like ministers welcoming parishioners to church. In this case, the First Church of Rock Bands Direct from Boston.

At first the audience was quiet, because there was nothing on the big screen but one blue word: WAITING. Benny and Norrie had plugged in their equipment and switched the TV's feed to Input 4. Then, suddenly, Little Bitch Road appeared in living color, complete with brightly colored leaves swirling down around the Marine sentries.

The crowd broke into applause and cheers.

Benny gave Norrie a high five, but that wasn't enough for Norrie; she kissed him on the mouth, and hard. It was the happiest moment of Benny's life, even better than staying vertical while doing a full-pipe roughie.

'Call him!' Norrie demanded.

'Right on,' Bennie said. His face felt as if it might actually catch fire and burn, but he was grinning. He punched REDIAL and held the phone to his ear. 'Dude, we got it! The picture's so radical it—'

Joe cut him off. 'Houston, we have a problem.'

15

'I don't know what you folks think you're doing,' Chief Randolph said, 'but I want an explanation, and that thing's shut down until I get one.' He pointed at the PowerBook.

'Pardon me, sir,' one of the Marines said. He was wearing a second lieutenant's stripes. 'That's Colonel Barbara, and he has official government sanction for this operation.'

To this, Big Jim offered his most sarcastic smile. A vein in his neck was throbbing. 'This man is a colonel of nothing but trouble-makers. He cooks in the local restaurant.'

'Sir, my orders—'

Big Jim shook his finger at the second lieutenant. 'In Chester's Mill, the only official government we're recognizing right now is our own, soldier, and I am its representative.' He turned to Randolph. 'Chief, if that kid won't turn it off, pull the plug.'

'It has no plug that I can see,' Randolph said. He was looking from Barbie to the Marine second lieutenant to Big Jim. He had begun to sweat.

'Then put a boot through the darn screen! Just kill it!'

Randolph stepped forward. Joe, looking scared but determined, stepped in front of the PowerBook on the carton. He still had the cell phone in his hand. 'You better not! It's mine, and I'm not breaking any laws!'

'Get back, Chief,' Barbie said. 'That's an order. If you still recognize the government of the country you live in, you'll obey it.'

Randolph looked around. 'Jim, maybe—'

'Maybe nothing,' Big Jim said. 'Right now *this* is the country you live in. *Kill that cotton-picking computer.*'

Julia stepped forward, grabbed the PowerBook, and turned it so that the iVision camera was taking in the new arrivals. Tendrils of hair had escaped her businesslike bun and hung against her pink cheeks. Barbie thought she looked extraordinarily beautiful.

'Ask Norrie if they see!' she told Joe.

Big Jim's smile froze into a grimace. 'Woman, put that down!'

'Ask them if they see!'

Joe spoke into the phone. Listened. Then said: 'They do. They're seeing Mr Rennie and Officer Randolph. Norrie says they want to know what's happening.'

There was dismay on Randolph's face; fury on Rennie's. '*Who* wants to know?' Randolph asked.

Julia said, 'We've set up a live feed to Dipper's—'

'*That* sinpit!' Big Jim said. His hands were clenched. Barbie estimated the man was probably a hundred pounds overweight, and he grimaced when he moved his right arm – as if he'd strained it – but he looked like he could still hit. And right now he looked mad enough to take a swing . . . although whether at him, Julia, or the boy, he didn't know. Maybe Rennie didn't, either.

'People have been gathering there since quarter of eleven,' she said. 'News travels fast.' She smiled with her head cocked to one side. 'Would you like to wave to your constituency, Big Jim?'

'It's a bluff,' Big Jim said.

'Why would I bluff about something so easy to check?' She turned to Randolph. 'Call one of your cops and ask them where the big gathering in town is this morning.' Then back to Jim again. 'If you shut this down, hundreds of people will know you closed off their view of an event that vitally concerns them. One their lives may depend on, in fact.'

'You had no sanction!'

Barbie, ordinarily quite good at controlling himself, felt his temper fraying. It wasn't that the man was stupid; he clearly wasn't. And that was exactly what was making Barbie mad.

'What is your problem, exactly? Do you see any danger here? Because I don't. The idea is to set this thing up, leave it broadcasting, then clear out.'

'If the missile doesn't work, it could cause a panic. Knowing something failed is one thing; actually *seeing* it fail is another. They're apt to do any darn old thing.'

'You have a very low opinion of the people you govern, Selectman.'

Big Jim opened his mouth to retort – something like *And they have justified it time and again* would have been Barbie's guess – but then remembered that a good portion of the town was watching this confrontation on the big-screen TV. Possibly in HD. 'I'd like you to wipe that sarcastic smile off your face, Barbara.'

'Are we now policing expressions, too?' Julia asked.

Scarecrow Joe covered his mouth, but not before Randolph and Big Jim saw the kid's grin. And heard the snicker that escaped from between his fingers.

'People,' the second lieutenant said, 'you had better clear the scene. Time is passing.'

'Julia, turn that camera on me,' Barbie said.

She did so.

16

Dipper's had never been so packed, not even at the memorable New Year's Eve show in 2009 featuring the Vatican Sex Kittens. And it had never been so silent. Over five hundred people stood shoulder to shoulder and hip to hip, watching as the camera on Joe's PowerBook Pro did a dizzying one-eighty and came to rest on Dale Barbara.

'There's my boy,' Rose Twitchell murmured, and smiled.

'Hello there, folks,' Barbie said, and the picture was so good that several people *hello*'d back. 'I'm Dale Barbara, and I've been recommissioned as a colonel in the United States Army.'

A general ripple of surprise greeted this.

'The video deal out here on Little Bitch Road is entirely my responsibility, and as you may have gathered, there has been a difference of opinion between myself and Selectman Rennie about whether or not to continue the feed.'

This time the ripple was louder. And not happy.

'We have no time to argue the fine points of command this morning,' Barbie continued. 'We're going to train the camera on the point where the missile is supposed to hit. Whether or not the broadcast continues is in the hands of your Second Selectman. If he kills the feed, take it up with him. Thanks for your attention.'

He walked out of the picture. For a moment the gathering on the dance floor had a view of nothing but woods, then the image rotated again, sank, and settled on the floating **X**. Beyond it, the sentries were packing the last of their gear into two big trucks.

Will Freeman, owner and operator of the local Toyota dealership (and no friend of James Rennie), spoke directly to the TV. 'Leave it alone, Jimmy, or there's gonna be a new Selectman in The Mill by the end of the week.'

There was a general rumble of agreement. The townspeople stood quietly, watching and waiting to see if the current program – both dull and unbearably exciting – would continue, or if the transmission would end.

17

'What do you want me to do, Big Jim?' Randolph asked. He took a handkerchief from his hip pocket and mopped the back of his neck.

'What do *you* want to do?' Big Jim responded.

For the first time since he'd taken the keys to the green Chief's car, Pete Randolph thought he would be quite willing to turn them over to someone else. He sighed and said, 'I want to let this alone.'

Big Jim nodded as if to say *Be it on your own head.* Then he smiled – if, that is, a pulling-back of the lips can be so characterized. 'Well, you're the Chief.' He turned back to Barbie, Julia, and Scarecrow Joe. 'We've been outmaneuvered. Haven't we, Mr Barbara?'

'I assure you that there's no maneuvering going on here, sir,' Barbie said.

'Bull . . . *pucky.* This is a bid for power, pure and simple. I've seen plenty in my time. I've seen them succeed . . . and I've seen them fail.' He stepped closer to Barbie, still favoring his sore right arm. Up close, Barbie could smell cologne and sweat. Rennie was breathing harshly. He lowered his voice. Perhaps Julia didn't hear what came next. But Barbie did.

'You're all in the pot, sonny. Every cent. If the missile punches through, you win. If it just bounces off . . . *beware me.*' For a moment his eyes – almost buried in their deep folds of flesh, but glinting with cold, clear intelligence – caught Barbie's and held them. Then he turned away. 'Come on, Chief Randolph. This situation is complicated enough, thanks to Mr Barbara and his friends. Let's go back to town. We'll want to get your troops in place in case of a riot.'

'That is the most ridiculous thing I've ever heard!' Julia said.

Big Jim flapped a hand at her without turning around.

'Do you want to go to Dipper's, Jim?' Randolph asked. 'We've got time.'

'I wouldn't set foot in that whore-hole,' Big Jim said. He opened the passenger door of the cruiser. 'What I want is a nap. But I won't

get one, because there's a lot to do. I've got big responsibilities. I didn't ask for them, but I have them.'

'Some men are great, and some men have greatness thrust upon them, isn't that so, Jim?' Julia asked. She was smiling her cool smile.

Big Jim turned to her, and the expression of naked hate on his face made her fall back a step. Then Rennie dismissed her. 'Come on, Chief.'

The cruiser headed back toward The Mill, its lights still flashing in the hazy, oddly summery light.

'Whew,' Joe said. 'Scary dude.'

'My sentiments exactly,' Barbie said.

Julia was surveying Barbie, all traces of her smile gone. 'You had an enemy,' she said. 'Now you have a blood-foe.'

'I think you do, too.'

She nodded. 'For both our sakes, I hope this missile thing works.'

The second lieutenant said, 'Colonel Barbara, we're leaving. I'd feel much more comfortable if I saw you three doing the same.'

Barbie nodded and for the first time in years snapped off a salute.

18

A B-52 which had taken off from Carswell Air Force Base in the early hours of that Monday morning had been on-station above Burlington, Vermont, since 1040 hours (the Air Force believes in showing up early for the prom whenever possible). The mission was code-named GRAND ISLE. The pilot-commander was Major Gene Ray, who had served in both the Gulf and Iraq wars (in private conversations he referred to the latter as 'Big Dubya's fuck-a-monkey show'). He had two Fasthawk Cruise missiles in his bomb bay. It was a good stick, the Fasthawk, more reliable and powerful than the old Tomahawk, but it felt very weird to be planning to shoot a live one at an American target.

At 1253, a red light on his control panel turned amber. The COMCOM took control of the plane from Major Ray and began to turn it into position. Below him, Burlington disappeared under the wings.

Ray spoke into his headset. 'It's just about show-time, sir.'

In Washington, Colonel Cox said: 'Roger that, Major. Good luck. Blast the bastard.'

'It'll happen,' Ray said.

At 1254, the amber light began to pulse. At 1254:55, it turned

green. Ray flicked the switch marked 1. There was no sensation and only a faint *whoosh* from below, but he saw the Fasthawk begin its flight on vid. It quickly accelerated to its maximum speed, leaving a jet contrail like a fingernail scratch across the sky.

Gene Ray crossed himself, finishing with a kiss at the base of his thumb. 'Go with God, my son,' he said.

The Fasthawk's maximum speed was thirty-five hundred miles an hour. Fifty miles from its target – about thirty miles west of Conway, New Hampshire, and now on the east side of the White Mountains – its computer first calculated and then authorized final approach. The missile's speed dropped from thirty-five hundred miles an hour to eighteen hundred and fifty as it descended. It locked on Route 302, which is North Conway's Main Street. Pedestrians looked up uneasily as the Fasthawk passed overhead.

'Isn't that jet way too low?' a woman in the parking lot of Settlers Green Outlet Village asked her shopping companion, shading her eyes. If the Fasthawk's guidance system could have talked, it might have said, 'You ain't seen nothin yet, sweetheart.'

It passed over the Maine–New Hampshire border at three thousand feet, trailing a sonic boom that rattled teeth and broke windows. When the guidance system picked up Route 119, it slipped first to a thousand feet, then down to five hundred. By now the computer was in high gear, sampling the guidance system's data and making a thousand course corrections a minute.

In Washington, Colonel James O. Cox said, 'Final approach, people. Hang onto your false teeth.'

The Fasthawk found Little Bitch Road and dropped almost to ground-level, still blasting at near-Mach 2 speed, reading every hill and turn, its tail burning too brightly to look at, leaving a toxic stench of propellant in its wake. It tore leaves from the trees, even ignited some. It imploded a roadside stand in Tarker's Hollow, sending boards and smashed pumpkins flying into the sky. The boom followed, causing people to fall to the floor with their hands over their heads.

This is going to work, Cox thought. *How can it not?*

19

In Dipper's, there were now eight hundred people crammed together. No one spoke, although Lissa Jamieson's lips moved soundlessly as she prayed to whatever New Age oversoul happened to be currently claiming her attention. She clutched a crystal in one hand; the Reverend Piper Libby was holding her mother's cross against her lips.

Ernie Calvert said, 'Here it comes.'

'Where?' Marty Arsenault demanded. 'I don't see noth—'

'*Listen!*' Brenda Perkins said.

They heard it come: a growing otherworldly hum from the western edge of town, a *mmmm* that rose to **MMMMMM** in a space of seconds. On the big-screen TV they saw almost nothing, until half an hour later, long after the missile had failed. For those still remaining in the roadhouse, Benny Drake was able to slow the recording down until it was advancing frame by frame. They saw the missile come slewing around what was known as Little Bitch Bend. It was no more than four feet off the ground, almost kissing its own blurred shadow. In the next frame the Fasthawk, tipped with a blast-fragmentation warhead designed to explode on contact, was frozen in midair about where the Marines' bivouac had been.

In the next frames, the screen filled with a white so bright it made the watchers shade their eyes. Then, as the white began to fade, they saw the missile fragments – so many black dashes against the diminishing blast – and a huge scorch mark where the red **X** had been. The missile had hit its spot exactly.

After that, the people in Dipper's watched the woods on the Tarker's side of the Dome burst into flame. They watched the asphalt on that side first buckle and then begin to melt.

20

'Fire the other one,' Cox said dully, and Gene Ray did. It broke more windows and scared more people in eastern New Hampshire and western Maine.

Otherwise, the result was the same.

IN THE FRAME

1

At 19 Mill Street, home of the McClatchey family, there was a moment of silence when the recording ended. Then Norrie Calvert burst into fresh tears. Benny Drake and Joe McClatchey, after looking at each other over her bowed head with identical *What do I do now* expressions, put their arms around her quaking shoulders and gripped each other's wrists in a kind of soul shake.

'That's *it*?' Claire McClatchey asked unbelievingly. Joe's mother wasn't crying, but she was close; her eyes glistened. She was holding her husband's picture in her hands, had taken it off the wall shortly after Joe and his friends had come in with the DVD. 'That's *all*?'

No one answered. Barbie was perched on the arm of the easy chair where Julia was sitting. *I could be in big trouble here*, he thought. But it wasn't his *first* thought; that had been that the town was in big trouble.

Mrs McClatchey got to her feet. She still held her husband's picture. Sam had gone to the flea market that ran at Oxford Speedway each Saturday until the weather got too cold. His hobby was refinishing furniture, and he often found good stuff at the stalls there. Three days later he was still in Oxford, sharing space at the Raceway Motel with several platoons of reporters and TV people; he and Claire couldn't speak to each other on the phone, but had been able to stay in touch by e-mail. So far.

'What happened to your computer, Joey?' she asked. 'Did it blow up?'

Joe, his arm still around Norrie's shoulders, his hand still gripping Benny's wrist, shook his head. 'I don't think so,' he said. 'It probably just melted.' He turned to Barbie. 'The heat might set the woods on fire out there. Someone ought to do something about that.'

'I don't think there are any fire engines in town,' Benny said. 'Well, maybe one or two old ones.'

'Let me see what I can do about that,' Julia said. Claire McClatchey towered over her; it was easy enough to see where Joe had gotten his height. 'Barbie, it would probably be best if I handled this on my own.'

'Why?' Claire looked bewildered. One of her tears finally overspilled and ran down her cheek. 'Joe said the government put you in charge, Mr Barbara — the President himself!'

'I had a disagreement with Mr Rennie and Chief Randolph about the video feed,' Barbie said. 'It got a little hot. I doubt if either of them would welcome my advice just now. Julia, I don't think they'd exactly welcome yours, either. At least not yet. If Randolph's halfway competent, he'll send a bunch of deputies out there with whatever's left in the firebarn. At the very least, there'll be hoses and Indian pumps.'

Julia considered this, then said: 'Would you step outside with me for a minute, Barbie?'

He looked at Joe's mother, but Claire was no longer paying them any attention. She had moved her son aside and was sitting next to Norrie, who pressed her face against Claire's shoulder.

'Dude, the government owes me a computer,' Joe said as Barbie and Julia walked toward the front door.

'Noted,' Barbie said. 'And thank you, Joe. You did well.'

'A lot better than their damn missile,' Benny muttered.

On the front stoop of the McClatchey home, Barbie and Julia stood silent, looking toward the town common, Prestile Stream, and the Peace Bridge. Then, in a voice that was low-pitched and angry, Julia said: 'He's not. That's the thing. That's the goddam thing.'

'Who's not what?'

'Peter Randolph is not halfway competent. Not even one-quarter. I went to school with him all the way from kindergarten, where he was a world-champion pants-wetter, to twelfth grade, where he was part of the Bra-Snapping Brigade. He was a C-minus intellect who got B-minus grades because his father was on the school board, and his brainpower has not increased. Our Mr Rennie has surrounded himself with dullards. Andrea Grinnell is an exception, but she's also a drug addict. OxyContin.'

'Back problems,' Barbie said. 'Rose told me.'

Enough of the trees on the common had shed their leaves for Barbie and Julia to be able to see Main Street. It was deserted now – most people would still be at Dipper's, discussing what they had seen – but its sidewalks would soon fill with stunned, disbelieving townsfolk drifting back to their homes. Men and women who would not yet even dare ask each other what came next.

Julia sighed and ran her hands through her hair. 'Jim Rennie thinks if he just keeps all the control in his own hands, things will eventually come rightside up. For him and his friends, at least. He's the worst kind of politician – selfish, too egocentric to realize he's way out of his league, and a coward underneath that bluff can-do

exterior of his. When things get bad enough, he'll send this town to the devil if he thinks he can save himself by doing so. A cowardly leader is the most dangerous of men. You're the one who should be running this show.'

'I appreciate your confidence—'

'But that's not going to happen no matter what your Colonel Cox and the President of the United States may want. It's not going to happen even if fifty thousand people march down Fifth Avenue in New York, waving signs with your face on them. Not with that fucking Dome still over our heads.'

'Every time I listen to you, you sound less Republican,' Barbie remarked.

She struck him on the bicep with a surprisingly hard fist. 'This is not a joke.'

'No,' Barbie said. 'It's not a joke. It's time to call for elections. And I urge you to stand for Second Selectman yourself.'

She looked at him pityingly. 'Do you think Jim Rennie is going to allow elections as long as the Dome is in place? What world are you living in, my friend?'

'Don't underestimate the will of the town, Julia.'

'And don't *you* underestimate James Rennie. He's been in charge here for donkey's years and people have come to accept him. Also, he's very talented when it comes to finding scapegoats. An out-of-towner – a drifter, in fact – would be perfect in the current situation. Do we know anybody like that?'

'I was expecting an idea from you, not a political analysis.'

For a moment he thought she was going to hit him again. Then she drew in a breath, let it out, and smiled. 'You come on all aw-shucks, but you've got some thorns, don't you?'

The Town Hall whistle began to blow a series of short blasts into the warm, still air.

'Someone's called in a fire,' Julia said. 'I think we know where.'

They looked west, where rising smoke smudged the blue. Barbie thought most of it had to be coming from the Tarker's Mills side of the Dome, but the heat would almost certainly have ignited small fires on the Chester side as well.

'You want an idea? Okay, here's one. I'll track down Brenda – she'll either be at home or at Dipper's with everyone else – and suggest she take charge of the fire-fighting operation.'

'And if she says no?'

'I'm pretty sure she won't. At least there's no wind to speak of – not on this side of the Dome – so it's probably just grass and brush.

She'll tap some guys to pitch in, and she'll know the right ones. They'll be the ones Howie would've picked.'

'None of them the new officers, I take it.'

'I'll leave that up to her, but I doubt if she'll be calling on Carter Thibodeau or Melvin Searles. Freddy Denton, either. He's been on the cops for five years, but I know from Brenda that Duke was planning to let him go. Freddy plays Santa every year at the elementary school, and the kids love him – he's got a great ho-ho-ho. He's also got a mean streak.'

'You'll be going around Rennie again.'

'Yes.'

'Payback could be a bitch.'

'I can be a bitch myself, when I have to be. Brenda too, if she gets her back up.'

'Go for it. And make sure she asks that guy Burpee. When it comes to putting out a brushfire, I'd trust him rather than any town firebarn leftovers. He's got everything in that store of his.'

She nodded. 'That's a damned good idea.'

'Sure you don't want me to tag along?'

'You've got other fish to fry. Did Bren give you Duke's key to the fallout shelter?'

'She did.'

'Then the fire may be just the distraction you need. Get that Geiger counter.' She started for her Prius, then stopped and turned back. 'Finding the generator – assuming there is one – is probably the best chance this town has got. Maybe the only one. And Barbie?'

'Right here, ma'am,' he said, smiling a little.

She didn't. 'Until you've heard Big Jim Rennie's stump speech, don't sell him short. There are reasons he's lasted as long as he has.'

'Good at waving the bloody shirt, I take it.'

'Yes. And this time the shirt is apt to be yours.'

She drove off to find Brenda and Romeo Burpee.

2

Those who had watched the Air Force's failed attempt to punch through the Dome left Dipper's pretty much as Barbie had imagined: slowly, with their heads down, not talking much. Many were walking with their arms about one another, some were crying. Three town police cars were parked across the road from Dipper's, and half a dozen cops stood leaning against them, ready for trouble. But there was no trouble.

The green Chief of Police car was parked farther up, in the front lot of Brownie's Store (where a hand-lettered sign in the window read CLOSED UNTIL 'FREEDOM!' ALLOWS FRESH SUPPLIES). Chief Randolph and Jim Rennie sat inside the car, watching.

'There,' Big Jim said with unmistakable satisfaction. 'I hope they're happy.'

Randolph looked at him curiously. 'Didn't you *want* it to work?'

Big Jim grimaced as his sore shoulder twinged. 'Of course, but I never thought it would. And that fellow with the girl's name and his new friend Julia managed to get everyone all worked up and hopeful, didn't they? Oh yes, you bet. Do you know she's never endorsed me for office in that rag of hers? Not one single time.'

He pointed at the pedestrians streaming back toward town.

'Take a good look, pal – this is what incompetency, false hope, and too much information gets you. They're just unhappy and disappointed now, but when they get over that, they'll be mad. We're going to need more police.'

'*More?* We've got eighteen already, counting the part-timers and the new deputies.'

'It won't be enough. And we've got—'

The town whistle began to hammer the air with short blasts. They looked west and saw the smoke rising.

'We've got Barbara and Shumway to thank,' Big Jim finished.

'Maybe we ought to do something about that fire.'

'It's a Tarker's Mills problem. And the U.S. government's, of course. They started a fire with their cotton-picking missile, let them deal with it.'

'But if the heat sparked one on this side—'

'Stop being an old woman and drive me back to town. I've got to find Junior. He and I have things to talk about.'

3

Brenda Perkins and the Reverend Piper Libby were in Dipper's parking lot, by Piper's Subaru.

'I never thought it would work,' Brenda said, 'but I'd be a liar if I said I wasn't disappointed.'

'Me too,' Piper said. 'Bitterly. I'd offer you a ride back to town, but I have to check on a parishioner.'

'Not out on Little Bitch, I hope,' Brenda said. She lifted a thumb at the rising smoke.

'No, the other way. Eastchester. Jack Evans. He lost his wife on Dome Day. A freak accident. Not that all of this isn't freakish.'

Brenda nodded. 'I saw him out at Dinsmore's field, carrying a sign with his wife's picture on it. Poor, poor man.'

Piper went to the open driver's-side window of her car, where Clover was sitting behind the wheel and watching the departing crowd. She rummaged in her pocket, gave him a treat, then said, 'Push over, Clove – you know you flunked your last driver's test.' To Brenda, she confided: 'He can't parallel-park worth a damn.'

The shepherd hopped onto the passenger side. Piper opened the car door and looked at the smoke. 'I'm sure the woods on the Tarker's Mills side are burning briskly, but that needn't concern us.' She gave Brenda a bitter smile. 'We have the Dome to protect us.'

'Good luck,' Brenda said. 'Give Jack my sympathy. And my love.'

'I'll do that,' Piper said, and drove off. Brenda was walking out of the parking lot with her hands in the pockets of her jeans, wondering how she was going to get through the rest of the day, when Julia Shumway drove up and helped her with that.

<div align="center">4</div>

The missiles exploding against the Dome didn't wake Sammy Bushey; it was the clattery wooden crash, followed by Little Walter's screams of pain, that did that.

Carter Thibodeau and his friends had taken all of her fridge-dope when they left, but they hadn't searched the place, so the shoebox with the rough skull-and-crossbones drawn on it was still in the closet. There was also this message, printed in Phil Bushey's scrawly, backslanting letters: MY SHIT! TOUCH IT AND U DIE!

There was no pot inside (Phil had always sneered at pot as a 'cocktail-party drug'), and she had no interest in the Baggie of crystal. She was sure the 'deputies' would have enjoyed smoking it, but Sammy thought crystal was crazy shit for crazy people – who else would inhale smoke that included the residue of matchbook striker-pads marinated in acetone? There was another, smaller Baggie, however, that contained half a dozen Dreamboats, and when Carter's posse left she had swallowed one of these with warm beer from the bottle stashed under the bed she now slept in alone . . . except for when she took Little Walter in with her, that was. Or Dodee.

She had briefly considered taking all of the Dreamboats and ending her crappy unhappy life once and for all; might even have

done it, if not for Little Walter. If she died, who would take care of him? He might even starve to death in his crib, a horrible thought.

Suicide was out, but she had never felt so depressed and sad and hurt in all her life. Dirty, too. She had been degraded before, God knew, sometimes by Phil (who had enjoyed drug-fueled threesomes before losing interest in sex completely), sometimes by others, sometimes by herself – Sammy Bushey had never gotten the concept of being her own best friend.

Certainly she'd had her share of one-night stands, and once, in high school, after the Wildcats basketball team had won the Class D championship, she had taken on four of the starters, one after the other, at a postgame party (the fifth had been passed out in a corner). It had been her own stupid idea. She had also sold what Carter, Mel, and Frankie DeLesseps had taken by force. Most frequently to Freeman Brown, owner of Brownie's Store, where she did most of her shopping because Brownie gave her credit. He was old and didn't smell very good, but he was randy, and that was actually a plus. It made him quick. Six pumps on the mattress in the storeroom was his usual limit, followed by a grunt and a squirt. It was never the highlight of her week, but it was comforting to know that line of credit was there, especially if she came up short at the end of the month and Little Walter needed Pampers.

And Brownie had never hurt her.

What had happened last night was different. DeLesseps hadn't been so bad, but Carter had hurt her up top and made her bleed down below. Worse had followed; when Mel Searles dropped his pants, he was sporting a tool like the ones she'd sometimes seen in the porno movies Phil had watched before his interest in crystal overtook his interest in sex.

Searles had gone at her hard, and although she tried to remember what she and Dodee had done two days before, it didn't work. She remained as dry as August with no rain. Until, that was, what Carter Thibodeau had only abraded ripped wide open. Then there was lubrication. She had felt it puddling under her, warm and sticky. There had been wetness on her face, too, tears trickling down her cheeks to nestle in the hollows of her ears. During Mel Searles's endless ride, it came to her that he might actually kill her. If he did, what would happen to Little Walter?

And weaving through it all, the shrill magpie voice of Georgia Roux: *Do her, do her, do that bitch! Make her holler!*

Sammy had hollered, all right. She had hollered plenty, and so had Little Walter, from his crib in the other room.

In the end they had warned her to keep her mouth shut and left her to bleed on the couch, hurt but alive. She'd watched their headlights move across the living room ceiling, then fade as they drove away toward town. Then it was just her and Little Walter. She had walked him back and forth, back and forth, stopping just once to put on a pair of underpants (not the pink ones; she never wanted to wear those again) and stuff the crotch with toilet paper. She had Tampax, but the thought of putting anything up there made her cringe.

Finally Little Walter's head had fallen heavily on her shoulder, and she felt his drool dampening her skin – a reliable sign that he was really and truly out. She had put him back in his crib (praying that he would sleep through the night), and then she had taken the shoebox down from the closet. The Dreamboat – some kind of powerful downer, she didn't know exactly what – had first damped the pain Down There, and then blotted out everything. She had slept for over twelve hours.

Now this.

Little Walter's screams were like a bright light cutting through heavy fog. She lurched out of bed and ran into his bedroom, knowing the goddam crib, which Phil had put together half-stoned, had finally collapsed. Little Walter had been shaking the shit out of it last night when the 'deputies' were busy with her. That must have weakened it enough so that this morning, when he began stirring around—

Little Walter was on the floor in the wreckage. He crawled toward her with blood pouring from a cut on his forehead.

'*Little Walter!*' she screamed, and swept him into her arms. She turned, stumbled over a broken cribslat, went to one knee, got up, and rushed into the bathroom with the baby wailing in her arms. She turned on the water and of course no water came: there was no power to run the well pump. She grabbed a towel and dry-mopped his face, exposing the cut – not deep but long and ragged. It would leave a scar. She pressed the towel against it as hard as she dared, trying to ignore Little Walter's renewed shrieks of pain and outrage. Blood pattered onto her bare feet in dime-sized drops. When she looked down, she saw the blue panties she'd put on after the 'deputies' had left were now soaked to a muddy purple. At first she thought it was Little Walter's blood. But her thighs were streaked, too.

5

Somehow she got Little Walter to hold still long enough to plaster three SpongeBob Band-Aids along the gash, and to get him into an undershirt and his one remaining clean overall (on the bib, red stitching

proclaimed MOMMY'S LI'L DEVIL). She dressed herself while Little Walter crawled in circles on her bedroom floor, his wild sobbing reduced to lackadaisical sniffles. She started by throwing the blood-soaked underpants into the trash and putting on fresh ones. She padded the crotch with a folded dish-wiper, and took an extra for later. She was still bleeding. Not gushing, but it was a far heavier flow than during her worst periods. And it had gone on all night. The bed was soaked.

She packed Little Walter's go-bag, then picked him up. He was heavy and she felt fresh pain settle in Down There: the sort of throbbing bellyache you got from eating bad food.

'We're going to the Health Center,' she said, 'and don't you worry, Little Walter, Dr Haskell will fix us both up. Also, scars don't matter as much to boys. Sometimes girls even think they're sexy. I'll drive as fast as I can, and we'll be there in no time.' She opened the door. 'Everything's going to be all right.'

But her old rustbucket Toyota was far from all right. The 'deputies' hadn't bothered with the back tires, but they had punctured both front ones. Sammy looked at the car for a long moment, feeling an even deeper depression settle over her. An idea, fleeting but clear, crossed her mind: she could split the remaining Dreamboats with Little Walter. She could grind his up and put them in one of his Playtex nursers, which he called 'boggies.' She could disguise the taste with chocolate milk. Little Walter loved chocolate milk. Accompanying the idea came the title of one of Phil's old record albums: *Nothing Matters and What If It Did?*

She pushed the idea away.

'I'm not that kind of mom,' she told Little Walter.

He goggled up at her in a way that reminded her of Phil, but in a good way: the expression that only looked like puzzled stupidity on her estranged husband's face was endearingly goofy on her son's. She kissed his nose and he smiled. That was nice, a nice smile, but the Band-Aids on his forehead were turning red. That wasn't so nice.

'Little change of plan,' she said, and went back inside. At first she couldn't find the Papoose, but finally spotted it behind what she would from now on think of as the Rape Couch. She finally managed to wriggle Little Walter into it, although lifting him hurt her all over again. The dish-wiper in her underwear was feeling ominously damp, but when she checked the crotch of her sweatpants, there were no spots. That was good.

'Ready for a walk, Little Walter?'

Little Walter only snuggled his cheek into the hollow of her

shoulder. Sometimes his paucity of speech bothered her – she had friends whose babies had been babbling whole sentences by sixteen months, and Little Walter only had nine or ten words – but not this morning. This morning she had other things to worry about.

The day felt dismayingly warm for the last full week of October; the sky overhead was its very palest shade of blue and the light was somehow blurry. She felt sweat spring out on her face and neck almost at once, and her crotch was throbbing badly – worse with every step, it seemed, and she had taken only a few. She thought of going back for aspirin, but wasn't it supposed to make bleeding worse? Besides, she wasn't sure she had any.

There was something else, as well, something she hardly dared admit to herself: if she went back into the house, she wasn't sure she'd have the heart to come back out again.

There was a white scrap of paper under the Toyota's left windshield wiper. It had **Just a Note from SAMMY** printed across the top and surrounded by daisies. Torn from her own kitchen pad. The idea caused a certain tired outrage. Scrawled under the daisies was this: *Tell anyone and more than your tires will be flat.* And below, in another hand: *Next time maybe we'll turn you over and play the other side.*

'In your dreams, motherfucker,' she said in a wan, tired voice.

She crumpled the note up, dropped it by one flat tire – poor old Corolla looked almost as tired and sad as she felt – and made her way out to the end of the driveway, pausing to lean against the mailbox for a few seconds. The metal was warm on her skin, the sun hot on her neck. And hardly a breath of breeze. October was supposed to be cool and invigorating. *Maybe it's that global warming stuff,* she thought. She was first to have this idea, but not the last, and the word which eventually stuck was not *global* but *local*.

Motton Road lay before her, deserted and charmless. Starting a mile or so to her left were the nice new homes of Eastchester, to which The Mill's higher-class workadaddies and workamommies came at the end of their days in the shops and offices and banks of Lewiston-Auburn. To her right lay downtown Chester's Mill. And the Health Center.

'Ready, Little Walter?'

Little Walter didn't say if he was or wasn't. He was snoring in the hollow of her shoulder and drooling on her Donna the Buffalo tee-shirt. Sammy took a deep breath, tried to ignore the throb coming from The Land Down Under, hitched up the Papoose, and started toward town.

When the whistle started up on top of the Town Hall, blowing

the short blasts that indicated a fire, she first thought it was in her own head, which was feeling decidedly weird. Then she saw the smoke, but it was far to the west. Nothing to concern her and Little Walter . . . unless someone came along who wanted a closer look at the fire, that was. If that happened, they would surely be neighborly enough to drop her off at the Health Center on their way to the excitement.

She began to sing the James McMurtry song that had been popular last summer, got as far 'We roll up the sidewalks at quarter of eight, it's a small town, can't sell you no beer,' then quit. Her mouth was too dry to sing. She blinked and saw she was on the edge of falling into the ditch, and not even the one she'd been walking next to when she started out. She'd woven all the way across the road, an excellent way to get hit instead of picked up.

She looked over her shoulder, hoping for traffic. There was none. The road to Eastchester was empty, the tar not quite hot enough to shimmer.

She went back to what she thought of as her side, swaying on her feet now, feeling all jelly-legged. *Drunken sailor*, she thought. *What do you do with a drunken sailor, ear-lye in the morning?* But it wasn't morning, it was afternoon, she had slept the clock around, and when she looked down she saw that the crotch of her sweats had turned purple, just like the underpants she'd been wearing earlier. *That won't come out, and I only have two other pairs of sweats that fit me.* Then she remembered one of those had a big old hole in the seat, and began to cry. The tears felt cool on her hot cheeks.

'It's all right, Little Walter,' she said. 'Dr Haskell's going to fix us up. Just fine. Fine as paint. Good as n—'

Then a black rose began to bloom in front of her eyes and the last of her strength left her legs. Sammy felt it go, running out of her muscles like water. She went down, holding onto one final thought: *On your side, on your side, don't squash the baby!*

That much she managed. She lay sprawled on the shoulder of Motton Road, unmoving in the hazy, July-ish sun. Little Walter awoke and began to cry. He tried to struggle out of the Papoose and couldn't; Sammy had snapped him in carefully, and he was pinned. Little Walter began to cry harder. A fly settled on his forehead, sampled the blood oozing through the cartoon images of SpongeBob and Patrick, then flew off. Possibly to report this taste-treat at Fly HQ and summon reinforcements.

Grasshoppers *reeee*'d in the grass.

The town whistle honked.

Little Walter, trapped with his unconscious mother, wailed for a

while in the heat, then gave up and lay silent, looking around list-lessly as sweat rolled out of his fine hair in large clear drops.

6

Standing beside the Globe Theater's boarded-up box office and under its sagging marquee (the Globe had gone out of business five years before), Barbie had a good view of both the Town Hall and the police station. His good buddy Junior was sitting on the cop-shop steps, massaging his temples as if the rhythmic whoop of the whistle hurt his head.

Al Timmons came out of the Town Hall and jogged down to the street. He was wearing his gray janitor's fatigues, but there was a pair of binoculars hanging from a strap around his neck and an Indian pump on his back – empty of water, from the ease with which he was carrying it. Barbie guessed Al had blown the fire whistle.

Go away, Al, Barbie thought. *How about it?*

Half a dozen trucks rolled up the street. The first two were pickups, the third a panel job. All three lead vehicles were painted a yellow so bright it almost screamed. The pickups had BURPEE'S DEPARTMENT STORE decaled on the doors. The panel truck's box bore the legendary slogan MEET ME FOR SLURPEE'S AT BURPEE'S. Romeo himself was in the lead truck. His hair was its usual Daddy Cool marvel of sweeps and spirals. Brenda Perkins was riding shotgun. In the pickup's bed were shovels, hoses, and a brand-new sump pump still plastered with the manufacturer's stickers.

Romeo stopped beside Al Timmons. 'Jump in the back, partner,' he said, and Al did. Barbie withdrew as far as he could into the shadow of the deserted theater's marquee. He didn't want to be drafted to help fight the fire out on Little Bitch Road; he had business right here in town.

Junior hadn't moved from the PD steps, but he was still rubbing his temples and holding his head. Barbie waited for the trucks to disappear, then hurried across the street. Junior didn't look up, and a moment later he was hidden from Barbie's view by the ivy-covered bulk of the Town Hall.

Barbie went up the steps and paused to read the sign on the message board: TOWN MEETING THURSDAY 7 P.M. IF CRISIS IS NOT RESOLVED. He thought of Julia saying *Until you've heard Big Jim Rennie's stump speech, don't sell him short.* He might get a chance Thursday night; certainly Rennie would make his pitch to stay in control of the situation.

And for more power, Julia's voice spoke up in his head. *He'll want that, too, of course. For the good of the town.*

The Town Hall had been built of quarried stone a hundred and sixty years before, and the vestibule was cool and dim. The generator was off; no need to run it with no one here.

Except someone was, in the main meeting hall. Barbie heard voices, two of them, belonging to children. The tall oak doors were standing ajar. He looked in and saw a skinny man with a lot of graying hair sitting up front at the selectmen's table. Opposite him was a pretty little girl of about ten. They had a checkerboard between them; the longhair had his chin propped on one hand, studying his next move. Down below, in the aisle between the benches, a young woman was playing leapfrog with a boy of four or five. The checker players were studious; the young woman and the boy were laughing.

Barbie started to withdraw, but too late. The young woman looked up. 'Hi? Hello?' She picked up the boy and came toward him. The checker players looked up, too. So much for stealth.

The young woman was holding out the hand she wasn't using to support the little boy's bottom. 'I'm Carolyn Sturges. That gentleman is my friend, Thurston Marshall. The little guy is Aidan Appleton. Say hi, Aidan.'

'Hi,' Aidan said in a small voice, and then plugged his thumb into his mouth. He looked at Barbie with eyes that were round and blue and mildly curious.

The girl ran up the aisle to stand beside Carolyn Sturges. The longhair followed more slowly. He looked tired and shaken. 'I'm Alice Rachel Appleton,' she said. 'Aidan's big sister. Take your thumb out of your mouth, Aide.'

Aide didn't.

'Well, it's nice to meet all of you,' Barbie said. He didn't tell them his own name. In fact, he sort of wished he were wearing a fake mustache. But this still might be all right. He was almost positive these people were out-of-towners.

'Are you a town official?' Thurston Marshall asked. 'If you're a town official, I wish to lodge a complaint.'

'I'm just the janitor,' Barbie said, then remembered they had almost certainly seen Al Timmons leave. Hell, probably had a conversation with him. 'The other janitor. You must have met Al.'

'I want my mother,' Aidan Appleton said. 'I miss her *bad.*'

'We met him,' Carolyn Sturges said. 'He claims the government shot some missiles at whatever is holding us in, and all they did was bounce off and start a fire.'

'That's true,' Barbie said, and before he could say more, Marshall weighed in again.

'I want to lodge a complaint. In fact, I want to lay a charge. I was assaulted by a so-called police officer. He punched me in the stomach. I had my gall bladder out a few years ago, and I'm afraid I may have internal injuries. Also, Carolyn was verbally abused. She was called a name that degraded her sexually.'

Carolyn laid a hand on his arm. 'Before we go making any charges, Thurse, you want to remember that we had D-O-P-E.'

'Dope!' Alice said at once. 'Our mom smokes marijuana sometimes, because it helps when she's having her P-E-R-I-O-D.'

'Oh,' Carolyn said. 'Right.' Her smile was wan.

Marshall drew himself up to his full height. 'Possession of marijuana is a misdemeanor,' he said. 'What they did to me was felony assault! And it hurts *terribly!*'

Carolyn gave him a look in which affection was mingled with exasperation. Barbie suddenly understood how it was between them. Sexy May had met Erudite November, and now they were stuck with each other, refugees in the New England version of *No Exit*. 'Thurse . . . I'm not sure that misdemeanor idea would fly in court.' She smiled apologetically at Barbie. 'We had quite a lot. They took it.'

'Maybe they'll smoke up the evidence,' Barbie said.

She laughed at this. Her graying boyfriend did not. His bushy brows had drawn together. 'All the same, I plan to lodge a complaint.'

'I'd wait,' Barbie said. 'The situation here . . . well, let's just say that a punch in the gut isn't going to be considered that big a deal as long as we're still under the Dome.'

'*I* consider it a big deal, my young janitor friend.'

The young woman now looked more exasperated than affectionate. 'Thurse—'

'The good side of that is nobody is going to make a big deal out of some pot, either,' Barbie said. 'Maybe it's a push, as the gamblers say. How'd you come by the kiddos?'

'The cops we ran into at Thurston's cabin saw us at the restaurant,' Carolyn said. 'The woman who runs it said they were closed until supper, but she took pity on us when we said we were from Massachusetts. She gave us sandwiches and coffee.'

'She gave us *peanut butter and jelly* and coffee,' Thurston corrected. 'There was no choice, not even tuna fish. I told her peanut butter sticks to my upper plate, but she said they were on rationing. Isn't that about the craziest thing you've ever heard?'

Barbie did think it was crazy, but since it had also been his idea, he said nothing.

'When I saw the cops come in, I was ready for more trouble,' Carolyn said, 'but Aide and Alice seemed to have mellowed them out.'

Thurston snorted. 'Not so mellow they apologized. Or did I miss that part?'

Carolyn sighed, then turned back to Barbie. 'They said maybe the pastor at the Congregational church could find the four of us an empty house to live in until this is over. I guess we're going to be foster parents, at least for awhile.'

She stroked the boy's hair. Thurston Marshall looked less than pleased at the prospect of becoming a foster parent, but he put an arm around the girl's shoulders, and Barbie liked him for that.

'One cop was *Joooo-nyer*,' Alice said. 'He's nice. Also a fox. Frankie isn't as good looking, but he was nice, too. He gave us a Milky Way bar. Mom says we're not supposed to take candy from strangers, but—' She shrugged to indicate things had changed, a fact she and Carolyn seemed to understand much more clearly than Thurston.

'They weren't nice before,' Thurston said. 'They weren't nice when they were punching me in the stomach, Caro.'

'You have to take the bitter with the sweet,' Alice said philosophically. 'That's what my mother says.'

Carolyn laughed. Barbie joined in, and after a moment so did Marshall, although he held his stomach while he did it and looked at his young girlfriend with a certain reproach.

'I went up the street and knocked on the church door,' Carolyn said. 'There was no answer, so I went in – the door was unlocked, but there was nobody there. Do you have any idea when the pastor will be back?'

Barbie shook his head. 'I'd take your checkerboard and go on up to the parsonage, if I were you. It's around back. You're looking for a woman named Piper Libby.'

'*Cherchez la femme*,' Thurston said.

Barbie shrugged, then nodded. 'She's good people, and God knows there are empty houses in The Mill. You could almost have your pick. And you'll probably find supplies in the pantry wherever you go.'

This made him think of the fallout shelter again.

Alice, meanwhile, had grabbed the checkers, which she stuffed in her pockets, and the board, which she carried. 'Mr Marshall's beat me every game so far,' she told Barbie. 'He says it's *pay*-tronizing to

let kids win just because they're kids. But I'm getting better, aren't I, Mr Marshall?'

She smiled up at him. Thurston Marshall smiled back. Barbie thought this unlikely quartet might be okay.

'Youth must be served, Alice my dear,' he said. 'But not immediately.'

'I want Mommy,' Aidan said morosely.

'If there was only a way to get in touch with her,' Carolyn said. 'Alice, you're sure you don't remember her e-mail address?' And to Barbie she said, 'Mom left her cell phone at the cabin, so *that's* no good.'

'She's a hotmail,' Alice said. 'That's all I know. Sometimes she says she used to be a hot female, but Daddy took care of that.'

Carolyn was looking at her elderly boyfriend. 'Blow this pop-shop?'

'Yes. We may as well repair to the parsonage, and hope the lady comes back soon from whatever errand of mercy she happens to be on.'

'Parsonage might be unlocked, too,' Barbie said. 'If it isn't, try under the doormat.'

'I wouldn't presume,' he said.

'*I* would,' Carolyn said, and giggled. The sound made the little boy smile.

'Pre-*zoom*!' Alice Appleton cried, and went flying up the center aisle with her arms outstretched and the checkerboard flapping from one hand. 'Pre-*zoom*, pre-*zoom*, come *on*, you guys, let's pre-*zoom*!'

Thurston sighed and started after her. 'If you break the checkerboard, Alice, you'll never beat me.'

'Yes I will, 'cos *youth* must be *served!*' she called back over her shoulder. 'Besides, we could tape it together! Come *on!*'

Aidan wriggled impatiently in Carolyn's arms. She set him down to chase after his sister. Carolyn held out her hand. 'Thank you, Mr—'

'More than welcome,' Barbie said, shaking with her. Then he turned to Thurston. The man had the fishbelly grip Barbie associated with guys whose intelligence-to-exercise ratio was out of whack.

They started out after the kids. At the double doors, Thurston Marshall looked back. A shaft of hazy sun from one of the high windows struck across his face, making him look older than he was. Making him look eighty. 'I edited the current issue of *Ploughshares,*' he said. His voice quivered with indignation and sorrow. 'That is a very good literary magazine, one of the best in the country. They had no right to punch me in the stomach, or laugh at me.'

'No,' Barbie said. 'Of course not. Take good care of those kids.'

'We will,' Carolyn said. She took the man's arm and squeezed it. 'Come on, Thurse.'

Barbie waited until he heard the outer door close, then went in search of the stairs leading to the Town Hall conference room and kitchen. Julia had said the fallout shelter was half a flight down from there.

7

Piper's first thought was that someone had left a bag of garbage beside the road. Then she got a little closer and saw it was a body.

She pulled over and scrambled out the car so fast she went to one knee, scraping it. When she got up she saw it wasn't one body but two: a woman and a toddler. The child, at least, was alive, waving its arms feebly.

She ran to them and turned the woman onto her back. She was young, and vaguely familiar, but not a member of Piper's congregation. Her cheek and brow were badly bruised. Piper freed the child from the carrier, and when she held him against her and stroked his sweaty hair, he began to cry hoarsely.

The woman's eyes fluttered open at the sound, and Piper saw that her pants were soaked with blood.

'Li'l Walter,' the woman croaked, which Piper misheard.

'Don't worry, there's water in the car. Lie still. I've got your baby, he's okay.' Not knowing if he was or not. 'I'll take care of him.'

'Li'l Walter,' the woman in the bloody jeans said again, and closed her eyes.

Piper ran back to her car with her heart beating hard enough for her to feel it in her eyeballs. Her tongue tasted coppery. *God help me*, she prayed, and could think of nothing else, so she thought it again: *God, oh God help me help that woman.*

The Subaru had air-conditioning, but she hadn't been using it in spite of the heat of the day; rarely did. Her understanding was that it wasn't very eco-friendly. But she turned it on now, full blast. She laid the baby on the backseat, rolled up the windows, closed the doors, started back toward the young woman lying in the dust, then was struck by a terrible thought: what if the baby managed to climb over the seat, pushed the wrong button, and locked her out?

God, I'm so stupid. The worst minister in the world when a real crisis comes. Help me not to be so stupid.

She rushed back, opened the driver's door again, looked over the seat, and saw the boy still lying where she had put him, but now

sucking his thumb. His eyes went to her briefly, then looked up at the ceiling as if he saw something interesting there. Mental cartoons, maybe. He had sweated right through the little tee-shirt beneath his overall. Piper twisted the electronic key fob back and forth in her fist until it broke free of the key ring. Then she ran back to the woman, who was trying to sit up.

'Don't,' Piper said, kneeling beside her and putting an arm around her. 'I don't think you should—'

'Li'l Walter,' the woman croaked.

Shit, I forgot the water! God, why did You let me forget the water?

Now the woman was trying to struggle to her feet. Piper didn't like this idea, which ran counter to everything she knew of first aid, but what other option was there? The road was deserted, and she couldn't leave her out in the blaring sun, that would be worse and more of it. So instead of pushing her back down, Piper helped her to stand.

'Slow,' she said, now holding the woman around the waist and guiding her staggering steps as best she could. 'Slow and easy does it, slow and easy wins the race. It's cool in the car. And there's water.'

'Li'l Walter!' The woman swayed, steadied, then tried to move a little faster.

'Water,' Piper said. 'Right. Then I'm taking you to the hospital.'

'Hell . . . Center.'

This Piper did understand, and she shook her head firmly. 'No way. You're going straight to the hospital. You and your baby both.'

'Li'l Walter,' the woman whispered. She stood swaying, head down, hair hanging in her face, while Piper opened the passenger door and then eased her inside.

Piper got the bottle of Poland Spring out of the center console and took off the cap. The woman snatched it from her before Piper could offer it, and drank greedily, water overspilling the neck and dripping off her chin to darken the top of her tee-shirt.

'What's your name?' Piper asked.

'Sammy Bushey.' And then, even as her stomach cramped from the water, that black rose began to open in front of Sammy's eyes again. The bottle dropped out of her hand and fell to the floormat, gurgling, as she passed out.

Piper drove as fast as she could, which was pretty fast, since Motton Road remained deserted, but when she got to the hospital, she discovered that Dr Haskell had died the day before and the physician's assistant, Everett, was not there.

Sammy was examined and admitted by that famed medical expert, Dougie Twitchell.

8

While Ginny was trying to stop Sammy Bushey's vaginal bleeding and Twitch was giving the badly dehydrated Little Walter IV fluids, Rusty Everett was sitting quietly on a park bench at the Town Hall edge of the common. The bench was beneath the spreading arms of a tall blue spruce, and he thought he was in shade deep enough to render him effectively invisible. As long as he didn't move around much, that was.

There were interesting things to look at.

He had planned to go directly to the storage building behind the Town Hall (Twitch had called it a shed, but the long wooden building, which also housed The Mill's four snowplows, was actually quite a bit grander than that) and check the propane situation there, but then one of the police cars pulled up, with Frankie DeLesseps at the wheel. Junior Rennie had emerged from the passenger side. The two had spoken for a moment or two, then DeLesseps had driven away.

Junior went up the PD steps, but instead of going in, he sat down there, rubbing his temples as if he had a headache. Rusty decided to wait. He didn't want to be seen checking up on the town's energy supply, especially not by the Second Selectman's son.

At one point Junior took his cell phone out of his pocket, flipped it open, listened, said something, listened some more, said something else, then flipped it closed again. He went back to rubbing his temples. Dr Haskell had said something about that young man. Migraine headaches, was it? It certainly looked like a migraine. It wasn't just the temple-rubbing; it was the way he was keeping his head down.

Trying to minimize the glare, Rusty thought. *Must have left his Imitrex or Zomig home. Assuming Haskell prescribed it, that is.*

Rusty had half-risen, meaning to cut across Commonwealth Lane to the rear of the Town Hall – Junior clearly not being at his most observant – but then he spotted someone else and sat down again. Dale Barbara, the short-order cook who had reputedly been elevated to the rank of colonel (by the President himself, according to some), was standing beneath the marquee of the Globe, even deeper in the shadows than Rusty was himself. And Barbara also appeared to be keeping an eye on young Mr Rennie.

Interesting.

Barbara apparently came to the conclusion that Rusty had already drawn: Junior wasn't watching but waiting. Possibly for someone to

pick him up. Barbara hustled across the street and – once he was blocked from Junior's potential view by the Town Hall itself – paused to scan the message board out front. Then he went inside.

Rusty decided to sit where he was awhile longer. It was nice under the tree, and he was curious about whom Junior might be waiting for. People were still straggling back from Dipper's (some would have stayed much longer had the booze been flowing). Most of them, like the young man sitting on the steps over yonder, had their heads down. Not in pain, Rusty surmised, but in dejection. Or maybe they were the same. It was certainly a point to ponder.

Now here came a boxy black gas–gobbler Rusty knew well: Big Jim Rennie's Hummer. It honked impatiently at a trio of townsfolk who were walking in the street, shunting them aside like sheep.

The Hummer pulled in at the PD. Junior looked up but didn't stand up. The doors opened. Andy Sanders got out from behind the wheel, Rennie from the passenger side. Rennie, allowing Sanders to drive his beloved black pearl? Sitting on his bench, Rusty raised his eyebrows. He didn't think he'd ever seen anyone but Big Jim himself behind the wheel of that monstrosity. *Maybe he's decided to promote Andy from dogsbody to chauffeur,* he thought, but when he watched Big Jim mount the steps to where his son still sat, he changed his mind.

Like most veteran medicos, Rusty was a pretty fair long-distance diagnostician. He would never have based a course of treatment on it, but you could tell a man who'd had a hip replacement six months ago from one currently suffering with hemorrhoids simply by the way he walked; you could tell a neck strain by the way a woman would turn her whole body instead of just looking back over her shoulder; you could tell a kid who'd picked up a good crop of lice at summer camp by the way he kept scratching his head. Big Jim held his arm against the upper slope of his considerable gut as he went up the steps, the classic body language of a man who has recently suffered either a shoulder strain, an upper arm strain, or both. Not so surprising that Sanders had been delegated to pilot the beast after all.

The three of them talked. Junior didn't get up but Sanders sat down beside him, rummaged in his pocket, and brought out something that twinkled in the hazy afternoon sunlight. Rusty's eyes were good, but he was at least fifty yards too far away to make out what the object might have been. Either glass or metal; that was all he could tell for sure. Junior put it in his pocket, then the three of them talked some more. Rennie gestured to the Hummer – he did it with his good arm – and Junior shook his head. Then Sanders pointed to

the Hummer. Junior declined it again, dropped his head, and went
back to working his temples. The two men looked at each other,
Sanders craning his neck because he was still sitting on the steps. And
in Big Jim's shadow, which Rusty thought appropriate. Big Jim
shrugged and opened his hands – a *what can you do* gesture. Sanders
stood up and the two men went into the PD building, Big Jim pausing
long enough to pat his son's shoulder. Junior gave no response to
that. He went on sitting where he was, as if he intended to sit out
the age. Sanders played doorman for Big Jim, ushering him inside
before following.

The two selectmen had no more than left the scene when a
quartet came out of the Town Hall: an oldish gent, a young woman,
a girl and a boy. The girl was holding the boy's hand and carrying a
checkerboard. The boy looked almost as disconsolate as Junior, Rusty
thought . . . and damned if he wasn't also rubbing one temple with
his free hand. The four of them cut across Comm Lane, then passed
directly in front of Rusty's bench.

'Hello,' the little girl said brightly. 'I'm Alice. This is Aidan.'

'We're going to live at the passionage,' the little boy named Aidan
said dourly. He was still rubbing his temple, and he looked very pale.

'That will be exciting,' Rusty said. 'Sometimes I wish *I* lived in
a passionage.'

The man and woman caught up with the kids. They were holding
hands. Father and daughter, Rusty surmised.

'Actually, we just want to talk to the Reverend Libby,' the woman
said. 'You wouldn't know if she's back yet, would you?'

'No idea,' Rusty said.

'Well, we'll just go over and wait. At the passionage.' She smiled
up at the older man when she said this. Rusty decided they might
not be father and daughter, after all. 'That's what the janitor said to
do.'

'Al Timmons?' Rusty had seen Al hop into the back of a Burpee's
Department Store struck.

'No, the other one,' the older man said. 'He said the Reverend
might be able to help us with lodgings.'

Rusty nodded. 'Was his name Dale?'

'I don't think he actually gave us his name,' the woman said.

'Come *on!*' The boy let go of his sister's hand and tugged at the
woman's instead. 'I want to play that other game you said.' But he
sounded more querulous than eager. Mild shock, maybe. Or some
physical ailment. If the latter, Rusty hoped it was only a cold. The
last thing The Mill needed right now was an outbreak of flu.

'They've misplaced their mother, at least temporarily,' the woman said in a low voice. 'We're taking care of them.'

'Good for you,' Rusty said, and meant it. 'Son, does your head hurt?'

'No.'

'Sore throat?'

'No,' the boy named Aidan said. His solemn eyes studied Rusty. 'Know what? If we don't trick-or-treat this year, I don't even care.'

'Aidan *Appleton*!' Alice cried, sounding shocked out of her shoes. Rusty jerked a little on the bench; he couldn't help it. Then he smiled. 'No? Why is that?'

'Because Mommy takes us around and Mommy went for splies.'

'He means supplies,' the girl named Alice said indulgently.

'She went for Woops,' Aidan said. He looked like a little old man – a little old *worried* man. 'I'd be ascairt to go Halloweenin without Mommy.'

'Come on, Caro,' the man said. 'We ought to—'

Rusty rose from the bench. 'Could I speak to you for a minute, ma'am? Just a step or two over here.'

Caro looked puzzled and wary, but stepped with him to the side of the blue spruce.

'Has the boy exhibited any seizure activity?' Rusty asked. 'That might include suddenly stopping what he's doing . . . you know, just standing still for a while . . . or a fixed stare . . . smacking of the lips—'

'Nothing like that,' the man said, joining them.

'No,' Caro agreed, but she looked frightened.

The man saw it and turned an impressive frown on Rusty. 'Are you a doctor?'

'Physician's assistant. I thought maybe—'

'Well, I'm sure we appreciate your concern, Mr—?'

'Eric Everett. Call me Rusty.'

'We appreciate your concern, Mr Everett, but I believe it's misplaced. Bear in mind that these children are without their mother—'

'And they spent two nights alone without much to eat,' Caro added. 'They were trying to make it to town on their own when those two . . . *officers*' – she wrinkled her nose as if the word had a bad smell – 'found them.'

Rusty nodded. 'That could explain it, I guess. Although the little girl seems fine.'

'Children react differently. And we better go. They're getting away from us, Thurse.'

Alice and Aidan were running across the park, kicking up colorful bursts of fallen leaves, Alice flapping the checkerboard and yelling, '*Passionage! Passionage!*' at the top of her lungs. The boy was keeping up with her stride for stride and also yelling.

Kid had a momentary fugue, that's all, Rusty thought. *The rest was coincidence. Not even that – what American kid isn't thinking of Halloween during the last half of October?* One thing was sure: if these people were asked later, they would remember exactly where and when they had seen Eric 'Rusty' Everett. So much for stealth.

The gray-haired man raised his voice. 'Chidren! Slow down!'

The young woman considered Rusty, then put out her hand. 'Thank you for your concern, Mr Everett. Rusty.'

'Probably overconcern. Occupational hazard.'

'You're totally forgiven. This has been the craziest weekend in the history of the world. Chalk it up to that.'

'You bet. And if you need me, check the hospital or the Health Center.' He pointed in the direction of Cathy Russell, which would be visible through the trees once the rest of the leaves fell. *If* they fell.

'Or this bench,' she said, still smiling.

'Or this bench, right.' Also smiling.

'Caro!' Thurse sounded impatient. 'Come *on!*'

She gave Rusty a little wave – no more than a twiddle of the fingertips – then ran after the others. She ran lightly, gracefully. Rusty wondered if Thurse knew that girls who could run lightly and gracefully almost always ran away from their elderly lovers, sooner or later. Maybe he did. Maybe it had happened to him before.

Rusty watched them cut across the common toward the spire of the Congo church. Eventually the trees screened them from sight. When he looked back at the PD building, Junior Rennie was gone.

Rusty sat where he was for a moment of two, drumming his fingers on his thighs. Then he came to a decision and stood up. Checking the town storage shed for the hospital's missing propane tanks could wait. He was more curious about what The Mill's one and only Army officer was doing in the Town Hall.

9

What Barbie was doing as Rusty crossed Comm Lane to the Town Hall was whistling appreciatively through his teeth. The fallout shelter was as long as an Amtrak dining car, and the shelves were fully stocked with canned goods. Most looked pretty fishy: stacks of sardines, ranks

of salmon, and a lot of something called Snow's Clam Fry-Ettes, which Barbie sincerely hoped he would never have to sample. There were boxes of dry goods, including many large plastic canisters marked RICE, WHEAT, POWDERED MILK, and SUGAR. There were stacked flats of bottles labeled DRINKING WATER. He counted ten large cartons of U.S. GOV'T SURPLUS CRACKERS. Two more were labeled U.S. GOV'T SURPLUS CHOCOLATE BARS. On the wall above these was a yellowing sign reading 700 CALORIES A DAY KEEPS HUNGER AT BAY.

'Dream on,' Barbie muttered.

There was a door at the far end. He opened it on Stygian blackness, felt around, found a light switch. Another room, not quite so big but still large. It looked old and disused – not dirty, Al Timmons at least must know about it because someone had been dusting the shelves and dry-mopping the floors – but neglected for sure. The stored water was in glass bottles, and he hadn't seen any of those since a brief stint in Saudi.

This second room contained a dozen folded cots plus plain blue blankets and mattresses that had been zipped into clear plastic covers, pending use. There were more supplies, including half a dozen cardboard canisters labeled SANITATION KIT and another dozen marked AIR MASKS. There was a small auxiliary generator that could supply minimal power. It was running; must have started up when he turned on the lights. Flanking the little gennie were two shelves. On one was a radio that looked as if it might have been new around the time C. W. McCall's novelty song 'Convoy' had been a hit. On the other shelf were two hotplates and a metal box painted bright yellow. The logo on the side was from the days when CD stood for something other than compact disc. It was what he had come to find.

Barbie picked it up, then almost dropped it – it was heavy. On the front was a gauge labeled COUNTS PER SECOND. When you turned the instrument on and pointed the sensor at something, the needle might stay in the green, rise to the yellow center of the dial . . . or go over into the red. That, Barbie assumed, would not be good.

He turned it on. The little power lamp stayed dark and the needle lay quiet against **0**.

'Battery's dead,' someone said from behind him. Barbie almost jumped out of his skin. He looked around and saw a tall, heavyset man with blond hair standing in the doorway between the two rooms.

For a moment the name eluded him, although the guy was at the restaurant most Sunday mornings, sometimes with his wife, always with his two little girls. Then it came to him. 'Rusty Evers, right?'

'Close; it's Everett.' The newcomer held out his hand. A little warily, Barbie walked over and shook it. 'Saw you come in. And that' – he nodded to the Geiger counter – 'is probably not a bad idea. *Something* must be keeping it in place.' He didn't say what he meant by *it* and didn't need to.

'Glad you approve. You almost scared me into a goddam heart attack. But you could take care of that, I guess. You're a doc, right?'

'PA,' Rusty said. 'That means—'

'I know what it means.'

'Okay, you win the waterless cookware.' Rusty pointed at the Geiger counter. 'That thing probably takes a six-volt dry cell. I'm pretty sure I saw some at Burpee's. Less sure anybody's there right now. So . . . maybe a little more rekkie?'

'What exactly would we be reconning?'

'The supply shed out back.'

'And we'd want to do that because?'

'That depends on what we find. If it's what we lost up at the hospital, you and I might exchange a little information.'

'Want to share on what you lost?'

'Propane, brother.'

Barbie considered this. 'What the hell. Let's take a look.'

10

Junior stood at the foot of the rickety stairs leading up the side of Sanders Hometown Drug, wondering if he could possibly climb them with his head aching the way it was. Maybe. Probably. On the other hand, he thought he might get halfway up and his skull would pop like a New Year's Eve noisemaker. The spot was back in front of his eye, jigging and jagging with his heartbeat, but it was no longer white. It had turned bright red.

I'd be okay in the dark, he thought. *In the pantry, with my girlfriends.*

If this went right, he could go there. Right now the pantry of the McCain house on Prestile Street seemed like the most desirable place on earth. Of course Coggins was there, too, but so what? Junior could always push *that* gospel-shouting asshole to one side. And Coggins had to stay hidden, at least for the time being. Junior had no interest in protecting his father (and was neither surprised nor dismayed at what his old man had done; Junior had always known Big Jim Rennie had murder in him), but he *did* have an interest in fixing Dale Barbara's little red wagon.

If we handle this right, we can do more than get him out of the way,

Big Jim had said that morning. *We can use him to unify the town in the face of this crisis. And that cotton-picking newspaperwoman. I have an idea about her, too.* He had laid a warm and hammy hand on his son's shoulder. *We're a team, son.*

Maybe not forever, but for the time being, they were pulling the same plow. And they would take care of *Baaarbie*. It had even occurred to Junior that Barbie was responsible for his headaches. If Barbie really had been overseas – Iraq was the rumor – then he might have come home with some weird Middle Eastern souvenirs. Poison, for instance. Junior had eaten in Sweetbriar Rose many times. Barbara could easily have dropped a little sumpin-sumpin in his food. Or his coffee. And if Barbie wasn't working the grill personally, he could have gotten Rose to do it. That cunt was under his spell.

Junior mounted the stairs, walking slowly, pausing every four steps. His head didn't explode, and when he reached the top, he groped in his pocket for the apartment key Andy Sanders had given him. At first he couldn't find it and thought he might have lost it, but at last his fingers came upon it, hiding under some loose change.

He glanced around. A few people were still walking back from Dipper's, but no one looked at him up here on the landing outside Barbie's apartment. The key turned in the lock, and he slipped inside.

He didn't turn on the lights, although Sanders's generator was probably sending juice to the apartment. The dimness made the pulsing spot in front of his eye less visible. He looked around curiously. There were books: shelves and shelves of them. Had *Baaarbie* been planning on leaving them behind when he blew town? Or had he made arrangements – possibly with Petra Searles, who worked downstairs – to ship them someplace? If so, he'd probably made similar arrangements to ship the rug on the living room floor – some camel-jockey-looking artifact Barbie had probably picked up in the local bazaar when there were no suspects to waterboard or little boys to bugger.

He hadn't made arrangements to have the stuff shipped, Junior decided. He hadn't needed to, because he had never planned to leave at all. Once the idea occurred, Junior wondered why he hadn't seen it before. *Baaarbie* liked it here; would never leave of his own free will. He was as happy as a maggot in dog-puke.

Find something he can't talk away, Big Jim had instructed. *Something that can only be his. Do you understand me?*

What do you think I am, Dad, stupid? Junior thought now. *If I'm stupid, how come it was* me *who saved* your *ass last night?*

But his father had a mighty swing on him when he got his mad on, that much was undeniable. He had never slapped or spanked

Junior as a child, something Junior had always attributed to his late mother's ameliorating influence. Now he suspected it was because his father understood, deep in his heart, that once he started, he might not be able to stop.

'Like father, like son,' Junior said, and giggled. It hurt his head, but he giggled, anyway. What was that old saying about laughter being the best medicine?

He went into Barbie's bedroom, saw the bed was neatly made, and thought briefly of how wonderful it would be to take a big shit right in the middle of it. Yes, and then wipe himself with the pillow-case. *How would you like that*, Baaarbie?

He went to the dresser instead. Three or four pairs of jeans in the top drawer, plus two pairs of khaki shorts. Under the shorts was a cell phone, and for a moment he thought that was what he wanted. But no. It was a discount store special; what the kids at college called a burner or a throw-away. Barbie could always say it wasn't his.

There were half a dozen pairs of skivvies and another four or five pairs of plain white athletic socks in the second drawer. Nothing at all in the third drawer.

He looked under the bed, his head thudding and whamming – not better after all, it seemed. And nothing under there, not even dust-kitties. *Baaarbie* was a neatnik. Junior considered taking the Imitrex in his watch-pocket, but didn't. He'd taken two already, with absolutely no effect except for the metallic aftertaste in the back of his throat. He knew what medicine he needed: the dark pantry on Prestile Street. And the company of his girlfriends.

Meantime, he was here. And there had to be *something*.

'Sumpin,' he whispered. 'Gotta have a little sumpin-sumpin.'

He started back to the living room, wiping water from the corner of his throbbing left eye (not noticing it was tinged with blood), then stopped, struck by an idea. He returned to the dresser, opened the sock-and-underwear drawer again. The socks were balled. When he was in high school, Junior had sometimes hidden a little weed or a couple of uppers in his balled-up socks; once one of Adriette Nedeau's thongs. Socks were a good hiding place. He took out the neatly made bundles one at a time, feeling them up.

He hit paydirt on the third ball, something that felt like a flat piece of metal. No, two of them. He unrolled the socks and shook the heavy one over the top of the dresser.

What fell out were Dale Barbara's dog tags. And in spite of his terrible headache, Junior smiled.

In the frame, Baaarbie, he thought. *You are in the fucking frame.*

11

On the Tarker's Mill side of Little Bitch Road, the fires set by the Fasthawk missiles were still raging, but would be out by dark; fire departments from four towns, augmented by a mixed detachment of Marine and Army grunts, were working on it, and gaining. It would have been out even sooner, Brenda Perkins judged, if the firefighters over there hadn't had a brisk wind to contend with. On The Mill side, they'd had no such problem. It was a blessing today. Later on, it might be a curse. There was no way to know.

Brenda wasn't going to let the question bother her this afternoon, because she felt good. If someone had asked her this morning when she thought she might feel good again, Brenda would have said, *Maybe next year. Maybe never.* And she was wise enough to know this feeling probably wouldn't last. Ninety minutes of hard exercise had a lot to do with it; exercise released endorphins whether the exercise was jogging or pounding out brushfires with the flat of a spade. But this was more than endorphins. It was being in charge of a job that was important, one that she could do.

Other volunteers had come to the smoke. Fourteen men and three women stood on either side of Little Bitch, some still holding the spades and rubber mats they'd been using to put out the creeping flames, some with the Indian pumps they'd been wearing on their backs now unslung and sitting on the unpaved hardpack of the road. Al Timmons, Johnny Carver, and Nell Toomey were coiling hoses and tossing them into the back of the Burpee's truck. Tommy Anderson from Dipper's and Lissa Jamieson – a little New Age-y but also as strong as a horse – were carrying the sump pump they'd used to draw water from Little Bitch Creek to one of the other trucks. Brenda heard laughter, and realized she wasn't the only one currently enjoying an endorphin rush.

The brush on both sides of the road was blackened and still smoldering, and several trees had gone up, but that was all. The Dome had blocked the wind and had helped them in another way, as well, partially damming the creek and turning the area on this side into a marsh-in-progress. The fire on the other side was a different story. The men fighting it over there were shimmering wraiths seen through the heat and the accumulating soot on the Dome.

Romeo Burpee sauntered up to her. He was holding a soaked broom in one hand and a rubber floormat in the other. The price tag was still clinging to the underside of the mat. The words on it

were charred but readable: EVERY DAY IS SALE DAY AT BURPEE'S! He dropped it and stuck out a grimy hand.

Brenda was surprised but willing. She shook firmly. 'What's that for, Rommie?'

'For you doin one damn fine job out here,' he said.

She laughed, embarrassed but pleased. 'Anybody could have done it, given the conditions. It was only a contact fire, and the ground's so squelchy it probably would have put itself out by sunset.'

'Maybe,' he said, then pointed through the trees to a raggedy clearing with a tumbledown rock wall meandering across it. 'Or maybe it would've gotten into that high grass, then the trees on the other side, and then Katy bar the door. It could have burned for a week or a month. Especially with no damn fire department.' He turned his head aside and spat. 'Even widdout wind, a fire will burn if it gets a foothold. They got mine fires down south that have burned for twenty, thirty years. I read it in *National Geographic*. No wind underground. And how do we know a good wind won't come up? We don't know jack about what that thing does or don't do.'

They both looked toward the Dome. The soot and ash had rendered it visible – sort of – to a height of almost a hundred feet. It had also dimmed their view of the Tarker's side, and Brenda didn't like that. It wasn't anything she wanted to consider deeply, not when it might rob some of her good feelings about the afternoon's work, but no – she didn't like it at all. It made her think of last night's weird, smeary sunset.

'Dale Barbara needs to call his friend in Washington,' she said. 'Tell him when they get the fire out on their side, they have to hose that whatever-it-is off. We can't do it from our side.'

'Good idea,' Romeo said. But something else was on his mind. 'Do you reckonize anything about your crew, ma'am? Because I sure do.'

Brenda looked startled. 'They're not my crew.'

'Oh yes they are,' he said. 'You were the one givin orders, that makes em your crew. You see any cops?'

She took a look.

'Not a one,' Romeo said. 'Not Randolph, not Henry Morrison, not Freddy Denton or Rupe Libby, not Georgie Frederick . . . none of the new ones, either. Those kids.'

'They're probably busy with . . .' She trailed off.

Romeo nodded. 'Right. Busy wit what? You don't know and neither do I. But whatever they're busy wit, I'm not sure I like it. Or think it's wort bein busy wit. There's gonna be a town meeting

Thursday night, and if this is still goin on, I think there should be
some changes.' He paused. 'I could be gettin out of my place here,
but I think maybe you ought to stand for Chief of Fire n Police.'

Brenda considered it, considered the file she had found marked
VADER, then shook her head slowly. 'It's too soon for anything like
that.'

'What about just Fire Chief? How bout dat one?' The Lewiston
on parle coming on stronger in his voice now.

Brenda looked around at the smoldering brush and charred
trashwood trees. Ugly, granted, like something out of a World War I
battlefield photo, but no longer dangerous. The people who had shown
up here had seen to that. The crew. *Her* crew.

She smiled. 'That I might consider.'

12

The first time Ginny Tomlinson came down the hospital hallway she
was running, responding to a loud beeping that sounded like bad
news, and Piper didn't have a chance to speak to her. Didn't even
try. She had been in the waiting room long enough to get the picture:
three people — two nurses and a teenage candy striper named Gina
Buffalino — in charge of an entire hospital. They were coping, but
barely. When Ginny came back, she was walking slowly. Her shoulders
were slumped. A medical chart dangled from one hand.

'Ginny?' Piper asked. 'Okay?'

Piper thought Ginny might snap at her, but she offered a tired
smile instead of a snarl. And sat down next to her. 'Fine. Just tired.'
She paused. 'Also, Ed Carty just died.'

Piper took her hand. 'I'm very sorry to hear that.'

Ginny squeezed her fingers. 'Don't be. You know how women
talk about having babies? This one had an easy delivery, this one had
it hard?'

Piper nodded.

'Death is like that, too. Mr Carty was in labor a long time, but
now he's delivered.'

To Piper the idea seemed beautiful. She thought she could use
it in a sermon . . . except she guessed that people wouldn't want to
hear a sermon on death this coming Sunday. Not if the Dome was
still in place.

They sat for a while, Piper trying to think of the best way to
ask what she had to ask. In the end, she didn't have to.

'She was raped,' Ginny said. 'Probably more than once. I was

afraid Twitch was going to have to try his suturing, but I finally got it stopped with a vaginal pack.' She paused. 'I was crying. Luckily, the girl was too stoned to notice.'

'And the baby?'

'Your basic healthy eighteen-month-old, but he gave us a scare. He had a mini-seizure. It was probably exposure to the sun. Plus dehydration . . . hunger . . . and he has a wound of his own.' Ginny traced a line across her forehead.

Twitch came down the hall and joined them. He looked light-years from his usual jaunty self.

'Did the men who raped her also hurt the baby?' Piper's voice remained calm, but a thin red fissure was opening in her mind.

'Little Walter? I think he just fell,' Twitch said. 'Sammy said something about the crib collapsing. It wasn't completely coherent, but I'm pretty sure it was an accident. *That* part, anyway.'

Piper was looking at him, bemused. '*That* was what she was saying. I thought it was "little water".'

'I'm sure she wanted water,' Ginny said, 'but Sammy's baby really is Little, first name, Walter, second name. They named him after a blues harmonica player, I believe. She and Phil—' Ginny mimed sucking a joint and holding in the smoke.

'Oh, Phil was a lot more than a smokehound,' Twitch said. 'When it came to drugs, Phil Bushey was a multitasker.'

'Is he dead?' Piper asked.

Twitch shrugged. 'I haven't seen him around since spring. If he is, good riddance.'

Piper looked at him reproachfully.

Twitch ducked his head a little. 'Sorry, Rev.' He turned to Ginny. 'Any sign of Rusty?'

'He needed some time off,' she said, 'and I told him to go. He'll be back soon, I'm sure.'

Piper sat between them, outwardly calm. Inside, the red fissure was widening. There was a sour taste in her mouth. She remembered a night when her father had forbidden her to go out to Skate Scene at the mall because she'd said something smart to her mother (as a teenager, Piper Libby had been an absolute font of smart things to say). She had gone upstairs, called the friend she had expected to meet, and told that friend – in a perfectly pleasant, perfectly even voice – that something had come up and she wouldn't be able to meet her after all. Next weekend? For sure, uh-huh, you bet, have a good time, no, I'm fine, b'bye. Then she had trashed her room. She finished by yanking her beloved Oasis poster off the wall and tearing

it up. By then she had been crying hoarsely, not in sorrow but in one of those rages that had blown through her teenage years like force-five hurricanes. Her father came up at some point during the festivities and stood in the doorway, regarding her. When she finally saw him there she stared back defiantly, panting, thinking how much she hated him. How much she hated them both. If they were dead, she could go live with her aunt Ruth in New York. Aunt Ruth knew how to have a good time. Not like some people. He had held his hands out to her, open, extended. It had been a somehow humble gesture, one that had crushed her anger and almost crushed her heart.

If you don't control your temper, your temper will control you, he had said, and then left her, walking down the hallway with his head bent. She hadn't slammed the door behind him. She had closed it, very quietly.

That was the year she had made her often vile temper her number one priority. Killing it completely would be killing part of herself, but she thought if she did not make some fundamental changes, an important part of her would remain fifteen for a long, long time. She had begun working to impose control, and mostly she had succeeded. When she felt that control slipping, she would remember what her father had said, and that open-handed gesture, and his slow walk along the upstairs hall of the house she had grown up in. She had spoken at his funeral service nine years later, saying *My father told me the most important thing I've ever heard*. She hadn't said what that thing was, but her mother had known; she had been sitting in the front pew of the church in which her daughter was now ordained.

For the last twenty years, when she felt the urge to flash out at someone – and often the urge was nearly uncontrollable, because people could be so stupid, so willfully *dumb* – she would summon her father's voice: *If you don't control your temper, your temper will control you.*

But now the red fissure was widening and she felt the old urge to throw things. To scratch skin until the blood came sweating out.

'Did you ask her who did it?'

'Yes, of course,' Ginny said. 'She won't say. She's scared.'

Piper remembered how she'd first thought the mother and baby lying beside the road were a bag of garbage. And that, of course, was what they'd been to whoever did this. She stood up. 'I'm going to talk to her.'

'That might not be such a good idea right now,' Ginny said. 'She's had a sedative, and—'

'Let her take a shot,' Twitch said. His face was pale. His hands were knotted between his knees. The knuckles cracked repeatedly. 'And make it a good one, Rev.'

13

Sammy's eyes were at half-mast. They opened slowly when Piper sat down beside her bed. 'You . . . were the one who . . .'

'Yes,' Piper said, taking her hand. 'My name is Piper Libby.'

'Thank you,' Sammy said. Her eyes began to drift closed again.

'Thank me by telling me the names of the men who raped you.'

In the dim room – warm, with the hospital's air-conditioning shut down – Sammy shook her head. 'They said they'd hurt me. If I told.' She glanced at Piper. It was a cowlike glance, full of dumb resignation. 'They might hurt Little Walter, too.'

Piper nodded. 'I understand you're frightened,' she said. 'Now tell me who they were. Give me the names.'

'Didn't you *hear* me?' Looking away from Piper now. 'They said they would hurt—'

Piper had no time for this; the girl would zone out on her. She grasped Sammy's wrist. 'I want those names, and you're going to give them to me.'

'I don't *dare.*' Sammy began to ooze tears.

'You're going to do it because if I hadn't come along, you might be dead now.' She paused, then drove the dagger the rest of the way in. She might regret it later, but not now. Right now the girl in the bed was only an obstacle standing between her and what she needed to know. 'Not to mention your baby. He might be dead, too. I saved your life, I saved his, and *I want those names.*'

'No.' But the girl was weakening now, and part of the Reverend Piper Libby was actually enjoying this. Later she'd be disgusted; later she'd think *You're not that much different from those boys, forcing is forcing.* But now, yes, there was pleasure, just as there had been pleasure in tearing the treasured poster from the wall and ripping it to shreds.

I like it because it is bitter, she thought. *And because it is my heart.*

She leaned over the crying girl. 'Dig the wax out of your ears, Sammy, because you need to hear this. What they've done once they'll do again. And when they do, when some other woman shows up here with a bloody snatch and possibly pregnant with a rapist's child, I will come to you, and I will say—'

'*No! Stop!*'

'"You were part of it. You were right there, cheering them on."'

'*No!*' Sammy cried. '*Not me, that was Georgia! Georgia was the one cheering them on!*'

Piper felt cold disgust. A woman. A woman had been there. In her head, the red fissure opened wider. Soon it would begin to spew lava.

'Give me the names,' she said.

And Sammy did.

<div align="center">

14

</div>

Jackie Wettington and Linda Everett were parked outside Food City. It was closing at five p.m. instead of eight. Randolph had sent them there thinking the early closing might cause trouble. A ridiculous idea, because the supermarket was almost empty. There were hardly a dozen cars in the parking lot, and the few remaining shoppers were moving in a slow daze, as if sharing the same bad dream. The two officers saw only one cashier, a teenager named Bruce Yardley. The kid was taking currency and writing chits instead of running credit cards. The meat counter was looking depleted, but there was still plenty of chicken and most of the canned and dry-goods shelves were fully stocked.

They were waiting for the last customers to leave when Linda's cell phone rang. She looked at the caller ID and felt a little stab of fear in her stomach. It was Marta Edmunds, who kept Janelle and Judy when Linda and Rusty were both working – as they had been, almost nonstop, since the Dome came down. She hit callback.

'Marta?' she said, praying it was nothing, Marta asking if it was okay for her to take the girls down to the common, something like that. 'Everything all right?'

'Well . . . yes. That is, I guess so.' Linda hating the worry she heard in Marta's voice. 'But . . . you know that seizure thing?'

'Oh God – did she have one?'

'I think so,' Marta said, then hurried on: 'They're perfectly okay now, in the other room, coloring.'

'What happened? Tell me!'

'They were on the swings. I was doing my flowers, getting them ready for winter—'

'Marta, *please!*' Linda said, and Jackie laid a hand on her arm.

'I'm sorry. Audi started to bark, so I turned around. I said, "Honey, are you all right?" She didn't answer, just got out of the swing and sat down underneath – you know, where there's a little dip from all the feet? She didn't *fall* out or anything, just sat down. She was staring

straight ahead and doing that lip-smacking thing you told me to watch for. I ran over . . . kind of shook her . . . and she said . . . let me think . . .'

Here it comes, Linda thought. *Stop Halloween, you have to stop Halloween.*

But no. It was something else entirely.

'She said, "The pink stars are falling. The pink stars are falling in lines." Then she said, "It's so dark and everything smells bad." Then she woke up and now everything's fine.'

'Thank God for that,' Linda said, and spared a thought for her five-year-old. 'Is Judy okay? Did it upset her?'

There was a long pause on the line and then Marta said, 'Oh.'

'*Oh?* What does that mean, *oh?*'

'It *was* Judy, Linda. Not Janelle. This time it was Judy.'

15

I want to play that other game you said, Aidan had told Carolyn Sturges when they had stopped on the common to talk to Rusty. The other game she had in mind was Red Light, although Carolyn had only the slightest recollection of the rules – not surprising, since she hadn't played it since she was six or seven.

But once she was standing against a tree in the commodious back-yard of the 'passionage,' the rules came back to her. And, unexpectedly, to Thurston, who seemed not only willing to play, but eager.

'Remember,' he instructed the children (who somehow seemed to have missed the pleasures of Red Light themselves), 'she can count to ten as fast as she wants to, and if she catches you moving when she turns around, you have to go all the way back.'

'She won't catch *me*,' Alice said.

'Me, either,' Aidan said stoutly.

'We'll see about that,' Carolyn said, and turned her face to the tree: 'One, two, three, four . . . five, six, seven . . . eight-nine-ten RED LIGHT!'

She whirled around. Alice was standing with a smile on her mouth and one leg extended in a big old giant step. Thurston, also smiling, had his hands extended in *Phantom of the Opera* claws. She caught the slightest movement from Aidan, but didn't even think about sending him back. He looked happy, and she had no intention of spoiling that.

'Good,' she said. 'Good little statues. Here comes Round Two.' She turned to the tree and counted again, invaded by the old,

childishly delicious fear of knowing people were moving in while her back was turned. 'Onetwo threefour fivesix seveneightnineten REDLIGHT!'

She whirled. Alice was now only twenty paces away. Aidan was ten paces or so behind her, trembling on one foot, a scab on his knee very visible. Thurse was behind the boy, one hand on his chest like an orator, smiling. Alice was going to be the one to catch her, but that was all right; in the second game the girl would be 'it' and her brother would win. She and Thurse would see to it.

She turned to the tree again. 'Onetwothreefo—'

Then Alice screamed.

Carolyn turned and saw Aidan Appleton lying on the ground. At first she thought he was still trying to play the game. One knee – the one with the scab on it – was up, as if he were trying to run on his back. His wide eyes were staring at the sky. His lips were folded into a poochy little **O**. There was a dark spot spreading on his shorts. She rushed to him.

'What's wrong with him?' Alice asked. Carolyn could see all the stress of the terrible weekend crushing in on her face. 'Is he all right?'

'Aidan?' Thurse asked. 'You okay, big fella?'

Aidan went on trembling, his lips seeming to suck at an invisible straw. His bent leg came down . . . then kicked out. His shoulders twitched.

'He's having some kind of seizure,' Carolyn said. 'Probably from overexcitement. I think he'll come out of it if we just give him a few m—'

'The pink stars are falling,' Aidan said. 'They make lines behind them. It's pretty. It's scary. Everyone is watching. No treats, only tricks. Hard to breathe. He calls himself the Chef. It's his fault. He's the one.'

Carolyn and Thurston looked at each other. Alice was kneeling by her brother, holding his hand.

'Pink stars,' Aidan said. 'They fall, they fall, they f—'

'*Wake up!*' Alice shouted into his face. '*Stop scaring us!*'

Thurston Marshall touched her shoulder gently. 'Honey, I don't think that's helping.'

Alice paid him no mind. '*Wake up, you . . . you CRAPHEAD!*'

And Aidan did. He looked at his sister's tear-streaked face, puzzled. Then he looked at Carolyn and smiled – the sweetest goddam smile she had ever seen in her life.

'Did I win?' he asked.

16

The gennie in the Town Hall's supply shed was badly maintained (someone had shoved an old-timey galvanized tin washbasin under it to catch the dripping oil), and, Rusty guessed, about as energy-efficient as Big Jim Rennie's Hummer. But he was more interested in the silver tank attached to it.

Barbie looked briefly at the generator, grimaced at the smell, then moved to the tank. 'It isn't as big as I would've expected,' he said . . . although it was a hell of a lot bigger than the canisters they used at Sweetbriar, or the one he had changed out for Brenda Perkins.

'It's called "municipal size,"' Rusty said. 'I remember that from the town meeting last year. Sanders and Rennie made a big deal of how the smaller tanks were going to save us big bucks during "these times of costly energy." Each one holds eight hundred gallons.'

'Which means a weight of . . . what? Sixty-four hundred pounds?'

Rusty nodded. 'Plus the weight of the tank. It's a lot to *lift* − you'd need a forklift or a hydraulic Power Step − but not to move. A Ram pickup is rated for sixty-eight hundred pounds, and it could probably carry more. One of these midsize tanks would fit in the bed, too. Sticking out the end a little bit, is all.' Rusty shrugged. 'Hang a red flag from it and you're good to go.'

'This is the only one here,' Barbie said. 'When it's gone, the Town Hall lights go out.'

'Unless Rennie and Sanders know where there are more,' Rusty agreed. 'And I'm betting they do.'

Barbie ran a hand over the blue stenciling on the tank: **CR HOSP.** 'This is what you lost.'

'We didn't lose it; it was stolen. That's what I'm thinking. Only there should be five more of our tanks in here, because we're missing a total of six.'

Barbie surveyed the long shed. Despite the stored plows and cartons of reserve parts, the place looked empty. Especially around the generator. 'Never mind whatever got kited from the hospital; where's the rest of the *town's* tanks?'

'I don't know.'

'And what could they be using them for?'

'I don't know,' Rusty said, 'but I mean to find out.'

PINK STARS FALLING

1

Barbie and Rusty stepped outside and breathed deeply of the open air. It had a smoky tang from the recently extinguished fire west of town, but seemed very fresh after the exhaust fumes in the shed. A lackadaisical little breeze cat's-pawed their cheeks. Barbie was carrying the Geiger counter in a brown shopping bag he'd found in the fallout shelter.

'This shit will not stand,' Rusty said. His face was set and grim.

'What are you going to do about it?' Barbie asked.

'Now? Nothing. I'm going back to the hospital and do rounds. Tonight, though, I intend to knock on Jim Rennie's door and ask for a goddam explanation. He better have one, and he better have the rest of our propane as well, because we're going to be dead out at the hospital by the day after tomorrow, even with every nonessential shut down.'

'This might be over by the day after tomorrow.'

'Do you believe it will be?'

Instead of answering the question, Barbie said, 'Selectman Rennie could be a dangerous man to press right about now.'

'Just now? That tags you for a town newbie like nothing else could. I've been hearing that about Big Jim for the ten thousand or so years he's been running this town. He either tells people to get lost or pleads patience. "For the good of the town," he says. That's number one on his hit parade. Town meeting in March is a joke. An article to authorize a new sewer system? Sorry, the town can't afford the taxes. An article to authorize more commercial zoning? Great idea, the town needs the revenue, let's build a Walmart out on 117. The University of Maine Small Town Environmental Study says there's too much graywater in Chester Pond? The selectmen recommend tabling discussion because everybody knows all those scientific studies are run by radical humanist bleeding-heart atheists. But the *hospital* is for the good of the town, wouldn't you say?'

'Yes. I would.' Barbie was a little bemused by this outburst.

Rusty stared at the ground with his hands in his back pockets. Then he looked up. 'I understand the President tapped you to take over. I think it's high time you did so.'

'It's an idea.' Barbie smiled. 'Except . . . Rennie and Sanders have got their police force; where's mine?'

Before Rusty could reply, his cell phone rang. He flipped it open and looked at the little window. 'Linda? What?'

He listened.

'All right, I understand. If you're sure they're both okay *now*. And you're sure it was Judy? Not Janelle?' He listened some more, then said: 'I think this is actually good news. I saw two other kids this morning – both with transient seizures that passed off quickly, long before I saw them, and both fine afterward. Had calls on three more. Ginny T. took another one. It could be a side effect of whatever force is powering the Dome.'

He listened.

'Because I didn't have a *chance* to,' he said. His tone patient, non-confrontational. Barbie could imagine the question which had prompted that: *Kids have been having seizures all day and* now *you tell me?*

'You're picking the kids up?' Rusty asked. He listened. 'Okay. That's good. If you sense anything wrong, call me ASAP. I'll come on the run. And make sure Audi stays with them. Yes. Uh-huh. Love you, too.' He hooked the phone on his belt and ran both hands through his hair hard enough to make his eyes look briefly Chinese. 'Jesus jumped-up Christ.'

'Who's Audi?'

'Our golden retriever.'

'Tell me about these seizures.'

Rusty did so, not omitting what Jannie had said about Halloween and what Judy had said about pink stars.

'The Halloween thing sounds like what the Dinsmore boy was raving about,' Barbie said.

'Does, doesn't it?'

'What about the other kids? Any of them talking about Halloween? Or pink stars?'

'The parents I saw today said their kids babbled while the seizure was ongoing, but they were too freaked to pay any attention.'

'The kids themselves didn't remember?'

'The kids didn't even know they'd had seizures.'

'Is that normal?'

'It's not *ab*normal.'

'Any chance your younger daughter was copying the older one? Maybe . . . I don't know . . . vying for attention?'

Rusty hadn't considered this – hadn't had the time, really. Now he did. 'Possible, but not likely.' He nodded to the old-fashioned yellow Geiger counter in the bag. 'You going prospecting with that thing?'

'Not me,' Barbie said. 'This baby's town property, and the powers that be don't like me much. I wouldn't want to be caught with it.' He held the bag out to Rusty.

'Can't. I'm just too busy right now.'

'I know,' Barbie said, and told Rusty what he wanted him to do. Rusty listened closely, smiling a little.

'Okay,' he said. 'Works for me. What are you going to be doing while I'm running your errands?'

'Cooking dinner at Sweetbriar. Tonight's special is chicken à la Barbara. Want me to send some up to the hospital?'

'Sweet,' Rusty said.

2

On his way back to Cathy Russell, Rusty stopped by the *Democrat*'s office and handed off the Geiger counter to Julia Shumway.

She listened as he relayed Barbie's instructions, smiling faintly. 'The man knows how to delegate, I'll say that for him. I'll see to this with pleasure.'

Rusty thought of cautioning her to be careful about who saw the town's Geiger counter in her possession, but didn't need to. The bag had disappeared into the kneehole of her desk.

On his way to the hospital, he reached Ginny Tomlinson and asked her about the seizure call she'd taken.

'Little kid named Jimmy Wicker. The grandfather called it in. Bill Wicker?'

Rusty knew him. Bill delivered their mail.

'He was taking care of Jimmy while the boy's mom went to gas up their car. They're almost out of regular at the Gas and Grocery, by the way, and Johnny Carver's had the nerve to jack the price of regular to eleven dollars a gallon. *Eleven!*'

Rusty bore this patiently, thinking he could have had his conversation with Ginny face-to-face. He was almost back to the hospital. When she was done complaining, he asked her if little Jimmy had said anything while he was seizing.

'Yes indeed. Bill said he babbled quite a bit. I think it was something about pink stars. Or Halloween. Or maybe I'm getting it confused with what Rory Dinsmore said after he was shot. People have been talking about that.'

Of course they have, Rusty thought grimly. *And they'll be talking about this, too, if they find out. As they probably will.*

'All right,' he said. 'Thanks, Ginny.'

'When you comin back, Red Ryder?'

'Almost there now.'

'Good. Because we have a new patient. Sammy Bushey. She was raped.'

Rusty groaned.

'It gets better. Piper Libby brought her in. I couldn't get the names of the doers out of the girl, but I think Piper did. She went out of here like her hair was on fire and her ass—' A pause. Ginny yawned loud enough for Rusty to hear. '—her ass was catching.'

'Ginny, my love – when's the last time you got some sleep?'

'I'm fine.'

'Go home.'

'Are you *kidding*?' Sounding aghast.

'No. Go home. Sleep. No setting the alarm, either.' Then an idea struck him. 'But stop by Sweetbriar Rose on the way, why don't you? They're having chicken. I heard it from a reliable source.'

'The Bushey girl—'

'I'll be checking on her in five minutes. What you're going to do is make like a bee and buzz.'

He closed his phone before she could protest again.

3

Big Jim Rennie felt remarkably good for a man who had committed murder the night before. This was partially because he did not see it as murder, no more than he had seen the death of his late wife as murder. It was cancer that had taken her. Inoperable. Yes, he had probably given her too many of the pain pills over the last week, and in the end he'd still had to help her with a pillow over her face (but lightly, ever so lightly, slowing her breathing, easing her into the arms of Jesus), but he had done it out of love and kindness. What had happened to Reverend Coggins was a bit more brutal – admittedly – but the man had been so *bullish*. So completely unable to put the town's welfare ahead of his own.

'Well, he's eating dinner with Christ the Lord tonight,' Big Jim said. 'Roast beef, mashed with gravy, apple crisp for dessert.' He himself was eating a large plate of fettuccini alfredo, courtesty of the Stouffer's company. A lot of cholesterol, he supposed, but there was no Dr Haskell around to nag him about it.

'I outlasted you, you old poop,' Big Jim told his empty study, and laughed goodnaturedly. His plate of pasta and a glass filled with milk (Big Jim Rennie did not drink alcohol) were set on his desk

blotter. He often ate in the study, and he saw no need to change that simply because Lester Coggins had met his end here. Besides, the room was once more squared away and spandy-clean. Oh, he supposed one of those investigation units like the ones on TV would be able to find plenty of blood-spatter with their luminol and special lights and things, but none of those people was going to be here in the immediate future. As for Pete Randolph doing any sleuthing in the matter . . . the idea was a joke. Randolph was an idiot.

'But,' Big Jim told the empty room in a lecturely tone, 'he's *my* idiot.'

He slurped up the last few strands of pasta, mopped his considerable chin with a napkin, then once more began to jot notes on the yellow legal pad beside the blotter. He had jotted plenty of notes since Saturday; there was so much to do. And if the Dome stayed in place, there would be more still.

Big Jim sort of hoped it *would* remain in place, at least for a while. The Dome offered challenges to which he felt certain he could rise (with God's help, of course). The first order of business was to consolidate his hold on the town. For that he needed more than a scapegoat; he needed a bogeyman. The obvious choice was Barbara, the man the Democrat Party's Commie-in-Chief had tapped to replace James Rennie.

The study door opened. When Big Jim looked up from his notes, his son was standing there. His face was pale and expressionless. There was something not quite right about Junior lately. As busy as he was with the town's affairs (and their other enterprise; that had also kept him busy), Big Jim realized this. But he felt confident in the boy just the same. Even if Junior let him down, Big Jim was sure he could handle it. He'd spent a lifetime making his own luck; that wasn't going to change now.

Besides, the boy had moved the body. That made him part of this. Which was good — the essence of smalltown life, in fact. In a small town, everybody was supposed to be a part of everything. How did that silly song put it? *We all support the team.*

'Son?' he asked. 'All right?'

'I'm fine,' Junior said. He wasn't, but he was better, the latest poisonous headache finally lifting. Being with his girlfriends had helped, as he'd known it would. The McCain pantry didn't smell so good, but after he'd sat there awhile, holding their hands, he'd gotten used to it. He thought he could even come to like that smell.

'Did you find anything in his apartment?'

'Yes.' Junior told him what he had found.

'That's excellent, Son. Really excellent. And are you ready to tell me where you put the . . . where you put him?'

Junior shook his head slowly back and forth, but his eyes stayed in exactly the same place while he did it – pinned on his father's face. It was a little eerie. 'You don't need to know. I told you that. It's a safe place, and that's enough.'

'So now you're telling *me* what I need to know.' But he said it without his usual heat.

'In this case, yes.'

Big Jim considered his son carefully. 'Are you sure you're all right? You look pale.'

'I'm fine. Just a headache. It's going now.'

'Why not have something to eat? There are a few more fettuccinis in the freezer, and the microwave does a great job on them.' He smiled. 'Might as well enjoy them while we can.'

The dark, considering eyes dropped for a moment to the puddle of white sauce on Big Jim's plate, then rose again to his father's face. 'Not hungry. When should I find the bodies?'

'*Bodies?*' Big Jim stared. 'What do you mean, *bodies?*'

Junior smiled, lips lifting just enough to show the tips of his teeth. 'Never mind. It'll help your cred if you're surprised like everyone else. Let's put it this way – once we pull the trigger, this town will be ready to hang *Baaarbie* from a sour apple tree. When do you want to do it? Tonight? Because that'll work.'

Big Jim considered the question. He looked down at his yellow pad. It was crammed with notes (and splattered with alfredo sauce), but only one was circled: *newspaper bitch.*

'Not tonight. We can use him for more than Coggins if we play this right.'

'And if the Dome comes down while you're playing it?'

'We'll be fine,' Big Jim said. Thinking, *And if Mr Barbara is somehow able to squirm free of the frame – not likely, but cockroaches have a way of finding cracks when the lights go on – there's always you. You and those other bodies.* 'Now get yourself something to eat, even if it's only a salad.'

But Junior didn't move. 'Don't wait too long, Dad,' he said.

'I won't.'

Junior considered it, considered *him* with those dark eyes that seemed so strange now, then seemed to lose interest. He yawned. 'I'm going up to my room and sleep awhile. I'll eat later.'

'Just make sure you do. You're getting too thin.'

'Thin is in,' his son replied, and offered a hollow smile that was

even more disquieting than his eyes. To Big Jim, it looked like a skull's smile. It made him think of the fellow who now just called himself The Chef – as if his previous life as Phil Bushey had been canceled. When Junior left the room, Big Jim breathed a sigh of relief without even being aware of it.

He picked up his pen: so much to do. He would do it, and do it well. It was not impossible that when this thing was over, his picture would be on the cover of *Time* magazine.

<div align="center">4</div>

With her generator still running – although it wouldn't be for much longer unless she could find some more LP canisters – Brenda Perkins was able to fire up her husband's printer and make a hard copy of everything in the VADER file. The incredible list of offenses Howie had compiled – and which he had apparently been about to act on at the time of his death – seemed more real to her on paper than they had on the computer screen. And the more she looked at them, the more they seemed to fit the Jim Rennie she'd known for most of her life. She had always known he was a monster; just not how *big* a monster.

Even the stuff about Coggins's Jesus-jumping church fit . . . although if she was reading this right, it was really not a church at all but a big old holy Maytag that washed money instead of clothes. Money from a drug-manufacturing operation that was, in her husband's words, 'maybe one of the biggest in the history of the United States.'

But there were problems, which both Police Chief Howie 'Duke' Perkins and the State AG had acknowledged. The problems were why the evidence-gathering phase of Operation Vader had gone on as long as it had. Jim Rennie wasn't just a big monster; he was a *smart* monster. That was why he had always been content to remain the Second Selectman. He had Andy Sanders to break trail for him.

And to wear a target – that, too. For a long time, Andy was the only one against whom Howie had had hard evidence. He was the frontman and probably didn't even know it, cheery gladhanding dumb-shit that he was. Andy was First Selectman, First Deacon at Holy Redeemer, first in the hearts of the townsfolk, and out front on a trail of corporate documents that finally disappeared into the obfus-catory financial swamps of Nassau and the Grand Cayman Island. If Howie and the State Attorney General had moved too soon, he would also have been first to get his picture taken while holding a number. Maybe the only one, should he believe Big Jim's inevitable promises

that all would be well if Andy just kept mum. And he probably would. Who was better at dummying up than a dummy?

Last summer, things had begun working toward what Howie had seen as the endgame. That was when Rennie's name had started showing up on some of the paperwork the AG had obtained, most notably that of a Nevada corporation called Town Ventures. The Town Ventures money had disappeared west instead of east, not into the Caribbean but into mainland China, a country where the key ingredients of decongestant drugs could be bought in bulk, with few or any questions.

Why would Rennie allow such exposure? Howie Perkins had been able to think of only one reason: the money had gotten too big too fast for one holy washing machine. Rennie's name had subsequently appeared on papers concerning half a dozen other fundamentalist churches in the northeast. Town Ventures and the other churches (not to mention half a dozen other religious radio stations and AM talkers, none as big as WCIK) were Rennie's first real mistakes. They left dangling strings. Strings could be pulled, and sooner or later – usually sooner – everything unraveled.

You couldn't let go, could you? Brenda thought as she sat behind her husband's desk, studying the papers. *You'd made millions – maybe tens of millions – and the risks were becoming outrageous, but you still couldn't let go. Like a monkey who traps himself because he won't let go of the food. You were sitting on a damn fortune and you just kept on living in that old three-story and selling cars at that pit of yours out on 119. Why?*

But she knew. It wasn't the money; it was the town. What he saw as *his* town. Sitting on a beach somewhere in Costa Rica or presiding over a guarded estate in Namibia, Big Jim would become Small Jim. Because a man without a sense of purpose, even one whose bank accounts are stuffed with money, is always a small man.

If she confronted him with what she had, could she make a deal with him? Force him out in return for her silence? She wasn't sure. And she dreaded the confrontation. It would be ugly, possibly dangerous. She would want to have Julia Shumway with her. And Barbie. Only Dale Barbara was now wearing his own target.

Howie's voice, calm but firm, spoke up in her head. *You can afford to wait a little while – I was waiting for a few final items of proof myself – but I wouldn't wait too long, honey. Because the longer this siege goes on, the more dangerous he'll become.*

She thought of Howie starting to back down the driveway, then stopping to put his lips on hers in the sunshine, his mouth almost as well known to her as her own, and certainly as well loved. Caressing

the side of her throat as he did it. As if he knew the end was coming, and one last touch would have to pay for all. An easy and romantic conceit for sure, but she almost believed it, and her eyes filled with tears.

Suddenly the papers and all the machinations contained therein seemed less important. Even the Dome didn't seem very important. What mattered was the hole that had appeared so suddenly in her life, sucking out the happiness she had taken for granted. She wondered if poor dumb Andy Sanders felt the same way. She supposed he did.

I'll give it twenty-four hours. If the Dome's still in place tomorrow night, I'll go to Rennie with this stuff – with copies of this stuff – and tell him he has to resign in favor of Dale Barbara. Tell him that if he doesn't, he's going to read all about his drug operation in the paper.

'Tomorrow,' she murmured, and closed her eyes. Two minutes later she was asleep in Howie's chair. In Chester's Mill, the supper hour had come. Some meals (including chicken à la king for a hundred or so) were cooked on electric or gas ranges courtesy of the generators in town that were still working, but there were also people who had turned to their woodstoves, either to conserve their gennies or because wood was now all they had. The smoke rose in the still air from hundreds of chimneys.

And spread.

5

After delivering the Geiger counter – the recipient took it willingly, even eagerly, and promised to begin prospecting with it early on Tuesday – Julia headed for Burpee's Department Store with Horace on his leash. Romeo had told her he had a pair of brand-new Kyocera photocopiers in storage, both still in their original shipping cartons. She was welcome to both.

'I also got a little propane tucked away,' he said, giving Horace a pat. 'I'll see you get what you need – for as long as I can, at least. We gotta keep that newspaper running, am I right? More important than ever, don't you t'ink?'

It was exactly what she t'ought, and Julia had told him so. She had also planted a kiss on his cheek. 'I owe you for this, Rommie.'

'I'll be expectin a big discount on my weekly advertising circular when this is over.' He had then tapped the side of his nose with a forefinger, as if they had a great big secret. Maybe they did.

As she left, her cell phone chirruped. She pulled it out of her pants pocket. 'Hello, this is Julia.'

'Good evening, Ms Shumway.'

'Oh, Colonel Cox, how wonderful to hear your voice,' she said brightly. 'You can't imagine how thrilled we country mice are to get out-of-town calls. How's life outside the Dome?'

'Life in general is probably fine,' he said. 'Where I am, it's on the shabby side. You know about the missiles?'

'Watched them hit. And bounce off. They lit a fine fire on your side—'

'It's not *my*—'

'—and a fairly good one on ours.'

'I'm calling for Colonel Barbara,' Cox said. 'Who should be carrying his own goddam phone by now.'

'Goddam right!' she cried, still in her brightest tone. 'And people in goddam hell should have goddam icewater!' She stopped in front of the Gas & Grocery, now shut up tight. The hand-lettered sign in the window read **HRS OF OP TOMORROW 11 AM–2 PM *GET HERE EARLY*!**

'Ms Shumway—'

'We'll discuss Colonel Barbara in a minute,' Julia said. 'Right now I want to know two things. First, when is the press going to be allowed at the Dome? Because the people of America deserve more than the government's spin on this, don't you think?'

She expected him to say he did *not* think, that there would be no *New York Times* or CNN at the Dome in the foreseeable future, but Cox surprised her. 'Probably by Friday if none of the other tricks up our sleeve work. What's the other thing you want to know, Ms Shumway? Make it brief, because I'm not a press officer. That's another pay grade.'

'You called me, so you're stuck with me. Suck it up, Colonel.'

'Ms Shumway, with all due respect, yours is not the only cell phone in Chester's Mill I can reach out and touch.'

'I'm sure that's true, but I don't think Barbie will talk to you if you shine me on. He's not particularly happy with his new position as prospective stockade commandant.'

Cox sighed. 'What's your question?'

'I want to know the temperature on the south or east side of the Dome – a *true* temperature, meaning away from the fire you guys set.'

'Why—'

'Do you have that information or not? I think you do, or can get it. I think you're sitting in front of a computer screen right now, and you have access to everything, probably including my underwear

size.' She paused. 'And if you say sixteen, this call is over.'

'Are you exhibiting your sense of humor, Ms Shumway, or are you always this way?'

'I'm tired and scared. Chalk it up to that.'

There was a pause on Cox's end. She thought she heard the click of computer keys. Then he said, 'It's forty-seven Fahrenheit in Castle Rock. Will that do?'

'Yes.' The disparity wasn't as bad as she had feared, but still considerable. 'I'm looking at the thermometer in the window of the Mill Gas and Grocery. It says fifty-eight. That's an eleven-degree difference between locations less than twenty miles apart. Unless there's a hell of a big warm front pushing through western Maine this evening, I'd say something's going on here. Do you agree?'

He didn't answer her question, but what he *did* say took her mind off it. 'We're going to try something else. Around nine this evening. It's what I wanted to tell Barbie.'

'One hopes Plan B will work better than Plan A. At this moment, I believe the President's appointee is feeding the multitudes at Sweetbriar Rose. Chicken à la king is the rumor.' She could see the lights down the street, and her belly rumbled.

'Will you listen and pass on a message?' And she heard what he did not add: *You contentious bitch?*

'Happy to,' she said. Smiling. Because she *was* a contentious bitch. When she had to be.

'We're going to try an experimental acid. A hydrofluoric compound, man-made. Nine times as corrosive as the ordinary stuff.'

'Living better through chemistry.'

'I'm told you could theoretically burn a hole two miles deep in the bedrock with it.'

'What highly amusing people you work for, Colonel.'

'We're going to try where Motton Road crosses—' There was a rustle of paper. 'Where it crosses into Harlow. I expect to be there.'

'Then I'll tell Barbie to have someone else wash up.'

'Will you also be favoring us with your company, Ms Shumway?'

She opened her mouth to say *I wouldn't miss it*, and that was when all hell broke loose up the street.

'What's going on there?' Cox asked.

Julia didn't reply. She closed her phone and stuck it in her pocket, already running toward the sound of yelling voices. And something else. Something that sounded like *snarling*.

The gunshot came while she was still half a block away.

6

Piper went back to the parsonage and discovered Carolyn, Thurston, and the Appleton kids waiting there. She was glad to see them, because they took her mind off Sammy Bushey. At least temporarily.

She listened to Carolyn's account of Aidan Appleton's seizure, but the boy seemed fine now – chowing ever deeper into a stack of Fig Newtons. When Carolyn asked if the boy should see a doctor, Piper said, 'Unless there's a recurrence, I think you can assume it was brought on by hunger and the excitement of the game.'

Thurston smiled ruefully. 'We were all excited. Having fun.'

When it came to possible lodging, Piper first thought of the McCain house, which was close by. Only she didn't know where their spare key might be hidden.

Alice Appleton was on the floor, feeding Fig Newton crumbs to Clover. The shepherd was doing the old my-muzzle's-on-your-ankle-because-I'm-your-best-friend routine in between offerings. 'This is the best dog I've ever seen,' she told Piper. 'I wish *we* could have a dog.'

'I've got a dragon,' Aidan offered. He was sitting comfortably on Carolyn's lap.

Alice smiled indulgently. 'That's his invisible F-R-E-I-N.'

'I see,' Piper said. She supposed they could always break a window at the McCain place; needs must when the devil drives.

But as she got up to check on the coffee, a better idea occurred. 'The Dumagens'. I should have thought of them right away. They went to Boston for a conference. Coralee Dumagen asked me to water her plants while they're gone.'

'I teach in Boston,' Thurston said. 'At Emerson. I edited the current issue of *Ploughshares*.' And sighed.

'The key is under a flowerpot to the left of the door,' Piper said. 'I don't believe they have a generator, but there's a woodstove in the kitchen.' She hesitated, thinking *City people*. 'Can you use a wood-stove to cook on without setting the house on fire?'

'I grew up in Vermont,' Thurston said. 'Was in charge of keeping the stoves lit – house *and* barn – until I went off to college. What goes around comes around, doesn't it?' And sighed again.

'There'll be food in the pantry, I'm sure,' Piper said.

Carolyn nodded. 'That's what the janitor at the Town Hall said.'

'Also *Joooon-yer*,' Alice put in. 'He's a cop. A *foxy* one.'

Thurston's mouth turned down. 'Alice's foxy cop assaulted me,' he said. 'Him or the other one. I couldn't tell them apart, myself.'

Piper's eyebrows went up.

'Punched Thurse in the stomach,' Carolyn said quietly. 'Called us Massholes – which, I suppose, we technically are – and laughed at us. For me, that was the worst part, how they laughed at us. They were better once they had the kids with them, but . . .' She shook her head. 'They were out of control.'

And just like that, Piper was back to Sammy. She felt a pulse beginning to beat in the side of her neck, very slow and hard, but she kept her voice even. 'What was the other policeman's name?'

'Frankie,' Carolyn said. 'Junior called him Frankie D. Do you know these guys? You must, huh?'

'I know them,' Piper said.

7

She gave the new, makeshift family directions to the Dumagens' – the house had the advantage of being near to Cathy Russell if the boy had another seizure – and sat awhile at her kitchen table after they were gone, drinking tea. She did it slowly. Took a sip and set the cup down. Took a sip and set it down. Clover whined. He was tuned in to her, and she supposed he could sense her rage.

Maybe it changes my smell. Makes it more acrid or something.

A picture was forming. Not a pretty one. A lot of new cops, very young cops, sworn in less than forty-eight hours ago and already running wild. The sort of license they had exhibited with Sammy Bushey and Thurston Marshall wouldn't spread to veteran cops like Henry Morrison and Jackie Wettington – at least she didn't think so – but to Fred Denton? Toby Whelan? Maybe. *Probably.* With Duke in charge, those guys had been all right. Not great, the kind of guys apt to lip you unnecessarily after a traffic stop, but all right. Certainly the best the town's budget could afford. But her mother had been wont to say, 'You buy cheap, you get cheap.' And with Peter Randolph in charge—

Something had to be done.

Only she had to control her temper. If she didn't, it would control her.

She took the leash from the peg by the door. Clover was up at once, tail swishing, ears perked, eyes bright.

'Come on, you big lug. We're going to lodge a complaint.'

Her shepherd was still licking Fig Newton crumbs from the side of his muzzle as she led him out the door.

8

Walking across the town common with Clover heeling neatly to her right, Piper felt she *did* have her temper under control. She felt that way until she heard the laughter. It came as she and Clove were approaching the police station. She observed the very fellows whose names she had gotten out of Sammy Bushey: DeLesseps, Thibodeau, Searles. Georgia Roux was also present, Georgia who had egged them on, according to Sammy: *Do that bitch*. Freddy Denton was there too. They were sitting at the top of the stone PD steps, drinking sodas, gassing among themselves. Duke Perkins never would have allowed such a thing, and Piper reflected that if he could see them from wherever he was, he'd be rolling in his grave fast enough to set his own remains on fire.

Mel Searles said something and they all broke up again, laughing and backslapping. Thibodeau had his arm around the Roux girl, the tips of his fingers on the sideswell of her breast. She said something, and they all laughed harder.

It came to Piper that they were laughing about the rape – what a goldurn good old time it had been – and after that, her father's advice never had a chance. The Piper who ministered to the poor and the sick, who officiated at marryings and buryings, who preached charity and tolerance on Sundays, was pushed rudely to the back of her mind, where she could only watch as though through a warped and wavery pane of glass. It was the other Piper who took over, the one who had trashed her room at fifteen, crying tears of rage rather than sorrow.

There was a slate-paved square known as War Memorial Plaza between the Town Hall and the newer brick PD building. At its center was a statue of Ernie Calvert's father, Lucien Calvert, who had been awarded a posthumous Silver Star for heroic action in Korea. The names of other Chester's Mill war dead, going all the way back to the Civil War, were engraved on the statue's base. There were also two flagpoles, the Stars and Stripes at the top of one and the state flag, with its farmer, sailor, and moose, at the top of the other. Both hung limp in the reddening light of oncoming sunset. Piper Libby passed between the poles like a woman in a dream, Clover still heeling behind her right knee with his ears up.

The 'officers' atop the steps burst into another hearty roar of laughter, and she thought of trolls in one of the fairy stories her dad had sometimes read her. Trolls in a cave, gloating over piles of ill-gotten gold. Then they saw her and quieted.

'Good evenin, Rev'run,' Mel Searles said, and got up, giving his belt a self-important little hitch as he did so. *Standing in the presence of a lady*, Piper thought. *Did his mother teach him that? Probably. The fine art of rape he probably learned somewhere else.*

He was still smiling as she reached the steps, but then it faltered and grew tentative, so he must have seen her expression. Just what that expression might be she didn't know. From the inside, her face felt frozen. Immobile.

She saw the biggest of them watching her closely. Thibodeau, his face as immobile as hers felt. *He's like Clover*, she thought. *He smells it on me. The rage.*

'Rev'run?' Mel asked. 'Everything okay? There a problem?'

She mounted the steps, not fast, not slow, Clover still heeling neatly behind her right knee. 'You *bet* there's a problem,' she said, looking up at him.

'What—'

'*You,*' she said. '*You're* the problem.'

She pushed him. Mel wasn't expecting it. He was still holding his cup of soda. He went tumbling into Georgia Roux's lap, flailing his arms uselessly for balance, and for a moment the soda was a dark manta ray hanging against the reddening sky. Georgia cried out in surprise as Mel landed on her. She sprawled backward, spilling her own soda. It went running across the wide granite slab in front of the double doors. Piper could smell either whiskey or bourbon. Their Cokes had been spiked with what the rest of the town could no longer buy. No wonder they'd been laughing.

The red fissure inside her head opened wider.

'You can't—' Frankie began, starting to get up himself. She pushed him. In a galaxy far far away, Clover – ordinarily the sweetest of dogs – was growling.

Frankie went on his back, eyes wide and startled, for a moment looking like the Sunday school boy he once might have been.

'*Rape* is the problem!' Piper shouted. '*Rape!*'

'Shut up,' Carter said. He was still sitting, and although Georgia was cowering against him, Carter remained calm. The muscles of his arms rippled below his short-sleeved blue shirt. 'Shut up and get out of here right now, if you don't want to spend the night in a cell downstai—'

'You're the one who'll be going into a cell,' Piper said. 'All of you.'

'Make her shut up,' Georgia said. She wasn't whimpering, but she was close. 'Make her shut up, Cart.'

'Ma'am—' Freddy Denton. His uniform shirt untucked and bourbon on his breath. Duke would have taken one look and fired his ass. Fired *all* their asses. He started to get up and this time *he* was the one who went sprawling, a look of surprise on his face that would have been comical under other circumstances. It was nice that they had been sitting while she was standing. Made it easier. But oh, how her temples were thudding. She returned her attention to Thibodeau, the most dangerous one. He was still looking at her with maddening calm. As though she were a freak he'd paid a quarter to see in a sideshow tent. But he was looking *up* at her, and that was her advantage.

'But it won't be a cell downstairs,' she said, speaking directly to Thibodeau. 'It'll be in Shawshank, where they do to little play-yard bullies like you what you did to that girl.'

'You stupid bitch,' Carter said. He spoke as if remarking on the weather. 'We weren't anywhere near her house.'

'That's right,' Georgia said, sitting up again. There was Coke splattered on one of her cheeks, where a virulent case of teenage acne was fading (but still holding onto a few final outposts). 'And besides, everyone knows Sammy Bushey is nothing but a lying lesbo cunt.'

Piper's lips stretched in a smile. She turned it on Georgia, who recoiled from the crazy lady who had appeared so suddenly on the steps while they'd been having a nice sunsetter or two. 'How did you know the lying lesbo cunt's name? *I* didn't say it.'

Georgia's mouth dropped into an **O** of dismay. And for the first time something flickered beneath Carter Thibodeau's calm. Whether fear or just annoyance, Piper didn't know.

Frank DeLesseps got cautiously to his feet. 'You better not go around spreading accusations you can't back up, Reverend Libby.'

'Nor assaulting police officers,' Freddy Denton said. 'I'm willing to let it go this time – everyone's under stress – but you have to cease and desist these accusations right now.' He paused, then added lamely: 'And the pushing, of course.'

Piper's gaze remained fixed on Georgia, her right hand curled so tightly around the black plastic grip of Clover's leash it was throbbing. The dog stood with his forepaws spread and his head lowered, still growling. He sounded like a powerful outboard motor set to idle. The fur on his neck had bushed out enough to hide his collar.

'How'd you know her name, Georgia?'

'I . . . I . . . I just assumed . . .'

Carter gripped her shoulder and squeezed it. 'Shut up, babe.'

And then, to Piper, still not standing (*Because he doesn't want to be pushed back down, the coward*), he said: 'I don't know what kind of bee you've got in your Jesus bonnet, but we were all together last night, at Alden Dinsmore's farm. Trying to see if we could get anything out of the soldier-boys stationed on 119, which we couldn't. That's on the other side of town from Busheys'.' He looked around at his friends.

'Right,' Frankie said.

'Right,' Mel chimed in, looking at Piper distrustfully.

'Yeah!' Georgia said. Carter's arm was around her again and her moment of doubt was gone. She looked at Piper defiantly.

'Georgie-girl *assumed* it was Sammy you were yelling about,' Carter said with that same infuriating calm. 'Because Sammy's the biggest lying scumbucket in this town.'

Mel Searles yodeled laughter.

'But you didn't use protection,' Piper said. Sammy had told her this, and when she saw Thibodeau's face tighten, she knew it was true. 'You didn't use protection and they rape-kitted her.' She had no idea if *this* was true, and didn't care. She could see from their widening eyes that they believed it, and their belief was enough. 'When they compare your DNA to what they found—'

'That's enough,' Carter said. 'Shut it.'

She turned her furious smile on him. 'No, Mr Thibodeau. We are only getting started, my son.'

Freddy Denton reached for her. She pushed him down, then felt her left arm caught and twisted. She turned and looked into Thibodeau's eyes. No calm there now; they were shining with rage.

Hello, my brother, she thought incoherently.

'Fuck you, you fucking bitch,' he remarked, and this time she was the one who was pushed.

Piper fell backward down the stairs, trying instinctively to tuck and roll, not wanting to hit her head on one of those stone risers, knowing they could smash her skull in. Kill her or – worse – leave her a vegetable. She struck on her left shoulder instead, and there was a sudden howl of pain there. *Familiar* pain. She had dislocated that one playing high school soccer twenty years ago, and damned if she hadn't just done it again.

Her legs flew over her head and she turned a back somersault, wrenching her neck, coming down on her knees and splitting the skin on both. She finally came to rest on her stomach and breasts. She had tumbled almost all the way to the bottom of the steps. Her cheek was bleeding, her nose was bleeding, her lips were bleeding, her neck hurt, but ah God, her shoulder was the worst, humped up

all crooked in a way she remembered well. The last time she'd seen a hump like that, it had been in a red nylon Wildcats jersey. Nevertheless, she struggled to her feet, thanking God she still had the power to command her legs; she could also have been paralyzed.

She'd lost hold of the leash halfway down and Clover jumped at Thibodeau, his teeth snapping at the chest and belly under his shirt, tearing the shirt open, knocking Thibodeau backward, going for the young man's vitals.

'*Get him off me!*' Carter screamed. Nothing calm about him now. '*He's gonna kill me!*'

And yes, Clover was trying. His front paws were planted on Carter's thighs, going up and down as Carter thrashed. He looked like a German shepherd on a bicycle. He shifted his angle of attack and bit deep into Carter's shoulder, eliciting another scream. Then Clover went for the throat. Carter got his hands on the dog's chest just in time to save his windpipe.

'*Make him stop!*'

Frank reached for the trailing leash. Clover turned and snapped at his fingers. Frank skittered backward, and Clover returned his attention to the man who had pushed his mistress down the steps. His muzzle opened, revealing a double line of shining white teeth, and he drove at Thibodeau's neck. Carter got his hand up, then shrieked in agony as Clover seized on it and began to shake it like one of his beloved rag toys. Only his rag toys didn't bleed, and Carter's hand did.

Piper came staggering up the steps, holding her left arm across her midriff. Her face was a mask of blood. A tooth clung to the corner of her mouth like a crumb of food.

'*GET HIM OFF ME, CHRIST, GET YOUR FUCKIN DOG OFF ME!*'

Piper was opening her mouth to tell Clover to stand down when she saw Fred Denton drawing his gun.

'No!' she screamed. '*No, I can make him stop!*'

Fred turned to Mel Searles, and pointed at the dog with his free hand. Mel stepped forward and kicked Clover in the haunch. He did it high and hard, as he had once (not so long ago) punted footballs. Clover was whipped sideways, losing his hold on Thibodeau's bleeding, shredded hand, where two fingers now pointed in unusual directions, like crooked signposts.

'*NO!*' Piper screamed again, so loud and so hard the world went gray before her eyes. '*DON'T HURT MY DOG!*'

Fred paid no attention. When Peter Randolph burst out through

the double doors, his shirttail out, his pants unzipped, the copy of *Outdoors* he had been reading on the crapper still held in one hand, Fred paid no attention to that, either. He pointed his service automatic at the dog, and fired.

The sound was deafening in the enclosed square. The top of Clover's head lifted off in a spray of blood and bone. He took one step toward his screaming, bleeding mistress – another – then collapsed.

Fred, gun still in hand, strode forward and grabbed Piper by her bad arm. The hump in her shoulder roared a protest. And still she kept her eyes on the corpse of her dog, whom she had raised from a pup.

'You're under arrest, you crazy bitch,' Fred said. He pushed his face – pale, sweaty, the eyes seeming ready to pop right out of their sockets – close enough to hers for her to feel the spray of his spittle. 'Anything you say can and will be used against your crazy ass.'

On the other side of the street, diners were pouring out of Sweetbriar Rose, Barbie among them, still wearing his apron and baseball cap. Julia Shumway arrived first.

She took in the scene, not seeing details so much as a gestalt summation: dead dog; clustered cops; bleeding, screaming woman with one shoulder higher than the other; bald cop – Freddy goddam Denton – shaking her by the arm connected to that shoulder; more blood on the steps, suggesting that Piper had fallen down them. Or had been pushed.

Julia did something she had never done before in her life: reached into her handbag, flipped her wallet open, and climbed the steps, holding it out, yelling '*Press! Press! Press!*'

It stopped the shaking, at least.

9

Ten minutes later, in the office that had been Duke Perkins's not so long ago, Carter Thibodeau sat on the sofa under Duke's framed pictures and certificates, with a fresh bandage on his shoulder and paper towels around his hand. Georgia was sitting beside him. Large beads of painsweat stood out on Thibodeau's forehead, but after saying 'I don't think nothin's broken,' he was silent.

Fred Denton sat in a chair in the corner. His gun was on the Chief's desk. He had surrendered it willingly enough, only saying, 'I had to do it – just look at Cart's hand.'

Piper sat in the office chair that was now Peter Randolph's. Julia had mopped most of the blood off Piper's face with more paper

towels. The woman was shivering with shock and in great pain, but
she was as silent about it as Thibodeau. Her eyes were clear.

'Clover only attacked him' – she raised her chin to Carter –
'after he pushed me down the stairs. The push caused me to lose
hold of the leash. What my dog did was justified. He was protecting
me from a criminal assault.'

'*She* attacked *us*!' Georgia cried. 'Crazy bitch attacked *us*! Came
up the steps spouting all this shit—'

'Shut up,' Barbie said. 'All of you, shut the hell up.' He looked
at Piper. 'This isn't the first time you've dislocated your shoulder, is
it?'

'I want you out of here, Mr Barbara,' Randolph said . . . but he
spoke with no great conviction.

'I can deal with this,' Barbie said. 'Can you?'

Randolph made no reply. Mel Searles and Frank DeLesseps stood
outside the door. They looked worried.

Barbie turned back to Piper. 'This is a subluxation – a partial
separation. Not bad. I can pop it back in before you go to the
hospital—'

'*Hospital?*' Fred Denton squawked. 'She's under arr—'

'Shut up, Freddy,' Randolph said. 'Nobody's under arrest. At least
not yet.'

Barbie held Piper's eyes with his own. 'But I have to do it now,
before the swelling gets bad. If you wait for Everett to do it at the
hospital, they'll have to give you anesthesia.' He leaned close to her
ear and murmured, 'While you're out, they'll be telling their side and
you won't be telling yours.'

'What are you saying?' Randolph asked sharply.

'That it's going to hurt,' Barbie said. 'Right, Rev?'

She nodded. 'Go on. Coach Gromley did it right on the sidelines,
and she was a total dope. Just hurry. And please don't screw it up.'

Barbie said: 'Julia, grab a sling from the first aid kit, then help
me lie her down on her back.'

Julia, very pale and feeling ill, did as she was told.

Barbie sat down on the floor to Piper's left, slipped off one shoe,
and then grasped her forearm just above her wrist with both hands.
'I don't know Coach Gromley's method,' he said, 'but this is how a
medic I knew in Iraq did it. You're going to count to three and then
yell wishbone.'

'Wishbone,' Piper said, bemused in spite of the pain. 'Well, okay,
you're the doctor.'

No, Julia thought – Rusty Everett was now the closest thing

the town had to a doctor. She'd contacted Linda and gotten his cell phone number, but her call had been immediately shunted to voice-mail.

The room was silent. Even Carter Thibodeau was watching. Barbie nodded to Piper. Beads of sweat stood out on her forehead, but she had her game-face on, and Barbie respected the shit out of that. He slipped his sock-foot into her left armpit, snugging it tight. Then, while pulling slowly but steadily on her arm, he applied counter pressure with his foot.

'Okay, here we go. Let's hear you.'

'One . . . two . . . three . . . *WISHBONE!*'

When Piper shouted, Barbie pulled. Everyone in the room heard the loud thunk as the joint went back into place. The hump in Piper's blouse magically disappeared. She screamed but didn't pass out. He slipped the sling over her neck and around the arm, immobilizing it as well as he could.

'Better?' he asked.

'Better,' she said. 'Much, thank God. Still hurts, but not as bad.'

'I've got some aspirin in my purse,' Julia said.

'Give her the aspirin and then get out,' Randolph said. 'All of you except for Carter, Freddy, the Reverend, and me.'

Julia looked at him unbelievingly. 'Are you kidding? The Reverend is going to the hospital. Can you walk, Piper?'

Piper stood up shakily. 'I think so. A little way.'

'Sit down, Reverend Libby,' Randolph said, but Barbie knew she was already gone. He could hear it in Randolph's voice.

'Why don't you make me?' She gingerly lifted her left arm and the sling holding it. The arm trembled, but it was working. 'I'm sure you can dislocate it again, very easily. Go on. Show these . . . these *boys* . . . that you're just like them.'

'And I'll put it all in the paper!' Julia said brightly. 'Circulation will double!'

Barbie said, 'Suggest you defer this business until tomorrow, Chief. Allow the lady to get some painkillers stronger than aspirin, and have those knee lacerations checked by Everett. Given the Dome, she's hardly a flight risk.'

'Her dog tried to kill me,' Carter said. In spite of the pain, he sounded calm again.

'Chief Randolph, DeLesseps, Searles, and Thibodeau are guilty of rape.' Piper was swaying now – Julia put an arm around her – but her voice was firm and clear. 'Roux is an accessory to rape.'

'The hell I am!' Georgia squawked.

'They need to be suspended immediately.'

'She's lying,' Thibodeau said.

Chief Randolph looked like a man watching a tennis match. He finally settled his gaze on Barbie. 'Are you telling me what to do, kiddo?'

'No, sir, just making a suggestion based on my enforcement experience in Iraq. You'll make your own decisions.'

Randolph relaxed. 'Okay, then. Okay.' He looked down, frowning in thought. They all watched him notice his fly was still unzipped and take care of that little problem. Then he looked up again and said, 'Julia, take Reverend Piper to the hospital. As for you, Mr Barbara, I don't care where you go but I want you out of here. I'll take statements from my officers tonight, and from Reverend Libby tomorrow.'

'Wait,' Thibodeau said. He extended his crooked fingers to Barbie. 'Can you do anything about these?'

'I don't know,' Barbie said – pleasantly enough, he hoped. The initial ugliness was over, and now came the political aftermath, which he remembered well from dealing with Iraqi cops who were not all that different from the man on the couch and the others crowding the doorway. What it came down to was making nice with people you wished you could spit on. 'Can you say *wishbone*?'

10

Rusty had turned his cell phone off before knocking on Big Jim's door. Now Big Jim sat behind his desk, Rusty in the seat before it – the chair of supplicants and applicants.

The study (Rennie probably called it a home office on his tax returns) had a pleasant, piney smell, as if it had recently been given a good scrubbing, but Rusty still didn't like it. It wasn't just the picture of an aggressively Caucasian Jesus delivering the Sermon on the Mount, or the self-congratulatory plaques, or the hardwood floor that really should have had a rug to protect it; it was all those things and something else as well. Rusty Everett had very little use for or belief in the supernatural, but nevertheless, this room felt almost haunted.

It's because he scares you a little, he thought. *That's all it is.*

Hoping that how he felt didn't show in his voice or face, Rusty told Rennie about the hospital's missing propane tanks. About how he had found one of them in the supply shed behind the Town Hall, currently running the Town Hall's generator. And how it was the *only* one.

'So I have two questions,' Rusty said. 'How did a tank from the hospital supply wander downtown? And where did the rest go?'

Big Jim rocked back in his chair, put his hands behind his neck, and looked up at the ceiling meditatively. Rusty found himself staring at the trophy baseball sitting on Rennie's desk. Propped in front of it was a note from Bill Lee, once of the Boston Red Sox. He could read the note because it was turned outward. Of course it was. It was for guests to see, and marvel over. Like the pictures on the wall, the baseball proclaimed that Big Jim Rennie had rubbed elbows with Famous People: *Look on my autographs, ye mighty, and despair.* To Rusty, the baseball and the note turned outward seemed to sum up his bad feelings about the room he was in. It was window-dressing, a tinny testimonial to smalltown prestige and smalltown power.

'I wasn't aware you had anyone's permission to go poking around in our supply shed,' Big Jim remarked to the ceiling. His hammy fingers were still laced together behind his head. 'Perhaps you're a town official, and I wasn't aware of it? If so, my mistake – my *bad,* as Junior says. I thought you were basically a nurse with a prescription pad.'

Rusty thought this was mostly technique – Rennie trying to piss him off. To divert him.

'I'm not a town official,' he said, 'but I *am* a hospital employee. And a taxpayer.'

'So?'

Rusty could feel blood rushing to his face.

'So those things make it partly *my* supply shed.' He waited to see if Big Jim would respond to this, but the man behind the desk remained impassive. 'Besides, it was unlocked. Which is all beside the point, isn't it? I saw what I saw, and I'd like an explanation. As a hospital employee.'

'And a taxpayer. Don't forget that.'

Rusty sat looking at him, not even nodding.

'I can't give you one,' Rennie said.

Rusty raised his eyebrows. 'Really? I thought you had your fingers on the pulse of this town. Isn't that what you said the last time you ran for Selectman? And now you're telling me you can't explain where the town's propane went? I don't believe it.'

For the first time, Rennie looked nettled. 'I don't care if you believe it or not. This is news to me.' But his eyes darted fractionally to one side as he said it, as if to check that his autographed photo of Tiger Woods was still there; the classic liars' tell.

Rusty said, 'The hospital's almost out of LP. Without it, the few

of us who are still on the job might as well be working in a Civil
War battlefield surgery tent. Our current patients – including a post-
coronary and a serious case of diabetes that may warrant amputation
– will be in serious trouble if the power goes out. The possible amp
is Jimmy Sirois. His car is in the parking lot. It's got a sticker on the
bumper that says ELECT BIG JIM.'

'I'll investigate,' Big Jim said. He spoke with the air of a man
conferring a favor. 'The town's propane is probably stored in some
other town facility. As for yours, I'm sure I can't say.'

'*What* other town facilities? There's the FD, and the sand-and-
salt pile out on God Creek Road – not even a shed there – but
those are the only ones I'm aware of.'

'Mr Everett, I'm a busy man. You'll have to excuse me now.'

Rusty stood. His hands wanted to ball into fists, but he wouldn't
let them. 'I'm going to ask you one more time,' he said. 'Straight out
and straight up. Do you know where those missing tanks are?'

'No.' This time it was Dale Earnhardt Rennie's eyes flickered to.
'And I'm not going to read any implication into that question, son,
because if I did I'd have to resent it. Now why don't you run along
and check on Jimmy Sirois? Tell him Big Jim sends his best, and he'll
stop by as soon as the nitpickery slows down a little.'

Rusty was still battling to hold onto his temper, but this was a
fight he was losing. '*Run along?* I think you forgot that you're a public
servant, not a private dictator. For the time being I'm this town's
chief medical officer, and I want some an—'

Big Jim's cell rang. He snared it. Listened. The lines around his
drawn-down mouth grew grimmer. 'Gosh*darn* it! Every time I turn
my darn *back* . . .' He listened some more, then said: 'If you've got
people with you in the office, Pete, shut your trap before you open
it too wide and fall right the heck in. Call Andy. I'll be right there,
and the three of us'll clean this up.'

He killed the phone and got to his feet.

'I have to go to the police station. It's either an emergency or
more nitpickery, I won't be able to tell which until I get there. And
you'll be wanted at either the hospital or the Health Center, I believe.
There seems to be a problem with the Reverend Libby.'

'Why? What happened to her?'

Big Jim's cold eyes surveyed him from hard little sockets. 'I'm
sure you'll hear her story. I don't know how true it'll be, but I'm sure
you'll hear it. So go do your job, young fella, and let me do mine.'

Rusty walked down the front hall and out of the house, his
temples throbbing. In the west, the sunset was a lurid bloodshow. The

air was almost completely still, but bore a smoky stench just the same. At the foot of the steps, Rusty raised a finger and pointed it at the public servant waiting for him to leave his property before he, Rennie, left himself. Rennie scowled at the finger, but Rusty did not drop it.

'Nobody needs to tell me to do my job. And I'm going to make looking for that propane part of it. If I find it in the wrong place, someone else is going to be doing *your* job, Selectman Rennie. That's a promise.'

Big Jim flapped a contemptuous hand at him. 'Get out of here, son. Go to work.'

11

During the first fifty-five hours of the Dome's existence, over two dozen children suffered seizures. Some, like those of the Everett girls, were noted. Many more were not, and in the days ahead, the seizure activity would rapidly taper down to nothing. Rusty would compare this to the minor shocks people experienced when they came too close to the Dome. The first time, you got that almost electric *frisson* that stiffened the hair on the back of your neck; after that, most people felt nothing. It was as if they had been inoculated.

'Are you saying the Dome is like chickenpox?' Linda asked him later. 'Catch it once and you're set for life?'

Janelle had two seizures, and so did a little kid named Norman Sawyer, but in both cases the second seizure was milder than the first, and not accompanied by any babble. Most of the kids Rusty saw had only the one, and there seemed to be no after-effects.

Only two adults had seizures during those first fifty-five hours. Both came around sunset on Monday evening, and both had easily traceable causes.

With Phil Bushey, aka The Chef, the cause was too much of his own product. Around the time Rusty and Big Jim parted company, Chef Bushey was sitting outside the storage barn behind WCIK, looking dreamily at the sunset (this close to the missile strikes, the scarlet in the sky was further darkened by soot on the Dome), his hitty-pipe clasped loosely in one hand. He was tweeked at least to the ionosphere; maybe a hundred miles beyond. In the few low-lying clouds which floated on that bloody light, he saw the faces of his mother, his father, his grandfather; he saw Sammy and Little Walter as well.

All the cloud-faces were bleeding.

When his right foot began to twitch and then his left foot picked

up the beat, he ignored it. Twitchin was part of tweekin, everyone knew that. But then his hands began to tremble and his pipe fell into the long grass (yellow and sere as a result of the factory work that went on out here). A moment later his head began to jerk from side to side.

This is it, he thought with a calm that was partly relief. *I finally overdid it. I'm checking out. Probably for the best.*

But he didn't check out, didn't even *pass* out. He slid slowly sideways, twitching and watching as a black marble rose in the red sky. It expanded to a bowling ball, then an overinflated beachball. It went on growing until it had eaten up the red sky.

The end of the world, he thought. *Probably for the best.*

For a moment he thought he was wrong, because the stars came out. Only they were the wrong color. They were pink. And then, oh God, they began to fall down, leaving long pink trails behind them.

Next came fire. A roaring furnace, as if someone had opened a hidden trapdoor and loosed Hell itself on Chester's Mill.

'It's our treat,' he muttered. His pipe pressed against his arm, making a burn he would see and feel later. He lay twitching in the yellow grass with his eyes turned up to glabrous whites that reflected the lurid sunset. 'Our Halloween treat. First the trick . . . then the treat.'

The fire was becoming a face, an orange version of the bloody ones he'd been looking at in the clouds just before the fit fell on him. It was the face of Jesus. Jesus was scowling at him.

And talking. Talking to *him*. Telling him that bringing the fire was *his* responsibility. *His.* The fire and the . . . the . . .

'The purity,' he muttered as he lay in the grass. 'No . . . the *purification.*'

Jesus didn't look so mad now. And He was fading. Why? Because The Chef had understood. First came the pink stars; then came the purifying fire; then the trial would end.

The Chef stilled as the seizure passed into the first real sleep he'd had in weeks, perhaps months. When he woke up, it was full dark – every trace of red gone from the sky. He was chilled to the bone, but not damp.

Under the Dome, dew no longer fell.

12

While The Chef was observing the face of Christ in that evening's infected sunset, Third Selectman Andrea Grinnell was sitting on her

couch and trying to read. Her generator had quit — or had it ever run at all? She couldn't remember. But she had a gadget called a Mighty Brite light that her sister Rose had tucked into her Christmas stocking last year. She'd never had occasion to use it until now, but it worked just fine. You clamped it to your book and turned it on. Easy-peasy. So light wasn't a problem. The words, unfortunately, were. The words kept squirming around on the page, sometimes even changing places with each other, and Nora Roberts's prose, ordinarily crystal clear, made absolutely no sense. Yet Andrea kept trying, because she could think of nothing else to do.

The house stank, even with the windows open. She was suffering diarrhea and the toilet would no longer flush. She was hungry but couldn't eat. She had tried a sandwich around five p.m. — just an inoffensive cheese sandwich — and had thrown it up in the kitchen wastebasket minutes after it was down. A shame, because eating that sandwich had been hard work. She was sweating heavily — had already changed her clothes once, probably should change them again, if she could manage to do it — and her feet kept jittering and jerking.

They don't call it kicking the habit for nothing, she thought. *And I'll never make the emergency meeting tonight, if Jim still means to have one.*

Considering how her last conversation with Big Jim and Andy Sanders had gone, maybe that was good; if she showed up, they'd just bully her some more. Make her do things she didn't want to do. Best she stay away until she was clear of this . . . this . . .

'This *shit*,' she said, and brushed her damp hair out of her eyes. 'This fucking shit in my system.'

Once she was herself again, she would stand up to Jim Rennie. It was long overdue. She would do it in spite of her poor aching back, which was such a misery without her OxyContin (but not the white-hot agony she had expected — that was a welcome surprise). Rusty wanted her to take methadone. *Methadone,* for God's sake! Heroin under an alias!

If you're thinking about going cold turkey, don't, he had told her. *You're apt to have seizures.*

But he'd said it could take ten days his way, and she didn't think she could wait that long. Not with this awful Dome over the town. Best to get it over with. Having come to this conclusion, she had flushed all of her pills — not just the methadone but a few last OxyContin pills she'd found in the back of her nightstand drawer — down the toilet. That had been just two flushes before the toilet gave up the ghost, and now she sat here shivering and trying to convince herself she'd done the right thing.

It was the only thing, she thought. *That kind of takes the right and wrong out of it.*

She tried to turn the page of her book and her stupid hand struck the Mighty Brite gadget. It went tumbling to the floor. The spot of brilliance it threw went up to the ceiling. Andrea looked at it and was suddenly rising out of herself. And fast. It was like riding an invisible express elevator. She had just a moment to look down and see her body still on the couch, twitching helplessly. Foamy drool was slipping down her chin from her mouth. She saw the wetness spreading around the crotch of her jeans and thought, *Yep — I'll have to change again, all right. If I live through this, that is.*

Then she passed through the ceiling, through the bedroom above it, through the attic with its dark stacked boxes and retired lamps, and from there out into the night. The Milky Way sprawled above her, but it was wrong. The Milky Way had turned pink.

And then began to fall.

Somewhere — far, far below her — Andrea heard the body she had left behind. It was screaming.

13

Barbie thought he and Julia would discuss what had happened to Piper Libby on their ride out of town, but they were mostly silent, lost in their own thoughts. Neither of them said they were relieved when the unnatural red sunset finally began to fade, but both of them were.

Julia tried the radio once, found nothing but WCIK booming out 'All Prayed Up,' and snapped it off again.

Barbie spoke only once, this just after they turned off Route 119 and began to drive west along the narrower blacktop of the Motton Road, where woods bulked up close on either side. 'Did I do the right thing?'

In Julia's opinion he had done a great many right things during the confrontation in the Chief's office — including the successful treatment of two patients with dislocations — but she knew what he was talking about.

'Yes. It was the exquisitely wrong time to try asserting command.'

He agreed, but felt tired and dispirited and not equal to the job he was beginning to see before him. 'I'm sure the enemies of Hitler said pretty much the same thing. They said it in nineteen thirty-four, and they were right. In thirty-six, and they were right. Also in thirty-eight. "The wrong time to challenge him," they said. And when they

realized the right time had finally come, they were protesting in Auschwitz or Buchenwald.'

'This is not the same,' she said.

'You think not?'

She made no reply to this, but saw his point. Hitler had been a paperhanger, or so the story went; Jim Rennie was a used car dealer. Six of one, half a dozen of the other.

Up ahead, fingers of brilliance shone through the trees. They printed an intaglio of shadows on the patched tar of Motton Road.

There were a number of military trucks parked on the other side of the Dome – it was Harlow over there at this edge of town – and thirty or forty soldiers moved hither and yon with a purpose. All had gas masks hooked to their belts. A silver tanker-truck bearing the legend **EXTREME DANGER KEEP BACK** had been backed up until it almost touched a door-size shape that had been spray-painted on the Dome's surface. A plastic hose was clamped to a valve on the back of the tanker. Two men were handling the hose, which ended in a wand no bigger than the barrel of a Bic pen. These men were wearing shiny all-over suits and helmets. There were air tanks on their backs.

On the Chester's Mill side, there was only one spectator. Lissa Jamieson, the town librarian, stood beside an old-fashioned ladies' Schwinn with a milk-box carrier on the rear fender. On the back of the box was a sticker reading WHEN THE POWER OF LOVE IS STRONGER THAN THE LOVE OF POWER, THE WORLD WILL KNOW PEACE – JIMI HENDRIX.

'What are you doing here, Lissa?' Julia asked, getting out of her car. She held up a hand to shield her eyes from the bright lights.

Lissa was nervously fiddling with the ankh she wore around her neck on a silver chain. She looked from Julia to Barbie, then back to Julia again. 'I go for a ride on my bike when I'm upset or worried. Sometimes I ride until midnight. It soothes my *pneuma*. I saw the lights and came to the lights.' She said this in an incantatory way, and let go of her ankh long enough to trace some kind of complicated symbol in the air. 'What are *you* doing out here?'

'Came to watch an experiment,' Barbie said. 'If it works, you can be the first one to leave Chester's Mill.'

Lissa smiled. It looked a little forced, but Barbie liked her for the effort. 'If I did that, I'd miss the Tuesday night special at Sweetbriar. Isn't it usually meatloaf?'

'Meatloaf's the plan,' he agreed, not adding that if the Dome was still in place the following Tuesday, the *spécialité de la maison* was apt to be zucchini quiche.

'They won't talk,' Lissa said. 'I tried.'

A squat fireplug of a man came out from behind the tanker and into the light. He was dressed in khakis, a poplin jacket, and a hat with the logo of the Maine Black Bears on it. The first thing to strike Barbie was that James O. Cox had put on weight. The second was his heavy jacket, zipped to what was now dangerously close to a double chin. Nobody else – Barbie, Julia, or Lissa – was wearing a jacket. There was no need of them on their side of the Dome.

Cox saluted. Barbie gave it back, and it actually felt pretty good to snap one off.

'Hello, Barbie,' Cox said. 'How's Ken?'

'Ken's fine,' Barbie said. 'And I continue to be the bitch that gets all the good shit.'

'Not this time, Colonel,' Cox said. 'This time it appears you got fucked at the drive-thru.'

14

'Who's he?' Lissa whispered. She was still working at the ankh. Julia thought she'd snap the chain soon, if she kept at it. 'And what are they doing over there?'

'Trying to get us out,' Julia said. 'And after the rather spectacular failure earlier in the day, I'd have to say they're wise to do it on the quiet.' She started forward. 'Hello, Colonel Cox – I'm your favorite newspaper editor. Good evening.'

Cox's smile was – to his credit, she thought – only slightly sour. 'Ms Shumway. You're even prettier than I imagined.'

'I'll say one thing for you, you're handy with the bullsh—'

Barbie intercepted her three yards from where Cox was standing and took her by the arms.

'What?' she asked.

'The camera.' She had almost forgotten she had it around her neck until he pointed to it. 'Is it digital?'

'Sure, Pete Freeman's extra.' She started to ask why, then got it. 'You think the Dome will fry it.'

'That'd be the best-case scenario,' Barbie said. 'Remember what happened to Chief Perkins's pacemaker.'

'Shit,' she said. '*Shit!* Maybe I've got my old Kodak in the trunk.'

Lissa and Cox were looking at each other with what Barbie thought was equal fascination. 'What are you going to do?' she asked. 'Is there going to be another bang?'

Cox hesitated. Barbie said, 'Might as well come clean, Colonel. If you don't tell her, I will.'

Cox sighed. 'You insist on total transparency, don't you?'

'Why not? If this thing works, the people of Chester's Mill will be singing your praises. The only reason you're playing em close is force of habit.'

'No. It's what my superiors have ordered.'

'They're in Washington,' Barbie said. 'And the press is in Castle Rock, most of em probably watching *Girls Gone Wild* on pay-per-view. Out here it's just us chickens.'

Cox sighed and pointed to the spray-painted door shape. 'That's where the men in the protective suits will apply our experimental compound. If we're lucky, the acid will eat through and we'll then be able to knock that piece of the Dome out the way you can knock a piece of glass out of a window after you've used a glass-cutter.'

'And if we're unlucky?' Barbie asked. 'If the Dome decomposes, giving off some poison gas that kills us all? Is that what the gas masks are for?'

'Actually,' Cox said, 'the scientists feel it more likely that the acid might start a chemical reaction that would cause the Dome to catch fire.' He saw Lissa's stricken expression and added, 'They consider both possibilities very remote.'

'They *can*,' Lissa said, twirling her ankh. 'They're not the ones who'd get gassed or roasted.'

Cox said, 'I understand your concern, ma'am—'

'Melissa,' Barbie corrected. It suddenly seemed important to him that Cox understand these were *people* under the Dome, not just a few thousand anonymous taxpayers. 'Melissa Jamieson. Lissa to her friends. She's the town librarian. She's also the middle-school guidance counselor, and teaches yoga classes, I believe.'

'I had to give that up,' Lissa said with a fretful smile. 'Too many other things to do.'

'Very nice to make your acquaintance, Ms Jamieson,' Cox said. 'Look – this is a chance worth taking.'

'If we felt differently, could we stop you?' she asked.

This Cox did not answer directly. 'There's no sign that this thing, whatever it is, is weakening or biodegrading. Unless we're able to breach it, we believe you're in for the long haul.'

'Do you have any idea what caused it? Any at all?'

'None,' Cox said, but his eyes shifted in a way Rusty Everett would have recognized from his conversation with Big Jim.

Barbie thought, *Why are you lying? Just that knee-jerk reaction again?*

Civilians are like mushrooms, keep them in the dark and feed them shit? Probably that was all it was. But it made him nervous.

'It's strong?' Lissa asked. 'Your acid – is it strong?'

'The most corrosive in existence, as far as we know,' Cox replied, and Lissa took two large steps back.

Cox turned to the men in the space-suits. 'Are you boys about ready?'

They gave him a pair of gloved thumbs-up. Behind them, all activity had stopped. The soldiers stood watching, with their hands on their gas masks.

'Here we go,' Cox said. 'Barbie, I suggest you escort those two beautiful ladies at least fifty yards back from—'

'Look at the *stars*,' Julia said. Her voice was soft, awestruck. Her head was tilted upward, and in her wondering face Barbie saw the child she had been thirty years ago.

He looked up and saw the Big Dipper, the Great Bear, Orion. All where they belonged . . . except they had smeared out of clear focus and turned pink. The Milky Way had turned into a bubblegum spill across the greater dome of the night.

'Cox,' he said. 'Do you *see* that?'

Cox looked up.

'See what? The stars?'

'What do they look like to you?'

'Well . . . very bright, of course – no light pollution to speak of in these parts—' Then a thought occurred to him, and he snapped his fingers. 'What are you seeing? Have they changed color?'

'They're beautiful,' Lissa said. Her eyes were wide and shining. 'But scary, too.'

'They're pink,' Julia said. 'What's happening?'

'Nothing,' Cox said, but he sounded oddly reluctant.

'What?' Barbie asked. 'Spill it.' And added, without thinking: 'Sir.'

'We got the meteorological report at nineteen hundred hours,' Cox said. 'Special emphasis on winds. Just in case . . . well, just in case. Leave it at that. The jet stream's currently coming west as far as Nebraska or Kansas, dipping south, then coming up the Eastern Seaboard. Pretty common pattern for late October.'

'What's that got to do with the stars?'

'As it comes north, the jet passes over a lot of cities and manu-facturing towns. What it picks up over those locations is collecting on the Dome instead of being whisked north to Canada and the Arctic. There's enough of it now to have created a kind of optical filter. I'm sure it's not dangerous . . .'

'Not *yet*,' Julia said. 'What about in a week, or a month? Are you going to hose down our airspace at thirty thousand feet when it starts getting *dark* in here?'

Before Cox could reply, Lissa Jamieson screamed and pointed into the sky. Then she covered her face.

The pink stars were falling, leaving bright contrails behind them.

15

'More dope,' Piper said dreamily as Rusty listened to her heartbeat.

Rusty patted Piper's right hand – the left one was badly scraped. 'No more dope,' he said. 'You're officially stoned.'

'Jesus wants me to have more dope,' she said in that same dreamy voice. 'I want to get as high as a mockingbird pie.'

'I believe that's "elephant's eye," but I'll take it under consideration.'

She sat up. Rusty tried to push her back down, but he dared push on only her right shoulder, and that wasn't enough. 'Will I be able to get out of here tomorrow? I have to see Chief Randolph. Those boys raped Sammy Bushey.'

'And could have killed you,' he said. 'Dislocation or not, you fell extremely lucky. Let me worry about Sammy.'

'Those cops are dangerous.' She put her right hand on his wrist. 'They can't go on being police. They'll hurt someone else.' She licked her lips. 'My mouth is so dry.'

'I can fix that, but you'll have to lie down.'

'Did you take sperm samples from Sammy? Can you match them to the boys? If you can, I'll hound Peter Randolph until he makes them give DNA samples. I'll hound him day and night.'

'We're not equipped for DNA matching,' Rusty said. *Also, there are no sperm samples. Because Gina Buffalino washed her up, at Sammy's own request.* 'I'll get you something to drink. All the fridges except for the ones in the lab are turned off to save juice, but there's an Igloo cooler at the nurses' station.'

'Juice,' she said, closing her eyes. 'Yes, juice would be good. Orange or apple. Not V8. Too salty.'

'Apple,' he said. 'You're on clear liquids tonight.'

Piper whispered: 'I miss my dog,' then turned her head away. Rusty thought she'd probably be out by the time he got back with her juice box.

Halfway down the corridor, Twitch rounded the corner from the nurses' station at a dead run. His eyes were wide and wild. 'Come outside, Rusty.'

'As soon as I get Reverend Libby a—'

'No, now. You have to see this.'

Rusty hurried back to room 29 and peeped in. Piper was snoring in a most unladylike way – not unusual, considering her swelled nose.

He followed Twitch down the corridor, almost running to keep up with the other man's long strides. 'What is it?' Meaning, *What now?*

'I can't explain, and you probably wouldn't believe me if I did. You have to see it for yourself.' He banged out through the lobby door.

Standing in the driveway beyond the protective canopy where drop-off patients arrived were Ginny Tomlinson, Gina Buffalino, and Harriet Bigelow, a friend whom Gina had recruited to help out at the hospital. The three of them had their arms around each other, as if for comfort, and were staring up into the sky.

It was filled with blazing pink stars, and many appeared to be falling, leaving long, almost fluorescent trails behind them. A shudder worked up Rusty's back.

Judy foresaw this, he thought. '*The pink stars are falling in lines.*'

And they were. They were.

It was as if heaven itself was coming down around their ears.

16

Alice and Aidan Appleton were asleep when the pink stars began falling, but Thurston Marshall and Carolyn Sturges weren't. They stood in the backyard of the Dumagen house and watched them come down in brilliant pink lines. Some of the lines crisscrossed each other, and when this happened, pink runes seemed to stand out in the sky before fading.

'Is it the end of the world?' Carolyn asked.

'Not at all,' he said. 'It's a meteor swarm. They're most commonly observed during autumn here in New England. I think it's too late in the year for the Perseids, so this one's probably a wandering shower – maybe dust and chunks of rock from an asteroid that broke up a trillion years ago. Think of that, Caro!'

She didn't want to. 'Are meteor showers always pink?'

'No,' he said. 'I think it probably looks white on the outside of the Dome, but we're seeing it through a film of dust and particulate matter. Pollution, in other words. It's changed the color.'

She thought about that as they watched the silent pink tantrum in the sky. 'Thurse, the little boy . . . Aidan . . . when he had that fit or whatever it was, he said . . .'

'I remember what he said. "The pink stars are falling, they make lines behind them."'

'How could he know that?'

Thurston only shook his head.

Carolyn hugged him tighter. At times like this (although there had never been a time exactly like this in her life), she was glad Thurston was old enough to be her father. Right now she wished he *was* her father.

'How could he know this was coming? How could he *know*?'

17

Aidan had said something else during his moment of prophecy: *Everyone is watching.* And by nine thirty on that Monday night, when the meteor shower was at its height, that was true.

The news spreads by cell phone and e-mail, but mostly in the old way: mouth to ear. By quarter of ten, Main Street is full of people watching the silent fireworks display. Most are equally silent. A few are crying. Leo Lamoine, a faithful member of the late Reverend Coggins's Holy Redeemer congregation, shouts it's the Apocalypse, that he sees the Four Horsemen in the sky, that the Rapture will begin soon, et cetera, et cetera. Sloppy Sam Verdreaux – back on the street again since three that afternoon, sober and grumpy – tells Leo that if Leo doesn't shut up about the Acrockashit, he'll be seeing his own stars. Rupe Libby of the CMPD, hand on the butt of his gun, tells them both to shut the hell up and stop scaring people. As if they are not scared already. Willow and Tommy Anderson are in the parking lot of Dipper's, Willow crying with her head on Tommy's shoulder. Rose Twitchell stands beside Anson Wheeler outside Sweetbriar Rose; both are still wearing their aprons and they also have their arms around each other. Norrie Calvert and Benny Drake are with their parents, and when Norrie's hand steals into Benny's, he takes it with a thrill the falling pink stars cannot match. Jack Cale, the current manager of Food City, is in the supermarket parking lot. Jack called Ernie Calvert, the previous manager, late that afternoon and asked if Ernie would help him do a complete inventory of supplies on hand. They were well into this job, hoping to be done by midnight, when the furor on Main Street broke out. Now they stand side by side, watching the pink stars fall. Stewart and Fernald Bowie are outside their funeral parlor, gazing up. Henry Morrison and Jackie Wettington stand across from the funeral parlor with Chaz Bender, who teaches history up to the high school. 'It's just a meteor shower

seen through a haze of pollution,' Chaz tells Jackie and Henry . . . but he still sounds awed.

The fact that accumulating particulate matter has actually changed the color of the stars brings the situation home to people in a new way, and gradually the weeping becomes more widespread. It is a soft sound, almost like rain.

Big Jim is less interested in a bunch of meaningless lights in the sky than he is in how people will *interpret* those lights. Tonight, he expects they'll just go home. Tomorrow, though, things may be different. And the fear he sees on most faces may not be such a bad thing. Fearful people need strong leaders, and if there's one thing Big Jim Rennie knows he can provide, it's strong leadership.

He's outside the police station doors with Chief Randolph and Andy Sanders. Standing below them, crowded together, are his problem children: Thibodeau, Searles, the Roux chippie, and Junior's friend, Frank. Big Jim descends the steps that Libby fell down earlier (*she could have done us all a favor if she'd broken her neck*, he thinks) and taps Frankie on the shoulder. 'Enjoying the show, Frankie?'

The boy's big scared eyes make him look twelve instead of twenty-two or whatever he is. 'What is it, Mr Rennie? Do you know?'

'Meteor shower. Just God saying hello to His people.'

Frank DeLesseps relaxes a little.

'We're going back inside,' Big Jim says, jerking his thumb at Randolph and Andy, who are still watching the sky. 'We'll talk for a while, then I'll call you four in. I want you all to tell the same cotton-picking story when I do. Have you got that?'

'Yes, Mr Rennie,' Frankie says.

Mel Searles looks at Big Jim, his eyes like saucers and his mouth hanging loose. Big Jim thinks the boy looks like his IQ might reach all the way up to seventy. Not that that's necessarily a bad thing, either. 'It looks like the end of the world, Mr Rennie,' he says.

'Nonsense. Are you Saved, son?'

'I guess so,' Mel says.

'Then you have nothing to worry about.' Big Jim surveys them one by one, ending with Carter Thibodeau. 'And the way to salvation tonight, young men, is all of you telling the same story.'

Not everyone sees the pink stars. Like the Appleton kids, Rusty Everett's Little Js are fast asleep. So is Piper. So is Andrea Grinnell. So is The Chef, sprawled on the dead grass beside what might be America's biggest methamphetamine lab. Ditto Brenda Perkins, who cried herself to sleep on her couch with the VADER printout scattered on the coffee table before her.

The dead also do not see, unless they look from a brighter place than this darkling plain where ignorant armies clash by night. Myra Evans, Duke Perkins, Chuck Thompson, and Claudette Sanders are tucked away in the Bowie Funeral Home; Dr Haskell, Mr Carty, and Rory Dinsmore are in the morgue of Catherine Russell Hospital; Lester Coggins, Dodee Sanders, and Angie McCain are still hanging out in the McCain pantry. So is Junior. He is between Dodee and Angie, holding their hands. His head aches, but only a little. He thinks he might sleep the night here.

On Motton Road, in Eastchester (not far from the place where the attempt to breach the Dome with an experimental acid compound is even then going on beneath the strange pink sky), Jack Evans, husband of the late Myra, is standing in his backyard with a bottle of Jack Daniels in one hand and his home protection weapon of choice, a Ruger SR9, in the other. He drinks and watches the pink stars fall. He knows what they are, and he wishes on every one, and he wishes for death, because without Myra, the bottom has dropped out of his life. He might be able to live without her, and he might be able to live like a rat in a glass cage, but he cannot manage both. When the falling meteors become more intermittent – this is around quarter after ten, about forty-five minutes after the shower began – he swallows the last of the Jack, casts the bottle onto the grass, and blows his brains out. He is The Mill's first official suicide.

He will not be the last.

18

Barbie, Julia, and Lissa Jamieson watched silently as the two space-suited soldiers removed the thin nozzle from the end of the plastic hose. They put it into an opaque plastic bag with a ziplock top, then put the bag into a metal case stenciled with the words **HAZARDOUS MATERIALS**. They locked it with separate keys, then took off their helmets. They looked tired, hot, and out of spirits.

Two older men – too old to be soldiers – wheeled a complicated-looking piece of equipment away from the site of the acid experiment, which had been performed three times. Barbie guessed the older guys, possibly scientists from NSA, had been doing some sort of spectrographic analysis. Or trying to. The gas masks they had been wearing during the testing procedure were now pushed up on top of their heads like weird hats. Barbie could have asked Cox what the tests were supposed to show, and Cox might even have given him a straight answer, but Barbie was also out of spirits.

Overhead, the last few pink meteoroids were zipping down the sky.

Lissa pointed back toward Eastchester. 'I heard something that sounded like a gunshot. Did you?'

'Probably a car backfiring or some kid shooting off a bottle rocket,' Julia said. She was also tired and drawn. Once, when it became clear that the experiment – the acid test, so to speak – wasn't going to work, Barbie had caught her wiping her eyes. It hadn't stopped her from taking pictures, with her Kodak, though.

Cox walked toward them, his shadow thrown in two different directions by the lights that had been set up. He gestured to the place where the door-shape had been sprayed on the Dome. 'I'd guess this little adventure cost the American taxpayer about three-quarters of a million dollars, and that's not counting the R&D expenses that went into developing the acid compound. Which ate the paint we sprayed on there and did absolutely fuck-all else.'

'Language, Colonel,' Julia said, with a ghost of her old smile.

'Thank you, Madam Editor,' Cox said sourly.

'Did you really think this would work?' Barbie asked.

'No, but I didn't think I'd ever live to see a man on Mars, either, but the Russians say they're going to send a crew of four in 2020.'

'Oh, I get it,' Julia said. 'The Martians got wind of it, and they're pissed.'

'If so, they retaliated on the wrong country,' Cox said . . . and Barbie saw something in his eyes.

'How sure are you, Jim?' he asked softly.

'I beg pardon?'

'That the Dome was put in place by extraterrestrials.'

Julia took two steps forward. Her face was pale, her eyes blazing. 'Tell us what you know, goddammit!'

Cox raised his hand. 'Stop. We don't know *anything*. There is a theory, however. Yes. Marty, come over here.'

One of the older gentlemen who had been running tests approached the Dome. He was holding his gas mask by the strap.

'Your analysis?' Cox asked, and when he saw the older gentleman's hesitation: 'Speak freely.'

'Well . . .' Marty shrugged. 'Trace minerals. Soil and airborne pollutants. Otherwise, nothing. According to spectrographic analysis, that thing isn't there.'

'What about the HY-908?' And, to Barbie and the women: 'The acid.'

'It's gone,' Marty said. 'The thing that isn't there ate it up.'

'Is that possible, according to what you know?'

'No. But the Dome isn't possible, according to what we know.'

'And does that lead you to believe that the Dome may be the creation of some life-form with more advanced knowledge of physics, chemistry, biology, whatever?' When Marty hesitated again, Cox repeated what he'd said earlier. 'Speak freely.'

'It's one possibility. It's also possible that some earthly supervillain set it up. A real-world Lex Luthor. Or it could be the work of a renegade country, like North Korea.'

'Who hasn't taken credit for it?' Barbie asked skeptically.

'I lean toward extraterrestrial,' Marty said. He knocked on the Dome without wincing; he'd already gotten his little shock from it. 'So do most of the scientists working on this right now – if we can be said to be working when we're not actually *doing* anything. It's the Sherlock Rule: When you eliminate the impossible, the answer, no matter how improbable, is what remains.'

'Has anyone or anything landed in a flying saucer and demanded to be taken to our leader?' Julia asked.

'No,' Cox said.

'Would you know if something had?' Barbie asked, and thought: *Are we having this discussion? Or am I dreaming it?*

'Not necessarily,' Cox said, after a brief hesitation.

'It could still be meteorological,' Marty said. 'Hell, even biological – a living thing. There's a school of thought that this thing is actually some kind of *E. coli* hybrid.'

'Colonel Cox,' Julia said quietly, 'are we something's experiment? Because that's what I feel like.'

Lissa Jamieson, meanwhile, was looking back toward the nice houses of the Eastchester burblet. Most of the lights there were out, either because the people who lived there had no generators or were saving them.

'That was a gunshot,' she said. 'I'm sure that was a gunshot.'

FEELING IT

1

Other than town politics, Big Jim Rennie had only one vice, and that was high school girls' basketball – Lady Wildcats basketball, to be exact. He'd had season tickets ever since 1998, and attended at least a dozen games a year. In 2004, the year the Lady Wildcats won the State Class D championship, he attended all of them. And although the autographs people noticed when they were invited into his home study were inevitably those of Tiger Woods, Dale Earnhardt, and Bill 'Spaceman' Lee, the one of which he was proudest – the one he treasured – was Hanna Compton's, the little sophomore point guard who had led the Lady Wildcats to that one and only gold ball.

When you're a season ticket holder, you get to know the other season ticket holders around you, and their reasons for being fans of the game. Many are relatives of the girls who play (and often the sparkplugs of the Booster Club, putting on bake sales and raising money for the increasingly expensive 'away' games). Others are basketball purists, who will tell you – with some justification – that the girls' games are just better. Young female players are invested in a team ethic that the boys (who love to run and gun, dunk, and shoot from way downtown) rarely match. The pace is slower, allowing you to see inside the game and enjoy every pick-and-roll or give-and-go. Fans of the girls' game relish the very low scores that boys' basketball fans sneer at, claiming that the girls' game puts a premium on defense and foul shooting, which are the very definition of old-school hoops.

There are also guys who just like to watch long-legged teenage girls run around in short pants.

Big Jim shared all these reasons for enjoying the sport, but his passion sprang from another source entirely, one he never vocalized when discussing the games with his fellow fans. It would not have been politic to do so.

The girls took the sport personally, and that made them better haters.

The boys wanted to win, yes, and sometimes a game could get hot if it was against a traditional rival (in the case of The Mills Wildcats sports teams, the despised Castle Rock Rockets), but mostly with the boys it was about individual accomplishments. Showing off, in other words. And when it was over, it was over.

The girls, on the other hand, loathed losing. They took loss back to the locker room and brooded over it. More importantly, they loathed and hated it as a *team*. Big Jim often saw that hate rear its head; during a loose ball-brawl deep in the second half with the score tied, he could pick up that *No you don't, you little bitch, that ball is MINE* vibe. He picked it up and fed on it.

Before 2004, the Lady Wildcats made the state tournament only once in twenty years, that appearance a one-and-done affair against Buckfield. Then had come Hanna Compton. The greatest hater of all time, in Big Jim's opinion.

As the daughter of Dale Compton, a scrawny pulp-cutter from Tarker's Mills who was usually drunk and always argumentative, Hanna had come by her out-of-my-face 'tude naturally enough. As a freshman she had played JV for most of the season; Coach swung her up to varsity only for the last two games, where she'd outscored everyone and left her opposite number from the Richmond Bobcats writhing on the hardwood after a hard but clean defensive play.

When that game was over, Big Jim had collared Coach Woodhead. 'If that girl doesn't start next year, you're crazy,' he said.

'I'm not crazy,' Coach Woodhead had replied.

Hanna had started hot and finished hotter, blazing a trail that Wildcats fans would still be talking about years later (season average: 27.6 points per game). She could spot up and drop a three-pointer any time she wanted, but what Big Jim liked best was to watch her split the defense and drive for the basket, her pug face set in a sneer of concentration, her bright black eyes daring anyone to get in her way, her short ponytail sticking out behind her like a raised middle finger. The Mill's Second Selectman and premier used car dealer had fallen in love.

In the 2004 championship game, the Lady Wildcats had been leading the Rock Rockets by ten when Hanna fouled out. Luckily for the Cats, there was only a buck-sixteen left to play. They ended up winning by a single point. Of their eighty-six total points, Hanna Compton had scored a brain-freezing *sixty-three*. That spring, her argumentative dad had ended up behind the wheel of a brand-new Cadillac, sold to him at cost-minus-forty-percent by James Rennie, Sr. New cars weren't Big Jim's business, but when he wanted one 'off the back of the carrier,' he could always get it.

Sitting in Peter Randolph's office, with the last of the pink meteor shower still fading away outside (and his problem children waiting – anxiously, Big Jim hoped – to be summoned and told their fate), Big Jim recalled that fabulous, that outright *mythic*, basketball

game; specifically the first eight minutes of the second half, which had begun with the Lady Wildcats down by nine.

Hanna had taken the game over with the single-minded brutality of Joseph Stalin taking over Russia, her black eyes glittering (and seemingly fixed upon some basketball Nirvana beyond the sight of normal mortals), her face locked in that eternal sneer that said, *I'm better than you, I'm the best, get out of my way or I'll run you the fuck down.* Everything she threw up during that eight minutes had gone in, including one absurd half-court shot that she launched when her feet tangled together, getting rid of the rock just to keep from being called for traveling.

There were phrases for that sort of run, the most common being *in the zone.* But the one Big Jim liked was *feeling it,* as in 'She's really *feeling it* now.' As though the game had some divine texture beyond the reach of ordinary players (although sometimes even ordinary players *felt it,* and were transformed for a brief while into gods and goddesses, every bodily defect seeming to disappear during their transitory divinity), a texture that on special nights could be touched: some rich and marvelous drape such as must adorn the hardwood halls of Valhalla.

Hanna Compton had never played her junior year; the championship game had been her valedictory. That summer, while driving drunk, her father had killed himself, his wife, and all three daughters while driving back to Tarker's Mills from Brownie's, where they had gone for ice cream frappes. The bonus Cadillac had been their coffin.

The multiple-fatality crash had been front-page news in western Maine — Julia Shumway's *Democrat* published an issue with a black border that week — but Big Jim had not been grief-stricken. Hanna never would have played college ball, he suspected; there the girls were bigger, and she might have been reduced to role-player status. She never would have stood for that. Her hate had to be fed by constant action on the floor. Big Jim understood completely. He sympathized completely. It was the main reason he had never even considered leaving The Mill. In the wider world he might have made more money, but wealth was the short beer of existence. Power was champagne.

Running The Mill was good on ordinary days, but in times of crisis it was better than good. In times like that you could fly on the pure wings of intuition, knowing that you couldn't screw up, absolutely *couldn't.* You could read the defense even before the defense had coalesced, and you scored every time you got the ball. You were *feeling it,* and there was no better time for that to happen than in a championship game.

This was *his* championship game, and everything was breaking his way. He had the sense – the total belief – that nothing could go wrong during this magical passage; even things that seemed wrong would become opportunities rather than stumbling blocks, like Hanna's desperation half-court shot that had brought the whole Derry Civic Center to its feet, the Mills fans cheering, the Castle Rockers raving in disbelief.

Feeling it. Which was why he wasn't tired, even though he should have been exhausted. Which was why he wasn't worried about Junior, in spite of Junior's reticence and pale watchfulness. Which was why he wasn't worried about Dale Barbara and Barbara's troublesome coterie of friends, most notably the newspaper bitch. Which was why, when Peter Randolph and Andy Sanders looked at him, dumbfounded, Big Jim only smiled. He could afford to smile. He was *feeling it.*

'Close the supermarket?' Andy asked. 'Won't that get a lot of people upset, Big Jim?'

'The supermarket and the Gas and Grocery,' Big Jim corrected, still smiling. 'Brownie's we don't have to worry about, it's already closed. A good thing, too – it's a dirty little place.' *Selling dirty little magazines*, he did not add.

'Jim, there's still plenty of supplies at Food City,' Randolph said. 'I spoke to Jack Cale about that just this afternoon. Meat's thin, but everything else is holding up.'

'I know that,' Big Jim said. 'I understand inventory, and Cale does, too. He should; he's Jewish, after all.'

'Well . . . I'm just saying everything's been orderly so far, because people keep their pantries well stocked.' He brightened. 'Now, I could see ordering *shorter* hours at Food City. I think Jack could be talked into that. He's probably already thinking ahead to it.'

Big Jim shook his head, still smiling. Here was another example of how things broke your way when you were *feeling it.* Duke Perkins would have said it was a mistake to put the town under any extra stress, especially after this night's unsettling celestial event. Duke was dead, however, and that was more than convenient; it was divine.

'Closed up,' he repeated. 'Both of them. Tight as ticks. And when they reopen, *we'll* be the ones handing out supplies. Stuff will last longer, and the distribution will be fairer. I'll announce a rationing plan at the Thursday meeting.' He paused. 'If the Dome isn't gone by then, of course.'

Andy said hesitantly, 'I'm not sure we have the authority to close down businesses, Big Jim.'

'In a crisis like this, we not only have the authority, we have the responsibility.' He clapped Pete Randolph heartily on the back. The Mill's new Chief wasn't expecting it and gave out a startled squeak.

'What if it starts a panic?' Andy was frowning.

'Well, that's a possibility,' Big Jim said. 'When you kick a nest of mice, they're all apt to come running out. We may have to increase the size of our police force quite a bit if this crisis doesn't end soon. Yes, quite a bit.'

Randolph looked startled. 'We're going on twenty officers now. Including—' He cocked his head toward the door.

'Yep,' Big Jim said, 'and speaking of those fellers, better bring em in, Chief, so we can finish this and send them home to bed. I think they're going to have a busy day tomorrow.'

And if they get roughed up a little, so much the better. They deserve it for not being able to keep their jackhandles in their pants.

2

Frank, Carter, Mel, and Georgia shuffled in like suspects onto a police lineup stage. Their faces were set and defiant, but the defiance was thin; Hanna Compton would have laughed at it. Their eyes were down, studying their shoes. It was clear to Big Jim that they expected to be fired, or worse, and that was just fine with him. Fright was the easiest of emotions to work with.

'Well,' he said. 'Here are the brave officers.'

Georgia Roux muttered something under her breath.

'Speak up, honeybunch.' Big Jim cupped a hand to his ear.

'Said we didn't do nothing wrong,' she said. Still in that teacher's-being-mean-to-me mumble.

'Then exactly what *did* you do?' And, when Georgia, Frank, and Carter all started to talk at once, he pointed at Frankie. 'You.' *And make it good, for gosh sake.*

'We *were* out there,' Frank said, 'but she invited us.'

'Right!' Georgia cried, folding her arms below her considerable bosom. '*She*—'

'Shut it.' Big Jim pointed a hammy finger at her. 'One speaks for all. That's how it works when you're a team. Are you a team?'

Carter Thibodeau saw where this was going. 'Yes, sir, Mr Rennie.'

'Glad to hear it.' Big Jim nodded for Frank to go on.

'She said she had some beers,' Frank said. 'That's the only reason we went out. Can't buy it in town, as you know. Anyway, we were

sitting around, drinking beers – just a can each, and we were pretty much off-duty—'

'*Completely* off-duty,' the Chief put in. 'Isn't that what you meant?'

Frank nodded respectfully. 'Yes, sir, that's what I meant to say. We drank our beers and then said we'd better go, but she said she appreciated what we were doing, every one of us, and wanted to say thank you. Then she kind of spread her legs.'

'Showing her woofer, you know,' Mel clarified with a large and vacant smile.

Big Jim winced and gave silent thanks that Andrea Grinnell wasn't here. Dope addict or not, she could have gone all politically correct in a situation like this.

'She took us in the bedroom one by one,' Frankie said. 'I know it was a bad decision, and we're all sorry, but it was purely voluntary on her part.'

'I'm sure it was,' Chief Randolph said. 'That girl has quite a reputation. Her husband, too. You didn't see any drugs out there, did you?'

'No, sir.' A four-part chorus.

'And you didn't hurt her?' Big Jim asked. 'I understand she's claiming she was punched around and whatnot.'

'Nobody hurt her,' Carter said. 'Can I say what I think happened?'

Big Jim flapped an assenting hand. He was beginning to think that Mr Thibodeau had possibilities.

'She probably fell down after we left. Maybe a couple of times. She was pretty drunk. Child Welfare should take that kid away from her before she kills it.'

No one picked up on that. In the town's current situation, the Child Welfare office in Castle Rock might as well have been on the moon.

'So basically, you're all clean,' Big Jim said.

'As a whistle,' Frank replied.

'Well, I think we're satisfied.' Big Jim looked around. 'Are we satisfied, gentlemen?'

Andy and Randolph nodded, looking relieved.

'Good,' Big Jim said. 'Now, it's been a long day – an *eventful* day – and we all need some sleep, I'm sure. You young officers especially need it, because you'll report back for duty at seven a.m. tomorrow. The supermarket and the Gas and Grocery are both going to be closed for the duration of this crisis, and Chief Randolph thought that you'd be just the ones to guard Food City in case the people

who show up there don't take kindly to the new order of things. Think you're up to that, Mr Thibodeau? With your . . . your war wound?'

Carter flexed his arm. 'I'm okay. Her dog didn't rip the tendon none.'

'We can put Fred Denton with them, too,' Chief Randolph said, getting into the spirit of the thing. 'Wettington and Morrison at the Gas and Grocery should be enough.'

'Jim,' Andy said, 'maybe we should put the more experienced officers at Food City, and the *less* experienced ones at the smaller—'

'I don't think so,' Big Jim said. Smiling. *Feeling it.* 'These young folks are the ones we want at Food City. The very ones. And another thing. A little bird told me that some of you folks have been carrying weapons in your cars, and a couple have even been wearing them on foot patrol.'

Silence greeted this.

'You're *probationary* officers,' Big Jim said. 'If you've got personal handguns, that's your right as Americans. But if I hear that any of you are strapped while standing out in front of Food City tomorrow and dealing with the good folks of this town, your police officer days are over.'

'Absolutely right,' Randolph said.

Big Jim surveyed Frank, Carter, Mel, and Georgia. 'Any problems with that? Any of you?'

They didn't look happy about it. Big Jim hadn't expected that they would be, but they were getting off easy. Thibodeau kept flexing his shoulder and his fingers, testing them.

'What if they weren't loaded?' Frank asked. 'What if they were just there, you know, as a warning?'

Big Jim raised a teacherly finger. 'I'm going to tell you what my father told me, Frank – there's no such thing as an unloaded gun. We've got a good town here. They'll behave, that's what I'm banking on. If *they* change, *we'll* change. Got it?'

'Yessir, Mr Rennie.' Frank didn't sound happy about it. That was fine with Big Jim.

He rose. Only instead of leading them out, Big Jim extended his hands. He saw their hesitation and nodded, still smiling. 'Come on, now. Tomorrow's going to be a big day, and we don't want to let this one go without a word of prayer. So grab on.'

They grabbed on. Big Jim closed his eyes and bowed his head. 'Dear Lord—'

It went on for some time.

3

Barbie mounted the outside steps to his apartment at a few minutes to midnight, his shoulders sagging with weariness, thinking that the only thing in the world he wanted was six hours of oblivion before answering the alarm and going up to Sweetbriar Rose to cook breakfast.

The weariness left him as soon as he snapped on the lights – which, courtesy of Andy Sanders's generator, still worked.

Someone had been in here.

The sign was so subtle that at first he couldn't isolate it. He closed his eyes, then opened them and let them swing casually about his combination living-room/kitchenette, trying to take in every-thing. The books he'd been planning to leave behind hadn't been moved around on the shelves; the chairs were where they had been, one under the lamp and the other by the room's only window, with its scenic view of the alley outside; the coffee cup and the toast plate were still in the dish drainer beside the tiny sink.

Then it clicked home, as such things usually did if you didn't push too hard. It was the rug. What he thought of as his Not Lindsay rug.

About five feet long and two wide, Not Lindsay was a repeating diamond pattern in blue, red, white, and brown. He had bought it in Baghdad, but had been assured by an Iraqi policeman he trusted that it was of Kurdish manufacture. 'Very old, very beautiful,' the policeman had said. His name was Latif abd al-Khaliq Hassan. A good troop. 'Look Turkey, but no-no-no.' Big grin. White teeth. A week after that day in the marketplace, a sniper's bullet had blown Latif abd al-Khaliq Hassan's brains right out through the back of his head. 'Not Turkey, Iraqi!'

The rug-merchant wore a yellow tee-shirt that had said DON'T SHOOT ME, I'M ONLY THE PIANO PLAYER. Latif listened to him, nodding. They laughed together. Then the merchant had made a startlingly American jackoff gesture and they laughed even harder.

'What was that about?' Barbie had asked.

'He says American senator bought five like these. Lindsay Graham. Five rug, five hundred dollar. Five hundred out front, for press. More on the down-low. But all senator rug fake. Yes-yes-yes. This one not fake, this one real. I, Latif Hassan, tell you this, Barbie. Not Lindsay Graham rug.'

Latif had raised his hand and Barbie slapped him five. That had been a good day. Hot, but good. He had bought the rug for two

hundred dollars American and an all-territories Coby DVD player. Not Lindsay was his one souvenir of Iraq, and he never stepped on it. He always stepped around it. He had planned to leave it behind when he left The Mill – he supposed down deep his idea had been to leave *Iraq* behind when he left The Mill, but fat chance of that. Wherever you went, there you were. The great Zen truth of the age.

He hadn't stepped on it, he was superstitious about that, he always detoured around it, as if to step on it would activate some computer in Washington and he would find himself back in Baghdad or fucking Fallujah. But *somebody* had, because Not Lindsay was mussed. Wrinkled. And a little crooked. It had been perfectly straight when he left this morning, a thousand years ago.

He went into the bedroom. The coverlet was as neat as always, but that sense that someone had been here was equally strong. Was it a lingering smell of sweat? Some psychic vibe? Barbie didn't know and didn't care. He went to his dresser, opened the top drawer, and saw that the pair of extra-faded jeans which had been on top of the pile was now on the bottom. And his khaki shorts, which he'd laid in with the zippers up, were now zippers-down.

He went immediately to the second drawer, and the socks. It took less than five seconds to verify that his dog tags were gone, and he wasn't surprised. No, not surprised at all.

He grabbed the disposable cell he had also been planning to leave behind and went back into the main room. The combined Tarker's–Chester's telephone directory was sitting on a table by the door, a book so skinny it was almost a pamphlet. He looked for the number he wanted, not really expecting it to be there; Chiefs of Police did not make a practice of listing their home phone numbers.

Except, it seemed, in small towns, they did. At least this one had, although the listing was discreet: **H and B Perkins 28 Morin Street.** Even though it was now past midnight, Barbie punched in the number without hesitation. He couldn't afford to wait. He had an idea that time might be extremely short.

4

Her phone was tweeting. Howie, no doubt, calling to tell her he was going to be late, to just lock up the house and go to bed—

Then it came down on her again, like unpleasant presents raining from a poison piñata: the realization that Howie was dead. She didn't know who could be calling her at – she checked her watch – twenty past midnight, but it wasn't Howie.

She winced as she sat up, rubbing her neck, cursing herself for falling asleep on the couch, also cursing whoever had wakened her at such an ungodly hour and refreshed her recollection of her strange new singularity.

Then it occurred to her that there could be only one reason for such a late call: the Dome was either gone or had been breached. She bumped her leg on the coffee table hard enough to make the papers there rattle, then limped to the phone beside Howie's chair (how it hurt her to look at that empty chair) and snatched it up. 'What? *What?*'

'It's Dale Barbara.'

'Barbie! Has it broken? Has the Dome broken?'

'No. I wish that's why I was calling, but it's not.'

'Then *why*? It's almost twelve-thirty in the morning!'

'You said your husband was investigating Jim Rennie.'

Brenda paused, getting the sense of this. She had put her palm against the side of her throat, the place where Howie had caressed her for the last time. 'He was, but I told you, he had no absolute—'

'I remember what you said,' Barbie told her. 'You need to listen to me, Brenda. Can you do that? Are you awake?'

'I am now.'

'Your husband had notes?'

'Yes. On his laptop. I printed them.' She was looking at the VADER file, spread out on the coffee table.

'Good. Tomorrow morning, I want you to put the printout in an envelope and take it to Julia Shumway. Tell her to put it in a safe place. An actual safe, if she's got one. A cash strongbox or a locked file cabinet, if she doesn't. Tell her she's only to open it if something happens to you or me or both of us.'

'You're scaring me.'

'She is *not* to open it otherwise. If you tell her that, will she do it? My instincts say she will.'

'Of course she will, but why not let her look?'

'Because if the editor of the local paper sees what your husband had on Big Jim and Big Jim *knows* she's seen it, most of the leverage we have will be gone. Do you follow that?'

'Ye-es . . .' She found herself wishing desperately that Howie were the one having this post-midnight conversation.

'I said I might be arrested today if the missile strike didn't work. Do you remember me telling you that?'

'Of course.'

'Well, I wasn't. That fat sonofabitch knows how to bide his

time. But he won't bide it much longer. I'm almost positive it's going to happen tomorrow – later today, I mean. If, that is, you can't put a stop to it by threatening to air whatever dirt your husband dug up.'

'What do you think they're going to arrest you for?'

'No idea, but it won't be shoplifting. And once I'm in jail, I think I might have an accident. I saw plenty of accidents like that in Iraq.'

'That's crazy.' But it had the horrid plausibility she had some-times experienced in nightmares.

'Think about it, Brenda. Rennie has something to cover up, he needs a scapegoat, and the new Police Chief is in his pocket. The stars are in alignment.'

'I was planning to go see him anyway,' Brenda said. 'And I was going to take Julia with me, for safety's sake.'

'Don't take Julia,' he said, 'but don't go alone.'

'You don't actually think he'd—'

'I don't know what he'd do, how far he'd go. Who do you trust besides Julia?'

She flashed back to that afternoon, the fires almost out, standing beside Little Bitch Road, feeling good in spite of her grief because she was flush with endorphins. Romeo Burpee telling her she ought to at least stand for Fire Chief.

'Rommie Burpee,' she said.

'Okay, then he's the one.'

'Do I tell him what Howie had on—'

'No,' Barbie said. 'He's just your insurance policy. And here's another one: lock up your husband's laptop.'

'Okay . . . but if I lock up the laptop and leave the printout with Julia, what am I going to show Jim? I guess I could print a second copy—'

'No. One of those floating around is enough. For now, at least. Putting the fear of God into him is one thing. Freaking him out would make him too unpredictable. Brenda, do you believe he's dirty?'

She did not hesitate. 'With all my heart.' *Because Howie believed it – that's good enough for me.*

'And you remember what's in the file?'

'Not the exact figures and the names of all the banks they used, but enough.'

'Then he'll believe you,' Barbie said. 'With or without a second copy of the paperwork, he'll believe you.'

5

Brenda put the VADER file in a manila envelope. On the front she printed Julia's name. She put the envelope on the kitchen table, then went into Howie's study and locked his laptop in the safe. The safe was small and she had to turn the Mac on its side, but in the end it just fit. She finished by giving the combination dial not just one but two spins, as per her dead husband's instructions. As she did, the lights went out. For a moment some primitive part of her was certain she had blown them just by giving the dial that extra spin.

Then she realized that the generator out back had died.

6

When Junior came in at five minutes past six on Tuesday morning, his pale cheeks stubbly, his hair standing up in haystacks, Big Jim was sitting at the kitchen table in a white bathrobe the approximate size of a clipper ship's mainsail. He was drinking a Coke.

Junior nodded at it. 'A good day starts with a good breakfast.'

Big Jim raised the can, took a swallow, and set it down. 'There's no coffee. Well, there is, but there's no electricity. The generator's out of LP. Grab yourself a pop, why don't you? They're still fairly cold, and you look like you could use it.'

Junior opened the fridge and peered into its dark interior. 'Am I supposed to believe you couldn't score some bottled gas anytime you wanted it?'

Big Jim started a little at that, then relaxed. It was a reasonable question, and didn't mean Junior knew anything. *The guilty man flees where none pursueth*, Big Jim reminded himself.

'Let's just say it might not be politic at this point in time.'

'Uh-huh.'

Junior closed the refrigerator door and sat down on the other side of the table. He looked at his old man with a certain hollow amusement (which Big Jim mistook for affection).

The family that slays together stays together, Junior thought. *At least for the time being. As long as it's* . . .

'Politic,' he said.

Big Jim nodded and studied his son, who was supplementing his early-morning beverage with a Big Jerk beefstick.

He did not ask *Where have you been?* He did not ask *What's wrong with you?*, although it was obvious, in the unforgiving first

light that flooded the kitchen, that something was. But he *did* have a question.

'There are bodies. Plural. Is that right?'

'Yes.' Junior took a big bite of his beefstick and washed it down with Coke. The kitchen was weirdly silent without the hum of the fridge and the burble of the Mr Coffee.

'And all these bodies can be laid at Mr Barbara's door?'

'Yes. All.' Another chomp. Another swallow. Junior looking at him steadily, rubbing his left temple as he did so.

'Can you plausibly discover those bodies around noon today?'

'No prob.'

'And the evidence against our Mr Barbara, of course.'

'Yes.' Junior smiled. 'It's good evidence.'

'Don't report to the police station this morning, son.'

'I better,' Junior said. 'It might look funny if I don't. Besides, I'm not tired. I slept with . . .' He shook his head. 'I slept, leave it at that.'

Big Jim also did not ask *Who did you sleep with?* He had other concerns than whom his son might be diddling; he was just glad the boy hadn't been among the fellows who'd done their business with that nasty piece of trailer trash out on Motton Road. Doing business with that sort of girl was a good way to catch something and get sick.

He's already sick, a voice in Big Jim's head whispered. It might have been the fading voice of his wife. *Just look at him.*

That voice was probably right, but this morning he had greater concerns than Junior Rennie's eating disorder, or whatever it was.

'I didn't say go to bed. I want you on motor patrol, and I want you to do a job for me. Just stay away from Food City while you're doing it. There's going to be trouble there, I think.'

Junior's eyes livened up. 'What kind of trouble?'

Big Jim didn't answer directly. 'Can you find Sam Verdreaux?'

'Sure. He'll be in that little shack out on God Creek Road. Ordinarily he'd be sleeping it off, but today he's more apt to be shaking himself awake with the DTs.' Junior snickered at this image, then winced and went back to rubbing his temple. 'You really think I'm the person to talk to him? He's not my biggest fan right now. He's probably even deleted me from his Facebook page.'

'I don't understand.'

'It's a joke, Dad. Forget it.'

'Do you think he'd warm up to you if you offered him three quarts of whiskey? And more later, if he does a good job?'

'That skanky old bastard would warm up to me if I offered him half a juice glass of Two-Buck Chuck.'

'You can get the whiskey from Brownie's,' Big Jim said. In addition to cheapass groceries and beaver-books, Brownie's was one of three agency liquor stores in The Mill, and the PD had keys to all three. Big Jim slid the key across the table. 'Back door. Don't let anyone see you going in.'

'What's Sloppy Sam supposed to do for the booze?'

Big Jim explained. Junior listened impassively . . . except for his bloodshot eyes, which danced. He had only one more question: Would it work?

Big Jim nodded. 'It will. I'm *feeling it*.'

Junior took another chomp on his beefstick and another swallow of his soda. 'So'm I, Dad,' he said. 'So'm I.'

7

When Junior was gone, Big Jim went into his study with his robe billowing grandly around him. He took his cell phone from the center drawer of his desk, where he kept it as much as possible. He thought they were Godless things that did nothing but encourage a lot of loose and useless talk – how many man-hours had been lost to useless gabble on these things? And what kind of nasty rays did they shoot into your head while you were gabbling?

Still, they could come in handy. He reckoned that Sam Verdreaux would do as Junior told him, but he also knew it would be foolish not to take out insurance.

He selected a number in the cell phone's 'hidden' directory, which could be accessed only via numeric code. The phone rang half a dozen times before it was picked up. '*What?*' the sire of the multi-tudinous Killian brood barked.

Big Jim winced and held the phone away from his ear for a second. When he put it back, he heard low clucking sounds in the background. 'Are you in the chickenhouse, Rog?'

'Uh . . . yessir, Big Jim, I sure am. Chickens got to be fed, come hell or high water.' A 180-degree turn from irritation to respect. And Roger Killian *ought* to be respectful; Big Jim had made him a gosh-darn millionaire. If he was wasting what could have been a good life with no financial worries by still getting up at dawn to feed a bunch of chickens, that was God's will. Roger was too dumb to stop. It was his heaven-sent nature, and would no doubt serve Big Jim well today.

And the town, he thought. *It's the town I'm doing this for. The good of the town.*

'Roger, I've got a job for you and your three oldest sons.'

'Only got two t'home,' Roger said. In his thick Yankee accent, *home* came out *hum*. 'Ricky and Randall are here, but Roland was in Oxford buying feed when the Christing Dome came down.' He paused and considered what he had just said. In the background, the chickens clucked. 'Sorry about the profanity.'

'I'm sure God forgives you,' Big Jim said. 'You and your *two* oldest, then. Can you get them to town by—' Big Jim calculated. It didn't take long. When you were *feeling it*, few decisions did. 'Say, nine o'clock, nine fifteen at the latest?'

'I'll have to rouse em, but sure,' Roger said. 'What are we doin? Bringin in some of the extra propa—'

'No,' Big Jim said, 'and you hush about that, God love you. Just listen.'

Big Jim talked.

Roger Killian, God love him, listened.

In the background roughly eight hundred chickens clucked as they stuffed themselves with steroid-laced feed.

8

'What? *What? Why?*'

Jack Cale was sitting at his desk in the cramped little Food City manager's office. The desk was littered with inventory lists he and Ernie Calvert had finally completed at one in the morning, their hopes of finishing earlier dashed by the meteor shower. Now he swept them up – handwritten on long yellow legal-pad sheets – and shook them at Peter Randolph, who stood in the office doorway. The new Chief had dolled up in full uniform for this visit. 'Look at these, Pete, before you do something foolish.'

'Sorry, Jack. Market's closed. It'll reopen on Thursday, as a food depot. Share and share alike. We'll keep all the records, Food City Corp won't lose a cent, I promise you—'

'That's not the *point*,' Jack nearly groaned. He was a baby-faced thirtysomething with a thatch of wiry red hair he was currently torturing with the hand not holding out the yellow sheets . . . which Peter Randolph showed no signs of taking.

'Here! Here! What in the name of jumped-up Jack Sprat Jesus are you talking about, Peter Randolph?'

Ernie Calvert came barreling up from the basement storage area. He was broad-bellied and red-faced, his gray hair mowed into the crewcut he'd worn all his life. He was wearing a green Food City duster.

'He wants to close the market!' Jack said.

'Why in God's name would you want to do that, when there's still plenty of food?' Ernie asked angrily. 'Why would you want to go scaring people like that? They'll be plenty scared in time, if this goes on. Whose dumb idea was this?'

'Selectmen voted,' Randolph said. 'Any problems you have with the plan, take them up at the special town meeting on Thursday night. If this isn't over by then, of course.'

'*What* plan?' Ernie shouted. 'Are you telling me Andrea Grinnell was in favor of this? She knows better!'

'I understand she's got the flu,' Randolph said. 'Flat on her back. So Andy decided. Big Jim seconded the decision.' No one had told him to put it this way; no one had to. Randolph knew how Big Jim liked to do business.

'Rationing might make sense at some point,' Jack said, 'but why now?' He shook the sheets again, his cheeks almost as red as his hair. 'Why, when we've still got so *much?*'

'That's the best time to start conserving,' Randolph said.

'That's rich, coming from a man with a powerboat on Sebago Lake and a Winnebago Vectra in his dooryard,' Jack said.

'Don't forget Big Jim's Hummer,' Ernie put in.

'Enough,' Randolph said. 'The Selectmen decided—'

'Well, *two* of them did,' Jack said.

'You mean *one* of them did,' Ernie said. 'And we know which one.'

'—and I carried the message, so there's an end to it. Put a sign in the window. MARKET CLOSED UNTIL FURTHER NOTICE.'

'Pete. Look. Be reasonable.' Ernie no longer seemed angry; now he seemed almost to be pleading. 'That'll scare the dickens out of people. If you're set on this, how about I put CLOSED FOR INVENTORY, WILL REOPEN SOON? Maybe add SORRY FOR THE TEMPORARY INCONVENIENCE. Put TEMPORARY in red, or something.'

Peter Randolph shook his head slowly and weightily. 'Can't let you, Ern. Couldn't let you even if you were still an official employee, like him.' He nodded to Jack Cale, who had put down the inventory sheets so he could torture his hair with both hands. 'CLOSED UNTIL FURTHER NOTICE. That's what the Selectmen told me, and I carry out their orders. Besides, lies always come back to bite you on the ass.'

'Yeah, well, Duke Perkins would have told them to take this particular order and *wipe* their asses with it,' Ernie said. 'You ought

to be ashamed, Pete, carrying that fat shit's water. He says jump, you ask how high.'

'You want to shut up right now, if you know what's good for you,' Randolph said, pointing at him. The finger shook a little. 'If you don't want to spend the rest of the day in jail on a disrespect charge, you just want to close your mouth and follow orders. This is a crisis situation—'

Ernie looked at him unbelievingly. '"Disrespect charge?" No such animal!'

'There is now. If you don't believe it, go on and try me.'

9

Later on – much too late to do any good – Julia Shumway would piece together most of how the Food City riot started, although she never got a chance to print it. Even if she had, she would have done so as a pure news story: the five Ws and the H. If asked to write about the emotional heart of the event, she would have been lost. How to explain that people she'd known all her life – people she respected, people she loved – had turned into a mob? She told herself *I could've gotten a better handle on it if I'd been there from the very beginning and seen how it started*, but that was pure rationalization, a refusal to face the orderless, reasonless beast that can arise when frightened people are provoked. She had seen such beasts on the TV news, usually in foreign countries. She never expected to see one in her own town.

And there was no need for it. This was what she kept coming back to. The town had been cut off for only seventy hours, and it was stuffed with provisions of almost every kind; only propane gas was in mysteriously short supply.

Later she would say, *It was the moment when this town finally realized what was happening*. There was probably truth in the idea, but it didn't satisfy her. All she could say with complete certainty (and she said it only to herself) was that she watched her town lose its mind, and afterward she would never be the same person.

10

The first two people to see the sign are Gina Buffalino and her friend Harriet Bigelow. Both girls are dressed in white nurse's uniforms (this was Ginny Tomlinson's idea; she felt the whites inspired more confidence among the patients than candy-striper pinafores), and they look most seriously cute. They also look tired, in spite of their youthful

resiliency. It has been a hard two days, and another is ahead of them, after a night of short sleep. They have come for candy bars – they will get enough for everyone but poor diabetic Jimmy Sirois, that's the plan – and they are talking about the meteor shower. The conversation stops when they see the sign on the door.

'The market *can't* be closed,' Gina says unbelievingly. 'It's Tuesday morning.' She puts her face to the glass with her hands cupped to the sides to cut the glare of the bright morning sun.

While she's so occupied, Anson Wheeler drives up with Rose Twitchell riding shotgun. They have left Barbie back at Sweetbriar, finishing up the breakfast service. Rose is out of the little panel truck with her namesake painted on the side even before Anson has turned off the engine. She has a long list of staples, and wants to get as much as she can, as soon as she can. Then she sees CLOSED UNTIL FURTHER NOTICE posted on the door.

'What the hell? I saw Jack Cale just last night, and he never said a word about this.'

She's speaking to Anson, who's chugging along in her wake, but it's Gina Buffalino who answers. 'It's still full of stuff, too. All the shelves are stocked.'

Other people are pulling in. The market is due to open in five minutes, and Rose isn't the only one who planned to get an early start on her marketing; folks from all over town woke up to find the Dome still in place and decided to stock up on supplies. Asked later to explain this sudden rush of custom, Rose would say: 'The same thing happens every winter when the Weather Bureau upgrades a storm warning to a blizzard warning. Sanders and Rennie couldn't have picked a worse day to pull this bullshit.'

Among the early arrivals are Units Two and Four of the Chester's Mill PD. Close behind them comes Frank DeLesseps in his Nova (he's ripped off the ASS, GAS, OR GRASS sticker, feeling it hardly becomes an officer of the law). Carter and Georgia are in Two; Mel Searles and Freddy Denton in Four. They have been parked down the street by LeClerc's Maison des Fleurs, by order of Chief Randolph. 'No need to get there too soon,' he has instructed them. 'Wait until there are a dozen or so cars in the parking lot. Hey, maybe they'll just read the sign and go home.'

This doesn't happen, of course, just as Big Jim Rennie knew it wouldn't. And the appearance of the officers – especially such young and callow ones, for the most part – acts as an incitement rather than a calmative. Rose is the first to begin haranguing them. She picks on Freddy, showing him her long list of supplies, then pointing through

the window, where most of the stuff she wants is ranked neatly on the shelves.

Freddy is polite to begin with, aware that people (not quite a crowd, not yet) are watching, but it's hard to keep his temper with this mouthy little pipsqueak in his face. Doesn't she realize he's only following orders?

'Who do you think is feeding this town, Fred?' Rose asks. Anson puts a hand on her shoulder. Rose shakes it off. She knows Freddy is seeing rage instead of the deep distress she feels, but she can't help it. 'Do you think a Sysco truck full of supplies is just going to parachute down from the sky?'

'Ma'am—'

'Oh, can it! Since when am I a ma'am to you? You've been eating blueberry pancakes and that nasty limp bacon you like at my place four and five days a week for twenty years, and calling me Rosie while you did it. But you won't be eating pancakes tomorrow unless I get some *flour* and some *shortening* and some *syrup* and . . .' She breaks off. 'Finally! Sense! Thank You, God!'

Jack Cale is opening one of the double doors. Mel and Frank have taken up station in front of it, and he has just room to squeeze between them. The prospective shoppers – there are nearly two dozen now, even though the market's official opening time of nine a.m. is still a minute away – surge forward, only to stop when Jack selects a key from the bunch on his belt, and locks up again. There's a collective groan.

'Why the hell'd you do that?' Bill Wicker calls out indignantly. 'My wife sent me down for aigs!'

'Take it up with the Selectmen and Chief Randolph,' Jack responds. His hair is raring every whichway. He throws Frank DeLesseps a black look and fires an even blacker one at Mel Searles, who is trying unsuccessfully to suppress a grin, perhaps even his famous *nyuck-nyuck-nyuck*. 'I know *I* will. But for now, I've had enough of this shit. I'm done.' He strides off through the crowd with his head down and his cheeks burning even brighter than his hair. Lissa Jamieson, just arriving on her bicycle (everything on her list will fit into the milk box perched on the rear fender; her wants are small-going-on-minuscule), has to swerve to avoid him.

Carter, Georgia, and Freddy are ranged in front of the large plate-glass window, where Jack would have set out wheelbarrows and fertilizer on an ordinary day. Carter's fingers are Band-Aided, and a thicker bandage bulks under his shirt. Freddy has his hand on his gun-butt as Rose Twitchell continues to chew on him, and Carter

wishes he could backhand her one. His fingers are okay, but his shoulder aches a bitch. The small cluster of would-be shoppers has become a large cluster, and more cars are turning into the parking lot.

Before Officer Thibodeau can really study the crowd, however, Alden Dinsmore gets into his personal space. Alden looks haggard, and seems to have lost twenty pounds since the death of his son. He's wearing a black mourning band on his left arm and seems dazed.

'Need to go in, son. My wife sent me to stock up on the canned.' Alden doesn't say the canned what. Probably the canned everything. Or maybe he just got thinking about the empty bed upstairs, the one that will never be filled again, and the Foo Fighters poster that will never be looked at again, and the model airplane on the desk that will never be finished, and clean forgot.

'Sorry, Mr Dimmesdale,' Carter says. 'You can't do that.'

'It's Dinsmore,' Alden says in a dazed voice. He starts toward the doors. They are locked, no way he can get in, but Carter still gives the farmer a good hearty shove backward. For the first time, Carter has some sympathy for the teachers who used to send him to detention back in high school; it is irritating not to be minded.

Also it's hot and his shoulder aches in spite of the two Percocet his mother gave him. Seventy-five at nine a.m. is rare in October, and the faded blue color of the sky says it will be hotter by noon, hotter still by three p.m.

Alden stumbles backward into Gina Buffalino, and they both would fall if not for Petra Searles – no lightweight she – steadying them. Alden doesn't look angry, only puzzled. 'M'wife sent me for the canned,' he explains to Petra.

A mutter comes from the gathering people. It's not an angry sound – not quite yet. They came for groceries and the groceries are there but the door is locked. Now a man has been shoved by a high-school dropout who was a car mechanic last week.

Gina is looking at Carter, Mel, and Frank DeLesseps with widening eyes. She points. 'Those are the guys that raped her!' she tells her friend Harriet without lowering her voice. 'Those are the guys that raped Sammy Bushey!'

The smile disappears from Mel's face; the urge to *nyuck-nyuck* has left him. 'Shut up,' he says.

At the back of the crowd, Ricky and Randall Killian have arrived in a Chevrolet Canyon pickemup. Sam Verdreaux is not far behind, walking, of course; Sam lost his license to drive for good in '07.

Gina takes a step backward, staring at Mel with wide eyes. Beside

her, Alden Dinsmore hulks like a farmer-robot with a dead battery. 'You guys are supposed to be police? Hel-*lo*?'

'That rape stuff was nothing but a whore lie,' Frank says. 'And you better quit yelling about it before you get arrested for disturbing the peace.'

'Fuckin right,' Georgia says. She has moved a little closer to Carter. He ignores her. He is surveying the crowd. And that's what it is now. If fifty people make a crowd, then this is one. More coming, too. Carter wishes he had his gun. He doesn't like the hostility he's seeing.

Velma Winter, who runs Brownie's (or did, before it closed), arrives with Tommy and Willow Anderson. Velma is a big, burly woman who combs her hair like Bobby Darin and looks like she could be the warrior queen of Dyke Nation, but she has buried two husbands and the story you can hear at the bullshit table in Sweetbriar is that she fucked them both to death and is looking for number three at Dipper's on Wednesdays; that's Country Karaoke Night, and draws an older crowd. Now she plants herself in front of Carter, hands on her meaty hips.

'Closed, huh?' she says in a businesslike voice. 'Let's see your paperwork.'

Carter is confused, and being confused makes him angry. 'Back off, bitch. I don't need no paperwork. The Chief sent us down here. The Selectmen ordered it. It's gonna be a food depot.'

'Rationing? That what you mean?' She snorts. 'Not in *my* town.' She shoves between Mel and Frank and starts hammering on the door. 'Open up! *Open up in there!*'

'Nobody home,' Frank says. 'You might as well quit it.'

But Ernie Calvert hasn't left. He comes down the pasta-flour-and-sugar aisle. Velma sees him and starts hammering louder. 'Open up, Ernie! Open up!'

'Open up!' voices from the crowd agree.

Frank looks at Mel and nods. Together they grab Velma and muscle her two hundred pounds away from the door. Georgia Roux has turned and is waving Ernie back. Ernie doesn't go. Numb fuck just stands there.

'*Open up!*' Velma bawls. '*Open up! Open up!*'

Tommy and Willow join her. So does Bill Wicker, the postman. So does Lissa, her face shining – all her life she has hoped to be part of a spontaneous demonstration, and here's her chance. She raises a clenched fist and begins to shake it in time – two small shakes on *open* and a big one on *up*. Others imitate her. *Open up* becomes *Oh-pun UP! Oh-pun UP! Oh-pun UP!* Now they are all shaking their fists in

that two–plus–one rhythm – maybe seventy people, maybe eighty, and more arriving all the time. The thin blue line in front of the market looks thinner than ever. The four younger cops look toward Freddy Denton for ideas, but Freddy has no ideas.

He does, however, have a gun. *You better fire it into the air pretty soon, Baldy*, Carter thinks, *or these people are gonna run us down.*

Two more cops – Rupert Libby and Toby Whelan – drive down Main Street from the PD (where they've been drinking coffee and watching CNN), blowing past Julia Shumway, who is jogging along with a camera slung over her shoulder.

Jackie Wettington and Henry Morrison also start toward the supermarket, but then the walkie-talkie on Henry's belt crackles. It's Chief Randolph, saying that Henry and Jackie should hold their station at the Gas & Grocery.

'But we hear—' Henry begins.

'Those are your orders,' Randolph says, not adding that they are orders he is just passing on – from a higher power, as it were.

'*Oh-pun UP! Oh-pun UP! Oh-pun UP!*' The crowd shaking fisted power-salutes in the warm air. Still scared, but excited, too. Getting into it. The Chef would have looked at them and seen a bunch of tyro tweekers, needing only a Grateful Dead tune on the soundtrack to make the picture complete.

The Killian boys and Sam Verdreaux are working their way through the crowd. They chant – not as protective coloration but because that crowd-molting-into-mob vibe is just too strong to resist – but don't bother shaking their fists; they have work to do. No one pays them any particular mind. Later, only a few people will remember seeing them at all.

Nurse Ginny Tomlinson is also working her way through the crowd. She has come to tell the girls they are needed at Cathy Russell; there are new patients, one a serious case. That would be Wanda Crumley from Eastchester. The Crumleys live next to the Evanses, out near the Motton town line. When Wanda went over this morning to check on Jack, she found him dead not twenty feet from where the Dome cut off his wife's hand. Jack was sprawled on his back with a bottle beside him and his brains drying on the grass. Wanda ran back to her house, crying her husband's name, and she had no more than reached him when she was felled by a coronary. Wendell Crumley was lucky not to crash his little Subaru wagon on his way to the hospital – he did eighty most of the way. Rusty is with Wanda now, but Ginny doesn't think Wanda – fifty, overweight, a heavy smoker – is going to make it.

'Girls,' she says. 'We need you at the hospital.'

'Those are the ones, Mrs Tomlinson!' Gina shouts. She *has* to shout to be heard over the chanting crowd. She's pointing at the cops and beginning to cry — partly from fear and tiredness, mostly from outrage. 'Those are the ones who raped her!'

This time Ginny looks beyond the uniforms, and realizes Gina's right. Ginny Tomlinson isn't afflicted with Piper Libby's admittedly vile temper, but she *has* a temper, and there's an aggravating factor at work here: unlike Piper, Ginny saw the Bushey girl with her pants off. Her vagina lacerated and swelled. Huge bruises on her thighs that couldn't be seen until the blood was washed off. Such a lot of blood.

Ginny forgets about the girls being needed at the hospital. She forgets about getting them out of a dangerous and volatile situation. She even forgets about Wanda Crumley's heart attack. She strides forward, elbowing someone out of her way (it happens to be Bruce Yardley, the cashier-*cum*-bagboy, who is shaking his fist like everyone else), and approaches Mel and Frank. They are both studying the ever more hostile crowd, and they don't see her coming.

Ginny raises both hands, looking for a moment like the bad guy surrendering to the sheriff in a Western. Then she brings both hands around and slaps both young men at the same time. 'You *bastards*!' she shouts. 'How *could* you? How could you be so *cowardly*? So catdirt *mean*? You'll go to *jail* for this, all of y—'

Mel doesn't think, just reacts. He punches her in the center of her face, breaking her glasses and her nose. She goes stumbling backward, bleeding, crying out. Her old-fashioned RN cap, shocked free of the bobbypins holding it, tumbles from her head. Bruce Yardley, the young cashier, tries to grab her and misses. Ginny hits a line of shopping carts. They go rolling like a little train. She drops to her hands and knees, crying in pain and shock. Bright drops of blood from her nose — not just broken but shattered — begin falling on the big yellow RK of NO PARKING ZONE.

The crowd goes temporarily silent, shocked, as Gina and Harriet rush to where Ginny crouches.

Then Lissa Jamieson's voice rises, a clear perfect soprano: '*YOU PIG BASTARDS!*'

That's when the chunk of rock flies. The first rock-thrower is never identified. It may be the only crime Sloppy Sam Verdreaux ever got away with.

Junior dropped him off at the upper end of town, and Sam, with visions of whiskey dancing in his head, went prospecting on the east

bank of Prestile Stream for just the right rock. Had to be big but not too big, or he wouldn't be able to throw it with any accuracy, even though once – a century ago, it seems sometimes; at others it seems very close – he was the starting pitcher for the Mills Wildcats in the first game of the Maine state tourney. He had found it at last, not far from the Peace Bridge: a pound, pound and a half, and as smooth as a goose egg.

One more thing, Junior had said as he dropped Sloppy Sam off. It wasn't Junior's one more thing, but Junior did not tell Sam this any more than Chief Randolph had told Wettington and Morrison, who had ordered them to stay on station. Wouldn't have been politic.

Aim for the chick. That was Junior's final word to Sloppy Sam before leaving him. *She deserves it, so don't miss.*

As Gina and Harriet in their white uniforms kneel beside the sobbing, bleeding RN on her hands and knees (and while everyone else's attention is there too), Sam winds up just as he did on that long-ago day in 1970, lets fly, and throws his first strike in over forty years.

In more ways than one. The twenty-ounce chunk of quartz-shot granite strikes Georgia Roux dead in the mouth, shattering her jaw in five places and all but four of her teeth. She goes reeling back against the plate-glass window, her jaw sagging grotesquely almost to her chest, her yawning mouth pouring blood.

An instant later two more rocks fly, one from Ricky Killian, one from Randall. Ricky's connects with the back of Bill Allnut's head and knocks the janitor to the pavement, not far from Ginny Tomlinson. *Shit!* Ricky thinks. *I was supposed to hit a fuckin cop!* Not only were those his orders; it's sort of what he has always wanted to do.

Randall's aim is better. He nails Mel Searles square in the forehead. Mel goes down like a bag of mail.

There is a pause, a moment of indrawn breath. Think of a car teetering on two wheels, deciding whether or not to go over. See Rose Twitchell looking around, bewildered and frightened, not sure what's happening, let alone what to do about it. See Anson put his arm around her waist. Listen to Georgia Roux howl through her hanging mouth, her cries weirdly like the sound the wind makes slipping across the waxed string of a tin-can mooseblower. Blood pours over her lacerated tongue as she hollers. See the reinforcements. Toby Whelan and Rupert Libby (he's Piper's cousin, though she doesn't brag on the connection) are first to arrive on the scene. They survey it . . . then hang back. Next comes Linda Everett. She's on foot with another part-time cop, Marty Arsenault, puffing along in her wake. She starts to push through the crowd, but Marty – who didn't even

put on his uniform this morning, just rolled out of bed and slipped into an old pair of bluejeans – grabs her by the shoulder. Linda almost breaks away from him, then thinks of her daughters. Ashamed of her own cowardice, she allows Marty to lead her over to where Rupe and Toby are watching developments. Of these four, only Rupe is wearing a gun this morning, and would he shoot? Balls he would; he can see his own wife in that crowd, holding hands with her mother (the mother-in-law Rupe wouldn't have minded shooting). See Julia arrive just behind Linda and Marty, gasping for breath but already grabbing her camera, dropping the lenscap in her hurry to start shooting. See Frank DeLesseps kneel down beside Mel just in time to avoid another rock, which whizzes over his head and shatters a hole in one of the supermarket doors.

Then . . .

Then someone yells. Who will never be known, not even the sex of the shouter will ever be agreed upon, although most think a woman, and Rose will tell Anson later she's almost sure it was Lissa Jamieson.

'*GET THEM!*'

Someone else bellows '*GROCERIES!*' and the crowd surges forward.

Freddy Denton fires his pistol once, into the air. Then he lowers it, in his panic about to empty it into the crowd. Before he can, someone wrests it from his hand. He goes down, shouting in pain. Then the toe of a big old farmer's boot – Alden Dinsmore's – connects with his temple. The lights don't go completely out for Officer Denton, but they dim considerably, and by the time they come back up to bright, the Great Supermarket Riot is over.

Blood seeps through the bandage on Carter Thibodeau's shoulder and small rosettes are blooming on his blue shirt, but he is – for the time being, at least – unaware of the pain. He makes no attempt to run. He sets his feet and unloads on the first person to come into range. This happens to be Charles 'Stubby' Norman, who runs the antique shop on the 117 edge of town. Stubby drops, clutching his spouting mouth.

'*Get back, you fucks!*' Carter snarls. '*Back, you sons of bitches! No looting! Get back!*'

Marta Edmunds, Rusty's babysitter, tries to help Stubby, and gets a Frank DeLesseps fist to the cheekbone for her pains. She staggers, holding the side of her face and looking unbelievingly at the young man who has just hit her . . . and is then knocked flat, with Stubby beneath her, by a wave of charging would-be shoppers.

Carter and Frank start punching at them, but they land only three blows before they are distracted by a weird, ululating scream. It's the town librarian, her hair hanging around her usually mild face. She's pushing a line of shopping carts, and she might be screaming banzai. Frank leaps out of her way, but the carts take care of Carter, sending him flying. He waves his arms, trying to stay up, and might actually manage to do so, except for Georgia's feet. He trips over them, lands on his back, and is trampled. He rolls over on his stomach, laces his hands over his head, and waits for it to be over.

Julia Shumway clicks and clicks and clicks. Perhaps the pictures will reveal the faces of people she knows, but she sees only strangers in the viewfinder. A mob.

Rupe Libby draws his sidearm and fires four shots into the air. The gunfire rolls off into the warm morning, flat and declamatory, a line of auditory exclamation points. Toby Whelan dives back into the car, bumping his head and knocking off his cap (CHESTER'S MILL DEPUTY on the front in yellow). He snatches the bullhorn off the back seat, puts it to his lips, and shouts: 'STOP WHAT YOU'RE DOING! BACK OFF! POLICE! STOP! THAT IS AN ORDER!'

Julia snaps him.

The crowd pays no attention to the gunshots or the bullhorn. They pay no attention to Ernie Calvert when he comes around the side of the building with his green duster churning about his pumping knees. '*Come in the back!*' he yells. '*You don't need to do that, I've opened up the back!*'

The crowd is intent upon breaking and entering. They smash against the doors with their stickers reading IN and OUT and EVERYDAY LOW PRICES. The doors hold at first, then the lock snaps under the crowd's combined weight. The first to arrive are crushed against the doors and suffer injuries: two people with broken ribs, one sprained neck, two broken arms.

Toby Whelan starts to raise the bullhorn again, then just sets it down, with exquisite care, on the hood of the car in which he and Rupe arrived. He picks up his DEPUTY cap, brushes it off, puts it back on. He and Rupe walk toward the store, then stop, helpless. Linda and Marty Arsenault join them. Linda sees Marta and leads her back to the little cluster of cops.

'What happened?' Marta asks, dazed. 'Did someone hit me? The side of my face is all hot. Who's watching Judy and Janelle?'

'Your sister took them this morning,' Linda says, and hugs her. 'Don't worry.'

'Cora?'

'Wendy.' Cora, Marta's older sister, has been living in Seattle for years. Linda wonders if Marta has suffered a concussion. She thinks that Dr Haskell should check her, and then remembers that Haskell is either in the hospital morgue or the Bowie Funeral Home. Rusty is on his own now, and today he is going to be very busy.

Carter is half-carrying Georgia toward unit Two. She is still howling those eerie mooseblower cries. Mel Searles has regained some soupy semblance of consciousness. Frankie leads him toward Linda, Marta, Toby, and the other cops. Mel tries to raise his head, then drops it back to his chest. His split forehead is pouring blood; his shirt is soaked.

People stream into the market. They race along the aisles, pushing shopping carts or grabbing baskets from a stack beside the charcoal briquets display (HAVE YOURSELF A FALL COOKOUT! the sign reads). Manuel Ortega, Alden Dinsmore's hired man, and his good friend Dave Douglas go straight to the checkout cash registers and start punching NO SALE buttons, grabbing money and stuffing it into their pockets, laughing like fools as they do so.

The supermarket is full now; it is sale day. In frozen foods, two women are fighting over the last Pepperidge Farm Lemon Cake. In deli, one man baffs another man with a kielbasa, telling him to leave some of that goddam lunchmeat for other folks. The lunchmeat shopper turns and biffs the kielbasa wielder in the nose. Soon they are rolling on the floor, fists flying.

Other brawls are breaking out. Rance Conroy, proprietor and sole employee of Conroy's Western Maine Electrical Service & Supplies ('Smiles Our Specialty'), punches Brendan Ellerbee, a retired University of Maine science teacher, when Ellerbee beats him to the last large sack of sugar. Ellerbee goes down, but he holds onto the ten-pound bag of Domino's, and when Conroy bends to take it, Ellerbee snarls 'Here, then!' and smacks him in the face with it. The sugarsack bursts wide open, enveloping Rance Conroy in a white cloud. The electrician falls against one of the shelves, his face as white as a mime's, screaming that he can't see, he's blind. Carla Venziano, with her baby goggling over her shoulder from the carrier on her back, pushes Henrietta Clavard away from the display of Texmati Rice – Baby Steven loves rice, he also loves to play with the empty plastic containers, and Carla means to make sure she has plenty. Henrietta, who was eighty-four in January, goes sprawling on the hard knot of scrawn that used to be her butt. Lissa Jamieson shoves Will Freeman, who owns the local Toyota dealership, out of her way so she can get the last chicken in the coldcase. Before she can grab it, a teenage girl

wearing a PUNK RAGE tee-shirt snatches it, sticks out her pierced tongue at Libby, and hies gaily away.

There's a sound of shattering glass followed by a hearty cheer made up mostly (but not entirely) of men's voices. The beer cooler has been breached. Many shoppers, perhaps planning on HAVING THEMSELVES A FALL COOKOUT, stream in that direction. Instead of *Oh-pun UP*, the chant is now '*Beer! Beer! Beer!*'

Other folks are streaming into the storerooms below and out back. Soon men and women are packing wine out by the jug and the case. Some carry cartons of vino on their heads like native bearers in an old jungle movie.

Julia, her shoes crunching on crumbles of glass, shoots shoots shoots.

Outside, the rest of the town cops are pulling up, including Jackie Wettington and Henry Morrison, who have abandoned their post at the Gas & Grocery by mutual consent. They join the other cops in a huddled worry-cluster off to one side and simply watch. Jackie sees Linda Everett's stricken face and folds Linda into her arms. Ernie Calvert joins them, yelling 'So unnecessary! So completely unnecessary!' with tears streaming down his chubby cheeks.

'What do we do now?' Linda asks, her cheek pressed against Jackie's shoulder. Marta stands close beside her, gaping at the market and pressing a palm against the discolored, rapidly swelling bruise on the side of her face. Beyond them, Food City surges with yells, laughter, the occasional cry of pain. Objects are thrown; Linda sees a roll of toilet tissue unspooling like a party streamer as it arcs over the housewares aisle.

'Honey,' Jackie says, 'I just don't know.'

11

Anson snatched Rose's shopping list and went running into the market with it before the lady herself could stop him. Rose hesitated beside the restaurant panel truck, clenching and unclenching her hands, wondering whether or not to go in after him. She had just decided to stay put when an arm slipped around her shoulders. She jumped, then turned her head and saw Barbie. The depth of her relief actually weakened her knees. She clutched his arm – partly for comfort, mostly so she wouldn't faint.

Barbie was smiling, without much humor. 'Some fun, huh, kid?'

'I don't know what to do,' she said. 'Anson's in there . . . *every-body* is . . . and the cops are just *standing around*.'

'Probably don't want to get beat up any worse than they already

have been. And I don't blame them. This was well planned and
beautifully executed.'

'What are you talking about?'

'Never mind. Want to take a shot at stopping it before it gets
any worse?'

'How?'

He lifted the bullhorn, plucked from the hood of the car where
Toby Whelan left it. When he tried to hand it to her, Rose drew
back, holding her hands to her chest. 'You do it, Barbie.'

'No. You're the one who's been feeding them for years, you're
the one they know, you're the one they'll listen to.'

She took the bullhorn, although hesitantly. 'I don't know what
to say. I can't think of a single thing that will make them stop. Toby
Whelan already tried. They didn't pay any attention.'

'Toby tried to give orders,' Barbie said. 'Giving orders to a mob
is like giving orders to an anthill.'

'I still don't know what to—'

'I'm going to tell you.' Barbie spoke calmly, and that calmed her.
He paused long enough to beckon Linda Everett. She and Jackie
came together, their arms around each other's waists.

'Can you get in touch with your husband?' Barbie asked.

'If his cell phone's on.'

'Tell him to get down here – with an ambulance, if possible. If
he doesn't answer his phone, grab a police car and drive on up to
the hospital.'

'He's got patients . . .'

'He's got some patients right here. He just doesn't know it.'
Barbie pointed to Ginny Tomlinson, now sitting with her back against
the cinderblock side of the market and her hands pressed to her
bleeding face. Gina and Harriet Bigelow crouched on either side of her,
but when Gina tried to stanch the bleeding from Ginny's radically
altered nose with a folded handkerchief, Ginny cried out in pain and
turned her head away. 'Starting with one of his two remaining trained
nurses, if I'm not mistaken.'

'What are *you* going to do?' Linda asked, taking her cell phone
from her belt.

'Rose and I are going to make them stop. Aren't we, Rose?'

12

Rose stopped inside the door, mesmerized by the chaos before her.
The eye-watering smell of vinegar was in the air, mingled with the

aromas of brine and beer. Mustard and ketchup were splattered like gaudy puke on the linoleum of aisle 3. A cloud of mingled sugar and flour arose from aisle 5. People pushed their loaded shopping carts through it, many coughing and wiping their eyes. Some of the carts slued as they rolled through a drift of spilled dry beans.

'Stay there a sec,' Barbie said, although Rose showed no sign of moving; she was hypnotized with the bullhorn clasped between her breasts.

Barbie found Julia shooting pictures of the looted cash registers. 'Quit that and come with me,' he said.

'No, I have to do this, there's no one else. I don't know where Pete Freeman is, and Tony—'

'You don't have to shoot it, you have to stop it. Before something a lot worse than that happens.' He was pointing to Fern Bowie, who was strolling past with a loaded basket in one hand and a beer in the other. His eyebrow was split and blood was dripping down his face, but Fern seemed content enough withal.

'How?'

He leads her back to Rose. 'Ready, Rose? Showtime.'

'I . . . well . . .'

'Remember, *serene*. Don't try to stop them; just try to lower the temperature.'

Rose took a deep breath, then raised the bullhorn to her mouth. 'HI, EVERYBODY, THIS IS ROSE TWITCHELL, FROM SWEETBRIAR ROSE.'

To her everlasting credit, she *did* sound serene. People looked around when they heard her voice – not because it sounded urgent, Barbie knew, but because it didn't. He had seen this in Takrit, Fallujah, Baghdad. Mostly after bombings in crowded public places, when the police and the troop carriers arrived. 'PLEASE FINISH YOUR SHOPPING AS QUICKLY AND CALMLY AS POSSIBLE.'

A few people chuckled at this, then looked around at each other as if coming to. In aisle 7, Carla Venziano, shamefaced, helped Henrietta Clavard to her feet. *There's plenty of Texmati for both of us*, Carla thought. *What in God's name was I thinking?*

Barbie nodded at Rose to go on, mouthing *Coffee*. In the distance, he could hear the sweet warble of an approaching ambulance.

'WHEN YOU'RE DONE, COME TO SWEETBRIAR FOR COFFEE. IT'S FRESH AND IT'S ON THE HOUSE.'

A few people clapped. Some leatherlungs yelled, '*Who wants coffee? We got BEER!*' Laughter and whoops greeted this sally.

Julia twitched Barbie's sleeve. Her forehead was creased in what

Barbie thought was a very Republican frown. 'They're not shopping; they're stealing.'

'Do you want to editorialize or get them out of here before some-one gets killed over a bag of Blue Mountain Dry Roast?' he asked.

She thought it over and nodded, her frown giving way to that inward-turning smile he was coming to like a great deal. 'You have a point, Colonel,' she said.

Barbie turned to Rose, made a cranking gesture, and she started in again. He began to walk the two women up and down the aisles, starting with the mostly denuded deli and dairy section, on the lookout for anyone who might be cranked up enough to offer interference. There was no one. Rose was gaining confidence, and the market was quieting. People were leaving. Many were pushing carts laden with loot, but Barbie still took it as a good sign. The sooner they were out the better, no matter how much shit they took with them . . . and the key was for them to hear themselves referred to as shoppers rather than stealers. Give a man or woman back his self-respect, and in most cases – not all, but most – you also give back that person's ability to think with at least some clarity.

Anson Wheeler joined them, pushing a shopping cart full of supplies. He looked slightly shamefaced, and his arm was bleeding. 'Someone hit me with a jar of olives,' he explained. 'Now I smell like an Italian sandwich.'

Rose handed the bullhorn to Julia, who began broadcasting the same message in the same pleasant voice: Finish up, shoppers, and leave in orderly fashion.

'We can't take that stuff,' Rose said, pointing at Anson's cart.

'But we need it, Rosie,' he said. He sounded apologetic but firm. 'We really do.'

'We'll leave some money, then,' she said. 'If no one's stolen my purse out of the truck, that is.'

'Um . . . I don't think that'll work,' Anson said. 'Some guys were stealing the money out of the registers.' He had seen which guys, but didn't want to say. Not with the editor of the local paper walking next to him.

Rose was horrified. 'What's happening here? In the name of God, what's *happening*?'

'I don't know,' Anson said.

Outside, the ambulance pulled up, the siren dying to a growl. A minute or two later, while Barbie, Rose, and Julia were still canvassing the aisles with the bullhorn (the crowd was thinning out now), someone behind them said, 'That's enough. Give me that.'

Barbie was not surprised to see acting chief Randolph, tricked out to the nines in his dress uniform. Here he was, a day late and a dollar short. Right on schedule.

Rose was working the bullhorn, extolling the virtues of free coffee at Sweetbriar. Randolph plucked it from her hand and immediately began giving orders and making threats.

'LEAVE NOW! THIS IS CHIEF PETER RANDOLPH, ORDERING YOU TO LEAVE NOW! DROP WHAT YOU ARE HOLDING AND LEAVE NOW! IF YOU DROP WHAT YOU'RE HOLDING AND LEAVE NOW, YOU MAY AVOID CHARGES!'

Rose looked at Barbie, dismayed. He shrugged. It didn't matter. The spirit of the mob had departed. The cops who were still ambulatory – even Carter Thibodeau, staggering but on his feet – started hustling people out. When the 'shoppers' wouldn't drop their loaded baskets, the cops struck several to the ground, and Frank DeLesseps overturned a loaded shopping cart. His face was grim and pale and angry.

'Are you going to make those boys stop that?' Julia asked Randolph.

'No, Ms Shumway, I am not,' Randolph said. 'Those people are looters and they're being treated as such.'

'Whose fault is that? Who closed the market?'

'Get out of my way,' Randolph said. 'I've got work to do.'

'Shame you weren't here when they broke in,' Barbie remarked.

Randolph looked at him. The glance was unfriendly yet satisfied. Barbie sighed. Somewhere a clock was ticking. He knew it, and Randolph did, too. Soon the alarm would ring. If not for the Dome, he could run. But, of course, if not for the Dome, none of this would be happening.

Down front, Mel Searles tried to take Al Timmons's loaded shopping basket. When Al wouldn't give it up, Mel tore it away . . . and then pushed the older man down. Al cried out in pain and shame and outrage. Chief Randolph laughed. It was a short, choppy, unamused sound – *Haw! Haw! Haw!* – and in it Barbie thought he heard what Chester's Mill might soon become, if the Dome didn't lift.

'Come on, ladies,' he said. 'Let's get out of here.'

13

Rusty and Twitch were lining up the wounded – about a dozen in all – along the cinderblock side of the market when Barbie, Julia, and

Rose came out. Anson was standing by the Sweetbriar panel truck with a paper towel pressed to his bleeding arm.

Rusty's face was grim, but when he saw Barbie, he lightened up a little. 'Hey, sport. You're with me this morning. In fact, you're my new RN.'

'You wildly overestimate my triage skills,' Barbie said, but he walked toward Rusty.

Linda Everett ran past Barbie and threw herself into Rusty's arms. He gave her a brief hug. 'Can I help, honey?' she asked. It was Ginny she was looking at, and with horror. Ginny saw the look and wearily closed her eyes.

'No,' Rusty said. 'You do what you need to. I've got Gina and Harriet, and I've got Nurse Barbara.'

'I'll do what I can,' Barbie said, and almost added: *Until I'm arrested, that is.*

'You'll be fine,' Rusty said. In a lower voice he added, 'Gina and Harriet are the most willing helpers in the world, but once they get past giving pills and slapping on Band-Aids, they're pretty much lost.'

Linda bent to Ginny. 'I'm so sorry,' she said.

'I'll be fine,' Ginny said, but she did not open her eyes.

Linda gave her husband a kiss and a troubled look, then walked back toward where Jackie Wettington was standing with a pad in her hand, taking Ernie Calvert's statement. Ernie wiped his eyes repeatedly as he talked.

Rusty and Barbie worked side by side for over an hour, while the cops strung yellow police tape in front of the market. At some point, Andy Sanders came down to survey the damage, clucking and shaking his head. Barbie heard him ask someone what the world was coming to, when hometown folks could get up to a thing like this.

He also shook Chief Randolph's hand and told him he was doing a hell of a job.

Hell of a job.

14

When you're *feeling it*, lousy breaks disappear. Strife becomes your friend. Bad luck turns hit-the-Megabucks good. You do not accept these things with gratitude (an emotion reserved for wimps and losers, in Big Jim Rennie's opinion) but as your due. *Feeling it* is like riding in a magic swing, and one should (once more in Big Jim's opinion) glide imperiously.

If he had emerged from the big old Rennie manse on Mill

Street a little later or a little earlier, he would not have seen what he did, and he might have dealt with Brenda Perkins in an entirely different way. But he came out at exactly the right time. That was how it went when you were *feeling it*; the defense collapsed and you rushed through the magical hole thus created, making the easy layup.

It was the chanted cries of *Oh-pun UP! Oh-pun UP!* that got him out of his study, where he had been making notes for what he planned to call the Disaster Administration . . . of which cheerful, grinning Andy Sanders would be the titular head and Big Jim would be the power behind the throne. *If it ain't broke, don't fix it* was Rule One in Big Jim's political operating manual, and having Andy out front always worked like a charm. Most of Chester's Mill knew he was an idiot, but it didn't matter. You could run the same game on people over and over, because ninety-eight percent of them were even bigger idiots. And although Big Jim had never planned a political campaign on such a grand scale – it amounted to a municipal dictator-ship – he had no doubt it would work.

He hadn't included Brenda Perkins in his list of possible compli-cating factors, but no matter. When you were *feeling it*, complicating factors had a way of disappearing. This you also accepted as your due.

He walked down the sidewalk to the corner of Mill and Main, a distance of no more than a hundred paces, with his belly swinging placidly before him. The Town Common was directly across the way. A little farther down the hill on the other side of the street were the Town Hall and the PD, with War Memorial Plaza in between.

He couldn't see Food City from the corner, but he could see all of the Main Street business section. And he saw Julia Shumway. She came hurrying out of the *Democrat's* office, a camera in one hand. She jogged down the street toward the sound of the chanting, trying to sling the camera over her shoulder while on the move. Big Jim watched her. It was funny, really – how anxious she was to get to the latest disaster.

It got funnier. She stopped, turned, jogged back, tried the news-paper office's door, found it open, and locked it. Then she hurried off once more, anxious to watch her friends and neighbors behaving badly.

She is realizing for the first time that once the beast is out of its cage, it could bite anyone, anywhere, Big Jim thought. *But don't worry, Julia – I'll take care of you, just as I always have. You may have to tone down that tiresome rag of yours, but isn't that a small price to pay for safety?*

Of course it was. And if she persisted . . .

'Sometimes stuff happens,' Big Jim said. He was standing on the

corner with his hands in his pockets, smiling. And when he heard the first screams . . . the sound of breaking glass . . . the gunshots . . . his smile widened. *Stuff happens* wasn't exactly how Junior put it, but Big Jim reckoned it was close enough for government w—

His smile folded into a frown as he spotted Brenda Perkins. Most of the people on Main Street were heading toward Food City to see what all the ruckus was about, but Brenda was walking *up* Main Street instead of down. Maybe even up to the Rennie house . . . which would mean up to no good.

What could she want with me this morning? What could be so important it trumps a food riot at the local supermarket?

It was entirely possible he was the last thing on Brenda's mind, but his radar was pinging and he watched her closely.

She and Julia passed on opposite sides of the street. Neither noticed the other. Julia was trying to run while managing her camera. Brenda was staring at the red ramshackle bulk of Burpee's Department Store. She had a canvas carrier-bag that swung at her knee.

When she reached Burpee's, Brenda tried the door with no success. Then she stood back and glanced around the way people do when they've hit an unexpected obstacle to their plans and are trying to decide what to do next. She might still have seen Shumway if she'd looked behind her, but she didn't. Brenda looked left, right, then across Main Street, at the offices of the *Democrat*.

After another look at Burpee's, she crossed to the *Democrat* and tried that door. Also locked, of course; Big Jim had watched Julia do it. Brenda tried it again, rattling the knob for good measure. She knocked. Peered in. Then she stood back, hands on hips, carrier-bag dangling. When she once more started up Main Street – trudging, no longer looking around – Big Jim retreated to his house at a brisk pace. He didn't know why he wanted to make sure Brenda didn't see him watching . . . but he didn't *have* to know. You only had to act on your instincts when you were *feeling it*. That was the beauty of the thing.

What he *did* know was that if Brenda knocked on his door, he would be ready for her. No matter what she wanted.

15

Tomorrow morning I want you to take the printout to Julia Shumway, Barbie had told her. But the *Democrat's* office was locked and dark. Julia was almost certainly at whatever mess was going on at the market. Pete Freeman and Tony Guay probably were, too.

So what was she supposed to do with Howie's VADER file? If

there had been a mail slot, she might have slipped the manila envelope in her carrier-bag through it. Only there *was* no mail slot.

Brenda supposed she should either go find Julia at the market or return home to wait until things quieted down and Julia came back to her office. Not being in a particularly logical mood, neither choice appealed. As to the former, it sounded like a full-scale riot was going on at Food City, and Brenda did not want to get sucked in. As to the latter . . .

That was clearly the better choice. The *sensible* choice. Hadn't *All things come to him who waits* been one of Howie's favorite sayings?

But waiting had never been Brenda's forte, and her mother had also had a saying: *Do it and have done with it.* That was what she wanted to do now. Face him, wait out his ranting, his denials, his justifications, and then give him his choice: resign in favor of Dale Barbara or read all about his dirty deeds in the *Democrat.* Confrontation was bitter medicine to her, and the thing to do with bitter medicine was swallow it as fast as you could, then rinse your mouth. She planned to rinse hers with a double bourbon, and she wouldn't wait until noon to do it, either.

Only . . .

Don't go alone. Barbie had said that, too. And when he'd asked who else she trusted, she'd said Romeo Burpee. But Burpee's was closed too. What did that leave?

The question was whether or not Big Jim would actually hurt her, and Brenda thought the answer was no. She believed she was physically safe from Big Jim, no matter what worries Barbie might have – worries that were, no doubt, partly the result of his wartime experiences. This was a dreadful miscalculation on her part, but understandable; she wasn't the only one who clung to the notion that the world was as it had been before the Dome came down.

16

Which still left the problem of the VADER file.

Brenda might be more afraid of Big Jim's tongue than of bodily harm, but she knew it would be mad to show up on his doorstep with the file still in her possession. He might take it from her even if she said it wasn't the only copy. *That* she would not put past him.

Halfway up Town Common Hill, she came to Prestile Street, cutting along the upper edge of the common. The first house belonged to the McCains. The one beyond was Andrea Grinnell's. And although Andrea was almost always overshadowed by her male counterparts

on the Board of Selectmen, Brenda knew she was honest and had no love for Big Jim. Oddly enough, it was Andy Sanders to whom Andrea was more apt to kowtow, although why anyone would take *him* seriously was beyond Brenda's understanding.

Maybe he's got some sort of hold on her, Howie's voice spoke up in her head.

Brenda almost laughed. That was ridiculous. The important thing about Andrea was that she had been a Twitchell before Tommy Grinnell married her, and Twitchells were tough, even the shy ones. Brenda thought she could leave the envelope containing the VADER file with Andrea . . . assuming *her* place wasn't also locked and empty. She didn't think it would be. Hadn't she heard from someone that Andrea was down with the flu?

Brenda crossed Main, rehearsing what she'd say: *Would you hold this for me? I'll be back for it in about half an hour. If I don't come back for it, give it to Julia at the newspaper. Also, make sure Dale Barbara knows.*

And if she was asked what all the mystery was about? Brenda decided she'd be frank. The news that she intended to force Jim Rennie's resignation would probably do Andrea more good than a double dose of Theraflu.

In spite of her desire to get her distasteful errand done, Brenda paused for a moment in front of the McCain house. It looked deserted, but there was nothing strange about that — plenty of families had been out of town when the Dome came down. It was something else. A faint smell, for one thing, as if food were spoiling in there. All at once the day felt hotter, the air closer, and the sounds of whatever was going on at Food City seemed far away. Brenda realized what it came down to: she felt watched. She stood thinking about how much those shaded windows looked like closed eyes. But not completely closed, no. *Peeking* eyes.

Shake it off, woman. You've got things to do.

She walked on to Andrea's house, pausing once to look back over her shoulder. She saw nothing but a house with drawn shades, sitting gloomily in the mild stink of its decaying supplies. Only meat smelled so bad so soon. Henry and LaDonna must have had a lot put by in their freezer, she thought.

17

It was Junior who watched Brenda, Junior on his knees, Junior dressed only in his underpants, his head whamming and slamming. He watched from the living room, peering around the edge of a drawn shade.

When she was gone, he went back into the pantry. He would have to give his girlfriends up soon, he knew, but for now he wanted them. And he wanted the dark. He even wanted the stink rising from their blackening skin.

Anything, anything, that would soothe his fiercely aching head.

18

After three twists of the old-fashioned crank doorbell, Brenda resigned herself to going home after all. She was turning away when she heard slow, shuffling steps approaching the door. She arranged a little *Hello, neighbor* smile on her face. It froze there when she saw Andrea – cheeks pale, dark circles under her eyes, hair in disarray, cinching the belt of a bathrobe around her middle, pajamas underneath. And this house smelled, too – not of decaying meat but of vomit.

Andrea's smile was as wan as her cheeks and brow. 'I know how I look,' she said. The words came out in a croak. 'I better not invite you in. I'm on the mend, but I still might be catching.'

'Have you seen Dr—' But no, of course not. Dr Haskell was dead. 'Have you seen Rusty Everett?'

'Indeed I have,' Andrea said. 'All will soon be well, I'm told.'

'You're perspiring.'

'Still a little touch of fever, but it's almost gone. Can I help you with something, Bren?'

She almost said no – she didn't want to saddle a woman who was still clearly sick with a responsibility like the one in her carrier-bag – but then Andrea said something that changed her mind. Great events often turn on small wheels.

'I'm so sorry about Howie. I loved that man.'

'Thank you, Andrea.' *Not just for the sympathy, but for calling him Howie instead of Duke.*

To Brenda he'd always been Howie, her dear Howie, and the VADER file was his last work. Probably his greatest work. Brenda suddenly decided to *put* it to work, and with no further delay. She dipped into the carrier-bag and brought out the manila envelope with Julia's name printed on the front. 'Will you hold this for me, dear? Just for a little while? I have an errand to run and I don't want to take it with me.'

Brenda would have answered any questions Andrea asked, but Andrea apparently had none. She only took the bulky envelope with a sort of distracted courtesy. And that was all right. It saved time. Also,

it would keep Andrea out of the loop, and might spare her political blowback at some later date.

'Happy to,' Andrea said. 'And now . . . if you'll excuse me . . . I think I'd better get off my feet. But I'm not going to sleep!' she added, as if Brenda had objected to this plan. 'I'll hear you when you come back.'

'Thank you,' Brenda said. 'Are you drinking juices?'

'By the gallon. Take your time, hon – I'll babysit your envelope.'

Brenda was going to thank her again, but The Mill's Third Selectman had already closed the door.

19

Toward the end of her conversation with Brenda, Andrea's stomach began to flutter. She fought it, but this was a fight she was going to lose. She blathered something about drinking juice, told Brenda to take her time, then closed the door in the poor woman's face and sprinted for her stinking bathroom, making guttural *urk-urk* noises deep down in her throat.

There was an end table beside the living room couch, and she tossed the manila envelope at it blindly as she rushed past. The envelope skittered across the polished surface and fell off the other side, into the dark space between the table and the couch.

Andrea made it to the bathroom but not to the toilet . . . which was just as well; it was nearly filled with the stagnant, stinking brew that had been her body's output during the endless night just past. She leaned over the basin instead, retching until it seemed to her that her very esophagus would come loose and land on the splattery porcelain, still warm and pulsing.

That didn't happen, but the world turned gray and teetered away from her on high heels, growing smaller and less tangible as she swayed and tried not to faint. When she felt a little better, she walked slowly down the hall on elastic legs, sliding one hand along the wood to keep her balance. She was shivering and she could hear the jittery clitter of her teeth, a horrible sound she seemed to pick up not with her ears but with the backs of her eyes.

She didn't even consider trying to reach her bedroom upstairs but went out onto the screened-in back porch instead. The porch should have been too cold to be comfortable this late in October, but today the air was sultry. She did not lie down on the old chaise longue so much as collapse into its musty but somehow comforting embrace.

I'll get up in a minute, she told herself. *Get the last bottle of Poland Spring out of the fridge and wash that foul taste out of my mou . . .*

But here her thoughts slipped away. She fell into a deep and profound sleep from which not even the restless twitching of her feet and hands could wake her. She had many dreams. One was of a terrible fire people ran from, coughing and retching, looking for anyplace where they might find air that was still cool and clean. Another was of Brenda Perkins coming to her door and giving her an envelope. When Andrea opened it, a never-ending stream of pink OxyContin pills poured out. By the time she woke up it was evening, and the dreams were forgotten.

So was Brenda Perkins's visit.

20

'Come into my study,' Big Jim said cheerfully. 'Or would you like something to drink, first? I have Cokes, although I'm afraid they're a little warm. My generator died last night. Out of propane.'

'But I imagine you know where you can get more,' she said.

He raised his eyebrows questioningly.

'The methamphetamine you're making,' she said patiently. 'My understanding – based on Howie's notes – is that you've been cooking it in large batches. "Amounts that boggle the mind" is how he put it. That must take a lot of propane gas.'

Now that she was actually into this, she found her jitters had melted away. She even took a certain cold pleasure in watching the color mount in his cheeks and go dashing across his forehead.

'I have no idea what you're talking about. I think your grief . . .' He sighed, spread his blunt-fingered hands. 'Come inside. We'll discuss this and I'll set your mind at rest.'

She smiled. That she *could* smile was sort of a revelation, and it helped more to imagine Howie watching her – from somewhere. Also telling her to be careful. That was advice she planned to heed.

On the Rennie front lawn, two Adirondack chairs sat amid the fallen leaves. 'It's nice enough out here for me,' she said.

'I prefer to talk business inside.'

'Would you prefer to see your picture on the front page of the *Democrat*? Because I can arrange that.'

He winced as if she had struck him, and for just a moment she saw hate in those small, deepset, piggy eyes. 'Duke never liked me, and I suppose it's natural that his feelings should have been communicated to—'

'His name was *Howie!*'

Big Jim threw up his hands as if to say there was no reasoning with some women, and led her to the chairs overlooking Mill Street.

Brenda Perkins talked for almost half an hour, growing colder and angrier as she spoke. The meth lab, with Andy Sanders and – almost certainly – Lester Coggins as silent partners. The staggering size of the thing. Its probable location. The mid-level distributors who had been promised immunity in exchange for information. The money trail. How the operation had gotten so big the local pharmacist could no longer safely supply the necessary ingredients, necessitating import from overseas.

'The stuff came into town in trucks marked Gideon Bible Society,' Brenda said. 'Howie's comment on that was "too clever by half."'

Big Jim sat looking out at the silent residential street. She could feel the anger and hate baking off him. It was like heat from a casserole dish.

'You can't prove any of this,' he said at last.

'That won't matter if Howie's file turns up in the *Democrat*. It's not due process, but if anyone can understand bypassing a little thing like that, it would be you.'

He flapped a hand. 'Oh, I'm sure you had a *file*,' he said, 'but my name is on nothing.'

'It's on the Town Ventures paperwork,' she said, and Big Jim rocked in his chair as if she had lashed out with her fist and hit him in the temple. 'Town Ventures, incorporated in Carson City. And from Nevada, the money trail leads to Chongqing City, the pharma capital of the People's Republic of China.' She smiled. 'You thought you were smart, didn't you? So smart.'

'Where is this file?'

'I left a copy with Julia this morning.' Bringing Andrea into it was the last thing she wanted to do. And thinking it was in the newspaper editor's hands would bring him to heel that much quicker. He might feel that he or Andy Sanders could jawbone Andrea.

'There are other copies?'

'What do you think?'

He considered a moment, then said: 'I kept it out of the town.'

She said nothing.

'It was for the *good* of the town.'

'You've done a lot of good for the town, Jim. We've got the same sewer system we had in nineteen sixty, Chester Pond is filthy, the business district is moribund . . .' She was sitting straight now, gripping the arms of her chair. 'You fucking self-righteous turdworm.'

'What do you want?' He was staring straight ahead at the empty street. A large vein beat in his temple.

'For you to announce your resignation. Barbie takes over as per the President's—'

'I'll never resign in favor of *that* cotton-picker.' He turned to look at her. He was smiling. It was an appalling smile. 'You didn't leave anything with Julia, because Julia's at the market, watching the food fight. You might have Duke's file locked away somewhere, but you didn't leave a copy with *anyone*. You tried Rommie, then you tried Julia, then you came here. I saw you walking up Town Common Hill.'

'I did,' she said. 'I did have it.' And if she told him where she had left it? Bad luck for Andrea. She started to get up. 'You had your chance. Now I'm leaving.'

'Your other mistake was thinking you'd be safe outside on the street. An *empty* street.' His voice was almost kind, and when he touched her arm, she turned to look at him. He seized her face. And twisted.

Brenda Perkins heard a bitter crack, like the breaking of a branch overloaded with ice, and followed the sound into a great darkness, trying to call her husband's name as she went.

21

Big Jim went inside and got a Jim Rennie's Used Cars gimme cap from the front hall closet. Also some gloves. And a pumpkin from the pantry. Brenda was still in her Adirondack chair, with her chin on her chest. He looked around. No one. The world was his. He put the hat on her head (pulling the brim low), the gloves on her hands, and the pumpkin in her lap. It would serve perfectly well, he thought, until Junior came back and took her to where she could become part of Dale Barbara's butcher's bill. Until then, she was just another stuffed Halloween dummy.

He checked her carrier-bag. It contained her wallet, a comb, and a paperback novel. So *that* was all right. It would be fine down cellar, behind the dead furnace.

He left her with the hat slouched on her head and the pumpkin in her lap and went inside to stash her bag and wait for his son.

IN THE JUG

1

Selectman Rennie's assumption that no one had seen Brenda come to his house that morning was correct. But she *was* seen on her morning travels, not by one person but by three, including one who also lived on Mill Street. If Big Jim had known, would the knowledge have given him pause? Doubtful; by then he was committed to his course and it was too late to turn back. But it might have caused him to reflect (for he *was* a reflective man, in his own way) on murder's similarity to Lay's potato chips: it's hard to stop with just one.

2

Big Jim didn't see the watchers when he came down to the corner of Mill and Main. Neither did Brenda as she walked up Town Common Hill. This was because they didn't want to be seen. They were sheltering just inside the Peace Bridge, which happened to be a condemned structure. But that wasn't the worst of it. If Claire McClatchey had seen the cigarettes, she would have shit a brick. In fact, she might have shit two. And certainly she never would have let Joe chum with Norrie Calvert again, not even if the fate of the town hinged upon their association, because it was Norrie who supplied the smokes – badly bent and croggled Winstons, which she had found on a shelf in the garage. Her father had quit smoking the year before and the pack was covered with a fine scrim of dust, but the cigarettes inside had looked okay to Norrie. There were just three, but three was perfect: one each. Think of it as a good-luck rite, she instructed.

'We'll smoke like Indians praying to the gods for a successful hunt. Then we'll go to work.'

'Sounds good,' Joe said. He had always been curious about smoking. He couldn't see the attraction, but there must be one, because a lot of people still did it.

'Which gods?' Benny Drake asked.

'The gods of your choice,' Norrie answered, looking at him as if he were the dumbest creature in the universe. '*God* god, if that's the one you like.' Dressed in faded denim shorts and a pink sleeveless top, her hair for once down and framing her foxy little face instead of scrooped back in its usual sloppin-around-town ponytail,

she looked good to both boys. Totally awesome, in fact. '*I* pray to Wonder Woman.'

'Wonder Woman is not a goddess,' Joe said, taking one of the elderly Winstons and smoothing it straight. 'Wonder Woman is a superhero.' He considered. 'Maybe a superher-*ette*.'

'She's a goddess to me,' Norrie replied with a grave-eyed sincerity that could not be gainsaid, let alone ridiculed. She was carefully straightening her own cigarette. Benny left his the way it was; he thought a bent cigarette had a certain coolness factor. 'I had Wonder Woman Power Bracelets until I was nine, but then I lost them. I think that bitch Yvonne Nedeau stole them.'

She lit a match and touched it first to Scarecrow Joe's cigarette, then to Benny's. When she tried to use it to light her own, Benny blew it out.

'What did you do that for?' she asked.

'Three on a match. Bad luck.'

'You *believe* that?'

'Not much,' Benny said, 'but today we're going to need all the luck we can get.' He glanced at the shopping bag in the basket of his bike, then took a pull on his cigarette. He inhaled a little and then coughed the smoke back out, his eyes watering. 'This tastes like panther-shit!'

'Smoked a lot of that, have you?' Joe asked. He dragged on his own cigarette. He didn't want to look like a wuss, but he didn't want to start coughing and maybe throw up, either. The smoke burned, but in sort of a good way. Maybe there was something to this, after all. Only he already felt a little woozy.

Go easy on the inhaling part, he thought. *Passing out would be almost as uncool as puking.* Unless, maybe, he passed out in Norrie Calvert's lap. That might be very cool indeed.

Norrie reached into her shorts pocket and brought out the cap of a Verifine juice bottle. 'We can use this for an ashtray. I want to do the Indian smoke ritual, but I don't want to catch the Peace Bridge on fire.' She then closed her eyes. Her lips began to move. Her cigarette was between her fingers, growing an ash.

Benny looked at Joe, shrugged, then closed his own eyes. 'Almighty GI Joe, please hear the prayer of your humble pfc Drake—'

Norrie kicked him without opening her eyes.

Joe got up (a little dizzy, but not too bad; he chanced another drag when he was on his feet) and walked past their parked bikes to the town common end of the covered walkway.

'Where you goin?' Norrie asked without opening her eyes.

'I pray better when I look at nature,' Joe said, but he actually just wanted a breath of fresh air. It wasn't the burning tobacco; he sort of liked that. It was the other smells inside the bridge – decaying wood, old booze, and a sour chemical aroma that seemed to be rising up from the Prestile beneath them (that was a smell, The Chef might have told him, that you could come to love).

Even the outside air wasn't that wonderful; it had a slightly *used* quality that made Joe think of the trip he'd made with his parents to New York the previous year. The subways had smelled a little like this, especially late in the day when they were crowded with people headed home.

He tapped ashes into his hand. As he scattered them, he spotted Brenda Perkins making her way up the hill.

A moment later, a hand touched his shoulder. Too light and delicate to be Benny's. 'Who's that?' Norrie asked.

'Know the face, not the name,' he said.

Benny joined them. 'That's Mrs Perkins. The Sheriff's widow.'

Norrie elbowed him. 'Police Chief, dummy.'

Benny shrugged. 'Whatever.'

They watched her, mostly because there was no one else to watch. The rest of the town was at the supermarket, apparently having the world's biggest food fight. The three kids had investigated, but from afar; they did not need persuasion to stay away, given the valuable piece of equipment that had been entrusted to their care.

Brenda crossed Main to Prestile, paused outside the McCain house, then went on to Mrs Grinnell's.

'Let's get going,' Benny said.

'We *can't* get going until she's gone,' Norrie said.

Benny shrugged. 'What's the big deal? If she sees us, we're just some kids goofing around on the town common. And know what? She probably wouldn't see us if she looked right at us. Adults *never* see kids.' He considered this. 'Unless they're on skateboards.'

'Or smoking,' Norrie added. They all glanced at their cigarettes.

Joe hooked a thumb at the shopping bag sitting in the carrier attached to the handlebars of Benny's Schwinn High Plains. 'They also have a tendency to see kids who are goofing around with expensive town property.'

Norrie tucked her cigarette in the corner of her mouth. It made her look wonderfully tough, wonderfully pretty, and wonderfully *adult*.

The boys went back to watching. The Police Chief's widow was now talking to Mrs Grinnell. It wasn't a long conversation. Mrs Perkins had taken a big brown envelope from her carrier-bag as she

came up the steps, and they watched her hand it to Mrs Grinnell. A few seconds later, Mrs Grinnell pretty much slammed the door in her visitor's face.

'Whoa, that was rude,' Benny said. 'Week's detention.'

Joe and Norrie laughed.

Mrs Perkins stood where she was for a moment, as if perplexed, then went back down the steps. She was now facing the common, and the three children instinctively stepped further into the shadows of the walkway. This caused them to lose sight of her, but Joe found a handy gap in the wooden siding and peered through that.

'Going back to Main,' he reported. 'Okay, now she's going up the hill . . . now she's crossing over again . . .'

Benny held an imaginary microphone. 'Video at eleven.'

Joe ignored this. 'Now she's going onto *my* street.' He turned to Benny and Norrie. 'Do you think she's going to see my mom?'

'Mill Street's four blocks long, dude,' Benny said. 'What are the chances?'

Joe felt relieved even though he could think of no reason why Mrs Perkins's going to see his mom would be a bad thing. Except his mother was all worried about Dad being out of town, and Joe would sure hate to see her more upset than she already was. She had almost forbidden him to go on this expedition. Thank God Miz Shumway had talked her out of *that* idea, mostly by telling her that Dale Barbara had mentioned Joe specifically for this job (which Joe – Benny and Norrie, too – preferred to think of as 'the mission').

'Mrs McClatchey,' Julia had said, 'if anyone can put this gadget to use, Barbie thinks it's probably your son. It could be very important.'

That had made Joe feel good, but looking at his mother's face – worried, drawn – made him feel bad. It hadn't even been three days since the Dome had come down, but she'd lost weight. And the way she kept holding his dad's picture, that made him feel bad, too. It was like she thought he'd died instead of just being holed up in a motel somewhere, probably drinking beer and watching HBO.

She had agreed with Miz Shumway, though. 'He's a smart boy about gadgets, all right. He always has been.' She looked him over from head to foot, and sighed. 'When did you get so tall, Son?'

'I don't know,' he had replied truthfully.

'If I let you do this, will you be careful?'

'And take your friends with you,' Julia said.

'Benny and Norrie? Sure.'

'Also,' Julia had added, 'be a little discreet. Do you know what that means, Joe?'

'Yes, ma'am, I sure do.'

It meant don't get caught.

3

Brenda disappeared into the screening trees that lined Mill Street. 'Okay,' Benny said. 'Let's go.' He carefully crushed his cigarette in the makeshift ashtray, then lifted the shopping bag out of the bike's wire carrier. Inside the bag was the old-fashioned yellow Geiger counter, which had gone from Barbie to Rusty to Julia . . . and finally to Joe and his posse.

Joe took the juice lid and crushed out his own smoke, thinking he would like to try again when he had more time to concentrate on the experience. On the other hand, it might be better not to. He was addicted to computers, the graphic novels of Brian K. Vaughan, and skateboarding. Maybe that was enough monkeys for one back.

'People are gonna come by,' he said to Benny and Norrie. 'Probably lots of people, once they get tired of playing in the supermarket. We'll just have to hope they don't pay any attention to us.'

In his mind he heard Miz Shumway telling his mom how important this could be to the town. She didn't have to tell *him*; he probably understood it better than they did.

'But if any *cops* come by . . .' Norrie said.

Joe nodded. 'Back into the bag it goes. And out comes the Frisbee.'

'You really think there's some kind of alien generator buried under the town common?' Benny asked.

'I said there *might* be,' Joe replied, more sharply than he had intended. 'Anything's possible.'

In truth, Joe thought it more than possible; he thought it likely. If the Dome wasn't supernatural in origin, then it was a force field. A force field had to be generated. It looked like a QED situation to him, but he didn't want to get their hopes up too high. Or his own, for that matter.

'Let's start looking,' Norrie said. She ducked under the sagging yellow police tape. 'I just hope you two prayed enough.'

Joe didn't believe in praying for things he could do for himself, but he *had* sent up a brief one on a different subject: that if they found the generator, Norrie Calvert would give him another kiss. A nice long one.

4

Earlier that morning, during their pre-exploration meeting in the McClatchey living room, Scarecrow Joe had taken off his right sneaker, then the white athletic sock beneath.

'Trick or treat, smell my feet, give me something good to eat,' Benny said cheerfully.

'Shut up, stupid,' Joe replied.

'Don't call your friend stupid,' Claire McClatchey said, but she gave Benny a reproachful look.

Norrie added no repartee of her own, only watched with interest as Joe laid the sock on the living room rug and smoothed it out with the flat of his hand.

'This is Chester's Mill,' Joe said. 'Same shape, right?'

'You are correctamundo,' Benny agreed. 'It's our fate to live in a town that looks like one of Joe McClatchey's athletic socks.'

'Or the old woman's shoe,' Norrie put in.

'"There was an old woman who lived in a shoe,"' Mrs McClatchey recited. She was sitting on the couch with the picture of her husband in her lap, just as she had been when Miz Shumway came by with the Geiger counter late yesterday afternoon. '"She had so many children she didn't know what to do."'

'Good one, Mom,' Joe said, trying not to grin. The middle-school version had been revised to *She had so many children her cunt fell off.*

He looked down at the sock again. 'So does a sock have a middle?'

Benny and Norrie thought it over. Joe let them. The fact that such a question could interest them was one of the things he dug about them.

'Not like a circle or square has a center,' Norrie said at last. 'Those are geometric shapes.'

Benny said, 'I guess a sock is also a geometric shape – technically – but I don't know what you'd call it. A socktagon?'

Norrie laughed. Even Claire smiled a little.

'On the map, The Mill's closer to a hexagon,' Joe said, 'but never mind that. Just use common sense.'

Norrie pointed to the place on the sock where the foot-shaped bottom flowed into the tube top. 'There. That's the middle.'

Joe dotted it with the tip of his pen.

'I'm not sure that'll come out, mister.' Claire sighed. 'But you

need new ones anyway, I suppose.' And, before he could ask the next question, she said: 'On a map, that would be about where the town common is. Is that where you're going to look?'

'It's where we're going to look *first*,' Joe said, a little deflated at having his explicatory thunder stolen.

'Because if there's a generator,' Mrs McClatchey mused, 'you think it should be in the middle of the township. Or as close to it as possible.'

Joe nodded.

'Cool, Mrs McClatchey,' Benny said. He raised one hand. 'Give me five, mother of my soul-brother.'

Smiling wanly, still holding the picture of her husband, Claire McClatchey slapped Benny five. Then she said, 'At least the town common's a safe place.' She paused to consider that, frowning slightly. 'I hope so, anyway, but who really knows?'

'Don't worry,' Norrie said. 'I'll watch out for them.'

'Just promise me that if you *do* find something, you'll let the experts handle things,' Claire said.

Mom, Joe thought, *I think maybe* we're *the experts*. But he didn't say it. He knew it would bum her out even more.

'Word up,' Benny said, and held his hand up again. 'Five more, o mother of my—'

This time she kept both hands on the picture. 'I love you, Benny, but sometimes you tire me out.'

He smiled sadly. 'My mom says the exact same thing.'

5

Joe and his friends walked downhill to the bandstand that stood in the center of the common. Behind them, the Prestile murmured. It was lower now, dammed up by the Dome where it crossed into Chester's Mill from the northwest. If the Dome was still in place tomorrow, Joe thought it would be nothing but a mudslick.

'Okay,' Benny said. 'Enough with the Freddy Fuckaround. Time for the board-bangers to rescue Chester's Mill. Let's fire that baby up.'

Carefully (and with real reverence), Joe lifted the Geiger counter out of the shopping bag. The battery that powered it had been a long-dead soldier and the terminals had been thick with gunk, but a little baking soda took care of the corrosion, and Norrie had found not just one but three six-volt dry cells in her father's tool closet. 'He's kind of a freak when it comes to batteries,' she had

confided, 'and he's gonna kill himself trying to learn boarding, but I love him.'

Joe put his thumb on the power switch, then looked at them grimly. 'You know, this thing could read zilch everywhere we take it and there still might be a generator, just not one that emits alpha or beta wa—'

'*Do* it, for God's sakes!' Benny said. 'The suspense is killin me.'

'He's right,' Norrie said. 'Do it.'

But here was an interesting thing. They had tested the Geiger counter plenty around Joe's house, and it worked fine – when they tried it on an old watch with a radium dial, the needle jerked appreciably. They'd each taken a turn. But now that they were out here – on-site, so to speak – Joe felt frozen. There was sweat on his forehead. He could feel it beading up and getting ready to trickle down.

He might have stood there quite awhile if Norrie hadn't put her hand over his. Then Benny added his. The three of them ended up pushing the slide-switch together. The needle in the COUNTS PER SECOND window immediately jumped to +5, and Norrie clutched Joe's shoulder. Then it settled back to +2, and she relaxed her hold. They had no experience with radiation counters, but they all guessed they were seeing no more than a background count.

Slowly, Joe walked around the bandstand with the Geiger-Müller tube held out on its coiled phone receiver-type cord. The power lamp glowed a bright amber, and the needle jiggled a little bit from time to time, but mostly it stayed close to the zero end of the dial. The little jumps they saw were probably being caused by their own movements. He wasn't surprised – part of him knew it couldn't be so easy – but at the same time, he was bitterly disappointed. It was amazing, really, how well disappointment and lack of surprise comple-mented each other; they were like the Olsen Twins of emotion.

'Let me,' Norrie said. 'Maybe I'll have better luck.'

He gave it over without protest. Over the next hour or so, they crisscrossed the town common, taking turns with the Geiger counter. They saw a car turn down Mill Street, but didn't notice Junior Rennie – who was feeling better again – behind the wheel. Nor did he notice them. An ambulance sped down Town Common Hill in the direction of Food City with its lights flashing and its siren wailing. This they looked at briefly, but were again absorbed when Junior reappeared shortly after, this time behind the wheel of his father's Hummer.

They never used the Frisbee they had brought as camouflage; they were too preoccupied. Nor did it matter. Few of the townspeople

heading back to their homes bothered looking into the Common. A few were hurt. Most were carrying liberated foodstuffs, and some were wheeling loaded shopping carts. Almost all looked ashamed of themselves.

By noon, Joe and his friends were ready to give up. They were also hungry. 'Let's go to my house,' Joe said. 'My mom'll make us something to eat.'

'Great,' Benny said. 'Hope it's chop suey. Your ma's chop suey is tight.'

'Can we go through the Peace Bridge and try the other side first?' Norrie asked.

Joe shrugged. 'Okay, but there's nothing over there but woods. Also, it's moving away from the center.'

'Yes, but . . .' She trailed off.

'But what?'

'Nothing. Just an idea. It's probably stupid.'

Joe looked at Benny. Benny shrugged and handed her the Geiger counter.

They went back to the Peace Bridge and ducked under the sagging police tape. The walkway was dim, but not too dim for Joe to look over Norrie's shoulder and see the Geiger counter's needle stir as they passed the halfway point, walking single file so as not to test the rotted boards under their feet too much. When they came out on the other side, a sign informed them YOU ARE NOW LEAVING THE CHESTER'S MILL TOWN COMMON, EST. 1808. A well-worn path led up a slope of oak, ash, and beech. Their fall foliage hung limply, looking sullen rather than gay.

By the time they reached the foot of this path, the needle in the COUNTS PER SECOND window stood between +5 and +10. Beyond +10, the meter's calibration rose steeply to +500 and then to +1000. The top end of the dial was marked in red. The needle was miles below that, but Joe was pretty sure its current position indicated more than just a background count.

Benny was looking at the faintly quivering needle, but Joe was looking at Norrie.

'What were you thinking about?' he asked her. 'Don't be afraid to spill it, because it doesn't seem like such a stupid idea, after all.'

'No,' Benny agreed. He tapped the COUNTS PER SECOND window. The needle jumped, then settled back to +7 or 8.

'I was thinking a generator and a transmitter are practically the same thing,' Norrie said. 'And a transmitter doesn't have to be in the middle, just high up.'

'The CIK tower isn't,' Benny said. 'Just sits in a clearing, pumpin out the Jesus. I've seen it.'

'Yeah, but that thing's, like, super-powerful,' Norrie replied. 'My dad said it's a hundred thousand watts, or something. Maybe what we're looking for has a shorter range. So then I thought, "What's the highest part of the town?"'

'Black Ridge,' Joe said.

'Black Ridge,' she agreed, and held up a small fist.

Joe bumped her, then pointed. 'That way, two miles. Maybe three.' He turned the Geiger-Müller tube in that direction and they all watched, fascinated, as the needle rose to + 10.

'I'll be fucked,' Benny said.

'Maybe when you're forty,' Norrie said. Tough as ever . . . but blushing. Just a little.

'There's an old orchard out on the Black Ridge Road,' Joe said. 'You can see the whole Mill from it – TR-90, too. That's what my dad says, anyway. It could be there. Norrie, you're a genius.' He didn't have to wait for her to kiss him, after all. He did the honors, although daring no more than the corner of her mouth.

She looked pleased, but there was still a frown line between her eyes. 'It might not mean anything. The needle's not exactly going crazy. Can we go out there on our bikes?'

'Sure!' Joe said.

'After lunch,' Benny added. He thought of himself as the practical one.

6

While Joe, Benny, and Norrie were eating lunch at the McClatchey house (it was indeed chop suey) and Rusty Everett, assisted by Barbie and the two teenage girls, were treating supermarket-riot casualties at Cathy Russell, Big Jim Rennie sat in his study, going over a list and checking off items.

He saw his Hummer roll back up the driveway, and checked off another item: Brenda dropped off with the others. He thought he was ready – as ready as he could be, anyway. And even if the Dome disappeared this afternoon, he thought his butt was covered.

Junior came in and dropped the Hummer's keys on Big Jim's desk. He was pale and needed a shave worse than ever, but he no longer looked like death on a cracker. His left eye was red, but not flaming.

'All set, Son?'

Junior nodded. 'Are we going to jail?' He spoke with an almost disinterested curiosity.

'No,' Big Jim said. The idea that he might go to jail had never crossed his mind, not even when the Perkins witch had shown up here and started making her accusations. He smiled. 'But Dale Barbara is.'

'No one's going to believe he killed Brenda Perkins.'

Big Jim continued to smile. 'They will. They're frightened, and they will. It's how these things work.'

'How would you know?'

'Because I'm a student of history. You ought to try it sometime.' It was on the tip of his tongue to ask Junior why he had left Bowdoin – had he quit, flunked out, or been asked to leave? But this wasn't the time or the place. Instead he asked his son if he was up to one more errand.

Junior rubbed at his temple. 'I guess. In for a penny, in for a pound.'

'You'll need help. You could take Frank, I suppose, but I'd prefer the Thibodeau lad, if he's able to move around today. Not Searles, though. A good fellow, but stupid.'

Junior said nothing. Big Jim wondered again what was wrong with the boy. But did he really want to know? Perhaps when this crisis was over. In the meantime, he had many pots and skillets on the stove, and dinner would be served soon.

'What do you want me to do?'

'Let me check one thing first.' Big Jim picked up his cell. Each time he did this, he expected to find it as useless as tits on a bull, but it was still working. At least for in-town calls, which was all he cared about. He selected PD. It rang three times at the cop-shop before Stacey Moggin picked up. She sounded harried, not at all like her usual businesslike self. Big Jim wasn't surprised by that, given the morning's festivities; he could hear quite an uproar in the background.

'Police,' she said. 'If this isn't an emergency, please hang up and call back later. We're awfully bus—'

'It's Jim Rennie, hon.' He knew that Stacey hated being called *hon*. Which was why he did it. 'Put on the Chief. Chop-chop.'

'He's trying to break up a fistfight in front of the main desk right now,' she said. 'Maybe you could call back la—'

'No, I can't call back later,' Big Jim said. 'Do you think I'd be calling if this wasn't important? Just go over there, hon, and Mace the most aggressive one. Then you send Pete into his office to—'

She didn't let him finish, and she didn't put him on hold, either.

The phone hit the desk with a clunk. Big Jim was not put out of countenance; when he was getting under somebody's skin, he liked to know it. In the far distance, he heard someone call someone else a thieving sonofabitch. This made him smile.

A moment later he *was* put on hold, Stacey not bothering to inform him. Big Jim listened to McGruff the Crime Dog for awhile. Then the phone was picked up. It was Randolph, sounding out of breath.

'Talk fast, Jim, because this place is a madhouse. The ones who didn't go to the hospital with broken ribs or something are mad as hornets. Everybody's blaming everybody else. I'm trying to keep from filling up the cells downstairs, but it's like half of them *want* to go there.'

'Does increasing the size of the police force sound like a better idea to you today, Chief?'

'Christ, yes. We took a beating. I've got one of the new officers – that Roux girl – up to the hospital with the whole lower half of her face broken. She looks like the Bride of Frankenstein.'

Big Jim's smile widened to a grin. Sam Verdreaux had come through. But of course that was another thing about *feeling it*; when you *did* have to pass the ball, on those infrequent occasions when you couldn't shoot it yourself, you always passed it to the right person.

'Someone nailed her with a rock. Mel Searles, too. He was knocked out for a while, but he seems to be all right now. It's ugly, though. I sent him to the hospital to get patched up.'

'Well, that's a shame,' Big Jim said.

'Someone was targeting my officers. More than *one* someone, I think. Big Jim, can we really get more volunteers?'

'I think you'll find plenty of willing recruits among the upstanding young people of this town,' Big Jim said. 'In fact, I know several from the Holy Redeemer congregation. The Killian boys, for instance.'

'Jim, the Killian boys are dumber than Crackerjacks.'

'I know, but they're strong and they'll take orders.' He paused. 'Also, they can shoot.'

'Are we going to arm the new police?' Randolph sounded doubtful and hopeful at the same time.

'After what happened today? Of course. I was thinking ten or a dozen good trustworthy young people to start with. Frank and Junior can help pick them out. And we'll need more if this thing isn't sorted out by next week. Pay em in scrip. Give em first dibs on supplies, when and if rationing starts. Them and their families.'

'Okay. Send Junior down, will you? Frank's here, and so's Thibodeau. He got banged around some at the market and he had to get the bandage on his shoulder changed, but he's pretty much good to go.' Randolph lowered his voice. 'He said Barbara changed the bandage. Did a good job, too.'

'That's ducky, but our Mr Barbara won't be changing bandages for long. And I've got another job for Junior. Officer Thibodeau, too. Send him up here.'

'What for?'

'If you needed to know, I'd tell you. Just send him up. Junior and Frank can make a list of possible new recruits later on.'

'Well . . . if you say s—'

Randolph was interrupted by a fresh uproar. Something either fell over or was thrown. There was a crash as something else shattered.

'*Break that up!*' Randolph roared.

Smiling, Big Jim held the phone away from his ear. He could hear perfectly well, just the same.

'*Get those two . . . not those two, you idiot, the OTHER two . . . NO, I don't want em arrested! I want em the hell out of here! On their asses, if they won't go any other way!*'

A moment later he was speaking to Big Jim again. 'Remind me why I wanted this job, because I'm starting to forget.'

'It'll sort itself out,' Big Jim soothed. 'You'll have five new bodies by tomorrow − fresh young bucks − and another five by Thursday. Another five at least. Now send young Thibodeau up here. And make sure that cell at the far end downstairs is ready for a fresh occupant. Mr Barbara will be using it as of this afternoon.'

'On what charge?'

'How about four counts of murder, plus inciting a riot at the local supermarket? Will that do?'

He hung up before Randolph could reply.

'What do you want me and Carter to do?' Junior asked.

'This afternoon? First, a little reconnaissance and planning. I'll assist with the planning. Then you take part in arresting Barbara. You'll enjoy that, I think.'

'Yes I will.'

'Once Barbara's in the jug, you and Officer Thibodeau should eat a good supper, because your real job's tonight.'

'What?'

'Burning down the *Democrat* office − how does that sound?'

Junior's eyes widened. 'Why?'

That his son had to ask was a disappointment. 'Because, for the

immediate future, having a newspaper is not in the town's best interest. Any objections?'

'Dad – has it ever occurred to you that you might be crazy?'

Big Jim nodded. 'Like a fox,' he said.

7

'All the times I've been in this room,' Ginny Tomlinson said in her new foggy voice, 'and I never once imagined myself on the table.'

'Even if you had, you probably wouldn't have imagined being worked on by the guy who serves you your morning steak and eggs.' Barbie tried to keep it light, but he'd been patching and bandaging since arriving at Cathy Russell on the ambulance's first run, and he was tired. A lot of that, he suspected, was stress: he was scared to death of making someone worse instead of better. He could see the same worry on the faces of Gina Buffalino and Harriet Bigelow, and they didn't have the Jim Rennie clock ticking in their heads to make things worse.

'I think it will be awhile before I'm capable of eating another steak,' Ginny said.

Rusty had set her nose before seeing any of the other patients. Barbie had assisted, holding the sides of her head as gently as he could and murmuring encouragement. Rusty plugged her nostrils with gauze soaked in medicinal cocaine. He gave the anesthetic ten minutes to work (using the time to treat a badly sprained wrist and put an elastic bandage on an obese woman's swollen knee), then tweezed out the gauze strips and grabbed a scalpel. The PA was admirably quick. Before Barbie could tell Ginny to say *wishbone*, Rusty had slid the scalpel's handle up the clearer of her nostrils, braced it against her septum, and used it as a lever.

Like a man prying off a hubcap, Barbie had thought, listening to the small but perfectly audible crunch as Ginny's nose came back to something approximating its normal position. She didn't scream, but her fingernails tore holes in the paper covering the examination table, and tears poured down her cheeks.

She was calm now – Rusty had given her a couple of Percocets – but tears were still leaking from her less swollen eye. Her cheeks were a puffy purple. Barbie thought she looked a little like Rocky Balboa after the Apollo Creed fight.

'Look on the bright side,' he said.

'Is there one?'

'Definitely. The Roux girl is looking at a month of soup and milkshakes.'

'Georgia? I heard she took a hit. How bad?'

'She'll live, but it's going to be a long time before she's pretty.'

'That one was never going to be Miss Apple Blossom.' And, in a lower voice: 'Was it her screaming?'

Barbie nodded. Georgia's yowls had filled the whole hospital, it seemed. 'Rusty gave her morphine, but she didn't go down for a long time. She must have the constitution of a horse.'

'And the conscience of an alligator,' Ginny added in her foggy voice. 'I wouldn't wish what happened to her on anybody, but it's still a damned good argument for karmic retribution. How long have I been here? My darn watch is broken.'

Barbie glanced at his own. 'It's now fourteen thirty. So I guess that puts you about five and a half hours on the road to recovery.' He twisted at the hips, heard his back crackle, and felt it loosen up a little. He decided Tom Petty was right: the waiting was the hardest part. He reckoned he would feel easier once he was actually in a cell. Unless he was dead. It had crossed his mind that it might be convenient for him to be killed while resisting arrest.

'What are you smiling about?' she asked.

'Nothing.' He held up a set of tweezers. 'Now be quiet and let me do this. Soonest begun, soonest done.'

'I ought to get up and pitch in.'

'If you try it, the only pitching you'll do will be straight down to the floor.'

She looked at the tweezers. 'Do you know what you're doing with those?'

'You bet. I won a gold medal in Olympic Glass Removal.'

'Your bullshit quotient is even higher than my ex-husband's.' She was smiling a little. Barbie guessed it hurt her, even with painkillers on board, and he liked her for it.

'You're not going to be one of those tiresome medical people who turns into a tyrant when it's her turn for treatment, are you?' he asked.

'That was Dr Haskell. He ran a big splinter under his thumb-nail once, and when Rusty offered to take it out, The Wiz said he wanted a specialist.' She laughed, then winced, then groaned.

'If it makes you feel any better, the cop who punched you took a rock in the head.'

'More karma. Is he up and around?'

'Yep.' Mel Searles had walked out of the hospital two hours ago with a bandage wrapped around his head.

When Barbie bent toward her with the tweezers, she instinctively

turned her head away. He turned it back, pressing his hand – very gently – against the cheek that was less swollen.

'I know you have to,' she said. 'I'm just a baby about my eyes.'

'Given how hard he hit you, you're lucky the glass is around them instead of in them.'

'I know. Just don't hurt me, okay?'

'Okay,' he said. 'You'll be on your feet in no time, Ginny. I'll make this quick.'

He wiped his hands to make sure they were dry (he hadn't wanted the gloves, didn't trust his grip in them), then bent closer. There were maybe half a dozen small splinters of broken spectacle-lens peppered in her brows and around her eyes, but the one he was worried about was a tiny dagger just below the corner of her left eye. Barbie was sure Rusty would have taken it out himself if he'd seen it, but he had been concentrating on her nose.

Do it quick, he thought. *He who hesitates is usually fucked.*

He tweezed the shard out and dropped it into a plastic basin on the counter. A tiny seed-pearl of blood welled up where it had been. He let out his breath. 'Okay. Nothing to the rest of these. Smooth sailing.'

'From your lips to God's ear,' Ginny said.

He had just removed the last of the splinters when Rusty opened the door of the exam room and told Barbie he could use a little help. The PA was holding a tin Sucrets box in one hand.

'Help with what?'

'A hemorrhoid that walks like a man,' Rusty said. 'This anal sore wants to leave with his ill-gotten gains. Under normal circumstances I'd be delighted to see his miserable backside going out the door, but right now I might be able to use him.'

'Ginny?' Barbie asked. 'You okay?'

She made a waving gesture at the door. He had reached it, following after Rusty, when she called, 'Hey, handsome.' He turned back and she blew him a kiss.

Barbie caught it.

8

There was only one dentist in Chester's Mill. His name was Joe Boxer. His office was at the end of Strout Lane, where his dental suite offered a scenic view of Prestile Stream and the Peace Bridge. Which was nice if you were sitting up. Most visitors to said suite were in the reclining position, with nothing to look at but several dozen pictures of Joe Boxer's Chihuahua pasted on the ceiling.

'In one of them, the goddam dog looks like he's unloading,' Dougie Twitchell told Rusty after one visit. 'Maybe it's just the way that kind of dog sits down, but I don't think so. I think I spent half an hour looking at a dishrag with eyes take a shit while The Box dug two wisdom teeth out of my jaw. With a screwdriver, it felt like.'

The shingle hung outside Dr Boxer's office looked like a pair of basketball shorts large enough to fit a fairy-tale giant. They were painted a gaudy green and gold – the colors of the Mills Wildcats. The sign read JOSEPH BOXER, DDS. And, below that: **BOXER IS BRIEF!** And he *was* fairly speedy, everyone agreed, but he recognized no medical plans and accepted only cash. If a pulpcutter walked in with his gums suppurating and his cheeks puffed out like those of a squirrel with a mouthful of nuts and started talking about his dental insurance, Boxer would tell him to get the money from Anthem or Blue Cross or whoever and then come back to see him.

A little competition in town might have forced him to soften these Draconian policies, but the half a dozen who'd tried to make a go of it in The Mill since the early nineties had given up. There was speculation that Joe Boxer's good friend Jim Rennie might have had something to do with the paucity of competition, but no proof. Meantime, Boxer might be seen on any given day cruising around in his Porsche, with its bumper sticker reading MY OTHER CAR IS *ALSO* A PORSCHE!

As Rusty came down the hall with Barbie trailing after, Boxer was heading for the main doors. Or trying to; Twitch had him by the arm. Hung from Dr Boxer's other arm was a basket filled with Eggo waffles. Nothing else; just packages and packages of Eggos. Barbie wondered – not for the first time – if maybe he was lying in the ditch that ran behind Dipper's parking lot, beaten to a pulp and having a terrible brain-damaged dream.

'I'm *not* staying!' Boxer yapped. 'I have to get these home to the freezer! What you're proposing has almost no chance of working, anyway, so take your hands off me.'

Barbie observed the butterfly bandage bisecting one of Boxer's eyebrows and the larger bandage on his right forearm. The dentist had fought the good fight for his frozen waffles, it seemed.

'Tell this goon to take his hands off me,' he said when he saw Rusty. 'I've been treated, and now I'm going home.'

'Not just yet,' Rusty said. 'You were treated gratis, and I expect you to pay that forward.'

Boxer was a little guy, no more than five-four, but he drew himself up to his full height and puffed out his chest. 'Expect and be

damned. I hardly see oral surgery – which the State of Maine hasn't certified me to do, by the way – as a quid pro quo for a couple of bandages. I work for a living, Everett, and I expect to be paid for my work.'

'You'll be paid back in heaven,' Barbie said. 'Isn't that what your friend Rennie would say?'

'He has nothing to do with th—'

Barbie took a step closer and peered into Boxer's green plastic shopping basket. The words **PROPERTY OF FOOD CITY** were printed on the handle. Boxer tried, with no great success, to shield the basket from him.

'Speaking of payment, did you pay for those waffles?'

'Don't be ridiculous. Everybody was taking everything. All *I* took were these.' He looked at Barbie defiantly. 'I have a very large freezer, and I happen to enjoy waffles.'

'"Everyone was taking everything" won't be much of a defense if you're charged with looting,' Barbie said mildly.

It was impossible for Boxer to draw himself up any further, and yet somehow he did. His face was so red it was almost purple. 'Then take me to court! *What* court? Case closed! Ha!'

He started to turn away again. Barbie reached out and grabbed him, not by the arm but by the basket. 'I'll just confiscate this, then, shall I?'

'You can't do that!'

'No? Take me to court, then.' Barbie smiled. 'Oh, I forgot – *what* court?'

Dr Boxer glared at him, lips drawn back to show the tips of tiny perfect teeth.

'We'll just toast those old waffles up in the caff,' Rusty said. 'Yum! Tasty!'

'Yeah, while we've still got some electricity to toast em with,' Twitch muttered. 'After that we can poke em on forks and cook em over the incinerator out back.'

'You can't do this!'

Barbie said, 'Let me be perfectly clear: unless you do whatever it is Rusty wants you to do, I have no intention of letting go your Eggos.'

Chaz Bender, who had a Band-Aid on the bridge of his nose and another on the side of his neck, laughed. Not very kindly. 'Pay up, Doc!' he called. 'Isn't that what you always say?'

Boxer turned his glare first on Bender, then on Rusty. 'What you want has almost no chance of working. You must know that.'

Rusty opened the Sucrets box and held it out. Inside were six teeth. 'Torie McDonald picked these up outside the supermarket. She got down on her knees and grubbed through puddles of Georgia Roux's blood to find them. And if you want to have Eggos for breakfast in the near future, Doc, you're going to put them back in Georgia's head.'

'And if I just walk away?'

Chaz Bender, the history teacher, took a step forward. His fists were clenched. 'In that case, my mercenary friend, I'll beat the shit out of you in the parking lot.'

'I'll help,' Twitch said.

'I won't help,' Barbie said, 'but I'll watch.'

There was laughter and some applause. Barbie felt simultaneously amused and sick to his stomach.

Boxer's shoulders slumped. All at once he was just a little man caught in a situation too big for him. He took the Sucrets box, then looked at Rusty. 'An oral surgeon working under optimum conditions might be able to reimplant these teeth, and they might actually root, although he would be careful to give the patient no guarantees. If I do it, she'll be lucky to get back one or two. She's more likely to pull them down her windpipe and choke on them.'

A stocky woman with a lot of flaming red hair shouldered Chaz Bender aside. 'I'll sit with her and make sure that doesn't happen. I'm her mother.'

Dr Boxer sighed. 'Is she unconscious?'

Before he could get any further, two Chester's Mill police units, one of them the green Chief's car, pulled up in the turnaround. Freddy Denton, Junior Rennie, Frank DeLesseps, and Carter Thibodeau got out of the lead car. Chief Randolph and Jackie Wettington emerged from the Chief's car. Rusty's wife got out of the back. All were armed, and as they approached the main doors of the hospital, they drew their weapons.

The little crowd that had been watching the confrontation with Joe Boxer murmured and drew back, some in its number undoubtedly expecting to be arrested for theft.

Barbie turned to Rusty Everett. 'Look at me,' he said.

'What do you m—'

'Look at me!' Barbie lifted his arms, turning them to show both sides. Then he pulled up his tee-shirt, showing first his flat stomach, then turning to exhibit his back. 'Do you see marks? Bruises?'

'No—'

'Make sure *they* know that,' Barbie said.

It was all he had time for. Randolph led his officers through the door. 'Dale Barbara? Step forward.'

Before Randolph could lift his gun and point it at him, Barbie did so. Because accidents happen. Sometimes on purpose.

Barbie saw Rusty's puzzlement, and liked him even better for his innocence. He saw Gina Buffalino and Harriet Bigelow, their eyes wide. But most of his attention was reserved for Randolph and his backups. All the faces were stony, but on Thibodeau's and DeLesseps's he saw undeniable satisfaction. For them this was all about payback for that night at Dipper's. And payback was going to be a bitch.

Rusty stepped in front of Barbie, as if to shield him.

'Don't do that,' Barbie murmured.

'Rusty, *no!*' Linda cried.

'Peter?' Rusty asked. 'What's this about? Barbie's been helping out, and he's been doing a damned good job.'

Barbie was afraid to move the big PA aside or even touch him. He raised his arms instead, very slowly, holding his palms out.

When they saw his arms go up, Junior and Freddy Denton came at Barbie, and fast. Junior bumped Randolph on his way by, and the Beretta clutched in the Chief's fist went off. The sound was deafening in the reception area. The bullet went into the floor three inches in front of Randolph's right shoe, making a surprisingly large hole. The smell of gunpowder was immediate and startling.

Gina and Harriet screamed and bolted back down the main corridor, vaulting nimbly over Joe Boxer, who was crawling along with his head tucked and his normally neat hair hanging in his face. Brendan Ellerbee, who had been treated for a mildly dislocated jaw, kicked the dentist in the forearm as he stampeded past. The Sucrets box spun out of Boxer's hand, struck the main desk, and flew open, scattering the teeth Torie McDonald had so carefully picked up.

Junior and Freddy grabbed Rusty, who made no effort to fight them. He looked totally confused. They pushed him aside. Rusty went stumbling across the main lobby, trying to keep his feet. Linda grabbed him, and they sprawled to the floor together.

'*What the fuck?*' Twitch was roaring. '*What in the fuck?*'

Limping slightly, Carter Thibodeau approached Barbie, who saw what was coming but kept his hands raised. Lowering them could get him killed. And maybe not just him. Now that one gun had been fired, the chance of others going off was that much higher.

'Hello, hoss,' Carter said. 'Ain't you been a busy boy.' He punched Barbie in the stomach.

Barbie had tensed his muscles in anticipation of the blow, but it still doubled him over. The sonofabitch was strong.

'*Stop that!*' Rusty roared. He still looked bewildered, but now he looked angry, as well. '*Stop that right goddam now!*'

He tried to get up, but Linda put both of her arms around him and held him down. 'Don't,' she said. 'Don't, he's dangerous.'

'*What?*' Rusty turned his head and stared at her with disbelief. 'Are you *crazy?*'

Barbie was still holding his hands up, showing them to the cops. Doubled over as he was, it made him look like he was salaaming.

'Thibodeau,' Randolph said. 'Step back. That's enough.'

'Put that gun away, you idiot!' Rusty shouted at Randolph. 'You want to kill someone?'

Randolph gave him a brief look of dismissive contempt, then turned to Barbie. 'Stand up straight, son.'

Barbie did. It hurt, but he managed. He knew that if he hadn't been prepared for Thibodeau's gutpunch, he would have been curled on the floor, gasping for breath. And would Randolph have tried kicking him to his feet? Would the other cops have joined him in spite of the spectators in the hall, some of whom were now creeping back for a better view? Of course, because their blood was up. It was how these things went.

Randolph said, 'I'm arresting you for the murders of Angela McCain, Doreen Sanders, Lester A. Coggins, and Brenda Perkins.'

Each name struck Barbie, but the last one hit the hardest. The last one was a fist. That sweet woman. She had forgotten to be careful. Barbie couldn't blame her – she had still been in deep grief for her husband – but he could blame himself for letting her go to Rennie. For encouraging her.

'What happened?' he asked Randolph. 'What in God's name did you people do?'

'Like you don't know,' Freddy Denton said.

'What kind of psycho are you?' Jackie Wettington asked. Her face was a twisted mask of loathing, her eyes small with rage.

Barbie ignored them both. He was staring into Randolph's face with his hands still raised over his head. All it would take was the smallest excuse and they'd be on him. Even Jackie, ordinarily the pleasantest of women, might join in, although with her it would take a reason instead of just an excuse. Or perhaps not. Sometimes even good people snapped.

'A better question,' he said to Randolph, 'is what you let Rennie do. Because this is his mess, and you know it. His fingerprints are all over it.'

'Shut up.' Randolph turned to Junior. 'Cuff him.'

Junior reached for Barbie, but before he could so much as touch a raised wrist, Barbie put his hands behind his back and turned around. Rusty and Linda Everett were still on the floor, Linda with her arms wrapped around her husband's chest in a restraining bearhug.

'Remember,' Barbie said to Rusty as the plastic cuffs went on . . . and were then tightened until they dug into the scant meat above the heels of his hands.

Rusty stood up. When Linda tried to hold him, he pushed her away and gave her a look she had never seen before. There was sternness in it, and reproach, but there was also pity. 'Peter,' he said, and when Randolph began to turn away, he raised his voice to a shout. '*I'm talking to you!* You look at me while I do!'

Randolph turned. His face was a stone.

'He knew you were here for him.'

'Sure he did,' Junior said. 'He may be crazy, but he's not stupid.'

Rusty took no notice of this. 'He showed me his arms, his face, raised his shirt to show me his stomach and back. He's unmarked, unless he raises a bruise where Thibodeau suckerpunched him.'

Carter said, 'Three women? Three women and a *preacher*? He deserved it.'

Rusty didn't shift his gaze from Randolph. 'This is a setup.'

'All due respect, Eric, not your department,' Randolph said. He had holstered his sidearm. Which was a relief.

'That's right,' Rusty said. 'I'm a patch-em-up guy, not a cop or a lawyer. What I'm telling you is if I have occasion to look him over again while he's in your custody and he's got a lot of cuts and bruises, God help you.'

'What are you gonna do, call the Civil Liberties Union?' Frank DeLesseps asked. He was white-lipped with fury. 'Your friend there beat four people to death. Brenda Perkins's neck was broken. One of the girls was my fiancée, and she was sexually molested. Probably after she was dead as well as before, is the way it looks.'

Most of the crowd that had scattered at the gunshot had crept back to watch, and now a soft and horrified groan arose from it.

'This is the guy you're defending? You ought to be in jail yourself!'

'Frank, shut up!' Linda said.

Rusty looked at Frank DeLesseps, the boy he had treated for

chicken pox, measles, head lice picked up at summer camp, a broken wrist suffered sliding into second base, and once, when he was twelve, a particularly malicious case of poison ivy. He saw very little resemblance between that boy and this man. 'And if I was locked up? Then what, Frankie? What if your mother has another gallbladder attack, like last year? Do I wait for visiting hours at the jail to treat her?'

Frank stepped forward, raising a hand to either slap or punch. Junior grabbed him. 'He'll get his, don't worry. Everyone on Barbara's side will. All in good time.'

'Sides?' Rusty sounded honestly bewildered. 'What are you talking about, *sides*? This isn't a goddam football game.'

Junior smiled as if he knew a secret.

Rusty turned to Linda. 'Those are your colleagues talking. Do you like how they sound?'

For a moment she couldn't look at him. Then, with an effort, she did. 'They're mad, that's all, and I don't blame them. I am, too. Four people, Eric – didn't you hear? He killed them, and he almost certainly raped at least two of the women. I helped take them out of the hearse at Bowie's. I saw the stains.'

Rusty shook his head. 'I just spent the morning with him, watching him help people, not hurt them.'

'Let it go,' Barbie said. 'Stand back, big guy. It's not the ti—'

Junior poked him in the ribs. Hard. 'You have the right to remain silent, assmunch.'

'He did it,' Linda said. She stretched out a hand to Rusty, saw he wasn't going to take it, and dropped it to her side. 'They found his dog tags in Angie McCain's hand.'

Rusty was speechless. He could only watch as Barbie was hustled out to the Chief's car and locked in the backseat with his hands still cuffed behind him. There was one moment when Barbie's eyes found Rusty's. Barbie shook his head. A single shake only, but hard and firm.

Then he was driven away.

There was silence in the lobby. Junior and Frank had gone with Randolph. Carter, Jackie, and Freddy Denton headed out to the other police car. Linda stood looking at her husband with pleading and anger. Then the anger disappeared. She stepped toward him, raising her arms, wanting to be held, if only for a few seconds.

'No,' he said.

She stopped. 'What's *wrong* with you?'

'What's wrong with *you*? Did you miss what just happened here?'

'Rusty, she was holding his *dog tags!*'

He nodded slowly. 'Convenient, wouldn't you say?'

Her face, which had been both hurt and hopeful, now froze. She seemed to notice that her arms were still held out to him, and she lowered them.

'Four people,' she said, 'three beaten almost beyond recognition. There *are* sides, and you need to think about which one you're on.'

'So do you, honey,' Rusty said.

From outside, Jackie called, 'Linda, come on!'

Rusty was suddenly aware he had an audience, and that many among it had voted for Jim Rennie again and again. 'Just think about this, Lin. And think about who Pete Randolph works for.'

'*Linda!*' Jackie called.

Linda Everett left with her head dropped. She didn't look back. Rusty was okay until she got into the car. Then he began to tremble. He thought if he didn't sit down soon, he might fall down.

A hand fell on his shoulder. It was Twitch. 'You okay, boss?'

'Yes.' As if saying so would make it so. Barbie had been hauled off to jail and he'd had his first real argument with his wife in — what? — four years? More like six. No, he wasn't okay.

'Got a question,' Twitch said. 'If those people were murdered, why'd they take the bodies to the Bowie Funeral Home instead of bringing them here for postmortem examination? Whose idea was that?'

Before Rusty could reply, the lights went out. The hospital generator had finally run dry.

9

After watching them polish off the last of her chop suey (which had contained the last of her hamburger), Claire motioned the three children to stand in front of her in the kitchen. She looked at them solemnly and they looked back — so young and scarily determined. Then, with a sigh, she handed Joe his backpack. Benny peered inside and saw three PB&Js, three deviled eggs, three bottles of Snapple, and half a dozen oatmeal-raisin cookies. Although still full of lunch, he brightened. 'Most excellent, Mrs McC.! You are a true—'

She paid no heed; all her attention was fixed on Joe. 'I understand that this could be important, so I'm going along. I'll even drive you out there if you—'

'Don't have to, Mom,' Joe said. 'It's an easy ride.'

'Safe, too,' Norrie added. 'Hardly anyone on the roads.'

Claire's eyes were locked on her son's in the Mom Death-Stare. 'But I need two promises. First, that you'll be home before dark . . . and I don't mean the last gasp of twilight, either, I mean while the sun is still up. Second, if you *do* find something, mark its location and then leave it *utterly* and *completely* alone. I accept that you three might be the best people to look for this whatever-it-might-be, but dealing with it is a job for adults. So do I have your word? Give it to me or I'll have to come with you as your chaperone.'

Benny looked doubtful. 'I've never been down Black Ridge Road, Mrs McC., but I've been past it. I don't think your Civic would exactly be, like, up to the task.'

'Then promise me or you stay right here, how's that?'

Joe promised. So did the other two. Norrie even crossed herself.

Joe started to shoulder the backpack. Claire slipped in her cell phone. 'Don't lose that, mister.'

'I won't, Mom.' Joe was shifting from foot to foot, anxious to be gone.

'Norrie? Can I trust you to put the brakes on if these two get crazy?'

'Yes, ma'am,' Norrie Calvert said, as if she hadn't dared death or disfigurement on her skateboard a thousand times just in the last year. 'You sure can.'

'I hope so,' she said. 'I hope so.' Claire rubbed at her temples as if she were getting a headache.

'Awesome lunch, Mrs McC.!' Benny said, and held up his hand. 'Slap me five.'

'Dear God, what am I doing?' Claire asked. Then she slapped him five.

10

Behind the chest-high front desk in the Police Department lobby, where people came to complain about such troubles as theft, vandalism, and the neighbor's ceaselessly barking dog, was the ready room. It contained desks, lockers, and a coffee station where a grouchy sign announced COFFEE AND DONUTS ARE *NOT* FREE. It was also the booking area. Here Barbie was photographed by Freddy Denton and fingerprinted by Henry Morrison while Peter Randolph and Denton stood close by with their guns drawn.

'Limp, keep em limp!' Henry shouted. This was not the man who had enjoyed talking with Barbie about the Red Sox–Yankees rivalry over lunch at Sweetbriar Rose (always a BLT with a dill pickle

spear on the side). This was a fellow who looked like he'd enjoy punching Dale Barbara in the nose. Hard. 'You don't roll em, I do, so keep em limp!'

Barbie thought of telling Henry it was hard to relax your hands when you were standing this close to men with guns, especially if you knew the men wouldn't mind using them. He kept his mouth shut instead, and concentrated on relaxing his hands so Henry could roll the prints. And he wasn't bad at it, not at all. Under other circumstances Barbie might have asked Henry why they were bothering, but he held his tongue on this subject, as well.

'All right,' Henry said when he judged the prints clear. 'Take him downstairs. I want to wash my hands. I feel dirty just touching him.'

Jackie and Linda had been standing to one side. Now, as Randolph and Denton holstered their guns and grabbed Barbie's arms, the two women drew their own. They were pointed down but ready.

'I'd puke up everything you ever fed me, if I could,' Henry said. 'You disgust me.'

'I didn't do it,' Barbie said. 'Think about it, Henry.'

Morrison only turned away. *Thinking's in short supply around here today*, Barbie thought. Which, he was sure, was just the way Rennie liked it.

'Linda,' he said. 'Mrs Everett.'

'Don't talk to me.' Her face was paper-pale except for dark purplish crescents beneath her eyes. They looked like bruises.

'Come on, sunshine,' Freddy said, and ground a knuckle into the small of Barbie's back, just above the kidney. 'Your suite awaits.'

11

Joe, Benny, and Norrie rode their bikes north along Route 119. The afternoon was summer-hot, the air hazy and humid. Not a breath of breeze stirred. Crickets sang dozily in the high weeds at the sides of the road. The sky at the horizon had a yellow look that Joe first took for clouds. Then he realized it was a mixture of pollen and pollution on the surface of the Dome. Out here, Prestile Stream ran close beside the highway, and they should have heard it chuckling as it sped southeast toward Castle Rock, eager to join the mighty Androscoggin, but they heard only the crickets and a few crows cawing lackadaisically in the trees.

They passed the Deep Cut Road, and came to the Black Ridge Road about a mile farther on. It was dirt, badly potholed, and marked

with two leaning, frost-heaved signs. The one on the left read 4-WHEEL DRIVE RECOMMENDED. The one on the right added BRIDGE WEIGHT LIMIT 4 TONS LARGE TRUCKS POSTED. Both signs were riddled with bulletholes.

'I like a town where the folks take regular target practice,' Benny said. 'Makes me feel safe from El Kliyder.'

'That's Al Qaeda, nitboy,' Joe said.

Benny shook his head, smiling indulgently. 'I'm talking about El *Kliyder,* the terrible Mexican bandit who has relocated to western Maine in order to avoid—'

'Let's try the Geiger counter,' Norrie said, dismounting her bike.

It was back in the carrier of Benny's High Plains Schwinn. They had nested it in a few old towels from Claire's rag-basket. Benny took it out and handed it to Joe, its yellow case the brightest thing in that hazy landscape. Benny's smile had disappeared. 'You do it. I'm too nervous.'

Joe considered the Geiger counter, then handed it off to Norrie.

'Chickenshits,' she said, not unkindly, and turned it on. The needle swung immediately to +50. Joe stared at it and felt his heart suddenly bumping in his throat instead of his chest.

'Whoa!' Benny said. 'We have liftoff!'

Norrie looked from the needle, which was steady (but still half a dial away from the red), to Joe. 'Keep going?'

'Hell, yeah,' he said.

12

There was no power shortage at the Police Department – at least not yet. A green-tiled corridor ran the length of the basement beneath fluorescents that cast a depressingly changeless light. Dawn or midnight, it was always the blare of noon down here. Chief Randolph and Freddy Denton escorted (if such a word could be used, considering the fists clamped on his upper arms) Barbie down the steps. The two women officers, guns still drawn, followed behind.

To the left was the file room. To the right were five cells, two on each side and one at the very end. The last was the smallest, with a narrow bunk all but overhanging the seatless steel toilet, and this was the one toward which they frog-marched him.

On orders from Pete Randolph – who had gotten his from Big Jim – even the worst actors in the supermarket riot had been released on their own recognizance (where were they going to go?), and all the cells were supposed to be empty. So it was a surprise when Melvin

Searles came bolting from number 4, where he had been lurking. The bandage wound around his head had slipped down and he was wearing sunglasses to mask two gaudily blackening eyes. In one hand he was carrying an athletic sock with something weighting the toe: a homemade blackjack. Barbie's first, blurred impression was that he was about to be attacked by the Invisible Man.

'Bastard!' Mel shouted, and swung his cosh. Barbie ducked. It whizzed over his head, striking Freddy Denton on the shoulder. Freddy bellowed and let go of Barbie. Behind them, the women were shouting.

'Fuckin *murderer*! Who'd you pay to bust my head? Huh?' Mel swung again, and this time connected with the bicep of Barbie's left arm. That arm seemed to fall dead. Not sand in the sock, but a paper-weight of some kind. Glass or metal, probably, but at least it was round. If it had had an angle, he would be bleeding.

'You fuckin fucked-up fuck!' Mel roared, and swung the loaded sock again. Chief Randolph ducked backward, also letting go of Barbie. Barbie grabbed the top of the sock, wincing as the weight inside wound the bottom around his wrist. He pulled back hard, and managed to yank Mel Searles's homemade weapon free. At the same time Mel's bandage fell down over his dark glasses like a blindfold.

'Hold it, hold it!' Jackie Wettington cried. 'Stop what you're doing, prisoner, this is your only warning!'

Barbie felt a small cold circle form between his shoulder blades. He couldn't see it, but knew without looking that Jackie had drawn her sidearm. *If she shoots me, that's where the bullet will go. And she might, because in a small town where big trouble's almost a complete stranger, even the professionals are amateurs.*

He dropped the sock. Whatever was in it clunked on the lino. Then he raised his hands. 'Ma'am, I have dropped it!' he called. 'Ma'am, I am unarmed, please lower your weapon!'

Mel brushed the slipping bandage aside. It unrolled down his back like the tail of a swami's turban. He hit Barbie twice, one in the solar plexus and once in the pit of the stomach. This time Barbie wasn't prepared, and the air exploded out of his lungs with a harsh *PAH* sound. He doubled over, then went to his knees. Mel hammered a fist down on the nape of his neck – or maybe it was Freddy; for all Barbie knew, it could have been the Fearless Leader himself – and he went sprawling, the world growing thin and indistinct. Except for a chip in the linoleum. That he could see very well. With breath-taking clarity, in fact, and why not? It was less than an inch from his eyes.

'Stop it, stop it, *stop hitting him!*' The voice was coming from a great distance, but Barbie was pretty sure it belonged to Rusty's wife. '*He's down, don't you see he's down?*'

Feet shuffled around him in a complicated dance. Someone stepped on his ass, stumbled, cried 'Oh *fuck!*' and then he was kicked in the hip. It was all happening far away. It might hurt later, but right now it wasn't too bad.

Hands grabbed him and hauled him upright. Barbie tried to raise his head, but it was easier, on the whole, just to let it hang. He was propelled down the hall toward the final cell, the green lino sliding between his feet. What had Denton said upstairs? *Your suite awaits.*

But I doubt if there's pillow mints or turndown service, Barbie thought. Nor did he care. All he wanted was to be left alone to lick his wounds.

Outside the cell someone put a shoe in his ass to hurry him along even more. He flew forward, raising his right arm to stop himself from crashing face-first into the green cinderblock wall. He tried to raise his left arm as well, but it was still dead from the elbow down. He managed to protect his head, though, and that was good. He rebounded, staggered, then went to his knees again, this time beside the cot, as if about to say a prayer prior to turning in. Behind him, the cell door rumbled shut along its track.

Barbie braced his hands on the bunk and pushed himself up, the left arm working a little now. He turned around just in time to see Randolph walking away in a pugnacious strut – fists clenched, head lowered. Beyond him, Denton was unwinding what remained of Searles's bandage while Searles glared (the power of the glare somewhat vitiated by the sunglasses, now sitting askew on his nose). Beyond the male officers, at the foot of the stairs, were the women. They wore identical expressions of dismay and confusion. Linda Everett's face was paler than ever, and Barbie thought he saw the gleam of tears in her lashes.

Barbie summoned all his will and called out to her. 'Officer Everett!'

She jumped a little, startled. Had anyone ever called her Officer Everett before? Perhaps schoolchildren, when she pulled crossing-guard duty, which had probably been her heaviest responsibility as a part-time cop. Up until this week.

'Officer Everett! Ma'am! Please, ma'am!'

'Shut up!' Freddy Denton said.

Barbie paid him no mind. He thought he was going to pass out, or at least gray out, but for the time being he held on grimly.

'Tell your husband to examine the bodies! Mrs Perkins's in particular! Ma'am, he *must* examine the bodies! They won't be at the hospital! Rennie won't allow them to—'

Peter Randolph strode forward. Barbie saw what he had taken off Freddy Denton's belt and tried to raise his arms across his face, but they were just too heavy.

'That's enough out of you, son,' Randolph said. He shoved the Mace dispenser between the bars and squeezed the pistol grip.

13

Halfway over the rust-eaten Black Ridge Bridge, Norrie stopped her bike and stood looking at the far side of the cut.

'We better keep going,' Joe said. 'Use the daylight while we've got it.'

'I know, but look,' Norrie said, pointing.

On the other bank, below a steep drop and sprawled on the drying mud where the Prestile had run full before the Dome began to choke its flow, were the bodies of four deer: a buck, two does, and a yearling. All were of good size; it had been a fine summer in The Mill, and they had fed well. Joe could see clouds of flies swarming above the carcasses, could even hear their somnolent buzz. It was a sound that would have been covered by running water on an ordinary day.

'What happened to them?' Benny asked. 'Do you think it has anything to do with what we're looking for?'

'If you're talking about radiation,' Joe said, 'I don't think it works that fast.'

'Unless it's really *high* radiation,' Norrie said uneasily.

Joe pointed at the Geiger counter's needle. 'Maybe, but this still isn't very high. Even if it was all the way in the red, I don't think it would kill animals as big as deer in only three days.'

Benny said, 'That buck's got a broken leg, you can see it from here.'

'I'm pretty sure one of the does has got *two*,' Norrie said. She was shading her eyes. 'The front ones. See how they're bent?'

Joe thought the doe looked as if she had died while trying to do some strenuous gymnastic stunt.

'I think they jumped,' Norrie said. 'Jumped off the bank like those little rat-guys are supposed to.'

'Lemons,' Benny said.

'Lem-*mings*, birdbrain,' Joe said.

'Trying to get away from something?' Norrie asked. 'Is that what they were doing?'

Neither boy answered. Both looked younger than they had the week before, like children forced to listen to a campfire story that's much too scary. The three of them stood by their bikes, looking at the dead deer and listening to the somnolent hum of the flies.

'Go on?' Joe asked.

'I think we have to,' Norrie said. She swung a leg over the fork of her bike and stood astride it.

'Right,' Joe said, and mounted his own bike.

'Ollie,' Benny said, 'this is another fine mess you've gotten me into.'

'Huh?'

'Never mind,' Benny said. 'Ride, my soul brother, ride.'

On the far side of the bridge, they could see that all the deer had broken legs. One of the yearlings also had a crushed skull, probably suffered when it came down on a large boulder that would have been covered by water on an ordinary day.

'Try the Geiger counter again,' Joe said.

Norrie turned it on. This time the needle danced just below +75.

14

Pete Randolph exhumed an old cassette recorder from one of Duke Perkins's desk drawers, tested it, and found the batteries still good. When Junior Rennie came in, Randolph pressed REC and set the little Sony on the corner of the desk where the young man could see it.

Junior's latest migraine was down to a dull mutter on the left side of his head, and he felt calm enough; he and his father had been over this, and Junior knew what to say.

'It'll be strictly softball,' Big Jim had said. 'A formality.'

And so it was.

'How'd you find the bodies, son?' Randolph asked, rocking back in the swivel chair behind the desk. He had removed all of Perkins's personal items and put them in a file cabinet on the other side of the room. Now that Brenda was dead, he supposed he could dump them in the trash. Personal effects were no good when there was no next of kin.

'Well,' Junior said, 'I was coming back from patrol out on 117 – I missed the whole supermarket thing—'

'Good luck for you,' Randolph said. 'That was a total cock-and-balls, if you'll pardon my fran-kays. Coffee?'

'No thanks, sir. I'm subject to migraines, and coffee seems to make them worse.'

'Bad habit, anyway. Not as bad as cigarettes, but bad. Did you know I smoked until I was Saved?'

'No, sir, I sure didn't.' Junior hoped this idiot would stop blathering and let him tell his story so he could get out of here.

'Yep, by Lester Coggins.' Randolph splayed his hands on his chest. 'Full-body immersion in the Prestile. Gave my heart to Jesus right then and there. I haven't been as faithful a churchgoer as some, certainly not as faithful as your dad, but Reverend Coggins was a good man.' Randolph shook his head. 'Dale Barbara's got a lot on his conscience. Always assuming he has one.'

'Yes, sir.'

'A lot to answer for, too. I gave him a shot of Mace, and that was just a small down payment on what he's got coming. So. You were coming back from patrol and?'

'And I got to thinking that someone told me they'd seen Angie's car in the garage. You know, the McCain garage.'

'Who told you that?'

'Frank?' Junior rubbed his temple. 'I think maybe it was Frank.'

'Go on.'

'So anyway, I looked in one of the garage windows, and her car *was* there. I went to the front door and rang the bell, but nobody answered. Then I went around to the back because I was worried. There was . . . a smell.'

Randolph nodded sympathetically. 'Basically, you just followed your nose. That was good police work, son.'

Junior looked at Randolph sharply, wondering if this was a joke or a sly dig, but the Chief's eyes seemed to hold nothing but honest admiration. Junior realized that his father might have found an assistant (the first word actually to occur to him was *accomplice*) who was even dumber than Andy Sanders. He wouldn't have thought that possible.

'Go on, finish up. I know this is painful to you. It's painful to all of us.'

'Yes, sir. Basically it's just what you said. The back door was unlocked, and I followed my nose straight to the pantry. I could hardly believe what I found there.'

'Did you see the dog tags then?'

'Yes. No. Kind of. I saw Angie had *something* in her hand . . .

on a chain . . . but I couldn't tell what it was, and I didn't want to touch anything.' Junior looked down modestly. 'I know I'm just a rookie.'

'Good call,' Randolph said. '*Smart* call. You know, we'd have a whole forensic team from the State Attorney General's office in there under ordinary circumstances – really nail Barbara to the wall – but these aren't ordinary circumstances. Still, we've got enough, I'd say. He was a fool to overlook those dog tags.'

'I used my cell phone and called my father. Based on all the radio chatter, I figured you'd be busy down here—'

'Busy?' Randolph rolled his eyes. 'Son, you don't know the half of it. You did the right thing calling your dad. He's practically a member of the department.'

'Dad grabbed two officers, Fred Denton and Jackie Wettington, and they came on over to the McCains' house. Linda Everett joined us while Freddy was photographing the crime scene. Then Stewart Bowie and his brother showed up with the funeral hack. My dad thought that was best, things being so busy at the hospital with the riot and all.'

Randolph nodded. 'Just right. Help the living, store the dead. Who found the dog tags?'

'Jackie. She pushed Angie's hand open with a pencil and they fell right out on the floor. Freddy took pictures of everything.'

'Helpful at a trial,' Randolph said. 'Which we'll have to handle ourselves, if this Dome thing doesn't clear up. But we can. You know what the Bible says: With faith, we can move mountains. What time did you find the bodies, son?'

'Around noon.' *After I took some time to say goodbye to my girl-friends.*

'And you called your father right away?'

'Not right away.' Junior gave Randolph a frank stare. 'First I had to go outside and vomit. They were beaten up so bad. I never saw anything like that in my life.' He let out a long sigh, being careful to put a small tremble in it. The tape recorder probably wouldn't pick up that tremble, but Randolph would remember it. 'When I was done heaving, that was when I called Dad.'

'Okay, I think that's all I need.' No more questions about the timeline or about his 'morning patrol'; not even a request for Junior to write up a report (which was good, since writing inevitably gave him a headache these days). Randolph leaned forward to snap off the tape recorder. 'Thank you, Junior. Why don't you take the rest of the day off? Go home and rest. You look beat.'

'I'd like to be here when you question him, sir. Barbara.'

'Well, you don't have to worry about missing that today. We're going to give him twenty-four hours to stew in his own juices. Your dad's idea, and a good one. We'll question him tomorrow afternoon or tomorrow night, and you'll be there. I give you my word. We're going to question him *vigorously.*'

'Yes, sir. Good.'

'None of this Miranda stuff.'

'No, sir.'

'And thanks to the Dome, no turning him over to the County Sheriff, either.' Randolph looked at Junior keenly. 'Son, this is going to be a true case of what happens in Vegas stays in Vegas.'

Junior didn't know whether to say *yes, sir* or *no, sir* to that, because he had no idea what the idiot behind the desk was talking about.

Randolph held him with that keen glance a moment or two longer, as if to assure himself that they understood one another, then clapped his hands together once and stood up. 'Go home, Junior. You've got to be shaken up a bit.'

'Yes, sir, I am. And I think I will. Rest, that is.'

'I had a pack of cigarettes in my pocket when Reverend Coggins dipped me,' Randolph said in a tone of fond-hearted reminiscence. He put an arm around Junior's shoulders as they walked to the door. Junior retained his respectful, listening expression, but felt like screaming at the weight of that heavy arm. It was like wearing a meat necktie. 'They were ruined, of course. And I never bought another pack. Saved from the devil's weed by the Son of God. How's that for grace?'

'Awesome,' Junior managed.

'Brenda and Angie will get most of the attention, of course, and that's normal – prominent town citizen and young girl with her life ahead of her – but Reverend Coggins had his fans, too. Not to mention a large and loving congregation.'

Junior could see Randolph's blunt-fingered hand from the corner of his left eye. He wondered what Randolph would do if he suddenly cocked his head around and bit it. Bit one of those fingers right off, maybe, and spat it on the floor.

'Don't forget Dodee.' He had no idea why he said it, but it worked. Randolph's hand dropped from his shoulder. The man looked thunderstruck. Junior realized he *had* forgotten Dodee.

'Oh God,' Randolph said. 'Dodee. Has anyone called Andy and told him?'

'I don't know, sir.'

'Your father will have, surely?'

'He's been awfully busy.'

That was true. Big Jim was at home in his study, drafting his speech for the town meeting on Thursday night. The one that he'd give just before the townsfolk voted the Selectmen emergency governing powers for the duration of the crisis.

'I better call him,' Randolph said. 'But maybe I'd better pray on it first. Do you want to get kneebound with me, son?'

Junior would have sooner poured lighter fluid down his pants and set his balls on fire, but didn't say so. 'Speak to God on your own, and you'll hear Him answer more clearly. That's what my dad always says.'

'All right, son. That's good advice.'

Before Randolph could say any more, Junior slipped first out of the office, then out of the police station. He walked home, deep in thought, mourning his lost girlfriends and wondering if he could get another. Maybe more than one.

Under the Dome, all sorts of things might be possible.

15

Pete Randolph *did* try to pray, but there was too much on his mind. Besides, the Lord helped those who helped themselves. He didn't think that was in the Bible, but it was true just the same. He called Andy Sanders's cell from the list of numbers thumb-tacked to the bulletin board on the wall. He hoped for no answer, but the guy picked up on the very first ring – wasn't that always the way?

'Hello, Andy. Chief Randolph here. I've got some pretty tough news for you, my friend. Maybe you better sit down.'

It was a difficult conversation. Hellacious, actually. When it was finally over, Randolph sat drumming his fingers on his desk. He thought – again – that if Duke Perkins were the one sitting behind this desk, he wouldn't be entirely sorry. Maybe not sorry at all. It had turned out to be a much harder and dirtier job than he had imagined. The private office wasn't worth the aggravation. Even the green Chief's car wasn't; every time he got behind the wheel and his butt slipped into the hollow Duke's meatier hind-quarters had made before him, the same thought occurred: *You're not up to this.*

Sanders was coming down here. He wanted to confront Barbara.

Randolph had tried to talk him out of it, but halfway through his suggestion that Andy's time would be better spent on his knees, praying for the souls of his wife and daughter – not to mention the strength to bear his cross – Andy had broken the connection.

Randolph sighed and punched up another number. After two rings, Big Jim's ill-tempered voice was in his ear. 'What? *What?*'

'It's me, Jim. I know you're working and I hate to interrupt you, but could you come down here? I need help.'

16

The three children stood in the somehow depthless afternoon light, under a sky that now had a decided yellowish tinge, and looked at the dead bear at the foot of the telephone pole. The pole was leaning crookedly. Four feet up from its base, the creosoted wood was splintered and splashed with blood. Other stuff, too. White stuff that Joe supposed was fragments of bone. And grayish mealy stuff that had to be brai—

He turned around, trying to control his gorge. He almost had it, too, but then Benny threw up – a big wet *yurp* sound – and Norrie followed suit. Joe gave in and joined the club.

When they were under control again, Joe unslung his backpack, took out the bottles of Snapple, and handed them around. He used the first mouthful to rinse with, and spat it out. Norrie and Benny did the same. Then they drank. The sweet tea was warm, but it still felt like heaven on Joe's raw throat.

Norrie took two cautious steps toward the black, fly-buzzing heap at the foot of the phone pole. 'Like the deer,' she said. 'Poor guy didn't have any riverbank to jump over, so he beat his brains out on a phone-pole.'

'Maybe it had rabies,' Benny said in a thin voice. 'Maybe the deer did, too.'

Joe guessed that was a technical possibility, but he didn't believe it. 'I've been thinking about this suicide thing.' He hated the tremble he heard in his voice, but couldn't seem to do anything about it. 'Whales and dolphins do it – they beach themselves, I've seen it on TV. And my dad says octopuses do it.'

'Pi,' Norrie said. 'Octopi.'

'Whatever. My dad said when their environment gets polluted, they eat off their own tentacles.'

'Dude, do you want me to throw up again?' Benny asked. He sounded querulous and tired.

'Is that what's going on here?' Norrie asked. 'The environment's polluted?'

Joe glanced up at the yellowish sky. Then he pointed southwest, where a hanging black residue from the fire started by the missile strike discolored the air. The smutch looked to be two or three hundred feet high and a mile across. Maybe more.

'Yes,' she said, 'but that's different. Isn't it?'

Joe shrugged.

'If we're gonna feel a sudden urge to kill ourselves, maybe we should go back,' Benny said. 'I got a lot to live for. I still haven't been able to beat *Warhammer.*'

'Try the Geiger counter on the bear,' Norrie said.

Joe held the sensor tube out toward the bear's carcass. The needle didn't drop, but it didn't rise either.

Norrie pointed east. Ahead of them, the road emerged from the thick band of black oak that gave the ridge its name. Once they were out of the trees, Joe thought they'd be able to see the apple orchard at the top.

'Let's at least keep going until we're out of the trees,' she said. 'We'll take a reading from there, and if it's still going up, we'll head back to town and tell Dr Everett or that guy Barbara or both of them. Let them figure it out.'

Benny looked doubtful. 'I don't know.'

'If we feel anything weird, we'll turn back right away,' Joe said.

'If it might help, we should do it,' Norrie said. 'I want to get out of The Mill before I go completely stir-crazy.'

She smiled to show this was a joke, but it didn't *sound* like a joke, and Joe didn't take it as one. Lots of people kidded about what a small burg The Mill was – it was probably why the James McMurtry song had been so popular – and it was, intellectually speaking, he supposed. Demographically, too. He could think of only one Asian American – Pamela Chen, who sometimes helped Lissa Jamieson out at the library – and there were no black people at all since the Laverty family had moved to Auburn. There was no McDonald's, let alone a Starbucks, and the movie theater was closed down. But until now it had always felt geographically big to him, with plenty of room to roam. It was amazing how much it shrank in his mind once he realized that he and his mom and dad couldn't just pile into the family car and drive to Lewiston for fried clams and ice cream at Yoder's. Also, the town had plenty of resources, but they wouldn't last forever.

'You're right,' he said. 'It's important. Worth the risk. At least I

think so. You can stay here if you want to, Benny. This part of the mission is strictly volunteer.'

'No, I'm in,' Benny said. 'If I let you guys go without me, you'd rank me to the dogs and back.'

'You're already there!' Joe and Norrie yelled in unison, then looked at each other and laughed.

17

'That's right, *cry*!'

The voice was coming from far away. Barbie struggled toward it, but it was hard to open his burning eyes.

'You've got a lot to cry *about*!'

The person making these declarations sounded like he was crying himself. And the voice was familiar. Barbie tried to see, but his lids felt swollen and heavy. The eyes beneath were pulsing with his heartbeat. His sinuses were so full his ears crackled when he swallowed.

'Why did you kill her? Why did you kill my baby?'

Some sonofabitch Maced me. Denton? No, Randolph.

Barbie managed to open his eyes by placing the heels of his hands over his eyebrows and shoving upward. He saw Andy Sanders standing outside the cell with tears rolling down his cheeks. And what was Sanders seeing? A guy in a cell, and a guy in a cell always looked guilty.

Sanders screamed, '*She was all I had!*'

Randolph stood behind him, looking embarrassed and shuffling like a kid twenty minutes overdue for a bathroom pass. Even with his eyes burning and his sinuses pounding, Barbie wasn't surprised that Randolph had let Sanders come down here. Not because Sanders was the town's First Selectman, but because Peter Randolph found it almost impossible to say no.

'Now, Andy,' Randolph said. 'That's enough. You wanted to see him and I let you, even though it was against my better judgment. He's jugged good and proper, and he'll pay the price for what he did. So now come on upstairs and I'll pour you a cup of—'

Andy grabbed the front of Randolph's uniform. He was four inches shorter, but Randolph still looked scared. Barbie didn't blame him. He was viewing the world through a deep red film, but he could see Andy Sanders's fury clearly enough.

'Give me your gun! A trial's too good for him! He's apt to get off, anyway! He's got friends in high places, Jim says so! I

want some satisfaction! I *deserve* some satisfaction, *so give me your gun!'*

Barbie didn't think Randolph's desire to please would go so far as handing over his weapon so that Andy could shoot him in this cell like a rat in a rainbarrel, but he wasn't entirely sure; there might be a reason other than the craven need to please that had caused Randolph to bring Sanders down here, and to bring him down alone.

He struggled to his feet. 'Mr Sanders.' Some of the Mace had gotten into his mouth. His tongue and throat were swollen, his voice an unconvincing nasal croak. 'I did not kill your daughter, sir. I did not kill anyone. If you think about this you'll see that your friend Rennie needs a scapegoat and I'm the most convenient—'

But Andy was in no shape to think about anything. He dropped his hands to Randolph's holster and began clawing at the Glock there. Alarmed, Randolph struggled to keep it where it was.

At that moment, a large-bellied figure descended the stairs, moving gracefully despite his bulk.

'Andy!' Big Jim boomed. 'Andy, pal – come here!'

He opened his arms. Andy stopped struggling for the gun and rushed to him like a weeping child to the arms of his father. And Big Jim enfolded him.

'I want a gun!' Andy babbled, lifting his tear-streaked, snot-creamy face to Big Jim's. 'Get me a gun, Jim! Now! Right now! I want to shoot him for what he did! It's my right as a father! He killed my baby girl!'

'Maybe not just her,' Big Jim said. 'Maybe not just Angie, Lester, and poor Brenda, either.'

This halted the verbal flood. Andy stared up into Big Jim's slab of a face, dumbfounded. Fascinated.

'Maybe your wife, too. Duke. Myra Evans. All the others.'

'Wha . . .'

'Somebody's responsible for the Dome, pal – am I right?'

'Ye . . .' Andy was capable of no more, but Big Jim nodded benignly.

'And it seems to me that the people who did it had to have at least one inside man. Someone to stir the pot. And who's better at pot-stirring than a short-order cook?' He put an arm around Andy's shoulder and led him to Chief Randolph. Big Jim glanced back at Barbie's red and swollen face as if looking at some species of bug. 'We'll find proof. I have no doubt of it. He's already demonstrated he's not smart enough to cover his tracks.'

Barbie fixed his attention on Randolph. 'This is a setup,' he said

in his nasal foghorning voice. 'It might have started just because Rennie needed to cover his ass, but now it's just a naked power-grab. You may not be expendable yet, Chief, but when you are, you'll go, too.'

'Shut up,' Randolph said.

Rennie was stroking Andy's hair. Barbie thought of his mother and how she used to stroke their cocker spaniel, Missy, when Missy got old and stupid and incontinent. 'He'll pay the price, Andy — you have my word on that. But first we're going to get all the details: the what, the when, the why, and who else was involved. Because he's not in it alone, you can bet your rooty-toot on that. He's got accomplices. He'll pay the price, but first we're going to wring him dry of information.'

'What price?' Andy asked. He was looking up at Big Jim almost rapturously now. 'What price will he pay?'

'Well, if he knows how to lift the Dome — and I wouldn't put it past him — I guess we'll have to be satisfied with seeing him in Shawshank. Life without parole.'

'Not good enough,' Andy whispered.

Rennie was still stroking Andy's head. 'If the Dome doesn't let go?' He smiled. 'In that case, we'll have to try him ourselves. And when we find him guilty, we'll execute him. Do you like that better?'

'Much,' Andy whispered.

'So do I, pal.'

Stroking. Stroking.

'So do I.'

18

They came out of the woods three abreast and stopped, looking up at the orchard.

'There's something up there!' Benny said. 'I see it!' His voice sounded excited, but to Joe it also sounded strangely far away.

'So do I,' Norrie said. 'It looks like a . . . a . . .' *Radio beacon* were the words she wanted to say, but she never got them out. She managed only an *rrr-rrr-rrr* sound, like a toddler playing trucks in a sandpile. Then she fell off her bike and lay on the road with her arms and legs jerking.

'Norrie?' Joe looked down at her — more with bemusement than alarm — then up at Benny. Their eyes met for just a moment and then Benny also toppled, pulling his bike over on top of him.

He began to thrash, kicking the High Plains off to one side. The Geiger counter flew into the ditch dial-side down.

Joe tottered toward it and reached out an arm that seemed to stretch like rubber. He turned the yellow box over. The needle had jumped to +200, just below the red danger zone. He saw this, then fell into a black hole full of orange flames. He thought they were coming from a huge heap of pumpkins – a funeral pyre of blazing jack-o-lanterns. Somewhere voices were calling: lost and terrified. Then the darkness swallowed him.

19

When Julia came into the *Democrat* office after leaving the supermarket, Tony Guay, the former sports reporter who was now the entire news department, was typing on his laptop. She handed him the camera and said, 'Stop what you're doing and print these.'

She sat down at her computer to write her story. She'd been holding the open in her head all the way up Main Street: *Ernie Calvert, the former manager of Food City, called for people to come in the back. He said he had opened the doors for them. But by then it was too late. The riot was on.* It was a good lead. The problem was, she couldn't write it. She kept hitting all the wrong keys.

'Go upstairs and lie down,' Tony said.

'No, I have to write—'

'You're not going to write anything like you are. You're shaking like a leaf. It's shock. Lie down for an hour. I'll print the pictures and send them to your computer desktop. Transcribe your notes, too. Go on up.'

She didn't like what he was saying, but recognized the wisdom of it. Only it turned out to be more than an hour. She hadn't slept well since Friday night, which seemed a century ago, and she had no more than put her head on the pillow before she fell into a deep sleep.

When she woke up, she saw with panic that the shadows in her bedroom had grown long. It was late afternoon. And Horace! He would've wet in some corner and would give her his most shame-faced look, as though it were his fault instead of hers.

She slipped on her sneakers, hurried into the kitchen, and found her Corgi not by the door, whining to go out, but peacefully asleep on his blanket bed between the stove and the refrigerator. There was a note on the kitchen table, propped up against the salt and pepper shakers.

3 p.m.

Julia—

Pete F. and I collaborated on the supermarket story. It ain't great, but will be when you put your stamp on it. The pix you got aren't bad, either. Rommie Burpee came by & says he still has plenty of paper, so we're OK on that score. Also says you need to write an editorial about what happened. 'Totally unnecessary,' he said. 'And totally incompetent. Unless they <u>wanted</u> it to happen. I wouldn't put it past that guy, and I don't mean Randolph.' Pete and I agree that there should be an editorial, but we need to watch our step until all the facts are known. We also agreed that you needed some sleep in order to write it the way it needs to be written. Those were suitcases under your eyes, boss! I'm going home to spend some time with my wife & kids. Pete's gone to the PD. Says 'something big' has happened, and he wants to find out what.

Tony G.

PS! I walked Horace. He did all his business.

Julia, not wanting Horace to forget she was a part of his life, woke him up long enough for him to gobble half a Beggin' Strip, then went downstairs to punch up the news story and write the editorial Tony and Pete were suggesting. Just as she was starting, her cell rang.

'Shumway, *Democrat.*'

'Julia!' It was Pete Freeman. 'I think you better get down here. Marty Arsenault's on the desk and he won't let me in. Told me to wait out-goddam-side! He's no cop, just a dumb pulp-jockey who picks up a little side-money directing traffic in the summertime, but now he's acting like Chief Big Dick of Horny Mountain.'

'Pete, I've got a ton of stuff to do here, so unless—'

'Brenda Perkins is dead. So are Angie McCain, Dodee Sanders—'

'*What?*' She stood up so suddenly her chair tipped over.

'—and Lester Coggins. They were killed. And get this – Dale Barbara's been arrested for the murders. He's in jail downstairs.'

'I'll be right there.'

'Ahh, fuck,' Pete said. 'Here comes Andy Sanders, and he's cryin his goddam eyes out. Should I try for a comment, or—'

'Not if the man lost his daughter three days after losing his wife. We're not the *New York Post*. I'll be right there.'

She broke the connection without waiting for a reply. Initially

she felt calm enough; she even remembered to lock up the office. But once she was on the sidewalk, in the heat and under that tobacco-stained sky, her calm broke and she began to run.

20

Joe, Norrie, and Benny lay twitching on the Black Ridge Road in sunlight that was too diffuse. Heat that was too hot blared down on them. A crow, not in the least suicidal, landed on a telephone wire and gazed at them with bright, intelligent eyes. It cawed once, then flapped away through the strange afternoon air.

'Halloween,' Joe muttered.

'Make them stop *screaming*,' Benny groaned.

'No sun,' Norrie said. Her hands groped at the air. She was crying. 'No sun, oh my God, there's no more sun.'

At the top of Black Ridge, in the apple orchard that overlooked all of Chester's Mill, a brilliant mauve light flashed.

Every fifteen seconds, it flashed again.

21

Julia hurried up the police station steps, her face still puffy from sleep, her hair standing up in back. When Pete made to fall in beside her, she shook her head. 'Better stay here. I may call you in when I get the interview.'

'Love the positive thinking, but don't hold your breath,' Pete said. 'Not long after Andy showed up, guess who?' He pointed at the Hummer parked in front of a fire hydrant. Linda Everett and Jackie Wettington were standing near it, deep in conversation. Both women looked seriously freaked out.

Inside the station, Julia was first struck by how warm it was – the air-conditioning had been turned off, presumably to save juice. Next, by the number of young men who were sitting around, including two of the God-knew-how-many Killian brothers – there was no mistaking those long beaks and bullet heads. The young men all seemed to be filling out forms. 'What if you didn't *have* no last place of employment?' one asked another.

There was tearful shouting from downstairs: Andy Sanders.

Julia headed toward the ready room, where she had been a frequent visitor over the years, even a contributor to the coffee-and-donuts fund (a wicker basket). She had never been stopped before, but this time Marty Arsenault said, 'You can't go back there, Miz

Shumway. Orders.' He spoke in an apologetic, conciliatory voice he probably had not used with Pete Freeman.

Just then Big Jim Rennie and Andy Sanders came up the stairs from what Mill PD officers called the Chicken Coop. Andy was crying. Big Jim had an arm around him and was speaking soothingly. Peter Randolph came behind them. Randolph's uniform was resplendent, but the face above it was that of a man who has barely escaped a bomb-blast.

'Jim! Pete!' Julia called. 'I want to talk to you, for the *Democrat*!'

Big Jim turned around long enough to give her a glance that said people in hell wanted icewater, too. Then he began leading Andy toward the Chief's office. Rennie was talking about praying.

Julia tried to bolt past the desk. Still looking apologetic, Marty grabbed her arm.

She said, 'When you asked me to keep that little altercation with your wife last year out of the paper, Marty, I did. Because you would have lost your job otherwise. So if you've got an ounce of gratitude in you, *let me go.*'

Marty let her go. 'I tried to stop you but you wouldn't listen,' he muttered. 'Remember that.'

Julia trotted across the ready room. 'Just a damn minute,' she said to Big Jim. 'You and Chief Randolph are town officials, and you're going to talk to me.'

This time the look Big Jim gave her was angry as well as contemptuous. 'No. We're not. You have no business back here.'

'But he does?' she asked, and nodded to Andy Sanders. 'If what I'm hearing about Dodee is right, he's the *last* person who should have been allowed downstairs.'

'*That sonofabitch killed my precious girl!*' Andy bawled.

Big Jim jabbed a finger at Julia. 'You'll get the story when we're ready to give it out. Not before.'

'I want to see Barbara.'

'He's under arrest for four murders. Are you insane?'

'If the father of one of his supposed victims can get downstairs to see him, why not me?'

'Because you're neither a victim nor a next of kin,' Big Jim said. His upper lip rose, exposing his teeth.

'Does he have a lawyer?'

'I'm done talking to you, wom—'

'*He doesn't need a lawyer, he needs to be hung! HE KILLED MY PRECIOUS GIRL!*'

'Come on, pal,' Big Jim said. 'We'll take it to the Lord in prayer.'

'What kind of evidence do you have? Has he confessed? If he hasn't, what kind of alibi has he offered? How does it match up with the times of death? Do you even know the times of death? If the bodies were just discovered, how can you? Were they shot, or stabbed, or—'

'Pete, get rid of this rhymes-with-witch,' Big Jim said without turning around. 'If she won't go on her own, throw her out. And tell whoever's on the desk that he's fired.'

Marty Arsenault winced and passed a hand over his eyes. Big Jim escorted Andy into the Chief's office and closed the door.

'Is he charged?' Julia asked Randolph. 'You can't charge him without a lawyer, you know. It isn't legal.'

And although he still didn't look dangerous, only stunned, Pete Randolph said something that chilled her heart. 'Until the Dome goes away, Julia, I guess legal is whatever we decide it is.'

'When were they killed? Tell me that much, anyhow.'

'Well, it looks like the two girls were fir—'

The office door opened, and she had no doubt at all that Big Jim had been standing on the other side, listening. Andy was sitting behind what was now Randolph's desk with his face in his hands.

'Get her *out!*' Big Jim snarled. 'I don't want to have to tell you again.'

'You can't hold him incommunicado, and you can't deny information to the people of this town!' Julia shouted.

'You're wrong on both counts,' Big Jim said. 'Have you ever heard that saying, "If you're not part of the solution, you're part of the problem?" Well, you're not solving anything by being here. You're a tiresome noseyparker. You always were. And if you don't leave, you're going to be arrested. Fair warning.'

'Fine! Arrest me! Stick me in a cell downstairs!' She held out her hands with the wrists together, as if for handcuffs.

For one moment, she thought Jim Rennie was going to hit her. The desire to do so was clear on his face. Instead, he spoke to Pete Randolph. 'For the last time, get this noseyparker out of here. If she resists, *throw* her out.' And he slammed the door.

Not meeting her eyes and with his cheeks the color of freshly fired brick, Randolph took her arm. This time, Julia went. As she passed the duty desk, Marty Arsenualt said – more in disconsolation than anger – 'Now look. I lost my job to one of *these* thuds, who don't know their asses from their elbows.'

'You won't lose your job, Marts,' Randolph said. 'I can talk him around.'

A moment later, she was outside, blinking in the sunlight.

'So,' Pete Freeman said. 'How'd *that* go?'

22

Benny was the first to come out of it. And aside from being hot – his shirt was stuck to his less-than-heroic chest – he felt okay. He crawled to Norrie and shook her. She opened her eyes and looked at him, dazed. Her hair was clumped to her sweaty cheeks.

'What happened?' she asked. 'I must have fallen asleep. I had a dream, only I can't remember what it was. It was bad, though. I know that.'

Joe McClatchey rolled over and pushed himself to his knees.

'Jo-Jo?' Benny asked. He hadn't called his friend Jo-Jo since fourth grade. 'You okay?'

'Yeah. The pumpkins were on fire.'

'*What* pumpkins?'

Joe shook his head. He couldn't remember. All he knew was that he wanted to grab some shade and drink the rest of his Snapple. Then he thought of the Geiger counter. He fished it out of the ditch and saw with relief that it was still working – they'd built things tough in the twentieth century, it seemed.

He showed Benny the +200 reading, and tried to show Norrie, but she was looking up the slope of Black Ridge to the orchard at the top.

'What's that?' she asked, and pointed.

Joe initially saw nothing. Then a bright purple light flashed out. It was almost too bright to look at. Shortly thereafter, it flashed again. He looked down at his watch, wanting to time the flashes, but his watch had stopped at 4:02.

'I think it's what we were looking for,' he said, getting to his feet. He expected his legs to feel rubbery, but they didn't. Except for being too hot, he felt pretty much okay. 'Now let's get the hell out of here before it makes us sterile, or something.'

'Dude,' Benny said. 'Who wants kids? They might turn out like me.' Nevertheless, he mounted his bike.

They rode back the way they came, not stopping to rest and drink until they were over the bridge and back to Route 119.

SALT

1

The female officers standing by Big Jim's H3 were still talking — Jackie now nervously puffing a cigarette — but they broke off as Julia Shumway stalked past them.

'Julia?' Linda asked hesitantly. 'What did—'

Julia kept on. The last thing she wanted while she was still boiling was to talk to any more representatives of law and order as it now seemed to exist in Chester's Mill. She walked halfway to the *Democrat*'s office before she realized that anger wasn't all she was feeling. It wasn't even most of what she was feeling. She stopped under the awning of Mill New & Used Books (CLOSED UNTIL FURTHER NOTICE, read the hand-lettered sign in the window), partly to wait for her racing heart to slow, mostly to look inside herself. It didn't take long.

'Mostly I'm just scared,' she said, and jumped a little at the sound of her own voice. She hadn't meant to speak aloud.

Pete Freeman caught up with her. 'Are you all right?'

'Fine.' It was a lie, but it emerged stoutly enough. Of course, she couldn't tell what her face was saying. She reached up and tried to flatten the sleepstack of hair at the back of her head. It went down . . . then sprang up again. *Bed head on top of everything else*, she thought. *Very nice. The finishing touch.*

'I thought Rennie was actually going to have our new Chief arrest you,' Pete said. He was big-eyed and at that moment looked much younger than his thirtysomething years.

'I was hoping.' Julia framed an invisible headline with her hands. '*DEMOCRAT* REPORTER SCORES EXCLUSIVE JAILHOUSE INTERVIEW WITH ACCUSED MURDERER.'

'Julia? What's going on here? Aside from the Dome, that is? Did you see all those guys filling out forms? It was kinda scary.'

'I saw it,' Julia said, 'and I intend to write about it. I intend to write about *all* this. And at town meeting on Thursday night, I don't think I'll be the only one with serious questions for James Rennie.'

She laid a hand on Pete's arm.

'I'm going to see what I can find out about these murders, then I'll write what I have. Plus an editorial as strong as I can make it without rabble-rousing.' She uttered a humorless bark of laughter. 'When it comes to rousing rabble, Jim Rennie's got the home court advantage.'

'I don't understand what you—'

'That's okay, just get busy. I need a couple of minutes to get hold of myself. Then maybe I can figure out who to talk to first. Because there isn't a helluva lot of time, if we're going to go to press tonight.'

'Photocopier,' he said.

'Huh?'

'Go to photocopier tonight.'

She gave him a shaky smile and shooed him on his way. At the door to the newspaper office he looked back. She tossed him a wave to show she was okay, then peered through the dusty window of the bookstore. The downtown movie theater had been shut for half a decade, and the drive-in outside of town was long gone (Rennie's auxiliary car lot stood where its big screen had once towered over 119), but somehow Ray Towle had kept this dirty little emporium galorium crutching along. Part of the window display consisted of self-help books. The rest of the window was heaped with paperbacks featuring fogbound mansions, ladies in distress, and barechested hunks both afoot and on horseback. Several of said hunks were waving swords and appeared to be dressed in just their underpants. GET THE HOTS FOR DARK PLOTS! the sign on this side read.

Dark plots indeed.

If the Dome wasn't bad enough, weird *enough, there's the Selectman from Hell.*

What worried her the most, she realized – what *scared* her the most – was how fast this was happening. Rennie had gotten used to being the biggest, meanest rooster in the farmyard, and she would have expected him to try to strengthen his hold on the town eventually – say after a week or a month cut off from the outside world. But this was only three days and change. Suppose Cox and his scientists cracked through the Dome tonight? Suppose it even disappeared on its own? Big Jim would immediately shrink back to his former size, only he'd have egg on his face, too.

'What egg?' she asked herself, still looking in at the DARK PLOTS. 'He'd just say he was doing the best he could under trying circumstances. And they'd believe him.'

That was probably true. But it still didn't explain why the man hadn't waited to make his move.

Because something went wrong and he had to. Also—

'Also, I don't think he's completely sane,' she told the heaped-up paperbacks. 'I don't think he ever was.'

Even if true, how did you explain people who still had fully stocked pantries rioting at the local supermarket? It made no sense, unless—

'Unless he instigated it.'

That was ridiculous, the Blue Plate Special at the Paranoid Café. Wasn't it? She supposed she could ask some of the people who'd been at Food City what they'd seen, but weren't the murders more important? She was the only real reporter she had, after all, and—

'Julia? Ms Shumway?'

Julia was so deep in thought she almost lifted out of her loafers. She wheeled around and might have fallen if Jackie Wettington hadn't steadied her. Linda Everett was with her, and it was she who had spoken. They both looked scared.

'Can we talk to you?' Jackie asked.

'Of course. Listening to people talk is what I do. The downside is that I write what they say. You ladies know that, don't you?'

'But you can't use our names,' Linda said. 'If you don't agree to that, forget the whole thing.'

'As far as I'm concerned,' Julia said, smiling, 'you two are just a source close to the investigation. Does that work?'

'If you promise to answer our questions, too,' Jackie said. 'Will you?'

'All right.'

'You were at the supermarket, weren't you?' Linda asked.

Curiouser and curiouser. 'Yes. So were you two. So let's talk. Compare notes.'

'Not here,' Linda said. 'Not on the street. It's too public. And not at the newspaper office, either.'

'Take it easy, Lin,' Jackie said, putting a hand on her shoulder.

'*You* take it easy,' Linda said. 'You're not the one with the husband who thinks you just helped railroad an innocent man.'

'I don't *have* a husband,' Jackie said – quite reasonably, Julia thought, and lucky for her; husbands were so often a complicating factor. 'But I do know a place we can go. It's private, and always unlocked.' She considered. 'At least it was. Since the Dome, I dunno.'

Julia, who had just been considering whom to interview first, had no intention of letting these two slip away. 'Come on,' she said. 'We'll walk on opposite sides of the street until we're past the police station, shall we?'

At this, Linda managed a smile. 'What a good idea,' she said.

2

Piper Libby lowered herself carefully in front of the altar of the First Congo Church, wincing even though she had put down a pew-pad for her bruised and swollen knees. She braced herself with her right hand, holding her recently dislocated left arm against her side. It seemed okay – less painful than her knees, in fact – but she had no intention of testing it unnecessarily. It would be all too easy to get it out of joint again; she had been informed of that (*sternly*) after her soccer injury in high school. She folded her hands and closed her eyes. Immediately her tongue went to the hole where there had been a tooth up until yesterday. But there was a worse hole in her life.

'Hello, Not-There,' she said. 'It's me again, back for another helping of Your love and mercy.' A tear trickled from beneath one swollen eyelid and ran down one swollen (not to mention colorful) cheek. 'Is my dog anywhere around? I only ask because I miss him so much. If he is, I hope you'll give him the spiritual equivalent of a chewbone. He deserves one.'

More tears now, slow and hot and stinging.

'Probably he's not. Most major religions agree that dogs don't go to heaven, although certain offshoot sects – and the *Reader's Digest*, I believe – disagree.'

Of course if there *was* no heaven, the question was moot, and the idea of this heavenless existence, this heavenless *cosmology*, was where what remained of her faith seemed more and more at home. Maybe oblivion; maybe something worse. A vast trackless plain under a white sky, say – a place where none was always the hour, nowhere the destination, and nobody your companions. Just a big old Not-There, in other words: for bad cops, lady preachers, kids who accidentally shot themselves, and galoot German shepherds who died trying to protect their mistresses. No Being to sort the wheat from the chaff. There was something histrionic about praying to such a concept (if not downright blasphemous), but occasionally it helped.

'But heaven's not the point,' she resumed. 'The point right now is trying to figure out how much of what happened to Clover was my fault. I know I have to own some of it – my temper got the best of me. Again. My religious teaching suggests You put that short fuse in me to begin with, and it's my job to deal with it, but I hate that idea. I don't completely reject it, but I hate it. It makes me

think of how, when you take your car to get repaired, the guys in the shop always find a way to blame the problem on you. You ran it too much, you didn't run it enough, you forgot to release the handbrake, you forgot to close your windows and the rain got in the wiring. And you know what's worse? If You're Not-There, I can't shove even a little of the blame off on You. What does that leave? Fucking genetics?'

She sighed.

'Sorry about the profanity; why don't You just pretend it Wasn't There? That's what my mother always used to do. In the meantime, I have another question: What do I do now? This town is in terrible trouble, and I'd like to do something to help, only I can't decide what. I feel foolish and weak and confused. I suppose if I was one of those Old Testament eremites, I'd say I need a sign. At this point, even YIELD or REDUCE SPEED IN SCHOOL ZONE would look good.'

The moment she finished saying this, the outside door opened, then boomed shut. Piper looked over her shoulder, half-expecting to see an angel, complete with wings and blazing white robe. *If he wants to wrestle, he'll have to heal my arm first,* she thought.

It wasn't an angel; it was Rommie Burpee. Half his shirt was untucked, hanging down his leg almost to mid-thigh, and he looked almost as downcast as she felt. He started down the center aisle, then saw her and stopped, as surprised to see Piper as she was him.

'Oh, gee,' he said, only with his Lewiston *on parle* accent, it came out *Oh, shee.* 'I'm sorry, I didn't know you was dere. I'll come back later.'

'No,' she said, and struggled to her feet, once more using just her right arm. 'I'm done, anyway.'

'I'm actually a Cat'lick,' he said (*No shit,* Piper thought), 'but there isn't a Cat'lick church in The Mill . . . which acourse you know, bein a minister . . . and you know what they say bout any port in a storm. I thought I'd come in and say a little prayer for Brenda. I always liked dat woman.' He rubbed a hand up one cheek. The rasp of his palm on the beard-stubble there seemed very loud in the hollow silence of the church. His Elvis 'do was drooping around his ears. 'Loved her, really. I never said, but I t'ink she knew.'

Piper stared at him with growing horror. She hadn't been out of the parsonage all day, and although she knew about what had happened at Food City — several of her parishioners had called her — she had heard nothing about Brenda Perkins.

'Brenda? What happened to her?'

'Murdered. Others, too. They're sayin that guy Barbie did it. He been arrested.'

Piper clapped a hand over her mouth and swayed on her feet. Rommie hurried forward and put a steadying arm around her waist. And that was how they were standing before the altar, almost like a man and woman about to be married, when the vestibule door opened again and Jackie led Linda and Julia inside.

'Maybe this isn't such a good place, after all,' Jackie said.

The church was a soundbox, and although she didn't speak loudly, Piper and Romeo Burpee heard her perfectly.

'Don't leave,' Piper said. 'Not if it's about what happened. I can't believe Mr Barbara . . . I would have said he was incapable. He put my arm back in after it was dislocated. He was very gentle about it.' She paused to think about that. 'As gentle as he could be, under the circumstances. Come down front. Please come down front.'

'People can fix a dislocated arm and still be capable of murder,' Linda said, but she was biting her lip and twisting her wedding ring.

Jackie put a hand on her wrist. 'We were going to keep this quiet, Lin – remember?'

'Too late for that,' Linda said. 'They've seen us with Julia. If she writes a story and those two say they saw us with her, we'll get blamed.'

Piper had no clear idea what Linda was talking about, but she got the general gist. She raised her right arm and swept it around. 'You're in my church, Mrs Everett, and what's said here stays here.'

'Do you promise?' Linda asked.

'Yes. So why don't we talk about it? I was just praying for a sign, and here you all are.'

'I don't believe in stuff like that,' Jackie said.

'Neither do I, actually,' Piper said, and laughed.

'I don't like it,' Jackie said. It was Julia she was addressing. 'No matter what she says, this is too many people. Losing my job like Marty is one thing. I could deal with that, the pay sucks, anyway. Getting Jim Rennie mad at me, though . . .' She shook her head. 'Not a good idea.'

'It isn't too many,' Piper said. 'It's just the right number. Mr Burpee, can you keep a secret?'

Rommie Burpee, who had done any number of questionable deals in his time, nodded and put a finger over his lips. 'Mum's the word,' he said. *Word* came out *woid*.

'Let's go in the parsonage,' Piper said. When she saw that Jackie still looked doubtful, Piper held out her left hand to her . . . very

carefully. 'Come, let us reason together. Maybe over a little tot of whiskey?'

And with this, Jackie was at last convinced.

3

**31 BURN CLEANSE BURN CLEANSE
THE BEAST WILL BE CAST INTO A
BURNING LAKE OF FIRE (REV 19:20)
"2 BE TORMENTED DAY & NITE 4-EVER" (20:10)
BURN THE WICKED
PURIFY THE SAINTLIE
BURN CLEANSE BURN CLEANSE 31**

31 JESUS OF FIRE COMING 31

The three men crammed into the cab of the rumbling Public Works truck looked at this cryptic message with some wonder. It had been painted on the storage building behind the WCIK studios, black on red and in letters so large they covered almost the entire surface.

The man in the middle was Roger Killian, the chicken farmer with the bullet-headed brood. He turned to Stewart Bowie, who was behind the wheel of the truck. 'What's it mean, Stewie?'

It was Fern Bowie who answered. 'It means that goddam Phil Bushey's crazier than ever, that's what it means.' He opened the truck's glove compartment, removed a pair of greasy work gloves, and revealed a .38 revolver. He checked the loads, then snapped the cylinder back into place with a flick of his wrist and jammed the pistol in his belt.

'You know, Fernie,' Stewart said, 'that is a goddam good way to blow your babymakers off.'

'Don't you worry about me, worry about *him*,' Fern said, pointing back at the studio. From it the faint sound of gospel music drifted to them. 'He's been gettin high on his own supply for most of a year now, and he's about as reliable as nitroglycerine.'

'Phil likes people to call him The Chef now,' Roger Killian said.

They had first pulled up outside the studio and Stewart had honked the PW truck's big horn – not once but several times. Phil Bushey had not come out. He might be in there hiding; he might be wandering in the woods behind the station; it was even possible,

Stewart thought, that he was in the lab. Paranoid. Dangerous. Which still didn't make the gun a good idea. He leaned over, plucked it from Fern's belt, and tucked it under the driver's seat.

'Hey!' Fern cried.

'You're not firing a gun in there,' Stewart said. 'You're apt to blow us all to the moon.' And to Roger, he said: 'When's the last time you saw that scrawny motherfucker?'

Roger mulled it over. 'Been four weeks, at least – since the last big shipment out of town. When we had that big Chinook helicopter come in.' He pronounced it *Shin-oook*. Rommie Burpee would have understood.

Stewart considered. Not good. If Bushey was in the woods, that was all right. If he was cowering in the studio, paranoid and thinking they were Feds, probably still no problem . . . unless he decided to come out shooting, that was.

If he was in the storage building, though . . . that *might* be a problem.

Stewart said to his brother, 'There's some goodsize junks of wood in the back of the truck. Get you one of those. If Phil shows and starts cuttin up rough, clock im one.'

'What if he has a gun?' Roger asked, quite reasonably.

'He won't,' Stewart said. And although he wasn't actually sure of this, he had his orders: two tanks of propane, to be delivered to the hospital posthaste. *And we're going to move the rest of it out of there as soon as we can*, Big Jim had said. *We're officially out of the meth business.*

That was something of a relief; when they were shut of this Dome thing, Stewart intended to get out of the funeral business, too. Move someplace warm, like Jamaica or Barbados. He never wanted to see another dead body. But he didn't want to be the one who told 'Chef' Bushey they were closing down, and he had informed Big Jim of that.

Let me worry about The Chef, Big Jim had said.

Stewart drove the big orange truck around the building and backed it up to the rear doors. He left the engine idling to run the winch and the hoist.

'Lookit that,' Roger Killian marveled. He was staring into the west, where the sun was going down in a troubling red smear. Soon it would sink below the great black smudge left by the woods-fire and be blotted out in a dirty eclipse. 'Don't that just beat the dickens.'

'Quit gawking,' Stewart said. 'I want to do this and get gone. Fernie, get you a junk. Pick out a good one.'

Fern climbed over the hoist and picked out a leftover piece of planking about as long as a baseball bat. He held it in both hands and gave it an experimental swish. 'This'll do,' he said.

'Baskin-Robbins,' Roger said dreamily. He was still shading his eyes and squinting west. The squint was not a good look for him; it made him resemble a fairy-tale troll.

Stewart paused while unlocking the back door, a complicated process that involved a touchpad and two locks. 'What are you pissing about?'

'Thirty-one flavors,' Roger said. He smiled, revealing a rotting set of teeth that had never been visited by Joe Boxer or probably any dentist.

Stewart had no idea what Roger was talking about, but his brother did. 'Don't think that's an ice cream ad on the side of the buildin',' Fern said. 'Unless there's Baskin-Robbins in the Book of Revelations.'

'Shut up, both of you,' Stewart said. 'Fernie, stand ready with that junk.' He pushed the door open and peered in. 'Phil?'

'Call im Chef,' Roger advised. 'Like that nigger cook on *South Park*. That's what he likes.'

'Chef?' Stewart called. 'You in there, Chef?'

No answer. Stewart fumbled into the gloom, half expecting his hand to be seized at any moment, and found the light switch. He turned it on, revealing a room that stretched about three-quarters the length of the storage building. The walls were unfinished bare wood, the spaces between the laths stuffed with pink foam insulation. The room was almost filled with LP gas tanks and canisters of all sizes and brands. He had no idea how many there were in all, but if forced to guess, he would have said between four and six hundred.

Stewart walked slowly up the center aisle, peering at the stenciling on the tanks. Big Jim had told him exactly which ones to take, had said they'd be near the back, and by God, they were. He stopped at the five municipal-size tanks with **CR HOSP** on the side. They were between tanks that had been filched from the post office and some with **MILL MIDDLE SCHOOL** on the sides.

'We're supposed to take two,' he said to Roger. 'Bring the chain and we'll hook em up. Fernie, go you down there and try that door to the lab. If it ain't locked, lock it.' He tossed Fern his key ring.

Fern could have done without this chore, but he was an obedient brother. He walked down the aisle between the piles of propane tanks. They ended ten feet from the door – and the door, he saw with a sinking heart, was standing ajar. Behind him he heard the

clank of the chain, then the whine of the winch and the low clatter of the first tank being dragged back to the truck. It sounded far away, especially when he imagined The Chef crouching on the other side of that door, red-eyed and crazy. All smoked up and toting a TEC-9.

'Chef?' he asked. 'You here, buddy?'

No answer. And although he had no business doing so – was probably crazy himself for doing so – curiosity got the better of him and he used his makeshift club to push open the door.

The fluorescents in the lab were on, but otherwise this part of the Christ Is King storage building looked empty. The twenty or so cookers – big electric grills, each hooked to its own exhaust fan and propane canister – were off. The pots, beakers, and expensive flasks were all on their shelves. The place stank (always had, always would, Fern thought), but the floor was swept and there was no sign of disarray. On one wall was a Rennie's Used Cars calendar, still turned to August. *Probably when the motherfucker finished losing touch with reality,* Fern thought. *Just flooaated away.* He ventured a little farther into the lab. It had made them all rich men, but he had never liked it. It smelled too much like the funeral parlor's downstairs prep room.

One corner had been partitioned off with a heavy steel panel. There was a door in the middle of it. This, Fern knew, was where The Chef's product was stored, long-glass crystal meth put up not in gallon Baggies but in Hefty garbage bags. Not shitglass, either. No tweeker scruffing the streets of New York or Los Angeles in search of a fix would have been able to credit such stocks. When the place was full, it held enough to supply the entire United States for months, perhaps even a year.

Why did Big Jim let him make so fucking much? Fern wondered. *And why did we go along? What were we thinking of?* He could come up with no answer to this question but the obvious one: because they could. The combination of Bushey's genius and all those cheap Chinese ingredients had intoxicated them. Also, it funded the CIK Corporation, which was doing God's work all up and down the East Coast. When anyone questioned, Big Jim always pointed this out. And he would quote scripture: *For the laborer is worthy of his hire* – Gospel of Luke – and *Thou shalt not muzzle the ox while he is threshing* – First Timothy.

Fern had never really gotten that one about the oxes.

'Chef?' Advancing in a little farther still. 'Goodbuddy?'

Nothing. He looked up and saw galleries of bare wood running along two sides of the building. These were being used for storage, and the contents of the cartons stacked there would have interested

the FBI, the FDA, and the ATF a great deal. No one was up there, but Fern spied something he thought was new: white cord running along the railings of both galleries, affixed to the wood by heavy staples. An electrical cord? Running to what? Had that nutball put more cookers up there? If so, Fern didn't see them. The cord looked too thick to be powering just a simple appliance, like a TV or a ra—

'Fern!' Stewart cried, making him jump. 'If he ain't there, come on and help us! I want to get out of here! They said there's gonna be an update on TV at six and I want to see if they've figured anything out!'

In Chester's Mill, 'they' had more and more come to mean anything or anyone in the world beyond the town's borders.

Fern went, not looking over the door and thus not seeing what the new electrical cords were attached to: a large brick of white clay-like stuff sitting on its own little shelf. It was explosive.

The Chef's own recipe.

4

As they drove back toward town, Roger said: 'Halloween. That's a thirty-one, too.'

'You're a regular fund of information,' Stewart said.

Roger tapped the side of his unfortunately shaped head. 'I store it up,' he said. 'I don't do it on purpose. It's just a knack.'

Stewart thought: *Jamaica. Or Barbados. Somewhere warm, for sure. As soon as the Dome lets go. I never want to see another Killian. Or anyone from this town.*

'There's also thirty-one cards in a deck,' Roger said.

Fern stared at him. 'What the fuck are you—'

'Just kiddin, just kiddin with you,' Roger said, and burst into a terrifying shriek of laughter that hurt Stewart's head.

They were coming up on the hospital now. Stewart saw a gray Ford Taurus pulling out of Catherine Russell.

'Hey, that's Dr Rusty,' Fern said. 'Bet he'll be glad to get this stuff. Give im a toot, Stewie.'

Stewart gave im a toot.

5

When the Godless ones were gone, Chef Bushey finally let go of the garage door opener he'd been holding. He had been watching the Bowie brothers and Roger Killian from the window in the studio men's room. His thumb had been on the button the whole time they

were in the storage barn, rummaging around in his stuff. If they had come out with product, he would have pushed the button and blown the whole works sky-high.

'It's in your hands, my Jesus,' he had muttered. 'Like we used to say when we were kids, I don't wanna but I will.'

And Jesus handled it. Chef had a feeling He would when he heard George Dow and the Gospel-Tones come over the sat-feed, singing 'God, How You Care for Me,' and it was a true feeling, a true Sign from Above. They hadn't come for long-glass but for two piddling tanks of LP.

He watched them drive away, then shambled down the path between the back of the studio and the combination lab-storage facility. It was *his* building now, *his* long-glass, at least until Jesus came and took it all for his own.

Maybe Halloween.

Maybe earlier.

It was a lot to think about, and thinking was easier these days when he was smoked up.

Much easier.

6

Julia sipped her small tot of whiskey, making it last, but the women cops slugged theirs like heroes. It wasn't enough to make them drunk, but it loosened their tongues.

'Fact is, I'm horrified,' Jackie Wettington said. She was looking down, playing with her empty juice glass, but when Piper offered her another splash, she shook her head. 'It never would have happened if Duke was still alive. That's what I keep coming back to. Even if he had reason to believe Barbara had murdered his wife, he would've followed due process. That's just how he was. And allowing the father of a victim to go down to the Coop and confront the perp? *Never.*' Linda was nodding agreement. 'It makes me scared for what might happen to the guy. Also . . .'

'If it could happen to Barbie, it could happen to anyone?' Julia asked.

Jackie nodded. Biting her lips. Playing with her glass. 'If something happened to him – I don't necessarily mean something balls-to-the-wall like a lynching, just an accident in his cell – I'm not sure I could ever put on this uniform again.'

Linda's basic concern was simpler and more direct. Her husband believed Barbie innocent. In the heat of her fury (and her revulsion

at what they had found in the McCain pantry), she had rejected that idea – Barbie's dog tags had, after all, been in Angie McCain's gray and stiffening hand. But the more she thought about it, the more she worried. Partly because she respected Rusty's judgment of things and always had, but also because of what Barbie had shouted just before Randolph had Maced him. *Tell your husband to examine the bodies. He must examine the bodies!*

'And another thing,' Jackie said, still spinning her glass. 'You don't Mace a prisoner just because he's yelling. We've had Saturday nights, especially after big games, when it sounded like the zoo at feeding time down there. You just let em yell. Eventually they get tired and go to sleep.'

Julia, meanwhile, was studying Linda. When Jackie had finished, Julia said, 'Tell me again what Barbie said.'

'He wanted Rusty to examine the bodies, especially Brenda Perkins's. He said they wouldn't be at the hospital. He *knew* that. They're at Bowie's, and that's not right.'

'Goddam funny, all right, if they was murdered,' Romeo said. 'Sorry for cussin, Rev.'

Piper waved this away. 'If he killed them, I can't understand why his most pressing concern would be having the bodies examined. On the other hand, if he didn't, maybe he thought a postmortem would exonerate him.'

'Brenda was the most recent victim,' Julia said. 'Is that right?'

'Yes,' Jackie said. 'She was in rigor, but not completely. At least it didn't look to me like she was.'

'She wasn't,' Linda said. 'And since rigor starts to set in about three hours after death, give or take, Brenda probably died between four and eight a.m. I'd say closer to eight, but I'm no doctor.' She sighed and ran her hands through her hair. 'Rusty isn't either, of course, but he could have nailed down the TOD a lot closer if he'd been called in. No one did that. Including me. I was just so freaked out . . . there was so much going on . . .'

Jackie pushed her glass aside. 'Listen, Julia – you were with Barbara at the supermarket this morning, weren't you?'

'Yes.'

'At a little past nine. That's when the riot started.'

'Yes.'

'Was he there first, or were you? Because I don't know.'

Julia couldn't remember, but her impression was that she had been there first – that Barbie had arrived later, shortly after Rose Twitchell and Anson Wheeler.

'We cooled it out,' she said, 'but he was the one who showed us how. Probably saved even more people from being seriously hurt. I can't square that with what you found in that pantry. Do you have any idea what the order of the deaths were? Other than Brenda last?'

'Angie and Dodee first,' Jackie said. 'Decomp was less advanced with Coggins, so he came later.'

'Who found them?'

'Junior Rennie. He was suspicious because he saw Angie's car in the garage. But that's not important. *Barbara's* the important thing here. Are you sure he arrived after Rose and Anse? Because that doesn't look good.'

'I am, because he wasn't in Rose's van. Just the two of them got out. So if we assume he wasn't busy killing people, then where would he . . . ?' But that was obvious. 'Piper, can I use your phone?'

'Of course.'

Julia briefly consulted the pamphlet-sized local phone book, then used Piper's cell to call the restaurant. Rose's greeting was curt: 'We're closed until further notice. Bunch of assholes arrested my cook.'

'Rose? It's Julia Shumway.'

'Oh. Julia.' Rose sounded only a shade less truculent. 'What do you want?'

'I'm trying to check out a possible alibi timeline for Barbie. Are you interested in helping?'

'You bet your ass. The idea that Barbie murdered those people is ridiculous. What do you want to know?'

'I want to know if he was at the restaurant when the riot started at Food City.'

'Of course.' Rose sounded perplexed. 'Where else would he be right after breakfast? When Anson and I left, he was scrubbing the grills.'

7

The sun was going down, and as the shadows lengthened, Claire McClatchey grew more and more nervous. Finally she went into the kitchen to do what she had been putting off: use her husband's cell phone (which he had forgotten to take on Saturday morning; he was always forgetting it) to call hers. She was terrified it would ring four times and then she'd hear her own voice, all bright and chirrupy, recorded before the town she lived in became a prison with invisible bars. *Hi, you've reached Claire's voice mail. Please leave a message at the beep.*

And what would she say? *Joey, call back if you're not dead?*

She reached for the buttons, then hesitated. *Remember, if he doesn't answer the first time, it's because he's on his bike and can't get the phone out of his backpack before it goes to voice mail. He'll be ready when you call the second time, because he'll know it's you.*

But if she got voice mail the second time? And the third? Why had she ever let him go in the first place? She must have been mad.

She closed her eyes and saw a picture of nightmare clarity: the telephone poles and storefronts of Main Street plastered with photos of Joe, Benny, and Norrie, looking like any kids you ever saw on a turnpike rest area bulletin board, where the captions always contained the words LAST SEEN ON.

She opened her eyes and dialed quickly, before she could lose her nerve. She was preparing her message – *I'm calling back in ten seconds and this time you better answer, mister* – and was stunned when her son answered, loud and clear, halfway through the first ring.

'Mom! Hey, Mom!' Alive and more than alive: bubbling over with excitement, from the sound.

Where are you? she tried to say, but at first she couldn't manage anything. Not a single word. Her legs felt rubbery and elastic; she leaned against the wall to keep from falling on the floor.

'Mom? You there?'

In the background she heard the swish of a car, and Benny, faint but clear, hailing someone: 'Dr Rusty! Yo, dude, whoa!'

She was finally able to throw her voice in gear. 'Yes. I am. Where are you?'

'Top of Town Common Hill. I was gonna call you because it's gettin near dark – tell you not to worry – and it rang in my hand. Surprised the heck out of me.'

Well, that put a spoke in the old parental scolding-wheel, didn't it? *Top of Town Common Hill. They'll be here in ten minutes. Benny probably wanting another three pounds of food. Thank You, God.*

Norrie was talking to Joe. It sounded like *Tell her, tell her.* Then her son was in her ear again, so loudly jubilant that she had to hold the receiver away from her ear a little bit. 'Mom, I think we found it! I'm almost positive! It's in the orchard on top of Black Ridge!'

'Found what, Joey?'

'I don't know for sure, don't want to jump to conclusions, but probably the thing generating the Dome. Almost gotta be. We saw a blinker, like the ones they put on radio towers to warn planes, only on the ground and purple instead of red. We didn't go close enough to see anything else. We passed out, all of us. When we woke up we were okay, but it was starting to get la—'

'Passed *out*?' Claire almost screamed this. 'What do you mean, you passed *out*? Get home! Get home right now so I can look at you!'

'It's okay, Mom,' Joe said soothingly. 'I think it's like . . . you know how when people first touch the Dome they get a little shock, then they don't? I think it's like that. I think you pass out the first time and then you're, like, immunized. Good to go. That's what Norrie thinks, too.'

'I don't care what she thinks or what you think, mister! You get home right now so I can see you're all right or I'm going to immunize your ass!'

'Okay, but we have to get in touch with that guy Barbara. He's the one who thought of the Geiger counter in the first place, and boy, he was right on the money. We should get Dr Rusty, too. He just drove by us. Benny tried to wave him down, but he didn't stop. We'll get him and Mr Barbara to come to the house, okay? We hafta figure out our next move.'

'Joe . . . Mr Barbara is . . .'

Claire stopped. Was she going to tell her son that Mr Barbara – whom some people had begun referring to as Colonel Barbara – had been arrested on multiple murder charges?

'What?' Joe asked. 'What about him?' The happy triumph in his voice had been replaced by anxiety. She supposed he could read her moods as well as she could read his. And he had clearly pinned a lot of hope on Barbara – Benny and Norrie had too, probably. This wasn't news she could keep from them (much as she would have liked to), but she didn't have to give it to them on the phone.

'Come home,' she said. 'We'll talk about it here. And Joe – I'm awfully proud of you.'

8

Jimmy Sirois died late that afternoon, as Scarecrow Joe and his friends were tearing back toward town on their bikes.

Rusty sat in the hallway with his arm around Gina Buffalino and let her cry against his chest. There was a time when he would have felt exceedingly uncomfortable about sitting this way with a girl who was barely seventeen, but times had changed. You only had to look at this hallway – lit now with hissing Coleman lanterns instead of by fluorescents shining calmly down from the paneled ceiling – to know that times had changed. His hospital had become an arcade of shadows.

'Not your fault,' he said. 'Not your fault, not mine, not even his. He didn't ask to have diabetes.'

Although, God knew, there were people who coexisted with it for years. People who took care of themselves. Jimmy, a semi-hermit who had lived by himself out on the God Creek Road, had not been one of those. When he had finally driven himself in to the Health Center – last Thursday, this had been – he hadn't even been able to get out of his car, just kept honking until Ginny came out to see who it was and what was wrong. When Rusty got the old fellow's pants off, he had observed a flabby right leg that had turned a cold, dead blue. Even if everything had gone right with Jimmy, the nerve damage probably would have been irreversible.

'Don't hurt at all, Doc,' Jimmy had assured Ron Haskell just before slipping into a coma. He had been in and out of consciousness ever since, the leg getting worse, Rusty putting off the amputation even though he knew it had to come if Jimmy were to have any chance at all.

When the power went out, the IVs feeding antibiotics to Jimmy and two other patients continued to drip, but the flowmeters stopped, making it impossible to fine-tune the amounts. Worse, Jimmy's cardiac monitor and respirator failed. Rusty disconnected the respirator, put a valve mask over the old man's face, and gave Gina a refresher course on how to use the Ambu bag. She was good with it, and very faithful, but around six o'clock, Jimmy had died anyway.

Now she was inconsolable.

She lifted her tear-streaked face from his chest and said, 'Did I give him too much? Too little? Did I choke him and kill him?'

'No. Jimmy was probably going to die anyway, and this way he's spared a very nasty amputation.'

'I don't think I can do this anymore,' she said, beginning to weep again. 'It's too scary. It's *awful* now.'

Rusty didn't know how to respond to this, but he didn't have to. 'You'll be okay,' a raspy, plugged-up voice said. 'You have to be, hon, because we need you.'

It was Ginny Tomlinson, walking slowly up the hallway toward them.

'You shouldn't be on your feet,' Rusty said.

'Probably not,' Ginny agreed, and sat down on Gina's other side with a sigh of relief. Her taped nose and the adhesive strips running beneath her eyes made her look like a hockey goalie after a difficult game. 'But I'm back on duty, just the same.'

'Maybe tomorrow—' Rusty began.

'No, now.' She took Gina's hand. 'And so are you, hon. Back in nursing school, this tough old RN had a saying: "You can quit when the blood dries and the rodeo's over."'

'What if I make a mistake?' Gina whispered.

'Everybody does. The trick is to make as few as possible. And I'll help you. You and Harriet both. So what do you say?'

Gina gazed doubtfully at Ginny's swollen face, the damage accented by an old pair of spectacles Ginny had found somewhere. 'Are you sure you're up to it, Ms Tomlinson?'

'You help me, I help you. Ginny and Gina, the Fighting Females.' She raised her fist. Managing a little smile, Gina tapped Ginny's knuckles with her own.

'That's all very hot shit and rah-rah,' Rusty said, 'but if you start to feel faint, find a bed and lie down for a while. Orders from Dr Rusty.'

Ginny winced as the smile her lips were trying on pulled at the wings of her nose. 'Never mind a bed, I'll just hosey Ron Haskell's old couch in the lounge.'

Rusty's cell phone rang. He waved the women away. They talked as they went, Gina with an arm around Ginny's waist.

'Hello, this is Eric,' he said.

'This is Eric's wife,' a subdued voice said. 'She called to apologize to Eric.'

Rusty walked into a vacant examining room and closed the door. 'No apology necessary,' he said . . . although he wasn't sure that was true. 'Heat of the moment. Have they let him go?' This seemed to him a perfectly reasonable question, given the Barbie he was coming to know.

'I'd rather not discuss it on the phone. Can you come to the house, honey? Please? We need to talk.'

Rusty supposed he could, actually. He'd had one critical patient, who had simplified his professional life considerably by dying. And while he was relieved to be on speaking terms again with the woman he loved, he didn't like the new caution he heard in her voice.

'I can,' he said, 'but not for long. Ginny's back on her feet, but if I don't monitor her, she'll overdo. Dinner?'

'Yes.' She sounded relieved. Rusty was glad. 'I'll thaw some of the chicken soup. We better eat as much of the frozen stuff as we can while we've still got the power to keep it good.'

'One thing. Do you still think Barbie's guilty? Never mind what the rest of them think, do you?'

A long pause. Then she said, 'We'll talk when you get here.' And with that, she was gone.

Rusty was leaning with his butt propped against the examination table. He held the phone in his hand for a moment, then pressed the END button. There were many things he wasn't sure of just now – he felt like a man swimming in a sea of perplexity – but he felt sure of one thing: his wife thought somebody might be listening. But who? The Army? Homeland Security?

Big Jim Rennie?

'Ridiculous,' Rusty said to the empty room. Then he went to find Twitch and tell him he was leaving the hospital for a little while.

9

Twitch agreed to keep an eye on Ginny and make sure she didn't overdo, but there was a quid pro quo: Rusty had to examine Henrietta Clavard, who had been injured during the supermarket melee, before leaving.

'What's wrong with her?' Rusty asked, fearing the worst. Henrietta was strong and fit for an old lady, but eighty-four was eighty-four.

'She says, and I quote, "One of those worthless Mercier sisters broke my goddam ass." She thinks Carla Mercier. Who's Venziano now.'

'Right,' Rusty said, then murmured, apropos nothing: 'It's a small town, and we all support the team. So is it?'

'Is it what, sensei?'

'Broken.'

'I don't know. She won't show it to me. She says, and I *also* quote, "I will only expose my smithyriddles to a professional eye."'

They burst out laughing, trying to stifle the sounds.

From beyond the closed door, an old lady's cracked and dolorous voice said: 'It's my ass that's broke, not my ears. I hear that.'

Rusty and Twitch laughed harder. Twitch had gone an alarming shade of red.

From behind the door, Henrietta said: 'If it was your ass, my buddies, you'd be laughing on the other side of your faces.'

Rusty went in, still smiling. 'I'm sorry, Mrs Clavard.'

She was standing rather than sitting, and to his immense relief, she smiled herself. 'Nah,' she said. '*Something* in this balls-up has got to be funny. It might as well be me.' She considered. 'Besides, I was in there stealing with the rest of them. I probably deserved it.'

10

Henrietta's ass turned out to be badly bruised but not broken. A good thing, because a smashed coccyx was really nothing to laugh about. Rusty gave her a pain-deadening cream, confirmed that she had Advil at home, and sent her away, limping but satisfied. As satisfied, anyway, as a lady of her age and temperament was ever likely to get.

On his second escape attempt, about fifteen minutes after Linda's call, Harriet Bigelow stopped him just short of the door to the parking lot. 'Ginny says you should know Sammy Bushey's gone.'

'Gone where?' Rusty asked. This under the old grade-school assumption that the only stupid question was the one you didn't ask.

'No one knows. She's just gone.'

'Maybe she went down to Sweetbriar to see if they're serving dinner. I hope that's it, because if she tries to walk all the way back to her place, she's apt to bust her stitches.'

Harriet looked alarmed. 'Could she, like, bleed to death? Bleeding to death from your woo-woo . . . that would be *bad.*'

Rusty had heard many terms for the vagina, but this one was new to him. 'Probably not, but she could end up back here for an extended stay. What about her baby?'

Harriet looked stricken. She was an earnest little thing who had a way of blinking distractedly behind the thick lenses of her glasses when she was nervous; the kind of girl, Rusty thought, who might treat herself to a mental breakdown about fifteen years after graduating summa cum laude from Smith or Vassar.

'The baby! Omigod, Little Walter!' She dashed down the hall before Rusty could stop her and came back looking relieved. 'Still here. He's not very lively, but that seems to be his nature.'

'Then she'll probably be back. Whatever other problems she might have, she loves the kid. In an absentminded sort of way.'

'Huh?' More furious blinking.

'Never mind. I'll be back as soon as I can, Hari. Keep em flying.'

'Keep *what* flying?' Her eyelids now appeared on the verge of catching fire.

Rusty almost said, *I mean keep your pecker up*, but that wasn't right, either. In Harriet's terminology, a pecker was probably a wah-wah.

'Keep busy,' he said.

Harriet was relieved. 'I can do that, Dr Rusty, no prob.'

Rusty turned to go, but now a man was standing there – thin,

not bad-looking once you got past the hooked nose, a lot of graying hair tied back in a ponytail. He looked a bit like the late Timothy Leary. Rusty was starting to wonder if he was going to get out of here, after all.

'Can I help you, sir?'

'Actually, I was thinking that perhaps I could help you.' He stuck out a bony hand. 'Thurston Marshall. My partner and I were weekending at Chester Pond, and got caught in this whatever-it-is.'

'Sorry to hear that,' Rusty said.

'The thing is, I have a bit of medical experience. I was a conscientious objector during the Vietnam mess. Thought about going to Canada, but I had plans . . . well, never mind. I registered as a CO and did two years as an orderly at a veterans' hospital in Massachusetts.'

That was interesting. 'Edith Nourse Rogers?'

'The very one. My skills are probably a bit out-of-date, but—'

'Mr Marshall, do I have a job for you.'

11

As Rusty headed down 119, a horn blew. He checked his mirror and saw one of the town's Public Works trucks preparing to turn in at Catherine Russell Drive. It was hard to tell in the red light of the lowering sun, but he thought Stewart Bowie was behind the wheel. What he saw on second glance gladdened Rusty's heart: there appeared to be a couple of LP tanks in the bed of the truck. He'd worry about where they came from later, maybe even ask some questions, but for now he was just relieved to know that soon the lights would be back on, the respirators and monitors online. Maybe not for the long haul, but he was in full one-day-at-a-time mode.

At the top of Town Common Hill he saw his old skateboarding patient, Benny Drake, and a couple of his friends. One was the McClatchey boy who'd set up the live video feed of the missile strike. Benny waved and shouted, obviously wanting Rusty to stop and shoot the shit. Rusty waved back, but didn't slow. He was anxious to see Linda. Also to hear what she had to say, of course, but mostly to see her, put his arms around her, and finish making up with her.

12

Barbie needed to take a piss but held his water. He had done interrogations in Iraq and knew how it worked over there. He didn't know if it would be the same here just yet, but it might be. Things were

moving very rapidly, and Big Jim had shown a ruthless ability to move with the times. Like most talented demagogues, he never underestimated his target audience's willingness to accept the absurd.

Barbie was also very thirsty, and it didn't surprise him much when one of the new officers showed up with a glass of water in one hand and a sheet of paper with a pen clipped to it in the other. Yes, it was how these things went; how they went in Fallujah, Takrit, Hilla, Mosul, and Baghdad. How they also now went in Chester's Mill, it seemed.

The new officer was Junior Rennie.

'Well, look at you,' Junior said. 'Don't look quite so ready to beat guys up with your fancy Army tricks right now.' He raised the hand holding the sheet of paper and rubbed his left temple with the tips of his fingers. The paper rattled.

'You don't look so good yourself.'

Junior dropped his hand. 'I'm fine as rain.'

Now *that* was odd, Barbie thought; some people said right as rain and some said fine as paint, but none, as far as he knew, said *fine as rain*. It probably meant nothing, but—

'Are you sure? Your eye's all red.'

'I'm fucking terrific. And I'm not here to discuss me.'

Barbie, who knew why Junior was here, said: 'Is that water?'

Junior looked down at the glass as if he'd forgotten it. 'Yeah. Chief said you might be thirsty. Thursday on a Tuesday, you know.' He laughed hard, as if this non sequitur was the wittiest thing to ever come out of his mouth. 'Want it?'

'Yes, please.'

Junior held the glass out. Barbie reached for it. Junior pulled it back. Of course. It was how these things went.

'Why'd you kill them? I'm curious, *Baaarbie*. Wouldn't Angie fuck you no more? Then when you tried Dodee, you found out she was more into crack-snacking than cock-gobbling? Maybe Coggins saw something he wasn't supposed to? And Brenda got suspicious. Why not? She was a cop herself, you know. By injection!'

Junior yodeled laughter, but underneath the humor there was nothing but black watchfulness. And pain. Barbie was quite sure of it.

'What? Nothing to say?'

'I said it. I'd like a drink. I'm thirsty.'

'Yep, I bet you are. That Mace is a bitch, idn't it? I understand you saw service in Iraq. What was that like?'

'Hot.'

Junior yodeled again. Some of the water in the glass spilled on

his wrist. Were his hands shaking a little? And that inflamed left eye was leaking tears at the corner. *Junior, what the hell's wrong with you? Migraine? Something else?*

'Did you kill anybody?'

'Only with my cooking.'

Junior smiled as if to say *Good one, good one.* 'You weren't any cook over there, *Baaaarbie.* You were a liaison officer. That was your job description, anyway. My dad looked you up on the Internet. There isn't a lot, but there's some. He thinks you were an interrogation guy. Maybe even a black ops guy. Were you like the Army's Jason Bourne?'

Barbie said nothing.

'Come on, did you kill anybody? Or should I ask, how *many* did you kill? Besides the ones you bagged here, I mean.'

Barbie said nothing.

'Boy, I bet this water is good. It came from the cooler upstairs. Chilly Willy!'

Barbie said nothing.

'You guys come back with all sorts of problems. At least that's what I breed and see on TV. Right or false? True or wrong?'

It isn't a migraine making him do that. At least not any migraine I ever heard of.

'Junior, how bad does your head hurt?'

'Doesn't hurt at all.'

'How long have you been having headaches?'

Junior set the glass carefully down on the floor. He was wearing a sidearm this evening. He drew it and pointed it through the bars at Barbie. The barrel was trembling slightly. 'Do you want to keep playing doctor?'

Barbie looked at the gun. The gun wasn't in the script, he was quite sure – Big Jim had plans for him, and probably not nice ones, but they didn't include Dale Barbara being shot in a jail cell when anybody from upstairs could rush down and see that the cell door was still locked and the victim unarmed. But he didn't trust Junior to follow the script, because Junior was ill.

'No,' he said. 'No doctoring. Very sorry.'

'Yeah, you're sorry, all right. One sorry shack of sit.' But Junior seemed satisfied. He holstered the gun and picked up the glass of water again. 'My theory is that you came back all fucked up from what you saw and did over there. You know, PTSS, STD, PMS, one of those. My theory is that you just snapped. That about right?'

Barbie said nothing.

Junior didn't seem very interested, anyway. He handed the glass through the bars. 'Take it, take it.'

Barbie reached for the glass, thinking it would be snatched away again, but it wasn't. He tasted it. Not cold and not drinkable, either.

'Go on,' Junior said. 'I only shook half a shaker in, you can deal with that, can't you? You salt your bread, don't you?'

Barbie only looked at Junior.

'You salt your bread? Do you salt it, motherfucker? Huh?'

Barbie held the glass out through the bars.

'Keep it, keep it,' Junior said magnanimously. 'And take this, too.' He passed the paper and pen through the bars. Barbie took them and looked the paper over. It was pretty much what he'd expected. There was a place for him to sign his name at the bottom.

He offered it back. Junior backed away in what was almost a dance step, smiling and shaking his head. 'Keep that, too. My dad said you wouldn't sign it right away, but you think about it. And think about getting a glass of water with no salt in it. And some food. Big old cheeseburger in paradise. Maybe a Coke. There's some cold in the fridge upstairs. Wouldn't you like a nice cone Cole?'

Barbie said nothing.

'You salt your bread? Go on, don't be shy. Do you, assface?'

Barbie said nothing.

'You'll come around. When you get hungry enough and thirsty enough, you will. That's what my dad says, and he's usually right about those things. Ta-ta, *Baaaarbie.*'

He started down the hall, then turned back.

'You never should have put your hands on me, you know. That was your big mistake.'

As he went up the stairs, Barbie observed that Junior was limping a tiny bit – or *dragging*. That was it, dragging to the left and pulling on the banister with his right hand to compensate. He wondered what Rusty Everett would think about such symptoms. He wondered if he'd ever get a chance to ask.

Barbie considered the unsigned confession. He would have liked to tear it up and scatter the pieces on the floor outside the cell, but that would be an unnecessary provocation. He was between the cat's claws now, and the best thing he could do was be still. He put the paper on the bunk and the pen on top of it. Then he picked up the glass of water. Salt. Seeded with salt. He could smell it. Which made him think about how Chester's Mill was now . . . only hadn't it already been this way? Even before the Dome? Hadn't Big Jim and his friends been seeding the ground with salt for some time now?

Barbie thought yes. He also thought that if he got out of this police station alive, it would be a miracle.

Nonetheless, they were amateurs at this; they had forgotten the toilet. Probably none of them had ever been in a country where even a little ditchwater could look good when you were carrying ninety pounds of equipment and the temperature was forty-six Celsius. Barbie poured out the salt water in the corner of the cell. Then he pissed in the glass and set it under the bunk. Then he knelt in front of the toilet bowl like a man at his prayers and drank until he could feel his belly bulging.

13

Linda was sitting on the front steps when Rusty pulled up. In the backyard, Jackie Wettington was pushing the Little Js on the swings and the girls were urging her to push harder and send them higher.

Linda came to him with her arms out. She kissed his mouth, drew back to look at him, then kissed him again with her hands on his cheeks and her mouth open. He felt the brief, humid touch of her tongue, and immediately began to get hard. She felt it and pressed against it.

'Wow,' he said. 'We should fight in public more often. And if you don't stop that, we'll be doing something else in public.'

'We'll do it, but not in public. First – do I need to say again that I'm sorry?'

'No.'

She took his hand and led him back to the steps. 'Good. Because we've got stuff to talk about. Serious stuff.'

He put his other hand over hers. 'I'm listening.'

She told him about what had happened at the station – Julia being turned away after Andy Sanders had been allowed down to confront the prisoner. She told about going to the church so she and Jackie could talk to Julia in private, and the later conversation at the parsonage, with Piper Libby and Rommie Burpee added to the mix. When she told him about the beginning rigor they had observed in Brenda Perkins's body, Rusty's ears pricked up.

'Jackie!' he called. 'How sure are you about the rigor?'

'Pretty!' she called back.

'Hi, Daddy!' Judy called. 'Me'n Jannie's gonna loop the loop!'

'No you're not,' Rusty called back, and stood to blow kisses from the palms of his hands. Each girl caught one; when it came to kiss-catching, they were aces.

'What time did you see the bodies, Lin?'

'Around ten-thirty, I think. The supermarket mess was long over.'

'And if Jackie's right about the rigor just setting in . . . but we can't be absolutely sure of that, can we?'

'No, but listen. I talked with Rose Twitchell. Barbara got to Sweetbriar at *ten minutes to six*. From then until the bodies were discovered, he's alibied. So he would've had to kill her when? Five? Five thirty? How likely is that, if rigor was just setting in five hours later?'

'Not likely but not impossible. Rigor mortis is affected by all sorts of variables. The temperature of the body-storage site, for one. How hot was it in that pantry?'

'Warm,' she admitted, then crossed her arms over her breasts and cupped her shoulders. 'Warm and *smelly*.'

'See what I mean? Under those circumstances, he could have killed her someplace at *four* a.m., then taken her there and stuffed her into the—'

'I thought you were on his side.'

'I am, and it's really not likely, because the pantry would have been much cooler at four in the morning. Why would he have been with Brenda at four in the morning, anyway? What would the cops say? That he was boffing her? Even if older women – *much* older – were his thing . . . three days after her husband of thirty-plus years was killed?'

'They'd say it wasn't consensual,' she told him bleakly. 'They'd say it was rape. Same as they're already saying for those two girls.'

'And Coggins?'

'If they're framing him, they'll think of something.'

'Is Julia going to print all this?'

'She's going to write the story and raise some questions, but she'll hold back the stuff about rigor being in the early stages. Randolph might be too stupid to figure out where that information came from, but Rennie would know.'

'It could still be dangerous,' Rusty said. 'If they muzzle her, she can't exactly go to the ACLU.'

'I don't think she cares. She's mad as hell. She even thinks the supermarket riot might have been a setup.'

Probably was, Rusty thought. What he said was, 'Damn, I wish I'd seen those bodies.'

'Maybe you still can.'

'I know what you're thinking, hon, but you and Jackie could

lose your jobs. Or worse, if this is Big Jim's way of getting rid of an annoying problem.'

'We can't just leave it like this—'

'Also, it might not do any good. *Probably* wouldn't. If Brenda Perkins commenced rigor between four and eight, she's probably in full rigor by now and there isn't much I can tell from the body. The Castle County ME might be able to, but he's as out of reach as the ACLU.'

'Maybe there's something else. Something about her corpse or one of the others. You know that sign they have in some post-mortem theaters? "This is where the dead speak to the living"?'

'Long shot. You know what would be better? If someone saw Brenda alive after Barbie reported to work at five fifty this morning. That would put a hole in their boat too big to plug.'

Judy and Janelle, dressed in their pajamas, came flying up for hugs. Rusty did his duty in this regard. Jackie Wettington, following along behind them, heard Rusty's last comment and said, 'I'll ask around.'

'But quietly,' he said.

'You bet. And for the record, I'm still not entirely convinced. His dog tags *were* in Angie's hand.'

'And he never noticed they were gone during the time between losing them and the bodies being found?'

'What bodies, Dad?' Jannie asked.

He sighed. 'It's complex, honey. And not for little girls.'

Her eyes said that was good. Her younger sister, meanwhile, had gone off to pick a few late flowers but came back empty-handed. 'They're dying,' she reported. 'All brown and yucky at the edges.'

'It's probably too warm for them,' Linda said, and for a moment Rusty thought she was going to cry. He stepped into the breach.

'You girls go in and brush your teeth. Get a little water from the jug on the counter. Jannie, you're the designated water-pourer. Now go.' He turned back to the women. To Linda in particular. 'You okay?'

'Yes. It's just that . . . it keeps hitting me in different ways. I think, "Those flowers have no business dying," and then I think, "None of this has any business happening in the first place."'

They were silent for a moment, thinking about this. Then Rusty spoke up.

'We should wait and see if Randolph asks me to examine the bodies. If he does, I'll get my look without any risk of hot water for you two. If he doesn't, it tells us something.'

'Meanwhile, Barbie's in jail,' Linda said. 'They could be trying to get a confession out of him right now.'

'Suppose you flashed your badges and got me into the funeral parlor?' Rusty asked. 'Further suppose I found something that exonerates Barbie. Do you think they'd just say "Oh shit, our bad" and let him out? And then let him take over? Because that's what the government wants; it's all over town. Do you think Rennie would allow—'

His cell phone went off. 'These things are the worst invention ever,' he said, but at least it wasn't the hospital.

'Mr Everett?' A woman. He knew the voice but couldn't put a name to it.

'Yes, but unless this is an emergency, I'm a little busy right n—'

'I don't know if it's an emergency, but it's very, very important. And since Mr Barbara — or Colonel Barbara, I guess — has been arrested, you're the one who has to deal with it.'

'Mrs McClatchey?'

'Yes, but Joe's the one you need to talk to. Here he is.'

'Dr Rusty?' The voice was urgent, almost breathless.

'Hi, Joe. What is it?'

'I think we found the generator. *Now* what are we supposed to do?'

The evening went dark so suddenly that all three of them gasped and Linda seized Rusty's arm. But it was only the big smoke-smudge on the western side of the Dome. The sun had gone behind it.

'Where?'

'Black Ridge.'

'Was there radiation, son?' Knowing there must have been; how else had they found it?

'The last reading was plus two hundred,' Joe said. 'Not quite into the danger zone. What do we do?'

Rusty ran his free hand through his hair. Too much happening. Too much, too fast. Especially for a smalltown fixer-upper who had never considered himself much of a decision-maker, let alone a leader.

'Nothing tonight. It's almost dark. We'll deal with this tomorrow. In the meantime, Joe, you have to make a promise. Keep quiet about this. You know, Benny and Norrie know, and your mom knows. Keep it that way.'

'Okay.' Joe sounded subdued. 'We have a lot to tell you, but I guess it can wait until tomorrow.' He took a breath. 'It's a little scary, isn't it?'

'Yes, son,' Rusty agreed. 'It's a little scary.'

14

The man in charge of The Mill's fate and fortunes was sitting in his study and eating a corned beef on rye in big snaffling bites when Junior came in. Earlier, Big Jim had caught a forty-five-minute power nap. Now he felt refreshed and once more ready for action. The surface of his desk was littered with sheets of yellow legal paper, notes he would later burn in the incinerator out back. Better safe than sorry.

The study was lit with hissing Coleman lanterns that threw a bright white glare. God knew he had access to plenty of propane – enough to light the house and run the appliances for fifty years – but for now the Colemans were better. When people passed by, he wanted them to see that bright white glare and know that Selectman Rennie wasn't getting any special perks. That Selectman Rennie was just like them, only more trustworthy.

Junior was limping. His face was drawn. 'He didn't confess.'

Big Jim hadn't expected Barbara to confess so soon and ignored this. 'What's wrong with you? You look peaky as hell.'

'Another headache, but it's letting go now.' This was true, although it had been very bad during his conversation with Barbie. Those blue-gray eyes either saw too much or seemed to.

I know what you did to them in the pantry, they said. *I know everything.*

It had taken all his will not to pull the trigger of his gun after he'd drawn it, and darken that damnable prying stare forever.

'You're limping, too.'

'That's because of those kids we found out by Chester Pond. I was carrying one of them around and I think I pulled a muscle.'

'Are you sure that's all it is? You and Thibodeau have a job to do in' – Big Jim looked at his watch – 'in about three and a half hours, and you can't mess it up. It has to go off perfectly.'

'Why not as soon as it's dark?'

'Because the witch is putting her paper together there with her two little trolls. Freeman and the other one. The sports reporter who's always down on the Wildcats.'

'Tony Guay.'

'Yes, him. I don't particularly care about them being hurt, especially her' – Big Jim's upper lip lifted in his doglike imitation smile – 'but there must not be any witnesses. No *eyeball* witnesses, I mean. What people *hear* . . . that's a very different kettle of cod.'

'What do you want them to hear, Dad?'

'Are you sure you're up to this? Because I can send Frank with Carter instead.'

'*No!* I helped you with Coggins and I helped you with the old lady this morning and I *deserve* to do this!'

Big Jim seemed to measure him. Then he nodded. 'All right. But you must not be caught, or even seen.'

'Don't worry. What do you want the . . . the earwitnesses to hear?'

Big Jim told him. Big Jim told him everything. It was good, Junior thought. He had to admit it: his dear old dad didn't miss a trick.

15

When Junior went upstairs to 'rest his leg,' Big Jim finished his sandwich, wiped the grease from his chin, then called Stewart Bowie's cell. He began with the question everybody asks when calling a cell phone. 'Where are you?'

Stewart said they were on their way to the funeral home for a drink. Knowing Big Jim's feeling about alcoholic beverages, he said this with a workingman's defiance: *I did my job, now let me take my pleasure.*

'That's all right, but make sure it's only the one. You aren't done for the night. Fern or Roger, either.'

Stewart protested strenuously.

After he'd finished having his say, Big Jim went on. 'I want the three of you at the Middle School at nine thirty. There'll be some new officers there – including Roger's boys, by the way – and I want you there, too.' An inspiration occurred. 'In fact, I'm going to make you fellows sergeants in the Chester's Mill Hometown Security Force.'

Stewart reminded Big Jim he and Fern had four new corpses to deal with. In his strong Yankee accent, the word came out *cawpses.*

'Those folks from the McCains' can wait,' Big Jim said. 'They're dead. We've got an emergency situation on our hands here, in case you didn't notice. Until it's over, we've all got to pull our weight. Do our bit. Support the team. Nine thirty at the Middle School. But I've got something else for you to do first. Won't take long. Put Fern on.'

Stewart asked why Big Jim wanted to talk to Fern, whom he regarded – with some justification – as the Dumb Brother.

'None of your beeswax. Just put him on.'

Fern said hello. Big Jim didn't bother.

'You used to be with the Volunteers, didn't you? Until they were disbanded?'

Fern said he had indeed been with this unofficial adjunct to the Chester's Mill FD, not adding that he had quit a year before the Vols had been disbanded (after the Selectmen recommended no money be allocated to them in the 2008 town budget). He also did not add that he found the Volunteers' weekend fund-raising activities were cutting into his drinking time.

Big Jim said, 'I want you to go to the PD and get the key to the FD. Then see if those Indian pumps Burpee used yesterday are in the barn. I was told that was where he and the Perkins woman put them, and that better be right.'

Fern said he believed the Indian pumps had come from Burpee's in the first place, which sort of made them Rommie's property. The Volunteers had had a few, but sold them on eBay when the outfit disbanded.

'They might have *been* his, but they aren't anymore,' Big Jim said. 'For the duration of the crisis, they're town property. We'll do the same with anything else we need. It's for the good of everyone. And if Romeo Burpee thinks he's going to start up the Vols again, he's got another think coming.'

Fern said – cautiously – that he'd heard Rommie did a pretty good job putting out the contact fire on Little Bitch after the missiles hit.

'That wasn't much more than cigarette butts smoldering in an ashtray,' Big Jim scoffed. A vein was pulsing in his temple and his heart was beating too hard. He knew he'd eaten too fast – again – but he just couldn't help it. When he was hungry, he gobbled until whatever was in front of him was gone. It was his nature. 'Anyone could have put it out. *You* could have put it out. Point is, I know who voted for me last time, and I know who didn't. Those who didn't get no cotton-picking candy.'

Fern asked Big Jim what he, Fern, was supposed to do with the pumps.

'Just make sure they're in the firebarn. Then come on over to the Middle School. We'll be in the gym.'

Fern said Roger Killian wanted to say something.

Big Jim rolled his eyes but waited.

Roger wanted to know which of his boys was goin on the cops.

Big Jim sighed, scrabbled through the litter of papers on his desk, and found the one with the list of new officers on it. Most were high-schoolers, and all were male. The youngest, Mickey Wardlaw,

was only fifteen, but he was a bruiser. Right tackle on the football team until he'd been kicked off for drinking. 'Ricky and Randall.'

Roger protested that them was his oldest and the only ones who could be reliably counted on for chorin. Who, he asked, was going to help out with them chickens?

Big Jim closed his eyes and prayed to God for strength.

16

Sammy was very aware of the low, rolling pain in her stomach – like menstrual cramps – and much sharper twinges coming from lower down. They would have been hard to miss, because another one came with each step. Nevertheless, she kept plodding along 119 toward the Motton Road. She would keep on no matter how much it hurt. She had a destination in mind, and it wasn't her trailer, either. What she wanted wasn't in the trailer, but she knew where it could be found. She'd walk to it even if it took her all night. If the pain got really bad, she had five Percocet tablets in her jeans pocket and she could chew them up. They worked faster when you chewed them. Phil had told her that.

Do her.

We'd come back and really *fuck you up.*

Do that bitch.

You better learn to keep your mouth for when you're on your knees.

Do her, do that bitch.

No one would believe you, anyway.

But the Reverend Libby had, and look what happened to her. Dislocated shoulder; dead dog.

Do that bitch.

Sammy thought she would hear that pig's squealing, excited voice in her head until she died.

So she walked. Overhead the first pink stars glimmered, sparks seen through a dirty pane of glass.

Headlights appeared, making her shadow jump long on the road ahead. A clattery old farm truck pulled up and stopped. 'Hey, there, climb in,' the man behind the wheel said. Only it came out *Hey-yere-lime-in*, because it was Alden Dinsmore, father of the late Rory, and Alden was drunk.

Nevertheless, Sammy climbed in – moving with an invalid's care.

Alden didn't appear to notice. There was a sixteen-ounce can of Bud between his legs and a half-empty case beside him. Empties rolled and rattled around Sammy's feet. 'Where you goin?' Alden

asked. 'Porrun? Bossum?' He laughed to show that, drunk or not, he could make a joke.

'Only out Motton Road, sir. Are you going that way?'

'Any way you want,' Alden said. 'I'm just drivin. Drivin and thinkin bout my boy. He died on Sarraday.'

'I'm real sorry for your loss.'

He nodded and drank. 'M'dad died las' winner, you know it? Gasped himself to death, poor old fella. Empha-seeme. Spent the last year of his life on oxygen. Rory used to change his tanks. He loved that ol' bassid.'

'I'm sorry.' She'd already said that, but what else *was* there to say?

A tear crept down his cheek. 'I'll go any way you want, Missy Lou. Gonna keep drivin till the beer's gone. You wa'm beer?'

'Yes, please.' The beer was warm but she drank greedily. She was very thirsty. She fished one of the Percs out of her pocket and swallowed it with another long gulp. She felt the buzz hit her in the head. It was fine. She fished out another Perc and offered it to Alden. 'Want one of these? They make you feel better.'

He took it and swallowed it with beer, not bothering to ask what it was. Here was the Motton Road. He saw the intersection late and swung wide, knocking the Crumleys' mailbox flat. Sammy didn't mind.

'Grab another, Missy Lou.'

'Thank you, sir.' She took another beer and popped the top.

'Wa'm see my boy?' In the glow of the dashboard lights, Alden's eyes looked yellow and wet. They were the eyes of a dog who'd stepped in a hole and went legbroke. 'Wa'm see my boy Rory?'

'Yes, sir,' Sammy said, 'I sure do. I was there, you know.'

'Everybody was. I rented my fiel. Prolly helped to kill im. Din know. We never know, do we?'

'No,' Sammy said.

Alden dug into the bib pocket of his overalls and pulled out a battered wallet. He took both hands off the wheel to pull it open, squinting and flipping through the little celluloid pockets. 'My boys gay me this warret,' he said. 'Ro'y and Orrie. Orrie's still 'live.'

'That's a nice wallet,' Sammy said, leaning across to take hold of the steering wheel. She had done the same for Phil when they were living together. Many times. Mr Dinsmore's truck went from side to side in slow and somehow solemn arcs, barely missing another mailbox. But that was all right; the poor old guy was only doing twenty, and Motton Road was deserted. On the radio, WCIK was playing low: 'Sweet Hope of Heaven,' by the Blind Boys of Alabama.

Alden thrust the wallet at her. 'There e is. There's my boy. Wif his grampa.'

'Will you drive while I look?' Sammy asked.

'Sure.' Alden took the wheel back. The truck began to move a little faster and a little straighter, although it was more or less straddling the white line.

The photograph was a faded color shot of a young boy and an old man with their arms around each other. The old man was wearing a Red Sox cap and an oxygen mask. The boy had a big grin on his face. 'He's a beautiful boy, sir,' Sammy said.

'Yeah, beauful boy. Beauful smart boy.' Alden let out a tearless bray of pain. He sounded like a donkey. Spittle flew from his lips. The truck plunged, then came right again.

'I have a beautiful boy, too,' Sammy said. She began to cry. Once, she remembered, she had taken pleasure in torturing Bratz. Now she knew how it felt to be in the microwave herself. Burning in the microwave. 'I'm going to kiss him when I see him. Kiss him once more.'

'You kiss im,' Alden said.

'I will.'

'You kiss im and hug im and hold im.'

'I will, sir.'

'I'd kiss my boy if I could. I'd kiss his cole-cole cheek.'

'I know you would, sir.'

'But we burrit him. This morning. Right on the place.'

'I'm so sorry for your loss.'

'Have another beer.'

'Thank you.' She had another beer. She was getting drunk. It was lovely to be drunk.

In this fashion they progressed as the pink stars grew brighter overhead, flickering but not falling: no meteor showers tonight. They passed Sammy's trailer, where she'd never go again, without slowing.

17

It was about quarter to eight when Rose Twitchell knocked on the glass panel of the *Democrat*'s door. Julia, Pete, and Tony were standing at a long table, creating copies of the newspaper's latest four-page broadside. Pete and Tony put them together; Julia stapled them and added them to the pile.

When she saw Rose, Julia waved her in energetically. Rose opened the door, then staggered a little. 'Jeez, it's hot in here.'

'Turned off the AC to save juice,' Pete Freeman said, 'and the copier gets hot when it's overused. Which it has been tonight.' But he looked proud. Rose thought they all looked proud.

'Thought you'd be overwhelmed at the restaurant,' Tony said.

'Just the opposite. Could've shot deer in there tonight. I think a lot of people don't want to face me because my cook's been arrested for murder. And I think a lot of people don't want to face each other because of what happened at Food City this morning.'

'Come on over here and grab a copy of the paper,' Julia said. 'You're a cover girl, Rose.'

At the top, in red, were the words **FREE** DOME CRISIS EDITION **FREE**. And below that, in sixteen-point type Julia had never used until the last two editions of the *Democrat*:

RIOT AND MURDERS AS CRISIS DEEPENS

The picture was of Rose herself. She was in profile. The bullhorn was to her lips. An errant lock of hair lay on her forehead and she looked extraordinarily beautiful. In the background was the pasta and juices aisle, with several bottles of what looked like spaghetti sauce smashed on the floor. The caption read: **Quiet Riot: Rose Twitchell, owner and proprietor of Sweetbriar Rose, quells food riot with the help of Dale Barbara, who has been arrested for murder (see story below and Editorial, p. 4).**

'Holy God,' Rose said. 'Well . . . at least you got my good side. If I can be said to have one.'

'Rose,' Tony Guay said solemnly, 'you look like Michelle Pfeiffer.'

Rose snorted and flipped him the bird. She was already turning to the editorial.

PANIC NOW, SHAME LATER
By Julia Shumway

Not everybody in Chester's Mill knows Dale Barbara – he is a relative newcomer to our town – but most people have eaten his cooking in Sweetbriar Rose. Those who do know him would have said, before today, that he was a real addition to the community, taking his turn at umpiring softball games in July and August, helping out with the Middle School Book Drive in September, and picking up trash on Common Cleanup Day just two weeks ago.

Then, today, 'Barbie' (as he is known by those who
do know him) was arrested for four shocking murders.
Murders of people who are well known and well loved
in this town. People who, unlike Dale Barbara, have
lived here most or all of their lives.

Under ordinary circumstances, 'Barbie' would have
been taken to the Castle County Jail, offered his one
phone call, and provided with a lawyer if he couldn't
afford one. He would have been charged, and the
evidence-gathering – by experts who know what they
are doing – would have begun.

None of that has happened, and we all know why:
because of the Dome that has now sealed our town off
from the rest of the world. But have due process and
common sense also been sealed off? No matter how
shocking the crime, unproved accusations are not
enough to excuse the way Dale Barbara has been
treated, or to explain the new Police Chief's refusal to
answer questions or allow this correspondent to verify
that Dale Barbara is still alive, although the father of
Dorothy Sanders – First Selectman Andrew Sanders –
was allowed to not only visit this uncharged prisoner
but to vilify him . . .

'Phew,' Rose said, looking up. 'You're really going to print this?'

Julia gestured to the stacked copies. 'It's already printed. Why?
Do you object?'

'No, but . . .' Rose was rapidly scanning the rest of the editorial,
which was very long and increasingly pro-Barbie. It ended with an
appeal for anyone with information about the crimes to come forward,
and the suggestion that when the crisis ended, as it surely would, the
behavior of the residents regarding these murders would be closely
scrutinized not just in Maine or the United States, but all over the
world. 'Aren't you afraid you'll get in trouble?'

'Freedom of the press, Rose,' Pete said, sounding remarkably
unsure himself.

'It's what Horace Greeley would have done,' Julia said firmly,
and at the sound of his name, her corgi – who had been asleep on
his dogbed in the corner – looked up. He saw Rose and came over
for a pat or two, which Rose was happy to provide.

'Do you have more than what's in here?' Rose asked, tapping
the editorial.

'A little,' Julia said. 'I'm holding it back. Hoping for more.'

'Barbie could never have done a thing like this. But I'm afraid for him, just the same.'

One of the cell phones scattered on the desk rang. Tony snared it. '*Democrat*, Guay.' He listened, then held out the phone to Julia. 'Colonel Cox. For you. He doesn't sound like a happy camper.'

Cox. Julia had forgotten all about him. She took the telephone.

'Ms Shumway, I need to talk to Barbie and find out what sort of progress he's making in taking administrative control there.'

'I don't think that will be happening anytime soon,' Julia said. 'He's in jail.'

'*Jail?* Charged with what?'

'Murder. Four counts, to be exact.'

'You're joking.'

'Do I sound like I'm joking, Colonel?'

There was a moment of silence. She could hear many voices in the background. When Cox spoke again, his voice was low. 'Explain this.'

'No, Colonel Cox, I think not. I've been writing about it for the last two hours, and as my mother used to say when I was a little girl, I don't chew my cabbage twice. Are you still in Maine?'

'Castle Rock. Our forward base is here.'

'Then I suggest that you meet me where we met before. Motton Road. I can't give you a copy of tomorrow's *Democrat*, even though it's free, but I can hold it up to the Dome and you can read it for yourself.'

'E-mail it to me.'

'I won't. I think e-mail is antithetical to the newspaper business. I'm very old-fashioned that way.'

'You're an irritating piece of work, dear lady.'

'I may be irritating, but I'm not your dear lady.'

'Tell me this: is it a frame job? Something to do with Sanders and Rennie?'

'Colonel, in your experience, does a bear defecate in the woods?'

Silence. Then he said, 'I'll meet you in an hour.'

'I'll be bringing company. Barbie's employer. I think you'll be interested in what she has to say.'

'Fine.'

Julia hung up the phone. 'Want to take a little ride with me out to the Dome, Rose?'

'If it'll help Barbie, sure.'

'We can hope, but I'm kind of thinking we're on our own here.'

Julia shifted her attention to Pete and Tony. 'Will you two finish stapling those? Stack em by the door and lock up when you leave. Get a good night's sleep, because tomorrow we all get to be newsboys. This paper's getting the old-school treatment. Every house in town. The close-in farms. And Eastchester, of course. Lots of new people out there, theoretically less susceptible to the Big Jim mystique.'

Pete raised his eyebrows.

'Our Mr Rennie's the home team,' Julia said. 'He's going to climb onto the stump at the emergency town meeting Thursday night and try to wind this town up like a pocketwatch. The visitors get first ups, though.' She pointed at the newspapers. 'Those are our first ups. If enough people read that, he'll have some tough questions to answer before he gets to speechifying. Maybe we can disrupt his rhythm a little.'

'Maybe a lot, if we find out who did the rock-throwing at Food City,' Pete said. 'And you know what? I think we will. I think this whole thing was put together on the fly. There's got to be loose ends.'

'I just hope Barbie's still alive when we start pulling them,' Julia said. She looked at her watch. 'Come on, Rosie, let's take a ride. You want to come, Horace?'

Horace did.

18

'You can let me off here, sir,' Sammy said. It was a pleasant ranch-style in Eastchester. Although the house was dark, the lawn was lit, because they were now close to the Dome, where bright lights had been set up at the Chester's Mill–Harlow town line.

'Wa'm nuther beer for the road, Missy Lou?'

'No, sir, this is the end of the road for me.' Although it wasn't. She still had to go back to town. In the yellow glow cast by the domelight, Alden Dinsmore looked eighty-five instead of forty-five. She had never seen such a sad face . . . except maybe for her own, in the mirror of her hospital room before she set out on this journey. She leaned over and kissed his cheek. The stubble there prickled her lips. He put his hand to the spot, and actually smiled a little.

'You ought to go home now, sir. You've got a wife to think about. And another boy to take care of.'

'I s'pose you're right.'

'I *am* right.'

'You be okay?'

'Yes, sir.' She got out, then turned back to him. 'Will you?'

'I'll try,' he said.

Sammy slammed the door and stood at the end of the driveway, watching him turn around. He went into the ditch, but it was dry and he got out all right. He headed back toward 119, weaving at first. Then the taillights settled into a more or less straight line. He was in the middle of the road again – fucking the white line, Phil would have said – but she thought that would be okay. It was going on eight thirty now, full dark, and she didn't think he'd meet anyone.

When his taillights winked out of sight, she walked up to the dark ranch house. It wasn't much compared to some of the fine old homes on Town Common Hill, but nicer than anything she'd ever had. It was nice inside, too. She had been here once with Phil, back in the days when he did nothing but sell a little weed and cook a little glass out back of the trailer for his own use. Back before he started getting his strange ideas about Jesus and going to that crappy church, where they believed everybody was going to hell but them. Religion was where Phil's trouble had started. It had led him to Coggins, and Coggins or someone else had turned him into The Chef.

The people who had lived here weren't tweekers; tweekers wouldn't be able to keep a house like this for long, they'd freebase the mortgage. But Jack and Myra Evans *had* enjoyed a little wacky tobacky from time to time, and Phil Bushey had been happy to supply it. They were nice people, and Phil had treated them nice. Back in those days he'd still been capable of treating people nice.

Myra gave them iced coffee. Sammy had been seven or so months gone with Little Walter then, showing plenty, and Myra had asked her if she wanted a boy or a girl. Not looking down her nose a bit. Jack had taken Phil into his little office-den to pay him, and Phil had called to her. 'Hey, honey, you should get a load of this!'

It all seemed so long ago.

She tried the front door. It was locked. She picked up one of the decorative stones that bordered Myra's flowerbed and stood in front of the picture window, hefting it in her hand. After some thought, she went around back instead of throwing it. Climbing through a window would be difficult in her current condition. And even if she was able (and careful), she might cut herself badly enough to interfere with the rest of her plans for the evening.

Also, it was a nice house. She didn't want to vandalize it if she didn't have to.

And she didn't. Jack's body had been taken away, the town was still functioning well enough for that, but no one had thought to

lock the back door. Sammy walked right in. There was no generator and it was darker than a raccoon's asshole, but there was a box of wooden matches on the kitchen stove, and the first one she lit showed her a flashlight on the kitchen table. It worked just fine. The beam illuminated what looked like a bloodstain on the floor. She switched it away from that in a hurry and started for Jack Evans's office-den. It was right off the living room, a cubby so small that there was really room for no more than a desk and a glass-fronted cabinet.

She ran the beam of the flashlight across the desk, then raised it so that it reflected in the glassy eyes of Jack's most treasured trophy: the head of a moose he'd shot up in TR-90 three years before. The moosehead was what Phil had called her in to see.

'I got the last ticket in the lottery that year,' Jack had told them. 'And bagged him with that.' He pointed at the rifle in the cabinet. It was a fearsome-looking thing with a scope.

Myra had come into the doorway, the ice rattling in her own glass of iced coffee, looking cool and pretty and amused – the kind of woman, Sammy knew, she herself would never be. 'It cost far too much, but I let him have it after he promised he'd take me to Bermuda for a week next December.'

'Bermuda,' Sammy said now, looking at the moosehead. 'But she never got to go. That's too sad.'

Phil, putting the envelope with the cash in it into his back pocket, had said: 'Awesome rifle, but not exactly the thing for home protection.'

'I've got that covered, too,' Jack had replied, and although he hadn't shown Phil just how he had it covered, he'd patted the top of his desk meaningfully. 'Got a couple of damn good handguns.'

Phil had nodded back, just as meaningfully. Sammy and Myra had exchanged a *boys will be boys* look of perfect harmony. She still remembered how good that look had made her feel, how *included*, and she supposed that was part of the reason she had come here instead of trying someplace else, someplace closer to town.

She paused to chew down another Percocet, then started opening the desk drawers. They were unlocked, and so was the wooden box in the third one she tried. Inside was the late Jack Evans's extra gun: a .45 Springfield XD automatic pistol. She took it, and after a little fumbling, ejected the magazine. It was full, and there was a spare clip in the drawer. She took that one, too. Then she went back to the kitchen to find a bag to carry it in. And keys, of course. To whatever might be parked in the late Jack and Myra's garage. She had no intention of walking back to town.

19

Julia and Rose were discussing what the future might hold for their town when their present nearly ended. Would have ended, if they had met the old farm truck on Esty Bend, about a mile and a half from their destination. But Julia got through the curve in time to see that the truck was in her lane, and coming at her head-on.

She swung the wheel of her Prius hard left without thinking, getting into the other lane, and the two vehicles missed each other by inches. Horace, who'd been sitting on the backseat wearing his usual expression of oh-boy-going-for-a-ride delight, tumbled to the floor with a surprised yip. It was the only sound. Neither woman screamed, or even cried out. It was too quick for that. Death or serious injury passed them by in an instant and was gone.

Julia swung back into her own lane, then pulled onto the soft shoulder and put her Prius in park. She looked at Rose. Rose looked back, all big eyes and open mouth. In back, Horace jumped onto the seat again and gave a single bark, as if to ask what the delay was. At the sound, both women laughed and Rose began patting her chest above the substantial shelf of her bosom.

'My heart, my heart,' she said.

'Yeah,' Julia said. 'Mine, too. Did you see how close that was?'

Rose laughed again, shakily. 'You kidding? Hon, if I'd had my arm cocked out the window, that sonofabitch would have amputated my elbow.'

Julia shook her head. 'Drunk, probably.'

'Drunk *assuredly*,' Rose said, and snorted.

'Are you okay to go on?'

'Are you?' Rose asked.

'Yes,' Julia said. 'How about you, Horace?'

Horace barked that he had been born ready.

'A near-miss rubs the bad luck off,' Rose said. 'That's what Granddad Twitchell used to claim.'

'I hope he was right,' Julia said, and got rolling again. She watched closely for oncoming headlights, but the next glow they saw was from the spots set up at the Harlow edge of the Dome. They didn't see Sammy Bushey. Sammy saw them; she was standing in front of the Evans garage, with the keys to the Evans Malibu in her hand. When they had gone by, she raised the garage door (she had to do it by hand, and it hurt considerably) and got behind the wheel.

20

There was an alley between Burpee's Department Store and the Mill Gas & Grocery, connecting Main Street and West Street. It was used mostly by delivery trucks. At quarter past nine that night, Junior Rennie and Carter Thibodeau walked up this alley in almost perfect darkness. Carter was carrying a five-gallon can, red with a yellow diagonal stripe on the side, in one hand. GASOLINE, read the word on the stripe. In the other hand he held a battery-powered bullhorn. This had been white, but Carter had wrapped the horn in black masking tape so it wouldn't stand out if anyone looked their way before they could fade back down the alley.

Junior was wearing a backpack. His head no longer ached and his limp had all but disappeared. He was confident that his body was finally beating whatever had fucked it up. Possibly a lingering virus of some kind. You could pick up every kind of shit at college, and getting the boot for beating up that kid had probably been a blessing in disguise.

At the head of the alley they had a clear view of the *Democrat*. Light spilled out onto the empty sidewalk, and they could see Freeman and Guay moving around inside, carrying stacks of paper to the door and then setting them down. The old wooden structure housing the newspaper and Julia's living quarters stood between Sanders Hometown Drug and the bookstore, but was separated from both – by a paved walkway on the bookstore side and an alley like the one in which he and Carter were currently lurking on the drugstore side. It was a windless night, and he thought that if his father mobilized the troops quickly enough, there would be no collateral damage. Not that he cared. If the entire east side of Main Street burned, that would be fine with Junior. Just more trouble for Dale Barbara. He could still feel those cool, assessing eyes on him. It wasn't right to be looked at that way, especially when the man doing the looking was behind bars. Fucking *Baaarbie*.

'I should have shot him,' Junior muttered.

'What?' Carter asked.

'Nothing.' He wiped his forehead. 'Hot.'

'Yeah. Frankie says if this keeps on, we're all apt to end up stewed like prunes. When are we supposed to do this?'

Junior shrugged sullenly. His father had told him, but he couldn't exactly remember. Ten o'clock, maybe. But what did it matter? Let those two over there burn. And if the newspaper bitch was upstairs

– perhaps relaxing with her favorite dildo after a hard day – let her burn, too. More trouble for *Baaarbie.*

'Let's do it now,' he said.

'You sure, bro?'

'You see anyone on the street?'

Carter looked. Main Street was deserted and mostly dark. The gennies behind the newspaper office and the drugstore were the only ones he could hear. He shrugged. 'All right. Why not?'

Junior undid the pack's buckles and flipped back the flap. On top were two pair of light gloves. He gave one pair to Carter and put on the other. Beneath was a bundle wrapped in a bath towel. He opened it and set four empty wine bottles on the patched asphalt. At the very bottom of the pack was a tin funnel. Junior put it in one of the wine bottles and reached for the gasoline.

'Better let me, bro,' Carter said. 'Your hands are shakin.'

Junior looked at them with surprise. He didn't feel shaky, but yes, they were trembling. 'I'm not afraid, if that's what you're thinking.'

'Never said you were. It ain't a head problem. Anybody can see that. You need to go to Everett, because you got somethin wrong with you and he's the closest thing we got to a doctor right now.'

'I feel fi—'

'Shut up before someone hears you. Do the fuckin towel while I do this.'

Junior took his gun from its holster and shot Carter in the eye. His head exploded, blood and brains everywhere. Then Junior stood over him, shooting him *again* and *again* and *ag*—

'Junes?'

Junior shook his head to clear away this vision – so vivid it was hallucinatory – and realized his hand was actually gripping the butt of his pistol. Maybe that virus wasn't quite out of his system yet.

And maybe it wasn't a virus after all.

What, then? What?

The fragrant odor of gas smacked his nostrils hard enough to make his eyes burn. Carter had begun filling the first bottle. *Glug glug glug* went the gas can. Junior unzipped the side pocket of the backpack and brought out a pair of his mother's sewing scissors. He used them to cut four strips from the towel. He stuffed one into the first bottle, then pulled it out and stuck the other end inside, letting a length of gasoline-soaked terry cloth hang. He repeated the process with the others.

His hands weren't shaking too badly for that.

21

Barbie's Colonel Cox had changed from the last time Julia had seen him. He had a good shave for going on half past nine, and his hair was combed, but his khakis had lost their neat press and tonight his poplin jacket seemed to be bagging on him, as if he had lost weight. He was standing in front of a few smudges of spray paint left over from the unsuccessful acid experiment, and he was frowning at the bracket shape like he thought he could walk through it if he only concentrated hard enough.

Close your eyes and click your heels three times, Julia thought. *Because there's no place like Dome.*

She introduced Rose to Cox and Cox to Rose. During their brief getting-to-know-you exchange, Julia looked around, not liking what she saw. The lights were still in place, shining at the sky as if signaling a glitzy Hollwood premiere, and there was a purring generator to run them, but the trucks were gone and so was the big green HQ tent that had been erected forty or fifty yards down the road. A patch of flattened grass marked the place where it had been. There were two soldiers with Cox, but they had the not-ready-for-prime-time look she associated with aides or attachés. The sentries probably weren't gone, but they had been moved back, establishing a perimeter beyond hailing distance of any poor slobs who might wander up on The Mill side to ask what was going on.

Ask now, plead later, Julia thought.

'Fill me in, Ms Shumway,' Cox said.

'First answer a question.'

He rolled his eyes (she thought she would have slapped him for that, if she'd been able to get at him; her nerves were still jangled from the near miss on the ride out here). But he told her to ask away.

'Have we been abandoned?'

'Absolutely not.' He replied promptly, but didn't quite meet her eye. She thought that was a worse sign than the queerly empty look she now saw on his side of the Dome – as if there had been a circus, but it had moved on.

'Read this,' she said, and plastered the front page of tomorrow's paper against the Dome's unseen surface, like a woman mounting a sale notice in a department store window. There was a faint, fugitive thrum in her fingers, like the kind of static shock you could get from touching metal on a cold winter morning, when the air was dry. After that, nothing.

He read the entire paper, telling her when to turn the pages. It took him ten minutes. When he finished, she said: 'As you probably noticed, ad space is way down, but I flatter myself the quality of the writing has gone up. Fuckery seems to bring out the best in me.'

'Ms Shumway—'

'Oh, why not call me Julia. We're practically old pals.'

'Fine. You're Julia and I'm JC.'

'I'll try not to confuse you with the one who walked on water.'

'You believe this fellow Rennie's setting himself up as a dictator? A kind of Downeast Manuel Noriega?'

'It's the progression to Pol Pot I'm worried about.'

'Do you think that's possible?'

'Two days ago I would have laughed at the idea – he's a used-car salesman when he isn't running selectmen's meetings. But two days ago we hadn't had a food riot. Nor did we know about these murders.'

'Not Barbie,' Rose said, shaking her head with stubborn weariness. '*Never.*'

Cox took no notice of this – not because he was ignoring Rose, Julia felt, but because he thought the idea was too ridiculous to warrant any attention. It warmed her toward him, at least a little. 'Do you think Rennie committed the murders, Julia?'

'I've been thinking about that. Everything he's done since the Dome appeared – from shutting down alcohol sales to appointing a complete dope as Police Chief – has been political, aimed at increasing his own clout.'

'Are you saying murder isn't in his repertoire?'

'Not necessarily. When his wife passed, there were rumors that he might have helped her along. I don't say they were true, but for rumors like that to start in the first place says something about how people see the man in question.'

Cox grunted agreement.

'But for the life of me I can't see how murdering and sexually abusing two teenage girls could be political.'

'Barbie would *never*,' Rose said again.

'The same with Coggins, although that ministry of his – especially the radio station part – is suspiciously well endowed. Brenda Perkins, now? *That* could have been political.'

'And you can't send in the Marines to stop him, can you?' Rose asked. 'All you guys can do is watch. Like kids looking into an aquarium where the biggest fish takes all the food, then starts eating the little ones.'

'I can kill the cellular service,' Cox mused. 'Also Internet. I can do that much.'

'The police have walkie-talkies,' Julia said. 'He'll switch to those. And at the meeting on Thursday night, when people complain about losing their links to the outside world, he'll blame you.'

'We were planning a press conference on Friday. I could pull the plug on that.'

Julia grew cold at the thought. 'Don't you dare. Then he wouldn't have to explain himself to the outside world.'

'Plus,' Rose said, 'if you kill the phones and the Internet, no one can tell you or anyone else what he's doing.'

Cox stood quiet for a moment, looking at the ground. Then he raised his head. 'What about this hypothetical generator that's maintaining the Dome? Any luck?'

Julia wasn't sure she wanted to tell Cox that they had put a middle-school kid in charge of hunting for it. As it turned out, she didn't have to, because that was when the town fire whistle went off.

22

Pete Freeman dropped the last stack of papers by the door. Then he straightened up, put his hands in the small of his back, and stretched his spine. Tony Guay heard the crackle all the way across the room. 'That sounded like it hurt.'

'Nope; feels good.'

'My wife'll be in the sack by now,' Tony said, 'and I've got a bottle ratholed in my garage. Want to come by for a nip on your way home?'

'No, I think I'll just—' Pete began, and that was when the first bottle crashed through the window. He saw the flaming wick from the corner of his eye and took a step backward. Only one, but it saved him from being seriously burned, perhaps even cooked alive.

The window and the bottle both shattered. The gasoline ignited and flared in a bright manta shape. Pete simultaneously ducked and pivoted from the hips. The fire-manta flew past him, igniting one sleeve of his shirt before landing on the carpet in front of Julia's desk.

'*What the FU*—' Tony began, and then another bottle came arcing through the hole. This one smashed on top of Julia's desk and rolled across it, spreading fire among the papers littered there and dripping more fire down the front. The smell of burning gas was hot and rich.

Pete ran for the water cooler in the corner, beating the sleeve of his shirt against his side. He lifted the water bottle awkwardly against his middle, then held his flaming shirt (the arm beneath now felt as if it were developing a bad sunburn) under the bottle's spouting mouth.

Another Molotov cocktail flew out of the night. It fell short, shattering on the sidewalk and lighting a small bonfire on the concrete. Tendrils of flaming gasoline ran into the gutter and went out.

'*Dump the water on the carpet!*' Tony shouted. '*Dump it before the whole place catches fire!*'

Pete only looked at him, dazed and panting. The water in the cooler bottle continued to gush onto a part of the carpet that did not, unfortunately, need wetting.

Although his sports reporting was always going to be strictly junior varsity, Tony Guay had been a three-letter man in high school. Ten years later, his reflexes were still mostly intact. He snatched the spouting cooler bottle from Pete and held it first over the top of Julia's desk and then over the carpet-blaze. The fire was already spreading, but maybe . . . if he was quick . . . and if there was another bottle or two in the hallway leading to the supply closet . . .

'*More!*' he shouted at Pete, who was gaping at the smoking remains of his shirtsleeve. '*Back hall!*'

For a moment Pete didn't seem to understand. Then he got it, and booked for the hall. Tony stepped around Julia's desk, letting the last pint or two of water fall on the flames trying to get a foothold there.

Then the final Molotov cocktail came flying out of the dark, and that was the one that really did the damage. It made a direct hit on the stacks of newspapers the men had placed near the front door. Burning gasoline ran beneath the baseboard at the front of the office and leaped up. Seen through the flames, Main Street was a wavering mirage. On the far side of the mirage, across the street, Tony could see two dim figures. The rising heat made them look like they were dancing.

'FREE DALE BARBARA OR THIS IS JUST THE BEGIN-NING!' an amplified voice bellowed. 'THERE ARE PLENTY OF US, AND WE'LL FIREBOMB THE WHOLE DAMN TOWN! FREE DALE BARBARA OR PAY THE PRICE!'

Tony looked down and saw a hot creek of fire run between his feet. He had no more water with which to put it out. Soon it would finish eating through the carpet and taste the old dry wood beneath. Meanwhile, the whole front of the office was now involved.

Tony dropped the empty cooler bottle and stepped back. The heat was already intense; he could feel it stretching his skin. *If not for the goddam newspapers, I might've—*

But it was too late for might'ves. He turned and saw Pete standing in the doorway from the back hall with another bottle of Poland Spring in his arms. Most of his charred shirtsleeve had dropped away. The skin beneath was bright red.

'*Too late!*' Tony shouted. He gave Julia's desk, which was now a pillar of fire shooting all the way to the ceiling, a wide berth, raising one arm to shield his face from the heat. '*Too late, out the back!*'

Pete Freeman needed no further urging. He heaved the bottle at the growing fire and ran.

23

Carrie Carver rarely had anything to do with Mill Gas & Grocery; although the little convenience store had made her and her husband a pretty good living over the years, she saw herself as Above All That. But when Johnny suggested they might go down in the van and take the remaining canned goods up to the house – 'for safekeeping' was the delicate way he put it – she had agreed at once. And although she was ordinarily not much of a worker (watching Judge Judy was more her speed), she had volunteered to help. She hadn't been at Food City, but when she'd gone down later to inspect the damage with her friend Leah Anderson, the shattered windows and the blood still on the pavement had frightened her badly. Those things had frightened her for the future.

Johnny lugged out the cartons of soups, stews, beans, and sauces; Carrie stowed them in the bed of their Dodge Ram. They were about halfway through the job when fire bloomed downstreet. They both heard the amplified voice. Carrie thought she saw two or three figures running down the alley beside Burpee's, but wasn't sure. Later on she *would* be sure, and would up the number of shadowy figures to at least four. Probably five.

'What does it mean?' she asked. 'Honey, what does it mean?'

'That the goddam murdering bastard isn't on his own,' Johnny said. 'It means he's got a gang.'

Carrie's hand was on his arm, and now she dug in with her nails. Johnny freed his arm and ran for the police station, yelling *fire* at the top of his lungs. Instead of following, Carrie Carver continued loading the truck. She was more frightened of the future than ever.

24

In addition to Roger Killian and the Bowie brothers, there were ten new officers from what was now the Chester's Mill Hometown Security Force sitting on the bleachers of the middle-school gymnasium, and Big Jim had only gotten started on his speech about what a responsibility they had when the fire whistle went off. *The boy's early*, he thought. *I can't trust him to save my soul. Never could, but now he's that much worse.*

'Well, boys,' he said, directing his attention particularly to young Mickey Wardlaw – God, what a bruiser! 'I had a lot more to say, but it seems we've got ourselves a little more excitement. Fern Bowie, do you happen to know if we have any Indian pumps in the FD barn?'

Fern said he'd had a peek into the firebarn earlier that evening, just to see what sort of equipment there might be, and there were almost a dozen Indian pumps. All full of water, too, which was convenient.

Big Jim, thinking that sarcasm should be reserved for those bright enough to understand what it was, said it was the good Lord looking out for them. He also said that if it was more than a false alarm, he would take charge with Stewart Bowie as his second-in-command.

There, you noseyparker witch, he thought as the new officers, looking bright-eyed and eager, rose from the bleachers. *Let's see how you like getting in my business now.*

25

'Where you going?' Carter asked. He had driven his car – with the lights off – down to where West Street **T**'d into Route 117. The building that stood here was a Texaco station that had closed up in 2007. It was close to town but offered good cover, which made it convenient. Back the way they had come, the fire whistle was honking six licks to a dozen and the first light of the fire, more pink than orange, was rising in the sky.

'Huh?' Junior was looking at the strengthening glow. It made him feel horny. It made him wish he still had a girlfriend.

'I asked where you're going. Your dad said to alibi up.'

'I left unit Two behind the post office,' Junior said, taking his eyes reluctantly away from the fire. 'Me'n Freddy Denton's together. And he'll *say* we were together. All night. I can cut across from here.

Might go back by West Street. Get a look at how it's catchin on.' He uttered a high-pitched giggle, almost a girl's giggle, that caused Carter to look at him strangely.

'Don't look too long. Arsonists are always gettin caught by goin back to look at their fires. I saw that on *America's Most Wanted.*'

'Nobody's wearing the Golden Sombrero for this motherfucker except *Baaarbie*,' Junior said. 'What about you? Where you going?'

'Home. Ma'll say I was there all night. I'll get her to change the bandage on my shoulder – fuckin dogbite hurts like a bastard. Take some aspirin. Then come on down, help fight the fire.'

'They've got heavier dope than aspirin at the Health Center and the hospital. Also the drugstore. We ought to look into that shit.'

'No doubt,' Carter said.

'Or . . . do you tweek? I think I can get some of that.'

'Meth? Never mess with it. But I wouldn't mind some Oxy.'

'Oxy!' Junior exclaimed. Why had he never thought of that? It would probably fix his headaches a lot better than Zomig or Imitrix. 'Yeah, bro! You talk about it!'

He raised his fist. Carter bumped it, but he had no intention of getting high with Junior. Junior was weird now. 'Better get goin, Junes.'

'I'm taillights.' Junior opened the door and walked away, still limping a little.

Carter was surprised at how relieved he was when Junior was gone.

26

Barbie woke to the sound of the fire whistle and saw Melvin Searles standing outside his cell. The boy's fly was unzipped and he was holding his considerable cock in his hand. When he saw he had Barbie's attention, he began to piss. His goal was clearly to reach the bunk. He couldn't quite make it and settled for a splattery letter **S** on the concrete instead.

'Go on, Barbie, drink up,' he said. 'You gotta be thirsty. It's a little salty, but what the fuck.'

'What's burning?'

'As if you didn't know,' Mel said, smiling. He was still pale – he must have lost a fair amount of blood – but the bandage around his head was crisp and unstained.

'Pretend I don't.'

'Your pals burned down the newspaper,' Mel said, and now his

smile showed his teeth. Barbie realized the kid was furious. Fright-
ened, too. 'Trying to scare us into letting you out. But *we . . . don't
. . . scare.*'

'Why would I burn down the newspaper? Why not the Town
Hall? And who are these pals of mine supposed to be?'

Mel was tucking his cock back into his pants. 'You won't be
thirsty tomorrow, Barbie. Don't worry about *that.* We've got a whole
bucket of water with your name on it, and a sponge to go with it.'

Barbie was silent.

'You seen that waterboarding shit in I–rack?' Mel nodded as if
he knew Barbie had. 'Now you'll get to experience it first hand.' He
pointed a finger through the bars. 'We're gonna find out who your
confederates are, fuckwad. And we're gonna find out what you did
to lock this town up in the first place. That waterboarding shit? *Nobody*
stands up to that.'

He started away, then turned back.

'Not fresh water, either. Salt. First thing. You think about it.'

Mel left, clumping up the basement hallway with his bandaged
head lowered. Barbie sat on the bunk, looked at the drying snake of
Mel's urine on the floor, and listened to the fire whistle. He thought
of the girl in the pickemup. The blondie who almost gave him a ride
and then changed her mind. He closed his eyes.

ASHES

1

Rusty was standing in the turnaround in front of the hospital, watching the flames rise from somewhere on Main Street, when the cell phone clipped to his belt played its little song. Twitch and Gina were with him, Gina holding Twitch's arm as if for protection. Ginny Tomlinson and Harriet Bigelow were both sleeping in the staff lounge. The old fellow who had volunteered, Thurston Marshall, was making medication rounds. He had turned out to be surprisingly good. The lights and the equipment were back on and, for the time being, things were on an even keel. Until the firewhistle went off, Rusty had actually dared to feel good.

He saw LINDA on the screen and said, 'Hon? Everything okay?'

'Here, yes. Kids are asleep.'

'Do you know what's bur—'

'The newspaper office. Be quiet and listen, because I'm turning my phone off in about a minute and a half so nobody can call me in to help fight the fire. Jackie's here. She'll watch the kids. You need to meet me at the funeral home. Stacey Moggin will be there, too. She came by earlier. She's with us.'

The name, while familiar, did not immediately call up a face in Rusty's mind. And what resonated was *She's with us.* There really were starting to be sides, starting to be *with us* and *with them.*

'Lin—'

'Meet me there. Ten minutes. It's safe as long as they're fighting the fire, because the Bowie brothers are on the crew. Stacey says so.'

'How did they get a crew together so f—'

'I don't know and don't care. Can you come?'

'Yes.'

'Good. Don't use the parking lot on the side. Go around back to the smaller one.' Then the voice was gone.

'What's on fire?' Gina asked. 'Do you know?'

'No,' Rusty said. 'Because nobody called.' He looked at them both, and hard.

Gina didn't follow, but Twitch did. 'Nobody at all.'

'I just took off, probably on a call, but you don't know where. I didn't say. Right?'

Gina still looked puzzled, but nodded. Because now these people were her people; she did not question the fact. Why would she? She

was only seventeen. *Us and them,* Rusty thought. *Bad medicine, usually. Especially for seventeen-year-olds.* 'Probably on a call,' she said. 'We don't know where.'

'Nope,' Twitch agreed. 'You grasshoppah, we lowly ants.'

'Don't make a big deal of it, either of you,' Rusty said. But it *was* a big deal, he knew that already. It was trouble. Gina wasn't the only kid in the picture; he and Linda had a pair, now fast asleep and with no knowledge that Mom and Dad might be sailing into a storm much too big for their little boat.

And still.

'I'll be back,' Rusty said, and hoped that wasn't just wishful thinking.

2

Sammy Bushey drove the Evanses' Malibu down Catherine Russell Drive not long after Rusty headed for the Bowie Funeral Parlor; they passed each other going in opposite directions on Town Common Hill.

Twitch and Gina had gone back inside and the turnaround in front of the hospital's main doors was deserted, but she didn't stop there; having a gun on the seat beside you made you wary. (Phil would have said paranoid.) She drove around back instead, and parked in the employees' lot. She grabbed the .45, pushed it into the waist-band of her jeans, and bloused her tee-shirt over it. She walked across the lot and stopped at the laundry room door, reading the sign that said SMOKING HERE WILL BE BANNED AS OF JANUARY 1ST. She looked at the doorknob, and knew that if it didn't turn, she'd give this up. It would be a sign from God. If, on the other hand, the door was unlocked—

It was. She slipped in, a pale and limping ghost.

3

Thurston Marshall was tired – exhausted, more like it – but happier than he had been in years. It was undoubtedly perverse; he was a tenured professor, a published poet, the editor of a prestigious literary magazine. He had a gorgeous young woman to share his bed, one who was smart and thought he was wonderful. That giving pills, slapping on salve, and emptying bedpans (not to mention wiping up the Bushey kid's beshitted bottom an hour ago) would make him happier than those things almost *had* to be perverse, and yet there it

was. The hospital corridors with their smells of disinfectant and floor-polish connected him with his youth. The memories had been very clear tonight, from the pervasive aroma of patchouli oil in David Perna's apartment to the paisley headband Thurse had worn to the candlelight memorial service for Bobby Kennedy. He went his rounds humming 'Big Leg Woman' very softly under his breath.

He peeped in the lounge and saw the nurse with the busted schnozz and the pretty little nurse's aide — Harriet, her name was — asleep on the cots that had been dragged in there. The couch was vacant, and soon he'd either catch a few hours' racktime on it or go back to the house on Highland Avenue that was now home. Probably back there.

Strange developments.

Strange world.

First, though, one more check of what he was already thinking of as his patients. It wouldn't take long in this postage stamp of a hospital. Most of the rooms were empty, anyway. Bill Allnut, who'd been forced to stay awake until nine because of the injury he'd suffered in the Food City melee, was now fast asleep and snoring, turned on his side to take the pressure off the long laceration at the back of his head.

Wanda Crumley was two doors down. The heart monitor was beeping and her BP was a little better, but she was on five liters of oxygen and Thurse feared she was a lost cause. Too much weight; too many cigarettes. Her husband and youngest daughter were sitting with her. Thurse gave Wendell Crumley a V-for-victory (which had been the peace sign in his salad days), and Wendell, smiling gamely, gave it back.

Tansy Freeman, the appendectomy, was reading a magazine. 'What's the fire whistle blowing for?' she asked him.

'Don't know, hon. How's your pain?'

'A three,' she said matter-of-factly. 'Maybe a two. Can I still go home tomorrow?'

'It's up to Dr Rusty, but my crystal ball says yes.' And the way her face lit up at that made him feel, for no reason he could understand, like crying.

'That baby's mom is back,' Tansy said. 'I saw her go by.'

'Good,' Thurse said. Although the baby hadn't been much of a problem. He had cried once or twice, but mostly he slept, ate, or lay in his crib, staring apathetically up at the ceiling. His name was Walter (Thurse had no idea the *Little* preceding it on the door card was an actual name), but Thurston Marshall thought of him as The Thorazine Kid.

Now he opened the door of room 23, the one with the yellow BABY ON BOARD sign attached to it with a plastic sucker, and saw that the young woman – a rape victim, Gina had whispered to him – was sitting in the chair beside the bed. She had the baby in her lap and was feeding him a bottle.

'Are you all right –' Thurse glanced at the other name on the doorcard. '– Ms Bushey?'

He pronounced it *Bouchez*, but Sammy didn't bother to correct him, or to tell him that in grade school the boys had called her Bushey the Tushie. 'Yes, Doctor,' she said.

Nor did Thurse bother to correct her misapprehension. That undefined joy – the kind that comes with tears hidden in it – swelled a little more. When he thought of how close he'd come to not volunteering . . . if Caro hadn't encouraged him . . . he would have missed this.

'Dr Rusty will be glad you're back. And so is Walter. Do you need any pain medication?'

'No.' This was true. Her privates still ached and throbbed, but that was far away. She felt as if she were floating above herself, tethered to earth by the thinnest of strings.

'Good. That means you're getting better.'

'Yes,' Sammy said. 'Soon I'll be well.'

'When you've finished feeding him, climb on into bed, why don't you? Dr Rusty will be in to check on you in the morning.'

'All right.'

'Good night, Ms Bouchez.'

'Good night, Doctor.'

Thurse closed the door softly and continued down the hall. At the end of the corridor was the Roux girl's room. One peek in there and then he'd call it a night.

She was glassy but awake. The young man who'd been visiting her was not. He sat in the corner, snoozing in the room's only chair with a sports magazine on his lap and his long legs sprawled out in front of him.

Georgia beckoned Thurse, and when he bent over her, she whispered something. Because of the low voice and her broken, mostly toothless mouth, he only got a word or two. He leaned closer.

'Doh wake im.' To Thurse, she sounded like Homer Simpson. 'He'th the oney one who cay to visih me.'

Thurse nodded. Visiting hours were long over, of course, and given his blue shirt and his sidearm, the young man would probably be gigged for not responding to the fire whistle, but still – what

harm? One firefighter more or less probably wouldn't make any differ-
ence, and if the guy was too far under for the sound of the whistle
to wake him, he probably wouldn't be much help, anyway. Thurse
put a finger to his lips and blew the young woman a *shhh* to show
they were conspirators. She tried to smile, then winced.

Thurston didn't offer her pain medication in spite of that;
according to the chart at the end of the bed, she was maxed until
two a.m. Instead he just went out, closed the door softly behind him,
and walked back down the sleeping hallway. He didn't notice that
the door to the BABY ON BOARD room was once more ajar.

The couch in the lounge called to him seductively as he went
by, but Thurston had decided to go back to Highland Avenue after all.

And check the kids.

4

Sammy sat by the bed with Little Walter in her lap until the new
doctor went by. Then she kissed her son on both cheeks and the
mouth. 'You be a good baby,' she said. 'Mama is going to see you in
heaven, if they let her in. I think they will. She's done her time in
hell.'

She laid him in his crib, then opened the drawer of the bedtable.

She had put the gun inside so Little Walter wouldn't feel it
poking into him while she held him and fed him for the last time.
Now she took it out.

5

Lower Main Street was blocked off by nose-to-nose police cars with
their jackpot lights flashing. A crowd, silent and unexcited – almost
sullen – stood behind them, watching.

Horace the Corgi was ordinarily a quiet dog, limiting his vocal
repertoire to a volley of welcome-home barks or the occasional yap
to remind Julia he was still present and accounted for. But when she
pulled over to the curb by Maison des Fleurs, he let out a low howl
from the backseat. Julia reached back blindly to stroke his head. Taking
comfort as much as giving it.

'Julia, my God,' Rose said.

They got out. Julia's original intention was to leave Horace
behind, but when he uttered another of those small, bereft howls –
as if he knew, as if he really knew – she fished under the passenger
seat for his leash, opened the rear door for him to jump out, and

then clipped the leash to his collar. She grabbed her personal camera, a pocket-sized Casio, from the seat pocket before closing the door. They pushed through the crowd of bystanders on the sidewalk, Horace leading the way, straining at his leash.

Piper Libby's cousin Rupe, a part-time cop who'd come to The Mill five years ago, tried to stop them. 'No one beyond this point, ladies.'

'That's my place,' Julia said. 'Up top is everything I own in the world – clothes, books, personal possessions, the lot. Underneath is the newspaper my great-grandfather started. It's only missed four press dates in over a hundred and twenty years. Now it's going up in smoke. If you want to stop me from watching it happen – at close range – you'll have to shoot me.'

Rupe looked unsure, but when she started forward again (Horace now at her knee and looking up at the balding man mistrustfully), Rupe stood aside. But only momentarily.

'Not you,' he told Rose.

'Yes, me. Unless you want ex-lax in the next chocolate frappe you order.'

'Ma'am . . . Rose . . . I have my orders.'

'Devil take your orders,' Julia said, with more weariness than defiance. She took Rose by the arm and led her down the sidewalk, stopping only when she felt the shimmer against her face rise from preheat to bake.

The *Democrat* was an inferno. The dozen or so cops weren't even trying to put it out, but they had plenty of Indian pumps (some still bearing stickers she could read easily in the firelight: ANOTHER BURPEE'S SALE DAYS SPECIAL!) and they were wetting down the drugstore and the bookstore. Given the windless conditions, Julia thought they might save both . . . and thus the rest of the business buildings on the east side of Main.

'Wonderful that they turned out so quick,' Rose said.

Julia said nothing, only watched the flames whooshing up into the dark, blotting out the pink stars. She was too shocked to cry.

Everything, she thought. *Everything.*

Then she remembered the one bundle of newspapers she had tossed in her trunk before leaving to meet with Cox and amended that to *Almost everything.*

Pete Freeman pushed through the ring of police who were currently dousing the front and north side of Sanders Hometown Drug. The only clean spots on his face were where tears had cut through the soot.

'Julia, I'm so sorry!' He was nearly wailing. 'We almost had it stopped . . . would have had it stopped . . . but then the last one . . . the last bottle the bastards threw landed on the papers by the door and . . .' He wiped his remaining shirtsleeve across his face, smearing the soot there. 'I'm so goddam sorry!'

She took him in her arms as if he were a baby, although Pete was six inches taller and outweighed her by a hundred pounds. She hugged him, trying to mind his hurt arm, and said: 'What happened?'

'Firebombs,' he sobbed. 'That fucking Barbara.'

'He's in jail, Pete.'

'His friends! His goddam *friends*! *They* did it!'

'*What?* You saw them?'

'Heard em,' he said, pulling back to look at her. 'Would've been hard not to. They had a bullhorn. Said if Dale Barbara wasn't freed, they'd burn the whole town.' He grinned bitterly. '*Free* him? We ought to *hang* him. Give me a rope and I'll do it myself.'

Big Jim came strolling up. The fire painted his cheeks orange. His eyes glittered. His smile was so wide that it stretched almost to his earlobes.

'How do you like your friend Barbie now, Julia?'

Julia stepped toward him, and there must have been something on her face, because Big Jim fell back a step, as if afraid she might take a swing at him. 'This makes no sense. None. And you know it.'

'Oh, I think it does. If you can bring yourself to consider the idea that Dale Barbara and his friends were the ones who set up the Dome in the first place, I think it makes perfect sense. It was an act of terrorism, pure and simple.'

'Bullshit. I was on his side, which means the *newspaper* was on his side. He *knew* that.'

'But they said—' Pete began.

'Yes,' she said, but she didn't look at him. Her eyes were still fixed on Rennie's firelit face. '*They* said, *they* said, but who the hell is *they*? Ask yourself that, Pete. Ask yourself this: if it wasn't Barbie – who had no motive – then who *did* have a motive? Who benefits by shutting Julia Shumway's troublesome mouth?'

Big Jim turned and motioned to two of the new officers – identifiable as cops only by the blue bandannas knotted around their biceps. One was a tall, hulking bruiser whose face suggested he was still little more than a child, no matter his size. The other could only be a Killian; that bullet head was as distinctive as a commemorative stamp. 'Mickey. Richie. Get these two women off the scene.'

Horace was crouched at the end of his leash, growling at Big Jim. Big Jim gave the little dog a contemptuous look.

'And if they won't go voluntarily, you have my permission to pick them up and throw them over the hood of the nearest police car.'

'This isn't finished,' Julia said, pointing a finger at him. Now she was beginning to cry herself, but the tears were too hot and painful to be those of sorrow. 'This isn't done, you son of a bitch.'

Big Jim's smile reappeared. It was as shiny as the finish on his Hummer. And as black. 'Yes it is,' he said. 'Done deal.'

6

Big Jim started back toward the fire – he wanted to watch it until there was nothing left of the noseyparker's newspaper but a pile of ashes – and swallowed a mouthful of smoke. His heart suddenly stopped in his chest and the world seemed to go swimming past him like some kind of special effect. Then his ticker started again, but in a flurry of irregular beats that made him gasp. He slammed a fist against the left side of his chest and coughed hard, a quick-fix for arrhythmia that Dr Haskell had taught him.

At first his heart continued its irregular galloping (*beat* . . . pause . . . *beatbeatbeat* . . . pause), but then it settled back to its normal rhythm. For just a moment he saw it encased in a dense globule of yellow fat, like a living thing that has been buried alive and struggles to get free before the air is all gone. Then he pushed the image away.

I'm all right. It's just overwork. Nothing seven hours of sleep won't cure.

Chief Randolph came over, an Indian pump strapped to his broad back. His face was running with sweat. 'Jim? You all right?'

'Fine,' Big Jim said. And he was. He was. This was the high point of his life, his chance to achieve the greatness of which he knew he'd always been capable. No dickey ticker was going to take that away from him. 'Just tired. I've been running pretty much nonstop.'

'Go home,' Randolph advised. 'I never thought I'd say thank God for the Dome, and I'm not saying it now, but at least it works as a windbreak. We're going to be all right. I've got men on the roofs of the drugstore and the bookstore in case any sparks jump, so go on and—'

'Which men?' His heartbeat smoothing out, smoothing out. Good.

'Henry Morrison and Toby Whelan on the bookstore. Georgie Frederick and one of those new kids on the drug. A Killian brat, I think. Rommie Burpee volunteered to go up with em.'

'Got your walkie?'

'Course I do.'

'And Frederick's got his?'

'All the regulars do.'

'Tell Frederick to keep an eye on Burpee.'

'Rommie? Why, for Lord sake?'

'I don't trust him. He could be a friend of Barbara's.' Although it wasn't Barbara Big Jim was worried about when it came to Burpee. The man had been a friend of Brenda's. And the man was sharp.

Randolph's sweaty face was creased. 'How many do you think there are? How many on the sonofabitch's side?'

Big Jim shook his head. 'Hard to say, Pete, but this thing is big. Must've been in the planning stages for a long time. You can't just look at the newbies in town and say it's got to be them. Some of the people in on it could have been here for years. Decades, even. It's what they call deep cover.'

'Christ. But *why*, Jim? *Why*, in God's name?'

'I don't know. Testing, maybe, with us for guinea pigs. Or maybe it's a power grab. I wouldn't put it past that thug in the White House. What matters is we're going to have to beef up security and watch for the liars trying to undermine our efforts to keep order.'

'Do you think *she*—' He inclined his head toward Julia, who was watching her business go up in smoke with her dog sitting beside her, panting in the heat.

'I don't know for sure, but the way she was this afternoon? Storming around the station, yelling to see him? What does that tell you?'

'Yeah,' Randolph said. He was looking at Julia Shumway with flat-eyed consideration. 'And burning up your own place, what better cover than that?'

Big Jim pointed a finger at him as if to say *You could have a bingo there*. 'I have to get off my feet. Get on the horn to George Frederick. Tell him to keep his good weather eye on that Lewiston Canuck.'

'All right.' Randolph unclipped his walkie-talkie.

Behind them, Fernald Bowie shouted: '*Roof's comin down! You on the street, stand back! You men on top of those other buildings at the ready, at the ready!*'

Big Jim watched with one hand on the driver's door of his

Hummer as the roof of the *Democrat* caved in, sending a gusher of sparks straight up into the black sky. The men posted on the adjacent buildings checked that their partners' Indian pumps were primed and then stood at parade rest, waiting for sparks with their nozzles in their hands.

The expression on Shumway's face as the *Democrat*'s roof let go did Big Jim's heart more good than all the cotton-picking medicines and pacemakers in the world. For years he'd been forced to put up with her weekly tirades, and while he wouldn't admit he had been afraid of her, he surely had been annoyed.

But look at her now, he thought. *Looks like she came home and found her mother dead on the pot.*

'You look better,' Randolph said. 'Your color's coming back.'

'I *feel* better,' Big Jim said. 'But I'll still go home. Grab some shuteye.'

'That's a good idea,' Randolph said. 'We need you, my friend. Now more than ever. And if this Dome thing doesn't go away . . .'

He shook his head, his basset-hound eyes never leaving Big Jim's face. 'I don't know how we'd get along without you, put it that way. I love Andy Sanders like a brother but he doesn't have much in the way of brains. And Andrea Grinnell hasn't been worth a tin shit since she fell and hurt her back. You're the glue that holds Chester's Mill together.'

Big Jim was moved by this. He gripped Randolph's arm and squeezed. 'I'd give my life for this town. That's how much I love it.'

'I know. Me too. And no one's going to steal it out from under us.'

'Got that right,' Big Jim said.

He drove away, mounting the sidewalk to get past the roadblock that had been placed at the north end of the business district. His heart was steady in his chest again (well, almost), but he was troubled, nonetheless. He'd have to see Everett. He didn't like the idea; Everett was another noseyparker bent on causing trouble at a time when the town had to pull together. Also, he was no doctor. Big Jim would almost have felt better about trusting a vet with his medical problems, except there was none in town. He'd have to hope that if he needed medicine, something to regularize his heartbeat, Everett would know the right kind.

Well, he thought, *whatever he gives me, I can check it out with Andy.*

Yes, but that wasn't the biggest thing troubling him. It was something else Pete had said: *If this Dome thing doesn't go away . . .*

Big Jim wasn't worried about that. Quite the opposite. If the

Dome *did* go away – too soon, that was – he could be in a fair spot of trouble even if the meth lab wasn't discovered. Certainly there would be cotton-pickers who would second-guess his decisions. One of the rules of political life that he'd grasped early was *Those who can, do; those who can't, question the decisions of those who can.* They might not understand that everything he'd done or ordered done, even the rock-throwing at the market this morning, had been of a caretaking nature. Barbara's friends on the outside would be especially prone to misunderstanding, because they would not *want* to understand. That Barbara *had* friends, powerful ones, on the outside was a thing Big Jim hadn't questioned since seeing that letter from the President. But for the time being they could do nothing. Which was the way Big Jim wanted it to stay for at least a couple of weeks. Maybe even a month or two.

The truth was, he liked the Dome.

Not for the long term, of course, but until the propane out there at the radio station was redistributed? Until the lab was dismantled and the supply barn that had housed it had been burned to the ground (another crime to be laid at the door of Dale Barbara's co-conspirators)? Until Barbara could be tried and executed by police firing squad? Until any blame for how things were done during the crisis could be spread around to as many people as possible, and the credit accrued to just one, namely himself?

Until then, the Dome was just fine.

Big Jim decided he'd get kneebound and pray on it before turning in.

7

Sammy limped down the hospital corridor, looking at the names on the doors and checking behind those with no names just to be sure. She was starting to worry that the bitch wasn't here when she came to the last one and saw a get-well card thumbtacked there. It showed a cartoon dog saying 'I heard you weren't feeling so well.'

Sammy drew Jack Evans's gun from the waistband of her jeans (that waistband a little looser now, she'd finally managed to lose some weight, better late than never) and used the automatic's muzzle to open the card. On the inside, the cartoon dog was licking his balls and saying, 'Need a hindlick maneuver?' It was signed *Mel, Jim Jr., Carter,* and *Frank,* and was exactly the sort of tasteful greeting Sammy would have expected of them.

She pushed the door open with the barrel of the gun. Georgia

wasn't alone. This did not disturb the deep calm that Sammy felt, the sense of peace nearly attained. It might have if the man sleeping in the corner had been an innocent – the bitch's father or uncle, say – but it was Frankie the Tit Grabber. The one who'd raped her first, telling her she'd better learn to keep her mouth for when she was on her knees. That he was sleeping didn't change anything. Because guys like him always woke up and recommenced their fuckery.

Georgia wasn't asleep; she was in too much pain, and the long-hair who'd come in to check her hadn't offered her any more dope. She saw Sammy, and her eyes widened. 'D'yew,' she said. 'Ged outta here.'

Sammy smiled. 'You sound like Homer Simpson,' she said.

Georgia saw the gun and her eyes widened. She opened her now mostly toothless mouth and screamed.

Sammy continued to smile. The smile widened, in fact. The scream was music to her ears and balm to her hurts.

'Do that bitch,' she said. 'Right, Georgia? Isn't that what you said, you heartless cunt?'

Frank woke up and stared around in wide-eyed befuddlement. His ass had migrated all the way to the edge of his chair, and when Georgia shrieked again, he jerked and fell onto the floor. He was wearing a sidearm now – they all were – and he grabbed for it, saying 'Put it down, Sammy, just put it down, we're all friends here, let's be friends here.'

Sammy said, 'You ought to keep your mouth closed except for when you're on your knees gobbling your friend Junior's cock.' Then she pulled the Springfield's trigger. The blast from the automatic was deafening in the small room. The first shot went over Frankie's head and shattered the window. Georgia screamed again. She was trying to get out of bed now, her IV line and monitor wires popping free. Sammy shoved her and she flopped askew on her back.

Frankie still didn't have his gun out. In his fear and confusion, he was tugging at the holster instead of the weapon, and succeeding at nothing but yanking his belt up on the right side. Sammy took two steps toward him, grasped the pistol in both hands like she'd seen people do on TV, and fired again. The left side of Frankie's head came off. A flap of scalp struck the wall and stuck there. He clapped his hand to the wound. Blood sprayed through his fingers. Then his fingers were gone, sinking into the oozing sponge where his skull had been.

'*No more!*' he cried. His eyes were huge and swimming with tears. '*No more, don't! Don't hurt me!*' And then: '*Mom! MOMMY!*'

'Don't bother, your mommy didn't raise you right,' Sammy said, and shot him again, this time in the chest. He jumped against the wall. His hand left his wrecked head and thumped to the floor, splashing in the pool of blood that was already forming there. She shot him a third time, in the place that had hurt her. Then she turned to the one on the bed.

Georgia was huddled in a ball. The monitor above her was beeping like crazy, probably because she'd pulled out the wires connected to it. Her hair hung in her eyes. She screamed and screamed.

'Isn't that what you said?' Sammy asked. 'Do that bitch, right?'

'I horry!'

'What?'

Georgia tried again. 'I horry! I horry, Hammy!' And then, the ultimate absurdity: 'I take it ack!'

'You can't.' Sammy shot Georgia in the face and again in the neck. Georgia jumped the way Frankie had, then lay still.

Sammy heard running footsteps and shouts in the corridor. Sleepy cries of concern from some of the rooms as well. She was sorry about causing a fuss, but sometimes there was just no choice. Sometimes things had to be done. And when they were, there could be peace.

She put the gun to her temple.

'I love you, Little Walter. Mumma loves her boy.'

And pulled the trigger.

<h1 style="text-align:center">8</h1>

Rusty used West Street to get around the fire, then hooked back onto Lower Main at the 117 intersection. Bowie's was dark except for small electric candles in the front windows. He drove around back to the smaller lot as his wife had instructed him, and parked beside the long gray Cadillac hearse. Somewhere close by, a generator was clattering.

He was reaching for the door handle when his phone twittered. He turned it off without looking to see who might be calling, and when he looked up again, a cop was standing beside his window. A cop with a drawn gun.

It was a woman. When she bent down, Rusty saw a cloudburst of frizzy blond hair, and at last had a face to go with the name his wife had mentioned. The police dispatcher and receptionist on the day shift. Rusty assumed she had been pressed into full-time service on or just after Dome Day. He also assumed that her current duty-assignment had been self-assigned.

She holstered the pistol. 'Hey, Dr Rusty. Stacey Moggin. You treated me for poison oak two years ago? You know, on my—' She patted her behind.

'I remember. Nice to see you with your pants up, Ms Moggin.'

She laughed as she had spoken: softly. 'Hope I didn't scare you.'

'A little. I was silencing my cell phone, and then there you were.'

'Sorry. Come on inside. Linda's waiting. We don't have much time. I'm going to stand watch out front. I'll give Lin a double-click on her walkie if someone comes. If it's the Bowies, they'll park in the side lot and we can drive out on East Street unnoticed.' She cocked her head a little and smiled. 'Well . . . that's a tad optimistic, but at least unidentified. If we're lucky.'

Rusty followed her, navigating by the cloudy beacon of her hair. 'Did you break in, Stacey?'

'Hell, no. There was a key at the cop-shop. Most of the businesses on Main Street give us keys.'

'And why are you in on this?'

'Because it's all fear-driven bullshit. Duke Perkins would have put a stop to it long ago. Now come on. And make this fast.'

'I can't promise that. In fact, I can't promise anything. I'm not a pathologist.'

'Fast as you can, then.'

Rusty followed her inside. A moment later, Linda's arms were around him.

<h1 style="text-align:center">9</h1>

Harriet Bigelow screamed twice, then fainted. Gina Buffalino only stared, glassy with shock. 'Get Gina out of here,' Thurse snapped. He had gotten as far as the parking lot, heard the shots, and come running back. To find this. This slaughter.

Ginny put an arm around Gina's shoulders and led her back into the hall, where the patients who were ambulatory – this included Bill Allnut and Tansy Freeman – were standing, big-eyed and frightened.

'Get this one out of the way,' Thurse told Twitch, pointing at Harriet. 'And pull her skirt down, give the poor girl some modesty.'

Twitch did as he was told. When he and Ginny reentered the room, Thurse was kneeling by the body of Frank DeLesseps, who had died because he'd come in place of Georgia's boyfriend and overstayed visiting hours. Thurse had flapped the sheet over Georgia, and it was already blooming with blood-poppies.

'Is there anything we can do, Doctor?' Ginny asked. She knew he wasn't a doctor, but in her shock it came automatically. She was looking down at Frank's sprawled body, and her hand was over her mouth.

'Yes.' Thurse rose and his bony knees cracked like pistol shots. 'Call the police. This is a crime scene.'

'All the ones on duty will be fighting that fire downstreet,' Twitch said. 'Those who aren't will either be on their way or sleeping with their phones turned off.'

'Well, call *somebody*, for the love of Jesus, and find out if we're supposed to do anything before we clean up the mess. Take photographs, or I don't know what. Not that there's much doubt about what happened. You'll have to excuse me for a minute. I'm going to vomit.'

Ginny stood aside so Thurston could go into the tiny WC attached to the room. He closed the door, but the sound of his retching was still loud, the sound of a revving engine with dirt caught in it somewhere.

Ginny felt a wave of faintness rush through her head, seeming to lift her and make her light. She fought it off. When she looked back at Twitch, he was just closing his cell phone. 'No answer from Rusty,' he said. 'I left a voice mail. Anyone else? What about Rennie?'

'No!' She almost shuddered. 'Not him.'

'My sister? Andi, I mean?'

Ginny only looked at him.

Twitch looked back for a moment, then dropped his eyes. 'Maybe not,' he mumbled.

Ginny touched him above the wrist. His skin was cold with shock. She supposed her own was, too. 'If it's any comfort,' she said, 'I think she's trying to get clean. She came to see Rusty, and I'm pretty sure that was what it was about.'

Twitch ran his hands down the sides of his face, turning it for a moment into an opéra bouffe mask of sorrow. 'This is a nightmare.'

'Yes,' Ginny said simply. Then she took out her cell phone again.

'Who you gonna call?' Twitch managed a little smile. 'Ghostbusters?'

'No. If Andi and Big Jim are out, who does that leave?'

'Sanders, but he's dogshit-useless and you know it. Why don't we just clean up the mess? Thurston's right, what happened here is obvious.'

Thurston came out of the bathroom. He was wiping his mouth with a paper towel. 'Because there are rules, young man. And under

the circumstances, it's more important than ever that we follow them. Or at least give it the good old college try.'

Twitch looked up and saw Sammy Bushey's brains drying high on one wall. What she had used to think with now looked like a clot of oatmeal. He burst into tears.

10

Andy Sanders was sitting in Dale Barbara's apartment, on the side of Dale Barbara's bed. The window was filled with orange fireglare from the burning *Democrat* building next door. From above him he heard footsteps and muffled voices – men on the roof, he assumed.

He had brought a brown bag with him when he climbed the inside staircase from the pharmacy below. Now he took out the contents: a glass, a bottle of Dasani water, and a bottle of pills. The pills were OxyContin tablets. The label read HOLD FOR A. GRINNELL. They were pink, the twenties. He shook some out, counted, then shook out more. Twenty. Four hundred milligrams. It might not be enough to kill Andrea, who'd had time to build up a tolerance, but he was sure it would do quite well for him.

The heat from the fire next door came baking through the wall. His skin was wet with sweat. It had to be at least a hundred in here, maybe more. He wiped his face with the coverlet.

Won't feel it much longer. There'll be cool breezes in heaven, and we'll all sit down to dinner together at the Lord's table.

He used the bottom of the glass to grind the pink pills into powder, making sure the dope would hit him all at once. Like a hammer on a steer's head. Just lie down on the bed, close his eyes, and then good night, sweet pharmacist, may flights of angels sing thee to thy rest.

Me . . . and Claudie . . . and Dodee. Together for eternity.

Don't think so, brother.

That was Coggins's voice, Coggins at his most dour and declamatory. Andy paused in the act of crushing the pills.

Suicides don't eat supper with their loved ones, my friend; they go to hell and dine on hot coals that burn forever in the belly. Can you give me hallelujah on that? Can you say amen?

'Bullspit,' Andy whispered, and went back to grinding the pills. 'You were snout-first in the trough with the rest of us. Why should I believe you?'

Because I speak the truth. Your wife and daughter are looking down on you right now, pleading with you not to do it. Can't you hear them?

'Nope,' Andy said. 'And that's not you, either. It's just the part of my mind that's cowardly. It's run me my whole life. It's how Big Jim got hold of me. It's how I got into this meth mess. I didn't need the money, I don't even *understand* that much money, I just didn't know how to say no. But I can say it this time. Nosir. I've got nothing left to live for, and I'm leaving. Got anything to say to that?'

It seemed that Lester Coggins did not. Andy finished reducing the pills to powder, then filled the glass with water. He brushed the pink dust into the glass using the side of his hand, then stirred with his finger. The only sounds were the fire and the dim shouts of the men fighting it and from above, the *thump-thud-thump* of other men walking around on his roof.

'Down the hatch,' he said . . . but didn't drink. His hand was on the glass, but that cowardly part of him — that part that didn't want to die even though any meaningful life was over — held it where it was.

'No, you don't win this time,' he said, but he let go of the glass so he could wipe his streaming face with the coverlet again. 'Not every time and not this time.'

He raised the glass to his lips. Sweet pink oblivion swam inside. But again he put it down on the bed table.

The cowardly part, still ruling him. God *damn* that cowardly part.

'Lord, send me a sign,' he whispered. 'Send me a sign that it's all right to drink this. If for no other reason than because it's the only way I can get out of this town.'

Next door, the roof of the *Democrat* went down in a stew of sparks. Above him, someone — it sounded like Romeo Burpee — shouted: '*Be ready, boys, be on the goddam ready!*'

Be ready. That was the sign, surely. Andy Sanders lifted the glassful of death again, and this time the cowardly part didn't hold his arm down. The cowardly part seemed to have given up.

In his pocket, his cell phone played the opening phrases of 'You're Beautiful,' a sentimental piece of crap that had been Claudie's choice. For a moment he almost drank, anyway, but then a voice whispered that *this* could be a sign, too. He couldn't tell if that was the voice of the cowardly part, or of Coggins, or of his own true heart. And because he couldn't, he answered the phone.

'Mr Sanders?' A woman's voice, tired and unhappy and frightened. Andy could relate. 'This is Virginia Tomlinson, up at the hospital?'

'Ginny, sure!' Sounding like his old cheery, helpful self. It was bizarre.

'We have a situation here, I'm afraid. Can you come?'

Light pierced the confused darkness in Andy's head. It filled him with amazement and gratitude. To have someone say *Can you come*. Had he forgotten how fine that felt? He supposed he had, although it was why he'd stood for Selectman in the first place. Not to wield power; that was Big Jim's thing. Only to lend a helping hand. That was how he'd started out; maybe it was how he could finish up.

'Mr Sanders? Are you there?'

'Yes. You hang in, Ginny. I'll be right there.' He paused. 'And none of that Mr Sanders stuff. It's Andy. We're all in this together, you know.'

He hung up, took the glass into the bathroom, and poured its pink contents into the commode. His good feeling – that feeling of light and amazement – lasted until he pushed the flush-lever. Then depression settled over him again like a smelly old coat. Needed? That was pretty funny. He was just stupid old Andy Sanders, the dummy who sat on Big Jim's lap. The mouthpiece. The gabbler. The man who read Big Jim's motions and proposals as if they were his own. The man who came in handy every two years or so, election-eering and laying on the cornpone charm. Things of which Big Jim was either incapable or unwilling.

There were more pills in the bottle. There was more Dasani in the cooler downstairs. But Andy didn't seriously consider these things; he had made Ginny Tomlinson a promise, and he was a man who kept his word. But suicide hadn't been rejected, only put on the back burner. Tabled, as they said in the smalltown political biz. And it would be good to get out of this bedroom, which had almost been his death chamber.

It was filling up with smoke.

11

The Bowies' mortuary workroom was belowground, and Linda felt safe enough turning on the lights. Rusty needed them for his examination.

'Look at this mess,' he said, waving an arm at the dirty, foot-tracked tile floor, the beer and soft drink cans on the counters, an open trashcan in one corner with a few flies buzzing over it. 'If the State Board of Funeral Service saw this – or the Department of Health – it'd be shut down in a New York minute.'

'We're not in New York,' Linda reminded him. She was looking at the stainless steel table in the center of the room. The surface was

cloudy with substances probably best left unnamed, and there was a balled-up Snickers wrapper in one of the runoff gutters. 'We're not even in Maine anymore, I don't think. Hurry up, Eric, this place stinks.'

'In more ways than one,' Rusty said. The mess offended him – hell, *outraged* him. He could have punched Stewart Bowie in the mouth just for the candy wrapper, discarded on the table where the town's dead had the blood drained from their bodies.

On the far side of the room were six stainless steel body-lockers. From somewhere behind them, Rusty could hear the steady rumble of refrigeration equipment. 'No shortage of propane here,' he muttered. 'The Bowie brothers are livin large in the hood.'

There were no names in the card slots on the fronts of the lockers – another sign of sloppiness – so Rusty pulled the whole sixpack. The first two were empty, which didn't surprise him. Most of those who had so far died under the Dome, including Ron Haskell and the Evanses, had been buried quickly. Jimmy Sirois, with no close relatives, was still in the small morgue at Cathy Russell.

The next four contained the bodies he had come to see. The smell of decomposition bloomed as soon as he pulled out the rolling racks. It overwhelmed the unpleasant but less aggressive smells of preservatives and funeral ointments. Linda retreated farther, gagging.

'Don't you vomit, Linny,' Rusty said, and went across to the cabinets on the far side of the room. The first drawer he opened contained nothing but stacked back issues of *Field & Stream*, and he cursed. The one under it, however, had what he needed. He reached beneath a trocar that looked as if it had never been washed and pulled out a pair of green plastic face masks still in their wrappers. He handed one mask to Linda, donned the other himself. He looked into the next drawer and appropriated a pair of rubber gloves. They were bright yellow, hellishly jaunty.

'If you think you're going to throw up in spite of the mask, go upstairs with Stacey.'

'I'll be all right. I should witness.'

'I'm not sure how much your testimony would count for; you're my wife, after all.'

She repeated, 'I should witness. Just be as quick as you can.'

The body-racks were filthy. This didn't surprise him after seeing the rest of the prep area, but it still disgusted him. Linda had thought to bring an old cassette recorder she'd found in the garage. Rusty pushed RECORD, tested the sound, and was mildly surprised to find it was not too bad. He placed the little Panasonic on one of the

empty racks. Then he pulled on the gloves. It took longer than it should have; his hands were sweating. There was probably talcum or Johnson's Baby Powder here somewhere, but he had no intention of wasting time looking for it. He already felt like a burglar. Hell, he *was* a burglar.

'Okay, here we go. It's ten forty-five p.m., October twenty-fourth. This examination is taking place in the prep room of the Bowie Funeral Home. Which is filthy, by the way. Shameful. I see four bodies, three women and a man. Two of the women are young, late teens or early twenties. Those are Angela McCain and Dodee Sanders.'

'Dorothy,' Linda said from the far side of the prep table. 'Her name is . . . was . . . Dorothy.'

'I stand corrected. Dorothy Sanders. The third woman is in late middle age. That's Brenda Perkins. The man is about forty. He's the Reverend Lester Coggins. For the record, I can identify all these people.'

He beckoned his wife and pointed at the bodies. She looked, and her eyes welled with tears. She raised the mask long enough to say, 'I'm Linda Everett, of the Chester's Mill Police Department. My badge number is seven-seven-five. I also recognize these four bodies.' She put her mask back in place. Above it, her eyes pleaded.

Rusty motioned her back. It was all a charade, anyway. He knew it, and guessed Linda did, too. Yet he didn't feel depressed. He had wanted a medical career ever since boyhood, would certainly have been a doctor if he hadn't had to leave school to take care of his parents, and what had driven him as a high school sophomore dissecting frogs and cows' eyes in biology class was what drove him now: simple curiosity. The need to know. And he *would* know. Maybe not everything, but at least *some* things.

This is where the dead help the living. Did Linda say that?

Didn't matter. He was sure they would help if they could.

'There has been no cosmeticizing of the bodies that I can see, but all four have been embalmed. I don't know if the process has been completed, but I suspect not, because the femoral artery taps are still in place.

'Angela and Dodee – excuse me, Dorothy – have been badly beaten and are well into decomposition. Coggins has also been beaten – savagely, from the look – and is also into decomp, although not as far; the musculature on his face and arms has just begun to sag. Brenda – Brenda Perkins, I mean . . .' He trailed off and bent over her.

'Rusty?' Linda asked nervously. 'Honey?'

He reached out a gloved hand, thought better of it, removed the glove, and cupped her throat. Then he lifted Brenda's head and felt the grotesquely large knot just below the nape. He eased her head down, then rotated her body onto one hip so he could look at her back and buttocks.

'Jesus,' he said.

'Rusty? What?'

For one thing, she's still caked with shit, he thought . . . but that wouldn't go on the record. Not even if Randolph or Rennie only listened to the first sixty seconds before crushing the tape under a shoe heel and burning whatever remained. He would not add that detail of her defilement.

But he would remember.

'*What?*'

He wet his lips and said, 'Brenda Perkins shows livor mortis on the buttocks and thighs, indicating she's been dead at least twelve hours, probably more like fourteen. There's significant bruising on both cheeks. They're handprints. There's no doubt in my mind of that. Someone took hold of her face and snapped her head hard to the left, fracturing the atlas and axis cervical vertebrae, C1 and C2. Probably severed her spine as well.'

'Oh, Rusty,' Linda moaned.

Rusty thumbed up first one of Brenda's eyelids, then the other. He saw what he had feared.

'Bruising to the cheeks and scleral petechiae – bloodspots in the whites of this woman's eyes – suggest death wasn't instantaneous. She was unable to draw breath and asphyxiated. She may or may not have been conscious. We'll hope not. That's all I can tell, unfortunately. The girls – Angela and Dorothy – have been dead the longest. The state of decomposition suggests they were stored in a warm place.'

He snapped off the recorder.

'In other words, I see nothing that absolutely exonerates Barbie and nothing we didn't goddam know already.'

'What if his hands don't match the bruises on Brenda's face?'

'The marks are too diffuse to be sure. Lin, I feel like the stupidest man on earth.'

He rolled the two girls – who should have been cruising the Auburn Mall, pricing earrings, buying clothes at Deb, comparing boyfriends – back into darkness. Then he turned to Brenda.

'Give me a cloth. I saw some stacked beside the sink. They even looked clean, which is sort of a miracle in this pigsty.'

'What are you—'

'Just give me a cloth. Better make it two. Wet them.'

'Do we have time to—'

'We're going to make time.'

Linda watched silently as her husband carefully washed Brenda Perkins's buttocks and the backs of her thighs. When he was done, he flung the dirty rags into the corner, thinking that if the Bowie brothers had been here, he would have stuffed one into Stewart's mouth and the other into fucking Fernald's.

He kissed Brenda on her cool brow and rolled her back into the refrigerated locker. He started to do the same with Coggins, then stopped. The Reverend's face had been given only the most cursory of cleanings; there was still blood in his ears, his nostrils, and grimed into his brow.

'Linda, wet another cloth.'

'Honey, it's been almost ten minutes. I love you for showing respect to the dead, but we've got the living to—'

'We may have something here. This wasn't the same kind of beating. I can see that even without . . . wet a cloth.'

She made no further argument, only wet another cloth, wrung it out, and handed it to him. Then she watched as he cleansed the remaining blood from the dead man's face, working gently but without the love he'd shown Brenda.

She had been no fan of Lester Coggins (who had once claimed on his weekly radio broadcast that kids who went to see Miley Cyrus were risking hell), but what Rusty was uncovering still hurt her heart. 'My God, he looks like a scarecrow after a bunch of kids used rocks on it for target practice.'

'I told you. Not the same kind of beating. This wasn't done with fists, or even feet.'

Linda pointed. 'What's that on his temple?'

Rusty didn't answer. Above his mask, his eyes were bright with amazement. Something else, too: understanding, just starting to dawn.

'What is it, Eric? It looks like . . . I don't know . . . *stitches.*'

'You bet.' His mask bobbed as the mouth beneath it broke into a smile. Not happiness; satisfaction. And of the grimmest kind. 'On his forehead, too. See? And his jaw. That one *broke* his jaw.'

'What sort of weapon leaves marks like that?'

'A baseball,' Rusty said, rolling the drawer shut. 'Not an ordinary one, but one that was gold-plated? Yes. If swung with enough force, I think it could. I think it *did.*'

He lowered his forehead to hers. Their masks bumped. He looked into her eyes.

'Jim Rennie has one. I saw it on his desk when I went to talk to him about the missing propane. I don't know about the others, but I think we know where Lester Coggins died. And who killed him.'

12

After the roof collapsed, Julia couldn't bear to watch anymore. 'Come home with me,' Rose said. 'The guest room is yours as long as you want it.'

'Thanks, but no. I need to be by myself now, Rosie. Well, you know . . . with Horace. I need to think.'

'Where will you stay? Will you be all right?'

'Yes.' Not knowing if she would be or not. Her mind seemed okay, thinking processes all in order, but she felt as if someone had given her emotions a big shot of Novocaine. 'Maybe I'll come by later.'

When Rosie was gone, walking up the other side of the street (and turning to give Julia a final troubled wave), Julia went back to the Prius, ushered Horace into the front seat, then got behind the wheel. She looked for Pete Freeman and Tony Guay and didn't see them anywhere. Maybe Tony had taken Pete up to the hospital to get some salve for his arm. It was a miracle neither of them had been hurt worse. And if she hadn't taken Horace with her when she drove out to see Cox, her dog would have been incinerated along with everything else.

When that thought came, she realized her emotions weren't numb after all, but only hiding. A sound – a kind of keening – began to come from her. Horace pricked up his considerable ears and looked at her anxiously. She tried to stop and couldn't.

Her father's paper.

Her grandfather's paper.

Her great-grandfather's.

Ashes.

She drove down to West Street, and when she came to the abandoned parking lot behind the Globe, she pulled in. She turned off the engine, drew Horace to her, and wept against one furry, muscular shoulder for five minutes. To his credit, Horace bore this patiently.

When she was cried out, she felt better. Calmer. Perhaps it was the calmness of shock, but at least she could think again. And what she thought of was the one remaining bundle of papers in the trunk. She leaned past Horace (who gave her neck a companionable lick)

and opened the glove compartment. It was jammed with rickrack, but she thought somewhere . . . just possibly . . .

And like a gift from God, there it was. A little plastic box filled with Push Pins, rubber bands, thumbtacks, and paper clips. Rubber bands and paper clips would be no good for what she had in mind, but the tacks and Push Pins . . .

'Horace,' she said. 'Do you want to go walkie-walk?'

Horace barked that he did indeed want to go walkie-walk.

'Good,' she said. 'So do I.'

She got the newspapers, then walked back to Main Street. The *Democrat* building was now just a blazing heap of rubble with cops pouring on the water (*from those oh-so-convenient Indian pumps*, she thought, *all loaded up and ready to go*). Looking at it hurt Julia's heart – of course it did – but not so badly, now that she had something to do.

She walked down the street with Horace pacing in state beside her, and on every telephone pole she put up a copy of the *Democrat*'s last issue. The headline – **RIOT AND MURDERS AS CRISIS DEEPENS** – seemed to glare out in the light of the fire. She wished now she had settled for a single word: **BEWARE.**

She went on until they were all gone.

13

Across the street, Peter Randolph's walkie-talkie crackled three times: *break-break-break*. Urgent. Dreading what he might hear, he thumbed the transmit button, and said: 'Chief Randolph. Go.'

It was Freddy Denton, who, as commanding officer of the night shift, was now the de facto Assistant Chief. 'Just got a call from the hospital, Pete. Double murder—'

'*WHAT?*' Randolph screamed. One of the new officers – Mickey Wardlaw – was gawking at him like a Mongolian ijit at his first county fair.

Denton continued, sounding either calm or smug. If it was the latter, God help him. '—and a suicide. Shooter was that girl who cried rape. Victims were ours, Chief. Roux and DeLesseps.'

'You . . . are . . . *SHITTING ME!*'

'I sent Rupe and Mel Searles up there,' Freddy said. 'Bright side, it's all over and we don't have to jug her down in the Coop with Barb—'

'You should've gone yourself, Fred. You're the senior officer.'

'Then who'd be on the desk?'

Randolph had no answer for that – it was either too smart or too stupid. He supposed he better get his ass up to Cathy Russell.

I no longer want this job. No. Not even a little bit.

But it was too late now. And with Big Jim to help him, he'd manage. That was the thing to concentrate on; Big Jim would see him through.

Marty Arsenault tapped his shoulder. Randolph almost hauled off and hit him. Arsenault didn't notice; he was looking across the street to where Julia Shumway was walking her dog. Walking her dog and . . . what?

Putting up newspapers, that was what. Tacking them to the goddam Christing telephone poles.

'That bitch won't quit,' he breathed.

'Want me to go over there and make her quit?' Arsenault asked.

Marty looked eager for the chore, and Randolph almost gave it to him. Then he shook his head. 'She'd just start giving you an earful about her damn civil rights. Like she doesn't realize that scaring the holy hell out of everyone isn't exactly in the town's best interest.' He shook his head. 'Probably she doesn't. She's incredibly . . .' There was a word for what she was, a French word he'd learned in high school. He didn't expect it to come to him, but it did. 'Incredibly naïve.'

'I'll stop her, Chief, I will. What's she gonna do, call her lawyer?'

'Let her have her fun. At least it's keeping her out of our hair. I better go up to the hospital. Denton says the Bushey girl murdered Frank DeLesseps and Georgia Roux. Then killed herself.'

'Christ,' Marty whispered, his face losing its color. 'Is that down to Barbara too, do you think?'

Randolph started to say it wasn't, then reconsidered. His second thought was of the girl's rape accusation. Her suicide gave it a ring of truth, and rumors that Mill police officers could have done such a thing would be bad for department morale, and hence for the town. He didn't need Jim Rennie to tell him that.

'Don't know,' he said, 'but it's possible.'

Marty's eyes were watering, either from smoke or from grief. Maybe both. 'Gotta get Big Jim on top of this, Pete.'

'I will. Meanwhile' – Randolph nodded toward Julia – 'Keep an eye on her, and when she finally gets tired and goes away, take all that shit down and toss it where it belongs.' He indicated the torch that had been a newspaper office earlier in the day. 'Put litter in its place.'

Marty snickered. 'Roger that, boss.'

And that was just what Officer Arsenault did. But not before

others in town had taken down a few of the papers for perusal in brighter light – half a dozen, maybe ten. They were passed from hand to hand in the next two or three days, and read until they quite literally fell apart.

14

When Andy got to the hospital, Piper Libby was already there. She was sitting on a bench in the lobby, talking to two girls in the white nylon pants and smock tops of nurses . . . although to Andy they seemed far too young to be real nurses. Both had been crying and looked like they might start again soon, but Andy could see Reverend Libby was having a calming effect on them. One thing he'd never had a problem with was judging human emotions. Sometimes he wished he'd been better at the thinking side of things.

Ginny Tomlinson was standing nearby, conversing quietly with an oldish-looking fellow. Both looked dazed and shaken. Ginny saw Andy and came over. The oldish-looking fellow trailed along behind. She introduced him as Thurston Marshall and said he was helping out.

Andy gave the new fellow a big smile and a warm handshake. 'Nice to meet you, Thurston. I'm Andy Sanders. First Selectman.'

Piper glanced over from the bench and said, 'If you were really the First Selectman, Andy, you'd rein in the Second Selectman.'

'I understand you've had a hard couple of days,' Andy said, still smiling. 'We all have.'

Piper gave him a look of singular coldness, then asked the girls if they wouldn't like to come down to the caff with her and have tea. 'I could sure use a cup,' she said.

'I called her after I called you,' Ginny said, a little apologetically, after Piper had led the two junior nurses away. 'And I called the PD. Got Fred Denton.' She wrinkled her nose as people do when they smell something bad.

'Aw, Freddy's a good guy,' Andy said earnestly. His heart was in none of this – his heart felt like it was still back on Dale Barbara's bed, planning to drink the poisoned pink water – but the old habits kicked in smoothly, nevertheless. The urge to make things all right, to calm troubled waters, turned out to be like riding a bicycle. 'Tell me what happened here.'

She did so. Andy listened with surprising calmness, considering he'd known the DeLesseps family all his life and had in high school once taken Georgia Roux's mother on a date (Helen had kissed with

her mouth open, which was nice, but had stinky breath, which wasn't). He thought his current emotional flatness had everything to do with knowing that if his phone hadn't rung when it did, he'd be unconscious by now. Maybe dead. A thing like that put the world in perspective.

'Two of our brand-new officers,' he said. To himself he sounded like the recording you got when you called a movie theater to get showtimes. 'One already badly hurt trying to clean up that super-market mess. Dear, dear.'

'This is probably not the time to say so, but I'm not very fond of your police department,' Thurston said. 'Although since the officer who actually punched me is now dead, lodging a complaint would be moot.'

'Which officer? Frank or the Roux girl?'

'The young man. I recognized him in spite of his . . . his mortal disfigurement.'

'Frank DeLesseps punched you?' Andy simply didn't believe this. Frankie had delivered his Lewiston *Sun* for four years and never missed a day. Well, yes, one or two, now that he thought of it, but those had come during big snowstorms. And once he'd had the measles. Or had it been the mumps?

'If that was his name.'

'Well, gosh . . . that's . . .' It was what? And did it matter? Did anything? Yet Andy pushed gamely forward. 'That's regrettable, sir. We believe in living up to our responsibilities in Chester's Mill. Doing the right thing. It's just that right now we're kind of under the gun. Circumstances beyond our control, you know.'

'I *do* know,' Thurse said. 'As far as I'm concerned, it's water over the dam. But sir . . . those officers were awfully young. And *very* out of line.' He paused. 'The lady I'm with was also assaulted.'

Andy just couldn't believe this fellow was telling the truth. Chester's Mill cops didn't hurt people unless they were provoked (*severely* provoked); that was for the big cities, where folks didn't know how to get along. Of course, he would have said a girl killing two cops and then taking her own life was also the kind of thing that didn't happen in The Mill.

Never mind, Andy thought. *He's not just an out-of-towner, he's an out-of-stater. Put it down to that.*

Ginny said, 'Now that you're here, Andy, I'm not sure what you can do. Twitch is taking care of the bodies, and—'

Before she could go on, the door opened. A young woman came in, leading two sleepy-looking children by the hands. The old fellow

– Thurston – hugged her while the children, a girl and a boy, looked on. Both of them were barefooted and wearing tee-shirts as night-shirts. The boy's, which came all the way down to his ankles, read PRISONER 9091 and PROPERTY OF SHAWSHANK STATE PRISON. Thurston's daughter and grandchildren, Andy supposed, and that made him miss Claudette and Dodee all over again. He pushed the thought of them away. Ginny had called him for help, and it was clear she needed some herself. Which would no doubt mean listening while she told the whole story again – not for his benefit but for her own. So she could get the truth of it and start making peace with it. Andy didn't mind. Listening was a thing he'd always been good at, and it was better than looking at three dead bodies, one the discarded husk of his old paperboy. Listening was such a simple thing, when you got right down to it, even a moron could listen, but Big Jim had never gotten the hang of it. Big Jim was better at talking. And planning – that, too. They were lucky to have him at a time like this.

As Ginny was winding up her second recitation, a thought came to Andy. Possibly an important one. 'Has anyone—'

Thurston returned with the newcomers in tow. 'Selectman Sanders – Andy – this is my partner, Carolyn Sturges. And these are the children we're taking care of. Alice and Aidan.'

'I want my binkie,' Aidan said morosely.

Alice said, 'You're too *old* for a binkie,' and elbowed him.

Aidan's face scrunched, but he didn't quite cry.

'Alice,' Carolyn Sturges said, 'that's mean. And what do we know about mean people?'

Alice brightened. '*Mean people suck!*' she cried, and collapsed into giggles. After considering a moment, Aidan joined her.

'I'm sorry,' Carolyn said to Andy. 'I had no one to watch them, and Thurse sounded so *distraught* when he called . . .'

It was hard to believe, but it seemed possible the old guy was bumping sweet spots with the young lady. The idea was only of passing interest to Andy, although under other circumstances he might have considered it deeply, pondering positions, wondering about whether she frenched him with that dewy mouth of hers, etc., etc. Now, however, he had other things on his mind.

'Has anyone told Sammy's husband that she's dead?' he asked.

'Phil Bushey?' It was Dougie Twitchell, coming down the hall and into the reception area. His shoulders were slumped and his complexion was gray. 'Sonofabitch left her and left town. Months ago.' His eyes fell on Alice and Aidan Appleton. 'Sorry, kids.'

'That's all right,' Caro said. 'We have an open-language house. It's much more truthful.'

'That's right,' Alice piped up. 'We can say shit and piss all we want, at least until Ma gets back.'

'But not bitch,' Aidan amplified. 'Bitch is *ex*-ist.'

Caro took no notice of this byplay. 'Thurse? What happened?'

'Not in front of the kids,' he said. 'Open language or no open language.'

'Frank's parents are out of town,' Twitch said, 'but I got in touch with Helen Roux. She took it quite calmly.'

'Drunk?' Andy asked.

'As a skunk.'

Andy wandered a little way up the hall. A few patients, clad in hospital johnnies and slippers, were standing with their backs to him. Looking at the scene of the slaughter, he presumed. He had no urge to do likewise, and was glad Dougie Twitchell had taken care of whatever needed taking care of. He was a pharmacist and a politician. His job was to help the living, not process the dead. And he knew something these people did not. He couldn't tell them that Phil Bushey was still in town, living like a hermit out at the radio station, but he could tell Phil that his estranged wife was dead. Could and should. Of course it was impossible to predict what Phil's reaction might be; Phil wasn't himself these days. He might lash out. He might even kill the bearer of bad tidings. But would that be so awful? Suicides might go to hell and dine on hot coals for eternity, but murder victims, Andy was quite sure, went to heaven and ate roast beef and peach cobbler at the Lord's table for all eternity.

With their loved ones.

15

In spite of the nap she'd had earlier in the day, Julia was more tired than ever in her life, or so it felt. And unless she took Rosie up on her offer, she had nowhere to go. Except her car, of course.

She went back to it, unclipped Horace's leash so he could jump onto the passenger seat, and then sat behind the wheel trying to think. She liked Rose Twitchell just fine, but Rosie would want to rehash the entire long and harrowing day. And she'd want to know what, if anything, was to be done about Dale Barbara. She would look to Julia for ideas, and Julia had none.

Meanwhile Horace was staring at her, asking with his cocked ears and bright eyes what came next. He made her think of the

woman who had lost *her* dog: Piper Libby. Piper would take her in and give her a bed without talking her ear off. And after a night's sleep, Julia might be able to think again. Even plan a little.

She started the Prius and drove up to the Congo church. But the parsonage was dark, and a note was tacked to the door. Julia pulled the tack, took the note back to the car, and read it by the dome light.

I have gone to the hospital. There has been a shooting there.

Julia started to make the keening noise again, and when Horace began to whine as if trying to harmonize, she made herself stop. She put the Prius in reverse, then put it back in Park long enough to return the note to where she had found it, in case some other parishioner with the weight of the world on his shoulders (or hers) might come by looking for The Mill's remaining spiritual advisor.

So now where? Rosie's after all? But Rosie might already have turned in. The hospital? Julia would have forced herself to go there in spite of her shock and her weariness if it had served a purpose, but now there was no newspaper in which to report whatever had happened, and without that, no reason to expose herself to fresh horrors.

She backed out of the driveway and turned up Town Common Hill with no idea where she was going until she came to Prestile Street. Three minutes later, she was parking in Andrea Grinnell's driveway. Yet this house was also dark. There was no answer to her soft knocks. Having no way of knowing that Andrea was in her bed upstairs, deeply asleep for the first time since dumping her pills, Julia assumed she had either gone to her brother Dougie's house or was spending the night with a friend.

Meanwhile, Horace was sitting on the welcome mat, looking up at her, waiting for her to take charge, as she had always done. But Julia was too hollowed out to take charge and too tired to go further. She was more than half convinced that she would drive the Prius off the road and kill them both if she tried going anywhere.

What she kept thinking about wasn't the burning building where her life had been stored but of how Colonel Cox had looked when she'd asked him if they had been abandoned.

Negative, he'd said. *Absolutely not.* But he hadn't quite been able to look at her while he said it.

There was a lawn glider on the porch. If necessary, she could curl up there. But maybe—

She tried the door and found it unlocked. She hesitated; Horace did not. Secure in the belief that he was welcome everywhere, he

went inside immediately. Julia followed on the other end of the leash, thinking, *My dog is now making the decisions. This is what it's come to.*

'Andrea?' she called softly. 'Andi, are you here? It's Julia.'

Upstairs, lying on her back and snoring like a truck driver at the end of a four-day run, only one part of Andrea stirred: her left foot, which hadn't yet given up its withdrawal-induced jerking and tapping.

It was gloomy in the living room, but not entirely dark; Andi had left a battery-powered lamp on in the kitchen. And there was a smell. The windows were open, but with no breeze, the odor of vomit hadn't entirely vented. Had someone told her that Andrea was ill? With the flu, maybe?

Maybe it is the flu, but it could just as easily be withdrawal if she ran out of the pills she takes.

Either way, sickness was sickness, and sick people usually didn't want to be alone. Which meant the house was empty. And she was so tired. Across the room was a nice long couch, and it called to her. If Andi came in tomorrow and found Julia there, she'd understand.

'She might even make me a cup of tea,' she said. 'We'll laugh about it.' Although the idea of laughing at anything, ever again, seemed out of the question to her right now. 'Come on, Horace.'

She unclipped his leash and trudged across the room. Horace watched her until she lay down and put a sofa pillow behind her head. Then he lay down himself and put his snout on his paw.

'You be a good boy,' she said, and closed her eyes. What she saw when she did was Cox's eyes not quite meeting hers. Because Cox thought they were under the Dome for the long haul.

But the body knows mercies of which the brain is unaware. Julia fell asleep with her head less than four feet from the manila envelope Brenda had tried to deliver to her that morning. At some point, Horace jumped onto the couch and curled up between her knees. And that was how Andrea found them when she came downstairs on the morning of October twenty-fifth, feeling more like her true self than she had in years.

16

There were four people in Rusty's living room: Linda, Jackie, Stacey Moggin, and Rusty himself. He served out glasses of iced tea, then summarized what he had found in the basement of the Bowie Funeral Home. The first question came from Stacey, and it was purely practical.

'Did you remember to lock up?'

'Yes,' Linda said.

'Then give me the key. I have to put it back.'

Us and them, Rusty thought again. *That's what this conversation is going to be about. What it's already about. Our secrets. Their power. Our plans. Their agenda.*

Linda handed over the key, then asked Jackie if the girls had given her any problems.

'No seizures, if that's what you're worried about. Slept like lambs the whole time you were gone.'

'What are we going to do about this?' Stacey asked. She was a little thing, but determined. 'If you want to arrest Rennie, the four of us will have to convince Randolph to do it. We three women as officers, Rusty as the acting pathologist.'

'No!' Jackie and Linda said it together, Jackie with decisiveness, Linda with fright.

'We have a hypothesis but no real proof,' Jackie said. 'I'm not sure Pete Randolph would believe us even if we had surveillance photos of Big Jim snapping Brenda's neck. He and Rennie are in it together now, sink or swim. And most of the cops would come down on Pete's side.'

'Especially the new ones,' Stacey said, and tugged at her cloud of blond hair. 'A lot of them aren't very bright, but they're dedicated. And they like carrying guns. Plus' – she leaned forward – 'there's six or eight more of them tonight. Just high-school kids. Big and stupid and enthusiastic. They scare the hell out of me. And something else. Thibodeau, Searles, and Junior Rennie are asking the newbies to recommend even *more*. Give this a couple of days and it won't be a police force anymore, it'll be an army of teenagers.'

'No one would listen to us?' Rusty asked. Not disbelieving, exactly; simply trying to get it straight. 'No one at all?'

'Henry Morrison might,' Jackie said. 'He sees what's happening and he doesn't like it. But the others? They'll go along. Partly because they're scared and partly because they like the power. Guys like Toby Whelan and George Frederick have never had any; guys like Freddy Denton are just mean.'

'Which means what?' Linda asked.

'It means for now we keep this to ourselves. If Rennie's killed four people, he's very, very dangerous.'

'Waiting will make him more dangerous, not less,' Rusty objected.

'We have Judy and Janelle to worry about, Rusty,' Linda said. She was nipping at her nails, a thing Rusty hadn't seen her do in

years. 'We can't risk anything happening to them. I won't consider it, and I won't let you consider it.'

'I have a kid, too,' Stacey said. 'Calvin. He's just five. It took all my courage just to stand guard at the funeral home tonight. The thought of taking this to that idiot Randolph . . .' She didn't need to finish; the pallor of her cheeks was eloquent.

'No one's asking you to,' Jackie said.

'Right now all I can prove is that the baseball was used on Coggins,' Rusty said. 'Anyone could have used it. Hell, his own son could have used it.'

'That actually wouldn't come as a total shock to me,' Stacey said. 'Junior's been weird lately. He got kicked out of Bowdoin for fighting. I don't know if his father knows it, but there was a police call to the gym where it happened, and I saw the report on the wire. And the two girls . . . if those were sex crimes . . .'

'They were,' Rusty said. 'Very nasty. You don't want to know.'

'But Brenda wasn't sexually assaulted,' Jackie said. 'To me that suggests Coggins and Brenda were different from the girls.'

'Maybe Junior killed the girls and his old man killed Brenda and Coggins,' Rusty said, and waited for someone to laugh. No one did. 'If so, why?'

They all shook their heads.

'There must have been a motive,' Rusty said, 'but I doubt if it was sex.'

'You think he has something to hide,' Jackie said.

'Yeah, I do. And I have an idea of someone who might know what it is. He's locked in the Police Department basement.'

'Barbara?' Jackie asked. 'Why would Barbara know?'

'Because he was talking to Brenda. They had quite a little heart-to-heart in her backyard the day after the Dome came down.'

'How in the world do you know that?' Stacey asked.

'Because the Buffalinos live next door to the Perkinses and Gina Buffalino's bedroom window overlooks the Perkins backyard. She saw them and mentioned it to me.' He saw Linda looking at him and shrugged. 'What can I say? It's a small town. We all support the team.'

'I hope you told her to keep her mouth shut,' Linda said.

'I didn't, because when she told me I didn't have any reason to suspect Big Jim might have killed Brenda. Or bashed Lester Coggins's head in with a souvenir baseball. I didn't even know they were dead.'

'We still don't know if Barbie knows anything,' Stacey said. 'Other than how to make a hell of a mushroom-and-cheese omelet, that is.'

'Somebody will have to ask him,' Jackie said. 'I nominate me.'

'Even if he does know something, will it do any good?' Linda asked. 'This is almost a dictatorship now. I'm just realizing that. I guess that makes me slow.'

'It makes you more trusting than slow,' Jackie said, 'and normally trusting's a good way to be. As to Colonel Barbara, we won't know what good he might do us until we ask.' She paused. 'And that's really not the point, you know. He's innocent. That's the point.'

'What if they kill him?' Rusty asked bluntly. 'Shot while trying to escape.'

'I'm pretty sure that won't happen,' Jackie said. 'Big Jim wants a show-trial. That's the talk at the station.' Stacey nodded. 'They want to make people believe Barbara's a spider spinning a vast web of conspiracy. Then they can execute him. But even moving at top speed, that's days away. Weeks, if we're lucky.'

'We won't be that lucky,' Linda said. 'Not if Rennie wants to move fast.'

'Maybe you're right, but Rennie's got the special town meeting to get through on Thursday first. And he'll want to question Barbara. If Rusty knows he's been with Brenda, then Rennie knows.'

'Of course he knows,' Stacey said. Sounding impatient. 'They were together when Barbara showed Jim the letter from the President.'

They thought about this in silence for a minute.

'If Rennie's hiding something,' Linda mused, 'he'll want time to get rid of it.'

Jackie laughed. The sound in that tense living room was almost shocking. 'Good luck on that. Whatever it is, he can't exactly put it in the back of a truck and drive it out of town.'

'Something to do with the propane?' Linda asked.

'Maybe,' Rusty said. 'Jackie, you were in the service, right?'

'Army. Two tours. Military Police. Never saw combat, although I saw plenty of casualties, especially on my second tour. Würzburg, Germany, First Infantry Division. You know, the Big Red One? Mostly I stopped bar fights or stood guard outside the hospital there. I knew guys like Barbie, and I would give a great deal to have him out of that cell and on our side. There was a reason the President put him in charge. Or tried to.' She paused. 'It might be possible to break him out. It's worth considering.'

The other two women – police officers who also happened to be mothers – said nothing to this, but Linda was nibbling her nails again and Stacey was worrying her hair.

'I know,' Jackie said.

Linda shook her head. 'Unless you have kids asleep upstairs and

depending on you to make breakfast for them in the morning, you don't.'

'Maybe not, but ask yourself this: If we're cut off from the outside world, which we are, and if the man in charge is a murderous nut-ball, which he may be, are things apt to get better if we just sit back and do nothing?'

'If you broke him out,' Rusty said, 'what would you do with him? You can't exactly put him in the Witness Protection Program.'

'I don't know,' Jackie said, and sighed. 'All I know is that the President ordered him to take charge and Big Jim Fucking Rennie framed him for murder so he couldn't.'

'You're not going to do anything right away,' Rusty said. 'Not even take the chance of talking to him. There's something else in play here, and it could change everything.'

He told them about the Geiger counter – how it had come into his possession, to whom he had passed it on, and what Joe McClatchey claimed to have found with it.

'I don't know,' Stacey said doubtfully. 'It seems too good to be true. The McClatchey boy's . . . what? Fourteen?'

'Thirteen, I think. But this is one bright kid, and if he says they got a radiation spike out on Black Ridge Road, I believe him. If they *have* found the thing generating the Dome, and we can shut it down . . .'

'Then this ends!' Linda cried. Her eyes were bright. 'And Jim Rennie collapses like a . . . a Macy's Thanksgiving Day balloon with a hole in it!'

'Wouldn't that be nice,' Jackie Wettington said. 'If it was on TV, I might even believe it.'

17

'Phil?' Andy called. '*Phil?*'

He had to raise his voice to be heard. Bonnie Nandella and The Redemption were working through 'My Soul is a Witness' at top volume. All those *ooo-oohs* and *whoa-yeahs* were a little disorienting. Even the bright light inside the WCIK broadcast facility was disorienting; until he stood beneath those fluorescents, Andy hadn't really realized how dark the rest of The Mill had become. And how much he'd adapted to it. 'Chef?'

No answer. He glanced at the TV (CNN with the sound off), then looked through the long window into the broadcast studio. The lights were on in there, too, and all the equipment was running (it

gave him the creeps, even though Lester Coggins had explained with great pride how a computer ran everything), but there was no sign of Phil.

All at once he smelled sweat, old and sour. He turned and Phil was standing right behind him, as if he had popped out of the floor. He was holding what looked like a garage door-opener in one hand. In the other was a pistol. The pistol was pointed at Andy's chest. The finger curled around the trigger was white at the knuckle and the muzzle was trembling slightly.

'Hello, Phil,' Andy said. 'Chef, I mean.'

'What are *you* doing here?' Chef Bushey asked. The smell of his sweat was yeasty, overpowering. His jeans and WCIK tee-shirt were grimy. His feet were bare (probably accounting for his silent arrival) and caked with dirt. His hair might last have been washed a year ago. Or not. His eyes were the worst, bloody and haunted. 'You better tell me quick, old hoss, or you'll never tell anyone anything again.'

Andy, who had narrowly cheated death by pink water not long before, received Chef's threat with equanimity, if not good cheer. 'You do what you have to do, Phil. Chef, I mean.'

Chef raised his eyebrows in surprise. It was bleary but genuine. 'Yeah?'

'Absolutely.'

'Why you out here?'

'I come bearing bad news. I'm very sorry.'

Chef considered this, then smiled, revealing his few surviving teeth. 'There is no bad news. Christ is coming back, and that's the good news that swallows all bad news. That's the Good News Bonus Track. Do you agree?'

'I do, and I say hallelujah. Unfortunately – or fortunately, I guess; you'd have to say fortunately – your wife is with Him already.'

'Say what?'

Andy reached out and pushed the muzzle of the gun floorward. Chef made no effort to stop him. 'Samantha's dead, Chef. I regret to say she took her own life earlier tonight.'

'Sammy? Dead?' Chef dropped the gun into the OUT basket on a nearby desk. He also lowered the garage door-opener, but kept hold of it; for the last two days it had not left his hand, even during his increasingly infrequent periods of sleep.

'I'm sorry, Phil. Chef.'

Andy explained the circumstances of Sammy's death as he under-stood them, concluding with the comforting news that 'the child'

was fine. (Even in his despair, Andy Sanders was a glass-half-full person.)

Chef waved away Little Walter's wellbeing with his garage door opener. 'She offed two pigs?'

Andy stiffened at that. 'They were police officers, Phil. Fine human beings. She was distraught, I'm sure, but it was still a very bad thing to do. You need to take that back.'

'Say *what*?'

'I won't have you calling our officers pigs.'

Chef considered. 'Yeah-yeah, kay-kay, I take it back.'

'Thank you.'

Chef bent down from his not-inconsiderable height (it was like being bowed to by a skeleton) and peered into Andy's face. 'Brave little motherfucker, ain't you?'

'No,' Andy said honestly. 'I just don't care.'

Chef seemed to see something that concerned him. He grasped Andy's shoulder. 'Brother, are you all right?'

Andy burst into tears and dropped onto an office chair under a sign advising that CHRIST WATCHETH EVERY CHANNEL, CHRIST LISTENETH EVERY WAVELENGTH. He rested his head on the wall below this strangely sinister slogan, crying like a child who has been punished for stealing jam. It was the *brother* that had done it; that totally unexpected *brother*.

Chef drew up a chair from behind the station manager's desk and studied Andy with the expression of a naturalist observing some rare animal in the wild. After awhile he said, 'Sanders! Did you come out here so I'd kill you?'

'No,' Andy said through his sobs. 'Maybe. Yes. I can't say. But everything in my life has gone wrong. My wife and daughter are dead. I think God might be punishing me for selling this shit—'

Chef nodded. 'That could be.'

'—and I'm looking for answers. Or closure. Or something. Of course, I also wanted to tell you about your wife, it's important to do the right thing—'

Chef patted his shoulder. 'You did, bro. I appreciate it. She wasn't much shakes in the kitchen, and she didn't keep house no better than a hog on a shitheap, but she could throw an *unearthly* fuck when she was stoned. What did she have against those two blueboys?'

Even in his grief, Andy had no intention of bringing up the rape accusation. 'I suppose she was upset about the Dome. Do you know about the Dome, Phil? Chef?'

Chef waved his hand again, apparently in the affirmative. 'What you say about the meth is correct. Selling it is wrong. An affront. Making it, though – that is God's will.'

Andy dropped his hands and peered at Chef from his swollen eyes. 'Do you think so? Because I'm not sure that can be right.'

'Have you ever had any?'

'No!' Andy cried. It was as if Chef had asked him if he had ever enjoyed sexual congress with a cocker spaniel.

'Would you take medicine if the doctor prescribed it?'

'Well . . . yes, of course . . . but . . .'

'Meth is medicine.' Chef looked at him solemnly, then tapped Andy's chest with a finger for emphasis. Chef had nibbled the nail all the way to the bloody quick. '*Meth* is *medicine*. Say it.'

'Meth is medicine,' Andy repeated, agreeably enough.

'That's right.' Chef stood up. 'It's a medicine for melancholy. That's from Ray Bradbury. You ever read Ray Bradbury?'

'No.'

'He's a fucking *head*. He *knew*. He wrote the motherfucking *book*, say hallelujah. Come with me. I'm going to change your life.'

18

The First Selectman of Chester's Mill took to meth like a frog to flies.

There was a ratty old couch behind the ranked cookers, and here Andy and Chef Bushey sat under a picture of Christ on a motor-cycle (title: *Your Unseen Road Buddy*), passing a pipe back and forth. While burning, meth smells like three-day-old piss in an uncovered thunderjug, but after his first tentative puff, Andy felt positive that the Chef was right: selling it might be Satan's work, but the stuff itself had to be God's. The world jumped into an exquisite, delicately trembling focus he had never seen before. His heart rate spiked, the blood vessels in his neck swelled to throbbing cables, his gums tingled, and his balls crawled in the most delightfully adolescent way. Better than any of these things, the weariness that had lain on his shoulders and muddled up his thinking disappeared. He felt he could move mountains in a wheelbarrow.

'In the Garden of Eden there was a Tree,' Chef said, passing him the pipe. Tendrils of green smoke drifted from both ends. 'The Tree of Good and Evil. Dig that shit?'

'Yes. It's in the Bible.'

'Bet your jackdog. And on that Tree was an Apple.'

'Right, right.' Andy took a puff so small it was actually a sip. He wanted more – he wanted it *all* – but feared that if he helped himself to a deep lungful, his head would explode off his neck and fly around the lab like a rocket, shooting fiery exhaust from its stump.

'The flesh of that Apple is Truth, and the skin of that Apple is Meth,' Chef said.

Andy looked at him. 'That's amazing.'

Chef nodded. 'Yes, Sanders. It is.' He took back the pipe. 'Is this good shit or what?'

'*Amazing* shit.'

'Christ is coming back on Halloween,' Chef said. 'Possibly a few days earlier; I can't tell. It's already the Halloween *season*, you know. Season of the motherfucking witch.' He handed Andy the pipe, then pointed with the hand holding the garage door opener. 'Do you see that? Up at the end of the gallery. Over the door to the storage side.'

Andy looked. 'What? That white lump? Looks like clay?'

'That's not clay,' Chef said. 'That's the Body of Christ, Sanders.'

'What about those wires coming out of it?'

'Vessels with the Blood of Christ running through em.'

Andy considered this concept and found it quite brilliant. 'Good.' He considered some more. 'I love you, Phil. Chef, I mean. I'm glad I came out here.'

'Me too,' Chef said. 'Listen, do you want to go for a ride? I've got a car here somewhere – I think – but I'm a little shaky.'

'Sure,' Andy said. He stood up. The world swam for a moment or two, then steadied. 'Where do you want to go?'

Chef told him.

19

Ginny Tomlinson was asleep at the reception desk with her head on the cover of a *People* magazine – Brad Pitt and Angelina Jolie frolicking in the surf on some horny little island where waiters brought you drinks with little paper parasols stuck in them. When something woke her up at quarter of two on Wednesday morning, an apparition was standing before her: a tall, scrawny man with hollow eyes and hair that stuck out in all directions. He was wearing a WCIK tee-shirt and jeans that floated low on his meager hips. At first she thought she was having a nightmare about walking corpses, but then she caught a whiff of him. No dream had ever smelled that bad.

'I'm Phil Bushey,' the apparition said. 'I've come for my wife's body. I'm gonna bury her. Show me where it is.'

Ginny didn't argue. She would have given him *all* the bodies, just to get rid of him. She led him past Gina Buffalino, who stood next to a gurney, watching Chef with pale apprehension. When he turned to look at her, she shrank back.

'Got your Halloween costume, kid?' Chef inquired.

'Yes . . .'

'Who you gonna be?'

'Glinda,' the girl said faintly. 'Although I guess I won't be going to the party, after all. It's in Motton.'

'I'm coming as Jesus,' Chef said. He followed Ginny, a dirty ghost in decaying Converse Hi-Tops. Then he turned back. He was smiling. His eyes were empty. 'And am I pissed.'

20

Chef Bushey came out of the hospital ten minutes later bearing Sammy's sheet-wrapped body in his arms. One bare foot, the toenails painted with chipped pink polish, nodded and dipped. Ginny held the door for him. She didn't look to see who was behind the wheel of the car idling in the turnaround, and for this Andy was vaguely grateful. He waited until she'd gone back inside, then got out and opened one of the back doors for Chef, who handled his burden easily for a man who now looked like no more than skin wrapped on an armature of bone. *Perhaps*, Andy thought, *meth conveys strength, too*. If so, his own was flagging. The depression was creeping back in. The weariness, too.

'All right,' Chef said. 'Drive. But pass me that, first.'

He had given Andy the garage door opener for safekeeping. Andy handed it over. 'To the funeral parlor?'

Chef looked at him as if he were mad. 'Back out to the radio station. That's where Christ will come first when He comes back.'

'On Halloween.'

'That's right,' Chef said. 'Or maybe sooner. In the meantime, will you help me bury this child of God?'

'Of course,' Andy said. Then, timidly: 'Maybe we could smoke a little more first.'

Chef laughed and clapped Andy on the shoulder. 'Like it, don't you? I knew you would.'

'A medicine for melancholy,' Andy said.

'True-dat, brother. True-dat.'

21

Barbie lay on the bunk, waiting for dawn and whatever came next. He had trained himself during his time in Iraq not to *worry* about what came next, and although this was an imperfect skill at best, he had mastered it to some degree. In the end, there were only two rules for living with fear (he had come to believe *conquering* fear was a myth), and he repeated them to himself now as he lay waiting.

I must accept those things over which I have no control.

I must turn my adversities into advantages.

The second rule meant carefully husbanding any resources and planning with those in mind.

He had one resource tucked into the mattress: his Swiss Army knife. It was a small one, only two blades, but even the short one would be capable of cutting a man's throat. He was incredibly lucky to have it, and he knew it.

Whatever intake routines Howard Perkins might have insisted upon had fallen apart since his death and the ascension of Peter Randolph. The shocks the town had endured over the last four days would have knocked any police department off its pins, Barbie supposed, but there was more to it than that. What it came down to was Randolph was both stupid and sloppy, and in any bureaucracy the rank-and-file tended to take their cues from the man at the top.

They had fingerprinted him and photographed him, but it had been five full hours before Henry Morrison, looking tired and disgusted, came downstairs and stopped six feet from Barbie's cell. Well out of grabbing distance.

'Forget something, did you?' Barbie asked.

'Dump out your pockets and shove everything into the corridor,' Henry said. 'Then take off your pants and put em through the bars.'

'If I do that, can I get something to drink I don't have to slurp out of the toiletbowl?'

'What are you talking about? Junior brought you water. I saw him.'

'He poured salt in it.'

'Right. Absolutely.' But Henry had looked a little unsure. Maybe there was a thinking human being still in there somewhere. 'Do what I tell you, Barbie. Barbara, I mean.'

Barbie emptied his pockets: wallet, keys, coins, a little fold of bills, the St Christopher's medal he carried as a good luck charm. By then the Swiss Army knife was long gone into the mattress. 'You can

still call me Barbie when you put a rope around my neck and hang me, if you want. Is that what Rennie's got in mind? Hanging? Or a firing squad?'

'Just shut up and shove your pants through the bars. Shirt, too.' He sounded like a total smalltown hardass, but Barbie thought he looked more unsure than ever. That was good. That was a start.

Two of the new kiddie-cops had come downstairs. One held a can of Mace; the other a Taser. 'Need any help, Officer Morrison?' one asked.

'No, but you can stand right there at the foot of the stairs and keep an eye out until I'm done here,' Henry had said.

'I didn't kill anybody.' Barbie spoke quietly, but with all the honest sincerity he could muster. 'And I think you know it.'

'What I know is that you better shut up, unless you want a Taser enema.'

Henry had rummaged through his clothes, but didn't ask Barbie to strip down to his underpants and spread his cheeks. A late search and piss-poor, but Barbie gave him some points for remembering to do one at all – no one else had.

When Henry had finished, he kicked the bluejeans, pockets now empty and belt confiscated, back through the bars.

'May I have my medallion?'

'No.'

'Henry, think about this. Why would I—'

'Shut up.'

Henry pushed past the two kiddie-cops with his head down and Barbie's personal effects in his hands. The kiddie-cops followed, one pausing long enough to grin at Barbie and saw a finger across his neck.

Since then he'd been alone, with nothing to do but lie on the bunk and look up at the little slit of a window (opaque pebbled glass reinforced with wire), waiting for the dawn and wondering if they would actually try to waterboard him or if Searles had just been gassing out his ass. If they took a shot at it and turned out to be as bad at boarding as they had been at prisoner intake, there was a good chance they'd drown him.

He also wondered if someone might come down before dawn. Someone with a key. Someone who might stand a little too close to the door. With the knife, escape was not completely out of the question, but once dawn came, it probably would be. Maybe he should have tried for Junior when Junior passed the glass of salt water through the bars . . . only Junior had been very eager to use his sidearm. It

would have been a long chance, and Barbie wasn't that desperate. At least not yet.

Besides . . . where would I go?

Even if he escaped and disappeared, he could be letting his friends in for a world of hurt. After strenuous 'questioning' by cops like Melvin and Junior, they might consider the Dome the least of their problems. Big Jim was in the saddle now, and once guys like him were in it, they tended to ride hard. Sometimes until the horse collapsed beneath them.

He fell into a thin and troubled sleep. He dreamed of the blonde in the old Ford pickemup. He dreamed that she stopped for him and they got out of Chester's Mill just in time. She was unbuttoning her blouse to display the cups of a lacy lavender bra when a voice said: 'Hey there, fuckstick. Wakey-wakey.'

22

Jackie Wettington spent the night at the Everett house, and although the kids were quiet and the guest-room bed was comfortable, she lay awake. By four o'clock that morning, she had decided what needed to be done. She understood the risks; she also understood that she couldn't rest with Barbie in a cell under the Police Department. If she herself had been capable of stepping up and organizing some sort of resistance – or just a serious investigation of the murders – she thought she would have started already. She knew herself too well, however, to even entertain the thought. She'd been good enough at what she did in Guam and Germany – rousting drunk troops out of bars, chasing AWOLs, and cleaning up after car crashes on the base was what it mostly came down to – but what was happening in Chester's Mill was far beyond a master sergeant's pay grade. Or the only full-time female street officer working with a bunch of small-town men who called her Officer Bazooms behind her back. They thought she didn't know this, but she did. And right now a little junior high-school-level sexism was the least of her worries. This had to end, and Dale Barbara was the man the President of the United States had picked to end it. Even the pleasure of the Commander in Chief wasn't the most important part. The first rule was you didn't leave your guys behind. That was sacred, the Fabled Automatic.

It had to begin with letting Barbie know he wasn't alone. Then he could plan his own actions accordingly.

When Linda came downstairs in her nightgown at five o'clock, first light had begun to seep in through the windows, revealing trees

and bushes that were perfectly still. Not a breath of breeze was stir-ring.

'I need a Tupperware,' Jackie said. 'A bowl. It should be small, and it needs to be opaque. Do you have anything like that?'

'Sure, but why?'

'Because we're going to take Dale Barbara his breakfast,' Jackie said. 'Cereal. And we're going to put a note in the bottom of it.'

'What are you talking about? Jackie, I can't do that. I've got kids.'

'I know. But I can't do it alone, because they won't let me go down there on my own. Maybe if I was a man, but not equipped with these.' She indicated her breasts. 'I need you.'

'What kind of note?'

'I'm going to break him out tomorrow night,' Jackie said, more calmly than she felt. 'During the big town meeting. I won't need you for that part—'

'You won't *get* me for that part!' Linda was clutching the neck of her nightgown.

'Keep your voice down. I'm thinking maybe Romeo Burpee – assuming I can convince him Barbie didn't kill Brenda. We'll wear balaclavas or something, so we can't be identified. No one will be surprised; everyone in this town already thinks he has cohorts.'

'You're insane!'

'No. There'll be nothing but a skeleton crew at the PD during the meeting – three, four guys. Maybe only a couple. I'm sure of it.'

'*I'm* not!'

'But tomorrow night's a long way away. He has to string them along at least that far. Now get me that bowl.'

'Jackie, I can't do this.'

'Yes, you can.' It was Rusty, standing in the doorway and looking relatively enormous in a pair of gym shorts and a New England Patriots tee-shirt. 'It's time to start taking risks, kids or no kids. We're on our own here, and this has got to stop.'

Linda looked at him for a moment, biting her lip. Then she bent to one of the lower cabinets. 'The Tupperware's down here.'

23

When they came into the police station, the duty desk was unmanned – Freddy Denton had gone home to catch some sleep – but half a dozen of the younger officers were sitting around, drinking coffee and talking, high enough on excitement to get up at an hour few

of them had experienced in a conscious state for a long time. Among them Jackie saw two of the multitudinous Killian brothers, a small-town biker chick and Dipper's habitué named Lauren Conree, and Carter Thibodeau. The others she couldn't name, but she recognized two as chronic truants from high school who had also been in on various minor drug and MV violations. The new 'officers' – the newest of the new – weren't wearing uniforms, but had swatches of blue cloth tied around their upper arms.

All but one were wearing guns.

'What are you two doing up so early?' Thibodeau asked, strolling over. 'I got an excuse – ran out of pain pills.'

The others guffawed like trolls.

'Brought breakfast for Barbara,' Jackie said. She was afraid to look at Linda, afraid of what expression she might see on Linda's face.

Thibodeau peered into the bowl. 'No milk?'

'He doesn't need milk,' Jackie said, and spat into the bowl of Special K. 'I'll wet it down for him.'

A cheer went up from the others. Several clapped.

Jackie and Linda got as far as the stairs before Thibodeau said, 'Gimme that.'

For a moment Jackie froze. She saw herself flinging the bowl at him, then taking to her heels. What stopped her was a simple fact: they had nowhere to run. Even if they made it out of the station, they'd be collared before they could get past the War Memorial.

Linda took the Tupperware bowl from Jackie's hands and held it out. Thibodeau peered into it. Then, instead of investigating the cereal for hidden treats, he spat into it himself.

'My contribution,' he said.

'Wait a minute, wait a minute,' the Conree girl said. She was a rangy redhead with a model's body and acne-ravaged cheeks. Her voice was a little foggy, because she had one finger rammed up her nose to the second knuckle. 'I got sumpin, too.' Her finger emerged with a large booger riding the end of it. Ms Conree deposited it on top of the cereal, to more applause and someone's cry of *'Laurie mines for the green gold!'*

'Every box of cereal s'posed to have a toy surprise in it,' she said, smiling vacantly. She dropped her hand to the butt of the .45 she was wearing. Thin as she was, Jackie thought the recoil would probably blow her right off her feet if she ever had occasion to fire it.

'All set,' Thibodeau said. 'I'll keep you company.'

'Good,' Jackie said, and when she thought of how close she'd come to just putting the note in her pocket and trying to hand it

to Barbie, she felt cold. All at once the risk they were taking seemed insane . . . but it was too late now. 'Stay back by the stairs, though. And Linda, you keep behind me. We take no chances.'

She thought he might argue that, but he didn't.

24

Barbie sat up on the bunk. On the other side of the bars stood Jackie Wettington with a white plastic bowl in one hand. Behind her, Linda Everett had her gun drawn and held in a double fist, pointing at the floor. Carter Thibodeau was last in line at the foot of the stairs with his hair in sleep-spikes and his blue uniform shirt unbuttoned to show the bandage covering the dogbite on his shoulder.

'Hello, Officer Wettington,' Barbie said. Thin white light was creeping in through his slit of a window. It was the kind of first light that makes life seem like the joke of jokes. 'I'm innocent of all accusations. I can't call them charges, because I haven't been—'

'Shut up,' Linda said from behind her. 'We're not interested.'

'Tell it, Blondie,' Carter said. 'You go, girl.' He yawned and scratched at the bandage.

'Sit right there,' Jackie said. 'Don't you move a muscle.'

Barbie sat. She pushed the plastic bowl through the bars. It was small, and just fit.

He picked up the bowl. It was filled with what looked like Special K. Spit gleamed on top of the dry cereal. Something else as well: a large green booger, damp and threaded with blood. And still his stomach rumbled. He was very hungry.

He was also hurt, in spite of himself. Because he'd thought Jackie Wettington, whom he had spotted as ex-military the first time he saw her (it was partly the haircut, mostly her way of carrying herself), was better than this. It had been easy to deal with Henry Morrison's disgust. This was harder. And the other woman cop – the one married to Rusty Everett – was looking at him as if he were some rare species of stinging bug. He had hoped at least some of the department's regular officers—

'Eat up,' Thibodeau called from his place on the steps. 'We fixed it nice for you. Didn't we, girls?'

'We did,' Linda agreed. The corners of her mouth twitched down. It was little more than a tic, but Barbie's heart lightened. He thought she was faking. Maybe that was hoping for too much, but—

She moved slightly, blocking Thibodeau's line of sight to Jackie with her body . . . although there was no real need. Thibodeau

was otherwise occupied with trying to peek under the edge of his bandage.

Jackie glanced back to make sure she was clear, then pointed to the bowl, turned her hands up, and raised her eyebrows: *Sorry*. After that she pointed two fingers at Barbie. *Pay attention.*

He nodded.

'Enjoy it, fuckstick,' Jackie said. 'We'll get you something better at noon. I'm thinking pissburger.'

From the stairs, where he was now picking at the edges of the bandage, Thibodeau gave a bark of laughter.

'If you've got any teeth left to eat it with,' Linda said.

Barbie wished she had kept silent. She didn't sound sadistic, or even angry. She only sounded scared, a woman who wished to be anywhere but here. Thibodeau, however, didn't seem to notice. He was still investigating the state of his shoulder.

'Come on,' Jackie said. 'I don't want to watch him eat.'

'That wet enough for you?' Thibodeau asked. He stood up as the women came down the corridor between the cells to the stairs, Linda reholstering her weapon. 'Cause if it's not . . .' He hawked back phlegm.

'I'll make do,' Barbie said.

'Course you will,' Thibodeau said. 'For a while. Then you won't.'

They went up the stairs. Thibodeau went last, and gave Jackie a whack on the butt. She laughed and slapped at him. She was good, a lot better than the Everett woman. But they had both just shown plenty of guts. *Fearsome* guts.

Barbie picked the booger off the Special K and flicked it toward the corner he'd pissed in. He wiped his hands on his shirt. Then he began to dig down through the cereal. At the bottom, his fingers found a slip of paper.

Try to make it until tomorrow night. If we can get you out can you think of a safe place. You know what to do with this.

Barbie did.

25

An hour after he ate the note and then the cereal, heavy footsteps slowly descended the stairs. It was Big Jim Rennie, already dressed in a suit and a tie for another day of under-the-Dome administration. He was followed by Carter Thibodeau and another fellow – a Killian, judging by the shape of his head. The Killian boy was carrying a chair, and making difficulties with it; he was what old-time Yankees would have called 'a gormy lad.' He handed the chair to Thibodeau,

who placed it in front of the cell at the end of the corridor. Rennie sat down, delicately tweezing his pantslegs first to preserve the crease.

'Good morning, Mr Barbara.' There was a slight, satisfied emphasis on the civilian title.

'Selectman Rennie,' Barbie said. 'What can I do for you besides give you my name, rank, and serial number . . . which I'm not sure I remember?'

'Confess. Save us some trouble and soothe your own soul.'

'Mr Searles mentioned something last night about waterboarding,' Barbie said. 'He asked me if I'd ever seen it in Iraq.'

Rennie's mouth was pursed in a slight smile that seemed to say *Tell me more, talking animals are so interesting.*

'In fact, I did. I have no idea how often the technique was actually used in the field – reports varied – but I saw it twice. One of the men confessed, although his confession was worthless. The man he named as an Al Qaeda bombmaker turned out to be a schoolteacher who'd left Iraq for Kuwait fourteen months previous. The other man had a convulsion and suffered brain damage, so there was no confession from him. Had he been capable, though, I'm sure he would have given one. *Everybody* confesses when they're waterboarded, usually in a matter of minutes. I'm sure I would, too.'

'Then save yourself some grief,' Big Jim said.

'You look tired, sir. Are you well?'

The tiny smile was replaced by a tiny frown. It emanated from the deep crease between Rennie's eyebrows. 'My current condition is none of your concern. A word of advice, Mr Barbara. Don't bullspit me and I won't bullspit you. What you should be concerned about is your own condition. It may be fine now, but that could change. In a matter of minutes. You see, I am indeed thinking of having you waterboarded. Am, in fact, seriously considering it. So confess to these murders. Save yourself a lot of pain and trouble.'

'I think not. And if you waterboard me, I'm apt to talk about all sorts of things. Probably ought to keep that in mind when you decide who you want in the room when I start talking.'

Rennie considered this. Although he was neatly put together, especially for such an early hour, his complexion was sallow and his small eyes were rimmed with purple flesh like bruises. He really did not look well. If Big Jim just dropped dead, Barbie could see two possible results. One was that the ugly political weather in The Mill would clear without spawning any further tornadoes. The other was a chaotic bloodbath in which Barbie's own death (quite likely by lynching rather than firing squad) would be followed by a purge of

his suspected co-conspirators. Julia might be first on that list. And Rose could be number two; frightened people were great believers in guilt by association.

Rennie turned to Thibodeau. 'Step back, Carter. All the way to the stairs, if you please.'

'But if he makes a grab for you—'

'Then you'd kill him. And he knows it. Don't you, Mr Barbara?'

Barbie nodded.

'Besides, I'm not getting any closer than this. Which is why I want you to step back. We're having a private conversation here.'

Thibodeau stepped back.

'Now, Mr Barbara – what things would you talk about?'

'I know all about the meth lab.' Barbie kept his voice pitched low. 'Chief Perkins knew, and he was getting ready to arrest you. Brenda found the file on his computer. It's why you killed her.'

Rennie smiled. '*That's* an ambitious fantasy.'

'The State Attorney General won't think so, given your motive. We're not talking about some half-assed cook-up in a mobile home; this is the General Motors of meth.'

'By the end of the day,' Rennie said, 'Perkins's computer will be destroyed. Hers, as well. I suppose there may be a copy of certain papers in Duke's home safe – meaningless, of course; vicious, politically motivated garbage from the mind of a man who always loathed me – and if so, the safe will be opened and the papers will be burned. For the town's good, not mine. This is a crisis situation. We all need to pull together.'

'Brenda passed on a copy of that file before she died.'

Big Jim grinned, revealing a double row of tiny teeth. 'One confabulation deserves another, Mr Barbara. Shall I confabulate?'

Barbie spread his hands: *Be my guest.*

'In my confabulation, Brenda comes to see me and tells me that same thing. She says she gave the copy of which you speak to Julia Shumway. But I know it's a lie. She may have meant to, but she did not. Even if she had—' He shrugged. 'Your cohorts burned down Shumway's newspaper last night. That was a bad decision on their part. Or was it your idea?'

Barbara repeated: 'There *is* another copy. I know where it is. If you waterboard me, I will confess that location. Loudly.'

Rennie laughed. 'Put with great sincerity, Mr Barbara, but I've spent my whole life dickering, and I know a bluff when I hear one. Perhaps I should just have you summarily executed. The town would cheer.'

'How loudly, if you did it without discovering my co-conspirators first? Even Peter Randolph might question that decision, and he's nothing but a dumb and frightened lickspittle.'

Big Jim stood up. His hanging cheeks had gone the color of old brick. 'You don't know who you're playing with here.'

'Sure I do. I saw your kind again and again in Iraq. They wear turbans instead of ties, but otherwise they're just the same. Right down to the blather about God.'

'Well, you've talked me out of waterboarding,' Big Jim said. 'It's a shame, too, because I always wanted to see it firsthand.'

'I'll bet.'

'For now we'll just keep you in this cozy cell, all right? I don't think you'll eat much, because eating interferes with thinking. Who knows? With constructive thinking, you may come up with better reasons for me to allow you to go on living. The names of those in town who are against me, for instance. A complete list. I'll give you forty-eight hours. Then, if you can't convince me otherwise, you'll be executed in War Memorial Plaza with the entire town looking on. You'll serve as an object lesson.'

'You really don't look well, Selectman.'

Rennie studied him gravely. 'It's your kind that causes most of the trouble in the world. If I didn't think your execution would serve this town as a unifying principle and a much-needed catharsis, I'd have Mr Thibodeau shoot you right now.'

'Do that and it all comes out,' Barbie said. 'People from one end of this town to the other will know about your operation. Try getting a consensus at your motherfucking town meeting then, you tinpot tyrant.'

The veins swelled on the sides of Big Jim's neck; another beat in the center of his forehead. For a moment he looked on the verge of exploding. Then he smiled. 'A for effort, Mr Barbara. But you lie.'

He left. They all left. Barbie sat on his bunk, sweating. He knew how close to the edge he was. Rennie had reasons to keep him alive, but not strong ones. And then there was the note delivered by Jackie Wettington and Linda Everett. The expression on Mrs Everett's face suggested that she knew enough to be terrified, and not just for herself. It would have been safer for him to try and escape using the knife. Given the current level of professionalism in the Chester's Mill PD, he thought it could be done. It would take a little luck, but it could be done.

He had, however, no way of telling them to let him try it on his own.

Barbie lay down and put his hands behind his head. One question nagged him above all others: what had happened to the copy of the VADER file meant for Julia? Because it hadn't reached her; about that he was sure Rennie had been telling the truth.

No way of knowing, and nothing to do but wait.

Lying on his back, looking up at the ceiling, Barbie began to do it.

PLAY THAT DEAD BAND SONG

1

When Linda and Jackie came back from the PD, Rusty and the girls were sitting on the front step waiting for them. The Js were still in their nighties – light cotton ones, not the flannels they were used to at this time of year. Although it was still not quite seven a.m., the thermometer outside the kitchen window had the temperature at sixty-six degrees.

Ordinarily, the two girls would have flown down the walk to embrace their mother far in advance of Rusty, but this morning he beat them by several yards. He seized Linda around the waist and she wrapped her arms around his neck with almost painful tightness – not a hello-handsome hug, but a drowner's grip.

'Are you all right?' he whispered in her ear.

Her hair brushed up and down against his cheek as she nodded. Then she drew back. Her eyes were shining. 'I was sure Thibodeau would look in the cereal, it was Jackie's idea to spit in it, that was genius, but I was *certain*—'

'Why is mommy crying?' Judy asked. She sounded ready to cry herself.

'I'm not,' she said, then wiped her eyes. 'Well, maybe a little. Because I'm so happy to see your dad.'

'We're *all* happy to see him!' Janelle told Jackie. 'Because my Daddy, *HE'S THE BOSS!*'

'News to me,' Rusty said, then kissed Linda on the mouth, hard.

'Lips-kissin!' Janelle said, fascinated. Judy covered her eyes and giggled.

'Come on, girls, swings,' Jackie said. 'Then you get dressed for school.'

'*I WANT TO LOOPIE DA LOOP!*' Janelle screamed, leading the way.

'School?' Rusty asked. 'Really?'

'Really,' Linda said. 'Just the little ones, at East Street Grammar. Half a day. Wendy Goldstone and Ellen Vanedestine volunteered to take classes. K through three in one room, four through six in another. I don't know if any actual learning will happen, but it'll give the kids a place to go, and a sense of normalcy. Maybe.' She looked up at the sky, which was cloudless but had a yellowish tinge all the same. *Like a blue eye with a cataract growing on it,* she thought. 'I could use some normalcy myself. Look at that sky.'

Rusty glanced up briefly, then held his wife at arms' length so he could study her. 'You got away with it? You're sure?'

'Yes. But it was close. This kind of thing may be fun in spy movies, but in real life it's awful. I won't break him out, honey. Because of the girls.'

'Dictators always hold the children hostage,' Rusty said. 'At some point people have to say that no longer works.'

'But not here and not yet. This is Jackie's idea, so let her handle it. I won't be a part of it, and I won't let *you* be a part of it.' Yet he knew that if he demanded this of her, she would do as he asked; it was the expression under her expression. If that made him the boss, he didn't want to be.

'You're going in to work?' he asked.

'Of course. Kids go to Marta, Marta takes kids to school, Linda and Jackie report for another day of police work under the Dome. Anything else would look funny. I hate having to think this way.' She blew out a breath. 'Also, I'm tired.' She glanced to make sure the kids were out of earshot. 'Fucking exhausted. I hardly slept at all. Are you going in to the hospital?'

Rusty shook his head. 'Ginny and Twitch are going to be on their own at least until noon . . . although with the new guy to help them out, I think they'll be okay. Thurston's kind of New Age-y, but he's good. I'm going over to Claire McClatchey's. I need to talk to those kids, and I need to go out to where they got the radiation spike on the Geiger counter.'

'What do I tell people who ask where you are?'

Rusty considered this. 'The truth, I guess. Some of it, anyway. Say I'm investigating a possible Dome generator. That might make Rennie think twice about whatever next step he's planning.'

'And when I'm asked about the location? Because I will be.'

'Say you don't know, but you think it's on the western side of town.'

'Black Ridge is north.'

'Yep. If Rennie tells Randolph to send out some of his Mounties, I want them to go to the wrong place. If someone calls you on it later, just say you were tired and must have gotten mixed up. And listen, hon – before you go in to the PD, make a list of people who may believe Barbie's innocent of the murders.' Thinking again, *Us and them.* 'We need to talk to those people before the town meeting tomorrow. Very discreetly.'

'Rusty, are you sure about this? Because after the fire last night, this whole town is going to be on the lookout for the Friends of Dale Barbara.'

'Am I sure? Yes. Do I like it? Most assuredly not.'

She looked up again at the yellow-tinged sky, then at the two oaks in their front yard, the leaves hanging limp and moveless, their bright colors fading to drab brown. She sighed. 'If Rennie framed Barbara, then he probably had the newspaper burned down. You know that, right?'

'I do.'

'And if Jackie *can* get Barbara out of jail, where will she put him? Where in town is safe?'

'I'll have to think about that.'

'If you can find the generator and turn it off, all this *I Spy* crap becomes unnecessary.'

'You pray that happens.'

'I will. What about radiation? I don't want you coming down with leukemia, or something.'

'I have an idea about that.'

'Should I ask?'

He smiled. 'Probably not. It's pretty crazy.'

She twined her fingers through his. 'Be careful.'

He kissed her lightly. 'You too.'

They looked at Jackie pushing the girls on the swings. They had a lot to be careful for. All the same, Rusty thought that risk was coming into his life as a major factor. If, that was, he wanted to be able to continue looking at his reflection when he took his morning shave.

2

Horace the Corgi liked peoplefood.

In fact, Horace the Corgi *loved* peoplefood. Being a little over-weight (not to mention a little gray about the muzzle in these latter years), he wasn't supposed to have it, and Julia had been good about stopping the table feeding after the vet had told her bluntly that her generosity was shortening her housemate's life. That conversation had taken place sixteen months ago; since then Horace had been restricted to Bil-Jac and the occasional dietetic dog treat. The treats resembled Styrofoam packing-poppers, and judging from the reproachful way Horace looked at her before eating them, she guessed they probably tasted like packing-poppers, too. But she stuck to her guns: no more fried chicken skin, no more Cheez Doodles, no more bites of her morning doughnut.

This limited Horace's intake of *verboten* comestibles, but did not

entirely end it; the imposed diet simply reduced him to foraging, which Horace rather enjoyed, returning him as it did to the hunting nature of his foxy forebears. His morning and evening walks were especially rich in culinary delights. It was amazing what people left in the gutters along Main Street and West Street, which formed his usual walkie-walk route. There were french fries, potato chips, discarded peanut butter crackers, the occasional ice cream bar wrapper with some chocolate still adhering to it. Once he came upon an entire Table Talk pie. It was out of its dish and in his stomach before you could say *cholesterol*.

He didn't succeed in snarking all the goodies he came upon; sometimes Julia saw what he was after and jerked him along on his leash before he could ingest it. But he got a lot, because Julia often walked him with a book or a folded copy of the *New York Times* in one hand. Being ignored in favor of the *Times* wasn't always good – when he wanted a thorough belly-scratch, for instance – but during walkies, ignorance was bliss. For small yellow Corgis, ignorance meant snacks.

He was being ignored this morning. Julia and the other woman – the one who owned this house, because her smell was all over it, especially in the vicinity of the room where humans went to drop their scat and mark their territory – were talking. Once the other woman cried, and Julia hugged her.

'I'm better, but not *all* better,' Andrea said. They were in the kitchen. Horace could smell the coffee they were drinking. Cold coffee, not hot. He could also smell pastries. The kind with icing. 'I still want it.' If she was talking about pastries with icing, so did Horace.

'The craving may go on for a long time,' Julia said, 'and that's not even the important part. I salute your courage, Andi, but Rusty was right – cold turkey is foolish and dangerous. You're damn lucky you haven't had a convulsion.'

'For all I know, I have.' Andrea drank some of her coffee. Horace heard the slurp. 'I've been having some damned vivid dreams. One was about a fire. A big one. On Halloween.'

'But you're better.'

'A little. I'm starting to think I can make it. Julia, you're welcome to stay here with me, but I think you could find a better place. The smell—'

'We can do something about the smell. We'll get a battery-powered fan from Burpee's. If room and board is a firm offer – one that includes Horace – I'll take you up on it. No one trying to kick an addiction should have to do it on her own.'

'I don't think there's any other way, hon.'

'You know what I mean. Why did you do it?'

'Because for the first time since I got elected, this town might need me. And because Jim Rennie threatened to withhold my pills if I objected to his plans.'

Horace tuned the rest of this out. He was more interested in a smell wafting to his sensitive nose from the space between the wall and one end of the couch. It was on this couch that Andrea liked to sit in better (if considerably more medicated) days, sometimes watching shows like *The Hunted Ones* (a clever sequel to *Lost*) and *Dancing with the Stars*, sometimes a movie on HBO. On movie nights she often had microwave popcorn. She'd put the bowl on the endtable. Because stoners are rarely neat, there was a scattering of popcorn down there below the table. This was what Horace had smelled.

Leaving the women to their blah, he worked his way under the little table and into the gap. It was a narrow space, but the endtable formed a natural bridge and he was a fairly narrow dog, especially since going on the Corgi version of WeightWatchers. The first kernels were just beyond the VADER file, lying there in its manila envelope. Horace was actually standing on his mistress's name (printed in the late Brenda Perkins's neat hand) and hoovering up the first bits of a surprisingly rich treasure trove, when Andrea and Julia walked back into the living room.

A woman said, *Take that to her.*

Horace looked up, his ears pricking. That was not Julia or the other woman; it was a deadvoice. Horace, like all dogs, heard deadvoices quite often, and sometimes saw their owners. The dead were all around, but living people saw them no more than they could smell most of the ten thousand aromas that surrounded them every minute of every day.

Take that to Julia, she needs it, it's hers.

That was ridiculous. Julia would never eat anything that had been in his mouth, Horace knew this from long experience. Even if he pushed it out with his snout she wouldn't eat it. It was peoplefood, yes, but now it was also floorfood.

Not the popcorn. The—

'Horace?' Julia asked in that sharp voice that said he was being bad – as in *Oh, you bad dog, you know better*, blah-blah-blah. 'What are you doing back there? Come out.'

Horace threw it in reverse. He gave her his most charming grin – gosh, Julia, how I love you – hoping that no popcorn was stuck

to the end of his nose. He'd gotten a few pieces, but he sensed the real motherlode had escaped him.

'Have you been foraging?'

Horace sat, looking up at her with the proper expression of adoration. Which he did feel; he loved Julia very much.

'A better question would be *what* have you been foraging?' She bent to look into the gap between the couch and the wall.

Before she could, the other woman began to make a gagging noise. She wrapped her arms around herself in an effort to stop a shivering fit, but was unsuccessful. Her smell changed, and Horace knew she was going to yark. He watched closely. Sometimes peopleyark had good things in it.

'Andi?' Julia asked. 'Are you okay?'

Stupid question, Horace thought. *Can't you smell her?* But that was a stupid question, too. Julia could hardly smell herself when she was sweaty.

'Yes. No. I shouldn't have eaten that raisin bun. I'm going to—' She hurried out of the room. To add to the smells coming from the piss-and-scat place, Horace assumed. Julia followed. For a moment Horace debated squeezing back under the table, but he smelled worry on Julia and hurried at her heels instead.

He had forgotten all about the deadvoice.

3

Rusty called Claire McClatchey from the car. It was early, but she answered on the first ring, and he wasn't surprised. No one in Chester's Mill was getting much sleep these days, at least not without pharmacological assistance.

She promised to have Joe and his friends at the house by eight thirty at the latest, would pick them up herself, if necessary. Lowering her voice, she said, 'I think Joe is crushing on the Calvert girl.'

'He'd be a fool not to,' Rusty said.

'Will you have to take them out there?'

'Yes, but not into a high radiation zone. I promise you that, Mrs McClatchey.'

'Claire. If I'm going to allow my son to go with you to an area where the animals apparently commit suicide, I think we should be on a first-name basis.'

'You get Benny and Norrie to your house and I promise to take care of them on the field trip. That work for you?'

Claire said it did. Five minutes after hanging up on her, Rusty

was turning off an eerily deserted Motton Road and onto Drummond Lane, a short street lined with Eastchester's nicest homes. The nicest of the nice was the one with BURPEE on the mailbox. Rusty was soon in the Burpee kitchen, drinking coffee (hot; the Burpee generator was still working) with Romeo and his wife, Michela. Both of them looked pale and grim. Rommie was dressed, Michela still in her housecoat.

'You t'ink dat guy Barbie really killed Bren?' Rommie asked. 'Because if he did, my friend, I'm gonna kill him myself.'

Michela put a hand on his arm. 'You ain't that dumb, honey.'

'I don't think so,' Rusty said. 'I think he was framed. But if you tell people I said that, we could all be in trouble.'

'Rommie always loved that woman.' Michela was smiling, but there was frost in her voice. 'More than me, I sometimes think.'

Rommie neither confirmed nor denied this — seemed, in fact, not to hear it at all. He leaned toward Rusty, his brown eyes intent. 'What you talking 'bout, doc? Framed how?'

'Nothing I want to go into now. I'm here on other business. And I'm afraid this is also secret.'

'Then I don't want to hear it,' Michela said. She left the room, taking her coffee cup with her.

'Ain't gonna be no lovin from dat woman tonight,' Rommie said.

'I'm sorry.'

Rommie shrugged. 'I got 'nother one, crosstown. Misha knows, although she don't let on. Tell me what your other bi'ness is, doc.'

'Some kids think they may have found what's generating the Dome. They're young but smart. I trust them. They had a Geiger counter, and they got a radiation spike out on Black Ridge Road. Not into the danger zone, but they didn't get all that close.'

'Close to what? What'd they see?'

'A flashing purple light. You know where the old orchard is?'

'Hell, yeah. The McCoy place. I used to take girls parkin dere. You can see the whole town. I had dis ole Willys . . .' He looked momentarily wistful. 'Well, never mind. Just a flashin light?'

'They also came across a lot of dead animals — some deer, a bear. Looked to the kids like they committed suicide.'

Rommie regarded him gravely. 'I'm going wit you.'

'That's fine . . . up to a point. One of us has got to go all the way, and that should be me. But I need a radiation suit.'

'What you got in mind, doc?'

Rusty told him. When he had finished, Rommie produced a package of Winstons and offered the pack across the table.

'My favorite OPs,' Rusty said, and took one. 'So what do you think?'

'Oh, I can help you,' Rommie said, lighting them up. 'I got everthin in dat store of mine, as everyone in dis town well know.' He pointed his cigarette at Rusty. 'But you ain't gonna want any pictures of yourself in the paper, because gonna look damn funny, you.'

'Not worried about dat, me,' Rusty said. 'Newspaper burned down last night.'

'I heard,' Rommie said. 'Dat guy Barbara again. His friens.'

'Do you believe that?'

'Oh, I'm a believin soul. When Bush said there was nukes an such in Iraq, I believed *dat*. I tell people, "He's the guy who knows." Also b'lieve dat Oswal' act alone, me.'

From the other room, Michela called: 'Stop talking that fake French shit.'

Rommie gave Rusty a grin that said, *You see what I have to put up with.* 'Yes, my dear,' he said, and with absolutely no trace of his Lucky Pierre accent. Then he faced Rusty again. 'Leave your car here. We'll take my van. More space. Drop me off at the store, then get those kids. I'll put together your radiation suit. But as for gloves . . . I don't know.'

'We've got lead-lined gloves in the X-ray room closet at the hospital. Go all the way up to the elbow. I can grab one of the aprons—'

'Good idea, hate to see you risk your sperm count—'

'Also there might be a pair or two of the lead-lined goggles the techs and radiologists used to wear back in the seventies. Although they could have been thrown out. What I'm hoping is that the radiation count doesn't go much higher than the last reading the kids got, which was still in the green.'

'Except you said they didn't get all dat close.'

Rusty sighed. 'If the needle on that Geiger counter hits eight hundred or a thousand counts per second, my continued fertility is going to be the least of my worries.'

Before they left, Michela — now dressed in a short skirt and a spectacularly cozy sweater — swept back into the kitchen and berated her husband for a fool. He'd get them in trouble. He'd done it before and would do it again. Only this might be worse trouble than he knew.

Rommie took her in his arms and spoke to her in rapid French. She replied in the same language, spitting the words. He responded.

She beat a fist twice against his shoulder, then cried and kissed him. Outside, Rommie turned to Rusty apologetically and shrugged.

'She can't help it,' he said. 'She's got the soul of a poet and the emotional makeup of a junkyard dog.'

4

When Rusty and Romeo Burpee got to the department store, Toby Manning was already there, waiting to open up and serve the public, if that was Rommie's pleasure. Petra Searles, who worked across the street in the drugstore, was sitting with him. They were in lawn chairs with tags reading END OF SUMMER BLOWOUT SALE hanging from the arms.

'Sure you don't want to tell me about this radiation suit you're going to build before' — Rusty looked at his watch — 'ten o'clock?'

'Better not,' Rommie said. 'You'd call me crazy. Go on, Doc. Get those gloves and goggles and the apron. Talk to the kids. Gimme some time.'

'We opening, boss?' Toby asked when Rommie got out.

'Dunno. Maybe this afternoon. Gonna be a l'il busy dis mornin, me.'

Rusty drove away. He was on Town Common Hill before he realized that both Toby and Petra had been wearing blue armbands.

5

He found gloves, aprons, and one pair of lead-lined goggles in the back of the X-ray closet, about two seconds before he was ready to give up. The goggles' strap was busted, but he was sure Rommie could staple it back together. As a bonus, he didn't have to explain to anyone what he was doing. The whole hospital seemed to be sleeping.

He went back out, sniffed at the air — flat, with an unpleasant smoky undertang — and looked west, at the hanging black smear where the missiles had struck. It looked like a skin tumor. He knew he was concentrating on Barbie and Big Jim and the murders because they were the human element, things he sort of understood. But ignoring the Dome would be a mistake — a potentially catastrophic one. It had to go away, and soon, or his patients with asthma and COPD were going to start having problems. And they were really just the canaries in the coal mine.

That nicotine-stained sky.

'Not good,' he muttered, and threw his salvage into the back of the van. 'Not good at all.'

6

All three children were at the McClatchey house when he got there, and oddly subdued for kids who might be acclaimed national heroes by the end of this Wednesday in October, if fortune favored them.

'You guys ready?' Rusty asked, more heartily than he felt. 'Before we go out there we have to stop at Burpee's, but that shouldn't take 1—'

'They've got something to tell you first,' Claire said. 'I wish to God they didn't. This just keeps getting worse and worse. Would you like a glass of orange juice? We're trying to drink it up before it goes spunky.'

Rusty held his thumb and forefinger close together to indicate just a little. He'd never been much of an OJ man, but he wanted her out of the room and sensed she wanted to go. She looked pale and sounded scared. He didn't think this was about what the kids had found out on Black Ridge; this was something else.

Just what I need, he thought.

When she was gone he said, 'Spill it.'

Benny and Norrie turned to Joe. He sighed, brushed his hair off his forehead, sighed again. There was little resemblance between this serious young adolescent and the sign-waving, hell-raising kid in Alden Dinsmore's field three days ago. His face was as pale as his mother's, and a few pimples – maybe his first – had appeared on his forehead. Rusty had seen such sudden outbreaks before. They were stress-pimples.

'What is it, Joe?'

'People say I'm smart,' Joe said, and Rusty was alarmed to see the kid was on the verge of tears. 'I guess I am, but sometimes I wish I wasn't.'

'Don't worry,' Benny said, 'you're stupid in lots of important ways.'

'Shut up, Benny,' Norrie said kindly.

Joe took no notice. 'I could beat my dad at chess when I was six, and my mom by the time I was eight. Get A's in school. Always won the Science Fair. Been writing my own computer programs for two years. I'm not bragging. I know I'm a geek.'

Norrie smiled and put her hand on his. He held it.

'But I just make connections, see? That's all it is. If A, then B. If *not* A, then B is out to lunch. And probably the whole alphabet.'

'What exactly are we talking about, Joe?'

'I don't think the cook did those murders. That is, *we* don't.'

He seemed relieved when Norrie and Benny both nodded. But that was nothing to the look of gladness (mixed with incredulity) that came over his face when Rusty said, 'Neither do I.'

'Told you he had major chops,' Benny said. 'Gives awesome stitches, too.'

Claire came back with juice in a tiny glass. Rusty sipped. Warm but drinkable. With no gennie, by tomorrow it wouldn't be.

'Why don't *you* think he did it?' Norrie asked.

'You guys first.' The generator on Black Ridge had momentarily slipped to the back of Rusty's mind.

'We saw Mrs Perkins yesterday morning,' Joe said. 'We were on the Common, just starting to prospect with the Geiger counter. She was going up Town Common Hill.'

Rusty put his glass on the table next to his chair and sat forward with his hands clasped between his knees. 'What time was this?'

'My watch stopped out at the Dome on Sunday, so I can't say exactly, but the big fight at the supermarket was going on when we saw her. So it had to be, like, quarter past nine. No later than that.'

'And no earlier. Because the riot was going on. You heard it.'

'Yeah,' Norrie said. 'It was really loud.'

'And you're positive it was Brenda Perkins? It couldn't have been some other woman?' Rusty's heart was thumping. If she had been seen alive during the riot, then Barbie was indeed in the clear.

'We all know her,' Norrie said. 'She was even my den mother in Girl Scouts before I quit.' The fact that she'd actually been kicked out for smoking did not seem relevant, so she omitted it.

'And I know from Mom what people are saying about the murders,' Joe said. 'She told me all she knew. You know, the dog tags.'

'Mom did not *want* to tell all she knew,' Claire said, 'but my son can be very insistent and this seemed important.'

'It is,' Rusty said. 'Where did Mrs Perkins go?'

Benny answered this one. 'First to Mrs Grinnell's, but whatever she said must not have been cool, because Mrs Grinnell slammed the door in her face.'

Rusty frowned.

'It's true,' Norrie said. 'I think Mrs Perkins was delivering her mail or something. She gave an envelope to Mrs Grinnell. Mrs Grinnell took it, then slammed the door. Like Benny said.'

'Huh,' Rusty said. As if there'd been any delivery in Chester's Mill since last Friday. But what seemed important was that Brenda had been alive and running errands at a time when Barbie was alibied. 'Then where did she go?'

'Crossed Main and walked up Mill Street,' Joe said.

'This street.'

'Right.'

Rusty switched his attention to Claire. 'Did she—'

'She didn't come here,' Claire said. 'Unless it was while I was down cellar, seeing what I have left for canned goods. I was down there for half an hour. Maybe forty minutes. I . . . I wanted to get away from the noise at the market.'

Benny said what he'd said the day before: 'Mill Street's four blocks long. Lot of houses.'

'To me that's not the important part,' Joe said. 'I called Anson Wheeler. He used to be a thrasher himself, and he sometimes still takes his board to The Pit over in Oxford. I asked him if Mr Barbara was at work yesterday morning, and he said yes. He said Mr Barbara went down to Food City when the riot started. He was with Anson and Miz Twitchell from then on. So Mr Barbara's alibied for Miz Perkins, and remember what I said about if *not* A, then not B? Not the whole alphabet?'

Rusty thought the metaphor was a little too mathematical for human affairs, but he understood what Joe was saying. There were other victims for whom Barbie might not have an alibi, but the same body-dump argued strongly for the same killer. And if Big Jim *had* done at least one of the victims – as the stitch marks on Coggins's face suggested – then he had likely done them all.

Or it might have been Junior. Junior who was now wearing a gun and carrying a badge.

'We need to go to the police, don't we?' Norrie said.

'I'm scared about that,' Claire said. 'I'm really, really scared about that. What if Rennie killed Brenda Perkins? He lives on this street, too.'

'That's what *I* said, yesterday,' Norrie told her.

'And doesn't it seem likely that if she went to see one selectman and got the door slammed in her face, she'd then go on and try the next one in the neighborhood?'

Joe said (rather indulgently), 'I doubt if there's any connection, Mom.'

'Maybe not, but she still could have been going to see Jim Rennie. And Peter Randolph . . .' She shook her head. 'When Big Jim says jump, Peter asks how high.'

'Good one, Mrs McClatchey!' Benny cried. 'You rule, o mother of my—'

'Thank you, Benny, but in this town, Jim Rennie rules.'

'What do we do?' Joe was looking at Rusty with troubled eyes.

Rusty thought of the smudge again. The yellow sky. The smell of smoke in the air. He also spared a thought for Jackie Wettington's determination to break Barbie out. Dangerous as it might be, it was probably a better chance for the guy than the testimony of three kids, especially when the Police Chief receiving it was just about capable of wiping his ass without an instruction booklet.

'Right now, nothing. Dale Barbara's safe right where he is.' Rusty hoped this was true. 'We've got this other thing to deal with. If you really found the Dome generator, and we can turn it off—'

'The rest of the problems will just about solve themselves,' Norrie Calvert said. She looked profoundly relieved.

'They actually might,' Rusty said.

7

After Petra Searles went back to the drugstore (to do inventory, she said), Toby Manning asked Rommie if he could help with anything. Rommie shook his head. 'Go on home. See what you can do for your dad and mom.'

'It's just Dad,' Toby said. 'Mom went to the supermarket over in Castle Rock Saturday morning. She says the prices at Food City are too high. What are you going to do?'

'Nothin much,' Rommie said vaguely. 'Tell me somethin, Tobes – why you an Petra wearin those blue rags around your arms?'

Toby glanced at it as if he'd forgotten it was there. 'Just showing solidarity,' he said. 'After what happened last night at the hospital . . . after *everything* that's been happening . . .'

Rommie nodded. 'You ain't deputized, nor nothin?'

'Heck, no. It's more . . . you remember after nine-eleven, when it seemed like everybody had a New York Fire Department or Police Department hat and shirt? It's like that.' He considered. 'I guess if they needed help, I'd be glad to pitch in, but it seems like they're doing fine. You sure you don't need help?'

'Yuh. Now scat. I'll call you if I decide to open this afternoon.'

'Okay.' Toby's eyes gleamed. 'Maybe we could have a Dome Sale. You know what they say – when life hands you lemons, make lemonade.'

'Maybe, maybe,' Rommie said, but he doubted there would be

any such sale. This morning he was much less interested than he had been in unloading shoddy goods at prices that looked like bargains. He felt that he had undergone big changes in the last three days — not so much of character as of perspective. Some of it had to do with fighting the fire and the camaraderie afterward. That had been the real town at work, he thought. The town's better nature. And a lot of it had to do with the murder of his once-upon-a-time lover, Brenda Perkins . . . whom Rommie still thought of as Brenda Neale. One hot ticket she'd been, and if he discovered who had cooled her off — assuming that Rusty was right about it not being Dale Barbara — that person would pay. Rommie Burpee would see to that personally.

At the back of his cavernous store was the Home Repairs section, conveniently located next to the Do-It-Yourself section. Rommie grabbed a set of heavy-duty metal snips from the latter, then entered the former and proceeded to the farthest, darkest, and dustiest corner of his retail kingdom. Here he found two dozen fifty-pound rolls of Santa Rosa lead sheeting, ordinarily used for roofing, flashing, and chimney insulation. He loaded two of the rolls (and the metal snips) into a shopping cart and rolled the cart back through the store until he reached the sports department. Here he set to work picking and choosing. Several times he burst out laughing. It was going to work, but yes, Rusty Everett was going to look *très amusant*.

When he was done, he straightened up to stretch the kinks out of his back and caught sight of a deer-in-the-crosshairs poster on the far side of the sports department. Printed above the deer was this reminder: HUNTING SEASON'S ALMOST HERE — TIME TO GUN UP!

Given the way things were going, Rommie thought that gunning up might be a good idea. Especially if Rennie or Randolph decided that confiscating any weapons but those belonging to the cops would be a good idea.

He rolled another shopping cart over to the locked rifle cases, working through the considerable ring of keys hanging from his belt by touch alone. Burpee's sold exclusively Winchester products, and given that deer season was only a week away, Rommie thought he could justify a few holes in his stock if he were asked. He selected a Wildcat .22, a speed-pump Black Shadow, and two Black Defenders, also with the speed-pump feature. To this he added a Model 70 Extreme Weather (with scope) and a 70 Featherweight (without). He took ammo for all the guns, then pushed the cart down to his office and stowed the guns in his old green Defender floor-safe.

This is paranoid, you know, he thought as he twirled the dial.

But it didn't *feel* paranoid. And as he went back out to wait for Rusty and the kids, he reminded himself to tie a blue rag around his arm. And to tell Rusty to do the same. Camouflage wasn't a bad idea.

Any deer hunter knew that.

8

At eight o'clock that morning, Big Jim was back in his home study. Carter Thibodeau – now his personal bodyguard for the duration, Big Jim had decided – was deep in an issue of *Car and Driver,* reading a comparison of the 2012 BMW H-car and the 2011 Ford Vesper R/T. They both looked like awesome cars, but anybody who didn't know that BMWs ruled was insane. The same was true, he thought, of anyone who didn't understand that Mr Rennie was now the BMW H-car of Chester's Mill.

Big Jim was feeling quite well, partly because he'd gotten another hour of sleep after visiting Barbara. He was going to need lots of power naps in the days ahead. He had to stay sharp, on top. He would not quite admit to himself that he was also worried about more arrhythmias.

Having Thibodeau on hand eased his mind considerably, especially with Junior behaving so erratically (*That's one way to put it,* he thought). Thibodeau looked like a thug, but he seemed to have a feel for the aide-de-camp role. Big Jim wasn't completely sure yet, but he thought Thibodeau might actually turn out to be smarter than Randolph.

He decided to test that.

'How many men guarding the supermarket, son? Do you know?'

Carter put his magazine aside and drew a battered little note-book from his back pocket. Big Jim approved.

After thumbing through it a little, Carter said: 'Five last night, three regular guys and two new ones. No problems. Today there's only gonna be three. All new ones. Aubrey Towle – his brother owns the bookshop, y'know – Todd Wendlestat, and Lauren Conree.'

'And do you concur that that should be enough?'

'Huh?'

'Do you *agree*, Carter. Concur means agree.'

'Yeah, that should do it. Daylight and all.'

No pause to calculate what the boss might want to hear. Rennie liked that a bunch.

'Okay. Now listen. I want you to get with Stacey Moggin this morning. Tell her to call every officer we've got on our roster. I want them all at Food City tonight at seven. I'm going to talk to them.'

Actually he was going to make another speech, this time with all the stops out. Wind them up like Granddad's pocketwatch.

'Okay.' Carter made a note in his little aide-de-camp book.

'And tell each of them to try and bring one more.'

Carter was running his gnawed-upon pencil down the list in his book. 'We've already got . . . lemme see . . . twenty-six.'

'That still might not be enough. Remember the market yesterday morning, and the Shumway woman's newspaper last night. It's us or anarchy, Carter. Do you know the meaning of *that* word?'

'Uh, yessir.' Carter Thibodeau was pretty sure it meant an archery range, and he supposed his new boss was saying that The Mill could become a shooting gallery or something if they didn't take a good hard hold. 'Maybe we ought to make a weapons sweep, or something.'

Big Jim grinned. Yes, in many ways a delightful boy. 'That's on the docket, probably starting next week.'

'If the Dome's still up. You think it will be?'

'I think so.' It *had* to be. There was still so much to do. He had to see that the propane cache was disseminated back into town. All traces of the meth lab behind the radio station had to be erased. Also – and this was crucial – he hadn't achieved his greatness yet. Although he was well on his way.

'In the meantime, have a couple of the officers – the *regular* officers – go on over to Burpee's and confiscate the guns there. If Romeo Burpee gives the officers any grief, they're to say we want to keep them out of the hands of Dale Barbara's friends. Have you got that?'

'Yep.' Carter made another note. 'Denton and Wettington? They okay?'

Big Jim frowned. Wettington, the gal with the big tiddies. He didn't trust her. He wasn't sure he would have liked any cop with tiddies, gals had no business in law enforcement, but it was more than that. It was the way she looked at him.

'Freddy Denton yes, Wettington no. Not Henry Morrison, either. Send Denton and George Frederick. Tell them to put the guns in the PD strong room.'

'Got it.'

Rennie's phone rang, and his frown deepened. He picked it up and said, 'Selectman Rennie.'

'Hello, Selectman. This is Colonel James O. Cox. I'm in charge of what's being called the Dome Project. I thought it was time we spoke.'

Big Jim leaned back in his chair, smiling. 'Well, then you just go on then, Colonel, and God bless you.'

'My information is that you've arrested the man the President of the United States tapped to take charge of matters in Chester's Mill.'

'That would be correct, sir. Mr Barbara is charged with murder. Four counts. I hardly think the President would want a serial killer in charge of things. Wouldn't do much for his standing in the polls.'

'Which puts you in charge.'

'Oh, no,' Rennie said, smiling more widely. 'I'm nothing but a humble Second Selectman. Andy Sanders is the man in charge, and Peter Randolph – our new Police Chief, as you may know – was the arresting officer.'

'Your hands are clean, in other words. That's going to be your position once the Dome is gone and the investigation starts.'

Big Jim enjoyed the frustration he heard in the cotton-picker's voice. Pentagon son-of-a-buck was used to riding; being rode was a new experience for him.

'Why would they be dirty, Colonel Cox? Barbara's dog tags were found with one of the victims. Can't get much more cut-and-dried than that.'

'Convenient.'

'Call it what you want.'

'If you tune in the cable news networks,' Cox said, 'you'll see that serious questions are being raised about Barbara's arrest, especially in light of his service record, which is exemplary. Questions are also being raised about your own record, which is not so exemplary.'

'Do you think any of that surprises me? You fellows are good at managing the news. You've been doing it since Vietnam.'

'CNN's got a story about you being investigated for shady bait-and-switch practices back in the late nineties. NBC's reporting that you were investigated for unethical loan practices in 2008. I believe you were accused of charging illegal rates of interest? Somewhere in the forty percent area? Then repo'ing cars and trucks that had already been paid for twice and sometimes three times over? Your constituents are probably seeing this on the news for themselves.'

All those charges had gone away. He had paid good money to *make* them go away. 'The people in my town know those news shows will put on any ridiculous thing if it sells a few more tubes of hemorrhoid cream and a few more bottles of sleeping pills.'

'There's more. According to the State of Maine Attorney General, the previous Police Chief – the one who died last Saturday – was investigating you for tax fraud, misappropriation of town funds and town property, and involvement in illegal drug activity. We have released none of this latest stuff to the press, and have no intention of doing so . . . *if* you'll compromise. Step down as Town Selectman. Mr Sanders should likewise step down. Name Andrea Grinnell, the Third Selectman, as the officer in charge, and Jacqueline Wettington as the President's representative in Chester's Mill.'

Big Jim was startled out of what remained of his good temper. 'Man, are you insane? Andi Grinnell is a drug addict – hooked on OxyContin – and the Wettington woman doesn't have a brain in her cotton-picking head!'

'I assure you that's not true, Rennie.' No more *Mister*, the Era of Good Feelings seemed to be over. 'Wettington was given a citation for helping to break up an illegal drug ring operating out of the Sixty-seventh Combat Support Hospital in Würzburg, Germany, and was personally recommended by a man named Jack Reacher, the toughest goddam Army cop that ever served, in my humble opinion.'

'There's nothing humble about you, sir, and your sacrilegious language doesn't go down well with me. I am a Christian.'

'A drug-selling Christian, according to my information.'

'Sticks and stones may break my bones, but names will never hurt me.' *Especially under the Dome,* Big Jim thought, and smiled. 'Do you have any actual proof?'

'Come on, Rennie – as one hardass to another, does it matter? The Dome is a bigger press event than nine-eleven. And it's *sympathetic* big press. If you don't start compromising, I'll tar you so thick you'll never get it off. Once the Dome breaks, I'll see you before a Senate subcommittee, a grand jury, and in jail. I promise you that. But step down and it all goes away. I promise you that, too.'

'Once the Dome breaks,' Rennie mused. 'And when will that be?'

'Maybe sooner than you think. I plan to be the first one inside, and my first order of business will be to snap handcuffs on you and escort you to an airplane which will fly you to Fort Leavenworth, Kansas, where you will be held as a guest of the United States pending trial.'

Big Jim was rendered momentarily speechless by the boldfaced audacity of this. Then he laughed.

'If you really wanted what's best for the town, Rennie, you'd step down. Look what's happened on your watch: six murders – two

at the hospital last night, we understand – a suicide, and a food riot. You're not up to this job.'

Big Jim's hand closed on the gold baseball and squeezed. Carter Thibodeau was looking at him with a worried frown.

If you were here, Colonel Cox, I'd give you a taste of what I gave Coggins. With God as my witness, I would.

'Rennie?'

'I'm here.' He paused. 'And you're there.' Another pause. 'And the Dome isn't coming down. I think we both know that. Drop the biggest A-bomb you've got on it, render the surrounding towns uninhabitable for two hundred years, kill everybody in Chester's Mill with the radiation if the radiation goes through, and *still* it won't come down.' He was breathing fast now, but his heart was beating strong and steady in his chest. 'Because the Dome is God's will.'

Which was, in his deepest heart, what he believed. As he believed it was God's will that he take this town and carry it through the weeks, months, and years ahead.

'*What?*'

'You heard me.' Knowing he was wagering everything, his entire future, on the continued existence of the Dome. Knowing some people would think he was crazy for doing so. Also knowing those people were unbelieving heathens. Like Colonel James O. Cotton-Picker Cox.

'Rennie, be reasonable. Please.'

Big Jim liked that *please*; it brought his good humor back in a rush. 'Let's recap, shall we, Colonel Cox? Andy Sanders is in charge here, not me. Although I appreciate the courtesy call from such a high mucky-muck as yourself, naturally. And while I'm sure Andy will appreciate your offer to manage things – by remote control, as it were – I think I can speak for him when I say you can take your offer and tuck it away where the sun doesn't shine. We're on our own in here, and we're going to *handle* it on our own.'

'You're crazy,' Cox said wonderingly.

'So unbelievers always call the religious. It's their final defense against faith. We're used to it, and I don't hold it against you.' This was a lie. 'May I ask a question?'

'Go on.'

'Are you going to cut off our phones and computers?'

'You'd sort of like that, wouldn't you?'

'Of course not.' Another lie.

'The phones and Internet stay. So does the press conference on Friday. At which you'll be asked some difficult questions, I assure you.'

'I won't be attending any press conferences in the foreseeable future, Colonel. Neither will Andy. And Mrs Grinnell wouldn't make much sense, poor thing. So you can just cancel your—'

'Oh, no. Not at all.' Was that a *smile* in Cox's voice? 'The press conference will be held at noon on Friday, in plenty of time to sell lots of hemorrhoid cream on the evening news.'

'And who do you expect will be attending from our town?'

'Everyone, Rennie. Absolutely everyone. Because we're going to allow their relatives to come to the Dome at the Motton town line – site of the airplane crash in which Mr Sanders's wife died, you may remember. The press will be there to record the whole thing. It's going to be like visiting day at the state prison, only no one's guilty of anything. Except maybe you.'

Rennie was infuriated all over again. '*You can't do that!*'

'Oh, but I can.' The smile *was* there. 'You can sit on your side of the Dome and thumb your nose at me; I can sit on mine and do the same. The visitors will be lined up, and as many as will agree to do so will be wearing tee-shirts reading DALE BARBARA IS INNOCENT and FREE DALE BARBARA and IMPEACH JAMES RENNIE. There will be tearful reunions, hands pressing against hands with the Dome in between, maybe even attempts to kiss. It will make *excellent* TV footage, and it will make *excellent* propaganda. Most of all, it's going to make people in your town wonder what they're doing with an incompetent like you at the controls.'

Big Jim's voice descended to a thick growl. 'I won't allow it.'

'How are you going to stop it? Over a thousand people. You couldn't shoot them all.' When he spoke again, his voice was calm and reasonable. 'Come on, Selectman, let's work this out. You can still come out of it clean. You only need to let go of the controls.'

Big Jim saw Junior drifting down the hall toward the front door like a ghost, still wearing his pajama pants and slippers, and barely noticed. Junior could have dropped dead in the hallway and Big Jim would have remained hunched over his desk, the gold baseball clutched in one hand and the telephone in the other. One thought beat in his head: putting Andrea Grinnell in charge, with Officer Tiddies as her second.

It was a joke.

A *bad* joke.

'Colonel Cox, you can go fuck yourself.'

He hung up, swiveled his desk chair, and hurled the gold baseball. It hit the signed photo of Tiger Woods. The glass shattered, the frame fell to the floor, and Carter Thibodeau, who was used to striking

fear into hearts but who rarely had fear struck into his own, jumped to his feet.

'Mr Rennie? Are you all right?'

He didn't look all right. Irregular purple patches flared on his cheeks. His small eyes were wide and bulging from their sockets of hard fat. The vein in his forehead pulsed.

'They will *never* take this town from me,' Big Jim whispered.

'Course they won't,' Carter said. 'Without you, we're sunk.'

This relaxed Big Jim to some degree. He reached for the telephone, then remembered Randolph had gone home to bed. The new Chief had gotten precious little rack-time since the crisis began, and had told Carter that he intended to sleep until at least noon. And that was okay. The man was useless, anyway.

'Carter, make a note. Show it to Morrison, if he's running things at the PD this morning, then leave it on Randolph's desk. After that, come right back here.' He paused to consider for a moment, frowning. 'And see if Junior's headed there. He went out while I was talking to Colonel Do-What-I-Want on the telephone. Don't go looking for him if he's not, but if he is, make sure he's all right.'

'Sure. What's the message?'

'"Dear Chief Randolph: Jacqueline Wettington is to be severed from the Chester's Mill PD immediately."'

'Does that mean fired?'

'Yes indeed.'

Carter was scribbling in his book, and Big Jim gave him time to catch up. He was okay again. Better than okay. He was *feeling it.* 'Add, "Dear Officer Morrison: When Wettington comes in today, please inform her she is relieved of duty and tell her to clean out her locker. If she asks you for cause, tell her we are reorganizing the department and her services will no longer be required."'

'Does *required* have a *c* in it, Mr Rennie?'

'The spelling doesn't matter. The *message* matters.'

'Okay. Right.'

'If she has further questions, she can see me.'

'Got it. Is that all?'

'No. Tell whichever one sees her first to take her badge and gun. If she gets poopy and says the gun's her personal property, they can give her a receipt and tell her it will either be returned or she'll be reimbursed when this crisis is over.'

Carter scribbled some more, then looked up. 'What do you think is wrong with Junes, Mr Rennie?'

'I don't know. Just megrims, I imagine. Whatever it is, I don't

have time to deal with it right now. There are more pressing matters at hand.' He pointed at the notebook. 'Bring me that.'

Carter did. His handwriting was the looping scrawl of a third-grader, but everything was there. Rennie signed it.

9

Carter took the fruits of his secretarial labor to the PD. Henry Morrison greeted them with an incredulity that fell just short of mutiny. Carter also looked around for Junior, but Junior wasn't there, and no one had seen him. He asked Henry to keep an eye out.

Then, on impulse, he went downstairs to visit Barbie, who was lying on his bunk with his hands behind his head.

'Your boss called,' he said. 'That guy Cox. Mr Rennie calls him Colonel Do-What-I-Want.'

'I'll bet he does,' Barbie said.

'Mr Rennie gave him the big fuck you. And you know what? Your Army pal had to eat it and smile. What do you think of that?'

'I'm not surprised.' Barbie kept looking at the ceiling. He sounded calm. It was irritating. 'Carter, have you thought about where all this is going? Have you tried taking the long view?'

'There isn't any long view, *Baaarbie*. Not anymore.'

Barbie just kept looking at the ceiling with a little smile dimpling the corners of his mouth. As if he knew something Carter did not. It made Carter want to unlock the cell door and punch the shitlicker's lights out. Then he remembered what had happened in Dipper's parking lot. Let Barbara see if he could fight a firing squad with his dirty tricks. Let him try that.

'I'll see you around, *Baaaarbie*.'

'I'm sure,' Barbie said, still not bothering to look at him. 'It's a small town, son, and we all support the team.'

10

When the parsonage doorbell rang, Piper Libby was still in the Bruins tee-shirt and shorts that served as her nightwear. She opened the door, assuming her visitor would be Helen Roux, an hour early for her ten o'clock appointment to discuss Georgia's funeral and burial arrangements. But it was Jackie Wettington. She was wearing her uniform, but there was no badge over her left breast and no gun on her hip. She looked stunned.

'Jackie? What's wrong?'

'I've been fired. That bastard has had it in for me since the PD Christmas party, when he tried to cop a feel and I slapped his hand, but I doubt if that was all of it, or even most of it—'

'Come in,' Piper said. 'I found a little gas-operated hotplate – from the last minister, I think – in one of the pantry cupboards, and for a wonder, it still works. Doesn't a cup of hot tea sound good?'

'Wonderful,' Jackie said. Tears welled in her eyes and overspilled. She wiped them off her cheeks almost angrily.

Piper led her into the kitchen and lit the single-burner Brinkman camp-grill on the counter. 'Now tell me everything.'

Jackie did, not failing to include Henry Morrison's condolences, which had been clumsy but sincere. 'He *whispered* that part,' she said, taking the cup Piper gave her. 'It's like the goddam Gestapo over there now. Excuse my language.'

Piper waved this away.

'Henry says that if I protest at the town meeting tomorrow, I'll only make things worse – Rennie'll whip out a bunch of trumped-up incompetency charges. He's probably right. But the biggest incompetent in the Department this morning is the one running the place. As for Rennie . . . he's packing the PD with officers who'll be loyal to him in case of any organized protest to the way he's doing things.'

'Of course he is,' Piper said.

'Most of the new hires are too young to buy a legal beer, but they're carrying guns. I thought of telling Henry he'd be the next to go – he's said things about the way Randolph's running the department, and of course the bootlickers will have passed his comments on – but I could see by his face that he already knows it.'

'Do you want me to go see Rennie?'

'It wouldn't do any good. I'm actually not sorry to be out, I just hate to be fired. The big problem is that I'll look very good for what's going to happen tomorrow night. I may have to disappear with Barbie. Always assuming we can find a place to disappear *to*.'

'I don't understand what you're talking about.'

'I know, but I'm going to tell you. And this is where the risks start. If you don't keep this to yourself, I'll wind up in the Coop myself. Maybe even standing next to Barbara when Rennie lines up his firing squad.'

Piper regarded her gravely. 'I've got forty-five minutes before Georgia Roux's mother shows up. Is that time enough for you to say what you have to say?'

'Plenty.'

Jackie began with the examination of the bodies at the funeral

home. Described the stitch marks on Coggins's face and the golden baseball Rusty had seen. She took a deep breath and next spoke of her plan to break Barbie out during the special town meeting the following night. 'Although I have no idea where we can put him if we *do* get him out.' She sipped her tea. 'So what do you think?'

'That I want another cuppa. You?'

'I'm good, thanks.'

From the counter, Piper said: 'What you're planning is terribly dangerous – I doubt if you need me to tell you that – but there may be no other way to save an innocent man's life. I never believed for a second that Dale Barbara was guilty of those murders, and after my own close encounter with our local law enforcement, the idea that they'd execute him to keep him from taking over doesn't surprise me much.' Then, following Barbie's train of thought without knowing it: 'Rennie isn't taking the long view, and neither are the cops. All they care about is who's boss of the treehouse. That kind of thinking is a disaster waiting to happen.'

She came back to the table.

'I've known almost from the day I came back here to take up the pastorate – which was my ambition ever since I was a little girl – that Jim Rennie was a monster in embryo. Now – if you'll pardon the melodramatic turn of phrase – the monster has been born.'

'Thank God,' Jackie said.

'Thank God the monster has been born?' Piper smiled and raised her eyebrows.

'No – thank God you're down with this.'

'There's more, isn't there?'

'Yes. Unless you don't want to be a part of it.'

'Honey, I'm already a part of it. If you can be jailed for plotting, I could be jailed for listening and not reporting. We're now what our government likes to call "homegrown terrorists."'

Jackie received this idea in glum silence.

'It isn't just Free Dale Barbara you're talking about, is it? You want to organize an active resistance movement.'

'I suppose I do,' Jackie said, and gave a rather helpless laugh. 'After six years with the U.S. Army, I never would have expected it – I've always been a my-country-right-or-wrong sort of girl – but . . . has it occurred to you that the Dome might not break? Not this fall, not this winter? Maybe not next year or even in our lifetimes?'

'Yes.' Piper was calm, but most of the color had left her cheeks. 'It has. I think it's occurred to everyone in The Mill, if only in the backs of their minds.'

'Then think about this. Do you want to spend a year or five years in a dictatorship run by a homicidal idiot? Assuming we have five years?'

'Of course not.'

'Then the only time to stop him might be now. He may no longer be in embryo, but this thing he's building – this machine – is still in its infancy. It's the best time.' Jackie paused. 'If he orders the police to start collecting guns from ordinary citizens, it might be the only time.'

'What do you want me to do?'

'Let us have a meeting here at the parsonage. Tonight. These people, if they'll all come.' From her back pocket she took the list she and Linda Everett had labored over.

Piper unfolded the sheet of notebook paper and studied it. There were eight names. She looked up. 'Lissa Jamieson, the librarian with the crystals? Ernie Calvert? Are you sure about those two?'

'Who better to recruit than a librarian when you're dealing with a fledgling dictatorship? As for Ernie . . . my understanding is that after what happened at the supermarket yesterday, if he came across Jim Rennie flaming in the street, he wouldn't piss on him to put him out.'

'Pronounally vague but otherwise colorful.'

'I was going to have Julia Shumway sound Ernie and Lissa out, but now I'll be able to do it myself. I seem to have come into a lot of free time.'

The doorbell rang. 'That may be the bereaved mother,' Piper said, getting to her feet. 'I imagine she'll be half-shot already. She enjoys her coffee brandy, but I doubt if it dulls the pain much.'

'You haven't told me how you feel about the meeting,' Jackie said.

Piper Libby smiled. 'Tell our fellow homegrown terrorists to arrive between nine and nine thirty tonight. They should come on foot, and by ones – standard French Resistance stuff. No need to advertise what we're doing.'

'Thank you,' Jackie said. 'So much.'

'Not at all. It's my town, too. May I suggest you slip out by the back door?'

11

There was a pile of clean rags in the back of Rommie Burpee's van. Rusty knotted two of them together, fashioning a bandanna he tied

over the lower half of his face, but still his nose, throat, and lungs were thick with the stench of dead bear. The first maggots had hatched in its eyes, open mouth, and the meat of its exposed brain.

He stood up, backed away, then reeled a little bit. Rommie grabbed him by the elbow.

'If he passes out, catch him,' Joe said nervously. 'Maybe that thing hits adults further out.'

'It's just the smell,' Rusty said. 'I'm okay now.'

But even away from the bear, the world smelled bad: smoky and heavy, as if the entire town of Chester's Mill had become a large closed room. In addition to the odors of smoke and decaying animal, he could smell rotting plant life and a swampy stench that no doubt arose from the drying bed of the Prestile. *If only there was a wind*, he thought, but there was just an occasional pallid puff of breeze that brought more bad smells. To the far west there were clouds – it was probably raining a bitch over in New Hampshire – but when they reached the Dome, the clouds parted like a river dividing at a large outcropping of rock. Rusty had become increasingly doubtful about the possibility of rain under the Dome. He made a note to check some meteorological websites . . . if he ever got a free moment. Life had become appallingly busy and unsettlingly unstructured.

'Did Br'er Bear maybe die of rabies, doc?' Rommie asked.

'I doubt it. I think it's exactly what the kids said: plain suicide.'

They piled into the van, Rommie behind the wheel, and drove slowly up Black Ridge Road. Rusty had the Geiger counter in his lap. It clucked steadily. He watched the needle rise toward the + 200 mark.

'Stop here, Mr Burpee!' Norrie cried. 'Before you come out of the woods! If you're gonna pass out, I'd just as soon you didn't do it while you were driving, even at ten miles an hour.'

Rommie obediently pulled the van over. 'Jump out, kids. I'm gonna babysit you. The doc's going on by himself.' He turned to Rusty. 'Take the van, but drive slow and stop the second the radiation count gets too high to be safe. Or if you start to feel woozy. We'll walk behind you.'

'Be careful, Mr Everett,' Joe said.

Benny added, 'Don't worry if you pass out and Wilson the van. We'll push you back onto the road when you come to.'

'Thanks,' Rusty said. 'You're all heart and a mile wide.'

'Huh?'

'Never mind.'

Rusty got behind the wheel and closed the driver's-side door.

On the passenger bucket, the Geiger counter clicked. He drove – very slowly – out of the woods. Up ahead, Black Ridge Road rose toward the orchard. At first he didn't see anything out of the ordinary, and had a moment of bone-deep disappointment. Then a bright purple flash hit him in the eyes and he jammed on the brakes in a hurry. Something up there, all right, a bright something amid the scrabble of untended apple trees. Just behind him, in the van's outside mirror, he saw the others stop walking.

'Rusty?' Rommie called. 'Okay?'

'I see it.'

He counted to fifteen, and the purple light flashed again. He was reaching for the Geiger counter when Joe looked in at him through the driver's-side window. The new pimples stood out on his skin like stigmata. 'Do you feel anything? Woozy? Swimmy in the head?'

'No,' Rusty said.

Joe pointed ahead. 'That's where we blacked out. Right there.' Rusty could see scuff-marks in the dirt at the left side of the road.

'Walk that far,' Rusty said. 'All four of you. Let's see if you pass out again.'

'Cheesus,' Benny said, joining Joe. 'What am I, a guinea pig?'

'Actually, I think Rommie's the guinea pig. You up for it, Rommie?'

'Yuh.' He turned to the kids. 'If I pass out and you don't, drag me back here. It seems to be out of range.'

The quartet walked to the scuff-marks, Rusty watching intently from behind the wheel of the van. They had almost reached them when Rommie first slowed, then staggered. Norrie and Benny reached out on one side to steady him, Joe on the other. But Rommie didn't fall. After a moment he straightened up again.

'Dunno if it was somethin real or only . . . what do you call it . . . the power of suggestion, but I'm okay now. Was just a little light-headed for a second, me. You kids feel anything?'

They shook their heads. Rusty wasn't surprised. It *was* like chickenpox: a mild sickness mostly suffered by children, who only caught it once.

'Drive ahead, Doc,' Rommie said. 'You don't want to be carryin all those pieces of lead sheet up there if you don't have to, but be careful.'

Rusty drove slowly forward. He heard the accelerating pace of clicks from the Geiger counter, but felt absolutely nothing out of the ordinary. From the ridge, the light flashed out at fifteen-second

intervals. He reached Rommie and the children, then passed them.

'I don't feel anyth—' he began, and then it came: not light-headedness, exactly, but a sense of strangeness and peculiar clarity. While it lasted he felt as if his head were a telescope and he could see anything he wanted to see, no matter how far. He could see his brother making his morning commute in San Diego, if he wanted to.

Somewhere, in an adjacent universe, he heard Benny call out: 'Whoa, Dr Rusty's losin it!'

But he wasn't; he could still see the dirt road perfectly well. *Divinely* well. Every stone and chip of mica. If he had swerved – and he supposed he had – it was to avoid the man who was suddenly standing there. The man was skinny, and made taller by an absurd red, white, and blue stovepipe hat, comically crooked. He was wearing jeans and a tee-shirt that read SWEET HOME ALABAMA PLAY THAT DEAD BAND SONG.

That's not a man, it's a Halloween dummy.

Yes, sure. What else could it be, with green garden trowels for hands and a burlap head and stitched white crosses for eyes?

'Doc! *Doc!*' It was Rommie.

The Halloween dummy burst into flames.

A moment later it was gone. Now there was just the road, the ridge, and the purple light, flashing at fifteen-second intervals, seeming to say *Come on, come on, come on.*

12

Rommie pulled open the driver's door. 'Doc . . . Rusty . . . you okay?'

'Fine. It came, it went. I assume it was the same for you. Rommie, did you *see* anything?'

'No. For a minute I t'ought I smelled fire. But I think that's cause the air smells so smoky.'

'I saw a bonfire of burning pumpkins,' Joe said. 'I told you that, right?'

'Yes.' Rusty hadn't attached enough significance to it, in spite of what he'd heard from his own daughter's mouth. Now he did.

'I heard screaming,' Benny said, 'but I forget the rest.'

'I heard it too,' Norrie said. 'It was daytime, but still dark. There was that screaming. And – I think – there was soot falling on my face.'

'Doc, maybe we better go back,' Rommie said.

'Isn't gonna happen,' Rusty said. 'Not if there's a chance I can get my kids – and everyone else's kids – out of here.'

'Bet some adults would like to go too,' Benny remarked. Joe threw him an elbow.

Rusty looked at the Geiger counter. The needle was pegged on +200. 'Stay here,' he said.

'Doc,' Joe said, 'what if the radiation gets heavy and you pass out? What do we do then?'

Rusty considered this. 'If I'm still close, drag me out of there. But not you, Norrie. Only the guys.'

'Why not me?' she asked.

'Because you might like to have kids someday. Ones with only two eyes and all the limbs attached in the right places.'

'Right. I'm totally here,' Norrie said.

'For the rest of you, short-term exposure should be okay. But I mean *very* short term. If I should go down halfway up the ridge or actually in the orchard, leave me.'

'Dat's harsh, Doc.'

'I don't mean for good,' Rusty said. 'You've got more lead roll back at the store, don't you?'

'Yeah. We should have brought it.'

'I agree, but you can't think of everything. If worst comes to worst, get the rest of the lead roll, stick pieces in the windows of whatever you're driving, and scoop me up. Hell, by then I might be on my feet again and walking toward town.'

'Yeah. Or still layin knocked out an' gettin a lethal dose.'

'Look, Rommie, we're probably worrying about nothing. I think the wooziness – the actual passing-out, if you're a kid – is like the other Dome-related phenomena. You feel it once, then you're okay.'

'You could be bettin your life on dat.'

'We've got to start placing bets at some point.'

'Good luck,' Joe said, and extended his fist through the window.

Rusty pounded it lightly, then did the same with Norrie and Benny. Rommie also extended his fist. 'What's good for the kids is good enough for me.'

13

Twenty yards beyond the place where Rusty had had the vision of the dummy in the stovepipe hat, the clicks from the Geiger counter mounted to a staticky roar. He saw the needle standing at +400, just into the red.

He pulled over and hauled out gear he would have preferred not to put on. He looked back at the others. 'A word of warning,' he said. 'And I'm talking to you in particular, Mr Benny Drake. If you laugh, you're walking home.'

'I won't laugh,' Benny said, but in short order they were all laughing, including Rusty himself. He took off his jeans, then pulled a pair of football practice pants up over his undershorts. Where pads on the thighs and buttocks should have gone, he stuffed precut pieces of lead roll. Then he donned a pair of catcher's shinguards and curved more lead roll over them. This was followed by a lead collar to shield his thyroid gland, and a lead apron to shield his testes. It was the biggest one they had, and hung all the way down to the bright orange shinguards. He had considered hanging another apron over his back (looking ridiculous was better than dying of lung cancer, in his view), and had decided against it. He had already pushed his weight to over three hundred pounds. And radiation didn't curve. If he faced the source, he thought he'd be okay.

Well. Maybe.

To this point, Rommie and the kids had managed to restrict themselves to discreet chuckles and a few strangulated giggles. Control wavered when Rusty stuffed a size XL bathing cap with two pieces of lead roll and pulled it down over his head, but it wasn't until he yanked on the elbow-length gloves and added the goggles that they lost it entirely.

'*It lives!*' Benny cried, striding around with his arms outstretched like Frankenstein's monster. '*Master, it lives!*'

Rommie staggered to the side of the road and sat on a rock, bellowing with laughter. Joe and Norrie collapsed on the road itself, rolling around like chickens taking a dustbath.

'Walking home, every one of you,' Rusty said, but he was smiling as he climbed (not without difficulty) back into the van.

Ahead of him, the purple light flashed out like a beacon.

14

Henry Morrison left the PD when the raucous, locker-room-at-halftime banter of the new recruits finally became too much to bear. It was going wrong, all of it. He supposed he'd known that even before Thibodeau, the thug who was now guarding Selectman Rennie, showed up with a signed order to can Jackie Wettington – a fine officer and an even finer woman.

Henry regarded this as the first move in what would probably

be a comprehensive effort to remove the older officers, the ones Rennie would see as Duke Perkins partisans, from the force. He himself would be next. Freddy Denton and Rupert Libby would probably stay; Rupe was a moderate asshole, Denton severe. Linda Everett would go. Probably Stacey Moggin, too. Then, except for that dimbulb Lauren Conree, the Chester's Mill PD would be an all-boys' club again.

He cruised slowly down Main Street, which was almost entirely empty – like a ghost-town street in a Western. Sloppy Sam Verdreaux was sitting under the marquee of the Globe, and that bottle between his knees probably did not contain Pepsi-Cola, but Henry didn't stop. Let the old sot have his tipple.

Johnny and Carrie Carver were boarding up the front windows of the Gas & Grocery. They were both wearing the blue armbands that had started to pop up all over town. They gave Henry the creeps.

He wished he'd taken the slot on the Orono police when it had been offered the previous year. It wasn't a step up careerwise, and he knew college kids could be shits to deal with when drunk or stoned, but the money was better, and Frieda said the Orono schools were top-of-the-line.

In the end, though, Duke had persuaded him to stay by promising to ram through a five-grand raise at the next town meeting, and by telling Henry – in absolute confidence – that he was going to fire Peter Randolph if Randolph wouldn't retire voluntarily. 'You'd move up to APC, and that's another ten grand a year,' Duke had said. 'When I retire, you can move all the way up to the top job, if you want to. The alternative, of course, is driving UMO kids with puke drying on their pants back to their dorms. Think 'er over.'

It had sounded good to him, it had sounded good (well . . . *fairly* good) to Frieda, and of course it relieved the kids, who had hated the idea of moving. Only now, Duke was dead, Chester's Mill was under the Dome, and the PD was turning into something that felt bad and smelled worse.

He turned onto Prestile Street and saw Junior standing outside the yellow police tape strung around the McCain house. Junior was wearing pajama pants and slippers and nothing else. He was swaying noticeably, and Henry's first thought was that Junior and Sloppy Sam had a lot in common today.

His second thought was of – and for – the PD. He might not be a part of it for much longer, but he was now, and one of Duke Perkins's firmest rules had been *Never let me see the name of a Chester's*

Mill PD officer in the Democrat's *Court Beat column.* And Junior, whether Henry liked it or not, was an officer.

He pulled unit Three to the curb and went to where Junior was rocking back and forth. 'Hey, Junes, let's get you back to the station, pour some coffee into you and . . .' *Sober you up* was how he intended to finish this, but then he observed that the kid's pajama pants were soaked. Junior had pissed himself.

Alarmed as well as disgusted – no one must see this, Duke would spin in his grave – Henry reached out and grasped Junior's shoulder. 'Come on, son. You're making a spectacle of yourself.'

'They were my goolfreds,' Junior said without turning. He rocked faster. His face – what Henry could see of it – was dreamy and rapt. 'I shilled them so I could fill them. No gooby. French.' He laughed, then spat. Or tried to. A thick white string hung down from his chin, swinging like a pendulum.

'That's enough. I'm taking you home.'

This time Junior turned, and Henry saw he wasn't drunk. His left eye was bright red. Its pupil was too big. The left side of his mouth was pulled down, exposing some of his teeth. That frozen glare made Henry think momentarily of *Mr Sardonicus*, a movie that had scared him as a kid.

Junior didn't need to go to the station for coffee, and he didn't need to go home to sleep it off. Junior needed to go to the hospital.

'Come on, kid,' he said. 'Walk.'

At first, Junior seemed willing enough. Henry escorted him most of the way to the car before Junior stopped again. 'They smelled alike and I liked it,' he said. 'Horry horry horry, the snow is about to start.'

'Right, absolutely.' Henry had hoped to get Junior around the hood of the cruiser and into the front seat, but now this seemed impractical. The rear would have to do, even though the backseats of their cruisers usually smelled pretty fragrant. Junior looked back over his shoulder at the McCain house, and an expression of longing came over his partially frozen face.

'Goolfreds!' Junior cried. 'Extendable! No gooby, French! All French, you fum-nuck!' He stuck out his tongue and flapped it rapidly against his lips. The noise was similar to the one Roadrunner makes before speeding away from Wile E. Coyote in a cloud of dust. Then he laughed and started back to the house.

'No, Junior,' Henry said, and grabbed him by the waistband of his pajama pants. 'We have to—'

Junior wheeled around with surprising speed. No laughter now; his face was a twitching cat's cradle of hate and rage. He rushed at

Henry, flailing his fists. He stuck out his tongue and bit it with his champing teeth. He was gobbling in some strange language that seemed to have no vowels.

Henry did the only thing he could think of: stood aside. Junior plunged past him and began to hammer punches at the jackpot lights on top of the cruiser, smashing one of them and lacerating his knuckles. Now people were coming out of their houses to see what was happening.

'*Gthn bnnt mnt!*' Junior raved. '*Mnt! Mnt! Gthn! Gthn!*'

One foot slipped off the curb and into the gutter. He staggered but kept his feet. There was blood as well as spit hanging from his chin now; both hands were badly cut and dripping.

'*She just made me so franning mad!*' Junior screamed. '*I kit her with my knee to shed her ump, and she frew a tit! Shit everywhere! I . . . I . . .*' He quit. Appeared to consider. Said: 'I need help.' Then popped his lips — the sound as loud as the report of a .22 pistol in the still air — and fell forward between the parked police car and the sidewalk.

Henry drove him to the hospital, using lights and siren. What he didn't do was think about the last things Junior had said, things that almost made sense. He wouldn't go there.

He had problems enough.

15

Rusty drove slowly up Black Ridge, looking frequently at the Geiger counter, which was now roaring like an AM radio set between stations. The needle rose from +400 to the +1K mark. Rusty was betting it would be swung all the way over to the +4K post by the time he topped the ridge. He knew this couldn't be good news — his 'radiation suit' was makeshift at best — but he kept going, reminding himself that rads were cumulative; if he moved fast, he wouldn't pick up a lethal dose. *I might temporarily lose some hair, but no way I'll get a lethal dose. Think of it as a bombing run: get in, do your business, and get back out again.*

He turned on the radio, got the Mighty Clouds of Joy on WCIK, and immediately turned it off again. Sweat rolled into his eyes and he blinked it away. Even with the air-conditioner blasting, it was devilishly hot in the van. He looked into the rearview mirror and saw his fellow explorers clustered together. They looked very small.

The roaring from the Geiger counter quit. He looked. The needle had dropped back to zero.

Rusty almost stopped, then realized if he did, Rommie and the

kids would think he was in trouble. Besides, it was probably just the battery. But when he looked again, he saw that the power lamp was still glowing brightly.

At the top of the hill the road ended in a turnaround in front of a long red barn. An old truck and an even older tractor stood in front of it, the tractor leaning on a single wheel. The barn looked to be in pretty good condition, although some of the windows were broken. Behind it stood a deserted farmhouse with part of the roof crushed in, probably by the weight of winter snow.

The end of the barn was standing open, and even with the windows shut and the air-conditioning running full tilt, Rusty could smell the cidery aroma of old apples. He stopped next to the steps leading up to the house. There was a chain across these with a sign hanging from it: TRESPASSERS WILL BE PROSECUTED. The sign was old, rusty, and obviously ineffective. Beer cans were scattered the length of the porch where the McCoy family must once have sat on summer evenings, catching the breeze and looking over long vistas: the entire town of Chester's Mill to the right, all the way into New Hampshire if you looked left. Someone had spray-painted WILDCATS RULE on a wall that had once been red and was now a faded pink. On the door, in spray-paint of a different color, was ORGY DEPOT. Rusty guessed that was wishful thinking on the part of some sex-starved teenager. Or maybe it was the name of a heavy-metal band.

He picked up the Geiger counter and tapped it. The needle jumped and the instrument clucked a few times. It seemed to be working fine; it just wasn't picking up any major radiation.

He got out of the van and − after a brief interior debate − stripped off most of his makeshift shielding, leaving only the apron, gloves, and goggles. Then he walked down the length of the barn, holding the sensor tube of the Geiger counter out in front of him and promising himself he'd go back for the rest of his 'suit' the second the needle jumped.

But when he emerged from the side of the barn and the light flashed out no more than forty yards away, the needle didn't stir. It seemed impossible − if, that was, the radiation was related to the light. Rusty could think of only one possible explanation: the generator had created a radiation belt to discourage explorers such as himself. To protect itself. The same could be true of the lightheadedness he'd felt, actual unconsciousness in the case of the kids. Protection, like a porcupine's quills or a skunk's perfume.

Isn't it more likely that the counter's malfunctioning? You could be giving

yourself a lethal dose of gamma rays at this very second. The damn thing's a cold war relic.

But as he approached the edge of the orchard, Rusty saw a squirrel dart through the grass and run up one of the trees. It paused on a branch weighted down with unpicked fruit and stared at the two-legs intruder below, its eyes bright, its tail bushed out. To Rusty it looked fine as fiddlesticks, and he saw no animal corpses in the grass, or on the overgrown lanes between the trees: no suicides, and no probable radiation victims, either.

Now he was very close to the light, its timed flashes so brilliant that he squeezed his eyes nearly shut each time it came. To his right, the whole world seemed to lie at his feet. He could see the town, toylike and perfect, four miles away. The grid of the streets; the steeple of the Congo church; the twinkle of a few cars on the move. He could see the low brick structure of Catherine Russell Hospital, and, far to the west, the black smudge where the missiles had struck. It hung there, a beauty mark on the cheek of the day. The sky over-head was a faded blue, almost its normal color, but at the horizon the blue became a poison yellow. He felt quite sure some of that color had been caused by pollution – the same crap that had turned the stars pink – but he suspected most of it was nothing more sinister than autumn pollen sticking to the Dome's unseen surface.

He got moving again. The longer he was up here – especially up here and out of view – the more nervous his friends would become. He wanted to go directly to the source of the light, but first he walked out of the orchard and to the edge of the slope. From here he could see the others, although they were little more than specks. He set the Geiger counter down, then waved both hands slowly back and forth over his head to show he was okay. They waved back.

'Okay,' he said. Inside the heavy gloves, his hands were slick with sweat. 'Let's see what we've got here.'

16

It was snack-time at East Street Grammar School. Judy and Janelle Everett sat at the far end of the play-yard with their friend Deanna Carver, who was six – thus fitting neatly between the Little Js, age-wise. Deanna was wearing a small blue armband around the left sleeve of her tee-shirt. She had insisted that Carrie tie it on her before she went to school, so she could be like her parents.

'What's it for?' Janelle asked.

'It means I like the police,' Deanna said, and munched on her Fruit Roll-Up.

'I want one,' Judy said, 'only yellow.' She pronounced this word very carefully. Back when she was a baby she'd said *lello*, and Jannie had laughed at her.

'They can't be yellow,' Deanna said, 'only blue. This Roll-Up is *good*. I wish I had a billion.'

'You'd get fat,' Janelle said. 'You'd *bust*.'

They giggled at this, then fell silent for a little while and watched the bigger kids, the Js nibbling on their homemade peanut butter crackers. Some girls were playing hopscotch. Boys were climbing on the monkeybars, and Miss Goldstone was pushing the Pruitt twins on the swing-glider. Mrs Vanedestine had organized a kickball game.

It all looked pretty normal, Janelle thought, but it wasn't normal. Nobody was shouting, nobody was wailing with a scraped knee, Mindy and Mandy Pruitt weren't begging Miss Goldstone to admire their matching hair-dos. They all looked like they were just *pretending* snack-time, even the grownups. And everyone – including her – kept stealing glances up at the sky, which should have been blue and wasn't, quite.

None of that was the worst, though. The worst – ever since the seizures – was the suffocating certainty that something bad was going to happen.

Deanna said, 'I was going to be the Little Mermaid on Halloween, but now I en't. I en't going to be nothing. I don't want to go out. I'm scared of Halloween.'

'Did you have a bad dream?' Janelle asked.

'Yes.' Deanna held out her Fruit Roll-Up. 'Do you want the rest of this. I en't so hungry as I thought.'

'No,' Janelle said. She didn't even want the rest of her peanut butter crackers, and that wasn't a bit like her. And Judy had eaten just half a cracker. Janelle remembered once how she'd seen Audrey corner a mouse in their garage. She remembered how Audrey had barked, and lunged at the mouse when it tried to scurry from the corner it was in. That had made her feel sad, and she called her mother to take Audrey away so she wouldn't eat the mousie. Mummy laughed, but she did it.

Now *they* were the mice. Jannie had forgotten most of the dreams she'd had during the seizures, but still she knew this much.

Now *they* were the ones in the corner.

'I'm just going to stay home,' Deanna said. A tear stood in her left eye, bright and clear and perfect. 'Stay home all Halloween. En't even coming to school. Won't. Can't nobody make me.'

Mrs Vanedestine left the kickball game and began ringing the all-in bell, but none of the three girls stood up at first.

'It's Halloween already,' Judy said. 'Look.' She pointed across the street to where a pumpkin stood on the porch of the Wheelers' house. 'And look.' This time she pointed to a pair of cardboard ghosts flanking the post office doors. 'And *look*.'

This last time she pointed at the library lawn. Here was a stuffed dummy that had been put up by Lissa Jamieson. She had undoubtedly meant it to be amusing, but what amuses adults often scares children, and Janelle had an idea the dummy on the library lawn might be back to visit her that night while she was lying in the dark and waiting to go to sleep.

The head was burlap with eyes that were white crosses made from thread. The hat was like the one the cat wore in the Dr Seuss story. It had garden trowels for hands (*bad old clutchy-grabby hands*, Janelle thought) and a shirt with something written on it. She didn't understand what it meant, but she could read the words: SWEET HOME ALABAMA PLAY THAT DEAD BAND SONG.

'See?' Judy wasn't crying, but her eyes were wide and solemn, full of some knowledge too complex and too dark to be expressed. 'Halloween already.'

Janelle took her sister's hand and pulled her to her feet. 'No it's not,' she said . . . but she was afraid it was. Something bad was going to happen, something with a fire in it. No treats, only tricks. *Mean* tricks. *Bad* tricks.

'Let's go inside,' she told Judy and Deanna. 'We'll sing songs and stuff. That'll be nice.'

It usually was, but not that day. Even before the big bang in the sky, it wasn't nice. Janelle kept thinking about the dummy with the white-cross eyes. And the somehow awful shirt: PLAY THAT DEAD BAND SONG.

17

Four years before the Dome dropped down, Linda Everett's grandfather had died and left each of his grandchildren a small but tidy sum of money. Linda's check had come to $17,232.04. Most of it went into the Js' college fund, but she had felt more than justified in spending a few hundred on Rusty. His birthday was coming up, and he'd wanted an Apple TV gadget since they'd come on the market some years earlier.

She had bought him more expensive presents during the course

of their marriage, but never one which pleased him more. The idea that he could download movies from the Net, then watch them on TV instead of being chained to the smaller screen of his computer, tickled him to death. The gadget was a white plastic square, about seven inches on a side and three-quarters of an inch thick. The object Rusty found on Black Ridge looked so much like his Apple TV add-on that he at first thought it actually *was* one . . . only modified, of course, so it could hold an entire town prisoner as well as broadcast *The Little Mermaid* to your television via Wi-Fi and in HD.

The thing on the edge of the McCoy Orchard was dark gray instead of white, and rather than the familar apple logo stamped on top of it, Rusty observed this somehow troubling symbol:

Above the symbol was a hooded excrescence about the size of the knuckle on his little finger. Inside the hood was a lens made of either glass or crystal. It was from this that the spaced purple flashes were coming.

Rusty bent and touched the surface of the generator – if it *was* a generator. A strong shock immediately surged up his arm and through his body. He tried to pull back and couldn't. His muscles were locked up tight. The Geiger counter gave a single bray, then fell silent. Rusty had no idea whether or not the needle swung into the danger zone, because he couldn't move his eyes, either. The light was leaving the world, funneling out of it like water going down a bathtub drain, and he thought with sudden calm clarity: *I'm going to die. What a stupid way to g—*

Then, in that darkness, faces arose – only they weren't human faces, and later he would not be sure they were faces at all. They were geometric solids that seemed to be padded in leather. The only parts of them that looked even vaguely human were diamond shapes on the sides. They could have been ears. The heads – if they *were* heads – turned to each other, either in discussion or something that could have been mistaken for it. He thought he heard laughter. He thought he sensed excitement. He pictured children in the play-yard at East Street Grammar – his girls, perhaps, and their friend Deanna Carver – exchanging snacks and secrets at recess.

All of this happened in a space of seconds, surely no more than four or five. Then it was gone. The shock dissipated as suddenly and

completely as it did when people first touched the surface of the Dome; as quickly as his lightheadedness and the accompanying vision of the dummy in the crooked tophat. He was just kneeling at the top of the ridge overlooking the town, and sweltering in his leaden accessories.

Yet the image of those leatherheads remained. Leaning together and laughing in obscenely childish conspiracy.

The others are down there watching me. Wave. Show them you're all right.

He raised both hands over his head – now they moved smoothly – and waved them slowly back and forth, just as if his heart were not pounding like a jackrabbit in his chest, as if sweat weren't running down his chest in sharply aromatic rivulets.

Below, on the road, Rommie and the kids waved back.

Rusty took several deep breaths to calm himself, then held the Geiger counter's sensor tube out to the flat gray square, which sat on a spongy mat of grass. The needle wavered just below the +5 mark. A background count, no more.

Rusty had little doubt that this flat square object was the source of their troubles. Creatures – not human beings, *creatures* – were using it to keep them prisoner, but that wasn't all. They were also using it to observe.

And having fun. The bastards were *laughing*. He had heard them.

Rusty stripped off the apron, draped it over the box with its slightly protruding lens, got up, backed away. For a moment nothing happened. Then the apron caught fire. The smell was pungent and nasty. He watched the shiny surface blister and bubble, watched the flames erupt. Then the apron, which was essentially no more than a plastic-coated sheet of lead, simply fell apart. For a moment there were burning pieces, the biggest one still lying on top of the box. A moment later, the apron – or what remained of it – disintegrated. A few swirling bits of ash remained – and the smell – but otherwise . . . *poof.* Gone.

Did I see that? Rusty asked himself, then said it aloud, asking the world. He could smell roasted plastic and a heavier smell that he supposed was smelted lead – insane, impossible – but the apron was gone nonetheless.

'Did I actually *see* that?'

As if in answer, the purple light flashed out of the hooded knuckle on top of the box. Were those pulses renewing the Dome, the way the touch of a finger on a computer keyboard could refresh

the screen? Were they allowing the leatherheads to watch the town? Both? Neither?

He told himself not to approach the flat square again. He told himself the smartest thing he could do would be to run back to the van (without the weight of the apron, he *could* run) and then drive like hell, slowing only to pick up his companions waiting below.

Instead he approached the box again and dropped to his knees before it, a posture too much like worship for his liking.

He stripped off one of the gloves, touched the ground beside the thing, then snatched his hand back. Hot. Bits of burning apron had scorched some of the grass. Next he reached for the box itself, steeling himself for another burn or another shock ... although neither was what he was most afraid of; he was afraid of seeing those leather shapes again, those not-quite-heads bent together in some laughing conspiracy.

But there was nothing. No visions and no heat. The gray box was cool to the touch, even though he'd seen the lead apron on top of it bubbling up and then actually catching fire.

The purple light flashed out. Rusty was careful not to put his hand in front of it. Instead, he gripped the thing's sides, mentally saying goodbye to his wife and girls, telling them he was sorry for being such a damn fool. He waited to catch fire and burn. When he didn't, he tried to lift the box. Although it had the surface area of a dinner plate and wasn't much thicker, he couldn't budge it. The box might as well have been welded to the top of a pillar planted in ninety feet of New England bedrock – except it wasn't. It was sitting on top of a grassy mat, and when he wriggled his fingers deeper beneath, they touched. He laced them together and tried again to lift the thing. No shock, no visions, no heat; no movement, either. Not so much as a wiggle.

He thought: *My hands are gripping some sort of alien artifact. A machine from another world. I may have even caught a glimpse of its operators.*

The idea was intellectually amazing – flabbergasting, even – but it had no emotional gradient, perhaps because he was too stunned, too overwhelmed with information that did not compute.

So what next? Just what the hell next?

He didn't know. And it seemed he wasn't emotionally flat after all, because a wave of despair rolled through him, and he was only just able to stop from vocalizing that despair in a cry. The four people down below might hear it and think he was in trouble. Which, of course, he was. Nor was he alone.

He got to his feet on legs that trembled and threatened to give

out beneath him. The hot, close air seemed to lie on his skin like oil. He made his way slowly back toward the van through the apple-heavy trees. The only thing he was sure of was that under no circumstances could Big Jim Rennie learn of the generator. Not because he would try to destroy it, but because he'd very likely set a guard around it to make sure it *wasn't* destroyed. To make sure it kept right on doing what it was doing, so he could keep on doing what *he* was doing. For the time being, at least, Big Jim liked things just the way they were.

Rusty opened the door of the van and that was when, less than a mile north of Black Ridge, a huge explosion rocked the day. It was as if God had leaned down and fired a heavenly shotgun.

Rusty shouted in surprise and looked up. He immediately shielded his eyes from the fierce temporary sun burning in the sky over the border between TR-90 and Chester's Mill. Another plane had crashed into the Dome. Only this time it had been no mere Seneca V. Black smoke billowed up from the point of impact, which Rusty estimated as being at least twenty thousand feet. If the black spot left by the missile strikes was a beauty mark on the cheek of the day, then this new mark was a skin tumor. One that had been allowed to run wild.

Rusty forgot about the generator. He forgot about the four people waiting for him. He forgot about his own children, for whom he had just risked being burned alive and then discorporated. For a space of two minutes, there was no room for anything in his mind but black awe.

Rubble was falling to earth on the other side of the Dome. The smashed forward quarter of the jetliner was followed by a flaming motor; the motor was followed by a waterfall of blue airline seats, many with passengers still strapped into them; the seats were followed by a vast shining wing, seesawing like a sheet of paper in a draft; the wing was followed by the tail of what was probably a 767. The tail was painted dark green. A lighter green shape had been superimposed on it. It looked to Rusty like a clover.

Not a clover, a shamrock.

Then the body of the plane crashed to earth like a defective arrow and lit the woods on fire.

18

The blast rocks the town and they all come out to see. All over Chester's Mill, they come out to see. They stand in front of their houses, in driveways, on sidewalks, in the middle of Main Street. And

although the sky north of their prison is mostly cloudy, they have to shield their eyes from the glare — what looked to Rusty, from his place atop Black Ridge, like a second sun.

They see what it is, of course; the sharper-eyed among them can even read the name on the body of the plummeting plane before it disappears below the treeline. It is nothing supernatural; it has even happened before, and just this week (although on a smaller scale, admittedly). But in the people of Chester's Mill, it inspires a kind of sullen dread that will hold sway over the town from then until the end.

Anyone who has ever cared for a terminal patient will tell you that there comes a tipping point when denial dies and acceptance finds its way in. For most people in Chester's Mill, the tipping point came at midmorning on October twenty-fifth, while they stood either alone or with their neighbors, watching as more than three hundred people plunged into the woods of TR-90.

Earlier that morning, perhaps fifteen percent of the town was wearing blue 'solidarity' armbands; by sundown on this Wednesday in October, it will be twice that. When the sun comes up tomorrow, it will be over fifty percent of the population.

Denial gives way to acceptance; acceptance breeds dependence. Anyone who's ever cared for a terminal patient will tell you that, too. Sick people need someone who will bring them their pills and glasses of cold sweet juice to wash them down with. They need someone to soothe their aching joins with arnica gel. They need someone to sit with them when the night is dark and the hours stretch out. They need someone to say, *Sleep now, it will be better in the morning. I'm here, so sleep. Sleep now. Sleep and let me take care of everything.*

Sleep.

19

Officer Henry Morrison got Junior to the hospital — by then the kid had regained a soupy semblance of consciousness, although he was still talking gibberish — and Twitch wheeled him away on a gurney. It was a relief to see him go.

Henry got Big Jim's home and Town Hall office numbers from directory assistance, but there was no answer at either — they were landlines. He was listening to a robot tell him that James Rennie's cell-phone number was unlisted when the jetliner exploded. He rushed out with everyone else who was ambulatory and stood in the

turnaround, looking at the new black mark on the Dome's invisible surface. The last of the debris was still fluttering down.

Big Jim was indeed in his Town Hall office, but he had killed the phone so he could work on both speeches – the one to the cops tonight, the one to the entire town tomorrow night – without interruption. He heard the explosion and rushed outside. His first thought was that Cox had set off a nuke. A cotton-picking nuke! If it broke through the Dome, it would ruin everything!

He found himself standing next to Al Timmons, the Town Hall janitor. Al pointed north, high in the sky, where smoke was still rising. It looked to Big Jim like an anti-aircraft burst in an old World War II movie.

'*It was an airplane!*' Al shouted. '*And a big one! Christ! Didn't they get the word?*'

Big Jim felt a cautious sense of relief, and his triphammering heart slowed a bit. If it was a plane . . . *just* a plane and not a nuke or some kind of super-missile . . .

His cell phone tweeted. He snatched it from the pocket of his suit coat and snapped it open. 'Peter? Is that you?'

'No, Mr Rennie. Colonel Cox here.'

'What did you do?' Rennie shouted. 'What in God's name did you people do now?'

'Nothing.' There was none of the former crisp authority in Cox's voice; he sounded stunned. 'It was nothing to do with us. It was . . . hold on a minute.'

Rennie waited. Main Street was full of people staring up into the sky with their mouths gaped open. To Rennie they looked like sheep dressed in human clothing. Tomorrow night they would crowd into the Town Hall and go *baaa baaa baaa*, when'll it get better? And *baaa baaa baaa*, take care of us until it does. And he would. Not because he wanted to, but because it was God's will.

Cox came back on. Now he sounded weary as well as stunned. Not the same man who had hectored Big Jim about stepping down. *And that's the way I want you to sound, pal,* Rennie thought. *Exactly the way.*

'My initial information is that Air Ireland flight 179 has struck the Dome and exploded. It originated in Shannon and was bound for Boston. We already have two independent witnesses who claim to have seen a shamrock on the tail, and an ABC crew that was filming just outside the quarantine zone in Harlow may have gotten . . . one more second.'

It was much more than a second; more than a minute. Big Jim's

heart had been slowing toward its normal speed (if a hundred and twenty beats per minute can be so characterized), but now it sped up again and took one of those looping misbeats. He coughed and pounded at his chest. His heart seemed almost to settle, then went into a full-blown arrhythmia. He felt sweat pop on his brow. The day, formerly dull, all at once seemed too bright.

'Jim?' It was Al Timmons, and although he was standing right beside Big Jim, his voice seemed to be coming from a galaxy far, far away. 'You okay?'

'Fine,' Big Jim said. 'Stay right there. I may want you.'

Cox was back. 'It was indeed the Air Ireland flight. I just watched ABC's streamed footage of the crash. A reporter was doing a stand-up, and it occurred right behind her. They caught the whole thing.'

'I'm sure their ratings will go up.'

'Mr Rennie, we may have had our differences, but I hope you'll convey to your constituents that this is nothing for them to worry about.'

'Just tell me how a thing like that—' His heart looped again. His breath tore in, then stopped. He pounded his chest a second time – harder – and sat down on a bench beside the brick path which ran from the Town Hall to the sidewalk. Al was looking at him instead of at the crash scar on the Dome now, his forehead furrowed with concern – and, Big Jim thought, fright. Even now, with all this happening, he was glad to see that, glad to know he was seen as indispensable. Sheep need a shepherd.

'Rennie? Are you there?'

'I'm here.' And so was his heart, but it was far from right. 'How did it happen? How *could* it? I thought you people got the word out.'

'We're not positive and won't be until we recover the black box, but we've got a pretty good idea. We sent out a directive warning all commercial air carriers away from the Dome, but this is 179's usual flight path. We think someone neglected to reprogram the autopilot. Simple as that. I'll get you further details as soon as we get them here, but right now the important thing is to quell any panic in town before it can take hold.'

But under certain circumstances, panic could be good. Under certain circumstances, it could – like food riots and acts of arson – have a beneficial effect.

'This was stupidity on a grand scale, but still just an accident,' Cox was saying. 'Make sure your people know that.'

They'll know what I tell them and believe what I want them to, Rennie thought.

His heart skittered like grease on a hot griddle, settled briefly into a more normal rhythm, then skittered again. He pushed the red END CALL button without responding to Cox and dropped the phone back into his pocket. Then he looked at Al.

'I need you to take me to the hospital,' he said, speaking as calmly as he could manage. 'I seem to be in some discomfort here.'

Al – who was wearing a Solidarity Armband – looked more alarmed than ever. 'Accourse, Jim. You just sit right there while I get my car. We can't let anything happen to you. The town needs you.'

Don't I know it, Big Jim thought, sitting on the bench and looking at the great black smear on the sky.

'Find Carter Thibodeau and tell him to meet me there. I want him on hand.'

There were other instructions he wanted to give, but just then his heart stopped completely. For a moment forever yawned at his feet, a clear dark chasm. Rennie gasped and pounded his chest. It burst into a full gallop. He thought at it: *Don't you quit on me now, I've got too much to do. Don't you dare, you cotton-picker. Don't you dare.*

20

'What was it?' Norrie asked in a high, childish voice, and then answered her own question. 'It was an airplane, wasn't it? An airplane full of people.' She burst into tears. The boys tried to hold their own tears back, and couldn't. Rommie felt like crying himself.

'Yuh,' he said. 'I think that's what it was.'

Joe turned to look at the van, now heading back toward them. When it got to the foot of the ridge it sped up, as if Rusty couldn't wait to get back. When he arrived and jumped out, Joe saw he had another reason for hurry: the lead apron was gone.

Before Rusty could say anything, his cell phone rang. He flipped it open, looked at the number, and took the call. He expected Ginny, but it was the new guy, Thurston Marshall. 'Yes, what? If it's about the plane, I saw—' He listened, frowning a little, then nodding. 'Okay, yes. Right. I'm coming now. Tell Ginny or Twitch to give him two milligrams of Valium, IV push. No, better make it three. And tell him to be calm. That's foreign to his nature, but tell him to try. Give his son five milligrams.'

He closed his phone and looked at them. 'Both Rennies are in the hospital, the elder with heartbeat arrhythmia, which he's had before. The damn fool has needed a pacemaker for two years. Thurston

says the younger has symptoms that look to him like a glioma. I hope he's wrong.'

Norrie turned her tearstained face up to Rusty's. She had her arm around Benny Drake, who was furiously wiping at his eyes. When Joe came and stood next to her, she put her other arm around him.

'That's a brain tumor, right?' she said. 'A bad one.'

'When they hit kids Junior Rennie's age, almost all of them are bad.'

'What did you find up there?' Rommie asked.

'And what happened to your apron?' Benny added.

'I found what Joe thought I'd find.'

'The generator?' Rommie said. 'Doc, are you sure?'

'Yeah. It's like nothing I ever saw before. I'm pretty sure no one on Earth's seen anything like it before.'

'Something from another planet,' Joe said in a voice so low it was a whisper. 'I *knew*.'

Rusty looked at him hard. 'You can't talk about it. None of us can. If you're asked, say we looked and found nothing.'

'Even to my mom?' Joe asked plaintively.

Rusty almost relented on that score, then hardened his heart. This was a secret now shared among five people, and that was far too many. But the kids had deserved to know, and Joe McClatchey had guessed anyway.

'Even her, at least for now.'

'I can't lie to her,' Joe said. 'It doesn't work. She's got Mom Vision.'

'Then just say I swore you to secrecy and it's better for her that way. If she presses, tell her to talk to me. Come on, I need to get back to the hospital. Rommie, you drive. My nerves are shot.'

'Aren't you gonna—' Rommie began.

'I'll tell you everything. On the way back. Maybe we can even figure out what the hell to do about it.'

21

An hour after the Air Ireland 767 crashed into the Dome, Rose Twitchell marched into the Chester's Mill PD with a napkin-covered plate. Stacey Moggin was back on the desk, looking as tired and distracted as Rose felt.

'What's that?' Stacey asked.

'Lunch. For my cook. Two toasted BLTs.'

'Rose, I'm not supposed to let you go down there. I'm not supposed to let *anyone* go down there.'

Mel Searles had been talking with two of the new recruits about a monster truck show he'd seen at the Portland Civic Center last spring. Now he looked around. 'I'll take em to him, Miz Twitchell.'

'You will *not*,' Rose said.

Mel looked surprised. And a little hurt. He had always liked Rose, and thought she liked him.

'I don't trust you not to drop the plate,' she explained, although this wasn't the exact truth; the fact was, she didn't trust him at all. 'I watched you play football, Melvin.'

'Aw, come on, I ain't that clumsy.'

'Also because I want to see if he's all right.'

'He's not supposed to have any visitors,' Mel said. 'That's from Chief Randolph, and he got it direct from Selectman Rennie.'

'Well, I'm going down. You'll have to use your Taser to stop me, and if you do that, I'll never make you another strawberry waffle the way you like them, with the batter all runny in the middle.' She looked around and sniffed. 'Besides, I don't see either of those men here right now. Or am I missing something?'

Mel considered getting tough, if only to impress the fresh fish, and then decided not to. He really did like Rose. And he liked her waffles, especially when they were a little gooshy. He hitched up his belt and said, 'Okay. But I hafta go with you, and you ain't taking him nothing until I look under that napkin.'

She raised it. Underneath were two BLTs, and a note written on the back of a Sweetbriar Rose customer check. *Stay strong*, it said. *We believe in you.*

Mel took the note, crumpled it, and threw it toward the waste-basket. It missed, and one of the recruits scurried to pick it up. 'Come on,' he said, then stopped, took half a sandwich, and tore out a monster bite. 'He couldn't eat all that, anyway,' he told Rose.

Rose said nothing, but as he led her downstairs, she *did* briefly consider braining him with the plate.

She got halfway down the lower corridor before Mel said, 'That's as close as you go, Miz Twitchell. I'll take it the rest of the way.'

She handed the plate over and watched unhappily as Mel knelt, pushed the plate through the bars, and announced: 'Lunch is served, mon-sewer.'

Barbie ignored him. He was looking at Rose. 'Thank you. Although if Anson made those, I don't know how grateful I'll be after the first bite.'

'I made them,' she said. 'Barbie – why did they beat you up? Were you trying to get away? You look *awful*.'

'Not trying to get away, resisting arrest. Wasn't I, Mel?'

'You want to quit the smart talk, or I'll come in there and take them samwidges away from you.'

'Well, you could try,' Barbie said. 'We could contest the matter.' When Mel showed no inclination to take him up on this offer, Barbie turned his attention to Rose once more. 'Was it an airplane? It sounded like an airplane. A big one.'

'ABC says it was an Air Ireland jetliner. Fully loaded.'

'Let me guess. It was on its way to Boston or New York and some not-so-bright spark forgot to reprogram the autopilot.'

'I don't know. They're not saying about that part yet.'

'Come on.' Mel came back and took her arm. 'That's enough chitter-chatter. You need to leave before I get in trouble.'

'Are you okay?' Rose asked Barbie, resisting this command – at least for a moment.

'Yeah,' Barbie said. 'How about you? Did you patch it up with Jackie Wettington yet?'

And what was the correct answer to *that* one? So far as Rose knew, she had nothing to patch up with Jackie. She thought she saw Barbie give a tiny shake of the head, and hoped it wasn't just her imagination.

'Not yet,' she said.

'You ought to. Tell her to stop being a bitch.'

'As if,' Mel muttered. He locked onto Rose's arm. 'Come on, now; don't make me drag you.'

'Tell her I said you're all right,' Barbie called as she went up the stairs, this time leading the way with Mel at her heels. 'You two really should talk. And thanks for the sandwiches.'

Tell her I said you're all right.

That was the message, she was quite sure of it. She didn't think Mel had caught it; he'd always been dull, and life under the Dome did not seem to have smartened him up any. Which was probably why Barbie had taken the risk.

Rose made up her mind to find Jackie as soon as possible, and pass on the message: *Barbie says I'm all right. Barbie says you can talk to me.*

'Thank you, Mel,' she said when they were back in the ready room. 'It was kind of you to let me do that.'

Mel looked around, saw no one of greater authority than himself, and relaxed. 'No problem-o, but don't think you're gettin down there

again with supper, because it ain't happenin.' He considered, then waxed philosophical. 'He deserves somethin nice though, I guess. Because come next week this time, he's gonna be as toasty as those samwidges you made im.'

We'll see about that, Rose thought.

22

Andy Sanders and The Chef sat beside the WCIK storage barn, smoking glass. Straight ahead of them, in the field surrounding the radio tower, was a mound of earth marked with a cross made out of crate-slats. Beneath the mound lay Sammy Bushey, torturer of Bratz, rape victim, mother of Little Walter. Chef said that later on he might steal a regular cross from the cemetery by Chester Pond. If there was time. There might not be.

He lifted his garage door opener as if to emphasize this point.

Andy felt sorry for Sammy, just as he felt sorry about Claudette and Dodee, but now it was a clinical sorrow, safely stored inside its own Dome: you could see it, could appreciate its existence, but you couldn't exactly get in there with it. Which was a good thing. He tried to explain this to Chef Bushey, although he got a little lost in the middle – it was a complex concept. Chef nodded, though, then passed Andy a large glass bong. Etched on the side were the words **NOT LEGAL FOR TRADE**.

'Good, ain't it?' Chef said.

'Yes!' Andy said.

For a little while then they discussed the two great texts of born-again dopers: what good shit this was, and how fucked up they were getting on this good shit. At some point there was a huge explosion to the north. Andy shielded his eyes, which were burning from all the smoke. He almost dropped the bong, but Chef rescued it.

'Holy shit, that's an *airplane!*' Andy tried to get up, but his legs, although buzzing with energy, wouldn't hold him. He settled back.

'No, Sanders,' Chef said. He puffed at the bong. Sitting with legs akimbo as he was, he looked to Andy like an Indian with a peace pipe.

Leaning on the side of shed between Andy and Chef were four full-auto AK-47s, Russian in manufacture but imported – like many other fine items stocked in the storage facility – from China. There were also five stacked crates filled with thirty-round clips and a box of RGD-5 grenades. Chef had offered Andy a translation of the ideograms on the box of grenades: *Do Not Drop This Motherfucker*.

Now Chef took one of the AKs and laid it across his knees. 'That was *not* an airplane,' he amplified.

'No? Then what was it?'

'A sign from God.' Chef looked at what he had painted on the side of the storage barn: two quotes (liberally interpreted) from the Book of Revelation with the number 31 featured prominently. Then he looked back at Andy. To the north, the plume of smoke in the sky was dissipating. Below it, fresh smoke was rising from where the plane had impacted in the woods. 'I got the date wrong,' he said in a brooding voice. 'Halloween really is coming early this year. Maybe today, maybe tomorrow, maybe the day after tomorrow.'

'Or the day after that,' Andy added helpfully.

'Maybe,' Chef allowed, 'but I think it'll be sooner. Sanders!'

'What, Chef?'

'Take you a gun. You're in the Lord's army now. You're a Christian soldier. Your days of licking that apostate son of a bitch's ass are over.'

Andy took an AK and laid it across his bare thighs. He liked the weight of it and the warmth of it. He checked to make sure the safety was on. It was. 'What apostate son of a bitch are you talking about, Chef?'

Chef fixed him with a look of utter contempt, but when Andy reached for the bong, he handed it over willingly enough. There was plenty for both of them, would be from now until the end, and yea, verily, the end would not be long. 'Rennie. *That* apostate son of a bitch.'

'He's my friend – my pal – but he can be a hardass, all right,' Andy admitted. 'My *goodness* but this is good shit.'

'It is,' Chef agreed moodily, and took the bong (which Andy now thought of as the Smokeum Peace Pipe) back. 'It's the longest of long glass, the purest of the pure, and what is it, Sanders?'

'A medicine for melancholy!' Andy returned smartly.

'And what is that?' Pointing at the new black mark on the Dome.

'A sign! From God!'

'Yes,' Chef said, mollified. 'That's exactly what it is. We're on a God-trip now, Sanders. Do you know what happened when God opened the seventh seal? Have you *read* Revelation?'

Andy had a memory, from the Christian camp he'd attended as a teenager, of angels popping out of that seventh seal like clowns from the little car at the circus, but he didn't want to say it that way. Chef might consider it blasphemous. So he just shook his head.

'Thought not,' Chef said. 'You might have gotten *preaching* at

Holy Redeemer, but preaching is not education. Preaching is not the true *visionary shit*. Do you understand that?'

What Andy understood was that he wanted another hit, but he nodded his head.

'When the seventh seal was opened, seven angels appeared with seven trumpets. And each time one blew the boogie, a plague smote down on the earth. Here, toke this shit, it'll help your concentration.'

How long had they been out here smoking? It seemed like hours. Had they really seen a plane crash? Andy thought so, but now he wasn't completely sure. It seemed awfully farfetched. Maybe he should take a nap. On the other hand, it was wonderful to the point of ecstasy just to be out here with Chef, getting stoned and educated. 'I almost killed myself, but God saved me,' he told Chef. The thought was so wonderful that tears filled his eyes.

'Yeah, yeah, that's obvious. This other stuff isn't. So listen.'

'I am.'

'First angel blew and hailed down blood on the earth. Second angel blew and a mountain of fire was cast into the sea. That's your volcanoes and shit.'

'Yes!' Andy shouted, and inadvertently squeezed the trigger of the AK-47 lying across his lap.

'You want to watch that,' Chef said. 'If the safety hadn't been on, you would have blown my tickle-stick into yonder pine tree. Hit on this shit.' He handed Andy the bong. Andy couldn't even remember giving it back to him, but he must have done. And what time *was* it? It looked like midafternoon, but how could that be? He hadn't gotten hungry for lunch and he *always* got hungry for lunch, it was his best meal.

'Now listen, Sanders, because this is the important part.'

Chef was able to quote from memory because he had made quite a study of the book of Revelations since moving out here to the radio station; he read and reread it obsessively, sometimes until dawn streaked the horizon. '"And the third angel sounded, and there fell a great star from heaven! Burning as if it were a lamp!"'

'We just saw that!'

Chef nodded. His eyes were fixed on the black smutch where Air Ireland 179 had met her end. '"And the name of the star is called Wormwood, and many men died because they were made bitter." Are *you* bitter, Sanders?'

'No!' Andy assured him.

'No. We're *mellow*. But now that Star Wormwood has blazed in the sky, bitter men will come. God has told me this, Sanders, and it's

no bullshit. Check me out and you find I'm all about zero bullshit. They're gonna try to take all this away from us. Rennie and his bull-shit cronies.'

'No way!' Andy cried. A sudden and horribly intense paranoia swept over him. They could be here already! Bullshit cronies creeping through those trees! Bullshit cronies driving down Little Bitch Road in a line of trucks! Now that Chef had brought it up, he even saw why Rennie would want to do it. He'd call it 'getting rid of the evidence.'

'Chef!' He gripped his new friend's shoulder.

'Let up a little, Sanders. That hurts.'

He let up a little. 'Big Jim's already talked about coming up and getting the propane tanks – *that's the first step*!'

Chef nodded. 'They've already been here once. Took two tanks. I let em.' He paused, then patted the grenades. 'I won't let em again. Are you down with that?'

Andy thought of the pounds of dope inside the building they were leaning against, and gave the answer Chef had expected. 'My brother,' he said, and embraced Chef.

Chef was hot and stinky, but Andy hugged with enthusiasm. Tears were rolling down his face, which he had neglected to shave on a weekday for the first time in over twenty years. This was great. This was . . . was . . .

Bonding!

'My brother,' he sobbed into Chef's ear.

Chef thrust him back and looked at him solemnly. 'We are agents of the Lord,' he said.

And Andy Sanders – now all alone in the world except for the scrawny prophet beside him – said amen.

23

Jackie found Ernie Calvert behind his house, weeding his garden. She was a little worried about approaching him in spite of what she'd told Piper, but she needn't have been. He gripped her shoulders with hands that were surprisingly strong for such a portly little man. His eyes shone.

'Thank God someone sees what that windbag's up to!' He dropped his hands. 'Sorry. I smudged your blouse.'

'That's all right.'

'He's dangerous, Officer Wettington. You know that, don't you?'

'Yes.'

'And clever. He set up that damned food riot the way a terrorist would plant a bomb.'

'I have no doubt of it.'

'But he's also stupid. Clever and stupid is a terrible combination. You can persuade people to go with you, you see. All the way to hell. Look at that fellow Jim Jones, remember him?'

'The one who got all his followers to drink poison. So you'll come to the meeting?'

'You bet. And mum's the word. Unless you want me to talk to Lissa Jamieson, that is. Glad to do it.'

Before Jackie could answer, her cell phone rang. It was her personal; she had turned in the one issued to her by the PD along with her badge and gun.

'Hello, this is Jackie.'

'*Mihi portatoe vulneratos*, Sergeant Wettington,' an unfamiliar voice said.

The motto of her old unit in Würzburg – *bring me your wounded* – and Jackie responded without even thinking: 'On stretchers, crutches, or in bags, we put em together with spit and rags. Who the hell is this?'

'Colonel James Cox, Sergeant.'

Jackie moved the phone away from her mouth. 'Give me a minute, Ernie?'

He nodded and went back to his garden. Jackie strolled toward the shakepole fence at the foot of the yard. 'What can I do for you, Colonel? And is this line secure?'

'Sergeant, if your man Rennie can tap cell phone calls made from beyond the Dome, we're in a world of hurt.'

'He's not my man.'

'Good to know.'

'And I'm no longer in the Army. The Sixty-seventh isn't even in my rearview mirror these days, sir.'

'Well, that's not exactly true, Sarge. By order of the President of the United States, you've been stop-lossed. Welcome back.'

'Sir, I don't know whether to say thank you or fuck you very much.'

Cox laughed without much humor. 'Jack Reacher says hello.'

'Is that where you got this number?'

'That and a recommendation. A recommendation from Reacher goes a long way. You asked what you can do for me. The answer is twofold, both parts simple. One, get Dale Barbara out of the mess he's in. Unless you think he's guilty of the charges?'

'No, sir. I'm sure he's not. That is to say, *we* are. There are several of us.'

'Good. *Very* good.' There was no mistaking the relief in the man's voice. 'Number two, you can knock that bastard Rennie off his perch.'

'That would be Barbie's job. If . . . you're positive this line's secure?'

'Positive.'

'If we can get him out.'

'That's in work, is it?'

'Yes, sir, I believe so.'

'Excellent. How many brownshirts does Rennie have?'

'Currently about thirty, but he's still hiring. And here in The Mill they're blueshirts, but I take your meaning. Don't sell him short, Colonel. He's got most of this town in his pocket. We're going to try to get Barbie out, and you better hope we succeed, because I can't do much about Big Jim on my own. Toppling dictators with no help from the outside world is about six miles above my pay grade. And just FYI, my own days on the Chester's Mill PD are over. Rennie shitcanned me.'

'Keep me informed when and as you can. Spring Barbara and turn your resistance operation over to him. We'll see who ends up getting shitcanned.'

'Sir, you sort of wish you were in here, don't you?'

'With all my heart.' No hesitation. 'I'd dewheel that sonofabitch's little red wagon in about twelve hours.'

Jackie doubted that, actually; things were different under the Dome. Outsiders couldn't understand. Even time was different. Five days ago, everything had been normal. Now look.

'One other thing,' Colonel Cox said. 'Take some time out of your busy schedule to look at the TV. We're going to do our level best to make Rennie's life uncomfortable.'

Jackie said goodbye and broke the connection. Then she walked back to where Ernie was gardening. 'Got a generator?' she asked.

'Died last night,' he said with sour good cheer.

'Well, let's go someplace where there's a working TV. My friend says we should check out the news.'

They headed for Sweetbriar Rose. On their way they met Julia Shumway and brought her along.

BUSTED

1

Sweetbriar was closed until 5 p.m., at which time Rose planned to offer a light supper, mostly leftovers. She was making potato salad and keeping an eye on the TV over the counter when the knocking on the door started. It was Jackie Wettington, Ernie Calvert, and Julia Shumway. Rose crossed the empty restaurant, wiping her hands on her apron, and unlocked the door. Horace the Corgi trotted at Julia's heel, ears up, grinning companionably. Rose made sure the CLOSED sign was still in place, then relocked the door behind them.

'Thanks,' Jackie said.

'Not at all,' Rose replied. 'I wanted to see you anyway.'

'We came for that,' Jackie said, and pointed to the TV. 'I was at Ernie's, and we met Julia on our way here. She was sitting across the street from her place, mooning at the wreckage.'

'I was not mooning,' Julia said. 'Horace and I were trying to figure how we're going to get a paper out after the town meeting. It'll have to be small – probably just two pages – but there *will* be a paper. My heart is set on it.'

Rose glanced back at the TV. On it, a pretty young woman was doing a stand-up. Beneath her was a banner reading EARLIER TODAY COURTESY ABC. All at once there was a bang and a fireball bloomed in the sky. The reporter flinched, cried out, wheeled around. By that point her cameraman was already zooming her out of the picture, homing in on the earthbound fragments of the Air Ireland.

'There's nothing but reruns of the plane-crash footage,' Rose said. 'If you haven't seen it before, be my guest. Jackie, I saw Barbie late this morning – I took him some sandwiches and they let me go down-stairs to where the cells are. I had Melvin Searles as my chaperone.'

'Lucky you,' Jackie said.

'How is he?' Julia asked. 'Is he okay?'

'He looks like the wrath of God, but I think so, yes. He said . . . maybe I should tell you privately, Jackie.'

'Whatever it is, I think you can say it in front of Ernie and Julia.'

Rose considered this, but only for a moment. If Ernie Calvert and Julia Shumway weren't all right, nobody was. 'He said I was supposed to talk to you. Make up with you, as if we'd had a fight. He said to tell you that I'm all right.'

Jackie turned to Ernie and Julia. It seemed to Rose that a question was asked and answered. 'If Barbie says you are, then you are,' Jackie said, and Ernie nodded emphatically. 'Hon, we're putting together a little meeting tonight. At the Congo parsonage. It's kind of a secret—'

'Not kind of, it *is*,' Julia said. 'And given the way things are in town right now, the secret better not get out.'

'If it's about what I think it's about, I'm in.' Then Rose lowered her voice. 'But not Anson. He's wearing one of those goddam armbands.'

Just then the CNN BREAKING NEWS logo came on the TV screen, accompanied by the annoying minor-key disaster music the network was now playing with each new Dome story. Rose expected either Anderson Cooper or her beloved Wolfie – both were now based in Castle Rock – but it was Barbara Starr, the network's Pentagon correspondent. She was standing outside the tent-and-trailer village serving as the Army's forward base in Harlow.

'Don, Kyra – Colonel James O. Cox, the Pentagon's point man since the mammoth mystery known as the Dome came into being last Saturday, is about to speak to the press for only the second time since this crisis began. The subject was announced to reporters just moments ago, and it's sure to galvanize the tens of thousands of Americans with loved ones in the beleaguered town of Chester's Mill. We were told—' She listened to something in her earpiece. 'Here's Colonel Cox.'

The four in the restaurant sat on stools at the counter, watching as the picture switched to the inside of a large tent. There were perhaps forty reporters seated in folding chairs, and more standing in the back. They were murmuring among themselves. A makeshift stage had been set up at one end of the tent. On it was a podium festooned with microphones and flanked by American flags. There was a white screen behind it.

'Pretty professional, for an on-the-fly operation,' Ernie said.

'Oh, I think this has been in the works,' Jackie said. She was recalling her conversation with Cox. *We're going to do our level best to make Rennie's life uncomfortable*, he'd said.

A flap opened to the left side of the tent, and a short, fit-looking man with graying hair strode briskly to the makeshift stage. No one had thought to put down a couple of stairs or even a box to stand on, but this presented no problem to the featured speaker; he hopped up easily, not even breaking stride. He was dressed in plain khaki BDUs. If he had medals, they weren't in evidence. There was nothing

on his shirt but a strip reading COL. J. COX. He held no notes. The reporters quieted immediately, and Cox gave them a little smile.

'This guy should have been holding press conferences all along,' Julia said. 'He looks *good*.'

'Hush, Julia,' Rose said.

'Ladies and gentlemen, thank you for coming,' Cox said. 'I'll be brief, and then I'll take a few questions. The situation as regards Chester's Mill and what we're all now calling the Dome is as it was: the town continues to be cut off, we still have no idea about what is causing this situation or what brought it about, and we have as yet had no success in breaching the barrier. You would know, of course, if we had. The best scientists in America – the best in the entire world – are on the case, however, and we're considering a number of options. Do not ask me about these, because you'll get no answers at this time.'

The reporters murmured discontentedly. Cox let them. Below him, the CNN super switched to NO ANSWERS AT THIS TIME. When the murmuring died, Cox went on.

'As you're aware, we have established a no-go zone around the Dome, initially of a mile, expanded to two on Sunday and four on Tuesday. There were a number of reasons for this, the most impor-tant being that the Dome is dangerous to people with certain implants, such as pacemakers. A second reason is that we were concerned the field generating the Dome might have other harmful effects which would be less clearly recognized.'

'Are you talking about radiation, Colonel?' someone called.

Cox froze him with a glance, and when he seemed to consider the reporter properly chastised (not Wolfie, Rose was pleased to see, but that half-bald no-spin yapper from FOX News), he went on.

'We now believe that there are no harmful effects, at least in the short term, and so we have designated Friday, October twenty-seventh – the day after tomorrow – as Visitors Day at the Dome.'

A perfect fury of thrown questions went up at this. Cox waited it out, and when the audience had quieted down, he took a remote from the shelf under the podium and pressed a button. A high-resolution photograph (much too good to have been downloaded from Google Earth, in Julia's estimation) popped up on the white screen. It showed The Mill and both towns to the south, Motton and Castle Rock. Cox put down the controller and produced a laser-pointer.

The super at the bottom of the screen now read FRIDAY DESIGNATED VISATORS DAY AT THE DOME. Julia smiled. Colonel Cox had caught CNN with its spell-checker down.

'We believe we can process and accommodate twelve hundred visitors,' Cox said crisply. 'These will be limited to close relatives, at least this time . . . and all of us hope and pray there will never have to be a next time. Rally points will be here, at the Castle Rock Fairgrounds, and here, at Oxford Plains Speedway.' He highlighted both locations. 'We will lay on two dozen buses, twelve at each location. These will be provided by six surrounding school districts, which are canceling classes that day to help in this effort, and we offer them our greatest thanks. A twenty-fifth bus will be available for press at Shiner's Bait and Tackle in Motton.' Dryly: 'Since Shiner's is also an agency liquor store, I'm sure most of you know it. There will also be one, I repeat, *one*, video truck allowed on this trip. You'll arrange pool coverage, ladies and gentlemen, the coverage provider to be chosen by lottery.'

A groan went up at this, but it was perfunctory.

'There are forty-eight seats on the press bus, and obviously there are hundreds of press representatives here, from all over the world—'

'*Thousands!*' a gray-haired man shouted, and there was general laughter.

'Boy, I'm glad *someone's* havin fun,' Ernie Calvert said bitterly.

Cox allowed himself a smile. 'I stand corrected, Mr Gregory. Seats will be allocated according to your news organization – TV networks, Reuters, Tass, AP, and so on – and it's up to those organizations to pick their representatives.'

'Better be Wolfie from CNN, that's all I can say,' Rose announced.

The reporters were babbling excitedly.

'May I go on?' Cox asked. 'And those of you sending text messages, kindly stop.'

'Ooo,' Jackie said. 'I love a forceful man.'

'Surely you folks recall that you're not the story here? Would you behave this way if it was a mine cave-in, or people trapped under collapsed buildings after an earthquake?'

Silence greeted this, the kind that falls over a fourth-grade class after the teacher finally loses his temper. He really *was* forceful, Julia thought, and for a moment wished with all her heart that Cox were here under the Dome, and in charge. But of course, if pigs had wings, bacon would be airborne.

'Your job, ladies and gentlemen, is twofold: to help us get the word out, and to make sure that things go smoothly on Visitors Day once it does.'

The CNN super became PRESS TO AID VISATORS ON FRIDAY.

'The last thing we want to do is start a stampede of relations from all over the country to western Maine. We've already got close to ten thousand relatives of those trapped under the Dome in this immediate area; the hotels, motels, and camping areas are full to bursting. The message to relatives in other parts of the country is, "If you're not here, don't come." Not only will you not be granted a visitors' pass, you'll be turned around at checkpoints here, here, here, and here.' He highlighted Lewiston, Auburn, North Windham, and Conway, New Hampshire.

'Relatives currently in the area should proceed to registration officers who are already standing by at the Fairgrounds and the Speedway. If you're planning to jump into your car right this minute, don't. This isn't the Filene's White Sale, and being first in line guarantees you nothing. Visitors will be chosen by lottery, and you must register to get in. Those applying to visit will need two photo IDs. We'll attempt to give priority to visitors with two or more relatives in The Mill, but no promises on that. And a warning, people: if you show up on Friday to board one of the buses and you have no pass or a counterfeit pass — if you clog up our operation, in other words — you'll find yourself in jail. Do *not* test us on this.

'Embarkation on Friday morning will commence at 0800 hours. If this goes smoothly, you'll have at least four hours with your loved ones, maybe longer. Gum up the works and everyone's time Domeside goes down. Buses will depart the Dome at seventeen hundred hours.'

'What's the visitors' site?' a woman shouted.

'I was just getting to that, Andrea.' Cox picked up his controller and zoomed in on Route 119. Jackie knew the area well; she had damned near broken her nose on the Dome out there. She could see the roofs of the Dinsmore farmhouse, outbuildings, and dairy barns.

'There's a flea market site on the Motton side of the Dome.' Cox binged it with his pointer. 'The buses will park there. Visitors will debark and walk to the Dome. There's plenty of field on both sides where people can gather. All the wreckage out there has been removed.'

'Will the visitors be allowed to go all the way up to the Dome?' a reporter asked.

Cox once more faced the camera, addressing the potential visitors directly. Rose could just imagine the hope and fear those people — watching in bars and motel TVs, listening on their car radios — must be feeling right now. She felt plenty of both herself.

'Visitors will be allowed within two yards of the Dome,' Cox said. 'We consider that a safe distance, although we make no guarantees. This isn't an amusement park ride that's been safety-tested. People with electronic implants must *stay away*. You're on your own with that; we can't check each and every chest for a pacemaker scar. Visitors will also leave all electronic devices, including but not limited to iPods, cell phones, and BlackBerries, on the buses. Reporters with mikes and cameras will be kept at a distance. The close-up space is for the visitors, and what goes on between them and their loved ones is no one's business but their own. People, this will work if you help us make it work. If I can put it in *Star Trek* terms, help us make it so.' He put the pointer down. 'Now I'll take a few questions. A *very* few. Mr Blitzer.'

Rose's face lit up. She raised a fresh cup of coffee and toasted the TV screen with it. 'Lookin good, Wolfie! You can eat crackers in my bed anytime you want.'

'Colonel Cox, are there any plans to add a press conference with the town officials? We understand that Second Selectman James Rennie is the actual man in charge. What's going on with that?'

'We *are* trying to make a press conference happen, with Mr Rennie and any other town officials who might be in attendance. That would be at noon, if things run to the schedule we have in mind.'

A round of spontaneous applause from the reporters greeted this. There was nothing they liked better than a press conference, unless it was a high-priced politician caught in bed with a high-priced whore.

Cox said, 'Ideally, the presser will take place right there on the road, with the town spokespersons, whoever they might be, on their side and you ladies and gentlemen on this one.'

Excited gabble. They liked the visual possibilities.

Cox pointed. 'Mr Holt.'

Lester Holt from NBC shot to his feet. 'How sure are you that Mr Rennie will attend? I ask because there have been reports of financial mismanagement on his part, and some sort of criminal investigation into his affairs by the State of Maine Attorney General.'

'I've heard those reports,' Cox said. 'I'm not prepared to comment on them, although Mr Rennie may want to.' He paused, not quite smiling. '*I'd* certainly want to.'

'Rita Braver, Colonel Cox, CBS. Is it true that Dale Barbara, the man you tapped as emergency administrator in Chester's Mill, has been arrested for murder? That the Chester's Mill police in fact believe him to be a serial killer?'

Total silence from the press; nothing but attentive eyes. The same was true of the four people seated at the counter in Sweetbriar Rose.

'It's true,' Cox said. A muted mutter went up from the assembled reporters. 'But we have no way of verifying the charges or vetting whatever evidence there may be. What we have is the same telephone and Internet chatter you ladies and gentlemen are no doubt getting. Dale Barbara is a decorated officer. He's never been arrested. I have known him for many years and vouched for him to the President of the United States. I have no reason to say I made a mistake based on what I know at this time.'

'Ray Suarez, Colonel, PBS. Do you believe the charges against Lieutenant Barbara – now Colonel Barbara – may have been politically motivated? That James Rennie may have had him jailed to keep him from taking control as the President ordered?'

And that's what the second half of this dog-and-pony show is all about, Julia realized. *Cox has turned the news media into the Voice of America, and we're the people behind the Berlin Wall.* She was all admiration.

'If you have a chance to question Selectman Rennie on Friday, Mr Suarez, you be sure to ask him that.' Cox spoke with a kind of stony calm. 'Ladies and gentlemen, that's all I have.'

He strode off as briskly as he'd entered, and before the assembled reporters could even begin shouting more questions, he was gone.

'Holy wow,' Ernie murmured.

'Yeah,' Jackie said.

Rose killed the TV. She looked glowing, energized. 'What time is this meeting? I don't regret a thing that Colonel Cox said, but this could make Barbie's life more difficult.'

2

Barbie found out about Cox's press conference when a red-faced Manuel Ortega came downstairs and told him. Ortega, formerly Alden Dinsmore's hired man, was now wearing a blue workshirt, a tin badge that looked homemade, and a .45 hung on a second belt that had been buckled low on his hips, gunslinger-style. Barbie knew him as a mild fellow with thinning hair and perpetually sun-burned skin who liked to order breakfast for dinner – pancakes, bacon, eggs over easy – and talk about cows, his favorite being the Belted Galloways that he could never persuade Mr Dinsmore to buy. He was Yankee to the core in spite of his name, and had a dry Yankee sense of humor. Barbie had always liked him. But this was a different Manuel, a stranger

with all the good humor boiled dry. He brought news of the latest development, most of it shouted through the bars and accompanied by a considerable dose of flying spit. His face was nearly radioactive with rage.

'Not a word about how they found your dog tags in that poor girl's hand, not word-fucking-*one* about that! And then the tin-pants bastid went and took after Jim Rennie, who's held this town together by himself since this happened! *By himself! With SPIT and BALING WIRE!*'

'Take it easy, Manuel,' Barbie said.

'That's Officer Ortega to you, motherfucker!'

'Fine. Officer Ortega.' Barbie was sitting on the bunk and thinking about just how easy it would be for Ortega to unholster the elderly .45 Schofield on his belt and start shooting. 'I'm in here, Rennie's out there. As far as he's concerned, I'm sure it's all good.'

'*SHUT UP!*' Manuel screamed. 'We're *ALL* in here! All under the fucking Dome! Alden don't do nothing but drink, the boy that's left won't eat, and Miz Dinsmore never stops crying over Rory. Jack Evans blew his brains out, do you know that? And those military pukes out there can't think of anything better to do than sling mud. A lot of lies and trumped-up stories while you start supermarket riots and then burn down our newspaper! Probably so Miz Shumway couldn't publish *WHAT YOU ARE!*'

Barbie kept silent. He thought that one word spoken in his own defense would get him shot for sure.

'This is how they get any politician they don't like,' Manuel said. 'They want a serial killer and a rapist – one who rapes the *dead* – in charge instead of a Christian? That's a new low.'

Manuel drew his gun, lifted it, pointed it through the bars. To Barbie the hole at the end looked as big as a tunnel entrance.

'If the Dome comes down before you been stood up against the nearest wall and ventilated,' Manuel continued, 'I'll take a minute to do the job myself. I'm head of the line, and right now in The Mill, the line waiting to do you is a long one.'

Barbie kept silent and waited to die or keep on drawing breath. Rose Twitchell's BLTs were trying to crowd back up his throat and choke him.

'We're trying to survive and all *they* can do is dirty up the man who's keeping this town out of chaos.' He abruptly shoved the oversized pistol back into its holster. 'Fuck you. You're not worth it.'

He turned and strode back toward the stairs, head down and shoulders hunched.

Barbie leaned back against the wall and let out a breath. There was sweat on his forehead. The hand he lifted to wipe it off was shaking.

3

When Romeo Burpee's van turned into the McClatchey driveway, Claire rushed out of the house. She was weeping.

'Mom!' Joe shouted, and was out even before Rommie could come to a complete stop. The others piled out after. 'Mom, what's wrong?'

'Nothing,' Claire sobbed, grabbing him and hugging him. 'There's going to be a Visitors Day! On Friday! Joey, I think we might get to see your dad!'

Joe let out a cheer and danced her around. Benny hugged Norrie . . . and took the opportunity to steal a quick kiss, Rusty observed. Cheeky little devil.

'Take me to the hospital, Rommie,' Rusty said. He waved to Claire and the kids as they backed down the driveway. He was glad to get away from Mrs McClatchey without having to talk to her; Mom Vision might work on PAs, as well. 'And could you do me a favor and talk English instead of that comic-book *on parle* shit while you do it?'

'Some people have no cultural heritage to fall back on,' Rommie said, 'and are thus jealous of those who do.'

'Yeah, and your mother wears galoshes,' Rusty said.

'Dat's true, but only when it rains, her.'

Rusty's cell phone chimed once: a text message. He flipped it open and read: MEETING AT 2130 CONGO PARSONAGE B THERE OR B SQUARE JW

'Rommie,' he said, closing his phone. 'Assuming I survive the Rennies, would you consider attending a meeting with me tonight?'

4

At the hospital, Ginny met him in the lobby. 'It's Rennie Day at Cathy Russell,' she announced, looking as if this did not exactly displease her. 'Thurse Marshall has been in to see them both. Rusty, that man is a gift from God. He clearly doesn't like Junior – he and Frankie were the ones who roughed him up out at the Pond – but he was totally professional. The guy's wasted in some college English department – he should be doing this.' She lowered her voice. 'He's better than me. And *way* better than Twitch.'

'Where is he now?'

'Went back to where he's living to see that young girlfriend of his and the two children they took on. He seems to genuinely care about the kids, too.'

'Oh my goodness, Ginny's in love,' Rusty said, grinning.

'Don't be juvenile.' She glared at him.

'What rooms are the Rennies in?'

'Junior in Seven, Senior in Nineteen. Senior came in with that guy Thibodeau, but must have sent him off to run errands, because he was on his own when he went down to see his kid.' She smiled cynically. 'He didn't visit long. Mostly he's been on that cell phone of his. The kid just sits, although he's rational again. He wasn't when Henry Morrison brought him in.'

'Big Jim's arrhythmia? Where are we with that?'

'Thurston got it quieted down.'

For the time being, Rusty thought, and not without satisfaction. *When the Valium wears off, he'll recommence the old cardiac jitterbug.*

'Go see the kid first,' Ginny said. They were alone in the lobby, but she kept her voice low-pitched. 'I don't like him, I've never liked him, but I feel sorry for him now. I don't think he's got long.'

'Did Thurston say anything about Junior's condition to Rennie?'

'Yes, that the problem was potentially serious. But apparently not as serious as all those calls he's making. Probably someone told him about Visitors Day on Friday. Rennie's pissed about it.'

Rusty thought of the box on Black Ridge, just a thin rectangle with an area of less than fifty square inches, and still he hadn't been able to lift it. Or even budge it. He also thought of the laughing leatherheads he'd briefly glimpsed.

'Some people just don't approve of visitors,' he said.

5

'How are you feeling, Junior?'

'Okay. Better.' He sounded listless. He was wearing a hospital johnny and sitting by the window. The light was merciless on his haggard face. He looked like a rode-hard forty-year-old.

'Tell me what happened before you passed out.'

'I was going to school, then I went to Angie's house instead. I wanted to tell her to make it up with Frank. He's been majorly bummin'.'

Rusty considered asking if Junior knew Frank and Angie were both dead, then didn't – what was the point? Instead he asked, 'You were going to school? What about the Dome?'

'Oh, right.' The same listless, affectless voice. 'I forgot about that.'

'How old are you, son?'

'Twenty . . . one?'

'What was your mother's name?'

Junior considered this. 'Jason Giambi,' he said at last, then laughed shrilly. But the listless, haggard expression on his face never changed.

'When did the Dome drop down?'

'Saturday.'

'And how long ago was that?'

Junior frowned. 'A week?' he said at last. Then, 'Two weeks? It's been awhile, for sure.' He turned at last to Rusty. His eyes were shining with the Valium Thurse Marshall had injected. 'Did *Baaarbie* put you up to all these questions? He killed them, you know.' He nodded. 'We found his gog bags.' A pause. '*Dog* tags.'

'Barbie didn't put me up to anything,' Rusty said. 'He's in jail.'

'Pretty soon he'll be in hell,' Junior said with dry matter-of-factness. 'We're going to try him and execute him. My dad said so. There's no death penalty in Maine, but he says these are wartime conditions. Egg salad has too many calories.'

'That's true,' Rusty said. He had brought a stethoscope, a blood-pressure cuff, and ophthalmoscope. Now he wrapped the cuff around Junior's arm. 'Can you name the last three presidents in order, Junior?'

'Sure. Bush, Push, and Tush.' He laughed wildly, but still with no facial expression.

Junior's bp was 147 over 120. Rusty had been prepared for worse. 'Do you remember who came in to see you before I did?'

'Yeah. The old guy me and Frankie found at the Pond just before we found the kids. I hope those kids are all right. They were totally cute.'

'Do you remember their names?'

'Aidan and Alice Appleton. We went to the club and that girl with the red hair jerked me off under the table. Thought she was gonna fair it right off before she was fun.' A pause. '*Done.*'

'Uh-huh.' Rusty employed the ophthalmoscope. Junior's right eye was fine. The optic disc of the left was bulging, a condition known as papilledema. It was a common symptom of advanced brain tumors and the attendant swelling.

'See anything green, McQueen?'

'Nope.' Rusty put the ophthalmoscope down, then held his index finger in front of Junior's face. 'I want you to touch my finger with your finger. Then touch your nose.'

Junior did so. Rusty began to move his finger slowly back and forth. 'Keep going.'

Junior succeeded in going from the moving finger to his nose once. Then he hit the finger but touched his cheek instead. The third time he missed the finger and touched his right eyebrow. 'Booya. Want more? I can do it all day, you know.'

Rusty pushed his chair back and stood up. 'I'm going to send Ginny Tomlinson in with a prescription for you.'

'After I get it, can I go roam? Home, I mean?'

'You're staying overnight with us, Junior. For observation.'

'But I'm all right, aren't I? I had one of my headaches before – I mean a real blinder – but it's gone. I'm okay, right?'

'I can't tell you anything right now,' Rusty said. 'I want to talk with Thurston Marshall and look at some books.'

'Man, that guy's no doctor. He's an English teacher.'

'Maybe so, but he treated you okay. Better than you and Frank treated him, is my understanding.'

Junior waved a dismissing hand. 'We were just playin. Besides, we treated those rids kite, didn't we?'

'Can't argue with you there. For now, Junior, just relax. Watch some TV, why don't you?'

Junior considered this, then asked, 'What's for supper?'

6

Under the circumstances, the only thing Rusty could think of to reduce the swelling in what passed for Junior Rennie's brain was IV mannitol. He pulled the chart out of the door and saw a note attached to it in an unfamiliar looping scrawl:

> *Dear Dr Everett: What do you think about mannitol for this patient? I cannot order, have no idea of the correct amount.*
> *Thurse*

Rusty jotted down the dose. Ginny was right; Thurston Marshall was good.

7

The door to Big Jim's room was open, but the room was empty. Rusty heard the man's voice coming from the late Dr Haskell's favorite snoozery. Rusty walked down to the lounge. He did

not think to take Big Jim's chart, an oversight he would come to regret.

Big Jim was fully dressed and sitting by the window with his phone to his ear, even though the sign on the wall showed a bright red cell phone with a red **X** over it for the reading-impaired. Rusty thought it would give him great pleasure to order Big Jim to terminate his call. It might not be the most politic way to start what was going to be a combination exam-discussion, but he meant to do it. He started forward, then stopped. Cold.

A clear memory arose: not being able to sleep, getting up for a piece of Linda's cranberry-orange bread, hearing Audrey whining softly from the girls' room. Going down there to check the Js. Sitting on Jannie's bed beneath Hannah Montana, her guardian angel.

Why had this memory been so slow in coming? Why not during his meeting with Big Jim, in Big Jim's home study?

Because then I didn't know about the murders; I was fixated on the propane. And because Janelle wasn't having a seizure, she was just in REM sleep. Talking *in her sleep.*

He has a golden baseball, Daddy. It's a bad baseball.

Even last night, in the mortuary, that memory hadn't resurfaced. Only now, when it was half-past too late.

But think what it means: that gadget up on Black Ridge may only be putting out limited radiation, but it's broadcasting something else. Call it induced precognition, call it something that doesn't even have a name, but whatever you call it, it's there. And if Jannie was right about the golden base-ball, then all the kids who've been making Sybil-like pronouncements about a Halloween disaster may be right, too. But does it mean on that exact day? Or could it be earlier?

Rusty thought the latter. For a townful of kids overexcited about trick-or-treating, it was Halloween already.

'I don't *care* what you've got on, Stewart,' Big Jim was saying. Three milligrams of Valium didn't seem to have mellowed him out; he sounded as fabulously grumpy as ever. 'You and Fernald get up there, and take Roger with y . . . huh? What?' He listened. 'I shouldn't even have to tell you. Haven't you been watching the cotton-picking TV? If he gives you any sass, you—'

He looked up and saw Rusty in the doorway. For just a moment Big Jim had the startled look of a man replaying his conversation and trying to decide how much the newcomer might have overheard.

'Stewart, someone's here. I'll get back to you, and when I do, you better tell me what I want to hear.' He broke the connection without saying goodbye, held the phone up to Rusty, and bared his

small upper teeth in a smile. 'I know, I know, very naughty, but town business won't wait.' He sighed. 'It's not easy to be the one everybody's depending on, especially when you're not feeling well.'

'Must be difficult,' Rusty agreed.

'God helps me. Would you like to know the philosophy I live by, pal?'

No. 'Sure.'

'When God closes a door, He opens a window.'

'Do you think so?'

'I *know* so. And the one thing I always try to remember is that when you pray for what you *want*, God turns a deaf ear. But when you pray for what you need, He's *all* ears.'

'Uh-huh.' Rusty entered the lounge. On the wall, the TV was tuned to CNN. The sound was muted, but there was a still photo of James Rennie, Sr., looming behind the talking head: black-and-white, not flattering. One of Big Jim's fingers was raised, and so was his upper lip. Not in a smile, but in a remarkably canine sneer. The super beneath read WAS DOME TOWN DRUG HAVEN? The picture switched to a Jim Rennie used car ad, the annoying one that always ended with one of the salespeople (never Big Jim himself) screaming '*You'll be WHEELIN, because Big Jim's DEALIN!*'

Big Jim gestured to it and smiled sadly. 'You see what Barbara's friends on the outside are doing to me? Well, what's the surprise? When Christ came to redeem mankind, they made him carry His own cross to Calvary Hill, where He died in blood and dust.'

Rusty reflected, and not for the first time, what a strange drug Valium was. He didn't know if there really was *veritas* in *vino*, but there was plenty of it in Valium. When you gave it to people – especially by IV – you often heard exactly what they thought of themselves.

Rusty pulled up a chair and readied the stethoscope for action. 'Lift your shirt.' When Big Jim put down his cell phone to do it, Rusty slipped it into his breast pocket. 'I'll just take this, shall I? I'll leave it at the lobby desk. That's an okay area for cell phones. The chairs aren't as well padded as these, but they're still not bad.'

He expected Big Jim to protest, maybe explode, but he didn't so much as peep, only exposed a bulging Buddha-belly and large soft manbreasts above it. Rusty bent forward and had a listen. It was far better than he'd expected. He would have been happy with a hundred and ten beats a minute plus moderate premature ventriculation. Instead, Big Jim's pump was loping along at ninety, with no misbeats at all.

'I'm feeling a lot better,' Big Jim said. 'It was stress. I've been

under *terrible* stress. I'm going to take another hour or two to rest right here – do you realize you can see all of downtown from this window, pal? – and I'm going to visit with Junior one more time. After that I'll just check myself out and—'

'It isn't just stress. You're overweight and out of shape.'

Big Jim bared his upper teeth in that bogus smile. 'I've been running a business and a town, pal – both in the black, by the way. That leaves little time for treadmills and StairMasters and such.'

'You presented with PAT two years ago, Rennie. That's paroxysmal atrial tachycardia.'

'I know what it is. I went to WebMD and it said healthy people often experience—'

'Ron Haskell told you in no uncertain terms to get your weight under control, to get the arrhythmia under control with medication, and if medication wasn't effective, to explore surgical options to correct the underlying problem.'

Big Jim had begun to look like an unhappy child imprisoned in a highchair. 'God told me not to! God said no pacemaker! And God was right! Duke Perkins had a pacemaker, and look what happened to him!'

'Not to mention his widow,' Rusty said softly. 'Bad luck for her, too. She must have just been in the wrong place at the wrong time.'

Big Jim regarded him, little pig eyes calculating. Then he looked up at the ceiling. 'Lights are on again, aren't they? I got you your propane, like you asked. Some people don't have much gratitude. Of course a man in my position gets used to that.'

'We'll be out again by tomorrow night.'

Big Jim shook his head. 'By tomorrow night you'll have enough LP to keep this place running until Christmas if it's necessary. It's my promise to you for having such a wonderful bedside manner and being such an all-around good fellow.'

'I *do* have trouble being grateful when people return what was mine to begin with. I'm funny that way.'

'Oh, so now you're equating yourself with the hospital?' Big Jim snorted.

'Why not? You just equated yourself with Christ. Let's return to your medical situation, shall we?'

Big Jim flapped his large, blunt-fingered hands disgustedly.

'Valium isn't a cure. If you walk out of here, you could be firing misbeats again by five p.m. Or just vaporlock completely. The bright side is that you could be meeting your savior before it gets dark here in town.'

· 'And what would you recommend?' Rennie spoke calmly. He had regained his composure.

'I could give you something that would probably take care of the problem, at least short-term. It's a drug.'

'What drug?'

'But there's a price.'

'I knew it,' Big Jim said softly. 'I knew you were on Barbara's side the day you came to my office with your give me this and give me that.'

The only thing Rusty had asked for was propane, but he ignored that. 'How did you know Barbara *had* a side then? The murders hadn't been discovered, so how did you know he *had* a side?'

Big Jim's eyes gleamed with amusement or paranoia or both. 'I have my little ways, pal. So what's the price? What would you like me to trade you for the drug that will keep me from having a heart attack?' And before Rusty could respond: 'Let me guess. You want Barbara's freedom, don't you?'

'No. This town would lynch him the minute he stepped outside.'

Big Jim laughed. 'Every now and then you show a lick of sense.'

'I want you to step down. Sanders, too. Let Andrea Grinnell take over, with Julia Shumway to help her out until Andi kicks her drug habit.'

Big Jim laughed louder this time, and slapped his thigh for good measure. 'I thought Cox was bad – he wanted the one with the big tiddies to help Andrea – but you're ever so much worse. Shumway! That rhymes-with-witch couldn't administrate herself out of a paper bag!'

· · 'I know you killed Coggins.'

He hadn't meant to say that, but it was out before he could pull it back. And what harm? It was just the two of them, unless you counted CNN's John Roberts, looking down from the TV on the wall. And besides, the results were worth it. For the first time since he had accepted the reality of the Dome, Big Jim was rocked. He tried to keep his face neutral and failed.

'You're crazy.'

'You know I'm not. Last night I went to the Bowie Funeral Home and examined the bodies of the four murder victims.'

'You had no right to do that! You're no pathologist! You're not even a cotton-picking *doctor*!'

'Relax, Rennie. Count to ten. Remember your heart.' Rusty paused. 'On second thought, *fuck* your heart. After the mess you left behind, and the one you're making now, *fuck* your heart. There were

marks all over Coggins's face and head. Very atypical marks, but easily identifiable. Stitch marks. I have no doubt they'll match the souvenir baseball I saw on your desk.'

'That doesn't mean anything.' But Rennie glanced toward the open bathroom door.

'It means plenty. Especially when you consider the other bodies were dumped in the same place. To me that suggests the killer of Coggins was the killer of the others. I think it was you. Or maybe you and Junior. Were you a father-and-son tag-team? Was that it?'

'I refuse to listen to this!' He started to get up. Rusty pushed him back down. It was surprisingly easy.

'Stay where you are!' Rennie shouted. 'Gosh-dammit, just stay where you are!'

Rusty said, 'Why did you kill him? Did he threaten to blow the whistle on your drug operation? Was he part of it?'

'Stay where you are!' Rennie repeated, although Rusty had already sat back down. It did not occur to him – then – that Rennie might not have been speaking to him.

'I can keep this quiet,' Rusty said. 'And I can give you something that will take care of your PAT better than Valium. The quid pro quo is that you step down. Announce your resignation – for medical reasons – in favor of Andrea tomorrow night at the big meeting. You'll go out a hero.'

There was no way he could refuse, Rusty thought; the man was backed into a corner.

Rennie turned to the open bathroom door again and said, 'Now you can come out.'

Carter Thibodeau and Freddy Denton emerged from the bathroom where they had been hiding – and listening.

8

'Goddam,' Stewart Bowie said.

He and his brother were in the basement workroom of the funeral parlor. Stewart had been doing a makeup job on Arletta Coombs, The Mill's latest suicide and the Bowie Funeral Home's latest customer. 'Goddam sonofabitch fucking *shitmonkey*.'

He dropped his cell phone onto the counter, and from the wide front pocket of his rubberized green apron removed a package of peanut butter-flavored Ritz Bits. Stewart always ate when he was upset, he had always been messy with food ('The pigs ate here,' their dad was wont to say when young Stewie left the table), and now

Ritz crumbs showered down on Arletta's upturned face, which was far from peaceful; if she'd thought quaffing Liquid-Plumr would be a quick and painless way to escape the Dome, she had been badly deceived. Darn stuff had eaten all the way through her stomach and out through her back.

'What's wrong?' Fern asked.

'Why did I ever get involved with fucking Rennie?'

'For money?'

'What good's money now?' Stewart raved. 'What'm I gonna do, go on a fuckin shopping spree at Burpee's Department Store? That'd give me a fuckin hardon for sure!'

He yanked open the elderly widow's mouth and slammed the remaining Ritz Bits inside. 'There you go, bitch, it's fucking snack-time.'

Stewart snatched up his cell, hit the CONTACTS button, and selected a number. 'If he isn't there,' he said – perhaps to Fern, more likely to himself – 'I'm going to go out there, find him, and stick one of his own chickens right up his fucking a—'

But Roger Killian was there. And in his goddam chickenhouse. Stewart could hear them clucking. He could also hear the swooping violins of Mantovani coming through the chickenhouse sound system. When the kids were out there, it was Metallica or Pantera.

'Lo?'

'Roger. It's Stewie. Are you straight, brother?'

'Pretty,' Roger agreed, which probably meant he'd been smoking glass, but what the fuck.

'Get down here to town. Meet me n Fern at the motor pool. We're gonna take two of the big trucks – the ones with the hoists – out there to WCIK. All the propane's got to be moved back to town. We can't do it in one day, but Jim says we gotta make a start. Tomorrow I'll recruit six or seven more guys we can trust – some of Jim's goddam private army, if he'll spare em – and we'll finish up.'

'Aw, Stewart, no – I got to feed these chickens! The boys I got left has all gone to be cops!'

Which means, Stewart thought, *you want to sit in that little office of yours, smoking glass and listening to shit music and looking at lesbian makeout videos on your computer.* He didn't know how you could get horny with the aroma of chickenshit so thick you could cut it with a knife, but Roger Killian managed.

'This is not a volunteer mission, my brother. I got ordered, and I'm ordering you. Half an hour. And if you do happen to see any of your kids hanging around, you shanghai em along.'

He hung up before Roger could recommence his whiny shit and for a moment just stood there, fuming. The last thing on earth he wanted to do with what remained of this Wednesday afternoon was muscle propane tanks into trucks . . . but that was what he was going to be doing, all right. Yes he was.

He snatched the spray hose from the sink, stuck it between Arletta Coombs's dentures, and triggered it. It was a high-pressure hose, and the corpse jumped on the table. 'Wash them crackers down, gramma,' he snarled. 'Wouldn't want you to choke.'

'Stop!' Fern cried. 'It'll squirt out the hole in her—'

Too late.

9

Big Jim looked at Rusty with a *see what it gets you* smile. Then he turned to Carter and Freddy Denton. 'Did you fellows hear Mr Everett try to coerce me?'

'We sure did,' Freddy said.

'Did you hear him threaten to withhold certain lifesaving medication if I refused to step down?'

'Yeah,' Carter said, and favored Rusty with a black look. Rusty wondered how he ever could have been so stupid.

It's been a long day – chalk it up to that.

'The medication in question might have been a drug called verapamil, which that fellow with the long hair administered by IV.' Big Jim exposed his small teeth in another unpleasant smile.

Verapamil. For the first time, Rusty cursed himself for not taking Big Jim's chart from its slot on the door and examining it. It would not be the last.

'What kind of crimes have we got here, do you suppose?' Big Jim asked. 'Criminal threatening?'

'Sure, and extortion,' Freddy said.

'Hell with that, it was attempted murder,' Carter said.

'And who do you suppose put him up to it?'

'Barbie,' Carter said, and slugged Rusty in the mouth. Rusty had no sense of it coming, and didn't even begin to get his guard up. He staggered backward, hit one of the chairs, and fell into it sideways with his mouth bleeding.

'You got that resisting arrest,' Big Jim remarked. 'But it's not enough. Put him on the floor, fellows. I want him on the floor.'

Rusty tried to run but barely got out of the chair before Carter grabbed one of his arms and spun him around. Freddy put a foot

behind his legs. Carter pushed. *Like kids in the schoolyard*, Rusty thought as he toppled over.

Carter dropped down beside him. Rusty got in one blow. It landed on Carter's left cheek. Carter shook it off impatiently, like a man ridding himself of a troublesome fly. A moment later he was sitting on Rusty's chest, grinning down at him. Yes, just like in the schoolyard, only with no playground monitor to break things up.

He turned his head to Rennie, who was now on his feet. 'You don't want to do this,' he panted. His heart was thudding hard. He could barely get enough breath to feed it. Thibodeau was very heavy. Freddy Denton was on his knees beside the two of them. To Rusty he looked like the ref in one of those put-up-job wrestling matches.

'But I do, Everett,' Big Jim said. 'In fact, God bless you, I *have* to. Freddy, snag my cell phone. It's in his breast pocket, and I don't want it getting broken. The cotton-picker stole it. You can add that to his bill when you get him to the station.'

'Other people know,' Rusty said. He had never felt so helpless. And so stupid. Telling himself that he wasn't the first to underestimate James Rennie Senior did not help. 'Other people know what you did.'

'Perhaps,' Big Jim said. 'But who are they? Other friends of Dale Barbara, that's who. The ones who started the food riot, the ones who burned down the newspaper office. The ones who set the Dome going in the first place, I have no doubt. Some sort of government experiment, that's what I think. But we're not rats in a box, are we? Are we, Carter?'

'No.'

'Freddy, what are you waiting for?'

Freddy had been listening to Big Jim with an expression that said *Now I get it*. He took Big Jim's cell phone from Rusty's breast pocket and tossed it onto one of the sofas. Then he turned back to Rusty. 'How long have you been planning it? How long you been planning to lock us up in town so you could see what we'd do?'

'Freddy, listen to yourself,' Rusty said. The words came out in a wheeze. God, but Thibodeau was heavy. 'That's crazy. It makes no sense. Can't you see th—'

'Hold his hand on the floor,' Big Jim said. 'The left one.'

Freddy did as he was ordered. Rusty tried to fight, but with Thibodeau pinning his arms, he had no leverage.

'I'm sorry to do this, pal, but the people of this town have to understand we're in control of the terrorist element.'

Rennie could say he was sorry all he wanted, but in the instant before he brought the heel of his shoe – and all of his two hundred and thirty pounds – down on Rusty's clenched left hand, Rusty saw a different motive poking out the front of the Second Selectman's gabardine trousers. He was enjoying this, and not just in a cerebral sense.

Then the heel was pressing and grinding: hard, harder, hardest. Big Jim's face was clenched with effort. Sweat stood out under his eyes. His tongue was clamped between his teeth.

Don't scream, Rusty thought. *It'll bring Ginny, and then she'll be in the cooking pot, too. Also, he wants you to. Don't give him the satisfaction.*

But when he heard the first snap from under Big Jim's heel, he did scream. He couldn't help it.

There was another snap. Then a third.

Big Jim stepped back, satisfied. 'Get him on his feet and take him to jail. Let him visit with his friend.'

Freddy was examining Rusty's hand, which was already swelling. Three of the four fingers were bent badly out of true. 'Busted,' he said with great satisfaction.

Ginny appeared in the lounge doorway, her eyes huge. 'What in God's name are you doing?'

'Arresting this bastard for extortion, criminal withholding, and attempted murder,' Freddy Denton said as Carter hauled Rusty Everett to his feet. 'And that's just a start. He resisted and we subdued him. Please step aside, ma'am.'

'You're nuts!' Ginny cried. 'Rusty, your *hand*!'

'I'm all right. Call Linda. Tell her these *thugs*—'

He got no further. Carter seized him by the neck and ran him out the door with his head bent down. In his ear Carter whispered: 'If I was sure that old guy knew as much about doctorin as you, I'd kill you myself.'

All this in four days and change, Rusty marveled as Carter forced him down the hallway, staggering and bent almost double by the grip on his neck. His left hand was no longer a hand, only a bellowing chunk of pain below his wrist. *Just four days and change.*

He wondered if the leatherheads – whatever or whoever they might be – were enjoying the show.

10

It was late afternoon before Linda finally came across The Mill's librarian. Lissa was biking back toward town along Route 117. She

said she'd been talking to the sentries out at the Dome, trying to glean further information about Visitors Day.

'They're not supposed to schmooze with the townies, but some will,' she said. 'Especially if you leave the top three buttons on your blouse undone. That seems to be a real conversation-starter. With the Army guys, anyway. The Marines . . . I think I could take off all my clothes and dance the Macarana and they still wouldn't say boo. Those boys seem immune to sex appeal.' She smiled. 'Not that I'll ever be mistaken for Kate Winslet.'

'Did you pick up any interesting gossip?'

'Nope.' Lissa was straddling her bike, and looking in at Linda through the passenger window. 'They don't know squat. But they're awfully concerned about us; I was touched by that. And they're hearing as many rumors as we are. One of them asked me if it was true that over a hundred people had committed suicide already.'

'Can you get in the car with me for a minute?'

Lissa's smile broadened. 'Am I being arrested?'

'There's something I want to talk to you about.'

Lissa put down the kickstand of her bike and got in, first moving Linda's citation clipboard and a nonfunctioning radar gun out of the way. Linda told her about the clandestine visit to the funeral home and what they'd found there, then about the proposed meeting at the parsonage. Lissa's response was immediate and vehement.

'I'll be there – you just try to keep me away.'

The radio cleared its throat then, and Stacey came on. 'Unit Four, Unit Four. Break-break-break.'

Linda grabbed the mike. It wasn't Rusty she was thinking of; it was the girls. 'This is Four, Stacey. Go.'

What Stacey Moggin said when she came back changed Linda's unease to outright terror. 'I've got something bad to tell you, Lin. I'd tell you to brace yourself, but I don't think you *can* brace yourself for a thing like this. Rusty's been arrested.'

'*What?*' Linda nearly screamed, but only to Lissa; she didn't depress the SEND button on the side of the mike.

'They've put him downstairs in the Coop with Barbie. He's all right, but it looks to me like he's got a broken hand – he was holding it against his chest and it was all swollen.' She lowered her voice. 'It happened resisting arrest, they said. Over.'

This time Linda remembered to key the mike. 'I'll be right there. Tell him I'm coming. Over.'

'I can't,' Stacey said. 'No one's allowed down there anymore except for officers on a special list . . . and I'm not one of them.

There's a whole basket of charges, including attempted murder and accessory to murder. Take it easy coming back to town. You won't be allowed to see him, so there's no sense wrecking your shop on the way—'

Linda keyed the mike three times: *break-break-break*. Then she said, 'I'll see him, all right.'

But she didn't. Chief Peter Randolph, looking freshly rested from his nap, met her at the top of the PD steps and told her he'd need her badge and gun; as Rusty's wife, she was also under suspicion of undermining the lawful town government and fomenting insurrection.

Fine, she wanted to tell him. *Arrest me, put me downstairs with my husband.* But then she thought of the girls, who would be at Marta's now, waiting to be picked up, wanting to tell her all about their day at school. She also thought of the meeting at the parsonage that night. She couldn't attend that if she was in a cell, and the meeting was now more important than ever.

Because if they were going to break one prisoner out tomorrow night, why not two?

'Tell him I love him,' Linda said, unbuckling her belt and sliding the holster off it. She hadn't really cared for the weight of the gun, anyway. Crossing the little ones on the way to school, and telling the middle-school kids to ditch both their cigarettes and their foul mouths . . . those things were more her forte.

'I will convey that message, Mrs Everett.'

'Has anyone looked at his hand? I heard from someone that his hand might be broken.'

Randolph frowned. 'Who told you that?'

'I don't know who called me. He didn't identify himself. It was one of our guys, I think, but the reception out there on 117 isn't very good.'

Randolph considered this, decided not to pursue it. 'Rusty's hand is fine,' he said. 'And our guys aren't your guys anymore. Go on home. I'm sure we'll have questions for you later.'

She felt tears and fought them back. 'And what am I supposed to tell my girls? Am I supposed to tell them their daddy is in jail? You know Rusty's one of the good guys; you *know* that. *God*, he was the one who diagnosed your hot gallbladder last year!'

'Can't help you much there, Mrs Everett,' Randolph said – his days of calling her Linda seemed to be behind him. 'But I suggest you *don't* tell them that Daddy conspired with Dale Barbara in the murder of Brenda Perkins and Lester Coggins – the others we're not

sure of, those were clearly sex crimes and Rusty may not have known about them.'

'That's insane!'

Randolph might not have heard. 'He also tried to kill Selectman Rennie by withholding vital medication. Luckily, Big Jim had the foresight to conceal a couple of officers nearby.' He shook his head. 'Threatening to withhold lifesaving medication from a man who's made himself sick caring for this town. That's your good guy; that's your goddam good guy.'

She was in trouble here, and knew it. She left before she could make it worse. The five hours before the meeting at the Congo parsonage stretched long before her. She could think of nowhere to go, nothing to do.

Then she did.

11

Rusty's hand was far from fine. Even Barbie could see that, and there were three empty cells between them. 'Rusty – anything I can do?'

Rusty managed a smile. 'Not unless you've got a couple of aspirin you can toss me. Darvocet would be even better.'

'Fresh out. They didn't give you anything?'

'No, but the pain's down a bit. I'll survive.' This talk was a good deal braver than he actually felt; the pain was very bad, and he was about to make it worse. 'I've got to do something about these fingers, though.'

'Good luck.'

For a wonder, none of the fingers was broken, although a bone in his hand was. It was a metacarpal, the fifth. The only thing he could do about that was tear strips from his tee-shirt and use them as a splint. But first . . .

He grasped his left index finger, which was dislocated at the proximal interphalangeal joint. In the movies, this stuff always happened fast. Fast was dramatic. Unfortunately, fast could make things worse instead of better. He applied slow, steady, increasing pressure. The pain was gruesome; he felt it all the way up to the hinges of his jaw. He could hear the finger creaking like the hinge of a door that hasn't been opened in a long time. Somewhere, both close by and in another country, he glimpsed Barbie standing at the door of his cell and watching.

Then, suddenly, the finger was magically straight again and the

pain was less. In that one, anyway. He sat down on the bunk, gasping like a man who has just run a race.

'Done?' Barbie asked.

'Not quite. I also have to fix my fuck-you finger. I may need it.'

Rusty grasped his second finger and began again. And again, just when it seemed the pain could get no worse, the dislocated joint slipped back into place. Now there was just the matter of his pinkie, which was sticking out as if he meant to make a toast.

And I would if I could, he thought. *'To the most fucked-up day in history.' In the history of Eric Everett, at least.*

He began to wrap the finger. This also hurt, and for this there was no quick fix.

'What'd you do?' Barbie asked, then snapped his fingers twice, sharply. He pointed at the ceiling, then cupped one hand to his ear. Did he actually know the Coop was bugged, or only suspect it? Rusty decided it didn't matter. It would be best to behave as if it were, although it was hard to believe anyone in this fumble-bunch had thought of it yet.

'Made the mistake of trying to get Big Jim to step down,' Rusty said. 'I have no doubt they'll add a dozen or so other charges, but basically I got jailed for telling him to quit pushing so hard or he'd have a heart attack.'

This, of course, ignored the Coggins stuff, but Rusty thought that might be just as well for his continued good health.

'How's the food in here?'

'Not bad,' Barbie said. 'Rose brought me lunch. You want to watch out for the water, though. It can be a trifle salty.'

He forked the first two fingers of his right hand, pointed them at his eyes, then pointed at his own mouth: *watch*.

Rusty nodded.

Tomorrow night, Barbie mouthed.

I know, Rusty mouthed back. Making the exaggerated syllables caused his lips to crack open and start bleeding again.

Barbie mouthed *We . . . need . . . a . . . safe . . . place*.

Thanks to Joe McClatchey and his friends, Rusty thought he had that part covered.

12

Andy Sanders had a seizure.

It was inevitable, really; he was unused to glass and he'd been smoking a lot of it. He was in the WCIK studio, listening to the Our

Daily Bread symphony soar through 'How Great Thou Art' and conducting along with it. He saw himself flying down eternal violin strings.

Chef was somewhere with the bong, but he'd left Andy a supply of fat hybrid cigarettes he called fry-daddies. 'You want to be careful with these, Sanders,' he said. 'They are dynamite. "For thee not used to drinking must be gentle." First Timothy. It also applies to fries.'

Andy nodded solemnly, but smoked like a demon once Chef was gone: two of the daddies, one after the other. He puffed until they were nothing but hot nubs that burned his fingers. The roasting cat-pee smell of the glass was already rising to the top of his aromatherapy hit parade. He was halfway through the third daddy and still conducting like Leonard Bernstein when he sucked in a particularly deep lungful and instantly blacked out. He fell to the floor and lay twitching in a river of sacred music. Spitfoam oozed between his clenched teeth. His half-open eyes rolled around in their sockets, seeing things that weren't there. At least, not yet.

Ten minutes later he was awake again, and lively enough to go flying along the path between the studio and the long red supply building out back.

'*Chef!*' he bawled. '*Chef, where are you? THEY'RE COMING!*'

Chef Bushey stepped from the supply building's side door. His hair stood up from his head in greasy quills. He was dressed in a filthy pair of pajama pants, pee-stained at the crotch and grass-stained at the bottoms. Printed with cartoon frogs saying RIBBIT, they hung precariously from the bony flanges of his hips, displaying a fluff of pubic hair in front and the crack of his ass in back. He had his AK-47 in one hand. On the stock he had carefully painted the words GOD'S WARRIOR. The garage door opener was in his other hand. He put God's Warrior down but not God's Door Opener. He grasped Andy's shoulders and gave him a smart shake.

'Stop it, Sanders, you're hysterical.'

'They're coming! The bitter men! Just like you said!'

Chef considered this. 'Did someone call and give you a heads-up?'

'No, it was a vision! I blacked out and had a vision!'

Chef's eyes widened. Suspicion gave way to respect. He looked from Andy to Little Bitch Road, and then back to Andy again. 'What did you see? How many? Is it all of them, or just a few, like before?'

'I . . . I . . . I . . .'

Chef shook him again, but much more gently this time. 'Calm down, Sanders. You're in the Lord's army now, and—'

'A Christian soldier!'

'Right, right, right. And I'm your superior. So report.'

'They're coming in two trucks.'

'Only two?'

'Yes.'

'Orange?'

'Yes!'

Chef hitched up his pjs (they subsided to their former position almost immediately) and nodded. 'Town trucks. Probably those same three dumbwits – the Bowies and Mr Chicken.'

'Mr—?'

'Killian, Sanders, who else? He smokes the glass but doesn't understand the *purpose* of the glass. He's a fool. They're coming for more propane.'

'Should we hide? Just hide and let them take it?'

'That's what I did before. But not this time. I'm done hiding and letting people take things. Star Wormwood has blazed. It's time for men of God to hoist their flag. Are you with me?'

And Andy – who under the Dome had lost everything that had ever meant anything to him – did not hesitate. 'Yes!'

'To the end, Sanders?'

'To the end!'

'Where-at did you put your gun?'

As best as Andy could recollect, it was in the studio, leaning against the poster of Pat Robertson with his arm around the late Lester Coggins.

'Let's get it,' Chef said, picking up GOD'S WARRIOR and checking the clip. 'And from now on you carry it with you, have you got that?'

'Okay.'

'Box of ammo in there?'

'Yep.' Andy had toted one of these crates in just an hour ago. At least he thought it had been an hour ago; fry-daddies had a way of bending time at the edges.

'Just a minute,' Chef said. He went down the side of the supply building to the box of Chinese grenades and brought back three. He gave two to Andy and told him to put them in his pockets. Chef hung the third grenade from the muzzle of GOD'S WARRIOR by the pull-ring. 'Sanders, I was told that you get seven seconds after you yank the pin to get rid of these cocksuckers, but when I tried one in the gravel-pit back yonder, it was more like four. You can't trust your Oriental races. Remember that.'

Andy said he would.

'All right, come on. Let's get your weapon.'

Hesitantly, Andy asked: 'Are we going to take them out?'

Chef looked surprised. 'Not unless we have to, no.'

'Good,' Andy said. In spite of everything, he didn't really want to hurt anyone.

'But if they force the issue, we'll do what's necessary. Do you understand that?'

'Yes,' Andy said.

Chef clapped him on the shoulder.

13

Joe asked his mother if Benny and Norrie could spend the night. Claire said it was okay with her if it was okay with their parents. It would, in fact, be something of a relief. After their adventure on Black Ridge, she liked the idea of having them under her eye. They could make popcorn on the woodstove and continue the raucous game of Monopoly they'd begun an hour ago. It was *too* raucous, actually; their chatter and catcalls had a nervy, whistling-past-the-graveyard quality she didn't care for.

Benny's mother agreed, and – somewhat to her surprise – so did Norrie's. 'Good deal,' Joanie Calvert said. 'I've been wanting to get schnockered ever since this happened. Looks like tonight's my chance. And Claire? Tell that girl to hunt up her grandfather tomorrow and give him a kiss.'

'Who's her grandfather?'

'Ernie. You know Ernie, don't you? Everybody knows Ernie. He worries about her. So do I, sometimes. That skateboard.' There was a shudder in Joanie's voice.

'I'll tell her.'

Claire had no more than hung up when there was a knock at the door. At first she didn't know who the middle-aged woman with the pale, strained face was. Then she realized it was Linda Everett, who ordinarily worked the school-crossing beat and ticketed cars that overstayed their welcome in the two-hour parking zones on Main Street. And she wasn't middle-aged at all. She just looked that way now.

'Linda!' Claire said. 'What's wrong? Is it Rusty? Has something happened to Rusty?' She was thinking of radiation . . . at least in the front of her mind. In the back, even worse ideas slithered around.

'He's been arrested.'

The Monopoly game in the dining room had ceased. The participants now stood together in the living room doorway, gazing at Linda solemnly.

'It's a whole laundry list of charges, including criminal complicity in the murders of Lester Coggins and Brenda Perkins.'

'*No!*' Benny cried.

Claire thought of telling them to leave the room and decided it would be hopeless. She thought she knew why Linda was here, and understood it, but still hated her a little for coming. And Rusty, too, for getting the kids involved. Except they were all involved, weren't they? Under the Dome, involvement was no longer a matter of choice.

'He got in Rennie's way,' Linda said. 'That's what it's really about. That's what it's *all* about now, as far as Big Jim's concerned: who's in his way and who isn't. He's forgotten entirely what a terrible situation we're in here. No, it's worse than that. He's *using* the situation.'

Joe looked at Linda solemnly. 'Does Mr Rennie know where we went this morning, Miz Everett? Does he know about the box? I don't think he should know about the box.'

'What box?'

'The one we found on Black Ridge,' Norrie said. 'We only saw the light it puts out; Rusty went right up and looked at it.'

'It's the generator,' Benny said. 'Only he couldn't shut it off. He couldn't even lift it, although he said it was real small.'

'I don't know anything about this,' Linda said.

'Then neither does Rennie,' Joe said. He looked as if the weight of the world had just slipped off his shoulders.

'How do you know?'

'Because he would have sent the cops to question us,' Joe said. 'And if we didn't answer the questions, they'd take *us* to jail.'

At a distance, there came a pair of faint reports. Claire cocked her head and frowned. 'Were those firecrackers or gunshots?'

Linda didn't know, and because they hadn't come from town — they were too faint for that — she didn't care. 'Kids, tell me what happened on Black Ridge. Tell me everything. What you saw and what Rusty saw. And later tonight there's some other people you may have to tell. It's time we put together everything we know. In fact, it's past time.'

Claire opened her mouth to say she didn't want to get involved, then didn't. Because there was no choice. None, at least, that she could see.

14

The WCIK studio was set well back from Little Bitch Road, and the driveway leading to it (paved, and in far better shape than the road itself) was almost a quarter of a mile long. At the Little Bitch end, it was flanked by a pair of hundred-year oaks. Their fall foliage, in a normal season brilliant enough to qualify for a calendar or tourism brochure, now hung limp and brown. Andy Sanders stood behind one of these crenellated trunks. Chef was behind the other. They could hear the approaching diesel roar of big trucks. Sweat ran into Andy's eyes and he wiped it away.

'Sanders!'

'What?'

'Is your safety off?'

Andy checked. 'Yes.'

'All right, listen and get it right the first time. If I tell you to start shooting, *spray* those motherfuckers! Top to bottom, fore and aft! If I *don't* tell you to shoot, just stand there. Have you got that?'

'Y-Yes.'

'I don't think there's going to be any killing.'

Thank God, Andy thought.

'Not if it's just the Bowies and Mr Chicken. But I can't be sure. If I do have to make a play, will you back me?'

'Yes.' No hesitation.

'And keep your finger off that damn trigger or you're apt to blow your own head off.'

Andy looked down, saw his finger was indeed curled around the trigger of the AK, and removed it in a hurry.

They waited. Andy could hear his heartbeat in the middle of his head. He told himself it was stupid to be afraid – if not for a fortuitous phone call, he'd already be dead – but it did no good. Because a new world had opened in front of him. He knew it might turn out to be a false world (hadn't he seen what dope had done to Andi Grinnell?), but it was better than the shitty world he'd been living in.

God, please let them just go away, he prayed. *Please.*

The trucks appeared, rolling slow and blowing dark smoke into the muted remains of the day. Peeking from behind his tree, Andy could see two men in the lead truck. Probably the Bowies.

For a long time Chef didn't move. Andy was beginning to think he'd changed his mind and meant to let them take the propane

after all. Then Chef stepped out and triggered off two quick rounds.

Stoned or not, Chef's aim was good. Both front tires of the lead truck went flat. The front end pogoed up and down three or four times, and then the truck came to a halt. The one behind almost rear-ended it. Andy could hear the faint sound of music, some hymn, and guessed that whoever was driving the second truck hadn't heard the gunshots over the radio. The cab of the lead truck, meanwhile, looked empty. Both men had ducked down out of sight.

Chef Bushey, still barefooted and wearing nothing but his RIBBIT pjs (the garage door opener was hooked over the sagging waistband like a beeper), stepped out from behind his tree. 'Stewart Bowie!' he called. 'Fern Bowie! Come on out of there and talk to me!' He leaned GOD'S WARRIOR against the oak.

Nothing from the cab of the lead truck, but the driver's door of the second truck opened and Roger Killian got out. 'What's the holdup?' he bawled. 'I got to get back and feed my chick—' Then he saw Chef. 'Hey there, Philly, what's up?'

'Get down!' one of the Bowies bawled. 'Crazy sonofabitch is shooting!'

Roger looked at Chef, then at the AK-47 leaning against the tree. 'Maybe he was, but he's put the gun down. Besides, it's just him. What's the deal, Phil?'

'I'm Chef now. Call me Chef.'

'Okay, Chef, what's the deal?'

'Come on out, Stewart,' Chef called. 'You too, Fern. Nobody's going to get hurt here, I guess.'

The doors of the lead truck opened. Without turning his head, Chef said: 'Sanders! If either of those two fools has a gun, you open up. Never mind single-shot; turn em into taco cheese.'

But neither Bowie had a gun. Fern had his hands hoisted.

'Who you talkin to, buddy?' Stewart asked.

'Step out here, Sanders,' Chef said.

Andy did. Now that the threat of immediate carnage seemed to have passed, he was starting to enjoy himself. If he'd thought to bring one of Chef's fry-daddies with him, he was sure he'd be enjoying himself even more.

'Andy?' Stewart said, astounded. 'What are *you* doing here?'

'I've been drafted into the Lord's army. And you are bitter men. We know all about you, and you have no place here.'

'Huh?' Fern said. He lowered his hands. The nose of the lead truck was slowly canting toward the road as the big front tires continued to deflate.

'Well said, Sanders,' Chef told him. Then, to Stewart: 'All three of you get in that second truck. Turn it around and haul your sorry asses back to town. When you get there, tell that apostate son of the devil that WCIK is ours now. That includes the lab and all the supplies.'

'What the fuck are you talking about, Phil?'

'*Chef.*'

Stewart made a flapping gesture with one hand. 'Call yourself whatever you want, just tell me what this is ab—'

'I know your brother's stupid,' Chef said, 'and Mr Chicken there probably can't tie his own shoes without a blueprint—'

'Hey!' Roger cried. 'Watch your mouth!'

Andy raised his AK. He thought that, when he got a chance, he would paint CLAUDETTE on the stock. 'No, you watch yours.'

Roger Killian went pale and fell back a step. That had never happened when Andy spoke at a town meeting, and it was very gratifying.

Chef went on talking as if there had been no interruption. 'But you've got at least half a brain, Stewart, so use it. Leave that truck setting right where it is and go back to town in t'other one. Tell Rennie this out here doesn't belong to him anymore, it belongs to God. Tell him Star Wormwood has blazed, and if he doesn't want the Apocalypse to come early, he better leave us alone.' He considered. 'You can also tell him we'll keep putting out the music. I doubt he's worried about that, but there's some in town might find it a comfort.'

'Do you know how many cops he's got now?' Stewart asked.

'I don't give a tin shit.'

'I think about thirty. By tomorrow it's apt to be fifty. And half the damn town's wearing blue support-armbands. If he tells em to posse up, it won't be no trouble.'

'It won't be no help, either,' Chef said. 'Our faith is in the Lord, and our strength is that of ten.'

'Well,' Roger said, flashing his math skills, 'that's twenty, but you're still outnumbered.'

'Shut up, Roger,' Fern said.

Stewart tried again. 'Phil – Chef, I mean – you need to chill the fuck out, because this ain't no thang. He don't want the dope, just the propane. Half the gennies in town are out. By the weekend it'll be three-quarters. Let us take the propane.'

'I need it to cook with. Sorry.'

Stewart looked at him as if he had gone mad. *He probably has,* Andy thought. *We probably both have.* But of course Jim Rennie was mad, too, so *that* was a wash.

'Go on, now,' Chef said. 'And tell him that if he tries sending troops against us, he will regret it.'

Stewart thought this over, then shrugged. 'No skin off my rosy red chinchina. Come on, Fern. Roger, I'll drive.'

'Fine by me,' Roger Killian said. 'I hate all them gears.' He gave Chef and Andy a final look rich with mistrust, then started back to the second truck.

'God bless you fellas,' Andy called.

Stewart threw a sour dart of a glance back over his shoulder. 'God bless you, too. Because God knows you're gonna need it.'

The new proprietors of the largest meth lab in North America stood side by side, watching the big orange truck back down the road, make a clumsy **K**-turn, and drive away.

'Sanders!'

'Yes, Chef?'

'I want to pep up the music, and immediately. This town needs some Mavis Staples. Also some Clark Sisters. Once I get that shit cued up, let's smoke.'

Andy's eyes filled with tears. He put his arm around the former Phil Bushey's bony shoulders and hugged. 'I love you, Chef.'

'Thanks, Sanders. Right back atcha. Just keep your gun loaded. From now on we'll have to stand watches.'

15

Big Jim was sitting at his son's bedside as approaching sunset turned the day orange. Douglas Twitchell had come in to give Junior a shot. Now the boy was deeply asleep. In some ways, Big Jim knew, it would be better if Junior died; alive and with a tumor pressing down on his brain, there was no telling what he might do or say. Of course the kid was his own flesh and blood, but there was the greater good to think about; the good of the town. One of the extra pillows in the closet would probably do it—

That was when his phone rang. He looked at the name in the window and frowned. Something had gone wrong. Stewart would hardly be calling so soon if it were otherwise. 'What.'

He listened with growing astonishment. *Andy* out there? Andy with a *gun?*

Stewart was waiting for him to answer. Waiting to be told what to do. *Get in line, pal,* Big Jim thought, and sighed. 'Give me a minute. I need to think. I'll call you back.'

He ended the call and considered this new problem. He could

take a bunch of cops out there tonight. In some ways it was an attract-
ive idea: whip them up at Food City, then lead the raid himself. If
Andy died, so much the better. That would make James Rennie,
Senior, the entire town government.

On the other hand, the special town meeting was tomorrow
night. Everyone would come, and there would be questions. He was
sure he could lay the meth lab off on Barbara and the Friends of
Barbara (in Big Jim's mind, Andy Sanders had now become an official
Friend of Barbara), but still . . . no.

No.

He wanted his flock scared, but not in an outright panic. Panic
wouldn't serve his purpose, which was to establish complete control
of the town. And if he let Andy and Bushey stay where they were
for a little while, what harm? It might even do some good. They'd
grow complacent. They might fancy themselves forgotten, because
drugs were full of Vitamin Stupid.

Friday, on the other hand – the day after tomorrow – was that
cotton-picker Cox's designated Visitors Day. Everybody would stream
out to the Dinsmore farm again. Burpee would no doubt set up
another hotdog stand. While that clustermug was going on, and while
Cox was conducting his one-man press conference, Big Jim himself
could lead a force of sixteen or eighteen police up to the radio station
and wipe those two troublesome stoners out.

Yes. That was the answer.

He called Stewart back and told him to leave well enough
alone.

'But I thought you wanted the propane,' Stewart said.

'We'll get it,' Big Jim said. 'And you can help us take care of
those two, if you want to.'

'You're damn right I want to. That sonofabitch – sorry, Big Jim
– that sonofabuck Bushey needs a payback.'

'He'll get it. Friday afternoon. Clear your schedule.'

Big Jim felt fine again, heart beating slowly and steadily in his
chest, nary a stutter or flutter. And that was good, because there was
so much to do, starting with tonight's police pep talk at Food City:
just the right environment in which to impress the importance of
order on a bunch of new cops. Really, there was nothing like a scene
of destruction to get people playing follow-the-leader.

He started out of the room, then went back and kissed his
sleeping son's cheek. Getting rid of Junior might become necessary,
but for the time being, that too could wait.

16

Another night is falling on the little town of Chester's Mill; another night under the Dome. But there is no rest for us; we have two meetings to attend, and we also ought to check up on Horace the Corgi before we sleep. Horace is keeping Andrea Grinnell company tonight, and although he is for the moment biding his time, he has not forgotten the popcorn between the couch and the wall.

So let us go then, you and I, while the evening spreads out against the sky like a patient etherized upon a table. Let us go while the first discolored stars begin to show overhead. This is the only town in a four-state area where they're out tonight. Rain has over-spread northern New England, and cable-news viewers will soon be treated to some remarkable satellite photographs showing a hole in the clouds that exactly mimics the sock-shape of Chester's Mill. Here the stars shine down, but now they're dirty stars because the Dome is dirty.

Heavy showers fall in Tarker's Mills and the part of Castle Rock known as The View; CNN's meteorologist, Reynolds Wolf (no relation to Rose Twitchell's Wolfie), says that while no one can as yet be *entirely* sure, it seems likely that the west-to-east airflow is pushing the clouds against the western side of the Dome and squeezing them like sponges before they can slide away to the north and south. He calls it 'a fascinating phenomenon.'

Suzanne Malveaux, the anchor, asks him what the long-term weather under the Dome might be like, if the crisis continues.

'Suzanne,' Reynolds Wolf says, 'that's a great question. All we know for sure is that Chester's Mill isn't getting any rain tonight, although the surface of the Dome is permeable enough so that some moisture may be seeping through where the showers are heaviest. NOAA meteorologists tell me the long-term prospects of precip under the Dome aren't good. And we know their principal waterway, Prestile Stream, has pretty much dried up.' He smiles, showing a great set of TV teeth. 'Thank God for artesian wells!'

'You bet, Reynolds,' Suzanne says, and then the Geico gekko appears on the TV screens of America.

That's enough cable news; let us float through certain half-deserted streets, past the Congo church and the parsonage (the meeting there hasn't started yet, but Piper has loaded up the big coffee urn, and Julia is making sandwiches by the light of a hissing Coleman lamp), past the McCain house surrounded by its sad sag of yellow

police tape, down Town Common Hill and past the Town Hall, where janitor Al Timmons and a couple of his friends are cleaning and sprucing up for the special town meeting tomorrow night, past War Memorial Plaza, where the statue of Lucien Calvert (Norrie's great-grandfather; I probably don't have to tell you that) keeps his long watch.

We'll stop for a quick check on Barbie and Rusty, shall we? There'll be no problem getting downstairs; there are only three cops in the ready room, and Stacey Moggin, who's on the desk, is sleeping with her head pillowed on her forearm. The rest of the PD is at Food City, listening to Big Jim's latest stemwinder, but it wouldn't matter if they were all here, because we are invisible. They would feel no more than a faint draft as we glide past them.

There's not much to see in the Coop, because hope is as invisible as we are. The two men have nothing to do but wait until tomorrow night, and hope that things break their way. Rusty's hand hurts, but the pain isn't as bad as he thought it might be, and the swelling isn't as bad as he feared. Also, Stacey Moggin, God bless her heart, snuck him a couple of Excedrin around five p.m.

For the time being, these two men – our heroes, I suppose – are sitting on their bunks and playing Twenty Questions. It's Rusty's turn to guess.

'Animal, vegetable, or mineral?' he asks.

'None of them,' Barbie replies.

'How can it be none of them? It *has* to be one.'

'It's not,' Barbie says. He is thinking of Poppa Smurf.

'You're jacking me up.'

'I'm not.'

'You *have* to be.'

'Quit bitching and start asking.'

'Can I have a hint?'

'No. That's your first no. Nineteen to go.'

'Wait a goddam minute. That's not fair.'

We'll leave them to shift the weight of the next twenty-four hours as best they can, shall we? Let us make our way past the still-simmering heap of ashes that used to be the *Democrat* (alas, no longer serving 'The Little Town That Looks Like A Boot'), past Sanders Hometown Drug (scorched but still standing, although Andy Sanders will never pass through its doors again), past the bookstore and LeClerc's Maison des Fleurs, where all the fleurs are now dead or dying. Let us pass under the dead stoplight marking the intersection of Routes 119 and 117 (we brush it; it sways slightly, then stills again),

and cross the Food City parking lot. We are as silent as a child's sleeping breath.

The supermarket's big front windows have been covered with plywood requisitioned from Tabby Morrell's lumberyard, and the worst of the gluck on the floor has been mopped up by Jack Cale and Ernie Calvert, but Food City is still a godawful mess, with boxes and dry goods strewn from hell to breakfast. The remaining merchandise (what hasn't been carted away to various town pantries or stored in the motor pool behind the PD, in other words) is scattered helter-skelter on the shelves. The soft-drink cooler, beer cooler, and ice cream freezer are busted in. There's the high stink of spilled wine. This left-over chaos is exactly what Big Jim Rennie wants his new – and awfully young, for the most part – cadre of enforcement officers to see. He wants them to realize the whole town could look like this, and he's canny enough to know he doesn't need to say it right out loud. They will get the point: this is what happens when the shepherd fails in his duty and the flock stampedes.

Do we need to listen to his speech? Nah. We'll be listening to Big Jim tomorrow night, and that should be enough. Besides, we all know how this one goes; America's two great specialties are demagogues and rock and roll, and we've all heard plenty of both in our time.

Yet we should examine the faces of his listeners before we go. Notice how rapt they are, and then remind yourself that many of these (Carter Thibodeau, Mickey Wardlaw, and Todd Wendlestat, to name just three) are chumps who couldn't get through a single week of school without scoring detention for causing trouble in class or fighting in the bathrooms. But Rennie has them hypnotized. He's never been much of a shake one-on-one, but when he's in front of a crowd . . . rowdy-dow and a hot-cha-cha, as old Clayton Brassey used to say back in the days when he still had a few working brain cells. Big Jim's telling them 'thin blue line' and 'the pride of standing with your fellow officers' and 'the town is depending on you.' Other stuff, too. The good stuff that never loses its charm.

Big Jim switches to Barbie. He tells them that Barbie's friends are still out there, sowing discord and fomenting dissension for their own evil purposes. Lowering his voice, he says: 'They'll try to discredit me. The lies they'll tell have no bottom.'

A growl of displeasure greets this.

'Will you listen to the lies? Will you let them discredit me? Will you allow this town to go without a strong leader in its time of greatest need?'

The answer, of course, is a resounding *NO!* And although Big Jim continues (like most politicians, he believes in not just gilding the lily but spray-painting it), we can leave him now.

Let's head up these deserted streets to the Congo parsonage. And look! Here's someone we can walk with: a thirteen-year-old girl dressed in faded jeans and an old-school Winged Ripper skateboard tee. The tough riot grrrl pout that is her mother's despair is gone from Norrie Calvert's face this evening. It has been replaced by an expression of wonder that makes her look like the eight-year-old she not so long ago was. We follow her gaze and see a vast full moon climbing from the clouds to the east of town. It is the color and shape of a freshly cut pink grapefruit.

'Oh . . . my . . . *God*,' Norrie whispers. One fisted hand is pressed between the scant nubs of her breasts as she looks at that pink freak of a moon. Then she walks on, not so amazed that she fails to look around herself from time to time to make sure she's not being noticed. This is as per Linda Everett's order: they were to go alone, they were to be unobtrusive, and they were to make absolutely sure they weren't followed.

'This isn't a game,' Linda told them. Norrie was more impressed by her pale, strained face than by her words. 'If we get caught, they won't just take away hit points or make us miss a turn. Do you kids understand that?'

'Can I go with Joe?' Mrs McClatchey asked. She was almost as pale as Mrs Everett.

Mrs Everett shook her head. 'Bad idea.' And that had impressed Norrie most of all. No, not a game; maybe life and death.

Ah, but there is the church, and the parsonage tucked in right beside it. Norrie can see the bright white light of Coleman lanterns around back, where the kitchen must be. Soon she'll be inside, out from under the gaze of that awful pink moon. Soon she'll be safe.

So she's thinking when a shadow detaches itself from one of the thicker shadows and takes her by the arm.

17

Norrie was too startled to scream, which was just as well; when the pink moon lit the face of the man who had accosted her, she saw it was Romeo Burpee.

'You scared the *crap* out of me,' she whispered.

'Sorry. Just keepin an eye out, me.' Rommie let go of her arm, and looked around. 'Where are your boyfriens?'

Norrie smiled at that. 'Dunno. We were supposed to come by ourselves, and different ways. That's what Mrs Everett said.' She looked down the hill. 'I think that's Joey's mom coming now. We should go in.'

They walked toward the light of the lanterns. The parsonage's inner door was standing open. Rommie knocked softly on the side of the screen and said, 'Rommie Burpee and a friend. If there's a password, we didn't get it.'

Piper Libby opened the door and let them in. She looked curiously at Norrie. 'Who are you?'

'Damn if that isn't my granddaughter,' Ernie said, coming into the room. He had a glass of lemonade in one hand and a grin on his face. 'Come here, girl. I've been missing you.'

Norrie gave him a strong hug and kissed him as her mother had instructed. She hadn't expected to obey those instructions so soon, but was glad to do so. And to him she could tell the truth that torture would not have dragged from her lips in front of the guys she hung with.

'Grampa, I'm so scared.'

'We all are, honey-girl.' He hugged her more tightly, then looked into her upturned face. 'I don't know what you're doing here, but now that you are, how about a glass of lemonade?'

Norrie saw the urn and said, 'I'd rather have coffee.'

'So would I,' Piper said. 'I got it all loaded with high-test and ready to go before I remembered I have no power.' She gave her head a little shake, as if to clear it. 'This keeps hitting me in different ways.'

There was another knock at the back door and Lissa Jamieson came in, her cheeks high with color. 'I stashed my bike in your garage, Reverend Libby. I hope that's okay.'

'Fine. And if we're engaging in criminal conspiracy here – as Rennie and Randolph would no doubt contend – you better call me Piper.'

18

They were all early, and Piper called the Chester's Mill Revolutionary Committee to order at just past nine o'clock. What impressed her initially was how uneven the sexual division was: eight females and only four males. And of the four males, one was past retirement age and two weren't old enough to get into an R-rated movie by themselves. She had to remind herself that a hundred guerrilla armies in various parts of the world had put guns in the hands of women and

kids no older than these here tonight. That didn't make it right, but sometimes what was right and what was necessary came into conflict.

'I'd like us to bow our heads for a minute,' Piper said. 'I'm not going to pray because I'm no longer sure just who I'm talking to when I do that. But you might want to say a word to the God of your understanding, because tonight we need all the help we can get.'

They did as she asked. Some still had their heads down and their eyes closed when Piper raised her own head to look at them: two recently fired lady cops, a retired supermarket manager, a newspaper-woman who no longer had a newspaper, a librarian, the owner of the local restaurant, a Dome-widow who couldn't stop spinning the wedding ring on her finger, the local department store tycoon, and three uncharacteristically solemn-faced kids sitting scrunched together on the sofa.

'Okay, amen,' Piper said. 'I'm going to turn the meeting over to Jackie Wettington, who knows what she's doing.'

'That's probably too optimistic,' Jackie said. 'Not to mention hasty. Because I'm going to turn the meeting over to Joe McClatchey.'

Joe looked startled. 'Me?'

'But before he gets going,' she went on, 'I'm going to ask his friends to serve as lookouts. Norrie in front and Benny in back.' Jackie saw the protest on their faces and raised a hand to forestall it. 'This isn't an excuse to get you out of the room – it's important. I don't need to tell you it might not be good if the powers that be caught us in conclave. You two are the smallest. Find some nice deep shadows and slide in. If you see someone coming who looks suspi-cious, or any of the town police cars, clap your hands like this.' She clapped once, then twice, then once more. 'You'll be filled in on everything later, I promise you. The new order of the day is pooled information, no secrets.'

When they were gone, Jackie turned to Joe. 'This box you told Linda about. Tell everyone. From beginning to end.'

Joe did it on his feet, as if reciting in school. 'Then we came back to town,' he finished. 'And that bastard Rennie had Rusty arrested.' He wiped sweat from his forehead and sat back down on the couch.

Claire put an arm around his shoulders. 'Joe says it would be bad for Rennie to find out about the box,' she said. 'He thinks Rennie might want it to keep on doing what it's doing instead of trying to turn it off or destroy it.'

'I think he's right,' Jackie said. 'So its existence and location are our first secret.'

'I don't know . . .' Joe said.

'What?' Julia asked. 'You think he *should* know?'

'Maybe. Sort of. I need to think.'

Jackie pushed on without questioning him further. 'Here's the second order of business. I want to try and break Barbie and Rusty out of jail. Tomorrow night, during the big town meeting. Barbie's the guy the President designated to take over the town administration—'

'Anybody but Rennie,' Ernie growled. 'Incompetent sonofabitch thinks he owns this burg.'

'He's good at one thing,' Linda said. 'Stirring up trouble when it suits him. The food riot and the newspaper being burned . . . I think both of those were done according to his orders.'

'Of course they were,' Jackie said. 'Anyone who could kill his own *pastor*—'

Rose goggled at her. 'Are you saying *Rennie* killed Coggins?'

Jackie told them about the basement workroom in the funeral parlor, and how the marks on Coggins's face matched the gold baseball Rusty had seen in Rennie's study. They listened with dismay but no disbelief.

'The girls, too?' Lissa Jamieson said in a small, horrified voice.

'I've got his son down for that.' Jackie spoke almost briskly. 'And those murders were probably not related to Big Jim's political machinations. Junior collapsed this morning. At the McCain house, incidentally, where the bodies were found. By him.'

'What a coincidence,' Ernie said.

'He's in the hospital. Ginny Tomlinson says it's almost certainly a brain tumor. Which can cause violent behavior.'

'A father-son murder team?' Claire was hugging Joe more tightly than ever.

'Not a team, exactly,' Jackie said. 'Call it the same wild strain of behavior – something genetic – coming out under pressure.'

Linda said, 'But the bodies being in the same place strongly suggests that if there *were* two murderers, they were working together. The point is, my husband and Dale Barbara are almost certainly being held by a killer who's using them to build a grand conspiracy theory. The only reason they haven't already been killed in custody is because Rennie wants to make an example of them. He wants them executed in public.' Her face cramped for a moment as she fought off tears.

'I can't believe he's gotten as far as he has,' Lissa said. She was twisting the ankh she wore back and forth. 'He's a *used car dealer*, for heaven's sake.'

Silence greeted this.

'Now look,' Jackie said after it had stretched out a bit. 'By telling you what Linda and I mean to do, I've made this a *real* conspiracy. I'm going to ask for a vote. If you want to be a part of this, raise your hand. Those who don't raise their hands can leave, contingent on a promise not to blab about what we've discussed. Which you wouldn't want to do, anyway; if you don't tell anybody who was here and what was discussed, you won't have to explain how you heard. This is dangerous. We might end up in jail, or even worse. So let's see some hands. Who wants to stay?'

Joe raised his hand first, but Piper, Julia, Rose, and Ernie Calvert were not far behind. Linda and Rommie raised their hands together. Lissa looked at Claire McClatchey. Claire sighed and nodded. The two women raised their hands.

'Way to go, Mom,' Joe said.

'If you ever tell your father what I let you get into,' she said, 'you won't need James Rennie to execute you. I'll do it myself.'

19

'Linda can't go into the PD after them,' Rommie said. He was speaking to Jackie.

'Who, then?'

'You and me, hon. Linda's gonna go to the big meeting. Where six or eight hundred people can testify that they saw her.'

'Why can't I go?' Linda asked. 'That's my *husband* they've got.'

'That's why,' Julia said simply.

'How do you want to do it?' Rommie asked Jackie.

'Well, I suggest we wear masks—'

'*Duh,*' Rose said, and made a face. They all laughed.

'Lucky us,' Rommie said. 'I got a great selection of Halloween masks at the store.'

'Maybe I'll be the Little Mermaid,' Jackie said, a little wistfully. She realized everyone was looking at her, and blushed. 'Whatever. In any case, we'll need guns. I have an extra at home – a Beretta. Do you have something, Rommie?'

'I put away some rifles and shotguns in the store safe. Got at least one wit' a scope. I won't say I saw this comin, but I saw *somethin* comin.'

Joe spoke up. 'You'll also need a getaway vehicle. And not your van, Rommie, because everyone knows it.'

'I got an idea about that,' Ernie said. 'Let's take a vehicle from

Jim Rennie's used car lot. He's got half a dozen high-mileage phone company vans he picked up last spring. They're out in the back. Using one of his'd be, whatdoyacallit, poetic justice.'

'And exactly how you gonna get the key?' Rommie asked. 'Break into his office at the showroom?'

'If the one we pick doesn't have an electronic ignition, I can hotwire it,' Ernie said. Fixing Joe with a frowning glance, he added: 'I'd prefer you didn't tell my granddaughter that, young man.'

Joe did a lip-zipping pantomime that made them all laugh again.

'The special town meeting is scheduled to start at seven tomorrow night,' Jackie said. 'If we go into the PD around eight—'

'We can do better than that,' Linda said. 'If I have to go to the damn meeting, I might as well do some good. I'll wear a dress with big pockets and carry my police radio – the extra that's still in my personal vehicle. You two be in the van, ready to go.'

Tension was creeping into the room; they all felt it. This was starting to be real.

'At the loadin dock behind my store,' Rommie said. 'Out of sight.'

'Once Rennie really gets going on his speech,' Linda said, 'I'll give you a triple break on the radio. That's your signal to roll.'

'How many police will there be at the station?' Lissa asked.

'I might be able to find out from Stacey Moggin,' Jackie said. 'There won't be many, though. Why would there be? So far as Big Jim knows, there are no real Friends of Barbie – just the straw men he's set up.'

'He'll also want to make sure his tender ass is well protected,' Julia said.

There was some laughter at this, but Joe's mother looked deeply troubled. 'There'll be *some* at the police station no matter what. What are you going to do if they resist you?'

'They won't,' Jackie said. 'We'll have them locked in their own cells before they know what's happening.'

'But if they do?'

'Then we'll try not to kill them.' Linda's voice was calm, but her eyes were those of a creature who has screwed its courage up in some final desperate effort to save itself. 'There's probably going to be killing anyway if the Dome stays up much longer. The execution of Barbie and my husband in War Memorial Plaza will only be the start of it.'

'Let's say you get them out,' Julia said. 'Where will you take them? Here?'

'No way,' Piper said, and touched her still-swollen mouth. 'I'm

already on Rennie's shit list. Not to mention that guy who's now his personal bodyguard. Thibodeau. My dog bit him.'

'Anywhere near the center of town's not a great idea,' Rose said. 'They could do a house-to-house. God knows they've got enough cops.'

'Plus all the people wearing the blue armbands,' Rommie added.

'What about one of the summer cabins out at Chester Pond?' Julia asked.

'Possible,' Ernie said, 'but they could think of that, too.'

'It still might be the best bet,' Lissa said.

'Mr Burpee?' Joe asked. 'Have you got any more of that lead roll?'

'Sure, tons. And make it Rommie.'

'If Mr Calvert can steal a van tomorrow, could you sneak it behind your store and put a bunch of precut pieces of lead roll in the back? Ones big enough to cover the windows?'

'I guess so . . .'

Joe looked at Jackie. 'And could you get hold of this Colonel Cox, if you had to?'

'Yes.' Jackie and Julia answered together, then looked at each other in surprise.

Light was dawning on Rommie's face. 'You're thinking about the old McCoy place, aren't you? Up on Black Ridge. Where the box is.'

'Yeah. It might be a bad idea, but if we all had to run . . . if we were all up there . . . we could defend the box. I know that sounds crazy, since it's the thing causing all the problems, but we can't let Rennie get it.'

'I hope it don't come to refighting the Alamo in an apple orchard,' Rommie said, 'but I see your point.'

'There's something else we could do, too,' Joe said. 'It's a little risky, and it might not work, but . . .'

'Spill it,' Julia said. She was looking at Joe McClatchey with a kind of bemused awe.

'Well . . . is the Geiger counter still in your van, Rommie?'

'I t'ink so, yeah.'

'Maybe someone could put it back in the fallout shelter where it came from.' Joe turned to Jackie and Linda. 'Could either of you get in there? I mean, I know you got fired.'

'Al Timmons would let us in, I think,' Linda said. 'And he'd let Stacey Moggin in for sure. She's with us. The only reason she's not here right now is because she's got the duty. Why risk it, Joe?'

'Because . . .' He was speaking with uncharacteristic slowness, feeling his way. 'Well . . . there's radiation out there, see? *Bad* radiation. It's just a belt – I bet you could drive right through it without any protection at all and not get hurt, if you drove fast and didn't try it too often – but *they* don't know that. The problem is, they don't know there's radiation out there at all. And they won't, if they don't have the Geiger counter.'

Jackie was frowning. 'It's a cool idea, kiddo, but I don't like the idea of pointing Rennie right at where we're going. That doesn't fit with my idea of a safe house.'

'It wouldn't have to be like that,' Joe said. He was still speaking slowly, testing for weak spots. 'Not exactly, anyway. One of you could get in touch with Cox, see? Tell him to call Rennie and say they're picking up spot radiation. Cox can say something like, "We can't exactly pinpoint it because it comes and goes, but it's pretty high, maybe even lethal, so watch out. You don't happen to have a Geiger counter, do you?"'

There was a long silence as they considered this. Then Rommie said, 'We take Barbara and Rusty out to the McCoy farm. We go there ourselves if we have to . . . which we probably will. And if *they* try to go out there—'

'They get a radiation spike on the Geiger counter that sends them running back to town with their hands over their worthless gonads,' Ernie rasped. 'Claire McClatchey, you got a genius there.'

Claire hugged Joe tight, this time with both arms. 'Now if I could only get him to pick up his room,' she said.

20

Horace lay on the rug in Andrea Grinnell's living room with his snout on one paw and his eye on the woman his mistress had left him with. Ordinarily Julia took him everywhere; he was quiet and never caused trouble even if there were cats, which he didn't care for because of their stinkweed smell. Tonight, however, it had occurred to Julia that seeing Horace alive when her own dog was dead might cause Piper Libby pain. She had also noticed that Andi liked Horace, and thought that the Corgi might take Andi's mind off her withdrawal symptoms, which had abated but not disappeared.

For a while it worked. Andi found a rubber ball in the toybox she still kept for her one grandchild (who was now well past the toybox stage of life). Horace chased the ball obediently and brought it back as was required, although there wasn't much challenge in it;

he preferred balls that could be caught on the fly. But a job was a job, and he continued until Andi started shivering as if she were cold.

'Oh. Oh fuck, here it comes again.'

She lay down on the couch, shaking all over. She clutched one of the sofa-pillows against her chest and stared at the ceiling. Pretty soon her teeth started to clatter – a very annoying sound, in Horace's opinion.

He brought her the ball, hoping to distract her, but she pushed him away. 'No, honey, not now. Let me get through this.'

Horace took the ball back in front of the blank TV and lay down. The woman's shaking moderated, and the sick-smell moderated along with it. The arms clutching the pillow loosened as she first began to drift and then to snore.

Which meant it was chowtime.

Horace slipped under the table again, walking over the manila envelope containing the VADER file. Beyond it was popcorn Nirvana. O lucky dog!

Horace was still snarking, his tailless rear end wagging with pleasure that was close to ecstasy (the scattered kernels were incredibly *buttery*, incredibly *salty*, and – best of all – aged to perfection), when the deadvoice spoke again.

Take that to her.

But he couldn't. His mistress was gone.

The other her.

The deadvoice brooked no refusal, and the popcorn was almost gone, anyway. Horace marked the few remaining blossoms for later attention, then backed up until the envelope was in front of him. For a moment he forgot what he was supposed to do. Then he remembered and picked it up in his mouth.

Good dog.

21

Something cold licked Andrea's cheek. She pushed it away and turned on her side. For a moment or two she almost escaped back into healing sleep, and then there was a bark.

'Shurrup, Horace.' She put the sofa pillow over her head.

There was another bark, and then thirty-four pounds of Corgi landed on her legs.

'*Ah!*' Andi cried, sitting up. She looked into a pair of brilliant hazel eyes and a foxy, grinning face. Only there was something interrupting that grin. A brown manila envelope. Horace dropped it on

her stomach and jumped back down. He wasn't supposed to get on furniture other than his own, but the deadvoice had made this seem like an emergency.

Andrea picked up the envelope, which had been dented by the points of Horace's teeth and was faintly marked with the tracks of his paws. There was also a kernel of popcorn stuck to it, which she brushed away. Whatever was inside felt fairly bulky. Printed on the front of the envelope in block letters were the words VADER FILE. Below that, also printed: JULIA SHUMWAY.

'Horace? Where did you get this?'

Horace couldn't answer that, of course, but he didn't have to. The kernel of popcorn told her where. A memory surfaced then, one so shimmery and unreal that it was more like a dream. *Was* it a dream, or had Brenda Perkins really come to her door after that first terrible night of withdrawal? While the food riot was going on at the other end of town?

Will you hold this for me, dear? Just for a little while? I have an errand to run and I don't want to take it with me.

'She was here,' she told Horace, 'and she had this envelope. I took it . . . at least I think I did . . . but then I had to throw up. Throw up *again*. I might have tossed it at the table while I was running for the john. Did it fall off? Did you find it on the floor?'

Horace uttered one sharp bark. It could have been agreement; it could have been *I'm ready for more ball if you are.*

'Well, thanks,' Andrea said. 'Good pup. I'll give it to Julia as soon as she comes back.'

She no longer felt sleepy, and she wasn't − for the moment − shivery, either. What she was was curious. Because Brenda was dead. Murdered. And it must have happened not long after she delivered this envelope. Which might make it important.

'I'll just have a tiny peek, shall I?' she said.

Horace barked again. To Andi Grinnell it sounded like *Why not?*

Andrea opened the envelope, and most of Big Jim Rennie's secrets fell out into her lap.

22

Claire got home first. Benny came next, then Norrie. The three of them were sitting together on the porch of the McClatchey house when Joe arrived, cutting across lawns and keeping to the shadows. Benny and Norrie were drinking warm Dr Brown's Cream Soda. Claire was nursing a bottle of her husband's beer as she rocked slowly

to and fro on the porch glider. Joe sat down beside her, and Claire put an arm around his bony shoulders. *He's fragile*, she thought. *He doesn't know it, but he is. No more to him than a bird.*

'Dude,' Benny said, handing him the soda he'd saved for him. 'We were startin to get a little worried.'

'Miz Shumway had a few more questions about the box,' Joe said. 'More than I could answer, really. Gosh, it's warm out, isn't it? Warm as a summer night.' He turned his gaze upward. 'And look at that *moon*.'

'I don't want to,' Norrie said. 'It's scary.'

'You okay, honey?' Claire asked.

'Yeah, Mom. You?'

She smiled. 'I don't know. Is this going to work? What do you guys think? I mean *really* think.'

For a moment none of them answered, and that scared her more than anything. Then Joe kissed her on the cheek and said, 'It'll work.'

'You're sure?'

'Yeah.'

She could always tell when he was lying – although she knew the talent might leave her when he was older – but she didn't call him on it this time. She just kissed him back, her breath warm and somehow fatherly with beer. 'Just as long as there's no bloodshed.'

'No blood,' Joe said.

She smiled. 'Okay; that's good enough for me.'

They sat there in the dark a while longer, saying little. Then they went inside, leaving the town to sleep under the pink moon.

It was just past midnight.

BLOOD EVERYWHERE

1

It was twelve-thirty on the morning of October twenty-sixth when Julia let herself into Andrea's house. She did it quietly, but there was no need; she could hear music from Andi's little portable radio: the Staples Singers, kicking holy ass with 'Get Right Church.'

Horace came down the hall to greet her, wagging his rear end and grinning that slightly mad grin of which only Corgis seem capable. He bowed before her, paws splayed, and Julia gave him a brief scratch behind the ears – it was his sweet spot.

Andrea was sitting on the couch, drinking a glass of tea.

'Sorry about the music,' she said, turning it down. 'I couldn't sleep.'

'It's your house, honey,' Julia said. 'And for WCIK, that really rocks.'

Andi smiled. 'It's been uptempo gospel ever since this afternoon. I feel like I hit the jackpot. How was your meeting?'

'Good.' Julia sat down.

'Want to talk about it?'

'You don't need the worry. What you need is to concentrate on feeling better. And you know what? You *look* a little better.'

It was true. Andi was still pale, and much too thin, but the dark circles under her eyes had faded a little, and the eyes themselves had a new spark. 'Thanks for saying so.'

'Was Horace a good boy?'

'Very good. We played ball, and then we both slept a little. If I look better, that's probably why. Nothing like a nap to improve a girl's looks.'

'What about your back?'

Andrea smiled. It was an oddly knowing smile, without much humor in it. 'My back isn't bad at all. Hardly a twinge, even when I bend over. Do you know what I think?'

Julia shook her head.

'I think that when it comes to drugs, the body and the mind are co-conspirators. If the brain wants drugs, the body helps out. It says, "Don't worry, don't feel guilty, it's okay, I really hurt." It's not exactly hypochondria I'm talking about, nothing so simple. Just . . .' She trailed off and her eyes grew distant as she went somewhere else.

Where? Julia wondered.

Then she came back. 'Human nature can be destructive. Tell me, do you think a town is like a body?'

'Yes,' Julia said instantly.

'And can it say it hurts so the brain can take the drugs it craves?' Julia considered, then nodded. 'Yes.'

'And right now, Big Jim Rennie is this town's brain, isn't he?'

'Yes, hon. I'd say he is.'

Andrea sat on the couch, head slightly lowered. Then she snapped off the little battery radio and got to her feet. 'I think I'll go up to bed. And do you know, I think I might actually be able to sleep.'

'That's good.' And then, for no reason she could have articulated, Julia asked: 'Andi, did anything happen while I was gone?'

Andrea looked surprised. 'Why, yes. Horace and I played ball.' She bent down without the slightest wince of pain – a movement she would only a week ago have claimed was impossible for her – and held out one hand. Horace came to her and allowed his head to be stroked. 'He's very good at fetching.'

2

In her room, Andrea settled on her bed, opened the VADER file, and began to read through it again. More carefully this time. When she finally slid the papers back into the manila envelope, it was close to two a.m. She put the envelope into the drawer of the table next to her bed. Also in the drawer was a .38 pistol, which her brother Douglas had given her for her birthday two years ago. She had been dismayed, but Dougie had insisted that a woman living alone should have protection.

Now she took it out, popped the cylinder, and checked the chambers. The one that would roll under the hammer when the trigger was pulled for the first time was empty, as per Twitch's instructions. The other five were full. She had more bullets on the top shelf of her closet, but they would never give her a chance to reload. His little army of cops would shoot her down first.

And if she couldn't kill Rennie with five shots, she probably didn't deserve to live, anyway.

'After all,' she murmured as she put the gun back in the drawer, 'what did I get straight for, anyway?' The answer seemed clear now that the Oxy had cleared her brain: she'd gotten straight to *shoot* straight.

'Amen to that,' she said, and turned out the light.

Five minutes later she was asleep.

3

Junior was wide awake. He sat by the window in the hospital room's only chair, watching the bizarre pink moon decline and slip behind a black smudge on the Dome that was new to him. This one was bigger and much higher than the one left by the failed missile strikes. Had there been some other effort to breach the Dome while he'd been unconscious? He didn't know and didn't care. What mattered was that the Dome was still holding. If it hadn't been, the town would have been lit like Vegas and crawling with GI Joes. Oh, there were lights here and there, marking a few diehard insomniacs, but for the most part, Chester's Mill slept. That was good, because he had things to think about.

Namely *Baaarbie* and Barbie's friends.

Junior had no headache as he sat by the window, and his memories had come back, but he was aware that he was a very sick boy. There was a suspicious weakness all down the left side of his body, and sometimes spit slipped from that side of his mouth. If he wiped it away with his left hand, sometimes he could feel skin against skin and sometimes he couldn't. In addition to this, there was a dark keyhole shape, quite large, floating on the left side of his vision. As if something had torn inside that eyeball. He supposed it had.

He could remember the wild rage he'd felt on Dome Day; could remember chasing Angie down the hall to the kitchen, throwing her against the fridge, and hoicking his knee into her face. He could remember the sound it made, as if there were a china platter behind her eyes and his knee had shattered it. That rage was gone now. What had taken its place was a silken fury that flowed through his body from some bottomless source deep inside his head, a spring that simultaneously chilled and clarified.

The old fuck he and Frankie had rousted at Chester Pond had come in to examine him earlier this evening. The old fuck acted professional, taking his temperature and blood pressure, asking how his headache was, even checking his knee reflexes with a little rubber hammer. Then, after he left, Junior heard talk and laughter. Barbie's name was mentioned. Junior crept to the door.

It was the old fuck and one of the candy stripers, the pretty dago whose name was Buffalo or something like Buffalo. The old fuck had her top open and was feeling her tits. She had his fly open and was jerking his dick. A poison green light surrounded them.

'Junior and his friend beat me up,' the old fuck was saying, 'but now his friend's dead and soon he will be, too. Barbie's orders.'

'I like to suck Barbie's dick like a peppermint stick,' the Buffalo-girl said, and the old fuck said he enjoyed that, too. Then, when Junior blinked his eyes, the two of them were just walking down the hall. No green aura, no dirty stuff. So maybe it had been a hallucination. On the other hand, maybe not. One thing was for sure: they were all in it together. All in league with *Baaarbie*. He was in jail, but that was just temporary. To gain sympathy, probably. All part of *Baaarbie's plaaan*. Plus, he thought that in jail he was beyond Junior's reach.

'Wrong,' he whispered as he sat by the window, looking out at the night with his now-defective vision. '*Wrong.*'

Junior knew exactly what had happened to him; it had come in a flash, and the logic was undeniable. He was suffering from thallium poisoning, like what had happened to that Russian guy in England. Barbie's dog tags had been coated with thallium dust, and Junior had handled them, and now he was dying. And since his father had sent him to Barbie's apartment, that meant *he* was a part of it, too. He was another of Barbie's . . . his . . . what did you call those guys . . .

'Minions,' Junior whispered. 'Just another one of Big Jim Rennie's filet minions.'

Once you thought about it – once your mind was *clarified* – it made perfect sense. His father wanted to shut him up about Coggins and Perkins. Hence, thallium poisoning. It all hung together.

Outside, beyond the lawn, a wolf loped across the parking lot. On the lawn itself, two naked women were in the 69 position. *Sixty-nine, lunchtime!* he and Frankie used to chant when they were kids and saw two girls walking together, not knowing what it meant, only knowing that it was rude. One of the cracksnackers looked like Sammy Bushey. The nurse – Ginny, her name was – had told him that Sammy was dead, which was obviously a lie and meant that Ginny was in on it, too; in on it with *Baaarbie*.

Was there anyone in this whole town who wasn't? Who he could be *sure* wasn't?

Yes, he realized, there were two. The kids he and Frank had found out by the Pond, Alice and Aidan Appleton. He remembered their haunted eyes, and how the girl had hugged him when he picked her up. When he told her she was safe, she had asked *Do you promise?*, and Junior had told her yes. It made him feel really good to promise. The trusting weight of her had made him feel good, too.

He made a sudden decision: he would kill Dale Barbara. If anyone

got in his way, he would kill them, too. Then he would find his father and kill him . . . a thing he had dreamed of doing for years, although he had never admitted it to himself fully until now.

Once that was done, he'd seek out Aidan and Alice. If someone tried to stop him, he'd kill them, too. He would take the kids back out to Chester Pond, and he would take care of them. He would keep the promise he had made to Alice. If he did, he wouldn't die. God would not let him die of thallium poisoning while he was taking care of those kids.

Now Angie McCain and Dodee Sanders went prancing across the parking lot, wearing cheerleader skirts and sweaters with big Mills Wildcats **W**s on their chests. They saw him looking and began to gyrate their hips and lift up their skirts. Their faces slopped and jiggled with decay. They were chanting, '*Open up the pantry door! Come on in, let's fuck some more! Go . . . TEAM!*'

Junior closed his eyes. Opened them. His girlfriends were gone. Another hallucination, like the wolf. About the 69 girls he wasn't so sure.

Maybe, he thought, he wouldn't take the children out to the Pond, after all. That was pretty far from town. Maybe he would take them to the McCain pantry, instead. That was closer. There was plenty of food.

And, of course, it was dark.

'I'll take care of you, kids,' Junior said. 'I'll keep you safe. Once Barbie's dead, the whole conspiracy will fall apart.'

After a while he leaned his forehead against the glass and then he too slept.

4

Henrietta Clavard's ass might only have been bruised instead of broken, but it still hurt like a sonofabitch – at eighty-four, she'd found, *every-thing* that went wrong with you hurt like a sonofabitch – and at first she thought it was her ass that woke her at first light on that Thursday morning. But the Tylenol she'd taken at three a.m. still seemed to be holding. Plus, she'd found her late husband's fanny-ring (John Clavard had suffered hemorrhoids), and that helped considerably. No, it was something else, and shortly after awakening, she realized what it was.

The Freemans' Irish setter, Buddy, was howling. Buddy *never* howled. He was the most polite dog on Battle Street, a short lane just beyond Catherine Russell Drive. Also, the Freemans' generator had stopped. Henrietta thought that might have actually been what

woke her up, not the dog. Certainly it had put her to sleep last night. It wasn't one of those rackety ones, blowing blue exhaust smoke into the air; the Freemans' generator gave off a low, sleek purr that was actually quite soothing. Henrietta supposed it was expensive, but the Freemans could afford it. Will owned the Toyota franchise Big Jim Rennie had once coveted, and although these were hard times for most car dealers, Will had always seemed the exception to the rule. Just last year, he and Lois had put a very nice and tasteful addition on the house.

But that *howling*. The dog sounded hurt. A hurt pet was the sort of thing nice people like the Freemans saw to immediately . . . so why weren't they?

Henrietta got out of bed (wincing a little as her butt came out of the comforting hole in the foam doughnut) and went to the window. She could see the Freemans' split-level perfectly well, although the light was gray and listless instead of sharp and clear, as it usually was on mornings in late October. From the window she could hear Buddy even better, but she couldn't see anyone moving around over there. The house was entirely dark, not so much as a Coleman lantern glowing in a single window. She would have thought they'd gone somewhere, but both cars were parked in the driveway. And where was there to go, anyway?

Buddy continued to howl.

Henrietta got on her housecoat and slippers and went outside. As she was standing on the sidewalk, a car pulled up. It was Douglas Twitchell, no doubt on his way to the hospital. He looked puffy-eyed and was clutching a takeout cup of coffee with the Sweetbriar Rose logo on the side as he got out of his car.

'You all right, Mrs Clavard?'

'Yes, but something's wrong at the Freemans'. Hear that?'

'Yeah.'

'Then so must they. Their cars are there, so why don't they stop it?'

'I'll take a look.' Twitch took a sip of his coffee, then set it down on the hood of his car. 'You stay here.'

'Nonsense,' said Henrietta Clavard.

They walked down twenty yards or so of sidewalk, then up the Freemans' driveway. The dog howled and howled. The sound of it made Henrietta's skin cold in spite of the morning's limp warmth.

'The air's very bad,' she said. 'It smells like Rumford used to when I was just married and all the paper mills were still running. This can't be good for people.'

Twitch grunted and rang the Freemans' bell. When that brought no response, he first knocked on the door and then hammered.

'See if it's unlocked,' Henrietta said.

'I don't know if I should, Mrs—'

'Oh, bosh.' She pushed past him and tried the knob. It turned. She opened the door. The house beyond it was silent and full of deep early morning shadows. 'Will?' she called. 'Lois? Are you here?'

No one answered but more howls.

'The dog's out back,' Twitch said.

It would have been quicker to cut straight through, but neither of them liked to do that, so they walked up the driveway and along the breezeway between the house and the garage where Will stored not his cars but his toys: two snowmobiles, an ATV, a Yamaha dirtbike and a bloated Honda Gold Wing.

There was a high privacy fence around the Freeman backyard. The gate was beyond the breezeway. Twitch pulled the gate open, and was immediately hit by seventy pounds of frantic Irish setter. He shouted in surprise and raised his hands, but the dog didn't want to bite him; Buddy was in full please-rescue-me mode. He put his paws on the front of Twitch's last clean tunic, smearing it with dirt, and began to slobber all over his face.

'Stop it!' Twitch shouted. He pushed Buddy, who went down but popped right back up, laying fresh tracks on Twitch's tunic and swabbing his cheeks with a long pink tongue.

'*Buddy, down!*' Henrietta commanded, and Buddy shrank onto his haunches at once, whining and rolling his eyes between them. A puddle of urine began to spread out beneath him.

'Mrs Clavard, this is not good.'

'No,' Henrietta agreed.

'Maybe you better stay with the d—'

Henrietta once more said bosh and marched into the Freemans' backyard, leaving Twitch to catch up with her. Buddy slunk along behind them, head down and tail tucked, whining disconsolately.

There was a stone-flagged patio with a barbecue on it. The barbecue was neatly covered with a green tarp that said THE KITCHEN'S CLOSED. Beyond this, on the edge of the lawn, was a redwood platform. On top of the platform was the Freemans' hot tub. Twitch supposed the high privacy fence was there so they could sit in it naked, maybe even pitch a little woo if the urge took them.

Will and Lois were in it now, but their woo-pitching days were done. They were wearing clear plastic bags over their heads. The bags appeared to have been cinched at the necks with either twine or

brown rubber bands. They had fogged up on the inside, but not so much that Twitch couldn't make out the empurpled faces. Sitting on the redwood apron between the earthly remains of Will and Lois Freeman was a whiskey bottle and a small medicine vial.

'Stop,' he said. He didn't know if he was talking to himself, or Mrs Clavard, or possibly to Buddy, who had just voiced another bereft howl. Certainly he couldn't be talking to the Freemans.

Henrietta didn't stop. She walked to the hot tub, marched up the two steps with her back as straight as a soldier's, looked at the discolored faces of her perfectly nice (and perfectly normal, she would have said) neighbors, glanced at the whiskey bottle, saw it was Glenlivet (at least they'd gone out in style), then picked up the medicine vial with its Sanders Hometown Drug label.

'Ambien or Lunesta?' Twitch asked heavily.

'Ambien,' she said, and was gratified the voice emerging from her dry throat and mouth sounded normal. 'Hers. Although I'd guess she shared it last night.'

'Is there a note?'

'Not here,' she said. 'Maybe inside.'

But there wasn't, at least not in any of the obvious places, and neither of them could think of a reason to hide a suicide note. Buddy followed them from room to room, not howling but whining deep in his throat.

'I guess I'll bring him back t'house with me,' Henrietta said.

'You'll have to. I can't take him to the hospital. I'll call Stewart Bowie to come and get . . . them.' He hooked a thumb back over his shoulder. His stomach was roiling, but that wasn't the bad part; the bad part was the depression that came stealing into him, putting a shadow across his normally sunny soul.

'I don't understand why they would do it,' Henrietta said. 'If we'd been a year under the Dome . . . or even a month . . . yes, maybe. But less than a *week*? This is not how stable people respond to trouble.'

Twitch thought he understood, but didn't want to say it to Henrietta: it *was* going to be a month, it *was* going to be a year. Maybe longer. And with no rain, fewer resources, and fouler air. If the most technologically hip country in the world hadn't been able to get a handle on what had happened to Chester's Mill by now (let alone solve the problem), it probably wasn't going to happen soon. Will Freeman must have understood that. Or maybe it had been Lois's idea. Maybe when the generator had died, she'd said *Let's do it before the water in the hot tub gets cold, honey. Let's get out from under the*

Dome while our bellies are still full. What do you say? One more dip, with a few drinks to see us off.

'Maybe it was the plane that pushed them over the edge,' Twitch said. 'The Air Ireland that hit the Dome yesterday.'

Henrietta didn't answer with words; she hawked back and spat snot into the kitchen sink. It was a somehow shocking gesture of repudiation. They went back outside.

'More people will do this, won't they?' she asked when they had reached the end of the driveway. 'Because suicide gets in the air sometimes. Like a cold germ.'

'Some already have.' Twitch didn't know if suicide was painless, as the song said, but under the right circumstances, it could certainly be catching. Maybe especially catching when the situation was unprecedented and the air started to smell as foul as it did on this windless, unnaturally warm morning.

'Suicides are cowards,' Henrietta said. 'A rule to which there are no exceptions, Douglas.'

Twitch, whose father had died a long and lingering death as a result of stomach cancer, wondered about that but said nothing.

Henrietta bent to Buddy with her hands on her bony knees. Buddy stretched his neck up to sniff her. 'Come next door, my furry friend. I have three eggs. You may eat them before they go bad.'

She started away, then turned back to Twitch. '*They are cowards,*' she said, giving each word its own special emphasis.

5

Jim Rennie checked out of Cathy Russell, slept soundly in his own bed, and woke refreshed. Although he would not have admitted it to anyone, part of the reason was knowing Junior was out of the house.

Now, at eight o'clock, his black Hummer was parked a door or two up from Rosie's (in front of a fire hydrant, but what the hell; currently there was no fire department). He was having breakfast with Peter Randolph, Mel Searles, Freddy Denton, and Carter Thibodeau. Carter had taken up what was becoming his usual station, at Big Jim's right hand. He wore two guns this morning: his own on his hip, and Linda Everett's recently returned Beretta Taurus in a shoulder rig.

The quintet had taken over the bullshit table at the back of the restaurant, deposing the regulars without a qualm. Rose wouldn't come near; she sent Anson to deal with them.

Big Jim ordered three fried eggs, double sausage, and home toast fried in bacon grease, the way his mother used to serve it. He

knew he was supposed to be cutting down on his cholesterol, but today he was going to need all the energy he could pack in. The next few days, actually; after that, things would be under control. He could go to work on his cholesterol then (a fable he had been telling himself for ten years).

'Where's the Bowies?' he asked Carter. 'I wanted the goshdarn Bowies here, so where are they?'

'Had to roll on a call out to Battle Street,' Carter said. 'Mr and Mrs Freeman committed suicide.'

'That cotton-picker topped himself?' Big Jim exclaimed. The few patrons – most at the counter, watching CNN – looked around, then looked away. 'Well, there! I'm not a bit surprised!' It occurred to him that now the Toyota dealership could be his for the taking . . . but why would he want it? A much bigger plum had fallen into his lap: the whole town. He had already started drafting a list of executive orders, which he would begin putting into effect as soon as he was granted full executive powers. That would happen tonight. And besides, he had hated that smarmy sonofabuck Freeman and his titsy rhymes-with-witch wife for years.

'Boys, he and Lois are eating breakfast in heaven.' He paused, then burst out laughing. Not very political, but he just couldn't help it. 'In the servants' quarters, I have no doubt.'

'While the Bowies were out there, they got another call,' Carter said. 'Dinsmore farm. Another suicide.'

'Who?' Chief Randolph asked. 'Arlen?'

'No. His wife. Shelley.'

That actually *was* sort of a shame. 'Let's us bow our heads for a minute,' Big Jim said, and extended his hands. Carter took one; Mel Searles took the other; Randolph and Denton linked up.

'Ohgod pleaseblessthesepoorsouls, Jesussakeamen,' Big Jim said, and raised his head. 'Little business, Peter.'

Peter hauled out his notebook. Carter's was already laid beside his plate; Big Jim liked the boy more and more.

'I've found the missing propane,' Big Jim announced. 'It's at WCIK.'

'Jesus!' Randolph said. 'We have to send some trucks out there to get it!'

'Yes, but not today,' Big Jim said. 'Tomorrow, while everyone's visiting their relatives. I've already started working on that. The Bowies and Roger will go out again, but we'll need a few officers, too. Fred, you and Mel. Plus I'm going to say four or five more. Not you, Carter, I want you with me.'

'Why do you need cops to get a bunch of propane tanks?' Randolph said.

'Well,' Jim said, mopping up egg yolk with a piece of fried toast, 'that goes back to our friend Dale Barbara and his plans to destabilize this town. There are a couple of armed men out there, and it looks like they may be protecting some kind of drug lab. I think Barbara had that in place long before he actually showed up in person; this was well planned. One of the current caretakers is Philip Bushey.'

'*That* loser,' Randolph grunted.

'The other one, I'm sorry to say, is Andy Sanders.'

Randolph had been spearing fried potatoes. Now he dropped his fork with a clatter. '*Andy!*'

'Sad but true. It was Barbara who set him up in business – I have that on good authority, but don't ask me for my source; he's requested anonymity.' Big Jim sighed, then stuffed a yolk-smeared chunk of fried bread into his cakehole. Dear *Lord* but he felt good this morning! 'I suppose Andy needed the money. I understand the bank was on the verge of foreclosing his drugstore. He never *did* have a head for business.'

'Or town government, either,' Freddy Denton added.

Big Jim ordinarily did not enjoy being interrupted by inferiors, but this morning he was enjoying everything. 'Unfortunately true,' he said, then leaned over the table as far as his large belly would allow. 'He and Bushey shot at one of the trucks I sent out there yesterday. Blew the front tires. Those cotton-pickers are dangerous.'

'Drug addicts with guns,' Randolph said. 'A law-enforcement nightmare. The men who go out there will have to wear vests.'

'Good idea.'

'And I can't vouch for Andy's safety.'

'God love you, I know that. Do what you have to do. We need that propane. The town's crying for it, and I intend to announce at the meeting tonight that we've discovered a fresh source.'

'Are you sure I can't go, Mr Rennie?' Carter asked.

'I know it's a disappointment to you, but I want you with me tomorrow, not out where they're having their visitors' party. Randolph, too, I think. Someone has to coordinate this business, which is apt to be a clustermug. We'll have to try to keep people from being trampled. Although some probably will be, because people don't know how to behave. Better tell Twitchell to get his ambulance out there.'

Carter wrote this down.

While he did, Big Jim turned back to Randolph. His face was

long with sorrow. 'I hate to say this, Pete, but my informant has suggested Junior may also have been involved with the drug lab.'

'Junior?' Mel said. 'Naw, not *Junior.*'

Big Jim nodded, and wiped a dry eye with the heel of his palm. 'It's hard for me to believe, too. I don't *want* to believe it, but you know he's in the hospital?'

They nodded.

'Drug overdose,' Rennie whispered, leaning even further over the table. 'That seems to be the most likely explanation for what's wrong with him.' He straightened and focused on Randolph again. 'Don't try going in from the main road, they'll be expecting that. About a mile east of the radio station, there's an access road—'

'I know the one,' Freddy said. 'That used to be Sloppy Sam Verdreaux's woodlot out there, 'fore the bank took it back. I think now all that land belongs to Holy Redeemer.'

Big Jim smiled and nodded, although the land actually belonged to a Nevada corporation of which he was president. 'Go in that way, then approach the station from the rear. It's mostly old growth out there, and you should have no trouble.'

Big Jim's cell phone rang. He looked at the display, almost let the phone ring over to voice mail, then thought: *What the heck.* Feeling as he did this morning, listening to Cox foam at the mouth might be enjoyable.

'This is Rennie. What do you want, Colonel Cox?'

He listened, his smile fading a little.

'How do I know you're telling the truth about this?'

He listened some more, then ended the call without saying goodbye. He sat frowning for a moment, processing whatever he'd heard. Then he raised his head and spoke to Randolph. 'Do we have a Geiger counter? In the fallout shelter, maybe?'

'Gee, I don't know. Al Timmons probably would.'

'Find him and have him check that out.'

'Is it important?' Randolph asked, and at the same time Carter asked, 'Is it radiation, boss?'

'It's nothing to worry about,' Big Jim said. 'As Junior would say, he's just trying to freak me out. I'm sure of it. But check on that Geiger counter. If we do have one – and it still works – bring it to me.'

'Okay,' Randolph said, looking frightened.

Big Jim wished now that he'd let the call go to voice mail after all. Or kept his mouth shut. Searles was apt to blab about this, start a rumor. Heck, *Randolph* was apt to. And it was probably nothing,

just that brass-hat cotton-picker trying to spoil a good day. The most important day of his life, maybe.

Freddy Denton, at least, had kept what mind he had on the issue at hand. 'What time do you want us to hit the radio station, Mr Rennie?'

Big Jim mentally reran what he knew about the Visitors Day schedule, then smiled. It was a genuine smile, wreathing his slightly greasy chops with good cheer and revealing his tiny teeth. 'Twelve o'clock. Everybody will be schmoozing out on highway 119 by then and the rest of the town will be empty. So you go in and take out those cotton-pickers sitting on our propane at high noon. Just like in one of those old Western movies.'

6

At quarter past eleven on that Thursday morning, the Sweetbriar Rose van went trundling south along Route 119. Tomorrow the highway would be clogged with cars and stinking of exhaust, but today it was eerily deserted. Sitting behind the wheel was Rose herself. Ernie Calvert was in the passenger bucket. Norrie sat between them on the engine housing, clutching her skateboard, which was covered with stickers bearing the logos of long-gone punk bands like Stalag 17 and the Dead Milkmen.

'The air smells so *bad*,' Norrie said.

'It's the Prestile, honey,' Rose said. 'It's turned into a big old stinky marsh where it used to run into Motton.' She knew it was more than just the smell of the dying river, but didn't say so. They had to breathe, so there was no point in worrying about what they might be breathing in. 'Have you talked to your mother?'

'Yeah,' Norrie said glumly. 'She'll come, but she's not crazy about the idea.'

'Will she bring whatever groceries she has, when it's time?'

'Yes. In the trunk of our car.' What Norrie didn't add was that Joanie Calvert would load in her booze supply first; food supplies would play second fiddle to that. 'What about the radiation, Rose? We can't plaster every car that goes up there with lead roll.'

'If people only go once or twice, they should be okay.' Rose had confirmed this for herself, on the Internet. She had also discovered that safety when it came to radiation depended on the strength of the rays, but saw no sense in worrying them about things they couldn't control. 'The important thing is to limit exposure . . . and Joe says the belt isn't wide.'

'Joey's mom won't want to come,' Norrie said.

Rose sighed. This she knew. Visitors Day was a mixed blessing. It might cover their retreat, but those with relatives on the other side would want to see them. *Maybe McClatchey will lose the lottery*, she thought.

Up ahead was Jim Rennie's Used Cars, with its big sign: YOU'LL LUV THE FEELIN' WHEN BIG JIM IS DEALIN'! **A$K U$ 4 CREDIT!**

'Remember—' Ernie began.

'I know,' Rose said. 'If someone's there, just turn around in front and head back to town.'

But at Rennie's all the RESERVED FOR EMPLOYEE slots were empty, the showroom was deserted, and there was a whiteboard bearing the message CLOSED UNTIL FURTHER NOTICE hanging on the main door. Rose drove around back in a hurry. Out here were ranks of cars and trucks with signs in the windows bearing prices and slogans like GREAT VALUE and CLEAN AS A WHISTLE and HEY LOOK ME OVER (with the **O**s turned into sexy long-lashed girl-eyes). These were the battered workhorses in Big Jim's stable, nothing like the snazzy Detroit and German thoroughbreds out front. At the far end of the lot, ranked against the chainlink fence separating Big Jim's property from a trash-littered patch of second-growth woods, was a line of phone company vans, some still bearing AT&T logos.

'Those,' Ernie said, reaching behind his seat. He brought out a long thin strip of metal.

'That's a slim jim,' Rose said, amused in spite of her nerves. 'Why would you have a slim jim, Ernie?'

'From when I was still working at Food City. You'd be surprised how many people lock their keys in their cars.'

'How will you get it started, Grampa?' Norrie asked.

Ernie smiled feebly. 'I'll figure somethin out. Stop here, Rose.'

He got out and trotted to the first van, moving with surprising nimbleness for a man approaching seventy. He peered through the window, shook his head, and went to the next in line. Then the third – but that one had a flat tire. After a look into the fourth, he turned back to Rose and gave her a thumbs-up. 'Go on, Rose. Buzz.'

Rose had an idea that Ernie didn't want his granddaughter seeing him use the slim jim. She was touched by that, and drove back around to the front without any further talk. Here she stopped again. 'You okay with this, sweetie?'

'Yes,' Norrie said, getting out. 'If he can't get it started, we'll just walk back to town.'

'It's almost three miles. Can he do that?'

Norrie's face was pale, but she managed a smile. 'Grampa could walk me right into the ground. He does four miles a day, says it keeps his joints oiled. Go on, now, before someone comes and sees you.'

'You're a brave girl,' Rose said.

'I don't *feel* brave.'

'Brave people never do, honey.'

Rose drove back toward town. Norrie watched until she was out of sight, then began to do rails and lazy diamonds in the front lot. The hottop had a slight slope, so she only had to piss-pedal one way . . . although she was so wired she felt like she could push the board all the way up Town Common Hill and not feel it. Hell, right now she could probably ass-knife and not feel it. And if someone came along? Well, she had walked out here with her grampa, who wanted to look at some vans. She was just waiting for him, then they'd walk back to town. Grampa loved to walk, everybody knew that. Oiling the joints. Except Norrie didn't think that was all of it, or even most of it. He had started doing his walks when Gramma started getting confused about stuff (no one came right out and said it was Alzheimer's, although everyone knew). Norrie thought he was walking off his sorrow. Was such a thing possible? She thought it was. She knew that when she was riding her skateboard, pulling off some sick double-kink at the skate park in Oxford, there was no room in her for anything but joy and fear, and joy ruled the house. Fear lived in the shack out back.

After a short while that felt long, the ex-phone company van rolled from behind the building with Grampa at the wheel. Norrie tucked her skateboard under her arm and jumped in. Her first ride in a stolen vehicle.

'Grampa, you are so gnarly,' she said, and kissed him.

7

Joe McClatchey was headed for the kitchen, wanting one of the remaining cans of apple juice in their dead refrigerator, when he heard his mother say *Bump* and stopped.

He knew that his parents had met in college, at the University of Maine, and that back then Sam McClatchey's friends had called him Bump, but Mom hardly ever called him that anymore, and when she did, she laughed and blushed, as if the nickname had some sort of dirty subtext. About that Joe didn't know. What he knew was that for her to slip like that – slip *back* like that – must mean she was upset.

He came a little closer to the kitchen door. It was chocked open and he could see his mother and Jackie Wettington, who was today dressed in a blouse and faded jeans instead of her uniform. They'd be able to see him, too, if they looked up. He had no intention of actually sneaking around; that wouldn't be cool, especially if his mom was upset, but for the time being they were only looking at each other. They were seated at the kitchen table. Jackie was holding Claire's hands. Joe saw that his mother's eyes were wet, and that made him feel like crying himself.

'You can't,' Jackie was saying. 'I know you want to, but you just can't. Not if things go like they're supposed to tonight.'

'Can I at least call him and tell him why I won't be there? Or e-mail him! I could do that!'

Jackie shook her head. Her face was kind but firm. 'He might talk, and the talk might get back to Rennie. If Rennie sniffs something in the wind before we break Barbie and Rusty out, we could have a total disaster on our hands.'

'If I tell him to keep it strictly to himself—'

'But Claire, don't you see? There's too much at stake. Two men's lives. Ours, too.' She paused. 'Your son's.'

Claire's shoulders sagged, then straightened again. 'You take Joe, then. I'll come after Visitors Day. Rennie won't suspect me; I don't know Dale Barbara from Adam, and I don't know Rusty, either, except to say hi to on the street. I go to Dr Hartwell over in Castle Rock.'

'But Joe knows *Barbie*,' Jackie said patiently. 'Joe was the one who set up the video feed when they shot the missiles. And Big Jim knows that. Don't you think he might take you into custody and sweat you until you told him where we went?'

'I wouldn't,' Claire said. 'I would *never* tell.'

Joe came into the kitchen. Claire wiped her cheeks and tried to smile. 'Oh, hi, honey. We were just talking about Visitors Day, and—'

'Mom, he might not just sweat you,' Joe said. 'He might *torture* you.'

She looked shocked. 'Oh, he wouldn't do *that*. I know he's not a nice man, but he's a town selectman, after all, and—'

'He *was* a town selectman,' Jackie said. 'Now he's auditioning for emperor. And sooner or later everybody talks. Do you want Joe to be somewhere imagining you having your fingernails pulled out?'

'Stop it!' Claire said. 'That's horrible!'

Jackie didn't let go of Claire's hands when Claire tried to pull them back. 'It's all or nothing, and it's too late to be nothing. This

thing is in motion, and we've got to move with it. If it was just Barbie escaping by himself with no help from us, Big Jim might actually let him go. Because every dictator needs a boogeyman. But it won't just be him, will it? And that means he'll try to find us, and wipe us out.'

'I wish I'd never gotten into this. I wish I'd never gone to that meeting, and never let Joe go.'

'But we've got to stop him!' Joe protested. 'Mr Rennie's trying to turn The Mill into a, you know, police state!'

'I can't stop anybody!' Claire nearly wailed. 'I'm a goddam *housewife!*'

'If it's any comfort,' Jackie said, 'you probably had a ticket for this trip as soon as the kids found that box.'

'It's *not* a comfort. It's *not.*'

'In some ways, we're even lucky,' Jackie went on. 'We haven't sucked too many innocent people into this with us, at least not yet.'

'Rennie and his police force will find us anyway,' Claire said. 'Don't you know that? There's only so much town *in* this town.'

Jackie smiled mirthlessly. 'By then there'll be more of us. With more guns. And Rennie will know it.'

'We have to take over the radio station as soon as we can,' Joe said. 'People need to hear the other side of the story. We have to broadcast the truth.'

Jackie's eyes lit up. 'That's a *hell* of a good idea, Joe.'

'Dear God,' Claire said. She put her hands over her face.

8

Ernie pulled the phone company van up to the Burpee's loading dock. *I'm a criminal now,* he thought, *and my twelve-year-old grand-daughter is my accomplice. Or is she thirteen now?* It didn't matter; he didn't think Peter Randolph would treat her as a juvenile if they were caught.

Rommie opened the rear door, saw it was them, and came out onto the loading dock with guns in both hands. 'Have any trouble?'

'Smooth as silk,' Ernie said, mounting the steps to the dock. 'There's nobody on the roads. Have you got more guns?'

'Yuh. A few. Inside, back of the door. You help too, Miss Norrie.'

Norrie picked up two rifles and handed them to her grampa, who stowed them in the back of the van. Rommie rolled a dolly out to the loading dock. On it were a dozen lead rolls. 'We don't need to unload dis right now,' he said. 'I'll just cut some pieces for

the windows. We'll do the windshield once we get out there. Leave a slit to see through – like an old Sherman tank – n drive dat way. Norrie, while Ernie and I do dis, see if you can push that other dolly out. If you can't, just leave it and we'll get it after.'

The other dolly was loaded with cartons of food, most of it canned stuff or pouches of concentrate meant for campers. One box was stuffed with envelopes of cut-rate powdered drink mix. The dolly was heavy, but once she got it moving, it rolled easily. Stopping it was another matter; if Rommie hadn't reached up and shoved from where he was standing at the back of the van, the dolly might have gone right off the dock.

Ernie had finished blocking the stolen van's small rear windows with pieces of lead roll held by generous applications of masking tape. Now he wiped his brow and said, 'This is risky as hell, Burpee – we're planning on a damn convoy out to the McCoy Orchard.'

Rommie shrugged, then began loading in cartons of supplies, lining the walls of the van and leaving the middle open for the passengers they hoped to have later. A tree of sweat was growing on the back of his shirt. 'We just gotta hope if we do it quick and quiet, the big meetin covers for us. Don't have much choice.'

'Will Julia and Mrs McClatchey get lead on their car windows?' Norrie asked.

'Yuh. This afternoon. I'll help em. And den they'll have to leave their cars behind the store. Can't go sportin round town with lead-lined car windows – people'd ask questions.'

'What about that Escalade of yours?' Ernie asked. 'That'd swallow the rest of these supplies without so much as a burp. Your wife could drive it out h—'

'Misha won't come,' Rommie said. 'Won't have nuthin t'do widdit, her. I asked, did all but get down on my knees n beg, but I might as well have been a gust of wind blowin round the house. I guess I already knew, because I didn't tell her no more than she knew already . . . which isn't much, but won't keep her out of trouble if Rennie comes down on her. But she won't see it, her.'

'Why won't she?' Norrie asked, eyes wide, aware that the question might be rude only after it was out and she saw her grampa frown.

'Because she's one stubborn honey. I told her she might get hurt. "Like to see em try," she said. That's my Misha. Well, hell. If I get a chance later on, I may sneak down and see if she change her mind. They say it's a woman's prerogative. Come on, let's put in a few more of those boxes. And don't cover up the guns, Ernie. We might need em.'

'I can't believe I got you into this, kiddo,' Ernie said.

'It's okay, Grampa. I'd rather be in than out.' And this much, at least, was true.

9

BONK. Silence.

 BONK. Silence.

 BONK. Silence.

 Ollie Dinsmore sat cross-legged four feet from the Dome with his old Boy Scout pack beside him. The pack was full of rocks he'd picked up in the dooryard – so full, in fact, that he'd staggered down here rather than walked, thinking that the canvas bottom would tear out of the pack and spill his ammo. But it hadn't, and here he was. He selected another rock – a nice smooth one, polished by some ancient glacier – and threw it overhand at the Dome, where it struck what appeared to be thin air and bounced back. He picked it up and threw it again.

 BONK. Silence.

 The Dome had one thing going for it, he thought. It might be the reason his brother and his mother were dead, but by the hairy old Jesus, one load of ammunition was enough to last all day.

 Rock boomerangs, he thought, and smiled. It was a real smile, but it made him look somehow terrible, because his face was far too thin. He hadn't been eating much, and he thought it would be a good long while before he felt like eating again. Hearing a shot and then finding your mother lying beside the kitchen table with her dress flipped up to show her underpants and half her head blown off . . . a thing like that did nothing for a fellow's appetite.

 BONK. Silence.

 The other side of the Dome was a hive of activity; a tent city had sprung up. Jeeps and trucks scooted to and fro, and hundreds of military guys went buzzing around while their superiors shouted orders and cussed them out, often in the same breath.

 In addition to the tents that had already been erected, three long new ones were being put up. The signs already planted in front of them read VISITORS' HOSPITALITY STATION 1, VISITORS' HOSPITALITY STATION 2, and FIRST AID STATION. Another tent, even longer, had a sign in front of it reading LIGHT REFRESH-MENTS. And shortly after Ollie sat down and began tossing his trove of rocks at the Dome, two flatbed trucks loaded with Port-A-Potties had arrived. Now ranks of cheery-looking blue shithouses stood over

there, well away from the area where relatives would stand to speak with loved ones they could look at but not touch.

The stuff that had come out of his mother's head had looked like moldy strawberry jam, and what Ollie couldn't understand was why she'd done it that way, and in that place. Why in the room where they ate most of their meals? Had she been so far gone that she hadn't realized she had another son, who might eat again (assuming he didn't starve to death first) but who would never forget the horror of what lay there on the floor?

Yep, he thought. *That far gone. Because Rory was always her favorite, her pet. She hardly knew I was around, unless I forgot to feed the cows or swab out the stalls when they were afield. Or if I brought home a D on my rank card. Because* he *never got nothing but As.*

He threw a rock.

BONK. Silence.

There were several Army guys putting up pairs of signs over there near the Dome. The ones facing in toward The Mill read

WARNING!
FOR YOUR OWN SAFETY!
KEEP 2 YARDS (6 FEET) FROM THE DOME!

Ollie guessed the signs pointing the other way said the same, and on the other side they might work, because on the other side there would be lots of guys to keep order. Over here, though, there were going to be maybe eight hundred townies and maybe two dozen cops, most of them new to the job. Keeping people back on this side would be like trying to protect a sand castle from the incoming tide.

Her underpants had been wet, and there had been a puddle between her splayed legs. She'd pissed herself either right before she pulled the trigger, or right after. Ollie thought probably after.

He threw a rock.

BONK. Silence.

There was one Army guy close by. He was pretty young. There wasn't any kind of insignia on his sleeves, so Ollie guessed he was probably a private. He looked about sixteen, but Ollie supposed he had to be older. He'd heard of kids lying about their age to get into the service, but he guessed that was before everybody had computers to keep track of such things.

The Army guy looked around, saw no one was paying him any attention, and spoke in a low voice. He had a southern accent. 'Kid? Would y'all stop doing that? It's drivin me bugshit.'

'Go someplace else, then,' Ollie said.

BONK. Silence.

'Caint. Orders.'

Ollie didn't reply. He threw another rock, instead.

BONK. Silence.

'Why y'all doin it?' the Army guy asked. He was now just fiddling with the pair of signs he was putting up so he could talk to Ollie.

'Because sooner or later, one of them won't bounce back. And when that happens, I'm going to get up and walk away and never see this farm again. Never milk another cow. What's the air like out there?'

'Good. Chilly, though. I'm from South Cah'lina. It ain't like this in South Cah'lina in October, I can tell you that.'

Where Ollie was, less than three yards from the southern boy, it was hot. Also stinky.

The Army guy pointed beyond Ollie. 'Why don't y'all quit on the rocks and do somethin about those cows?' He said it *cay-ows*. 'Herd em into the barn and milk em or rub soothin shit on their udders; somethin like at.'

'We don't need to herd them. They know where to go. Only now they don't need to be milked, and they don't need any Bag Balm, either. Their udders are dry.'

'Yeah?'

'Yeah. My dad says something's wrong with the grass. He says the grass is wrong because the air's wrong. It doesn't smell good in here, you know. It smells like crap.'

'Yeah?' The Army guy looked fascinated. He gave the tops of the back-to-back signs a tap or two with his hammer, although they already looked well seated.

'Yeah. My mother killed herself this morning.'

The Army guy had raised his hammer for another hit. Now he just dropped it to his side. 'Are you shittin me, kid?'

'No. She shot herself at the kitchen table. I found her.'

'Oh fuck, that's rough.' The Army guy approached the Dome.

'We took my brother to town when he died last Sunday, because he was still alive — a little — but my mom was dead as dead can be, so we buried her on the knoll. My dad and me. She liked it there. It was pretty there before everything got so *cruddy*.'

'Jesus, kid! You been through hell!'

'Still there,' Ollie said, and as if the words had turned a valve somewhere inside, he began to weep. He got up and went to the Dome. He and the young soldier faced each other, less than a foot

apart. The soldier raised his hand, wincing a little as the transient shock whipped through him and then out of him. He laid his hand on the Dome, fingers spread. Ollie lifted his own and pressed it against the Dome on his side. Their hands seemed to be touching, finger to finger and palm to palm, but they weren't. It was a futile gesture that would be repeated over and over the following day: hundreds of times, thousands.

'Kid—'

'*Private Ames!*' someone bawled. '*Get your sorry ass away from there!*'

Private Ames jumped like a kid who's been caught stealing jam. '*Get over here! Double time!*'

'Hang in there, kid,' Private Ames said, and ran off to get his scolding. Ollie imagined it had to be a scolding, since you couldn't very well demote a private. Surely they wouldn't put him in the stockade or whatever for talking to one of the animals in the zoo. *I didn't even get any peanuts*, Ollie thought.

For a moment he looked up at the cows that no longer gave milk – that hardly even cropped grass – and then he sat down by his pack. He searched for and found another nice round rock. He thought about the chipped polish on the nails of his dead mother's outstretched hand, the one with the still-smoking gun beside it. Then he threw the rock. It hit the Dome and bounced back.

BONK. Silence.

10

At four o'clock on that Thursday afternoon, while the overcast held over northern New England and the sun shone down on Chester's Mill like a bleary spotlight through the sock-shaped hole in the clouds, Ginny Tomlinson went to check on Junior. She asked if he needed something for headache. He said no, then changed his mind and asked for some Tylenol or Advil. When she came back, he walked across the room to get it. On his chart she wrote, *Limp is still present but seems improved*.

When Thurston Marshall poked his head in forty-five minutes later, the room was empty. He assumed Junior had gone down to the lounge, but when he checked there it was empty except for Emily Whitehouse, the heart attack patient. Emily was recovering nicely. Thurse asked her if she'd seen a young man with dark blond hair and a limp. She said no. Thurse went back to Junior's room and looked in the closet. It was empty. The young man with the probable brain

tumor had dressed and checked himself out without benefit of paperwork.

11

Junior walked home. His limp seemed to clear up entirely once his muscles were warm. In addition, the dark keyhole shape floating on the left side of his vision had shrunk to a ball the size of a marble. Maybe he hadn't gotten a full dose of thallium after all. Hard to tell. Either way, he had to keep his promise to God. If he took care of the Appleton kids, then God would take care of him.

As he left the hospital (by the back door), killing his father had been first on his to-do list. But by the time he actually got to the house – the house where his mother had died, the house where Lester Coggins and Brenda Perkins had died – he had changed his mind. If he killed his father now, the special town meeting would be canceled. Junior didn't want that, because the town meeting would provide good cover for his main errand. Most of the cops would be there, and that would make gaining access to the Coop easier. He only wished he had the poisoned dog tags. He'd enjoy stuffing them down *Baaarbie's* dying throat.

Big Jim wasn't at home, anyway. The only living thing in the house was the wolf he'd seen loping across the hospital parking lot in the small hours of the morning. It was halfway down the stairs, looking at him and growling deep in its chest. Its fur was ragged. Its eyes were yellow. Around its neck hung Dale Barbara's dog tags.

Junior closed his eyes and counted to ten. When he opened them, the wolf was gone.

'I'm the wolf now,' he whispered to the hot and empty house. 'I'm the werewolf, and I saw Lon Chaney dancing with the queen.'

He went upstairs, limping again but not noticing. His uniform was in the closet, and so was his gun – a Beretta 92 Taurus. The PD had a dozen of them, mostly paid for with federal Homeland Security money. He checked the Beretta's fifteen-round mag and saw it was full. He put the gun into its holster, cinched the belt around his shrinking waist, and left his room.

At the top of the stairs he paused, wondering where to go until the meeting was well under way and he could make his move. He didn't want to talk to anyone, didn't even want to be seen. Then it came to him: a good hiding place that was also close to the action. He descended the stairs carefully – the goddam limp was all the way back, plus the left side of his face was so numb it might have been

frozen – and lurched down the hall. He stopped briefly outside his father's study, wondering if he should open the safe and burn the money inside. He decided it wasn't worth the effort. He vaguely remembered a joke about bankers marooned on a desert island who'd gotten rich trading each other their clothes, and he uttered a brief yapping laugh even though he couldn't exactly recall the punchline and had never completely gotten the joke, anyway.

The sun had gone behind the clouds to the west of the Dome and the day had grown gloomy. Junior walked out of the house and disappeared into the murk.

12

At quarter past five, Alice and Aidan Appleton came in from the back yard of their borrowed house. Alice said, 'Caro? Will you take Aidan and I . . . Aidan and *me* . . . to the big meeting?'

Carolyn Sturges, who had been making PB&J sandwiches for supper on Coralee Dumagen's counter with Coralee Dumagen's bread (stale but edible), looked at the children with surprise. She had never heard of kids wanting to attend an adults' meeting before; would have said, if asked, that they'd probably run the other way to avoid such a boring event. She was tempted. Because if the kids went, *she* could go.

'Are you sure?' she asked, bending down. 'Both of you?'

Before these last few days, Carolyn would have said she had no interest in having children, that what she wanted was a career as a teacher and a writer. Maybe a novelist, although it seemed to her that writing novels was pretty risky; what if you spent all that time, wrote a thousand-pager, and it sucked? Poetry, though . . . going around the country (maybe on a motorcycle) . . . doing readings and teaching seminars, free as a bird . . . that would be cool. Maybe meeting a few interesting men, drinking wine and discussing Sylvia Plath in bed. Alice and Aidan had changed her mind. She had fallen in love with them. She wanted the Dome to break – of course she did – but giving these two back to their mom was going to hurt her heart. She sort of hoped it would hurt theirs a little too. Probably that was mean, but there it was.

'Ade? Is it what *you* want? Because grownup meetings can be awfully long and boring.'

'I want to go,' Aidan said. 'I want to see all the people.'

Then Carolyn understood. It wasn't the discussion of resources and how the town was going to use them as it went forward that

interested them; why would it be? Alice was nine and Aidan was five. But wanting to see everybody gathered together, like a great big extended family? That made sense.

'Can you be good? Not squirm and whisper too much?'

'Of course,' Alice said with dignity.

'And will you both pee yourselves dry before we go?'

'*Yes!*' This time the girl rolled her eyes to show what an annoying stupidnik Caro was being . . . and Caro sort of loved it.

'Then what I'll do is just pack these sandwiches to go,' Carolyn said. 'And we've got two cans of soda for kids who can be good and use straws. Assuming the kids in question have peed themselves dry before dumping any more liquid down their throats, that is.'

'I use straws like mad,' Aidan said. 'Any Woops?'

'He means Whoopie Pies,' Alice said.

'I know what he means, but there aren't any. I think there might be some graham crackers, though. The kind with cinnamon sugar on them.'

'Cinnamon graham crackers rock,' Aidan said. 'I love you, Caro.'

Carolyn smiled. She thought no poem she'd ever read had been so beautiful. Not even the Williams one about the cold plums.

13

Andrea Grinnell descended the stairs slowly but steadily while Julia stared in amazement. Andi had undergone a transformation. Makeup and a comb-out of the frizzy wreck that had been her hair had played a part, but that wasn't all of it. Looking at her, Julia realized how long it had been since she'd seen the town's Third Selectman looking like herself. This evening she was wearing a knockout red dress belted at the waist – it looked like Ann Taylor – and carrying a large fabric bag with a drawstring top.

Even Horace was gawking.

'How do I look?' Andi asked when she reached the bottom of the stairs. 'Like I could fly to the town meeting, if I had a broom?'

'You look great. Twenty years younger.'

'Thanks, hon, but I have a mirror upstairs.'

'If it didn't show you how much better you look, you better try one down here, where the light's better.'

Andi switched her bag to her other arm, as if it were heavy. 'Well. I guess I do. A little, anyway.'

'Are you sure you have strength enough for this?'

'I think so, but if I start to shake and shiver, I'll slip out the side

door.' Andi had no intention of slipping away, whether she shook or not.

'What's in the bag?'

Jim Rennie's lunch, Andrea thought. *Which I intend to feed him in front of this whole town.*

'I always take my knitting to town meeting. Sometimes they're just so slow and dull.'

'I don't think this one will be dull,' Julia said.

'You're coming, aren't you?'

'Oh, I imagine,' Julia said vaguely. She expected to be well away from downtown Chester's Mill before the meeting ended. 'I have a few things to do first. Can you get there on your own?'

Andi gave her a comical *Mother, please* look. 'Down the street, down the hill, and it's right there. Been doing it for years.'

Julia looked at her watch. It was quarter to six. 'Aren't you leaving awfully early?'

'Al will open the doors at six o'clock, if I'm not mistaken, and I want to be sure and get a good seat.'

'As a selectwoman, you should be right up there onstage,' Julia said. 'If it's what you want.'

'No, I don't think so.' Andi switched the bag to her other arm again. Her knitting *was* inside; so was the VADER file and the .38 her brother Twitch had given her for home protection. She thought it would serve just as well for town protection. A town *was* like a body, but it had one advantage over the human one; if a town had a bad brain, a transplant could be effected. And maybe it wouldn't come to killing. She prayed it wouldn't.

Julia was looking at her quizzically. Andrea realized she'd drifted off.

'I think I'll just sit with the common folk tonight. But I'll have my say when the time comes. You can count on that.'

14

Andi was right about Al Timmons opening the doors at six. By then Main Street, next to empty all day, was filling with citizens headed for the Town Hall. More walked in little groups down Town Common Hill from the residential streets. Cars began to arrive from Eastchester and Northchester, most filled to capacity. No one, it seemed, wanted to be alone tonight.

She was early enough to have her pick of seats, and chose the third row from the stage, on the aisle. Just ahead of her in the second

row were Carolyn Sturges and the Appleton children. The kids were gawking wide-eyed at everything and everyone. The little boy had what appeared to be a graham cracker clutched in his fist.

Linda Everett was another early arriver. Julia had told Andi about Rusty being arrested – utterly ridiculous – and knew his wife must be devastated, but she was hiding it well behind great makeup and a pretty dress with big patch pockets. Given her own situation (mouth dry, head aching, stomach roiling), Andi admired her courage.

'Come sit with me, Linda,' she said, patting the spot beside her. 'How is Rusty?'

'I don't know,' Linda said, slipping past Andrea and sitting down. Something in one of those amusing pockets clunked on the wood. 'They won't let me see him.'

'That situation will be rectified,' Andrea said.

'Yes,' Linda said grimly. 'It will.' Then she leaned forward. 'Hello, kids, what are your names?'

'This is Aidan,' Caro said, 'and this is—'

'I'm Alice.' The little girl held out a regal hand – queen to loyal subject. 'Me and Aidan . . . Aidan and *I* . . . are Dorphans. That means Dome orphans. Thurston made it up. He knows magic tricks, like pulling a quarter out of your ear and stuff.'

'Well, you seem to have landed on your feet,' Linda said, smiling. She didn't feel like smiling; she had never been so nervous in her life. Only *nervous* was too mild a word. She was scared shitless.

15

By six thirty, the parking lot behind the Town Hall was full. After that the spaces on Main Street went, and those on West Street and East Street. By quarter of seven, even the post office and FD parking lots were loaded, and almost every seat in the Town Hall was taken.

Big Jim had foreseen the possibility of an overflow, and Al Timmons, assisted by some of the newer cops, had put benches from the American Legion Hall on the lawn. SUPPORT OUR TROOPS was printed on some; PLAY MORE BINGO! on others. Large Yamaha speakers had been placed on either side of the front door.

Most of the town's police force – and all of the veteran cops, save one – were present to keep order. When latecomers grumbled about having to sit outside (or stand, when even the benches had filled up), Chief Randolph told them they should have come earlier: if you snooze, you lose. Also, he added, it was a pleasant night, nice and warm, and later there was apt to be another big pink moon.

'Pleasant if you don't mind the smell,' Joe Boxer said. The dentist had been in an unrelievedly crappy mood ever since the confrontation at the hospital over his liberated waffles. 'I hope we can hear all right through those things.' He pointed at the speakers.

'You'll hear fine,' Chief Randolph said. 'We got them from Dipper's. Tommy Anderson says they're state-of-the-art, and he set them up himself. Think of it as a drive-in movie without the picture.'

'I think of it as a pain in my ass,' Joe Boxer said, then crossed his legs and plucked fussily at the crease on his pants.

Junior watched them come from his hiding place inside the Peace Bridge, peeking through a crack in the wall. He was amazed to see so much of the town in the same place at the same time, and gratified by the speakers. He would be able to hear everything from where he was. And once his father got really cranked up, he would make his move.

God help anyone who gets in my way, he thought.

His father's slope-bellied bulk was impossible to miss even in the growing gloom. Also, the Town Hall was fully powered this evening, and light from one of the windows drew an oblong down to where Big Jim stood on the edge of the jammed parking lot. Carter Thibodeau was at his side.

Big Jim had no sense of being watched – or rather, he had a sense of being watched by *everybody*, which comes to the same. He checked his watch and saw it had just gone seven. His political sense, honed over many years, told him that an important meeting should always begin ten minutes late; no more and no less. Which meant this was the time to start down the taxiway. He was holding a folder with his speech inside it, but once he got going, he wouldn't need it. He knew what he was going to say. It seemed to him that he had given the speech in his sleep last night, not once but several times, and each time it had been better.

He nudged Carter. 'Time to put this show on the road.'

'Okay.' Carter ran over to where Randolph was standing on the Town Hall steps (*probably thinks he looks like Julius-Cotton-Picking-Caesar,* Big Jim thought) and brought the Chief back.

'We go in the side door,' Big Jim said. He consulted his watch. 'Five – no, four – minutes from now. You'll lead, Peter, I'll go second, Carter, you come behind me. We'll go straight to the stage, all right? Walk *confidently* – no goshdarn slouching. There'll be applause. Stand at attention until it starts to taper off. Then sit. Peter, you'll be on my left. Carter, on my right. I'll step forward to the podium. Prayer first, then everybody stands to sing the National Anthem. After that,

I'll speak and run the agenda just as fast as poop through a goose. They'll vote yea on everything. Got it?'

'I'm nervous as a witch,' Randolph confessed.

'Don't be. This is going to be fine.'

He was certainly wrong about that.

16

While Big Jim and his entourage were walking toward the side door of the Town Hall, Rose was turning the restaurant van into the McClatchey driveway. Following her was a plain Chevrolet sedan driven by Joanie Calvert.

Claire came out of the house, holding a suitcase in one hand and a canvas carry-bag filled with groceries in the other. Joe and Benny Drake also had suitcases, although most of the clothes in Benny's had come from Joe's dresser drawers. Benny was carrying another, smaller, canvas sack loaded with loot from the McClatchey pantry.

From down the hill came the amplified sound of applause.

'Hurry up,' Rose said. 'They're starting. Time for us to get out of Dodge.' Lissa Jamieson was with her. She slid open the van's door and began handing stuff inside.

'Is there lead roll to cover the windows?' Joe asked Rose.

'Yes, and extra pieces for Joanie's car as well. We'll drive as far as you say it's safe, then block the windows. Give me that suitcase.'

'This is insane, you know,' Joanie Calvert said. She walked a fairly straight line between her car and the Sweetbriar van, which led Rose to believe she'd had no more than a single drink or two to fortify herself. That was a good thing.

'You're probably right,' Rose said. 'Are you ready?'

Joanie sighed and put her arm around her daughter's slim shoulders. 'For what? Going to hell in a handbasket? Why not? How long will we have to stay up there?'

'I don't know,' Rose said.

Joanie gave another sigh. 'Well, at least it's warm.'

Joe asked Norrie, 'Where's your gramps?'

'With Jackie and Mr Burpee, in the van we stole from Rennie's. He'll wait outside while they go in to get Rusty and Mr Barbara.' She gave him a scared-to-death smile. 'He's going to be their wheelman.'

'No fool like an old fool,' Joanie Calvert remarked. Rose felt like hauling off and hitting her, and a glance at Lissa told her that Lissa felt the same. But this was no time for argument, let alone fisticuffs.

Hang together or hang separately, Rose thought.

'What about Julia?' Claire asked.

'She's coming with Piper. And her dog.'

From downtown, amplified (and with the bench-sitters outside adding their own voices), came the United Choir of Chester's Mill, singing 'The Star Spangled Banner.'

'Let's go,' Rose said. 'I'll lead the way.'

Joanie Calvert repeated, with a kind of dolorous good cheer: 'At least it's warm. Come on, Norrie, copilot your old mom.'

<div align="center">

17

</div>

There was a delivery lane on the south side of LeClerc's Maison des Fleurs, and here the stolen phone company van was parked, nose out. Ernie, Jackie, and Rommie Burpee sat listening to the National Anthem coming from up the street. Jackie felt a sting behind her eyes and saw that she wasn't the only one who was moved; Ernie, sitting behind the wheel, had produced a handkerchief from his back pocket and was dabbing at his eyes with it.

'Guess we won't need Linda to give us a heads-up,' Rommie said. 'I didn't expect them speakers. They didn't get em from me.'

'It's still good for people to see her there,' Jackie said. 'Got your mask, Rommie?'

He held up Dick Cheney's visage, stamped in plastic. In spite of his extensive stock, Rommie hadn't been able to provide Jackie with an Ariel mask; she had settled for Harry Potter's chum, Hermione. Ernie's Darth Vader mask was behind the seat, but Jackie thought they'd probably be in trouble if he actually had to put it on. She had not said this aloud.

And really, what does it matter? When we're suddenly not around town anymore, everybody's going to have a good idea why we're gone.

But suspecting wasn't the same as knowing, and if suspicion was the best Rennie and Randolph could do, the friends and relatives they were leaving behind might be subjected to no more than harsh questioning.

Might. Under circumstances like these, Jackie realized, that was a mighty big word.

The anthem ended. There was more applause, and then the town's Second Selectman began to speak. Jackie checked the pistol she was carrying – it was her extra – and thought that the next few minutes were probably going to be the longest of her life.

18

Barbie and Rusty stood at the doors of their respective cells, listening as Big Jim launched into his speech. Thanks to the speakers outside the main doors of the Town Hall, they could hear pretty well.

'*Thank you! Thank you, one and all! Thank you for coming! And thank you for being the bravest, toughest, can-do-ingest people in these United States of America!*'

Enthusiastic applause.

'*Ladies and gentlemen . . . and kiddies, too, I see a few of those in the audience . . .*'

Good-natured laughter.

'*We are in a terrible predicament here. This you know. Tonight I intend to tell you how we got into it. I don't know everything, but I will share what I know, because you deserve that. When I've finished putting you in the picture, we have a brief but important agenda to go through. But first and foremost, I want to tell you how PROUD I am of you, how HUMBLED I am to be the man God – and you – have chosen to be your leader at this critical juncture, and I want to ASSURE you that together we will come through this trial, together and with God's help we will emerge STRONGER and TRUER and BETTER than we ever were before! We may be Israelites in the desert now—*'

Barbie rolled his eyes and Rusty made a jacking-off gesture with his fist.

'*—but soon we will reach CANAAN and the feast of milk and honey which the Lord and our fellow Americans will surely set before us!*'

Wild applause. It sounded like a standing O. Fairly certain that even if there *was* a bug down here, the three or four cops upstairs would now be clustered in the PD doorway, listening to Big Jim, Barbie said: 'Be ready, my friend.'

'I am,' Rusty said. 'Believe me, I am.'

Just as long as Linda's not one of them planning to bust in, he thought. He didn't want her killing anyone, but more than that, he didn't want her to risk being killed. Not for him. *Let her stay right where she is. He may be crazy, but at least if she's with the rest of the town, she's safe.*

That was what he thought before the gunfire started.

19

Big Jim was exultant. He had them exactly where he wanted them: in the palm of his hand. Hundreds of people, those who had voted

for him and those who hadn't. He had never seen so many in this hall, not even when school prayer or the school budget was under discussion. They sat thigh to thigh and shoulder to shoulder, outside as well as in, and they were doing more than listening to him. With Sanders AWOL and Grinnell sitting in the audience (that red dress in the third row was hard to miss), he *owned* this crowd. Their eyes begged him to take care of them. To save them. What completed his exultancy was having his bodyguard beside him and seeing the lines of cops – *his* cops – ranged along both sides of the hall. Not all of them were kitted out in uniforms yet, but all were armed. At least a hundred more in the audience were wearing blue armbands. It was like having his own private army.

'My fellow townspeople, most of you know that we have arrested a man named Dale Barbara—'

A storm of boos and hisses arose. Big Jim waited for it to subside, outwardly grave, inwardly grinning.

'—for the murders of Brenda Perkins, Lester Coggins, and two lovely girls we all knew and loved: Angie McCain and Dodee Sanders.'

More boos, interspersed with cries of 'Hang him!' and 'Terrorist!' The terrorist-shouter sounded like Velma Winter, the day manager at Brownie's Store.

'What you do not know,' Big Jim continued, 'is that the Dome is the result of a conspiracy perpetrated by an elite group of rogue scientists and covertly funded by a government splinter group. *We are guinea pigs in an experiment, my fellow townspeople, and Dale Barbara was the man designated to chart and guide that experiment's course from the inside!*'

Stunned silence greeted this. Then there was a roar of outrage.

When it had quieted, Big Jim continued, hands planted on either side of the podium, his large face shining with sincerity (and, perhaps, hypertension). His speech lay in front of him, but it was still folded. There was no need to look at it. God was using his vocal cords and moving his tongue.

'When I speak of covert funding, you may wonder what I mean. The answer is horrifying but simple. Dale Barbara, aided by an as yet unknown number of townspeople, set up a drug-manufacturing facility which has been supplying huge quantities of crystal methamphetamine to drug lords, some with CIA connections, all up and down the Eastern Seaboard. And although he hasn't given us the names of all his co-conspirators yet, one of them – it breaks my heart to tell you this – appears to be Andy Sanders.'

Hubbub and cries of wonder from the audience. Big Jim saw Andi Grinnell start to rise from her seat, then settle back. *That's right,*

he thought, *just sit there. If you're reckless enough to question me, I'll eat you alive. Or point my finger at you and accuse you. Then* they'll *eat you alive.*

And in truth, he felt as if he could do that.

'Barbara's boss – his control – is a man you have all seen on the news. He claims to be a colonel in the U.S. Army, but in fact he is high in the councils of the scientists and government officials responsible for this Satanic experiment. I have Barbara's confession to this much right here.' He tapped his sportcoat, whose inner pocket contained his wallet and a digest-sized New Testament with the words of Christ printed in red.

Meanwhile, more cries of 'Hang him!' had arisen. Big Jim lifted one hand, head lowered, face grave, and the cries eventually stilled.

'We will vote on Barbara's punishment as a town – one unified body dedicated to the cause of freedom. It's in your hands, ladies and gentlemen. If you vote to execute, he will be executed. But there will be no hanging while I am your leader. He will be executed by police firing squad—'

Wild applause interrupted him, and most of the assembly rose to its feet. Big Jim leaned into the microphone.

'—but only after we get *every bit of information which is still hidden in his MISERABLE TRAITOR'S HEART!'*

Now almost all of them were up. Not Andi, though; she sat in the third row next to the center aisle, looking up at him with eyes that should have been soft and hazy and confused but were not. *Look at me all you want,* he thought. *Just as long as you sit there like a good little girl.*

Meanwhile, he basked in the applause.

20

'Now?' Rommie asked. 'What you t'ink, Jackie?'

'Wait a little longer,' she said.

It was instinct, nothing else, and usually her instincts were dependable.

Later she would wonder how many lives might have been saved if she had told Rommie *okay, let's roll.*

21

Looking through his crack in the sidewall of the Peace Bridge, Junior saw that even the people on the benches outside had risen to their feet, and the same instinct that told Jackie to stay a little longer told

him it was time to move. He limped from beneath the bridge on the Town Common side and cut across to the sidewalk. When the creature who had sired him resumed speaking, he started toward the Police Department. The dark spot on the left side of his field of vision had expanded again, but his mind was clear.

I'm coming, Baaarbie. I'm coming for you right now.

22

'These people are masters of disinformation,' Big Jim continued, 'and when you go out to the Dome to visit with your loved ones, the campaign against me will kick into high gear. Cox and his surrogates will stop at nothing to blacken me. They'll call me a liar and a thief, they may even say I ran their drug operation myself—'

'*You did,*' a clear, carrying voice said.

It was Andrea Grinnell. Every eye fixed upon her as she rose, a human exclamation point in her bright red dress. She looked at Big Jim for a moment with an expression of cool contempt, then turned to face the people who had elected her Third Selectwoman when old Billy Cale, Jack Cale's father, had died of a stroke four years ago.

'You people need to put your fears aside for a moment,' she said. 'When you do, you'll see that the story he's telling is ludicrous. Jim Rennie thinks you can be stampeded like cattle in a thunderstorm. I've lived with you all my life, and I think he's wrong.'

Big Jim waited for cries of protest. There were none. Not that the townspeople necessarily believed her; they were just stunned by this sudden turn of events. Alice and Aidan Appleton had turned all the way around and were kneeling on their benches, goggling at the lady in red. Caro was equally stunned.

'A secret experiment? What bullshit! Our government has gotten up to some pretty lousy stuff over the last fifty years or so, and I'd be the first to admit it, but holding a whole town prisoner with some sort of force field? Just to see what we'll do? It's idiotic. Only terrified people would believe it. Rennie knows that, so he's been orchestrating the terror.'

Big Jim had been momentarily knocked off his stride, but now he found his voice again. And, of course, he had the microphone. 'Ladies and gentlemen, Andrea Grinnell is a fine woman, but she's not herself tonight. She's as shocked as the rest of us, of course, but in addition, I'm sorry to say that she herself has a serious drug-dependency problem, as a result of a fall and her consequent use of an extremely addictive drug called—'

'I haven't had anything stronger than aspirin for days now,' Andrea said in a clear, carrying voice. 'And I have come into possession of papers which show—'

'Melvin Searles?' Big Jim boomed. 'Will you and several of your fellow officers gently but firmly remove Selectwoman Grinnell from the room and escort her home? Or perhaps to the hospital for observation. She's not herself.'

There were some approving murmurs, but not the clamor of approbation he'd expected. And Mel Searles had taken only a single step forward when Henry Morrison swept a hand into Mel's chest and sent him back against the wall with an audible thump.

'Let's let her finish,' Henry said. 'She's a town official too, so let her finish.'

Mel looked up at Big Jim, but Big Jim was watching Andi, almost hypnotized, as she drew a brown manila envelope from her big bag. He knew what it was the instant he saw it. *Brenda Perkins*, he thought. *Oh, what a bitch. Even dead, her bitchery continues.*

As Andi held the envelope up, it began to waver back and forth. The shakes were coming back, the fucking shakes. They couldn't have picked a worse time, but she wasn't surprised; in fact, she might have expected it. It was the stress.

'The papers in this envelope came to me from Brenda Perkins,' she said, and at least her voice was steady. 'They were compiled by her husband and the State Attorney General. Duke Perkins was investigating James Rennie for a laundry list of high crimes and misdemeanors.'

Mel looked at his friend Carter for guidance. And Carter was looking back, his gaze bright and sharp and almost amused. He pointed at Andrea, then held the side of his hand against his throat: *Shut her up.* This time when Mel started forward, Henry Morrison didn't stop him – like almost everyone else in the room, Henry was gaping at Andrea Grinnell.

Marty Arsenault and Freddy Denton joined Mel as he hurried along the front of the stage, bent over like a man running in front of a movie screen. From the other side of the Town Hall, Todd Wendlestat and Lauren Conree were also in motion. Wendlestat's hand was on a sawed-off piece of hickory cane he was carrying as a nightstick; Conree's was on the butt of her gun.

Andi saw them coming, but didn't stop. 'The proof is in this envelope, and I believe it's proof—' . . . *that Brenda Perkins died for*, she intended to finish, but at that moment her shaking, sweat-slicked left hand lost her grip on the drawstring top of her bag. It fell into

the aisle, and the barrel of her home protection .38 slid from the bag's puckered mouth like a periscope.

Clearly, heard by everyone in the now silent hall, Aidan Appleton said: 'Wow! That lady has a gun!'

Another instant of thunderstruck silence followed. Then Carter Thibodeau leaped from his seat and ran in front of his boss, screaming *'Gun! Gun! GUN!'*

Aidan slipped into the aisle to investigate more closely. *'No, Ade!'* Caro shouted, and bent over to grab him just as Mel fired the first shot.

It put a hole in the polished wood floor right in front of Carolyn Sturges's nose. Splinters flew up. One struck her just below the right eye and blood began to pour down her face. She was vaguely aware that everyone was screaming now. She knelt in the aisle, grabbed Aidan by the shoulders, and hiked him between her thighs like a football. He flew back into the row where they'd been sitting, surprised but unhurt.

'GUN! SHE'S GOT A GUN!' Freddy Denton shouted, and swept Mel out of his way. Later he would swear that the young woman was reaching for it, and that he had only meant to wound her, anyway.

23

Thanks to the speakers, the three people in the stolen van heard the change in the festivities at the town hall. Big Jim's speech and the accompanying applause were interrupted by some woman who was talking loudly but standing too far from the mike for them to make out the words. Her voice was drowned in a general uproar punctuated by screams. Then there was a gunshot.

'What the *hell*?' Rommie said.

More gunshots. Two, perhaps three. And screams.

'Doesn't matter,' Jackie said. 'Drive, Ernie, and fast. If we're going to do this, we have to do it now.'

24

'No!' Linda cried, leaping to her feet. *'No shooting! There are children! THERE ARE CHILDREN!'*

The Town Hall erupted in pandemonium. Maybe for a moment or two they hadn't been cattle, but now they were. The stampede for the front doors was on. The first few got out, then the crowd jammed

up. A few souls who had retained a scrap of common sense beat feet down the side and center aisles toward the exit doors which flanked the stage, but they were a minority.

Linda reached for Carolyn Sturges, meaning to pull her back to the relative safety of the benches, when Toby Manning, sprinting down the center aisle, ran into her. His knee connected with the back of Linda's head and she fell forward, dazed.

'*Caro!*' Alice Appleton was screaming from somewhere far away. '*Caro, get up! Caro, get up! Caro, get up!*'

Carolyn started getting to her feet and that was when Freddy Denton shot her squarely between the eyes, killing her instantly. The children began to shriek. Their faces were freckled with her blood.

Linda was vaguely aware of being kicked and stepped on. She got to her hands and knees (standing was currently out of the question) and crawled into the aisle opposite the one she'd been sitting in. Her hand squelched in more of Carolyn's blood.

Alice and Aidan were trying to get to Caro. Knowing they might be seriously hurt if they made it into the aisle (and not wanting them to see what had become of the woman she assumed was their mother), Andi reached over the bench just ahead of her to grab them. She had dropped the VADER envelope.

Carter Thibodeau had been waiting for this. He was still standing in front of Rennie, shielding him with his body, but he had drawn his gun and laid it over his forearm. Now he squeezed the trigger, and the troublesome woman in the red dress – the one who had caused this ruckus – went flying backward.

The Town Hall was in chaos, but Carter ignored it. He descended the stairs and walked steadily to where the woman in the red dress had fallen. When people came running down the center aisle, he threw them out of his way, first left and then right. The little girl, crying, tried to cling to his leg and Carter kicked her aside without looking at her.

He didn't see the envelope at first. Then he did. It was lying beside one of the Grinnell woman's outstretched hands. A large foot-track printed in blood had been stamped across the word VADER. Still calm in the chaos, Carter glanced around and saw that Rennie was staring at the shambles of his audience, his face shocked and unbelieving. Good.

Carter yanked out the tails of his shirt. A screaming woman – it was Carla Venziano – ran into him, and he hurled her aside. Then he jammed the VADER envelope into his belt at the small of his back and bloused the tails of his shirt out over it.

A little insurance was always a good thing.

He backed toward the stage, not wanting to be blindsided. When he reached the stairs, he turned and trotted up them. Randolph, the town's fearless Chief, was still in his seat with his hands planted on his meaty thighs. He could have been a statue except for the single vein pulsing in the center of his forehead.

Carter took Big Jim by the arm. 'Come on, boss.'

Big Jim looked at him as if he did not quite know where or even who he was. Then his eyes cleared a little. 'Grinnell?'

Carter pointed to the body of the woman sprawled in the center aisle, the growing puddle around her head matching her dress.

'Okay, good,' Big Jim said. 'Let's get out of here. Downstairs. You too, Peter. Get up.' And when Randolph continued to sit and stare at the maddened crowd, Big Jim kicked him in the shin. '*Move.*'

In the pandemonium, no one heard the shots from next door.

25

Barbie and Rusty stared at each other.

'What the *hell* is going on over there?' Rusty asked.

'I don't know,' Barbie said, 'but it doesn't sound good.'

There were more gunshots from the Town Hall, then one that was much closer: from upstairs. Barbie hoped it was their guys . . . and then he heard someone yell, '*No, Junior! What are you, crazy? Wardlaw, back me up!*' More gunshots followed. Four, maybe five.

'Ah, Jesus,' Rusty said. 'We're in trouble.'

'I know,' Barbie said.

26

Junior paused on the PD steps, looking over his shoulder toward the newly hatched uproar at the Town Hall. The people on the benches outside were now standing and craning their necks, but there was nothing to see. Not for them, and not for him. Perhaps someone had assassinated his father – he could hope; it would save him the trouble – but in the meantime, his business was inside the PD. In the Coop, to be specific.

Junior pushed through the door with WORKING TOGETHER: YOUR HOMETOWN POLICE DEPARTMENT AND YOU printed on it. Stacey Moggin came hurrying toward him. Rupe Libby was behind her. In the ready-room, standing in front of the grumpy

sign reading COFFEE AND DONUTS ARE *NOT* FREE, was Mickey Wardlaw. Hulk or not, he looked very frightened and unsure of himself.

'You can't come in here, Junior,' Stacey said.

'Sure, I can.' *Sure* came out *surrr*. It was the numbness at the side of his mouth. Thallium poisoning! Barbie! 'I'm on the force.' *Um onna forsh*.

'You're drunk, is what you are. What's going on over there?' But then, perhaps deciding he was incapable of any coherent reply, the bitch gave him a push in the center of his chest. It made him stagger on his bad leg and almost fall. 'Go away, Junior.' She looked back over her shoulder and spoke her last words on Earth. 'You stay where you are, Wardlaw. No one goes downstairs.'

When she turned back, meaning to bulldoze Junior out of the station ahead of her, she found herself looking into the muzzle of a police-issue Beretta. There was time for one more thought – *Oh no, he wouldn't* – and then a painless boxing glove hit her between the breasts and drove her backward. She saw Rupe Libby's amazed face upside down as her head tilted back. Then she was gone.

'*No, Junior! What are you, crazy?*' Rupe shouted, clawing for his gun. '*Wardlaw, back me up!*'

But Mickey Wardlaw only stood gaping as Junior pumped five bullets into Piper Libby's cousin. His left hand was numb, but his right was still okay; he didn't even need to be a particularly good shot, with a stationary target just seven feet away. The first two rounds went into Rupe's belly, driving him against Stacey Moggin's desk and knocking it over. Rupe doubled up, holding himself. Junior's third shot went wild, but the next two went into the top of Rupe's head. He went down in a grotesquely balletic posture, his legs splaying out to either side and his head – what remained of it – coming to rest on the floor, as if in a final deep bow.

Junior limped into the ready room with the smoking Beretta held out in front of him. He couldn't remember exactly how many shots he had fired; he thought seven. Maybe eight. Or eleventy-nine – who could know for sure? His headache was back.

Mickey Wardlaw raised his hand. There was a frightened, placatory smile on his large face. 'No trouble from me, bro,' he said. 'You do what you got to do.' And made the peace sign.

'I will,' Junior said. '*Bro*.'

He shot Mickey. The big boy went down, peace sign now framing the hole in his head that had lately held an eye. The remaining eye rolled up to look at Junior with the dumb humility of a sheep in

the shearing pen. Junior shot him again, just to be sure. Then he looked around. He had the place to himself, it appeared.

'Okay,' he said. 'Oh . . . *kay.*'

He started toward the stairs, then went back to Stacey Moggin's body. He verified the fact that she was carrying a Beretta Taurus like his, and ejected the mag from his own gun. He replaced it with a full one from her belt.

Junior turned, staggered, went to one knee, and got up again. The black spot on the left side of his vision now seemed as big as a manhole cover, and he had an idea that meant his left eye was pretty much fucked. Well, that was all right; if he needed more than one eye to shoot a man locked in a cell, he wasn't worth a hoot in a henhouse, anyway. He walked across the ready room, slipped in the late Mickey Wardlaw's blood, and almost fell again. But he caught himself in time. His head was thumping, but he welcomed it. *It's keeping me sharp*, he thought.

'Hello, *Baaarbie,*' he called down the stairs. 'I know what you did to me and I'm coming for you. If you've got a prayer to say, better make it a quick one.'

27

Rusty watched the limping legs descend the metal stairs. He could smell gunsmoke, he could smell blood, and he understood perfectly well that his time of dying had come round. The limping man was here for Barbie, but he would almost certainly not neglect a certain caged physician's assistant on his way by. He was never going to see Linda or the Js again.

Junior's chest came into view, then his neck, then his head. Rusty took one look at the mouth, which was dragged down on the left in a frozen leer, and at the left eye, which was weeping blood, and thought: *Very far gone. A wonder he's still on his feet and a pity he didn't wait just a little longer. A little longer and he wouldn't have been capable of crossing the street.*

Faintly, in another world, he heard a bullhorn-amplified voice from the Town Hall: 'DO NOT RUN! DO NOT PANIC! THE DANGER IS OVER! THIS IS OFFICER HENRY MORRISON, AND I REPEAT: THE DANGER IS OVER!'

Junior slipped, but by then he was on the last stair. Instead of falling and breaking his neck, he only went to one knee. He rested that way for a few moments, looking like a prizefighter waiting for the mandatory eight-count to rise and resume the bout. To Rusty

everything seemed clear, near, and very dear. The precious world, suddenly grown thin and insubstantial, was now only a single gauze wrapping between him and whatever came next. If anything.

Go all the way down, he thought at Junior. *Fall on your face. Pass out, you motherfucker.*

But Junior laboriously rose to his feet, gazed at the gun in his hand as if he had never seen such a thing before, then looked down the corridor to the cell at the end, where Barbie stood with his hands wrapped around the bars, looking back.

'*Baaarbie*,' Junior said in a crooning whisper, and started forward. Rusty stepped backward, thinking that perhaps Junior would miss him on his way by. And perhaps kill himself after finishing with Barbie. He knew these were craven thoughts, but he also knew they were practical thoughts. He could do nothing for Barbie, but he might be able to survive himself.

And it could have worked, had he been in one of the cells on the left side of the corridor, because that was Junior's blind side. But he had been put in one on the right, and Junior saw him move. He stopped and peered in at Rusty, his half-frozen face simultaneously bewildered and sly.

'Fusty,' he said. 'Is that your name? Or is it Berrick? I can't remember.'

Rusty wanted to beg for his life, but his tongue was pasted to the roof of his mouth. And what good would begging do? The young man was already raising the gun. Junior was going to kill him. No power on earth would stop him.

Rusty's mind, in its last extremity, sought an escape many other minds had found in their last moments of consciousness – before the switch was pulled, before the trap opened, before the pistol pressed against the temple spat fire. *This is a dream*, he thought. *All of it. The Dome, the craziness in Dinsmore's field, the food riot; this young man, too. When he pulls the trigger the dream will end and I'll wake up in my own bed, on a cool and crisp fall morning. I'll turn to Linda and say, 'What a nightmare I had, you won't believe it.'*

'Close your eyes, Fusty,' Junior said. 'It'll be better that way.'

28

Jackie Wettington's first thought upon entering the PD lobby was *Oh my dear God, there's blood everywhere.*

Stacey Moggin lay against the wall below the community outreach bulletin board with her cloud of blond hair spread around

her and her empty eyes staring up at the ceiling. Another cop – she couldn't make out which one – was sprawled on his face in front of the overturned reception desk, his legs spread out to either side in an impossibly deep split. Beyond him, in the ready room, a third cop lay dead on his side. That one had to be Wardlaw, one of the new kids on the block. He was too big to be anyone else. The sign over the coffee-station table was spattered with the kid's blood and brains. It now read C FEE AND DO ARE OT FREE.

There was a faint clacking sound from behind her. She whirled, unaware that she had raised her gun until she saw Rommie Burpee in the front sight. Rommie didn't even notice her; he was staring at the bodies of the three dead cops. The clack had been his Dick Cheney mask. He had taken it off and dropped it on the floor.

'Christ, what happened here?' he asked. 'Is this—'

Before he could finish, a shout came from downstairs in the Coop: '*Hey, fuckface! I got you, didn't I? I got you good!*'

And then, incredibly, laughter. It was high-pitched and maniacal. For a moment Jackie and Rommie could only stare at each other, unable to move.

Then Rommie said, 'I t'ink dat's Barbara.'

29

Ernie Calvert sat behind the wheel of the phone company van, which was idling at a curb stenciled POLICE BUSINESS 10 MINS ONLY. He had locked all the doors, afraid of being carjacked by one or more of the panic-stricken people fleeing down Main Street from the Town Hall. He was holding the rifle Rommie had stowed behind the driver's seat, although he wasn't sure he could shoot anybody who tried to break in; he knew these people, had for years sold them their groceries. Terror had rendered their faces strange but not unrecognizable.

He saw Henry Morrison coursing back and forth on the Town Hall lawn, looking like a hunting dog searching for scent. He was shouting into his bullhorn and trying to bring a little order out of the chaos. Someone knocked him over and Henry got right back up, God bless him.

And now here were others: Georgie Frederick, Marty Arsenault, the Searles kid (recognizable by the bandage he was still wearing on his head), both Bowie brothers, Roger Killian, and a couple of the other newbies. Freddy Denton was marching down the Hall's broad front steps with his gun drawn. Ernie didn't see Randolph, although anyone who didn't know better would have expected the Chief of

Police to be in charge of the pacification detail, which was itself teetering on the edge of chaos.

Ernie *did* know better. Peter Randolph had always been an ineffectual bluster-bug, and his absence at this particular Snafu Circus did not surprise Ernie in the least. Or concern him. What *did* concern him was that no one was coming out of the Police Department, and there had been more gunshots. These were muffled, as if they'd originated downstairs where the prisoners were kept.

Not ordinarily a praying fellow, Ernie prayed now. That none of the people fleeing the Town Hall would notice the old man behind the wheel of the idling van. That Jackie and Rommie would come out safe, with or without Barbara and Everett. It occurred to him that he could just drive away, and was shocked by how tempting the idea was.

His cell phone rang.

For a moment he just sat there, not sure of what he was hearing, and then he yanked it off his belt. When he opened it, he saw JOANIE in the window. But it wasn't his daughter-in-law; it was Norrie.

'Grampa! Are you all right?'

'Fine,' he said, looking at the chaos in front of him.

'Did you get them out?'

'It's happening right now, honey,' he said, hoping it was the truth. 'I can't talk. Are you safe? Are you at . . . at the place?'

'Yes! Grampy, *it glows at night!* The radiation belt! The cars glowed too, but then they stopped! Julia says she thinks it isn't dangerous! She says she thinks it's a fake, to scare people away!'

You better not count on that, Ernie thought.

Two more muffled, thudding gunshots came from inside the PD. Someone was dead downstairs in the Coop; just about had to be.

'Norrie, I can't talk now.'

'Is it going to be all right, Grampa?'

'Yes, yes. I love you, Norrie.'

He closed the phone. *It glows,* he thought, and wondered if he would ever see that glow. Black Ridge was close (in a small town, everything's close), but just now it seemed far away. He looked at the PD's doors, trying to will his friends to come out. And when they didn't, he climbed from the van. He couldn't just sit out here any longer. He had to go inside and see what was happening.

30

Barbie saw Junior raise the gun. He heard Junior tell Rusty to close his eyes. He shouted without thinking, with no idea of what he was

going to say until the words emerged from his mouth. '*Hey, fuckface! I got you, didn't I? I got you good!*' The laughter that followed sounded like the laugh of a lunatic who has been ditching his meds.

So that's how I laugh when I'm fixing to die, Barbie thought. *I'll have to remember that.* Which made him laugh harder.

Junior turned toward him. The right side of his face registered surprise; the left was frozen in a scowl. It reminded Barbie of some supervillain he'd read about in his youth, but he couldn't remember which. Probably one of Batman's enemies, they were always the creepiest. Then he remembered that when his little brother Wendell tried to say *enemies* it came out *enemas*. This made him laugh harder than ever.

There could be worse ways to go out, he thought as he reached both hands through the bars and shot Junior a nice double-bird. *Remember Stubbs, in* Moby-Dick? '*Whatever my fate, I'll go to it laughing.*'

Junior saw Barbie giving him the finger – in stereo – and forgot all about Rusty. He started down the short corridor with his gun held out in front of him. Barbie's senses were very clear now, but he didn't trust them. The people he thought he heard moving around and speaking upstairs were almost surely just his imagination. Still, you played your string out to the end. If nothing else, he could give Rusty a few more breaths and a little more time.

'There you are, fuckface,' he said. 'Remember how I cleaned your clock that night in Dipper's? You cried like a little bitch.'

'I didn't.'

It came out sounding like an exotic special on a Chinese menu. Junior's face was a wreck. Blood from his left eye was dribbling down one stubble-darkened cheek. It occurred to Barbie that he might just have a chance here. Not a good one, but bad chances were better than no chances. He began to pace from side to side in front of his bunk and his toilet, slowly at first, then faster. *Now you know what a mechanical duck in a shooting gallery feels like,* he thought. *I'll have to remember that, too.*

Junior followed his movements with his one good eye. 'Did you fuck her? Did you fuck Angie?' *Dih-ooo fuh'er? Dih-oo fuh An'yee?*

Barbie laughed. It was the crazy laugh, one he still didn't recognize as his own, but there was nothing counterfeit about it. 'Did I fuck her? Did I *fuck* her? Junior, I fucked her with her rightside up, her upside down, and her backside all present and accounted for. I fucked her until she sang "Hail to the Chief" and "Bad Moon Rising." I fucked her until she pounded on the floor and yelled for a whole lot more. I—'

Junior tilted his head toward the gun. Barbie saw it and jigged to the left without delay. Junior fired. The bullet struck the brick wall at the back of the cell. Dark red chips flew. Some hit the bars – Barbie heard the metallic rattle, like peas in a tin cup, even with the gunshot ringing in his ears – but none of them hit Junior. Shit. From down the hall, Rusty yelled something, probably trying to distract Junior, but Junior was done being distracted. Junior had his prime target in his sights.

Not yet, you don't, Barbie thought. He was still laughing. It was crazy, nuts, but there it was. *Not quite yet, you ugly one-eyed motherfucker.*

'She said you couldn't get it up, Junior. She called you El Limpdick Supremo. We used to laugh about that while we were—' He leaped to the right at the same instant Junior fired. This time he heard the bullet pass the side of his head: the sound was *zzzzzz*. More brick chips jumped. One stung the back of Barbie's neck.

'Come on, Junior, what's wrong with you? You shoot like woodchucks do algebra. You a headcase? That's what Angie and Frankie always used to say—'

Barbie faked to the right and then ran at the left side of the cell. Junior fired three times, the explosions deafening, the stink of the blown gunpowder rich and strong. Two of the bullets buried themselves in brick; the third hit the metal toilet low down with a *spang* sound. Water began to pour out. Barbie struck the far wall of the cell hard enough to rattle his teeth.

'Got you now,' Junior panted. *Gah-ooo d'now.* But deep down in what remained of his overheated thinking-engine, he wondered. His left eye was blind and his right one had blurred over. He saw not one Barbie but three.

The hateful sonofabitch hit the deck as Junior fired, and this bullet also missed. A small black eye opened in the center of the pillow at the head of the bunk. But at least he was down. No more jigging and jogging. *Thank God I put in that fresh clip,* Junior thought.

'You poisoned me, *Baaarbie.*'

Barbie had no idea what he was talking about, but agreed at once. 'That's right, you loathsome little fuckpuppet, I sure did.'

Junior pushed the Beretta through the bars and closed his bad left eye; that reduced the number of Barbies he saw to just a pair. His tongue was snared between his teeth. His face ran with blood and sweat. 'Let's see you run now, *Baaarbie.*'

Barbie couldn't run, but he could and did crawl, scuttling right at Junior. The next bullet whistled over his head and he felt a vague

burn across one buttock as the slug split his jeans and undershorts and removed the top layer of skin beneath them.

Junior recoiled, tripped, almost went down, caught the bars of the cell on his right, and hauled himself back up. '*Hold still, mother-fucker!*'

Barbie whirled to the bunk and groped beneath it for the knife. He had forgotten all about the fucking knife.

'You want it in the back?' Junior asked from behind him. 'Okay; that's all right with me.'

'*Get him!*' Rusty shouted. '*Get him, GET HIM!*'

Before the next gunshot came, Barbie had just time to think, *Jesus Christ, Everett, whose side are you on?*

31

Jackie came down the stairs with Rommie behind her. She had time to register the haze of gunsmoke drifting around the caged overhead lights, and the stink of expended powder, and then Rusty Everett was screaming *Get him, get him.*

She saw Junior Rennie at the end of the corridor, crowding against the bars of the cell at the far end, the one the cops sometimes called the Ritz. He was screaming something, but it was all garbled.

She didn't think. Nor did she tell Junior to raise his hands and turn around. She just put two in his back. One entered his right lung; the other pierced his heart. Junior was dead before he slid to the floor with his face pressed between two bars of the cell, his eyes pulled up so stringently he looked like a Japanese death mask.

What his collapsing body revealed was Dale Barbara himself, crouching on his bunk with the carefully secreted knife in his hand. He had never had a chance to open it.

32

Freddy Denton grabbed Officer Henry Morrison's shoulder. Denton was not his favorite person tonight, and was never going to be his favorite person again. *Not that he ever was*, Henry thought sourly.

Denton pointed. 'Why's that old fool Calvert going into the PD?'

'How the hell should I know?' Henry asked, and grabbed Donnie Baribeau as Donnie ran by, shouting some senseless shit about terrorists.

'Slow down!' Henry bellowed into Donnie's face. 'It's all over! Everything's cool!'

Donnie had been cutting Henry's hair and telling the same stale jokes twice a month for ten years, but now he looked at Henry as if at a total stranger. Then he tore free and ran in the direction of East Street, where his shop was. Perhaps he meant to take refuge there.

'No civilians got any business being in the PD tonight,' Freddy said. Mel Searles steamed up beside him.

'Well, why don't you go check him out, killer?' Henry said. 'Take this lug with you. Because neither of you are doing the slightest bit of damn good here.'

'She was going for a gun,' Freddy said for the first of what would be many times. 'And I didn't mean to kill her. Only wing her, like.'

Henry had no intention of discussing it. 'Go in there and tell the old guy to leave. You can also make sure nobody's trying to free the prisoners while we're out here running around like a bunch of chickens with their heads cut off.'

A light dawned in Freddy Denton's dazed eyes. 'The prisoners! Mel, let's go!'

They started away, only to be frozen by Henry's bullhorn-amplified voice three yards behind them: 'AND PUT AWAY THOSE GUNS, YOU IDIOTS!'

Freddy did as the amplified voice commanded. Mel did the same. They crossed War Memorial Plaza and trotted up the PD steps with their guns holstered, which was probably a very good thing for Norrie's grandfather.

33

Blood everywhere, Ernie thought, just as Jackie had. He stared at the carnage, dismayed, and then forced himself to move. Everything inside the reception desk had spilled out when Rupe Libby hit it. Lying amid the litter was a red plastic rectangle which he prayed the people downstairs might still be able to put to use.

He was bending down to get it (and telling himself not to throw up, telling himself it was still a lot better than the A Shau Valley in Nam) when someone behind him said, 'Holy fucking God in the morning! Stand up, Calvert, slow. Hands over your head.'

But Freddy and Mel were still reaching for their weapons when Rommie came up the stairs to search for what Ernie had already found. Rommie had the speed-pump Black Shadow he'd put away in his safe, and he pointed it at the two cops without a moment's hesitation.

'You fine fellas might as well come all the way in,' he said. 'And stay together. Shoulder to shoulder. If I see light between you, I'll shoot. Ain't fuckin the dog on dis, me.'

'Put that down,' Freddy said. 'We're police.'

'Prime assholes is what you are. Stand over dere against that bulletin board. And keep rubbin shoulders while you do it. Ernie, what the damn hell you doin in here?'

'I heard shooting. I was worried.' He held up the red key card that opened the cells in the Coop. 'You'll need this, I think. Unless . . . unless they're dead.'

'They ain't dead, but it was fuckin close. Take it down to Jackie. I'll watch these fellas.'

'You can't release em, they're prisoners,' Mel said. 'Barbie's a murderer. The other one tried to frame Mr Rennie with some papers or . . . or somethin like that.'

Rommie didn't bother replying. 'Go on, Ernie. Hurry.'

'What happens to us?' Freddy asked. 'You ain't gonna kill us, are you?'

'Why would I kill you, Freddy? You still owe on that rototiller you bought from me las' spring. Behind in payments, too, is my recollection. No, we'll just lock you in the Coop. See how you like it down dere. Smells kinda pissy, but who knows, you might like it.'

'Did you have to kill Mickey?' Mel asked. 'He wasn't nothing but a softheaded boy.'

'We didn't kill none of em,' Rommie said. 'Your good pal Junior did dat.' *Not that anybody will believe it come tomorrow night,* he thought.

'Junior!' Freddy exclaimed. 'Where is he?'

'Shoveling coal down in hell would be my guess,' Rommie said. 'Dat's where they put the new help.'

34

Barbie, Rusty, Jackie, and Ernie came upstairs. The two erstwhile prisoners looked as if they did not quite believe they were still alive. Rommie and Jackie escorted Freddy and Mel down to the Coop. When Mel saw Junior's crumpled body, he said, 'You'll be sorry for this!'

Rommie said, 'Shut your hole and get in your new home. Bot' in the same cell. You're chums, after all.'

As soon as Rommie and Jackie had returned to the top floor, the two men began to holler.

'Let's get out of here while we still can,' Ernie said.

35

On the steps, Rusty looked up at the pink stars and breathed air which stank and smelled incredibly sweet at the same time. He turned to Barbie. 'I never expected to see the sky again.'

'Neither did I. Let's blow town while we've got the chance. How does Miami Beach sound to you?'

Rusty was still laughing when he got into the van. Several cops were on the Town Hall lawn, and one of them – Todd Wendlestat – looked over. Ernie raised his hand in a wave; Rommie and Jackie followed suit; Wendlestat returned the wave, then bent to help a woman who had gone sprawling to the grass when her high heels betrayed her.

Ernie slid behind the wheel and mated the electrical wires hanging below the dashboard. The engine started, the side door slammed shut, and the van pulled away from the curb. It rolled slowly up Town Common Hill, weaving around a few stunned meeting-goers who were walking in the street. Then they were out of downtown and headed toward Black Ridge, picking up speed.

ANTS

1

They started seeing the glow on the other side of a rusty old bridge that now spanned nothing but a mudslick. Barbie leaned forward between the front seats of the van. 'What's that? It looks like the world's biggest Indiglo watch.'

'It's radiation,' Ernie said.

'Don't worry,' Rommie said. 'We've got plenty of lead roll.'

'Norrie called me on her mother's cell phone while I was waiting for you,' Ernie said. 'She told me about the glow. She says Julia thinks it's nothing but a kind of . . . scarecrow, I guess you'd say. Not dangerous.'

'I thought Julia's degree was in journalism, not science,' Jackie said. 'She's a very nice lady, and smart, but we're still going to armor this thing up, right? Because I don't much fancy getting ovarian or breast cancer as a fortieth birthday present.'

'We'll drive fast,' Rommie said. 'You can even slide a piece of dat lead roll down the front of your jeans, if it'll make you feel better, you.'

'That's so funny I forgot to laugh,' she said . . . then did just that when she got an image of herself in lead panties, fashionably high-cut on the sides.

They came to the dead bear at the foot of the telephone pole. They could have seen it even with the headlights off, because by then the combined light from the pink moon and the radiation belt was almost strong enough to read a newspaper by.

While Rommie and Jackie covered the van's windows with lead roll, the others stood around the rotting bear in a semicircle.

'Not radiation,' Barbie mused.

'Nope,' Rusty said. 'Suicide.'

'And there are others.'

'Yes. But the smaller animals seem to be safe. The kids and I saw plenty of birds, and there was a squirrel in the orchard. It was just as lively as can be.'

'Then Julia's almost certainly right,' Barbie said. 'The glowband's a scarecrow and the dead animals are another. It's the old belt-*and*-suspenders thing.'

'I'm not following you, my friend,' Ernie said.

But Rusty, who had learned the belt-and-suspenders approach

as a medical student, absolutely was. 'Two warnings to keep out,' he said. 'Dead animals by day, a glowing belt of radiation by night.'

'So far as I know,' Rommie said, joining them at the side of the road, 'radiation only glows in science fiction movies.'

Rusty thought of telling him they were *living* in a science fiction movie, and Rommie would realize it when he got close to that weird box on the ridge. But of course Rommie was right.

'We're *supposed* to see it,' he said. 'The same with the dead animals. You're supposed to say, "Whoa – if there's some kind of suicide-ray out here that affects big mammals, I better stay away. After all, *I'm* a big mammal."'

'But the kids didn't back off,' Barbie said.

'Because they're kids,' Ernie said. And, after a moment's consideration: 'Also skateboarders. They're a different breed.'

'I still don't like it,' Jackie said, 'but since we have noplace else to go, maybe we could drive through yonder Van Allen Belt before I lose what's left of my nerve. After what happened at the cop-shop, I'm feeling a little shaky.'

'Wait a minute,' Barbie said. 'There's something out of kilter here. I see it, but give me a second to think how to say it.'

They waited. Moonlight and radiation lit the remains of the bear. Barbie was staring at it. Finally he raised his head.

'Okay, here's what's troubling me. There's a *they*. We know that because the box Rusty found isn't a natural phenomenon.'

'Damn straight, it's a made thing,' Rusty said. 'But not terrestrial. I'd bet my life on that.' Then he thought how close he'd come to losing his life not an hour ago and shuddered. Jackie squeezed his shoulder.

'Never mind that part for now,' Barbie said. 'There's a *they*, and if they really wanted to keep us out, they could. They're keeping the whole *world* out of Chester's Mill. If they wanted to keep us away from their box, why not put a mini-Dome around it?'

'Or a harmonic sound that would cook our brains like chicken legs in a microwave,' Rusty suggested, getting into the spirit of the thing. 'Hell, *real* radiation, for that matter.'

'It might *be* real radiation,' Ernie said. 'In fact, the Geiger counter you brought up here pretty much confirmed that.'

'Yes,' Barbie agreed, 'but does that mean that what the Geiger counter's registering is dangerous? Rusty and the kids aren't breaking out in lesions, or losing their hair, or vomiting up the linings of their stomachs.'

'At least not yet,' Jackie said.

'*Dat's* cheerful,' Rommie said.

Barbie ignored the byplay. 'Surely if *they* can create a barrier so strong it bounces back the best missiles America can throw at it, they could set up a radiation belt that would kill quickly, maybe instantly. It would even be in their interest to do so. A couple of grisly human deaths would be a lot more apt to discourage explorers than a bunch of dead animals. No, I think Julia's right, and the so-called radiation belt will turn out to be a harmless glow that's been spiced up to register on our detection equipment. Which probably seems pretty damn primitive to *them*, if they really are extraterrestrial.'

'But why?' Rusty burst out. 'Why any barrier? I couldn't lift the damn thing, I couldn't even rock it! And when I put a lead apron on it, the apron caught fire. Even though the box itself is cool to the touch!'

'If they're protecting it, there must be some way of destroying it or turning it off,' Jackie said. 'Except . . .'

Barbie was smiling at her. He felt strange, almost as if he were floating above his own head. 'Go on, Jackie. Say it.'

'Except they're *not* protecting it, are they? Not from people who are determined to approach it.'

'There's more,' Barbie said. 'Couldn't we say they're actually *pointing* at it? Joe McClatchey and his friends were practically following a trail of bread crumbs.'

'Here it is, puny Earthlings,' Rusty said. 'What can you do about it, ye who are brave enough to approach?'

'That feels about right,' Barbie said. 'Come on. Let's get up there.'

2

'You better let me drive from here,' Rusty told Ernie. 'Up ahead's where the kids passed out. Rommie almost did. I felt it too. And I had a kind of hallucination. A Halloween dummy that burst into flames.'

'Another warning?' Ernie asked.

'I don't know.'

Rusty drove to where the woods ended and open, rocky land sloped up to the McCoy Orchard. Just ahead, the air glowed so brightly they had to squint, but there was no source; the brightness was just there, floating. To Barbie it looked like the sort of light fireflies gave off, only magnified a million times. The belt appeared to be about fifty yards wide. Beyond it, the world was again dark except for the pink glow of the moonlight.

'You're sure that faintness won't happen to you again?' Barbie asked.

'It seems to be like touching the Dome: the first time vaccinates you.' Rusty settled behind the wheel, dropped the transmission into drive, and said: 'Hang onto your false teeth, ladies and germs.'

He hit the gas hard enough to spin the rear tires. The van sped into the glow. They were too well armored to see what happened next, but several people already on the ridge saw it from where they had been watching – with increasing anxiety – from the edge of the orchard. For a moment the van was clearly visible, as if centered in a spotlight. When it ran out of the glow-belt it continued to shine for several seconds, as if the stolen van had been dipped with radium. And it dragged a fading cometary tail of brightness behind it, like exhaust.

'Holy shit,' Benny said. 'It's like the best special effect I ever saw.'

Then the glow around the van faded and the tail disappeared.

3

As they passed through the glow-belt, Barbie felt a momentary light-headedness; no more than that. For Ernie, the real world of this van and these people seemed to be replaced by a hotel room that smelled of pine and roared with the sound of Niagara Falls. And here was his wife of just twelve hours coming to him, wearing a nightgown that was really no more than a breath of lavender smoke, taking his hands and putting them on her breasts and saying *This time we don't have to stop, honey*.

Then he heard Barbie shouting, and that brought him back.

'Rusty! She's having some kind of fit! Stop!'

Ernie looked around and saw Jackie Wettington shaking, her eyes rolled up in their sockets, her fingers splayed.

'*He's holding up a cross and everything's burning!*' she screamed. Spittle sprayed from her lips. '*The world is burning! THE PEOPLE ARE BURNING!*' She let loose a shriek that filled the van.

Rusty almost ditched the van, pulled back into the middle of the road, leaped out, and ran around to the side door. By the time Barbie slide it open, Jackie was wiping spit from her chin with a cupped hand. Rommie had his arm around her.

'Are you all right?' Rusty asked her.

'Now, yes. I just . . . it was . . . everything was on fire. It was day, but it was dark. People were b-b-burning . . .' She started to cry.

'You said something about a man with a cross,' Barbie said.

'A big white cross. It was on a string, or a piece of rawhide. It was on his chest. His bare chest. Then he held it up in front of his face.' She drew in a deep breath, let it out in little hitches. 'It's all fading now. But . . . *hoo.*'

Rusty held two fingers up in front of her and asked how many she saw. Jackie gave the correct answer, and followed his thumb when he moved it first from side to side, then up and down. He patted her on the shoulder, then looked mistrustfully back at the glow-belt. What was it Gollum had said of Bilbo Baggins? *It's tricksy, precious.* 'What about you, Barbie? Okay?'

'Yeah. A little lightheaded for a few seconds, that's all. Ernie?'

'I saw my wife. And the hotel room we stayed in on our honeymoon. It was as clear as day.'

He thought again of her coming to him. He hadn't thought of that in years, and what a shame to neglect such an excellent memory. The whiteness of her thighs below her shortie nightgown; the neat dark triangle of her pubic hair; her nipples hard against silk, almost seeming to scrape the pads of his palms as she darted her tongue into his mouth and licked the inner lining of his lower lip.

This time we don't have to stop, honey.

Ernie leaned back and closed his eyes.

4

Rusty drove up the ridge – slowly now – and parked the van between the barn and the dilapidated farmhouse. The Sweetbriar Rose van was there; the Burpee's Department Store van; also a Chevrolet Malibu. Julia had parked her Prius inside the barn. Horace the Corgi sat by its rear bumper, as if guarding it. He did not look like a happy canine, and he made no move to come and greet them. Inside the farmhouse, a couple of Coleman lanterns glowed.

Jackie pointed at the van with EVERY DAY IS SALE DAY AT BURPEE'S on the side. 'How'd that get here? Did your wife change her mind?'

Rommie grinned. 'You don't know Misha if you ever t'ink dat. No, I got Julia to thank. She recruited her two star reporters. Dose guys—'

He broke off as Julia, Piper, and Lissa Jamieson appeared from the moonlit shadows of the orchard. They were stumbling along three abreast, holding hands, and all of them were crying.

Barbie ran to Julia and took her by the shoulders. She was on the end of their little line, and the flashlight she had been holding

in her free hand dropped to the weedy dirt of the dooryard. She looked up at him and made an effort to smile. 'So they got you out, Colonel Barbara. That's one for the home team.'

'What happened to you?' Barbie asked.

Now Joe, Benny, and Norrie came running up with their mothers close behind them. The kids' shouts cut short when they saw the state the three women were in. Horace ran to his mistress, barking. Julia went to her knees and buried her face in his fur. Horace sniffed her, then suddenly backed away. He sat down and howled. Julia looked at him and then covered her face, as if in shame. Norrie had grabbed Joe's hand on her left and Benny's on her right. Their faces were solemn and scared. Pete Freeman, Tony Guay, and Rose Twitchell came out of the farmhouse but did not approach; they stood clustered by the kitchen door.

'We went to look at it,' Lissa said dully. Her usual gosh-the-world-is-wonderful brightness was gone. 'We knelt around it. There's a symbol on it I've never seen before . . . it's not kabbalah . . .'

'It's awful,' Piper said, wiping at her eyes. 'And then Julia touched it. She was the only one, but we . . . we all . . .'

'Did you see them?' Rusty asked.

Julia dropped her hands and looked at him with something like wonder. 'Yes. I did, we all did. *Them.* Horrible.'

'The leatherheads,' Rusty said.

'*What?*' Piper said. Then she nodded. 'Yes, I suppose you could call them that. Faces without faces. *High* faces.'

High faces, Rusty thought. He didn't know what it meant, but he knew it was true. He thought again of his daughters and their friend Deanna exchanging secrets and snacks. Then he thought of his best childhood friend – for a while, anyway; he and Georgie had fallen out violently in second grade – and horror rolled over him in a wave.

Barbie grabbed him. 'What?' He was almost shouting. 'What is it?'

'Nothing. Only . . . I had this friend when I was little. George Lathrop. One year he got a magnifying glass for his birthday. And sometimes . . . at recess we . . .'

Rusty helped Julia to her feet. Horace had come back to her, as if whatever had scared him was fading like the glow had faded on the van.

'You did what?' Julia asked. She sounded almost calm again. 'Tell.'

'This was at the old Main Street Grammar. Just two rooms, one for grades one to four, the other for five to eight. The playground wasn't paved.' He laughed shakily. 'Hell, there wasn't even running water, just a privy the kids called—'

'The Honey House,' Julia said. 'I went there, too.'

'George and I, we'd go past the monkey bars to the fence. There were anthills there, and we'd set the ants on fire.'

'Don't take on about it, Doc,' Ernie said. 'Lots of kids have done that, and worse.' Ernie himself, along with a couple of friends, had once dipped a stray cat's tail in kerosene and put a match to it. This was a memory he would share with the others no more than he would tell them about the details of his wedding night.

Mostly because of how we laughed when that cat took off, he thought. *Gosh, how we did laugh.*

'Go on,' Julia said.

'I'm done.'

'You're not,' she said.

'Look,' said Joanie Calvert. 'I'm sure this is all very psychological, but I don't think this is the time—'

'Hush, Joanie,' Claire said.

Julia had never taken her eyes from Rusty's face.

'Why does it matter to you?' Rusty asked. He felt, at that moment, as though there were no onlookers. As if it were only the two of them.

'Just tell me.'

'One day while we were doing . . . that . . . it occurred to me that ants also have their little lives. I know that sounds like sentimental slop—'

Barbie said, 'Millions of people all over the world believe that very thing. They live by it.'

'Anyway, I thought "We're hurting them. We're burning them on the ground and maybe broiling them alive in their underground houses." About the ones who were getting the direct benefit of Georgie's magnifying glass there was no question. Some just stopped moving, but most actually caught fire.'

'That's awful,' Lissa said. She was twisting her ankh again.

'Yes, ma'am. And this one day I told Georgie to stop. He wouldn't. He said, "It's jukular war." I remember that. Not *nuclear* but *jukular.* I tried to take the magnifying glass away from him. Next thing you know, we were fighting, and his magnifying glass got broken.'

He stopped. 'That's not the truth, although it's what I said at the time and not even the hiding my father gave me could make me change my story. The one George told *his* folks was the true one: I broke the goddam thing on purpose.' He pointed into the dark. 'The way I'd break that box, if I could. Because now we're the ants and that's the magnifying glass.'

Ernie thought again of the cat with the burning tail. Claire McClatchey remembered how she and her third-grade best friend had sat on a bawling girl they both hated. The girl was new in school and had a funny southern accent that made her sound like she was talking through mashed potatoes. The more the new girl cried, the harder they laughed. Romeo Burpee remembered getting drunk the night Hillary Clinton cried in New Hampshire, toasting the TV screen and saying, 'Dat's it for you, you goddam baby, get out the way and let a man do a man's job.'

Barbie remembered a certain gymnasium: the desert heat, the smell of shit, and the sound of laughter.

'I want to see it for myself,' he said. 'Who'll go with me?'

Rusty sighed. 'I will.'

<div align="center">5</div>

While Barbie and Rusty were approaching the box with its strange symbol and brilliant pulsing light, Selectman James Rennie was in the cell where Barbie had been imprisoned until earlier this evening.

Carter Thibodeau had helped him lift Junior's body onto the bunk. 'Leave me with him,' Big Jim said.

'Boss, I know how bad you must feel, but there are a hundred things that need your attention right now.'

'I'm aware of that. And I'll take care of them. But I need a little time with my son first. Five minutes. Then you can get a couple of fellows to take him to the funeral parlor.'

'All right. I'm sorry for your loss. Junior was a good guy.'

'No he wasn't,' Big Jim said. He spoke in a mild just-telling-it-like-it-is tone of voice. 'But he was my son and I loved him. And this isn't all bad, you know.'

Carter considered. 'I know.'

Big Jim smiled. 'I *know* you know. I'm starting to think you're the son I should have had.'

Carter's face flushed with pleasure as he trotted up the stairs to the ready room.

When he was gone, Big Jim sat on the bunk and lowered Junior's head into his lap. The boy's face was unmarked, and Carter had closed his eyes. If you ignored the blood matting his shirt, he could have been sleeping.

He was my son and I loved him.

It was true. He had been ready to sacrifice Junior, yes, but there was precedent for that; you only had to look at what had happened

on Calvary Hill. And like Christ, the boy had died for a cause. Whatever damage had been caused by Andrea Grinnell's raving would be repaired when the town realized that Barbie had killed several dedicated police officers, including their leader's only child. Barbie on the loose and presumably planning new deviltry was a political plus.

Big Jim sat awhile longer, combing Junior's hair with his fingers and looking raptly into Junior's reposeful face. Then, under his breath, he sang to him as his mother had when the boy was an infant lying in his crib, looking up at the world with wide, wondering eyes. 'Baby's boat's a silver moon, sailing o'er the sky; sailing o'er the sea of dew, while the clouds float by . . . sail, baby, sail . . . out across the sea . . .'

There he stopped. He couldn't remember the rest. He lifted Junior's head and stood up. His heart did a jagged tarradiddle and he held his breath . . . but then it settled again. He supposed he would eventually have to get some more of that verapa-whatsis from Andy's pharmacy supplies, but in the meantime, there was work to do.

6

He left Junior and went slowly up the stairs, holding the railing. Carter was in the ready room. The bodies had been removed, and a double spread of newspapers was soaking up Mickey Wardlaw's blood.

'Let's go over to the Town Hall before this place fills up with cops,' he told Carter. 'Visitors Day officially starts in' – he looked at his watch – 'about twelve hours. We've got a lot to do before then.'

'I know.'

'And don't forget my son. I want the Bowies to do it right. A respectful presentation of the remains and a fine coffin. You tell Stewart if I see Junior in one of those cheap things from out back, I'll kill him.'

Carter was scribbling in his notebook. 'I'll take care of it.'

'And tell Stewart that I'll be talking to him soon.' Several officers came in the front door. They looked subdued, a little scared, very young and green. Big Jim heaved himself out of the chair he'd been sitting in while he recovered his breath. 'Time to move.'

'Okay by me,' Carter said. But he paused.

Big Jim looked around. 'Something on your mind, son?'

Son. Carter liked the sound of that *son*. His own father had been killed five years previous when he crashed his pickup into one of the twin bridges in Leeds, and no great loss. He had abused his wife and both sons (Carter's older brother was currently serving in the

Navy), but Carter didn't care about that so much; his mother had her coffee brandy to numb her up, and Carter himself had always been able to take a few licks. No, what he hated about the old man was that he was a whiner, and he was stupid. People assumed Carter was also stupid – hell, even Junes had assumed it – but he wasn't. Mr Rennie understood that, and Mr Rennie was sure no whiner.

Carter discovered that he was no longer undecided about what to do next.

'I've got something you may want.'

'Is that so?'

Big Jim had preceded Carter downstairs, giving Carter a chance to visit his locker. He opened it now and took out the envelope with VADER printed on it. He held it out to Big Jim. The bloody footprint stamped on it seemed to glare.

Big Jim opened the clasp.

'Jim,' Peter Randolph said. He had come in unnoticed and was standing by the overturned reception desk, looking exhausted. 'I think we've got things quieted down, but I can't find several of the new officers. I think they may have quit on us.'

'To be expected,' Big Jim said. 'And temporary. They'll be back when things settle and they realize Dale Barbara isn't going to lead a gang of bloodthirsty cannibals into town to eat them alive.'

'But with this damned Visitors Day thing—'

'Almost everyone is going to be on their best behavior tomorrow, Pete, and I'm sure we'll have enough officers to take care of any who aren't.'

'What do we do about the press con—'

'Do you see I happen to be a little busy here? Do you see that, Pete? Goodness! Come over to the Town Hall conference room in half an hour and we'll discuss anything you want. But for now, *leave me the heck alone.*'

'Of course. Sorry.' Pete backed away, his body as stiff and offended as his voice.

'Stop,' Rennie said.

Randolph stopped.

'You never offered me condolences on my son.'

'I . . . I'm very sorry.'

Big Jim measured Randolph with his eyes. 'Indeed you are.'

When Randolph was gone, Rennie pulled the papers out of the envelope, looked at them briefly, then stuffed them back in. He looked at Carter with honest curiosity. 'Why didn't you give this to me right away? Were you planning to keep it?'

Now that he'd handed over the envelope, Carter saw no option but the truth. 'Yuh. For a while, anyway. Just in case.'

'In case of what?'

Carter shrugged.

Big Jim didn't pursue the question. As a man who routinely kept files on anyone and everyone who might cause him trouble, he didn't have to. There was another question that interested him more.

'Why did you change your mind?'

Carter once again saw no option but the truth. 'Because I want to be your guy, boss.'

Big Jim hoisted his bushy eyebrows. '*Do* you. More than him?' He jerked his head toward the door Randolph had just walked out of.

'Him? He's a joke.'

'Yes.' Big Jim dropped a hand on Carter's shoulder. 'He is. Come on. And once we get over there to the Town Hall, burning these papers in the conference room woodstove will be our first order of business.'

7

They were indeed *high*. And horrible.

Barbie saw them as soon as the shock passing up his arms faded. His first, strong impulse was to let go of the box, but he fought it and held on, looking at the creatures who were holding them prisoner. Holding them and torturing them for pleasure, if Rusty was right.

Their faces – if they *were* faces – were all angles, but the angles were padded and seemed to change from moment to moment, as if the underlying reality had no fixed form. He couldn't tell how many of them there were, or where they were. At first he thought there were four; then eight; then only two. They inspired a deep sense of loathing in him, perhaps because they were so alien he could not really perceive them at all. The part of his brain tasked with interpreting sensory input could not decode the messages his eyes were sending.

My eyes couldn't see them, not really, even with a telescope. These creatures are in a galaxy far, far away.

There was no way to know that – reason told him the owners of the box might have a base under the ice at the South Pole, or might be orbiting the moon in their version of the starship *Enterprise* – but he did. They were at home . . . whatever *home* was for them. They were watching. And they were enjoying.

They had to be, because the sons of bitches were laughing.

Then he was back in the gym in Fallujah. It was hot because there was no air-conditioning, just overhead fans that paddled the soupy, jock-smelling air around and around. They had let all the interrogation subjects go except for two Abduls who were unwise enough to snot off a day after two IEDs had taken six American lives and a sniper had taken one more, a kid from Kentucky everyone liked – Carstairs. So they'd started kicking the Abduls around the gym, and pulling off their clothes, and Barbie would like to say he had walked out, but he hadn't. He would like to say that at least he hadn't participated, but he had. They got feverish about it. He remembered connecting with one Abdul's bony, shit-speckled ass, and the red mark his combat boot had left there. Both Abduls naked by then. He remembered Emerson kicking the other one's dangling *cojones* so hard they flew up in front of him and saying *That's for Carstairs, you fucking sandnigger*. Someone would soon be giving his mom a flag while she sat on a folding chair near the grave, same old same old. And then, just as Barbie was remembering that he was technically in charge of these men, Sergeant Hackermeyer pulled one of them up by the unwinding remains of the *hijab* that was now his only clothing and held him against the wall and put his gun to the Abdul's head and there was a pause and no one said *no* in the pause and no one said *don't do that* in the pause and Sergeant Hackermeyer pulled the trigger and the blood hit the wall as it's hit the wall for three thousand years and more, and that was it, that was goodbye, Abdul, don't forget to write when you're not busy cherrypopping those virgins.

Barbie let go of the box and tried to get up, but his legs betrayed him. Rusty grabbed him and held him until he steadied.

'Christ,' Barbie said.

'You saw them, didn't you?'

'Yes.'

'Are they children? What do you think?'

'Maybe.' But that wasn't good enough, wasn't what his heart believed. 'Probably.'

They walked slowly back to where the others were clustered in front of the farmhouse.

'You all right?' Rommie asked.

'Yes,' Barbie said. He had to talk to the kids. And Jackie. Rusty, too. But not yet. First he had to get himself under control.

'You sure?'

'Yes.'

'Rommie, is there more of that lead roll at your store?' Rusty asked.

'Yuh. I left it on the loading dock.'

'Good,' Rusty said, and borrowed Julia's cell phone. He hoped Linda was home and not in an interrogation room at the PD, but hoping was all he could do.

8

The call from Rusty was necessarily brief, less than thirty seconds, but for Linda Everett it was long enough to turn this terrible Thursday a hundred and eighty degrees toward sunshine. She sat at the kitchen table, put her hands to her face, and cried. She did it as quietly as possible, because there were now four children upstairs instead of just two. She had brought the Appleton kids home with her, so now she had the As as well as the Js.

Alice and Aidan had been terribly upset – dear God, of course they had been – but being with Jannie and Judy had helped. So had doses of Benadryl all around. At the request of her girls, Linda had spread sleeping bags in their room, and now all four of them were conked out on the floor between the beds, Judy and Aidan with their arms wrapped around each other.

Just as she was getting herself under control again, there was a knock at the kitchen door. Her first thought was the police, although given the bloodshed and confusion downtown, she hadn't expected them so soon. But there was nothing authoritative about that soft rapping.

She went to the door, pausing to snatch a dish towel from the end of the counter and wipe her face. At first she didn't recognize her visitor, mostly because his hair was different. It was no longer in a ponytail; it fell to Thurston Marshall's shoulders, framing his face, making him look like an elderly washerwoman who has gotten bad news – terrible news – after a long, hard day.

Linda opened the door. For a moment Thurse remained on the stoop. 'Is Caro dead?' His voice was low and hoarse. *As if he screamed it out at Woodstock doing the Fish Cheer and it just never came back*, Linda thought. 'Is she really dead?'

'I'm afraid she is,' Linda said, speaking low herself. Because of the children. 'Mr Marshall, I'm so sorry.'

For a moment he continued to just stand there. Then he grabbed the gray locks hanging on either side of his face and began to rock back and forth. Linda didn't believe in May–December romances; she was old-fashioned that way. She would have given Marshall and Caro Sturges two years at most, maybe only six months – however long

it took their sex organs to stop smoking – but tonight there was no doubting the man's love. Or his loss.

Whatever they had, those kids deepened it, she thought. *And the Dome, too.* Living under the Dome intensified everything. Already it seemed to Linda that they had been under it not for days but years. The outside world was fading like a dream when you woke up.

'Come in,' she said. 'But be quiet, Mr Marshall. The children are sleeping. Mine and yours.'

9

She gave him sun-tea – not cold, not even particularly cool, but the best she could do under the circumstances. He drank half of it off, set the glass down, then screwed his fists into his eyes like a child up long past his bedtime. Linda recognized this for what it was, an effort to get himself under control, and sat quietly, waiting.

He pulled in a deep breath, let it out, then reached into the breast pocket of the old blue workshirt he was wearing. He took out a piece of rawhide and tied his hair back. She took this as a good sign.

'Tell me what happened,' Thurse said. 'And how it happened.'

'I didn't see it all. Someone kicked me a good one in the back of my head while I was trying to pull your . . . Caro . . . out of the way.'

'But one of the cops shot her, isn't that right? One of the cops in this goddam cop-happy, gun-happy town.'

'Yes.' She reached across the table and took his hand. 'Someone shouted *gun*. And there *was* a gun. It was Andrea Grinnell's. She might have brought it to the meeting with the idea of assassinating Rennie.'

'Do you think that justifies what happened to Caro?'

'God, no. And what happened to Andi was flat-out murder.'

'Caro died trying to protect the children, didn't she?'

'Yes.'

'Children that weren't even her own.'

Linda said nothing.

'Except they were. Hers and mine. Call it fortunes of war or fortunes of Dome, they were ours, the kids we never would have had otherwise. And until the Dome breaks – if it ever does – they're mine.'

Linda was thinking furiously. Could this man be trusted? She thought so. Certainly Rusty had trusted him; had said the guy was

a hell of a good medic for someone who'd been out of the game so long. And Thurston hated those in authority here under the Dome. He had reasons to.

'Mrs Everett—'

'Please, Linda.'

'Linda, may I sleep on your couch? I'd like to be here if they wake up in the night. If they don't — I *hope* they don't — I'd like them to see me when they come downstairs in the morning.'

'That's fine. We'll all have breakfast together. It'll be cereal. The milk hasn't turned yet, although it will soon.'

'That sounds good. After the kids eat, we'll be out of your hair. Pardon me for saying this if you're a homegirl, but I've had a bellyful of Chester's Mill. I can't secede from it entirely, but I intend to do the best I can. The only patient at the hospital in serious condition was Rennie's son, and he checked himself out this afternoon. He'll be back, that mess growing in his head will *make* him come back, but for now—'

'He's dead.'

Thurston didn't look particularly surprised. 'A seizure, I suppose.'

'No. Shot. In the jail.'

'I'd like to say I'm sorry, but I'm not.'

'Neither am I,' Linda said. She didn't know for sure what Junior had been doing there, but she had a good idea of how the grieving father would spin it.

'I'll take the kids back to the pond where Caro and I were staying when this happened. It's quiet there, and I'm sure I'll be able to find enough comestibles to last for a while. Maybe quite a while. I may even find a place with a generator. But as far as community life goes' — he gave the words a satiric spin — 'I'm quits. Alice and Aidan, too.'

'I might have a better place to go.'

'Really?' And when Linda said nothing, he stretched a hand across the table and touched hers. 'You have to trust someone. It might as well be me.'

So Linda told him everything, including how they'd have to stop for lead roll behind Burpee's before leaving town for Black Ridge. They talked until almost midnight.

10

The north end of the McCoy farmhouse was useless — thanks to the previous winter's heavy snow, the roof was now in the parlor — but

there was a country-style dining room almost as long as a railroad car on the west side, and it was there that the fugitives from Chester's Mill gathered. Barbie first questioned Joe, Norrie, and Benny about what they had seen, or dreamed about, when they passed out on the edge of what they were now calling the glow-belt.

Joe remembered burning pumpkins. Norrie said everything had turned black, and the sun was gone. Benny at first claimed to remember nothing. Then he clapped a hand over his mouth. 'There was screaming,' he said. 'I heard screaming. It was bad.'

They considered this in silence. Then Ernie said, 'Burnin punkins doesn't narrow things down much, if that's what you're trying to do, Colonel Barbara. There's probably a stack of em on the sunny side of every barn in town. It's been a good season for em.' He paused. 'At least it was.'

'Rusty, what about your girls?'

'Pretty much the same,' Rusty said, and told them what he could remember.

'Stop Halloween, stop the Great Pumpkin,' Rommie mused.

'Dudes, I'm seeing a pattern here,' Benny said.

'No shit, Sherlock,' Rose said, and they all laughed.

'Your turn, Rusty,' Barbie said. 'How about when you passed out on your way up here?'

'I never exactly passed out,' Rusty said. 'And all of this stuff could be explained by the pressure we've been under. Group hysteria – including group hallucinations – is common when people are under stress.'

'Thank you, Dr Freud,' Barbie said. 'Now tell us what you saw.'

Rusty got as far as the stovepipe hat with its patriotic stripes when Lissa Jamieson exclaimed, 'That's the dummy on the library lawn! He's wearing an old tee-shirt of mine with a Warren Zevon quote on it—'

'"Sweet home Alabama, play that dead band's song,"' Rusty said. 'And garden trowels for hands. Anyway, it caught on fire. Then, poof, it was gone. So was the lightheadedness.'

He looked around at them. Their wide eyes. 'Relax, people, I probably saw the dummy before all this happened, and my subconscious just coughed it back up.' He leveled a finger at Barbie. 'And if you call me Dr Freud again, I'm apt to pop you one.'

'*Did* you see it before?' Piper asked. 'Maybe when you went to pick up your girls at school, or something? Because the library's right across from the playground.'

'Not that I remember, no.' Rusty didn't add that he hadn't picked

up the girls at school since very early in the month, and he doubted that any of the town's Halloween displays had been up then.

'Now you, Jackie,' Barbie said.

She wet her lips. 'Is it really so important?'

'I think it is.'

'People burning,' she said. 'And smoke, with fire shining through it whenever it shifted. The whole world seemed to be burning.'

'Yeah,' Benny said. 'The people were screaming because they were on fire. Now I remember.' Abruptly he put his face against Alva Drake's shoulder. She put her arm around him.

'Halloween's still five days away,' Claire said.

Barbie said, 'I don't think so.'

11

The woodstove in the corner of the Town Hall conference room was dusty and neglected but still usable. Big Jim made sure the flue was open (it squeaked rustily), then removed Duke Perkins's paperwork from the envelope with the bloody footprint on it. He thumbed through the sheets, grimaced at what he saw, then tossed them into the stove. The envelope he saved.

Carter was on the phone, talking to Stewart Bowie, telling him what Big Jim wanted for his son, telling him to get on it right away. *A good boy*, Big Jim thought. *He may go far. As long as he remembers which side his bread's buttered on, that is.* People who forgot paid a price. Andrea Grinnell had found that out tonight.

There was a box of wooden matches on the shelf beside the stove. Big Jim scratched one alight and touched it to the corner of Duke Perkins's 'evidence.' He left the stove door open so he could watch it burn. It was very satisfying.

Carter walked over. 'Stewart Bowie's on hold. Should I tell him you'll get back to him later?'

'Give it to me,' Big Jim said, and held out his hand for the phone.

Carter pointed at the envelope. 'Don't you want to throw that in, too?'

'No. I want you to stuff it with blank paper from the photocopy machine.'

It took a moment for Carter to get it. 'She was just having a bunch of dope-ass hallucinations, wasn't she?'

'Poor woman,' Big Jim agreed. 'Go down to the fallout shelter, son. There.' He cocked his thumb at a door – unobtrusive except for

an old metal plaque showing black triangles against a yellow field – not far from the woodstove. 'There are two rooms. At the end of the second one there's a small generator.'

'Okay . . .'

'In front of the gennie there's a trapdoor. Hard to see, but you will if you look. Lift it and look inside. There should be eight or ten little canisters of LP snuggled down in there. At least there were the last time I looked. Check and tell me how many.'

He waited to see if Carter would ask why, but Carter didn't. He just turned to do as he was told. So Big Jim told him.

'Only a precaution, son. Dot every *i* and cross every *t*, that's the secret of success. And having God on your side, of course.'

When Carter was gone, Big Jim pushed the hold button . . . and if Stewart wasn't still there, his butt was going to be in a high sling.

Stewart was. 'Jim, I'm so sorry for your loss,' he said. Right up front with it, a point in his favor. 'We'll take care of everything. I'm thinking the Eternal Rest casket – it's oak, good for a thousand years.'

Go on and pull the other one, Big Jim thought, but kept silent.

'And it'll be our best work. He'll look ready to wake up and smile.'

'Thank you, pal,' Big Jim said. Thinking, *He damn well better.*

'Now about this raid tomorrow,' Stewart said.

'I was going to call you about that. You're wondering if it's still on. It is.'

'But with everything that's happened—'

'Nothing's happened,' Big Jim said. 'For which we can thank God's mercy. Can I get an amen on that, Stewart?'

'Amen,' Stewart said dutifully.

'Just a clustermug caused by a mentally disturbed woman with a gun. She's eating dinner with Jesus and all the saints right now, I have no doubt, because none of what happened was her fault.'

'But Jim—'

'Don't interrupt me when I'm talking, Stewart. It was the drugs. Those damn things rotted her brain. People are going to realize that as soon as they calm down a little. Chester's Mill is blessed with sensible, courageous folks. I trust them to come through, always have, always will. Besides, right now they don't have a thought in their heads except for seeing their nearest and dearest. Our operation is still a go for noon. You, Fern, Roger. Melvin Searles. Fred Denton will be in charge. He can pick another four or five, if he thinks he needs them.'

'He the best you can do?' Stewart asked.

'Fred is fine,' Big Jim said.

'What about Thibodeau? That boy who's been hanging around with y—'

'Stewart Bowie, every time you open your mouth, half your guts fall out. You need to shut up for once and listen. We're talking about a scrawny drug addict and a pharmacist who wouldn't say boo to a goose. You got an amen on that?'

'Yeah, amen.'

'Use town trucks. Grab Fred as soon as you're off the phone – he's got to be around there someplace – and tell him what's what. Tell him you fellows should armor up, just to be on the safe side. We've got all that happy Homeland Security crappy in the back room of the police station – bulletproof vests and flak jackets and I don't know whatall – so we might as well make use of it. Then you go in there and take those fellows out. We need that propane.'

'What about the lab? I was thinking maybe we should burn it—'

'Are you *crazy*?' Carter, who had just walked back into the room, looked at him in surprise. 'With all those chemicals stored there? The Shumway woman's newspaper is one thing; that storage building is an entirely different kettle of chowder. You want to look out, pal, or I'll start thinking you're as stupid as Roger Killian.'

'All right.' Stewart sounded sulky, but Big Jim reckoned he would do as told. He had no more time for him, anyway; Randolph would be arriving any minute.

The parade of fools never ends, he thought.

'Now give me a big old praise God,' Big Jim said. In his mind he had a picture of himself sitting on Stewart's back and grinding his face into the dirt. It was a cheering picture.

'Praise God,' Stewart Bowie muttered.

'Amen, brother,' Big Jim said, and hung up.

12

Chief Randolph came in shortly thereafter, looking tired but not unsatisfied. 'I think we've lost some of the younger recruits for good – Dodson, Rawcliffe, and the Richardson boy are all gone – but most of the others stuck. And I've got some new ones. Joe Boxer . . . Stubby Norman . . . Aubrey Towle . . . his brother owns the bookstore, you know . . .'

Big Jim listened to this recitation patiently enough, if with only

half an ear. When Randolph finally ran down, Big Jim slid the VADER envelope across the polished conference table to him. 'That's what poor old Andrea was waving around. Have a look.'

Randolph hesitated, then bent back the clasps and slid out the contents. 'There's nothing here but blank paper.'

'Right you are, right as rain. When you assemble your force tomorrow – seven o'clock sharp, at the PD, because you can believe your Uncle Jim when he says the ants are going to start trekking out of the hill mighty early – you might make sure they know the poor woman was just as deluded as the anarchist who shot President McKinley.'

'Isn't that a mountain?' Randolph asked.

Big Jim spared a moment to wonder which dumbtree Mrs Randolph's little boy had fallen out of. Then he pressed ahead. He wouldn't get a good eight hours' sleep tonight, but with the blessing he might manage five. And he needed it. His poor old heart needed it.

'Use all the police cars. Two officers to a car. Make sure everyone has Mace and Tasers. But anyone who discharges a firearm in sight of reporters and cameras and the cotton-picking outside world . . . I'll have that man's guts for garters.'

'Yessir.'

'Have them drive along the shoulders of 119, flanking the crowd. No sirens, but lights flashing.'

'Like in a parade,' Randolph said.

'Yes, Pete, like in a parade. Leave the highway itself for the people. Tell those in cars to leave them and walk. Use your loud-speakers. I want them good and tired when they get out there. Tired people tend to be well-behaved people.'

'You don't think we should spare a few troops to hunt for the escaped prisoners?' He saw Big Jim's eyes flash and raised one hand. 'Just asking, just asking.'

'Well, and you deserve an answer. You're the Chief, after all. Isn't he, Carter?'

'Yup,' Carter said.

'The answer is *no,* Chief Randolph, because . . . listen closely now . . . *they can't escape.* There's a Dome around Chester's Mill and they *absotively . . . positulety . . .* can*not* escape. Now do you follow that line of reasoning?' He observed the color rising in Randolph's cheeks and said, 'Be careful how you answer, now. *I* would, anyway.'

'I follow it.'

'Then follow this, as well: with Dale Barbara on the loose, not to mention his co-conspirator Everett, the people will look even

more fervently to their public servants for protection. And hard-pressed though we may be, we'll rise to the occasion, won't we?'

Randolph finally got it. He might not know that there was a president as well as a mountain named McKinley, but he *did* seem to grasp that a Barbie in the bush was in many ways more useful to them than a Barbie in the hand.

'Yes,' he said. 'We will. Damn straight. What about the press conference? If you're not going to do it, do you want to appoint—'

'No, I do not. I will be right here at my post, where I belong, monitoring developments. As for the press, they can darn well conference with the thousand or so people that are going to be grubbed up out there on the south side of town like gawkers at a construction site. And good luck to them translating the babble they'll get.'

'Some folks may say things that aren't exactly flattering to us,' Randolph said.

Big Jim flashed a wintery smile. 'That's why God gave us the big shoulders, pal. Besides, what's that meddling cotton-picker Cox going to do? March in here and turn us out of office?'

Randolph gave a dutiful chuckle, started for the door, then thought of something else. 'There are going to be a lot of people out there, and for a long time. The military's put up Porta-Potties on their side. Should we do something like that on ours? I think we've got a few in the supply building. For road crews, mostly. Maybe Al Timmons could—'

Big Jim gave him a look that suggested he thought the new Chief of Police had gone mad. 'If it had been left up to me, our folks would be safe in their homes tomorrow instead of streaming out of town like the Israelites out of Egypt.' He paused for emphasis. 'If some of them get caught short, let them poop in the goshdarn woods.'

13

When Randolph was finally gone, Carter said: 'If I swear I'm not brown-nosing, can I tell you something?'

'Yes, of course.'

'I love to watch you operate, Mr Rennie.'

Big Jim grinned – a great big sunny one that lit his whole face. 'Well, you're going to get your chance, son; you've learned from the rest, now learn from the best.'

'I plan on it.'

'Right now I need you to give me a lift home. Meet me promptly at eight o'clock tomorrow morning. We'll come down here and watch

the show on CNN. But first we'll sit up on Town Common Hill and watch the exodus. Sad, really; Israelites with no Moses.'

'Ants without a hill,' Carter added. 'Bees without a hive.'

'But before you pick me up, I want you to visit a couple of people. Or try; I've got a bet with myself that you'll find them absent without leave.'

'Who?'

'Rose Twitchell and Linda Everett. The medico's wife.'

'I know who she is.'

'You might also take a check for Shumway. I heard she might be staying with Libby, the preacher-lady with the badnatured dog. If you find any of them, question them about the whereabouts of our escapees.'

'Hard or soft?'

'Moderate. I don't necessarily want Everett and Barbara captured right away, but I wouldn't mind knowing where they are.'

On the step outside, Big Jim breathed deeply of the smelly air and then sighed with something that sounded like satisfaction. Carter felt pretty satisfied himself. A week ago, he'd been replacing mufflers, wearing goggles to keep the sifting rust flakes from salt-rotted exhaust systems out of his eyes. Today he was a man of position and influence. A little smelly air seemed a small price to pay for that.

'I have a question for you,' Big Jim said. 'If you don't want to answer, it's okay.'

Carter looked at him.

'The Bushey girl,' Big Jim said. 'How was she? Was she good?'

Carter hesitated, then said: 'A little dry at first, but she oiled up a-country fair.'

Big Jim laughed. The sound was metallic, like the sound of coins dropping into the tray of a slot machine.

14

Midnight, and the pink moon descending toward the Tarker's Mills horizon, where it might linger until daylight, turning into a ghost before finally disappearing.

Julia picked her way through the orchard to where the McCoy land sloped down the western side of Black Ridge, and was not surprised to see a darker shadow sitting against one of the trees. Off to her right, the box with the alien symbol engraved on its top sent out a flash every fifteen seconds: the world's smallest, strangest lighthouse.

'Barbie?' she asked, keeping her voice low. 'How's Ken?'

'Gone to San Francisco to march in the Gay Pride parade. I always knew that boy wasn't straight.'

Julia laughed, then took his hand and kissed it. 'My friend, I'm awfully glad you're safe.'

He took her in his arms, and kissed her on both cheeks before letting her go. Lingering kisses. Real ones. 'My friend, so am I.'

She laughed, but a thrill went straight through her, from neck to knees. It was one she recognized but hadn't felt in a long time. *Easy, girl,* she thought. *He's young enough to be your son.*

Well, yes . . . if she'd gotten pregnant at thirteen.

'Everyone else is asleep,' Julia said. 'Even Horace. He's in with the kids. They had him chasing sticks until his tongue was practically dragging on the ground. Thinks he died and went to heaven, I bet.'

'I tried sleeping. Couldn't.'

Twice he'd come close to drifting off, and both times he found himself back in the Coop, facing Junior Rennie. The first time Barbie had tripped instead of jigging to the right and had gone sprawling to the bunk, presenting a perfect target. The second time, Junior had reached through the bars with an impossibly long plastic arm and had seized him to make him hold still long enough to give up his life. After that one, Barbie had left the barn where the men were sleeping and had come out here. The air still smelled like a room where a lifelong smoker had died six months ago, but it was better than the air in town.

'So few lights down there,' she said. 'On an ordinary night there'd be nine times as many, even at this hour. The streetlights would look like a double strand of pearls.'

'There's that, though.' Barbie had left one arm around her, but he lifted his free hand and pointed at the glow-belt. But for the Dome, where it ended abruptly, she thought it would have been a perfect circle. As it was, it looked like a horseshoe.

'Yes. Why do you suppose Cox hasn't mentioned it? They must see it on their satellite photos.' She considered. 'At least he hasn't said anything to me. Maybe he did to you.'

'Nope, and he would've. Which means they *don't* see it.'

'You think the Dome . . . what? Filters it out?'

'Something like that. Cox, the news networks, the outside world – they don't see it because they don't need to see it. I guess we do.'

'Is Rusty right, do you think? Are we just ants being victimized by cruel children with a magnifying glass? What kind of intelligent race

would allow their children to do such a thing to another intelligent race?'

'*We* think we're intelligent, but do they? We know that ants are social insects – home builders, colony builders, amazing architects. They work hard, as we do. They bury their dead, as we do. They even have race wars, the blacks against the reds. We know all this, but we don't assume ants are intelligent.'

She pulled his arm tighter around her, although it wasn't cold. 'Intelligent or not, it's wrong.'

'I agree. Most people would. Rusty knew it even as a child. But most kids don't have a moral fix on the world. That takes years to develop. By the time we're adults, most of us have put away childish things, which would include burning ants with a magnifying glass or pulling the wings off flies. Probably *their* adults have done the same. If they notice the likes of us at all, that is. When's the last time you bent over and really examined an anthill?'

'But still . . . if we found ants on Mars, or even microbes, we wouldn't destroy them. Because life in the universe is such a precious commodity. Every other planet in our system is a wasteland, for God's sake.'

Barbie thought if NASA found life on Mars, they would have no compunctions whatever about destroying it in order to put it on a microscope slide and study it, but he didn't say so. 'If we were more scientifically advanced – or more spiritually advanced, maybe that's what it actually takes to go voyaging around in the great what's-out-there – we might see that there's life everywhere. As many inhabited worlds and intelligent life-forms as there are anthills in this town.'

Was his hand now resting on the sideswell of her breast? She believed it was. It had been a long time since there had been a man's hand there, and it felt very good.

'The one thing I'm sure of is that there are other worlds than the ones we can see with our puny telescopes here on Earth. Or even with the Hubble. And . . . *they're* not here, you know. It's not an invasion. They're just looking. And . . . maybe . . . playing.'

'I know what that's like,' she said. 'To be played with.'

He was looking at her. Kissing distance. She wouldn't mind being kissed; no, not at all.

'What do you mean? Rennie?'

'Do you believe there are certain defining moments in a person's life? Watershed events that actually do change us?'

'Yes,' he said, thinking of the red smile his boot had left on

the Abdul's buttock. Just the ordinary asscheek of a man living his ordinary little life. 'Absolutely.'

'Mine happened in fourth grade. At Main Street Grammar.'

'Tell me.'

'It won't take long. That was the longest afternoon of my life, but it's a short story.'

He waited.

'I was an only child. My father owned the local newspaper – he had a couple of reporters and one ad salesman, but otherwise he was pretty much a one-man band, and that was just how he liked it. There was never any question that I'd take over when he retired. He believed it, my mother believed it, my teachers believed it, and of course *I* believed it. My college education was all planned out. Nothing so bush-league as the University of Maine, either, not for Al Shumway's girl. Al Shumway's girl was going to Princeton. By the time I was in the fourth grade, there was a Princeton pennant over my bed and I practically had my bags packed.

'Everyone – not excluding me – just about worshipped the ground I walked on. Except for my fellow fourth-graders, that was. At the time I didn't understand the causes, but now I wonder how I missed them. I was the one who sat in the front row and always raised my hand when Mrs Connaught asked a question, and I always got the answer right. I turned in my assignments ahead of time if I could, and volunteered for extra credit. I was a grade-grind and a bit of a wheedler. Once, when Mrs Connaught came back into class after having to leave us alone for a few minutes, little Jessie Vachon's nose was bleeding. Mrs Connaught said we'd all have to stay after unless someone told her who did it. I raised my hand and said it was Andy Manning. Andy punched Jessie in the nose when Jessie wouldn't lend Andy his art-gum eraser. And I didn't see anything wrong with that, because it was the truth. Are you getting this picture?'

'You're coming in five-by.'

'That little episode was the last straw. One day not long afterwards, I was walking home across the Common and a bunch of girls were laying for me inside the Peace Bridge. There were six of them. The ringleader was Lila Strout, who's now Lila Killian – she married Roger Killian, which serves her absolutely right. Don't ever let anyone tell you children can't carry their grudges into adulthood.

'They took me to the bandstand. I struggled at first, but then two of them – Lila was one, Cindy Collins, Toby Manning's mother, was the other – punched me. Not in the shoulder, the way kids usually do, either. Cindy hit me in the cheek, and Lila punched me

square in the right boob. How that hurt! I was just getting my breasts, and they ached even when they were left alone.

'I started crying. That's usually the signal – among kids, at least – that things have gone far enough. Not that day. When I started screaming, Lila said, "Shut up or you get worse." There was nobody to stop them, either. It was a cold, drizzly afternoon, and the Common was deserted except for us.

'Lila slapped me across the face hard enough to make my nose bleed and said, "Tattle-tale tit! All the dogs in town come to have a little bit!" And the other girls laughed. They said it was because I told on Andy, and at the time I thought it was, but now I see it was everything, right down to the way my skirts and blouses and even my hair ribbons matched. They wore clothes, I had outfits. Andy was just the last straw.'

'How bad was it?'

'There was slapping. Some hair-pulling. And . . . they spit on me. All of them. That was after my legs gave out and I fell down on the bandstand. I was crying harder than ever, and I had my hands over my face, but I felt it. Spit's warm, you know?'

'Yeah.'

'They were saying stuff like *teacher's pet* and *goody-goody-gumdrops* and *little miss shit-don't-stink*. And then, just when I thought they were done, Corrie Macintosh said, "Let's pants her!" Because I was wearing slacks that day, nice ones my mom got from a catalogue. I loved them. They were the kind of slacks you might see a coed wearing as she crossed the Quad at Princeton. At least that's what I thought then.

'I fought them harder that time, but they won, of course. Four of them held me down while Lila and Corrie pulled off my slacks. Then Cindy Collins started laughing and pointing and saying, "She's got frickin Poohbear on her underpants!" Which I did, along with Eeyore and Roo. They all started laughing, and . . . Barbie . . . I got smaller . . . and smaller . . . and smaller. Until the bandstand floor was like a great flat desert and I was an insect stuck in the middle of it. *Dying* in the middle of it.'

'Like an ant under a magnifying glass, in other words.'

'Oh, no! No, Barbie! It was *cold*, not hot. I was *freezing*. I had goosebumps on my legs. Corrie said, "Let's take her pannies, too!" but that was a little farther than they were prepared to go. As the next best thing, maybe, Lila took my nice slacks and threw them onto the roof of the bandstand. After that, they left. Lila was the last one to go. She said, "If you tattle this time, I'll get my brother's knife and cut off your bitch nose."'

'What happened?' Barbie asked. And yes, his hand was definitely resting against the side of her breast.

'What happened at first was just a scared little girl crouching there on the bandstand, wondering how she was going to get home without half the town seeing her in her silly baby underwear. I felt like the smallest, dumbest Chiclet who ever lived. I finally decided I'd wait until dark. My mother and father would be worried, they might even call the cops, but I didn't care. I was going to wait until dark and then sneak home by the sidestreets. Hide behind trees if anyone came along.

'I must have dozed a little bit, because all at once Kayla Bevins was standing over me. She'd been right in there with the rest, slapping and pulling my hair and spitting on me. She didn't say as much as the rest, but she was part of it. She helped hold me while Lila and Corrie pantsed me, and when they saw one of the legs of my slacks was hanging off the edge of the roof, Kayla got up on the railing and flipped it all the way up, so I wouldn't be able to reach it.

'I begged her not to hurt me anymore. I was beyond things like pride and dignity. I begged her not to pull my underwear down. Then I begged her to help me. She just stood there and listened, like I was nothing to her. I *was* nothing to her. I knew that then. I guess I forgot it over the years, but I've sort of reconnected with that particular home truth as a result of the Dome experience.

'Finally I ran down and just lay there sniffling. She looked at me a little longer, then pulled off the sweater she was wearing. It was an old baggy brown thing that hung almost to her knees. She was a big girl and it was a big sweater. She threw it down on top of me and said, "Wear it home, it'll look like a dress."

'That was all she said. And although I went to school with her for eight more years – all the way to graduation at Mills High – we never spoke again. But sometimes in my dreams I still hear her saying that one thing: *Wear it home, it'll look like a dress.* And I see her face. No hate or anger in it, but no pity, either. She didn't do it out of pity, and she didn't do it to shut me up. I don't know why she did it. I don't know why she even came back. Do you?'

'No,' he said, and kissed her mouth. It was brief, but warm and moist and quite terrific.

'Why did you do that?'

'Because you looked like you needed it, and I know I did. What happened next, Julia?'

'I put on the sweater and walked home – what else? And my parents were waiting.'

She lifted her chin pridefully.

'I never told them what happened, and they never found out. For about a week I saw the pants on my way to school, lying up there on the bandstand's little conical roof. Every time I felt the shame and the hurt – like a knife in my heart. Then one day they were gone. That didn't make the pain all gone, but after that it was a little better. Dull instead of sharp.

'I never told on those girls, although my father was furious and grounded me until June – I could go to school but nothing else. I was even forbidden the class trip to the Portland Museum of Art, which I'd been looking forward to all year. He told me I could go on the trip and have all my privileges restored if I named the kids who had "abused" me. That was his word for it. I wouldn't, though, and not just because dummying up is the kids' version of the Apostles' Creed.'

'You did it because somewhere deep inside, you thought you deserved what happened to you.'

'*Deserved* is the wrong word. I thought I'd bought and paid for it, which isn't the same thing at all. My life changed after that. I kept on getting good grades, but I stopped raising my hand so much. I never quit grade-grinding, but I stopped grade-*grubbing*. I could have been valedictorian in high school, but I backed off during the second semester of my senior year. Just enough to make sure Carlene Plummer would win instead of me. I didn't want it. Not the speech, not the attention that went with the speech. I made some friends, the best ones in the smoking area behind the high school.

'The biggest change was going to school in Maine instead of at Princeton . . . where I was indeed accepted. My father raved and thundered about how no daughter of his was going to go to a land-grant cow college, but I stood firm.'

She smiled.

'*Pretty* firm. But compromise is love's secret ingredient, and I loved my dad plenty. I loved them both. My plan had been to go to the University of Maine at Orono, but during the summer after my senior year, I made a last-minute application to Bates – what they call a Special Circumstances application – and was accepted. My father made me pay the late fee out of my own bank account, which I was glad to do, because there was finally a modicum of peace in the family after sixteen months of border warfare between the country of Controlling Parents and the smaller but well-fortified principality of Determined Teenager. I declared a journalism major, and that finished the job of healing the breach . . . which had really been there

ever since that day on the bandstand. My parents just never knew why. I'm not here in The Mill because of that day – my future at the *Democrat* was pretty much foreordained – but I am who I am in large part because of that day.'

She looked up at him again, her eyes shining with tears and defiance. 'I am not an ant, however. I am *not* an ant.'

He kissed her again. She wrapped her arms around him tightly and gave back as good as she got. And when his hand tugged her blouse from the waistband of her slacks and then slipped up across her midriff to cup her breast, she gave him her tongue. When they broke apart, she was breathing fast.

'Want to?' he asked.

'Yes. Do you?'

He took her hand and put it on his jeans, where how much he wanted to was immediately evident.

A minute later he was poised above her, resting on his elbows. She took him in hand to guide him in. 'Take it easy on me, Colonel Barbara. I've kind of forgotten how this thing goes.'

'It's like riding a bicycle,' Barbie said.

Turned out he was right.

15

When it was over, she lay with her head on his arm, looking up at the pink stars, and asked what he was thinking about.

He sighed. 'The dreams. The visions. The whatever-they-are. Do you have your cell phone?'

'Always. And it's holding its charge nicely, although for how much longer I couldn't say. Who are you planning to call? Cox, I suppose.'

'You suppose correctly. Do you have his number in memory?'

'Yes.'

Julia reached over for her discarded pants and pulled the phone off her belt. She called COX and handed the phone to Barbie, who started talking almost at once. Cox must have answered on the first ring.

'Hello, Colonel. It's Barbie. I'm out. I'm going to take a chance and tell you our location. It's Black Ridge. The old McCoy orchard. Do you have that on your . . . you do. Of course you do. And you have satellite images of the town, right?'

He listened, then asked Cox if the images showed a horseshoe of light encircling the ridge and ending at the TR-90 border. Cox

replied in the negative, and then, judging from the way Barbie was listening, asked for details.

'Not now,' Barbie said. 'Right now I need you to do something for me, Jim, and the sooner the better. You'll need a couple of Chinooks.'

He explained what he wanted. Cox listened, then replied.

'I can't go into it right now,' Barbie said, 'and it probably wouldn't make a lot of sense if I did. Just take it from me that some very dinky-dau shit is going on in here, and I believe that worse is on the way. Maybe not until Halloween, if we're lucky. But I don't think we're going to be lucky.'

16

While Barbie was speaking with Colonel James Cox, Andy Sanders was sitting against the side of the supply building behind WCIK, looking up at the abnormal stars. He was high as a kite, happy as a clam, cool as a cucumber, other similes may apply. Yet there was a deep sadness — oddly tranquil, almost comforting — running beneath, like a powerful underground river. He had never had a premonition in his whole prosy, practical, workaday life. But he was having one now. This was his last night on earth. When the bitter men came, he and Chef Bushey would go. It was simple, and not really all that bad.

'I was in the bonus round, anyway,' he said. 'Have been ever since I almost took those pills.'

'What's that, Sanders?' Chef came strolling along the path from the rear of the station, shining a flashlight beam just ahead of his bare feet. The froggy pajama pants still clung precariously to the bony wings of his hips, but something new had been added: a large white cross. It was tied around his neck on a rawhide loop. Slung over his shoulder was GOD'S WARRIOR. Two grenades swung from the stock on another length of rawhide. In the hand not holding the flashlight, he carried the garage door opener.

'Nothing, Chef,' Andy said. 'I was just talking to myself. Seems like I'm the only one who listens these days.'

'That's bullshit, Sanders. Utter and complete bullshit-aroonie. *God* listens. He's tapped into souls the way the FBI's tapped into phones. I listen, too.'

The beauty of this — and the comfort — made gratitude well up in Andy's heart. He offered the bong. 'Hit this shit. It'll get your boiler lit.'

Chef uttered a hoarse laugh, took a deep drag on the glasspipe,

held the smoke in, then coughed it out. 'Bazoom!' he said. 'God's power! Power by the *hour*, Sanders!'

'Got that right,' Andy agreed. It was what Dodee always said, and at the thought of her, his heart broke all over again. He wiped his eyes absently. 'Where did you get the cross?'

Chef pointed the flashlight toward the radio station. 'Coggins has got an office in there. The cross was in his desk. The top drawer was locked, but I forced it open. You know what else was in there, Sanders? Some of the *skankiest* jerk-off material I have ever seen.'

'Kids?' Andy asked. He wouldn't be surprised. When the devil got a preacher, he was apt to fall low, indeed. Low enough to put on a tophat and crawl under a rattlesnake.

'Worse, Sanders.' He lowered his voice. 'Orientals.'

Chef picked up Andy's AK-47, which had been lying across Andy's thighs. He shone the light on the stock, where Andy had carefully printed CLAUDETTE with one of the radio station's Magic Markers.

'My wife,' Andy said. 'She was the first Dome casualty.'

Chef gripped him by the shoulder. 'You're a good man to remember her, Sanders. I'm glad God brought us together.'

'Me too.' Andy took back the bong. 'Me too, Chef.'

'You know what's apt to happen tomorrow, don't you?'

Andy gripped CLAUDETTE's stock. It was answer enough.

'They'll most likely be wearing body armor, so if we have to go to war, aim for the head. No single-shot stuff; just hose em down. And if it looks like they're going to overrun us . . . you know what comes next, right?'

'Right.'

'To the end, Sanders?' Chef raised the garage door opener in front of his face and shone the flashlight on it.

'To the end,' Andy agreed. He touched the door opener with CLAUDETTE's muzzle.

17

Ollie Dinsmore snapped awake from a bad dream, knowing something was wrong. He lay in bed, looking at the wan and somehow dirty first light peeping through the window, trying to persuade himself that it was just the dream, some nasty nightmare he couldn't quite recall. Fire and shouting was all he could remember.

Not shouting. Screaming.

His cheap alarm clock was ticking away on the little table beside

his bed. He grabbed it. Quarter of six and no sound of his father moving around in the kitchen. More telling, no smell of coffee. His father was always up and dressed by five fifteen at the very latest ('Cows won't wait' was Alden Dinsmore's favorite scripture), and there was always coffee brewing by five thirty.

Not this morning.

Ollie got up and pulled on yesterday's jeans. 'Dad?'

No answer. Nothing but the tick of the clock, and — distant — the lowing of one disaffected bossy. Dread settled over the boy. He told himself there was no reason for it, that his family — all together and perfectly happy only a week ago — had sustained all the tragedies God would allow, at least for awhile. He told himself, but himself didn't believe it.

'Daddy?'

The generator out back was still running and he could see the green digital readouts on both the stove and the microwave when he went into the kitchen, but the Mr Coffee stood dark and empty. The living room was empty, too. His father had been watching TV when Ollie turned in last night, and it was still on, although muted. Some crooked-looking guy was demonstrating the new and improved ShamWow. 'You're spending forty bucks a month on paper towels and throwing your money away,' the crooked-looking guy said from that other world where such things might matter.

He's out feeding the cows, that's all.

Except wouldn't he have turned off the TV to save electricity? They had a big tank of propane, but it would only last so long.

'*Dad?*'

Still no answer. Ollie crossed to the window and looked out at the barn. No one there. With increasing trepidation, he went down the back hall to his parents' room, steeling himself to knock, but there was no need. The door was open. The big double bed was messy (his father's eye for mess seemed to fall blind once he stepped out of the barn) but empty. Ollie started to turn away, then saw something that scared him. A wedding portrait of Alden and Shelley had hung on the wall in here for as long as Ollie could remember. Now it was gone, with only a brighter square of wallpaper to mark where it had been.

That's nothing to be scared of.

But it was.

Ollie continued on down the hall. There was one more door, and this one, which had stood open for the last year, was now closed. Something yellow had been tacked to it. A note. Even before he was

close enough to read it, Ollie recognized his father's handwriting. He should have; there had been enough notes in that big scrawl waiting for him and Rory when they came home from school, and they always ended the same way.

Sweep the barn, then go play. Weed the tomatoes and beans, then go play. Take in your mother's washing, and mind you don't drag it in the mud. Then go play.

Playtime's over, Ollie thought dismally.

But then a hopeful thought occurred to him: maybe he was dreaming. Wasn't it possible? After his brother's death by ricochet and his mother's suicide, why wouldn't he dream of waking to an empty house?

The cow lowed again, and even that was like a sound heard in a dream.

The room behind the door with the note on it had been Grampy Tom's. Suffering the slow misery of congestive heart failure, he had come to live with them when he could no longer do for himself. For a while he'd been able to hobble as far as the kitchen to take meals with the family, but in the end he'd been bedridden, first with a plastic thingie jammed up his nose — it was called a candelabra, or something like that — and then with a plastic mask over his face most of the time. Rory once said he looked like the world's oldest astronaut, and Mom had smacked his face for him.

At the end they had all taken turns changing his oxygen tanks, and one night Mom found him dead on the floor, as if he'd been trying to get up and had died of it. She screamed for Alden, who came, looked, listened to the old man's chest, then turned off the oxy. Shelley Dinsmore began to cry. Since then, the room had mostly been closed.

Sorry was what the note on the door said. *Go to town Ollie. The Morgans or Dentons or Rev Libby will take you in.*

Ollie looked at the note for a long time, then turned the knob with a hand that didn't seem to be his own, hoping it wouldn't be messy.

It wasn't. His father lay on Grampy's bed with his hands laced together on his chest. His hair was combed the way he combed it when he was going to town. He was holding the wedding picture. One of Grampy's old green oxygen tanks still stood in the corner; Alden had hung his Red Sox cap, the one that said WORLD SERIES CHAMPS, over the valve.

Ollie shook his father's shoulder. He could smell booze, and for a few seconds hope (always stubborn, sometimes hateful) lived in his heart again. Maybe he was only drunk.

'Dad? *Daddy?* Wake up!'

Ollie could feel no breath against his cheek, and now saw that his father's eyes weren't completely closed; little crescents of white peeped out between the upper and lower lids. There was a smell of what his mother called eau de pee.

His father had combed his hair, but as he lay dying he had, like his late wife, pissed his pants. Ollie wondered if knowing that might happen would have stopped him.

He backed slowly away from the bed. Now that he wanted to feel like he was having a bad dream, he didn't. He was having a bad *reality*, and that was something from which you could not wake. His stomach clenched and a column of vile liquid rose up his throat. He ran for the bathroom, where he was confronted by a glare-eyed intruder. He almost screamed before recognizing himself in the mirror over the sink.

He knelt at the toilet, grasping what he and Rory had called Grampy's crip-rails, and vomited. When it was out of him, he flushed (thanks to the gennie and a good deep well, he *could* flush), lowered the lid, and sat on it, trembling all over. Beside him, in the sink, were two of Grampy Tom's pill bottles and a bottle of Jack Daniels. All the bottles were empty. Ollie picked up one of the pill bottles. PERCOCET, the label said. He didn't bother with the other one.

'I'm alone now,' he said.

The Morgans or Dentons or Rev Libby will take you in.

But he didn't want to be taken in — it sounded like what his mom would have done to a piece of clothing in her sewing room. He had sometimes hated this farm, but he had always loved it more. The farm had him. The farm and the cows and the woodpile. They were his and he was theirs. He knew that just as he knew that Rory would have gone away to have a bright and successful career, first at college and then in some city far from here where he would go to plays and art galleries and things. His kid brother had been smart enough to make something of himself in the big world; Ollie himself might have been smart enough to stay ahead of the bank loans and credit cards, but not much more.

He decided to go out and feed the cows. He would treat them to double mash, if they would eat it. There might even be a bossy or two who'd want to be milked. If so, he might have a little straight from the teat, as he had when he was a kid.

After that, he would go as far down the big field as he could, and throw rocks at the Dome until the people started showing up to visit with their relatives. *Big doins*, his father would have said. But

there was no one Ollie wanted to see, except maybe Private Ames from South Cah'lina. He knew that Aunt Lois and Uncle Scooter might come – they lived just over in New Gloucester – but what would he say if they did? *Hey, Unc, they're all dead but me, thanks for coming?*

No, once the people from outside the Dome started to arrive, he reckoned he'd go up to where Mom was buried and dig a new hole nearby. That would keep him busy, and maybe by the time he went to bed, he'd be able to sleep.

Grampy Tom's oxygen mask was dangling from the hook on the bathroom door. His mother had carefully washed it clean and hung it there; who knew why. Looking at it, the truth finally crashed down on him, and it was like a piano hitting a marble floor. Ollie clapped his hands over his face and began to rock back and forth on the toilet seat, wailing.

18

Linda Everett packed up two cloth grocery sacks' worth of canned stuff, almost put them by the kitchen door, then decided to leave them in the pantry until she and Thurse and the kids were ready to go. When she saw the Thibodeau kid coming up the driveway, she was glad she'd done so. That young man scared the hell out of her, but she would have had much more to fear if he'd seen two bags filled with soup and beans and tuna fish.

Going somewhere, Mrs Everett? Let's talk about that.

The trouble was, of all the new cops Randolph had taken on, Thibodeau was the only one who was smart.

Why couldn't Rennie have sent Searles?

Because Melvin Searles was dumb. Elementary, my dear Watson.

She glanced out the kitchen window into the backyard and saw Thurston pushing Jannie and Alice on the swings. Audrey lay nearby, with her snout on one paw. Judy and Aidan were in the sandbox. Judy had her arm around Aidan and appeared to be comforting him. Linda loved her for that. She hoped she could get Mr Carter Thibodeau satisfied and on his way before the five people in the backyard even knew he'd been there. She hadn't acted since playing Stella in *A Streetcar Named Desire* back in junior college, but she was going onstage again this morning. The only good review she wanted was her continued freedom and that of the people out back.

She hurried through the living room, fixing what she hoped was a suitably anxious look on her face before opening the door.

Carter was standing on the WELCOME mat with his fist raised to knock. She had to look up at him; she was five-nine, but he was over half a foot taller.

'Well, look at you,' he said, smiling. 'All brighteyed and bushy-tailed, and it's not even seven-thirty.'

He did not feel that much like smiling; it hadn't been a product-ive morning. The preacher lady was gone, the newspaper bitch was gone, her two pet reporters seemed to have disappeared, and so had Rose Twitchell. The restaurant was open and the Wheeler kid was minding the store, but said he had no clue as to where Rose might be. Carter believed him. Anse Wheeler looked like a dog who's forgotten where he buried his favorite bone. Judging by the horrible smells coming from the kitchen, he had no clue when it came to cooking, either. Carter had gone around back, checking for the Sweet-briar van. It was gone. He wasn't surprised.

After the restaurant he'd checked the department store, hammering first in front, then in back, where some careless clerk had left a bunch of roofing material rolls out for any Light-Finger Harry to steal. Except when you thought about it, who'd bother with roofing material in a town where it no longer rained?

Carter had thought Everett's house would also be a dry hole, only went there so he could say he'd followed the boss's instructions to the letter, but he had heard kids in the backyard as he walked up the driveway. Also, her van was there. No doubt it was hers; one of those stick-on bubble-lights was sitting on the dash. The boss had said moderate questioning, but since Linda Everett was the only one he could find, Carter thought he might go on the hard side of moderate. Like it or not – and she wouldn't – Everett would have to answer for the ones he hadn't been able to find as well as herself. But before he could open his mouth, she was talking. Not only talking, but taking him by the hand, actually pulling him inside.

'Have you found him? Please, Carter, is Rusty okay? If he's not . . .' She let go of his hand. 'If he's not, keep your voice down, the kids are out back and I don't want them any more upset than they are already.'

Carter walked past her into the kitchen and peered out through the window over the sink. 'What's the hippie doctor doing here?'

'He brought the kids he's taking care of. Caro brought them to the meeting last night, and . . . you know what happened to her.'

This speed-rap babble was the last thing Carter had expected. Maybe she didn't know anything. The fact that she'd been at the meeting last night and was still here this morning certainly argued

in favor of the idea. Or maybe she was just trying to keep him off-balance. Making a what-did-you-call-it, preemptive strike. It was possible; she was smart. You only had to look at her to see that. Also sort of pretty, for an older babe.

'Have you found him? Did Barbara . . .' She found it easy to put a catch in her voice. 'Did Barbara hurt him? Hurt him and leave him somewhere? You can tell me the truth.'

He turned to her, smiling easily in the diluted light coming in through the window. 'You go first.'

'What?'

'You go first, I said. You tell *me* the truth.'

'All I know is he's gone.' She let her shoulders slump. 'And you don't know where. I can see you don't. What if Barbara kills him? What if he's killed him alre—'

Carter grabbed her, spun her around as he would have spun a partner at a country dance, and hoisted her arm behind her back until her shoulder creaked. It was done with such eerie, liquid speed that she had no idea he meant to do it until it was done.

He knows! He knows and he's going to hurt me! Hurt me until I tell—

His breath was hot in her ear. She could feel his beard-stubble tickling her cheek as he spoke, and it made her break out in shivers.

'Don't bullshit a bullshitter, Mom.' It was little more than a whisper. 'You and Wettington have always been tight – hip to hip and tit to tit. You want to tell me you didn't know she was going to break your husband out? That what you're saying?'

He jerked her arm higher and Linda had to bite her lip to stifle a scream. The kids were right out there, Jannie calling over her shoulder for Thurse to push her higher. If they heard a scream from the house—

'If she'd told me, I would have told Randolph,' she panted. 'Do you think I'd risk Rusty getting hurt when he didn't do anything?'

'He did plenty. Threatened to withhold medicine from the boss unless he stepped down. Fucking blackmail. I *heard* it.' He jerked her arm again. A little moan escaped her. 'Got anything to say about that? *Mom?*'

'Maybe he did. I haven't seen him or talked to him, so how would I know? But he's still the closest thing this town has to a doctor. Rennie never would have executed him. Barbara, maybe, but not Rusty. I knew it, and you must know it, too. Now let me go.'

For a moment he almost did. It all hung together. Then he had a better idea, and marched her to the sink. 'Bend over, Mom.'

'No!'

He jerked her arm up again. It felt like the ball of her shoulder was going to tear right out of its socket. 'Bend *over*. Like you're going to wash that pretty blond hair.'

'Linda?' Thurston called. 'How are you doing?'

Jesus, don't let him ask about the groceries. Please, Jesus.

And then another thought struck her: Where were the kids' suitcases? Each of the girls had packed a little traveling case. What if they were sitting in the living room?

'Tell him you're fine,' Carter said. 'We don't want to bring the hippie into this. Or the kids. Do we?'

God, no. But where were their suitcases?

'Fine!' she called.

'Almost finished?' he called.

Oh, Thurse, shut up!

'I need five minutes!'

Thurston stood there looking like he might say something else, but then went back to pushing the girls.

'Good job.' He was pressing against her now, and he had a hardon. She could feel it against the seat of her jeans. It felt as big as a monkey wrench. Then he pulled away. 'Almost finished with what?'

She almost said *making breakfast*, but the used bowls were in the sink. For a moment her mind was a roaring blank and she almost wished he'd put his damn boner on her again, because when men were occupied with their little heads, their big ones switched to a test pattern.

But he jerked her arm up again. 'Talk to me, Mom. Make Dad happy.'

'Cookies!' she gasped. 'I said I'd make cookies. The kids asked!'

'Cookies with no power,' he mused. 'Best trick of the week.'

'They're the no-bake kind! Look in the pantry, you son of a bitch!' If he looked, he would indeed find no-bake oatmeal cookie mix on the shelf. But of course if he looked down, he would also see the supplies she had packed. And he might well do that, if he registered how many of the pantry shelves were now half or wholly empty.

'You don't know where he is.' The erection was back against her. With the throbbing pain in her shoulder, she hardly registered it. 'You're sure about that.'

'Yes. I thought you knew. I thought you came to tell me he was hurt or d-d—'

'I think you're lying your pretty round ass off.' Her arm jerked up higher, and now the pain was excruciating, the need to cry out

unbearable. But somehow she did bear it. 'I think you know plenty, Mom. And if you don't tell me, I'm going to rip your arm right out of its socket. Last chance. Where is he?'

Linda resigned herself to having her arm or shoulder broken. Maybe both. The question was whether or not she could keep from screaming, which would bring the Js and Thurston on the run. Head down, hair dangling in the sink, she said: 'Up my ass. Why don't you kiss it, motherfucker? Maybe he'll pop out and say hi.'

Instead of breaking her arm, Carter laughed. That was a good one, actually. And he believed her. She would never dare to talk to him like that unless she was telling the truth. He only wished she wasn't wearing Levi's. Fucking her probably still would have been out of the question, but he certainly could have gotten a good deal closer to it if she'd been in a skirt. Still, a dry hump wasn't the worst way to start Visitors Day, even if it was against a pair of jeans instead of some nice soft panties.

'Hold still and keep your mouth shut,' he said. 'If you can do that, you may get out of this in one piece.'

She heard the jingle of his belt-buckle and the rasp of his zipper. Then what had been rubbing against her was rubbing again, only now with a lot less cloth between them. Some faint part of her was glad that at least she'd put on a fairly new pair of jeans; she could hope he'd give himself a nasty rug rash.

Just as long as the Js don't come in and see me like this.

Suddenly he pressed tighter and harder. The hand not holding her arm groped her breast. 'Hey, Mom,' he murmured. 'Hey-hey, my-my.' She felt him spasm, although not the wetness that followed such spasms as day follows night; the jeans were too thick for that, thank God. A moment later the upward pressure on her arm finally loosened. She could have cried with relief but didn't. Wouldn't. She turned around. He was buckling his belt again.

'Might want to change those jeans before you go making any cookies. At least, I would if I were you.' He shrugged. 'But who knows – maybe you like it. Different strokes for different folks.'

'Is this how you keep the law around here now? Is this how your boss wants the law kept?'

'He's more of a big-picture man.' Carter turned to the pantry, and her racing heart seemed to stop. Then he glanced at his watch and yanked up his zipper. 'You call Mr Rennie or me if your husband gets in touch. It's the best thing to do, believe me. If you don't, and I find out, the next load I shoot is going straight up the old wazoo. Whether the kids are watching or not. I don't mind an audience.'

'Get out of here before they come in.'

'Say please, Mom.'

Her throat worked, but she knew Thurston would soon be checking on her, and she got it out. 'Please.'

He headed for the door, then looked into the living room and stopped. He had seen the little suitcases. She was sure of it.

But something else was on his mind.

'And turn in the bubble light I saw in your van. In case you forgot, you're fired.'

19

She was upstairs when Thurston and the kids came in three minutes later. The first thing she did was look in the kids' room. The traveling cases were on their beds. Judy's teddy was sticking out of one.

'Hey, kids!' she called down gaily. *Toujours gai,* that was her. 'Look at some picture-books, and I'll be down in a few!'

Thurston came to the foot of the stairs. 'We really ought to—'

He saw her face and stopped. She beckoned him.

'Mom?' Janelle called. 'Can we have the last Pepsi if I share it out?'

Although she ordinarily would have vetoed the idea of soda this early, she said: 'Go ahead, but don't spill!'

Thurse came halfway up the stairs. 'What happened?'

'Keep your voice down. There was a cop. Carter Thibodeau.'

'The big tall one with the broad shoulders?'

'That's him. He came to question me—'

Thurse paled, and Linda knew he was replaying what he'd called to her when he thought she was alone.

'I think we're okay,' she said, 'but I need you to make sure he's really gone. He was walking. Check the street and over the back fence into the Edmundses' yard. I have to change my pants.'

'What did he do to you?'

'*Nothing!*' she hissed. 'Just check to make sure he's gone, and if he is, we are getting the holy hell out of here.'

20

Piper Libby let go of the box and sat back, looking at the town with tears welling in her eyes. She was thinking of all those late-night prayers to The Not-There. Now she knew that had been nothing

but a silly, sophomoric joke, and the joke, it turned out, was on her. There *was* a There there. It just wasn't God.

'Did you see them?'

She started. Norrie Calvert was standing there. She looked thinner. Older, too, and Piper saw that she was going to be beautiful. To the boys she hung with, she probably already was.

'Yes, honey, I did.'

'Are Rusty and Barbie right? Are the people looking at us just kids?'

Piper thought, *Maybe it takes one to know one.*

'I'm not a hundred percent sure, honey. Try it for yourself.'

Norrie looked at her. 'Yeah?'

And Piper – not knowing if she was doing right or doing wrong – nodded. 'Yeah.'

'If I get . . . I don't know . . . weird or something, will you pull me back?'

'Yes. And you don't have to if you don't want to. It's not a dare.'

But to Norrie it was. And she was curious. She knelt in the high grass and gripped the box firmly on either side. She was immediately galvanized. Her head snapped back so hard Piper heard the vertebrae in her neck crack like knuckles. She reached for the girl, then dropped her hand as Norrie relaxed. Her chin went to her breastbone and her eyes, which had squeezed shut when the shock hit her, opened again. They were distant and hazy.

'Why are you doing this?' she asked. *'Why?'*

Piper's arms broke out in gooseflesh.

'Tell me!' A tear fell from one of Norrie's eyes and struck the top of the box, where it sizzled and then disappeared. '*Tell* me!'

Silence spun out. It seemed very long. Then the girl let go and rocked backward until her butt sat on her heels. 'Kids.'

'For sure?'

'For sure. I couldn't tell how many. It kept changing. They have leather hats on. They have bad mouths. They were wearing goggles and looking at their own box. Only theirs is like a television. They see *everywhere*, all over town.'

'How do you know?'

Norrie shook her head helplessly. 'I can't tell you, but I know it's true. They're bad kids with bad mouths. I never want to touch that box again. I feel so *dirty*.' She began to cry.

Piper held her. 'When you asked them why, what did they say?'

'Nothing.'

'Did they hear you, do you think?'

'They heard. They just didn't care.'

From behind them came a steady beating sound, growing louder. Two transport helicopters were coming in from the north, almost skimming the TR-90 treetops.

'They better watch out for the Dome or they'll crash like the airplane!' Norrie cried.

The copters did not crash. They reached the edge of safe airspace some two miles distant, then began to descend.

21

Cox had told Barbie of an old supply road that ran from the McCoy orchard to the TR-90 border, and said it still looked passable. Barbie, Rusty, Rommie, Julia, and Pete Freeman drove along it around seven thirty Friday morning. Barbie trusted Cox, but not necessarily pictures of an old truck-track snapped from two hundred miles up, so they'd taken the van Ernie Calvert had stolen from Big Jim Rennie's lot. *That* one Barbie was perfectly willing to lose, if it got stuck. Pete was sans camera; his digital Nikon had ceased to work when he got close to the box.

'ETs don't like the paparazzi, broha,' Barbie said. He thought it was a moderately funny line, but when it came to his camera, Pete had no sense of humor.

The ex-phone company van made it to the Dome, and now the five of them watched as the two huge CH-47s waddled toward an overgrown hayfield on the TR-90 side. The road continued over there, and the Chinooks' rotors churned dust up in great clouds. Barbie and the others shielded their eyes, but that was only instinct, and unnecessary; the dust billowed as far as the Dome and then rolled off to either side.

The choppers alit with the slow decorum of overweight ladies settling into theater seats a tad too small for their bottoms. Barbie heard the hellish *screeee* of metal on a protruding rock, and the copter to the left lumbered thirty yards sideways before trying again.

A figure jumped from the open bay of the first one and strode through the cloud of disturbed grit, waving it impatiently aside. Barbie would have known that no-nonsense little fireplug anywhere. Cox slowed as he approached, and put out one hand like a blindman feeling for obstructions in the dark. Then he was wiping away the dust on his side.

'It's good to see you breathing free air, Colonel Barbara.'

'Yes, sir.'

Cox shifted his gaze. 'Hello, Ms Shumway. Hello, you other Friends of Barbara. I want to hear everything, but it will have to be quick – I've got a little dog-and-pony show going on across town, and I want to be there for it.'

Cox jerked a thumb over his shoulder where the unloading had already begun: dozens of Air Max fans with attached generators. They were big ones, Barbie saw with relief, the kind used for drying tennis courts and racetrack pit areas after heavy rains. Each was bolted to its own two-wheeled dolly-platform. The gennies looked twenty-horsepower at most. He hoped that would be enough.

'First, I want you to tell me *those* aren't going to be necessary.'

'I don't know for sure,' Barbie said, 'but I'm afraid they might be. You may want to get some more on the 119 side, where the townspeople are meeting their relatives.'

'By tonight,' Cox said. 'That's the best we can do.'

'Take some of these,' Rusty said. 'If we need them all, we'll be in extremely deep shit, anyway.'

'Can't happen, son. Maybe if we could cut across Chester's Mill airspace, but if we could do that, there wouldn't be a problem, would there? And putting a line of generator-powered industrial fans where the visitors are going to be kind of defeats the purpose. Nobody would be able to hear anything. Those babies are *loud*.' He glanced at his watch. 'Now how much can you tell me in fifteen minutes?'

HALLOWEEN COMES EARLY

1

At quarter to eight, Linda Everett's almost-new Honda Odyssey Green rolled up to the loading dock behind Burpee's Department Store. Thurse was riding shotgun. The kids (far too silent for children setting off on an adventure) were in the backseat. Aidan was hugging Audrey's head. Audi, probably sensing the little boy's distress, bore this patiently.

Linda's shoulder was still throbbing in spite of three aspirin, and she couldn't get Carter Thibodeau's face out of her mind. Or his smell: a mixture of sweat and cologne. She kept expecting him to pull up behind her in one of the town police cars, blocking their retreat. *The next load I shoot is going straight up the old wazoo. Whether the kids are watching or not.*

He'd do it, too. He would. And while she couldn't get all the way out of town, she was wild to put as much distance between herself and Rennie's new Man Friday as possible.

'Grab a whole roll, and the metal-snips,' she told Thurse. 'They're under that milk box. Rusty told me.'

Thurston had opened the door, but now he paused. 'I can't do that. What if somebody else needs them?'

She wasn't going to argue; she'd probably wind up screaming at him and scaring the children.

'Whatever. Just hurry up. This is like a box canyon.'

'As fast as I can.'

Yet it seemed to take him forever to snip pieces of the lead roll, and she had to restrain herself from leaning out the window and asking if he had been born a prissy old lady or just grew into one.

Keep it shut. He lost someone he loved last night.

Yes, and if they didn't hurry, she might lose everything. There were already people on Main Street, heading out toward 119 and the Dinsmore dairy farm, intent on getting the best places. Linda jumped every time a police loudspeaker blared, 'CARS ARE NOT ALLOWED ON THE HIGHWAY! UNLESS YOU ARE PHYSICALLY DISABLED, YOU MUST WALK.'

Thibodeau was smart, and he had sniffed something. What if he came back and saw that her van was gone? Would he look for it? Meanwhile, Thurse just kept snipping pieces of lead from the roofing roll. He turned and she thought he was done, but he was only visually measuring the windshield. He started cutting again.

Whacking off another piece. Maybe he was actually *trying* to drive her mad. A silly idea, but once it had entered her mind it wouldn't leave.

She could still feel Thibodeau rubbing against her bottom. The tickle of his stubble. The fingers squeezing her breast. She told herself not to look at what he'd left on the seat of her jeans when she took them off, but she couldn't help it. The word that rose in her mind was *mansplat*, and she'd found herself in a short, grim struggle to keep her breakfast down. Which also would have pleased him, if he had known.

Sweat sprang out on her brow.

'Mom?' Judy, right in her ear. Linda jumped and uttered a cry. 'I'm sorry, I didn't mean to jump you. Can I have something to eat?'

'Not now.'

'Why does that man keep loudspeakering?'

'Honey, I can't talk to you right now.'

'Are you bummin?'

'Yes. A little. Now sit back.'

'Are we going to see Daddy?'

'Yes.' *Unless we get caught and I get raped in front of you.* 'Now sit back.'

Thurse was finally coming. Thank God for small favors. He appeared to be carrying enough cut squares and rectangles of lead to armor a tank. 'See? That wasn't so ba— oh, shit.'

The kids giggled, the sound like rough files sawing away at Linda's brain. 'Quarter in the swear-jar, Mr Marshall,' Janelle said.

Thurse was looking down, bemused. He had stuck the metal-snips in his belt.

'I'll just put these back under the milk box—'

Linda snatched them before he could finish, restrained a moment-ary urge to bury them up to the handles in his narrow chest – admirable restraint, she thought – and got out to put them away herself.

As she did, a vehicle slid in behind the van, blocking access to West Street, the only way out of this cul-de-sac.

2

Atop Town Common Hill, just below the **Y**-intersection where Highland Avenue split off from Main Street, Jim Rennie's Hummer sat idling. From below came the amplified exhortations for people to leave their cars and walk unless they were disabled. People were

flowing down the sidewalks, many with packs on their backs. Big Jim eyed them with that species of longsuffering contempt which is felt only by caretakers who do their jobs not out of love but out of duty.

Going against the tide was Carter Thibodeau. He was striding in the middle of the street, every now and then shoving someone out of his way. He reached the Hummer, got in on the passenger side, and armed sweat from his forehead. 'Man, that AC feels good. Not hardly eight in the morning and it's got to be seventy-five degrees out there already. And the air smells like a frickin ashtray. 'Scuse the language, boss.'

'What kind of luck did you have?'

'The bad kind. I talked to Officer Everett. *Ex*-Officer Everett. The others are in the breeze.'

'Does she know anything?'

'No. She hasn't heard from the doc. And Wettington treated her like a mushroom, kept her in the dark and fed her shit.'

'You're sure?'

'Yeah.'

'Her kids there with her?'

'Yup. The hippy, too. The one who straightened out your ticker. Plus the two kids Junior and Frankie found out at the Pond.' Carter thought about this. 'With his chick dead and her husband gone, him and Everett'll probably be boinking each other's brains out by the end of the week. If you want me to take another run at her, boss, I will.'

Big Jim flicked a single finger up from the steering wheel to show that wouldn't be necessary. His attention was elsewhere. 'Look at them, Carter.'

Carter couldn't very well help it. The foot traffic out of town was thickening every minute.

'Most of them will be at the Dome by nine, and their cotton-picking relatives won't arrive until ten. At the earliest. By then they'll be good and thirsty. By noon the ones who didn't think to bring water will be drinking cow-piddle out of Alden Dinsmore's pond, God love them. God *must* love them, because the majority are too dumb to work and too nervous to steal.'

Carter barked laughter.

'That's what we've got to deal with,' Rennie said. 'The mob. The cotton-picking rabble. What do they want, Carter?'

'I don't know, boss.'

'Sure you do. They want food, Oprah, country music, and a

warm bed to thump uglies in when the sun goes down. So they can make more just like them. And goodness me, here comes another member of the tribe.'

It was Chief Randolph, trudging up the hill and mopping his bright red face with a handkerchief.

Big Jim was now in full lecture mode. 'Our job, Carter, is to take care of them. We may not like it, we may not always think they're worth it, but it's the job God gave us. Only to do it, we have to take care of ourselves first, and that's why a good deal of fresh fruit and veg from Food City was stored in the Town Clerk's office two days ago. You didn't know that, did you? Well, that's all right. You're a step ahead of them and I'm a step ahead of you and that's how it's supposed to be. The lesson is simple: the Lord helps those that help themselves.'

'Yes, sir.'

Randolph arrived. He was puffing, there were circles under his eyes, and he appeared to have lost weight. Big Jim pushed the button that ran down his window.

'Step in, Chief, grab yourself some AC.' And when Randolph started for the front passenger seat, Big Jim added: 'Not there, Carter's sitting there.' He smiled. 'Get in back.'

3

It wasn't a police car that had pulled up behind the Odyssey van; it was the hospital ambulance. Dougie Twitchell was at the wheel. Ginny Tomlinson was in the passenger seat with a sleeping baby in her lap. The rear doors opened and Gina Buffalino got out. She was still in her candy-striper uniform. The girl who followed her, Harriet Bigelow, wore jeans and a tee-shirt that said U.S. OLYMPIC KISSING TEAM.

'What . . . what . . .' That seemed to be all Linda was capable of. Her heart was racing, the blood pounding so hard in her head that she seemed to feel her eardrums flapping.

Twitch said, 'Rusty called and told us to get out to the orchard at Black Ridge. I didn't even know there was an orchard up there, but Ginny did, and . . . Linda? Honey, you're white as a ghost.'

'I'm okay,' Linda said, and realized she was on the verge of fainting. She pinched her earlobes, a trick Rusty had taught her a long time ago. Like many of his folk-remedies (beating down wens with the spine of a heavy book was another), it worked. When she spoke again, her voice seemed both nearer and somehow *realer*. 'He told you to come here first?'

'Yes. To get some of that.' He pointed to the lead roll sitting on the loading dock. 'Just to be on the safe side is what he said. But I'll need those snips.'

'Uncle Twitch!' Janelle cried, and dashed into his arms.

'What's up, Tiger Lily?' He hugged her, swung her, set her down. Janelle peered into the passenger window at the baby. 'What's *her* name?'

'It's a he,' Ginny said. 'His name's Little Walter.'

'Cool!'

'Jannie, get back in the van, we have to go,' Linda said.

Thurse asked, 'Who's minding the store, you guys?'

Ginny looked embarrassed. 'Nobody. But Rusty said not to worry, unless there was somebody in need of constant care. Other than Little Walter, there wasn't. So I grabbed the baby and we boogied. We might be able to go back later, Twitch says.'

'*Somebody* better be able to,' Thurse said gloomily. Gloom, Linda had noticed, seemed to be Thurston Marshall's default position. 'Three-quarters of the town is hoofing it out 119 to the Dome. The air quality's bad and it's going to be eighty-five by ten o'clock, which will be about the time the visitor buses arrive. If Rennie and his cohorts have done anything about providing shelter, I haven't heard of it. There's apt to be a lot of sick people in Chester's Mill before sundown. With luck, only heatstroke and asthma, but there could be a few heart attacks as well.'

'Guys, maybe we should go back,' Gina said. 'I feel like a rat deserting a sinking ship.'

'No!' Linda said so sharply that they all looked at her, even Audi. 'Rusty said something bad is going to happen. It might not be today . . . but he said it might be. Get your lead for the ambulance windows and *go*. I don't dare wait around. One of Rennie's thugs came to see me this morning, and if he swings by the house and sees the van's gone—'

'Go on, go,' Twitch said. 'I'll back up so you can get out. Don't bother with Main Street, it's already a mess.'

'Main Street past the cop-shop?' Linda almost shuddered. 'No thanks. Mom's taxi goes West Street up to Highland.'

Twitch got in behind the wheel of the ambulance and the two young nurse draftees got in back again, Gina giving Linda a final doubtful look over her shoulder.

Linda paused, looking first at the sleeping, sweaty baby, then at Ginny. 'Maybe you and Twitch can go back to the hospital tonight to see how things are there. Say you were on a call way the hell and

gone out in Northchester, or something. Just, whatever you do, don't mention anything about Black Ridge.'

'No.'

Easy to say now, Linda thought. *You might not find dummying up so easy if Carter Thibodeau bends you over a sink.*

She pushed Audrey back, shut the slider, and got behind the wheel of the Odyssey Green.

'Let's get out of here,' Thurse said, climbing in beside her. 'I haven't been this paranoid since my off-the-pig days.'

'Good,' she said. 'Because perfect paranoia is perfect awareness.'

She backed her van around the ambulance and started up West Street.

4

'Jim,' Randolph said from the backseat of the Hummer, 'I've been thinking about this raid.'

'Have you, now. Why don't you give us the benefit of your thinking, Peter?'

'I'm the Chief of Police. If it comes down to a choice between crowd control at Dinsmore's farm and leading a raid on a drug lab where there may be armed addicts guarding illegal substances . . . well, I know where my duty lies. Let's just say that.'

Big Jim discovered he didn't want to argue the point. Arguing with fools was counterproductive. Randolph had no idea what sort of weapons might be stockpiled at the radio station. In truth, neither did Big Jim himself (there was no telling what Bushey might have put on the corporate tab), but at least he could imagine the worst, a mental feat of which this uniformed gasbag seemed incapable. And if something should happen to Randolph . . . well, hadn't he already decided that Carter would be a more than adequate replacement?

'All right, Pete,' he said. 'Far be it for me to stand between you and your duty. You're the new OIC, with Fred Denton as your second. That satisfy you?'

'You're gosh-damn right it does!' Randolph puffed his chest. He looked like a fat rooster about to crow. Big Jim, although not renowned for his sense of humor, had to stifle a laugh.

'Then get down there to the PD and start putting together your crew. Town trucks, remember.'

'Correct! We strike at noon!' He shook a fist in the air.

'Go in through the woods.'

'Now, Jim, I wanted to talk to you about that. It seems a little

complicated. Those woods behind the station are pretty snarly . . . there'll be poison ivy . . . and poison oak, which is even w—'

'There's an access road,' Big Jim said. He was reaching the end of his patience. 'I want you to use it. Hit them on their blind side.'

'But—'

'A bullet in the head would be much worse than poison ivy. Nice talking to you, Pete. Glad to see you're so . . .' But what was he so? Pompous? Ridiculous? Idiotic?

'So totally gung-ho,' Carter said.

'Thank you, Carter, my thought exactly. Pete, tell Henry Morrison he's now in charge of crowd control out on 119. *And use the access road.*'

'I really think—'

'Carter, get the door for him.'

5

'Oh my God,' Linda said, and swerved the van to the left. It bumped up over the curb not a hundred yards from where Main and Highland intersected. All three girls laughed at the bump, but poor little Aidan only looked scared, and grabbed the longsuffering Audrey's head once more.

'What?' Thurse snapped. '*What?*'

She parked on someone's lawn, behind a tree. It was a good-sized oak, but the van was big, too, and the oak had lost most of its listless leaves. She wanted to believe they were hidden but couldn't.

'That's Jim Rennie's Hummer sitting in the middle of the goddam intersection.'

'You swore big,' Judy said. '*Two* quarters in the swear-jar.'

Thurse craned. 'Are you sure?'

'Do you think anybody else in town has a vehicle that humongous?'

'Oh Jesus,' Thurston said.

'Swear-jar!' This time Judy and Jannie said it together.

Linda felt her mouth dry up, and her tongue stuck to the roof of her mouth. Thibodeau was emerging from the Hummer's passenger side, and if he looked this way . . .

If he sees us, I'm going to run him down, she thought. The idea brought a certain perverse calm.

Thibodeau opened the back door of the Hummer. Peter Randolph got out.

'That man is picking his seat,' Alice Appleton informed the

company at large. 'My mother says that means you're going to the movies.'

Thurston Marshall burst out laughing, and Linda, who would have said she didn't have a laugh anywhere in her, joined him. Soon they were all laughing, even Aidan, who certainly didn't know what they were laughing about. Linda wasn't sure she did, either.

Randolph headed down the hill on foot, still yanking at the seat of his uniform trousers. There was no reason for it to be as funny, and that made it funnier.

Not wanting to be left out, Audrey began to bark.

6

Somewhere a dog was barking.

Big Jim heard it, but didn't bother turning around. Watching Peter Randolph stride down the hill suffused him with well-being.

'Look at him picking his pants out of his butt,' Carter remarked. 'My father used to say that meant you were going to the movies.'

'The only place he's going is out to WCIK,' Big Jim said, 'and if he's bullheaded about making a frontal assault, it's likely to be the last place he ever goes. Let's go down to the Town Hall and watch this carnival on TV for awhile. When that becomes tiresome, I want you to find the hippy doctor and tell him if he tries to scoot off somewhere, we'll run him down and throw him in jail.'

'Yes, sir.' This was duty he didn't mind. Maybe he could take another run at ex-officer Everett, this time get her pants off.

Big Jim put the Hummer in gear and rolled slowly down the hill, honking at people who didn't get out of his way quickly enough.

As soon as he had turned into the Town Hall driveway, the Odyssey van rolled through the intersection and headed out of town. There was no foot traffic on Upper Highland Street, and Linda accelerated rapidly. Thurse Marshall began singing 'The Wheels on the Bus,' and soon all the kids were singing with him.

Linda, who felt a little more terror leave her with each tenth of a mile the odometer turned, soon began to sing along.

7

Visitors Day has come to Chester's Mill, and a mood of eager anticipation fills the people walking out Route 119 toward the Dinsmore farm, where Joe McClatchey's demonstration went so wrong just five days ago. They are hopeful (if not exactly happy) in spite of that

memory – also in spite of the heat and smelly air. The horizon beyond the Dome now appears blurred, and above the trees, the sky has darkened, due to accumulated particulate matter. It's better when you look straight up, but still not right; the blue has a yellowish cast, like a film of cataract on an old man's eye.

'It's how the sky used to look over the paper mills back in the seventies, when they were running full blast,' says Henrietta Clavard – she of the not-quite-broken ass. She offers her bottle of ginger ale to Petra Searles, who's walking beside her.

'No, thank you,' Petra says, 'I have some water.'

'Is it spiked with vodka?' Henrietta inquires. 'Because this is. Half and half, sweetheart; I call it a Canada Dry Rocket.'

Petra takes the bottle and downs a healthy slug. 'Yow!' she says.

Henrietta nods in businesslike fashion. 'Yes, ma'am. It's not fancy, but it does brighten up a person's day.'

Many of the pilgrims are carrying signs they plan on flashing to their visitors from the outside world (and to the cameras, of course) like the audience at a live network morning show. But network morning show signs are uniformly cheerful. Most of these are not. Some, left over from the previous Sunday's demo, read FIGHT THE POWER and LET US OUT, DAMMIT! There are new ones that say GOVERNMENT EXPERIMENT: *WHY???*, END THE COVER-UP, and WE'RE HUMAN BEINGS, NOT GUINEA PIGS. Johnny Carver's reads STOP WHATEVER YOU'RE DOING IN THE NAME OF GOD! BEFORE IT'S 2-LATE!! Frieda Morrison's asks – ungrammatically but passionately – WHO'S CRIMES ARE WE DYING FOR? Bruce Yardley's is the only one to strike a completely positive note. Attached to a seven-foot stick and wrapped in blue crepe paper (at the Dome it will tower over all the others), it reads HELLO MOM & DAD IN CLEVELAND! LOVE YOU GUYS!

Nine or ten signs feature scriptural references. Bonnie Morrell, wife of the town's lumberyard owner, carries one that proclaims **DON'T** FORGIVE THEM, BECAUSE THEY **DO** KNOW WHAT THEY DO! Trina Cale's says THE LORD IS MY SHEPHERD below a drawing of what is probably a sheep, although it's tough to be sure.

Donnie Baribeau's simply reads PRAY FOR US.

Marta Edmunds, who sometimes babysits for the Everetts, isn't among the pilgrims. Her ex-husband lives in South Portland, but she doubts if he'll show up, and what would she say if he did? *You're behind on the alimony, cocksucker?* She goes out Little Bitch Road instead

of down Route 119. The advantage is that she doesn't have to walk. She takes her Acura (and runs the air-conditioning full blast). Her destination is the cozy little house where Clayton Brassey has spent his declining years. He is her great-great uncle once removed (or some damn thing), and while she isn't quite sure of either their kinship or degree of separation, she knows he has a generator. If it's still working, she can watch on TV. She also wants to assure herself that Uncle Clayt's still okay – or as okay as it's possible to be when you're a hundred and five and your brains have turned to Quaker Oatmeal.

He's not okay. Clayton Brassey has given up the mantle of oldest living town resident. He's sitting in the living room in his favorite chair with his chipped enamel urinal in his lap and the *Boston Post* cane leaning against the wall nearby, and he's cold as a cracker. There's no sign of Nell Toomey, his great-great granddaughter and chief caregiver; she's gone out to the Dome with her brother and sister-in-law.

Marta says, 'Oh, Unc – I'm sorry, but probably it was time.'

She goes into the bedroom, gets a fresh sheet from the closet, and tosses it over the old man. The result makes him look a bit like a covered piece of furniture in an abandoned house. A highboy, perhaps. Marta can hear the gennie putting away out back and thinks what the hell. She turns on the TV, tunes it to CNN, and sits on the couch. What's unfolding on-screen almost makes her forget she's keeping company with a corpse.

It's an aerial shot, taken with a powerful distance lens from a helicopter hovering above the Motton flea market where the visitor buses will park. The early starters inside the Dome have already arrived. Behind them comes the *haj*: two-lane blacktop filled from side to side and stretching all the way back to Food City. The similarity of the town's citizens to trekking ants is unmistakable.

Some newscaster is blabbing away, using words like *wonderful* and *amazing*. The second time he says *I have never seen anything like this*, Marta mutes the sound, thinking *Nobody has, you dummocks*. She is thinking about getting up and seeing what there might be in the kitchen to snack on (maybe that's wrong with a corpse in the room, but she's hungry, dammit), when the picture goes to a split screen. On the left half, another helicopter is now tracking the line of buses heading out of Castle Rock, and the super at the bottom of the screen reads VISITORS TO ARRIVE SHORTLY AFTER 10 A.M.

There's time to fix a little something, after all. Marta finds crackers, peanut butter, and – best of all – three cold bottles of Bud. She takes everything back into the living room on a tray and settles in. 'Thanks, Unc,' she says.

Even with the sound off (*especially* with the sound off), the juxtaposed images are riveting, hypnotic. As the first beer hits her (joyously!), Marta realizes it's like waiting for an irresistible force to meet an immovable object, and wondering if there will be an explosion when they come together.

Not far from the gathering crowd, on the knoll where he has been digging his father's grave, Ollie Dinsmore leans on his spade and watches the crowd arrive: two hundred, then four, then eight. Eight hundred at least. He sees a woman with a baby on her back in one of those Papoose carriers, and wonders if she's insane, bringing a kid that small out in this heat, without even a hat to protect its head. The arriving townsfolk stand in the hazy sun, watching and waiting anxiously for the buses. Ollie thinks what a slow, sad walk they are going to have once the hoopla's over. All the way back to town in the simmering late-afternoon heat. Then he turns once more to the job at hand.

Behind the growing crowd, on both shoulders of 119, the police – a dozen mostly new officers led by Henry Morrison – park with their flashers throbbing. The last two police cars are late arriving, because Henry ordered them to fill their trunks with containers of water from the spigot at the Fire Department, where, he has discovered, the generator is not only working but looks good to go for another couple of weeks. There's nowhere near enough water – a foolishly meager amount, in fact, given the size of the crowd – but it's the best they can do. They'll save it for the folks who faint in the sun. Henry hopes there won't be many, but he knows there will be some, and he curses Jim Rennie for the lack of preparation. He knows it's because Rennie doesn't give a damn, and to Henry's mind that makes the negligence worse.

He has ridden out with Pamela Chen, the only one of the new 'special deputies' he completely trusts, and when he sees the size of the crowd, he tells her to call the hospital. He wants the ambulance out here, standing by. She comes back five minutes later with news Henry finds both incredible and completely unsurprising. One of the patients answered the phone at reception, Pamela says – a young woman who came in early this morning with a broken wrist. She says all the medical personnel is gone, and the ambulance is gone, too.

'Well, that's just great,' Henry says. 'I hope your first aid skills are up to snuff, Pammie, because you may have to use them.'

'I can give CPR,' she says.

'Good.' He points to Joe Boxer, the Eggo-loving dentist. Boxer

is wearing a blue armband and self-importantly waving people to either side of the road (most pay no attention). 'And if someone gets a toothache, that self-important prick can pull it for them.'

'If they've got the cash to pay,' Pamela says. She has had experience of Joe Boxer, when her wisdom teeth came in. He said something about 'trading one service for another' while eying her breasts in a way she didn't care for at all.

'I think there's a Red Sox hat in the back of my car,' Henry says. 'If so, would you take it over there?' He points to the woman Ollie has already noticed, the one with the bareheaded baby. 'Put it on the kid and tell that woman she's an idiot.'

'I'll take the hat but I won't tell her any such thing,' Pamela says quietly. 'That's Mary Lou Costas. She's seventeen, she's been married for a year to a trucker who's almost twice her age, and she's probably hoping he comes to see her.'

Henry sighs. 'She's still an idiot, but I guess at seventeen we all are.'

And still they come. One man appears to have no water, but he *is* carrying a large boombox that's blaring WCIK gospel. Two of his friends are unfurling a banner. The words on it are flanked by gigantic, clumsily drawn Q-Tips. PLEASE RES-Q US, the sign reads.

'This is going to be bad,' Henry says, and of course he is right, but he has no idea how bad.

The growing crowd waits in the sun. The ones with weak bladders wander into the underbrush west of the road to pee. Most get scratched up before finding relief. One overweight woman (Mabel Alston; she also suffers from what she calls the dia-betties) sprains her ankle and lies there hollering until a couple of men come over and get her on her remaining good foot. Lennie Meechum, the town postmaster (at least until this week, when delivery of the U.S. mail was canceled for the foreseeable future), borrows a cane for her. Then he tells Henry that Mabel needs a ride back to town. Henry says he can't spare a car. She'll have to rest in the shade, he says.

Lennie waves his arms at both sides of the road. 'In case you didn't notice, it's cow-pasture on one side and brambles on the other. No shade to speak of.'

Henry points to the Dinsmore dairy barn. 'Plenty of shade there.'

'It's a quarter of a mile away!' Lennie says indignantly.

It's an eighth of a mile at most, but Henry doesn't argue. 'Put her in the front seat of my car.'

'Awful hot in the sun,' Lennie says. 'She'll need the fac'try air.'

Yes, Henry knows she'll need the air-conditioning, which means running the motor, which means burning gasoline. There's no shortage

of that right now – assuming they can pump it out of the tanks at the Gas & Grocery, that is – and he supposes they'll have to worry about later later.

'Key's in the ignition,' he says. 'Turn it to low cool, do you understand?'

Lennie says he does and heads back to Mabel, but Mabel's not ready to move, although sweat is pouring down her cheeks and her face is bright red. 'I didn't go yet!' she bawls. 'I got to *go!*'

Leo Lamoine, one of the new officers, strolls up to Henry. This is company Henry could do without; Leo has the brain of a turnip. 'How'd she get out here, sport?' he asks. Leo Lamoine is the kind of man who calls everyone 'sport.'

'I don't know, but she did,' Henry says wearily. He's getting a headache. 'Round up some women to take her behind my police car and hold her up while she piddles.'

'Which ones, sport?'

'Big ones,' Henry says, and walks away before the sudden strong urge to punch Leo Lamoine in the nose can overpower him.

'What kind of police force is this?' a woman asks as she and four others escort Mabel to the rear of unit Three, where Mabel will pee while holding onto the bumper, the others standing in front of her for modesty's sake.

Thanks to Rennie and Randolph, your fearless leaders, the unprepared kind, Henry would like to reply, but he doesn't. He knows his mouth got him into trouble the night before, when he spoke in favor of Andrea Grinnell's being heard. What he says is: 'The only one you've got.'

To be fair, most people are, like Mabel's female honor guard, more than willing to help one another. Those who have remembered to bring water share it with those who did not, and most drink sparingly. There are idiots in every crowd, though, and those in this one pig the water freely and without thought. Some folks munch cookies and crackers that will leave them thirstier later on. Mary Lou Costas's baby begins to cry fretfully beneath the Red Sox cap, which is much too big for her. Mary Lou has brought a bottle of water, and she now begins to dab the baby's overheated cheeks and neck with it. Soon the bottle will be empty.

Henry grabs Pamela Chen and again points to Mary Lou. 'Take that bottle and fill it from what we brought,' he says. 'Try not to let too many people see you, or it'll all be gone before noon.'

She does as told, and Henry thinks, *There's one at least who might actually make a good smalltown cop, if she ever wanted the job.*

Nobody bothers to watch where Pamela is going. That's good. When the buses come, these folks will forget all about being hot and thirsty, for a while. Of course, after the visitors go . . . and with a long walk back to town staring them in the face . . .

An idea hits him. Henry scopes out his 'officers' and sees a lot of dumbbells but few people he trusts; Randolph has taken most of the halfway decent ones on some sort of secret mission. Henry thinks it has to do with the drug operation Andrea accused Rennie of running, but he doesn't care what it is. All he knows is that they aren't here and he can't run this errand himself.

But he knows who could, and hails him over.

'What do you want, Henry?' Bill Allnut asks.

'Have you got your keys to the school?'

Allnut, who's been the Middle School janitor for thirty years, nods. 'Right here.' The key ring hanging from his belt glitters in the hazy sun. 'Always carry em, why?'

'Take unit Four,' Henry says. 'Go back to town as fast as you can without running over any latecomers. Get one of the school-buses and bring it out here. One of the forty-four seaters.'

Allnut doesn't look pleased. His jaw sets in a Yankee way Henry – a Yankee himself – has seen all his life, knows well, and hates. It's a penurious look that says *I gutta take care of m'self, chummy.* 'You can't get all these people in one schoolbus, are you nuts?'

'Not all,' Henry says, 'just the ones who won't be able to make it back on their own.' He's thinking of Mabel and the Corso girl's overheated baby, but of course by three this afternoon there will be more who can't walk all the way back to town. Or maybe at all.

Bill Allnut's jaw sets even more firmly; now his chin is sticking out like the prow of a ship. 'Nossir. My two sons and their wives are coming, they said so. They're bringing their kids. I don't want to miss em. And I ain't leaving m'wife. She's all upset.'

Henry would like to shake the man for his stupidity (and outright throttle him for his selfishness). Instead he demands Allnut's keys and asks to be shown which one opens the motor pool. Then he tells Allnut to go back to his wife.

'I'm sorry, Henry,' Allnut says, 'but I gut to see m'kids n grand-kids. I deserve to. I didn't ask the lame, the halt, n the blind to come out here, and I shouldn't have to pay for their stupidity.'

'Ayup, you're a fine American, no question about that,' Henry says. 'Get out of my sight.'

Allnut opens his mouth to protest, thinks better of it (perhaps it's something he sees on Officer Morrison's face), and shuffles away.

Henry yells for Pamela, who does not protest when told she's to go back to town, only asks where, what, and why. Henry tells her.

'Okay, but . . . are those schoolbuses standard shift? Because I can't drive a standard.'

Henry shouts the question to Allnut, who is standing at the Dome with his wife Sarah, both of them eagerly scanning the empty highway on the other side of the Motton town line.

'Number Sixteen is a standard!' Allnut shouts back. 'All the rest are automatics! And tell her to mind the interlock! Them buses won't start unless the driver fastens his seatbelt!'

Henry sends Pamela on her way, telling her to hurry as much as prudence will allow. He wants that bus ASAP.

At first the people at the Dome stand, anxiously watching the empty road. Then most of them sit down. Those who have brought blankets spread them. Some shade their heads from the hazy sun with their signs. Conversation lags, and Wendy Goldstone can be heard quite clearly when she asks her friend Ellen where the crickets are – there's no singing in the high grass. 'Or have I gone deaf?' she asks.

She hasn't. The crickets are either silent or dead.

In the WCIK studio, the airy (and comfortably cool) center space resounds to the voice of Ernie 'The Barrel' Kellogg and His Delight Trio rocking out on 'I Got a Telephone Call from Heaven and It Was Jesus on the Line.' The two men aren't listening; they're watching the TV, as transfixed by the split-screen images as Marta Edmunds (who's on her second Bud and has forgotten all about the corpse of old Clayton Brassey under the sheet). As transfixed as everyone in America, and – yes – the world beyond.

'Look at them, Sanders,' Chef breathes.

'I am,' Andy says. He's got CLAUDETTE on his lap. Chef has offered him a couple of hand grenades as well, but this time Andy has declined. He's afraid he might pull the pin on one and then freeze. He saw that in a movie once. 'It's amazing, but don't you think we better get ready for our company?'

Chef knows Andy's right, but it's hard to look away from the side of the screen where the copter is tracking the buses and the large video truck that leads the parade. He knows every landmark they're passing; they are recognizable even from above. The visitors are getting close now.

We're all getting close now, he thinks.

'Sanders!'

'What, Chef?'

Chef hands him a Sucrets tin. 'The rock will not hide them; the

dead tree gives no shelter, nor the cricket relief. Just which book that's in slips my mind.'

Andy opens the tin, sees six fat home-rolled cigarettes crammed in there, and thinks: *These are soldiers of ecstasy.* It is the most poetic thought of his life, and makes him feel like weeping.

'Can you give me an amen, Sanders?'

'Amen.'

The Chef uses the remote control to turn off the TV. He'd like to see the buses arrive – stoned or not, paranoid or not, he's as fond of a happy reunion story as anyone – but the bitter men might come at any time.

'Sanders!'

'Yes, Chef.'

'I'm going to get the Christian Meals on Wheels truck out of the garage and park it on the far side of the supply building. I can settle in behind it and have a clear view of the woods.' He picks up GOD'S WARRIOR. The grenades attached to it dangle and swing. 'The more I think of it, the more sure I am that's the way they'll come. There's an access road. They probably think I don't know about it, but' – Chef's red eyes gleam – 'the Chef knows more than people think.'

'I know. I love you, Chef.'

'Thank you, Sanders. I love you, too. If they come from the woods, I'll let them get out in the open and then cut them down like wheat at harvest-time. But we can't put all our eggs in one basket. So I want you to go out front to where we were the other day. If any of them come that way—'

Andy raises CLAUDETTE.

'That's right, Sanders. But don't be hasty. Draw out as many as you can before you start shooting.'

'I will.' Sometimes Andy is struck by the feeling that he must be living in a dream; this is one of those times. 'Like wheat at harvest-time.'

'Yea verily. But listen, because this is important, Sanders. Don't come right away if you hear me start shooting. And I won't come right away if I hear *you* start. They might guess we're not together, but I'm wise to that trick. Can you whistle?'

Andy sticks a couple of fingers in his mouth and lets loose a piercing whistle.

'That's good, Sanders. Amazing, in fact.'

'I learned it in grammar school.' *When life was much simpler,* he does not add.

'Don't do it unless you're in danger of being overwhelmed. Then I'll come. And if you hear *me* whistle, run like hell to reinforce my position.'

'Okay.'

'Let's have a smoke on it, Sanders, what do you say?'

Andy seconds the motion.

On Black Ridge, at the edge of the McCoy orchard, seventeen exiles from town stand against the smudged skyline like Indians in a John Ford Western. Most are staring in fascinated silence at the silent parade of people moving out Route 119. They are almost six miles distant, but the size of the crowd makes it impossible to miss.

Rusty's the only one who's looking at something closer, and it fills him with a relief so great it seems to sing. A silver Odyssey van is speeding along Black Ridge Road. He stops breathing as it approaches the edge of the trees and the glow-belt, which is now invisible again. There is time for him to think how horrible it would be if whoever is driving – Linda, he assumes – blacked out and the van crashed, but then it's past the danger point. There might have been the smallest swerve, but he knows even that could have been his imagination. They'll be here soon.

They are standing a hundred yards to the left of the box, but Joe McClatchey thinks he can feel it, just the same: a little pulse that digs at his brain each time the lavender light shines out. That might just be his mind playing tricks on him, but he doesn't think so.

Barbie is standing next to him, with his arm around Miz Shumway. Joe taps him on the shoulder and says, 'This feels bad, Mr Barbara. All those people together. This feels *awful.*'

'Yes,' Barbie says.

'*They're* watching. The leatherheads. I can feel them.'

'So can I,' Barbie says.

'Me too,' Julia says, in a voice almost too low to hear.

In the conference room of the Town Hall, Big Jim and Carter Thibodeau watch silently as the split-screen image on the TV gives way to a shot at ground level. At first the image is jerky, like video of an approaching tornado or the immediate aftermath of a car-bombing. They see sky, gravel, and running feet. Someone mutters, 'Come on, hurry up.'

Wolf Blitzer says, 'The pool-coverage truck has arrived. They're obviously hurrying, but I'm sure that in a moment . . . yes. Oh my goodness, look at that.'

The camera steadies on the hundreds of Chester's Mill residents at the Dome just as they rise to their feet. It's like watching a large

group of open-air worshippers rising from prayer. The ones at the front are being jostled against the Dome by the ones behind; Big Jim sees flattened noses, cheeks, and lips, as if the townspeople are being pressed against a glass wall. He feels a moment of vertigo and realizes why: this is the first time he's seeing from the outside. For the first time the enormity of it and the reality of it strike home. For the first time he is truly frightened.

Faintly, slightly deadened by the Dome, comes the sound of pistol shots.

'I think I'm hearing gunfire,' Wolf says. 'Anderson Cooper, do you hear gunfire? What's happening?'

Faintly, sounding like a call from a satellite phone originating deep in the Australian outback, Cooper comes back: 'Wolf, we're not there yet, but I've got a small monitor and it looks like—'

'I see it now,' Wolf says. 'It appears to be—'

'It's Morrison,' Carter says. 'The guy's got guts, I'll say that much.'

'He's out as of tomorrow,' Big Jim replies.

Carter looks at him, eyebrows raised. 'What he said at the meeting last night?'

Big Jim points a finger at him. 'I knew you were a bright boy.'

At the Dome, Henry Morrison isn't thinking about last night's meeting, or bravery, or even doing his duty; he's thinking that people are going to be crushed against the Dome if he doesn't do something, and quick. So he fires his gun into the air. Taking the cue, several other cops – Todd Wendlestat, Rance Conroy, and Joe Boxer – do the same.

The shouting voices (and the cries of pain from the people at the front who are being squashed) give way to shocked silence, and Henry uses his bullhorn: 'SPREAD OUT! SPREAD OUT, GODDAMMIT! THERE'S ROOM FOR EVERYONE *IF YOU JUST SPREAD THE FUCK OUT!*'

The profanity has an even more sobering effect on them than the gunshots, and although the most stubborn ones remain on the highway (Bill and Sarah Allnut are prominent among them; so are Johnny and Carrie Carver), the others begin to spread along the Dome. Some head to the right, but the majority shuffle to the left, into Alden Dinsmore's field, where the going's easier. Henrietta and Petra are among them, weaving slightly from liberal applications of Canada Dry Rocket.

Henry holsters his weapon and tells the other officers to do the same. Wendlestat and Conroy comply, but Joe Boxer continues to hold his snubnosed .38 – a Saturday-night special if Henry has ever seen one.

'Make me,' he sneers, and Henry thinks: *It's all a nightmare. I'll wake up soon in my own bed and I'll go to the window and stand there looking out at a beautiful crisp fall day.*

Many of those who have chosen to stay away from the Dome (a disquieting number have remained in town because they're beginning to experience respiratory problems) are able to watch on television. Thirty or forty have gravitated to Dipper's. Tommy and Willow Anderson are at the Dome, but they've left the roadhouse open and the big-screen TV on. The people who gather on the honky-tonk hardwood floor to watch do so quietly, although there is some weeping. The HDTV images are crystal clear. They are heartbreaking.

Nor are they the only ones who are affected by the sight of eight hundred people lining up along the invisible barrier, some with their hands planted on what appears to be thin air. Wolf Blitzer says, 'I have never seen such longing on human faces. I . . .' He chokes up. 'I think I better let the images speak for themselves.'

He falls silent, and that's a good thing. This scene needs no narration.

At his press conference, Cox said, *Visitors will debark and walk . . . visitors will be allowed within two yards of the Dome, we consider that a safe distance.* Nothing like that happens, of course. As soon as the doors of the buses open, people spill out in a flood, calling the names of their nearest and dearest. Some fall and are briskly trampled (one will be killed in this stampede and fourteen will be injured, half a dozen seriously). Soldiers who attempt to enforce the dead zone directly in front of the Dome are swept aside. The yellow DO NOT CROSS tapes are knocked down and disappear in the dust raised by running feet. The newcomers swarm forward and spread out on their side of the Dome, most crying and all of them calling for their wives, their husbands, their grandparents, their sons, their daughters, their fiancées. Four people have either lied about their various electronic medical devices or forgotten about them. Three of these die immediately; the fourth, who didn't see his battery-powered hearing-aid implant on the list of forbidden devices, will linger in a coma for a week before expiring of multiple brain hemorrhages.

Little by little they sort themselves out, and the pool TV cameras see it all. They observe the townspeople and the visitors pressing their hands together, with the invisible barrier between; they watch them try to kiss; they examine men and women weeping as they look into each other's eyes; they note the ones who faint, both inside the Dome and out, and those who fall to their knees and pray facing each other with their folded hands raised; they record the man on the outside

who begins hammering his fists against the thing keeping him from his pregnant wife, hammering until his skin splits and his blood beads on thin air; they peer at the old woman trying to trace her fingers, the tips pressed white and smooth against the unseen surface between them, over her sobbing granddaughter's forehead.

The press helicopter takes off again and hovers, sending back images of a double human snake spread over a quarter of a mile. On the Motton side, the leaves flame and dance with late October color; on the Chester's Mill side they hang limp. Behind the townsfolk – on the road, in the fields, caught in the bushes – are dozens of discarded signs. At this moment of reunion (or almost-reunion), politics and protest have been forgotten.

Candy Crowley says: 'Wolf, this is without a doubt the saddest, strangest event I've witnessed in all my years of reporting.'

Yet human beings are nothing if not adaptable, and little by little the excitement and the strangeness begin to wear off. The reunions merge into the actual visiting. And behind the visitors, those who have been overwhelmed – on both sides of the Dome – are being carried away. On The Mill side, there's no Red Cross tent to drag them to. The police put them in such scant shade as the police cars allow, to wait for Pamela Chen and the schoolbus.

In the police station, the WCIK raiding party is watching with the same silent fascination as everyone else. Randolph lets them; there is a little time yet. He checks the names off on his clipboard, then motions Freddy Denton to join him on the front steps. He has expected grief from Freddy for taking over the head honcho role (Peter Randolph has been judging others by himself his whole life), but there is none. This is a far bigger deal than rousting scuzzy old drunks out of convenience stores, and Freddy is delighted to hand off the responsibility. He wouldn't mind taking credit if things went well, but suppose they don't? Randolph has no such qualms. One unemployed troublemaker and a mild-mannered druggist who wouldn't say shit if it was in his cereal? What can possibly go wrong?

And Freddy discovers, as they stand on the steps Piper Libby tumbled down not so long ago, that he isn't going to be able to duck the leadership role completely. Randolph hands him a slip of paper. On it are seven names. One is Freddy's. The other six are Mel Searles, George Frederick, Marty Arsenault, Aubrey Towle, Stubby Norman, and Lauren Conree.

'You will take this party down the access road,' Randolph says. 'You know the one?'

'Yep, busts off from Little Bitch this side of town. Sloppy Sam's father laid that little piece of roa—'

'I don't care who laid it,' Randolph says, 'just drive to the end of it. At noon, you take your men through the belt of woods there. You'll come out in back of the radio station. *Noon*, Freddy. That doesn't mean a minute before or a minute after.'

'I thought we were *all* supposed to go in that way, Pete.'

'Plans have changed.'

'Does Big Jim know they've changed?'

'Big Jim is a selectman, Freddy. I'm the Police Chief. I'm also your superior, so would you kindly shut up and listen?'

'Soh-*ree*,' Freddy says, and cups his hands to his ears in a way that is impudent, to say the least.

'I'll be parked down the road that runs past the *front* of the station. I'll have Stewart and Fern with me. Also Roger Killian. If Bushey and Sanders are foolish enough to engage you – if we hear shooting from behind the station, in other words – the three of us will swoop in and take them from behind. Have you got it?'

'Yeah.' It actually sounds like a pretty good plan to Freddy.

'All right, let's synchronize watches.'

'Uh . . . sorry?'

Randolph sighs. 'We have to make sure they're the same, so noon comes at the same time for both of us.'

Freddy still looks puzzled, but he complies.

From inside the station, someone – it sounds like Stubby – shouts: 'Whoop, another one bites the dust! The fainters're stacked up behind them cruisers like cordwood!' This is greeted by laughter and applause. They are pumped up, excited to have pulled what Melvin Searles calls 'possible shootin duty.'

'We saddle up at eleven fifteen,' Randolph tells Freddy. 'That gives us almost forty-five minutes to watch the show on TV.'

'Want popcorn?' Freddy asks. 'We got a whole mess of it in the cupboard over the microwave.'

'Might as well, I guess.'

Out at the Dome, Henry Morrison goes to his car and helps himself to a cool drink. His uniform is soaked through with sweat and he can't recall ever feeling so tired (he thinks a lot of that is down to bad air – he can't seem to completely catch his breath), but on the whole he is satisfied with himself and his men. They have managed to avoid a mass crushing at the Dome, nobody has died on this side – yet – and folks are settling down. Half a dozen TV cameramen race to and fro on the Motton side, recording as many

heartwarming reunion vignettes as possible. Henry knows it's an invasion of privacy, but he supposes America and the world beyond may have a right to see this. And on the whole, people don't seem to mind. Some even like it; they are getting their fifteen minutes. Henry has time to search for his own mother and father, although he's not surprised when he doesn't see them; they live all the way to hell and gone up in Derry, and they're getting on in years now. He doubts if they even put their names in the visitor lottery.

A new helicopter is beating in from the west, and although Henry doesn't know it, Colonel James Cox is inside. Cox is also not entirely displeased with the way Visitors Day has gone so far. He has been told no one on the Chester's Mill side seems to be preparing for a press conference, but this doesn't surprise or discommode him. Based on the extensive files he has been accumulating, he would have been more surprised if Rennie had put in an appearance. Cox has saluted a lot of men over the years, and he can smell a bully-pulpit coward a mile away.

Then Cox sees the long line of visitors and the trapped towns-people facing them. The sight drives James Rennie from his mind. 'Isn't that the damndest thing,' he murmurs. 'Isn't that just the damndest thing anyone ever saw.'

On the Dome side, Special Deputy Toby Manning shouts: *'Here comes the bus!'* Although the civilians barely notice – they are either raptly engaged with their relatives or still searching for them – the cops raise a cheer.

Henry walks to the back of his cruiser, and sure enough, a big yellow schoolbus is just passing Jim Rennie's Used Cars. Pamela Chen may not weigh more than a hundred and five pounds soaking wet, but she's come through bigtime, and with a big bus.

Henry checks his watch and sees that it's twenty minutes past eleven. *We're going to get through this,* he thinks. *We're going to get through this just fine.*

On Main Street, three big orange trucks are rolling up Town Common Hill. In the third one, Peter Randolph is crammed in with Stew, Fern, and Roger (redolent of chickens). As they head out 119 northbound toward Little Bitch Road and the radio station, Randolph is struck by a thought, and barely restrains himself from smacking his palm against his forehead.

They have plenty of firepower, but they have forgotten the helmets and Kevlar vests.

Go back and get them? If they do that, they won't be in position until quarter past twelve, maybe even later. And the vests would almost

certainly turn out to be a needless precaution, anyway. It's eleven against two, and the two are probably stoned out of their gourds.

Really, it should be a tit.

8

Andy Sanders was stationed behind the same oak he'd used for cover the first time the bitter men came. Although he hadn't taken any grenades, he had six ammo clips stuck in the front of his belt, plus four more poking into the small of his back. There were another two dozen in the wooden crate at his feet. Enough to hold off an army . . . although he supposed if Big Jim actually sent an army, they'd take him out in short order. After all, he was just a pill-roller.

One part of him couldn't believe he was doing this, but another part – an aspect of his character he might never have suspected without the meth – was grimly delighted. Outraged, too. The Big Jims of the world didn't get to have everything, nor did they get to take everything away. There would be no negotiation this time, no politics, no backing down. He would stand with his friend. His *soul-mate*. Andy understood that his state of mind was nihilistic, but that was all right. He had spent his life counting the cost, and stoned don't-give-a-shit-itis was a delirious change for the better.

He heard trucks approaching and checked his watch. It had stopped. He looked up at the sky, and judged by the position of the yellow-white blear that used to be the sun that it must be close to noon.

He listened to the swelling sound of diesel engines, and when the sound diverged, Andy knew his *compadre* had smelled out the play – smelled it out as surely as any wise old defensive lineman on a Sunday afternoon. Some of them were swinging around toward the back of the station to the access road there.

Andy took one more deep drag of his current fry-daddy, held his breath as long as he could, then huffed it out. Regretfully, he dropped the roach and stepped on it. He didn't want any smoke (no matter how deliciously clarifying) to give away his position.

I love you, Chef, Andy Sanders thought, and pushed off the safety of his Kalashnikov.

9

There was a light chain across the rutted access road. Freddy, behind the wheel of the lead truck, did not hesitate, simply hit it and snapped

it with the grille. The lead truck and the one behind it (piloted by Mel Searles) headed into the woods.

Stewart Bowie was behind the wheel of the third truck. He stopped in the middle of Little Bitch Road, pointed at the WCIK radio tower, then looked at Randolph, who was jammed against the door with his HK semiauto between his knees.

'Go another half a mile,' Randolph instructed, 'then pull up and kill the engine.' It was just eleven thirty-five. Excellent. Plenty of time.

'What's the plan?' Fern asked.

'The plan is we wait until noon. When we hear shooting, we roll at once, and take them from behind.'

'These trucks is pretty noisy,' Roger Killian said. 'What if those guys hear em comin? We'll lose that whatdoyoucallit, elephant of surprise.'

'They won't hear us,' Randolph said. 'They'll be sitting in the station, watching television in air-conditioned comfort. They're not going to know what hit them.'

'Shouldn't we have gotten some bulletproof vests or something?' Stewart asked.

'Why carry all that weight on such a hot day? Stop worrying. Ole Cheech and Chong there are going to be in hell before they even know they're dead.'

10

Shortly before twelve o'clock, Julia looked around and saw that Barbie was gone. When she walked back to the farmhouse, he was loading canned goods into the rear of the Sweetbriar Rose van. He'd put several bags in the stolen phone company van as well.

'What are you doing? We just unloaded those last night.'

Barbie turned a strained, unsmiling face toward her. 'I know, and I think we were wrong to do it. I don't know if it's being close to the box or not, but all at once I seem to feel that magnifying glass Rusty talked about right over my head, and pretty soon the sun's going to come out and start shining through it. I hope I'm wrong.'

She studied him. 'Is there more stuff? I'll help you if there is. We can always put it back later.'

'Yes,' Barbie said, and gave her a strained grin. 'We can always put it back later.'

11

At the end of the access road there was a small clearing with a long-abandoned house in it. Here the two orange trucks pulled up, and the raiding party disembarked. Teams of two swung down long, heavy duffle bags that had been stenciled with the words **HOMELAND SECURITY**. On one of the bags some wit had added REMEMBER THE ALAMO in Magic Marker. Inside were more HK semiautos, two Mossberg pump shotguns with eight-round capacity, and ammo, ammo, ammo.

'Uh, Fred?' It was Stubby Norman. 'Shouldn't we have vests, or somethin?'

'We're hitting them from behind, Stubby. Don't worry about it.' Freddy hoped he sounded better than he felt. He had a gutful of butterflies.

'Do we give em a chance to surrender?' Mel asked. 'I mean, Mr Sanders being a selectman and all?'

Freddy had thought about this. He'd also thought about the Honor Wall, where photographs of the three Chester's Mill cops who had died in the line of duty since World War II were hung. He had no urge to have his own photo on that wall, and since Chief Randolph hadn't given him specific orders on this subject, he felt free to issue his own.

'If their hands are up, they live,' he said. 'If they're unarmed, they live. Anything else, they fucking die. Anyone got a problem with that?'

No one did. It was eleven fifty-six. Almost showtime.

He surveyed his men (plus Lauren Conree, so hard-faced and small-busted she almost could have passed for one), pulled in a deep breath, and said: 'Follow me. Single-file. We'll stop at the edge of the woods and scope things out.'

Randolph's concerns about poison ivy and poison oak proved groundless, and the trees were spaced widely enough to make the going quite easy, even loaded down with ordnance. Freddy thought his little force moved through the clumps of juniper they couldn't avoid with admirable stealth and silence. He was starting to feel that this was going to be all right. In fact, he was almost looking forward to it. Now that they were actually on the move, the butterflies in his stomach had flown away.

Easy does it, he thought. *Easy and quiet. Then, bang! They'll never know what hit em.*

12

Chef, crouched behind the blue panel truck parked in the high grass at the rear of the supply building, heard them almost as soon as they left the clearing where the old Verdreaux homestead was gradually sinking back into the earth. To his drug-jacked ears and Condition Red brain, they sounded like a herd of buffalo looking for the nearest waterhole.

He scurried to the front of the truck and knelt with his gun braced on the bumper. The grenades which had been hung from the barrel of GOD'S WARRIOR now lay on the ground behind him. Sweat gleamed on his skinny, pimple-studded back. The door opener was clipped to the waistband of his RIBBIT pajamas.

Be patient, he counseled himself. *You don't know how many there are. Let them get out into the open before you start shooting, then mow them down in a hurry.*

He scattered several extra clips for GOD'S WARRIOR in front of him and waited, hoping to Christ Andy wouldn't have to whistle. Hoping he wouldn't either. It was possible they could still get out of this and live to fight another day.

13

Freddy Denton reached the edge of the woods, pushed a fir bough aside with the barrel of his rifle, and peered out. He saw an overgrown hayfield with the radio tower in the middle of it, emitting a low hum he seemed to feel in the fillings of his teeth. A fence posted with signs reading HIGH VOLTAGE surrounded it. To the far left of his position was the one-story brick studio building. In between was a big red barn. He assumed the barn was for storage. Or making drugs. Or both.

Marty Arsenault eased in beside him. Circles of sweat darkened his uniform shirt. His eyes looked terrified. 'What's that truck doing there?' he asked, pointing with the barrel of his gun.

'That's the Meals On Wheels truck,' Freddy said. 'For shut-ins and such. Haven't you seen that around town?'

'Seen it and helped load it,' Marty said. 'I gave up the Catholics for Holy Redeemer last year. How come it's not inside the barn?' He said *barn* the Yankee way, making it sound like the cry of a discontented sheep.

'How do I know and why would I care?' Freddy asked. 'They're in the studio.'

'How do you know?'

'Because that's where the TV is, and the big show out at the Dome is on all the channels.'

Marty raised his HK. 'Let me put a few rounds in that truck just to be sure. It could be booby-trapped. Or they could be inside it.'

Freddy pushed the barrel down. 'Jesus-please-us, are you crazy? They don't know we're here and you just want to give it away? Did your mother have any kids that lived?'

'Fuck you,' Marty said. He considered. 'And fuck your mother, too.'

Freddy looked back over his shoulder. 'Come on, you guys. We'll cut across the field to the studio. Look through the back windows and make sure of their positions.' He grinned. 'Smooth sailing.'

Aubrey Towle, a man of few words, said: 'We'll see.'

14

In the truck that had remained on Little Bitch Road, Fern Bowie said, 'I don't hear nothing.'

'You will,' Randolph said. 'Just wait.'

It was twelve oh-two.

15

Chef watched as the bitter men broke cover and began moving diagonally across the field toward the rear of the studio. Three were wearing actual police uniforms; the other four had on blue shirts that Chef guessed were *supposed* to be uniforms. He recognized Lauren Conree (an old customer from his pot-peddling days) and Stubby Norman, the local junkman. He also recognized Mel Searles, another old customer and a friend of Junior's. Also a friend of the late Frank DeLesseps, which probably meant he was one of the guys who had raped Sandy. Well, he wouldn't be raping anyone else – not after today.

Seven. On this side, at least. On Sanders's, who knew?

He waited for more, and when no more came, he got to his feet, planted his elbows on the hood of the panel truck, and shouted: *'BEHOLD, THE DAY OF THE LORD COMETH, CRUEL BOTH WITH WRATH AND FIERCE ANGER, TO LAY THE LAND DESOLATE!'*

Their heads snapped around, but for a moment they froze, neither

trying to raise their weapons nor scatter. They weren't cops at all, Chef saw; just birds on the ground too dumb to fly.

'*AND HE SHALL DESTROY THE SINNERS OUT OF IT! ISAIAH THIRTEEN! SELAH, MOTHERFUCKERS!*'

With this homily and call to judgment, Chef opened fire, raking them from left to right. Two of the uniformed cops and Stubby Norman flew backward like broken dolls, painting the high trash-grass with their blood. The paralysis of the survivors broke. Two turned and fled toward the woods. Conree and the last of the uniformed cops booked for the studio. Chef tracked them and opened fire again. The Kalashnikov burped a brief burst, and then the clip was empty.

Conree clapped her hand to the back of her neck as if stung, went facedown into the grass, kicked twice, and was still. The other one – a bald guy – made it to the rear of the studio. Chef didn't care too much about the pair who'd run for the woods, but he didn't want to let Baldy get away. If Baldy got around the corner of the building, he was apt to see Sanders, and might shoot him in the back.

Chef grabbed a fresh clip and rammed it home with the heel of his hand.

16

Frederick Howard Denton, aka Baldy, wasn't thinking about anything when he reached the back of the WCIK studio. He had seen the Conree girl go down with her throat blown out, and that was the end of rational consideration. All he knew now was that he didn't want his picture on the Honor Wall. He had to get under cover, and that meant inside. There was a door. Behind it, some gospel group was singing 'We'll Join Hands Around the Throne.'

Freddy grabbed the knob. It refused to turn.

Locked.

He dropped his gun, raised the hand which had been holding it, and screamed: '*I surrender! Don't shoot, I sur—*'

Three heavy blows boxed him low in the back. He saw a splash of red hit the door and had time to think, *We should have remembered the body armor.* Then he crumpled, still holding onto the knob with one hand as the world rushed away from him. Everything he was and everything he'd ever known diminished to a single burning-bright point of light. Then it went out. His hand slipped off the knob. He died on his knees, leaning against the door.

17

Melvin Searles didn't think either. Mel had seen Marty Arsenault, George Frederick, and Stubby Norman cut down in front of him, he had felt at least one bullet whicker right in front of his mother-fucking *eyes*, and those kinds of things were not conducive to thought.

Mel just ran.

He blundered back through the trees, oblivious to the branches that whipped against his face, falling once and getting back up, finally bursting into the clearing where the trucks were. Firing one up and driving it away would have been the most reasonable course of action, but Mel and reason had parted company. He probably would have sprinted straight down the access road to Little Bitch if the other survivor of the backdoor raiding-party hadn't grabbed him by the shoulder and shoved him against the trunk of a large pine.

It was Aubrey Towle, the bookstore owner's brother. He was a big, shambling, pale-eyed man who sometimes helped his brother Ray stocking the shelves but rarely said much. There were people in town who thought Aubrey was simpleminded, but he didn't look simple now. Nor did he look panicked.

'I'm going back and get that sonofawhore,' he informed Mel.

'Good luck to you, buddy,' Mel said. He pushed away from the tree and turned toward the access road again.

Aubrey Towle shoved him back harder this time. He brushed his hair out of his eyes, then pointed his Heckler Koch rifle at Mel's midsection. 'You ain't going anywhere.'

From behind them came another rattle of gunfire. And screams.

'Do you hear that?' Mel asked. 'You want to go back into *that*?'

Aubrey looked at him patiently. 'You don't have to come with me, but you're going to cover me. Do you understand that? You do that or I'll shoot you myself.'

18

Chief Randolph's face split in a taut grin. 'The enemy is engaged at the rear of our objective. All according to plan. Roll, Stewart. Straight up the driveway. We'll disembark and cut through the studio.'

'What if they're in the barn?' Stewart asked.

'Then we'll still be able to hit them from behind. Now *roll*! Before we miss it!'

Stewart Bowie rolled.

19

Andy heard the gunfire from behind the storage building, but Chef didn't whistle and so he stayed where he was, snug behind his tree. He hoped everything was going all right back there, because now he had his own problems: a town truck preparing to turn into the station's driveway.

Andy circled his tree as it came, always keeping the oak between him and the truck. It stopped. The doors opened and four men got out. Andy was pretty sure that three of them were the ones who'd come out here before . . . and about Mr Chicken there was no doubt. Andy would have recognized those beshitted green gumrubber boots anywhere. Bitter men. Andy had no intention of letting them blindside The Chef.

He emerged from behind the tree and began walking straight up the middle of the driveway, CLAUDETTE held across his chest in the port arms position. His feet crunched on the gravel, but there was plenty of sound-cover: Stewart had left the truck running and loud gospel music was pouring from the studio.

He raised the Kalashnikov, but made himself wait. *Let them bunch together, if they're going to.* As they approached the front door of the studio, they did indeed bunch together.

'Well, it's Mr Chicken and all his friends,' Andy said in a passable John Wayne drawl. 'How you doing, boys?'

They started to turn. *For you, Chef*, Andy thought, and opened fire.

He killed both Bowie brothers and Mr Chicken with his first fusillade. Randolph he only winged. Andy popped the clip as Chef Bushey had taught him, grabbed another from the waistband of his pants, and slammed it home. Chief Randolph was crawling toward the door of the studio with blood pouring down his right arm and leg. He looked back over his shoulder, his peering eyes huge and bright in his sweaty face.

'Please, Andy,' he whispered. 'Our orders weren't to hurt you, only to bring you back so you could work with Jim.'

'Right,' Andy said, and actually laughed. 'Don't bullshit a bullshitter. You were going to take all this—'

A long, stuttering blast of gunfire erupted behind the studio. Chef might be in trouble, might need him. Andy raised CLAUDETTE.

'*Please don't kill me!*' Randolph screamed. He put a hand over his face.

'Just think about the roast beef dinner you'll be eating with Jesus,' Andy said. 'Why, three seconds from now you'll be spreading your napkin.'

The sustained blast from the Kalashnikov rolled Randolph almost all the way to the studio door. Then Andy ran for the rear of the building, ejecting the partially used clip and putting in a full one as he went.

From the field came a sharp, piercing whistle.

'I'm coming, Chef!' Andy shouted. *'Hold on, I'm coming!'*

Something exploded.

20

'You cover me,' Aubrey said grimly from the edge of the woods. He had taken off his shirt, torn it in two, and cinched half of it around his forehead, apparently going for the Rambo look. 'And if you're thinking about scragging me, you better get it right the first time, because if you don't, I'll come back here and cut your goddam throat.'

'I'll cover you,' Mel promised. And he would. At least from here at the edge of the woods, he'd be safe.

Probably.

'That crazy tweeker is not getting away with this,' Aubrey said. He was breathing rapidly, psyching himself up. 'That loser. That druggie fuck.' And, raising his voice: *'I'm coming for you, you nutbag druggie fuck!'*

Chef had emerged from behind the Meals On Wheels truck to look at his kill. He redirected his attention to the woods just as Aubrey Towle burst from them, screaming at the top of his lungs.

Then Mel began to fire, and although the burst was nowhere near him, Chef crouched instinctively. When he did, the garage door opener tumbled from the sagging waistband of his pajama pants and into the grass. He bent to get it, and that was when Aubrey opened up with his own automatic rifle. Bulletholes stitched a crazy course up the side of the Meals On Wheels truck, making hollow punching sounds in the metal and smashing the passenger-side window to glistening crumbs. A bullet whined off the strip of metal at the side of the windshield.

Chef abandoned the garage door opener and returned fire. But the element of surprise was gone, and Aubrey Towle was no sitting duck. He was weaving from side to side and heading toward the radio tower. It wouldn't provide cover, but it would clear Searles's line of fire.

Aubrey's clip ran dry, but the last bullet in it grooved the left side of Chef's head. Blood flew and a clump of hair fell onto one of Chef's thin shoulders, where it stuck in his sweat. Chef plopped down on his ass, momentarily lost his hold on GOD'S WARRIOR, then regained it. He didn't think he was seriously wounded, but it was high time for Sanders to come if he could still do so. Chef Bushey stuck two fingers in his mouth and whistled.

Aubrey Towle reached the fence surrounding the radio tower just as Mel opened fire again from the edge of the woods. Mel's target this time was the rear end of the Meals On Wheels truck. The slugs tore it open in metal hooks and flowers. The gas tank exploded and the truck's rear half rose on a cushion of flame.

Chef felt monstrous heat bake against his back and had time to think of the grenades. Would they blow? He saw the man by the radio tower aiming at him, and suddenly there was a clear choice: shoot back or grab the door opener. He chose the door opener, and as his hand closed on it, the air around him was suddenly full of unseen buzzing bees. One stung his shoulder; another punched into his side and rearranged his intestines. Chef Bushey tumbled and rolled over, once more losing his grip on the door opener. He reached for it and another swarm of bees filled the air around him. He crawled into the high grass, leaving the door opener where it was, now only hoping for Sanders. The man from the radio tower – *One brave bitter man among seven*, Chef thought, *yea, verily* – was walking toward him. GOD'S WARRIOR was very heavy now, his whole body was heavy, but Chef managed to get to his knees and pull the trigger.

Nothing happened.

Either the clip was empty or it had jammed.

'You numb fuck,' Aubrey Towle said. 'You nutbag tweeker. Tweek on this, fuckhea—'

'*Claudette!*' Sanders screamed.

Towle wheeled around, but he was too late. There was a short, hard rattle of gunfire, and four 7.62 Chinese slugs tore most of Aubrey's head from his shoulders.

'Chef!' Andy screamed, and ran to where his friend knelt in the grass, blood streaming from his shoulder, side, and temple. The entire left side of Chef's face was red and wet. '*Chef! Chef!*' He fell to his knees and hugged Chef. Neither of them saw Mel Searles, the last man standing, emerge from the woods and begin to walk cautiously toward them.

'Get the trigger,' Chef whispered.

'What?' Andy looked down at CLAUDETTE's trigger for a moment, but that obviously wasn't what Chef meant.

'Door opener,' Chef whispered. His left eye was drowning in blood; the other regarded Andy with bright and lucid intensity. 'Door opener, Sanders.'

Andy saw the garage door opener lying in the grass. He picked it up and handed it to the Chef. Chef wrapped his hand around it.

'You . . . too . . . Sanders.'

Andy curled his hand over Chef's hand. 'I love you, Chef,' he said, and kissed Chef Bushey's dry, blood-freckled lips.

'Love . . . you . . . too . . . Sanders.'

'Hey, fags!' Mel cried with a kind of delirious joviality. He was standing just ten yards away. 'Get a room! No, wait, I got a better idea! *Get a room in hell!*'

'Now . . . Sanders . . . *now.*'

Mel opened fire.

Andy and Chef were driven sideways by the bullets, but before they were torn asunder, their joined hands pushed the white button marked OPEN.

The explosion was white and all-encompassing.

21

On the edge of the orchard, the Chester's Mill exiles are having a picnic lunch when gunfire breaks out – not from 119, where the visiting continues, but to the southwest.

'That's out on Little Bitch Road,' Piper says. 'God, I wish we had some binoculars.'

But they need none to see the yellow bloom that opens when the Meals On Wheels truck explodes. Twitch is eating deviled chicken with a plastic spoon. 'I dunno what's going on down there, but that's the radio station for sure,' he says.

Rusty grabs Barbie's shoulder. 'That's where the propane is! They stockpiled it to make drugs! *That's where the propane is!*'

Barbie has one moment of clear, premonitory terror; one moment when the worst is still ahead. Then, four miles distant, a brilliant white spark flicks the hazy sky, like a stroke of lightning that goes up instead of down. A moment later, a titanic explosion hammers a hole straight through the center of the day. A red ball of fire blots out first the WCIK tower, then the trees behind it, and then the whole horizon as it spreads north and south.

The people on Black Ridge scream but are unable to hear

themselves over the vast, grinding, building roar as eighty pounds of plastic explosive and ten thousand gallons of propane undergo an explosive change. They cover their eyes and stagger backward, stepping on their sandwiches and spilling their drinks. Thurston snatches Alice and Aidan into his arms and for a moment Barbie sees his face against the blackening sky – the long and terrified face of a man observing the literal Gates of Hell swing open, and the ocean of fire waiting just beyond.

'*We have to go back to the farmhouse!*' Barbie yells. Julia is clinging to him, crying. Beyond her is Joe McClatchey, trying to help his weeping mother to her feet. These people are going nowhere, at least for a while.

To the southwest, where most of Little Bitch Road will within the next three minutes cease to exist, the yellowy-blue sky is turning black and Barbie has time to think, with perfect calm: *Now we're under the magnifying glass.*

The blast shatters every window in the mostly deserted downtown, sends shutters soaring, knocks telephone poles askew, rips doors from their hinges, flattens mailboxes. Up and down Main Street, car alarms go off. To Big Jim Rennie and Carter Thibodeau, it feels as if the conference room has been struck by an earthquake.

The TV is still on. Wolf Blitzer is asking, in tones of real alarm, 'What's that? Anderson Cooper? Candy Crowley? Chad Myers? Soledad O'Brien? Does anybody know what the hell *that* was? What's going on?'

At the Dome, America's newest TV stars are looking around, showing the cameras only their backs as they shield their eyes and stare toward town. One camera pans up briefly, for a moment disclosing a monstrous column of black smoke and swirling debris on the horizon.

Carter gets to his feet. Big Jim grabs his wrist. 'One quick look,' Big Jim says. 'To see how bad it is. Then get your butt back down here. We may have to go to the fallout shelter.'

'Okay.'

Carter races up the stairs. Broken glass from the mostly vaporized front doors crunches beneath his boots as he runs down the hall. What he sees when he comes out on the steps is so beyond anything he has ever imagined that it tumbles him back into childhood again and for a moment he freezes where he is, thinking *It's like the biggest, awfulest thunderstorm anyone ever saw, only worse.*

The sky to the west is a red-orange inferno surrounded by billowing clouds of deepest ebony. The air is already stenchy with

exploded LP. The sound is like the roar of a dozen steel mills running at full blast.

Directly above him, the sky is dark with fleeing birds.

The sight of them – birds with nowhere to go – is what breaks Carter's paralysis. That, and the rising wind he feels against his face. There has been no wind in Chester's Mill for six days, and this one is both hot and vile, stinking of gas and vaporized wood.

A huge smashed oak lands in Main Street, pulling down snarls of dead electrical cable.

Carter flees back down the corridor. Big Jim is standing at the head of the stairs, his heavy face pale and frightened and, for once, irresolute.

'Downstairs,' Carter says. 'Fallout shelter. It's coming. The fire's coming. And when it gets here, it's going to eat this town alive.'

Big Jim groans. 'What did those idiots *do*?'

Carter doesn't care. Whatever they did, it's done. If they don't move quickly, they will be done, too. 'Is there air-purifying machinery down there, boss?'

'Yes.'

'Hooked to the gennie?'

'Yes, of course.'

'Thank Christ for that. Maybe we've got a chance.'

Helping Big Jim down the stairs to make him move more quickly, Carter only hopes they don't cook alive down there.

The doors of Dipper's roadhouse have been chocked open, but the force of the explosion breaks the chocks and sweeps the doors shut. The glass coughs inward and several of the people standing at the back of the dance floor are cut. Henry Morrison's brother Whit suffers a slashed jugular.

The crowd stampedes toward the doors, the big-screen TV completely forgotten. They trample poor Whit Morrison as he lies dying in a spreading pool of his own blood. They hit the doors, and more people are lacerated as they push through the jagged openings.

'Birds!' someone cries. 'Ah, God, look at all them birds!'

But most of them look west instead of up – west, where burning doom is rolling down upon them below a sky that is now midnight-black and full of poison air.

Those who can run take a cue from the birds and begin trotting, jogging, or flat-out galloping straight down the middle of Route 117. Several others throw themselves into their cars, and there are multiple fender-benders in the gravel parking lot where, once upon an antique time, Dale Barbara took a beating. Velma Winter gets into her old

Datsun pickup and, after avoiding the demolition derby in the parking lot, discovers her right-of-way to the road is blocked by fleeing pedestrians. She looks right – at the firestorm billowing toward them like some great burning dress, eating the woods between Little Bitch and downtown – and drives blindly ahead in spite of the people in her way. She strikes Carla Venziano, who is fleeing with her infant in her arms. Velma feels the truck jounce as it passes over their bodies, and resolutely blocks her ears to Carla's shrieks as her back is broken and baby Steven is crushed to death beneath her. All Velma knows is that she has to get out of here. Somehow, she has to get out.

At the Dome, the reunions have been ended by an apocalyptic party-crasher. Those on the inside have something more important than relatives to occupy them now: the giant mushroom cloud that's growing to the northwest of their position, rising on a muscle of fire already almost a mile high. The first feather of wind – the wind that has sent Carter and Big Jim fleeing for the fallout shelter – strikes them, and they cringe against the Dome, mostly ignoring the people behind them. In any case, the people behind them are retreating. They're lucky; they *can*.

Henrietta Clavard feels a cold hand wrap around hers. She turns and sees Petra Searles. Petra's hair has come loose from the clips that were holding it and hangs against her cheeks.

'Got any more of that joy-juice?' Petra asks, and manages a ghastly let's-party smile.

'Sorry, all out,' Henrietta says.

'Well – maybe it doesn't matter.'

'Hang onto me, honey,' Henrietta says. 'Just hang onto me. We're going to be okay.'

But when Petra looks into the old woman's eyes, she sees no belief and no hope. The party's almost over.

Look, now. Look and see. Eight hundred people are crammed against the Dome, their heads tilted up and their eyes wide, watching as their inevitable end rushes toward them.

Here are Johnny and Carrie Carver, and Bruce Yardley, who worked at Food City. Here is Tabby Morrell, who owns a lumberyard soon to be reduced to swirling ash, and his wife, Bonnie; Toby Manning, who clerked at the department store; Trina Cole and Donnie Baribeau; Wendy Goldstone with her friend and fellow teacher Ellen Vanedestine; Bill Allnut, who wouldn't go get the bus, and his wife, Sarah, who is screaming for Jesus to save her as she watches the oncoming fire. Here are Todd Wendlestat and Manuel Ortega with their faces raised dumbly to the west, where the world is disappearing

in smoke. Tommy and Willow Anderson, who will never book another band from Boston into their roadhouse. See them all, a whole town with its back to an invisible wall.

Behind them, the visitors go from backing up to retreat, and from retreat into full flight. They ignore the buses and pound straight down the highway toward Motton. A few soldiers hold position, but most throw their guns down, tear after the crowd, and look back no more than Lot looked back at Sodom.

Cox doesn't flee. Cox approaches the Dome and shouts: '*You! Officer in charge!*'

Henry Morrison turns, walks to the Colonel's position, and braces his hands on a hard and mystic surface he can't see. Breathing has become difficult; bad wind pushed by the firestorm hits the Dome, swirls, then backdrafts toward the hungry thing that's coming: a black wolf with red eyes. Here, on the Motton town line, is the lambfold where it will feed.

'Help us,' Henry says.

Cox looks at the firestorm and estimates it will reach the crowd's current position in no more than fifteen minutes, perhaps as few as three. It's not a fire or an explosion; in this closed and already polluted environment, it is a cataclysm.

'Sir, I cannot,' he says.

Before Henry can reply, Joe Boxer grabs his arm. He is gibbering.

'Quit it, Joe,' Henry says. 'There's nowhere to run and nothing to do but pray.'

But Joe Boxer does not pray. He is still holding his stupid little hockshop pistol, and after a final crazed look at the oncoming inferno, he puts the gun to his temple like a man playing Russian roulette. Henry makes a grab for it, but is too late. Boxer pulls the trigger. Nor does he die at once, although a gout of blood flies from the side of his head. He staggers away, waving the stupid little pistol like a handkerchief, screaming. Then he falls to his knees, throws his hands up once to the darkening sky like a man in the grip of a godhead revelation, and collapses face-first on the broken white line of the highway.

Henry turns his stunned face back to Colonel Cox, who is simultaneously three feet and a million miles away. 'I'm so sorry, my friend,' Cox says.

Pamela Chen stumbles up. '*The bus!*' she screams to Henry over the building roar. '*We have to take the bus and drive straight through it! It's our only chance!*'

Henry knows this is no chance at all, but he nods, gives Cox a

final look (Cox will never forget the cop's hellish, despairing eyes), takes Pammie Chen's hand, and follows her to Bus 19 as the smoky blackness races toward them.

The fire reaches downtown and explodes along Main Street like a blowtorch in a pipe. The Peace Bridge is vaporized. Big Jim and Carter cringe in the fallout shelter as the Town Hall implodes above them. The PD sucks its brick walls in, then spews them high into the sky. The statue of Lucien Calvert is uprooted from its base in War Memorial Plaza. Lucien flies into the burning black with his rifle bravely raised. On the library lawn, the Halloween dummy with the jolly top hat and the garden trowel hands goes up in a sheet of flame. A great whooshing noise − it sounds like God's own vacuum cleaner − has arisen as the oxygen-hungry fire sucks in good air to fill its single poisonous lung. The buildings along Main Street explode one after another, tossing their boards and goods and shingles and glass into the air like confetti on New Year's Eve: the abandoned moviehouse, Sanders Hometown Drug, Burpee's Department Store, the Gas & Grocery, the bookstore, the flower shop, the barber-shop. In the funeral parlor, the most recent additions to the roll of the dead begin roasting in their metal lockers like chickens in a Dutch oven. The fire finishes its triumphant run down Main Street by engulfing Food City, then rolls onward toward Dipper's, where those still in the parking lot scream and clutch at each other. Their last sight on earth is of a firewall a hundred yards high running eagerly to meet them, like Albion to his beloved. Now the flames are rolling down the main roads, boiling their tar into soup. At the same time it is spreading into Eastchester, snacking on both yuppie homes and the few yuppies cowering inside. Michela Burpee will soon run for her cellar, but too late; her kitchen will explode around her and her last sight on earth will be her Amana refrigerator, melting.

The soldiers standing by the Tarker−Chester border − closest to the origin of this catastrophe − stumble backward as the fire beats impotent fists against the Dome, turning it black. The soldiers feel the heat bake through, raising the temperature twenty degrees in seconds, crisping the leaves on the nearest trees. One of them will later say, 'It was like standing outside a glass ball with a nuclear explosion inside of it.'

Now the people cowering against the Dome begin to be bombarded by dead and dying birds as the fleeing sparrows, robins, grackles, crows, gulls, and even geese slam against the Dome they so quickly learned to avoid. And across Dinsmore's field comes a stampede of the town's dogs and cats. There are also skunks, woodchucks,

porcupines. Deer leap among them, and several clumsily galloping moose, and of course Alden Dinsmore's cattle, eyes rolling and mooing their distress. When they reach the Dome they crash against it. The lucky animals die. The unlucky ones lie sprawled on pincushions of broken bones, barking and squealing and miaowing and bellowing.

Ollie Dinsmore sees Dolly, the beautiful Brown Swiss who once won him a 4-H blue ribbon (his mother named her, thought Ollie and Dolly was just so cute). Dolly gallops heavily toward the Dome with somebody's Weimaraner nipping at her legs, which are already bloody. She hits the barrier with a crunch he can't hear over the oncoming fire . . . except in his mind he *can* hear it, and somehow seeing the equally doomed dog pounce on poor Dolly and begin ripping at her defenseless udder is even worse than finding his father dead.

The sight of the dying cow that was once his darling breaks the boy's paralysis. He doesn't know if there's even the slightest chance of surviving this terrible day, but he suddenly sees two things with utter clarity. One is the oxygen tank with his dead father's Red Sox cap hung on it. The other is Grampy Tom's oxygen mask dangling from the hook of the bathroom door. As Ollie runs for the farm where he's lived his whole life – the farm that will soon cease to exist – he has only one completely coherent thought: the potato cellar. Buried under the barn and running beneath the hill behind it, the potato cellar may be safe.

The expatriates are still standing at the edge of the orchard. Barbie hasn't been able to make them hear him, let alone move them. Yet he must get them back to the farmhouse and the vehicles. Soon.

From here they have a panoramic view of the whole town, and Barbie is able to judge the fire's course the way a general might judge the most likely route of an invading army by aerial photographs. It's sweeping southeast, and may stay on the western side of the Prestile. The river, although dry, should still serve as a natural firebreak. The explosive windstorm the fire has generated will also help to keep it from the town's northernmost quadrant. If the fire burns all the way to where the Dome borders on Castle Rock and Motton – the heel and sole of the boot – then those parts of Chester's Mill bordering on TR-90 and northern Harlow may be saved. From fire, at least. But it's not fire that concerns him.

What concerns him is that wind.

He feels it now, rushing over his shoulders and between his spread legs hard enough to ripple his clothes and blow Julia's hair around her face. It's rushing away from them to feed the fire, and

because The Mill is now an almost completely closed environment, there will be very little good air to replace what is being lost. Barbie has a nightmare image of goldfish floating dead on the surface of an aquarium from which all the oxygen has been exhausted.

Julia turns to him before he can grab her and points at something below: a figure trudging along Black Ridge Road, pulling a wheeled object. From this distance Barbie can't tell if the refugee is a man or a woman, and it doesn't matter. Whoever it is will almost certainly die of asphyxiation long before reaching the highland.

He takes Julia's hand and puts his lips to her ear. 'We have to go. Grab Piper, and have her grab whoever's next to her. Everybody—'

'*What about him?*' she shouts, still pointing to the trudging figure. It might be a child's wagon he or she's pulling. It's loaded with something that must be heavy, because the figure is bent over and moving very slowly.

Barbie has to make her understand, because time has grown short. 'Never mind him. We're going back to the farmhouse. *Now.* Everybody joins hands so nobody gets left behind.'

She tries to turn and look at him, but Barbie holds her still. He wants her ear − literally − because he has to make her understand. 'If we don't go now, it may be too late. We'll run out of air.'

On Route 117, Velma Winter leads a parade of fleeing vehicles in her Datsun truck. All she can think about is the fire and smoke filling the rearview mirror. She's doing seventy when she hits the Dome, which she has in her panic forgotten completely (just another bird, in other words, this one on the ground). The collision occurs at the same spot where Billy and Wanda Debec, Nora Robichaud, and Elsa Andrews came to grief a week before, shortly after the Dome came down. The engine of Velma's light truck shoots backward and tears her in half. Her upper body exits through the windshield, trailing intestines like party streamers, and splatters against the Dome like a juicy bug. It is the start of a twelve-vehicle pileup in which many die. The majority are only injured, but they will not suffer long.

Henrietta and Petra feel the heat wash against them. So do all the hundreds pressed against the Dome. The wind lifts their hair and ruffles clothes that will soon be burning.

'Take my hand, honey,' Henrietta says, and Petra does.

They watch the big yellow bus make a wide, drunken turn. It totters along the ditch, barely missing Richie Killian, who first dodges away and then leaps nimbly forward, grabbing onto the back door as the bus goes by. He lifts his feet and squats on the bumper.

'I hope they make it,' Petra says.

'So do I, honey.'

'But I don't think they will.'

Now some of the deer leaping out of the approaching conflagration are on fire.

Henry has taken the wheel of the bus. Pamela stands beside him, holding onto a chrome pole. The passengers are about a dozen townsfolk, most loaded in earlier because they were experiencing physical problems. Among them are Mabel Alston, Mary Lou Costas, and Mary Lou's baby, still wearing Henry's baseball cap. The redoubtable Leo Lamoine has also gotten onboard, although his problem seems to be emotional rather than physical; he is wailing in terror.

'*Step on it and head north!*' Pamela shouts. The fire has almost reached them, it's less than five hundred yards ahead, and the sound of it shakes the world. '*Drive like a motherfucker and don't stop for anything!*'

Henry knows it's hopeless, but because he also knows he would rather go out this way than helplessly cowering with his back to the Dome, he yanks on the headlights and gets rolling. Pamela is thrown backward into the lap of Chaz Bender, the teacher – Chaz was helped into the bus when he began to suffer heart palpitations. He grabs Pammie to steady her. There are shrieks and cries of alarm, but Henry barely hears them. He knows he is going to lose sight of the road in spite of the headlights, but so what? As a cop he has driven this stretch a thousand times.

Use the force, Luke, he thinks, and actually laughs as he drives into the flaming darkness with the accelerator pedal jammed to the mat. Clinging to the back door of the bus, Richie Killian suddenly cannot breathe. He has time to see his arms catch fire. A moment later the temperature outside the bus pops to eight hundred degrees and he is burned off his perch like a fleck of meat off a hot barbecue grill.

The lights running down the center of the bus are on, casting a weak luncheonette-at-midnight glow over the terrified, sweat-drenched faces of the passengers, but the world outside has turned dead black. Whirlpools of ash eddy in the radically foreshortened beams of the headlights. Henry steers by memory, wondering when the tires will explode beneath him. He's still laughing, although he can't hear himself over the scalded-cat screech of 19's engine. He's keeping to the road; there's that much. How long until they break through the other side of the firewall? Is it possible they *can* break through? He's beginning to think it might be. Good God, how thick can it be?

'You're doing it!' Pamela shouts. 'You're *doing* it!'

Maybe, Henry thinks. *Maybe I am*. But Christ, the *heat*! He is reaching for the air-conditioning knob, meaning to turn it all the way to MAX COOL, and that's when the windows implode and the bus fills with fire. Henry thinks, *No! No! Not when we're so close!*

But when the charred bus charges clear of the smoke, he sees nothing beyond but a black wasteland. The trees have been burned away to glowing stubs and the road itself is a bubbling ditch. Then an overcoat of fire drops over him from behind and Henry Morrison knows no more. 19 skids from the remains of the road and overturns with flames spewing from every broken window. The quickly blackening message on the back reads: SLOW DOWN, FRIEND! WE LOVE OUR CHILDREN!

Ollie Dinsmore sprints to the barn. Wearing Grampy Tom's oxygen mask around his neck and carrying two tanks with a strength he never knew he had (the second he spied as he cut through the garage), the boy runs for the stairs that will take him down to the potato cellar. There's a ripping, snarling sound from overhead as the roof begins to burn. On the west side of the barn the pumpkins also begin to burn, the smell rich and cloying, like Thanksgiving in hell.

The fire moves toward the southern side of the Dome, racing through the last hundred yards; there is an explosion as Dinsmore's dairy barns are destroyed. Henrietta Clavard regards the oncoming fire and thinks: *Well, I'm old. I've had my life. That's more than this poor girl can say.*

'Turn around, honey,' she tells Petra, 'and put your head on my bosom.'

Petra Searles turns a tearstained and very young face up to Henrietta's. 'Will it hurt?'

'Only for a second, honey. Close your eyes, and when you open them, you'll be bathing your feet in a cool stream.'

Petra speaks her last words. 'That sounds nice.'

She closes her eyes. Henrietta does the same. The fire takes them. At one second they're there, at the next . . . gone.

Cox is still close on the other side of the Dome, and the cameras are still rolling from their safe position at the flea-market site. Everyone in America is watching in shocked fascination. The commentators have been stunned to silence, and the only soundtrack is the fire, which has plenty to say.

For a moment Cox can still see the long human snake, although the people who make it up are only silhouettes against the fire. Most of them – like the expatriates on Black Ridge, who are at last making their way back to the farmhouse and their vehicles – are holding

hands. Then the fire boils against the Dome and they are gone. As if to make up for their disappearance, the Dome itself becomes visible: a great charred wall rearing into the sky. It holds most of the heat in, but enough flashes out to turn Cox around and send him running. He tears off his smoking shirt as he goes.

The fire has burned on the diagonal Barbie foresaw, sweeping across Chester's Mill from northwest to southeast. When it dies, it will do so with remarkable quickness. What it has taken is oxygen; what it leaves behind is methane, formaldehyde, hydrochloric acid, carbon dioxide, carbon monoxide, and trace gases equally noxious. Also choking clouds of particulate matter: vaporized houses, trees, and – of course – people.

What it leaves behind is poison.

22

Twenty-eight exiles and two dogs convoyed out to where the Dome bordered on TR-90, known to the oldtimers as Canton. They were crammed into three vans, two cars, and the ambulance. By the time they arrived the day had grown dark and the air had become increasingly hard to breathe.

Barbie jammed on the brakes of Julia's Prius and ran to the Dome, where a concerned Army lieutenant colonel and half a dozen other soldiers stepped forward to meet him. The run was short, but by the time Barbie reached the red band spray-painted on the Dome, he was gasping. The good air was disappearing like water down a sink.

'The fans!' he panted at the lieutenant colonel. 'Turn on the fans!'

Claire McClatchey and Joe spilled out of the department store van, both of them staggering and gasping. The phone company van came next. Ernie Calvert got out, took two steps, and went to his knees. Norrie and her mother tried to help him to his feet. Both were crying.

'Colonel Barbara, what happened?' the lieutenant colonel asked. According to the name-strip on his fatigues, he was STRINGFELLOW. 'Report.'

'Fuck your report!' Rommie shouted. He was holding a semi-conscious child – Aidan Appleton – in his arms. Thurse Marshall staggered along behind him with his arm around Alice, whose sparkle-sprinkled top was sticking to her; she'd retched down her front. 'Fuck your report, *just turn on dose fans, you*!'

Stringfellow gave the order and the refugees knelt, their hands pressed against the Dome, greedily gasping in the faint breeze of clean air the huge fans were able to force through the barrier.

Behind them, the fire raged.

SURVIVORS

1

Only three hundred and ninety-seven of The Mill's two thousand residents survive the fire, most of them in the northeast quadrant of town. By the time night falls, rendering the smudged darkness inside the Dome complete, there will be a hundred and six.

When the sun comes up on Saturday morning, shining weakly through the only part of the Dome not charred completely black, the population of Chester's Mill is just thirty-two.

2

Ollie slammed the door to the potato cellar before running downstairs. He also flicked the switch that turned on the lights, not knowing if they would still work. They did. As he stumbled down to the barn's basement (chilly now but not for long; he could already feel the heat starting to push in behind him), Ollie remembered the day four years ago when the guys from Ives Electric in Castle Rock backed up to the barn to unload the new Honda generator.

'Overpriced sonofawhore better work right,' Alden had said, chewing on a piece of grass, 'because I'm in hock up to my eyeballs for it.'

It *had* worked right. It was still working right, but Ollie knew it wouldn't much longer. The fire would take it as the fire had taken everything else. If he had as much as a minute of light left, he would be surprised.

I may not even be alive in a minute.

The potato grader stood in the middle of the dirty concrete floor, a complexity of belts and chains and gears that looked like some ancient instrument of torture. Beyond it was a huge pile of spuds. It had been a good fall for them, and the Dinsmores had finished the harvest only three days before the Dome came down. In an ordinary year, Alden and his boys would have graded them all through November to sell at the Castle Rock co-op produce market and various roadside stands in Motton, Harlow, and Tarker's Mills. No spud-money this year. But Ollie thought they might save his life.

He ran to the edge of the pile, then stopped to examine the two tanks. The dial on the one from the house read only half full, but the needle on the one from the garage was all the way in the

green. Ollie let the half-full one clang to the concrete and attached the mask to the one from the garage. He had done this many times when Grampy Tom was alive, and it was the work of seconds.

Just as he hung the mask around his neck again, the lights went out.

The air was growing warmer. He dropped to his knees and began burrowing into the cold weight of the potatoes, pushing with his feet, protecting the long tank with his body and yanking it along beneath him with one hand. With the other he made awkward swimming motions.

He heard potatoes avalanche down behind him and fought a panicky urge to back out. It was like being buried alive, and telling himself that if he *wasn't* buried alive he'd surely die didn't help much. He was gasping, coughing, seeming to breathe in as much potato-dirt as air. He clapped the oxygen mask over his face and . . . nothing.

He fumbled at the tank valve for what seemed like forever, his heart pounding in his chest like an animal in a cage. Red flowers began to open in the darkness behind his eyes. Cold vegetable weight bore down on him. He had been crazy to do this, as crazy as Rory had been, shooting off a gun at the Dome, and he was going to pay the price. He was going to die.

Then his fingers finally found the valve. At first it wouldn't turn, and he realized he was trying to spin it the wrong way. He reversed his fingers and a rush of cool, blessed air gusted into the mask.

Ollie lay under the potatoes, gasping. He jumped a little when the fire blew in the door at the top of the stairs; for a moment he could actually see the dirty cradle he lay in. It was getting warmer, and he wondered if the half-full tank he had left behind would blow. He also wondered how much additional time the full one had bought him, and if it was worth it.

But that was his brain. His body had only one imperative, and that was life. Ollie began to crawl deeper into the potato pile, dragging the tank along, adjusting the mask on his face each time it came askew.

3

If the Vegas bookies had given odds on those likely to survive the Visitors Day catastrophe, those on Sam Verdreaux would have been a thousand to one. But longer odds have been beaten – it's what keeps bringing people back to the tables – and Sam was the figure

Julia had spotted laboring along Black Ridge Road shortly before the expatriates ran for the vehicles at the farmhouse.

Sloppy Sam the Canned Heat Man lived for the same reason Ollie did: he had oxygen.

Four years ago, he had gone to see Dr Haskell (The Wiz — you remember him). When Sam said he couldn't seem to catch his breath just lately, Dr Haskell listened to the old rumpot's wheezing respiration and asked him how much he smoked.

'Well,' Sam had said, 'I used to go through as much as four packs a day when I was in the woods, but now that I'm on disability and sociable security, I've cut back some.'

Dr Haskell asked him what that meant in terms of actual consumption. Sam said he guessed he was down to two packs a day. American Iggles. 'I used to smoke Chesterfoggies, but now they only come with the filter,' he explained. 'Also, they're expensive. Iggles is cheap, and you can pick the filter off before you light up. Easy as pie.' Then he began to cough.

Dr Haskell found no lung cancer (something of a surprise), but the X-rays seemed to show a damned fine case of emphysema, and he told Sam that he'd probably be using oxygen for the rest of his life. It was a bad diagnosis, but give the guy a break. As the doctors say, when you hear hoofbeats, you don't think zebras. Also, folks have a tendency to see what they're looking for, don't they? And although Dr Haskell died what might be called a hero's death, no one, including Rusty Everett, ever mistook him for Gregory House. What Sam actually had was bronchitis, and it cleared up not too long after The Wiz made his diagnosis.

By then, however, Sam was signed up for oxygen deliveries every week from Castles in the Air (a company based in Castle Rock, of course), and he never canceled the service. Why would he? Like his hypertension medicine, the oxygen was covered by what he referred to as THE MEDICAL. Sam didn't really understand THE MEDICAL, but he understood that the oxygen cost him nothing out of pocket. He also discovered that huffing pure oxygen had a way of cheering a body up.

Sometimes, however, weeks would pass before it crossed Sam's mind to visit the scurgy little shed he thought of as 'the oxygen bar.' Then, when the guys from Castles in the Air came to retrieve the empties (a thing they were often lax about), Sam would go out to his oxygen bar, open the valves, run the tanks dry, pile them in his son's old red wagon, and trundle them out to the bright blue truck with the air-bubbles on it.

If he had still lived out on Little Bitch road, site of the old Verdreaux home place, Sam would have burned to a crisp (as Marta Edmunds did) in the minutes after the initial explosion. But the home place and the woodlots which had once surrounded it had been taken for unpaid taxes long since (and purchased back in '08 by one of several Jim Rennie dummy corporations . . . at bargain-basement rates). His baby sis owned a little patch of land out on God Creek, however, and that was where Sam was residing on the day the world blew up. The shack wasn't much, and he had to do his business in an outhouse (the only running water was supplied by an old hand-pump in the kitchen), but by gorry the taxes were paid, little sis saw to that . . . and he had THE MEDICAL.

Sam was not proud of his part in instigating the Food City riot. He had drunk many shots and beers with Georgia Roux's father over the years, and felt bad about hitting the man's daughter in the face with a rock. He kept thinking about the sound that piece of quartz had made when it connected, and how Georgia's broken jaw had sagged, making her look like a ventriloquist's dummy with a busted mouth. He could have killed her, by the living Jesus. Was probably a miracle that he hadn't . . . not that she had lasted long. And then an even sadder idea had occurred to him: if he'd left her alone, she wouldn't have been in the hospital. And if she hadn't been in the hospital, she'd probably still be alive.

If you looked at it that way, he *had* killed her.

The explosion at the radio station caused him to sit bolt upright out of a drunken sleep, clutching his chest and staring around wildly. The window above his bed had blown out. In fact, every window in the place had blown out, and his shack's west-facing front door had been torn clean off its hinges.

He stepped over it and stood frozen in his weedy and tire-strewn front yard, staring west, where the whole world appeared to be on fire.

4

In the fallout shelter below where the Town Hall had once stood, the generator – small, old-fashioned, and now the only thing standing between the occupants and the great hereafter – ran steadily. Battery-powered lights cast a yellowish glow from the corners of the main room. Carter was sitting in the only chair, Big Jim taking up most of the elderly two-person sofa and eating sardines from a can, plucking them out one by one with his thick fingers and laying them on Saltines.

The two men had little to say to each other; the portable TV

Carter had found gathering dust in the bunkroom took up all of their attention. It got only a single station – WMTW out of Poland Spring – but one was enough. Too much, really; the devastation was hard to comprehend. Downtown had been destroyed. Satellite photos showed that the woods around Chester Pond had been reduced to slag, and the Visitors Day crowd at 119 was now dust in a dying wind. To a height of twenty thousand feet, the Dome had become visible: an endless, sooty prison wall surrounding a town that was now seventy percent burned over.

Not long after the explosion, the temperature in the cellar had begun to climb appreciably. Big Jim told Carter to turn on the air-conditioning.

'Will the gennie handle that?' Carter had asked.

'If it won't, we'll cook,' Big Jim had replied irritably, 'so what's the difference?'

Don't you snap at me, Carter thought. *Don't you snap at me when you were the one who made this happen. The one who's responsible.*

He'd gotten up to find the air-conditioning unit, and as he did, another thought crossed his mind: those sardines really stank. He wondered what the boss would say if he told him the stuff he was putting in his mouth smelled like old dead pussy.

But Big Jim had called him *son* like he meant it, so Carter kept his mouth shut. And when he turned on the air-conditioner, it had started right up. The sound of the generator had deepened a little, though, as it shouldered the extra burden. It would burn through their supply of LP that much quicker.

Doesn't matter, he's right, we gotta have it, Carter told himself as he watched the relentless scenes of devastation on the TV. The majority were coming from satellites or high-flying reconnaissance planes. At lower levels, most of the Dome had become opaque.

But not, he and Big Jim discovered, at the northeastern end of town. Around three o'clock in the afternoon, the coverage abruptly switched there, with video coming from just beyond a bustling Army outpost in the woods.

'This is Jake Tapper in TR-90, an unincorporated township just north of Chester's Mill. This is as close as we've been allowed, but as you can see, there *are* survivors. I repeat, there *are* survivors.'

'There are survivors right here, you dummy,' Carter said.

'Shut up,' Big Jim said. Blood was mounting in his heavy cheeks and dashing across his forehead in a wavy line. His eyes bulged in their sockets and his hands were clenched. 'That's Barbara. It's that son-of-a-buck Dale Barbara!'

Carter saw him among the others. The picture was being transmitted from a camera with an extremely long lens, which made the image shaky — it was like looking at people through a heat-haze — but it was still clear enough. Barbara. The mouthy minister. The hippy doctor. A bunch of kids. The Everett woman.

That bitch was lying all along, he thought. *She lied and stupid Carter believed her.*

'The roaring sound you hear is not helicopters,' Jake Tapper was saying. 'If we can pull back a little . . .'

The camera pulled back, revealing a line of huge fans on dollies, each connected to its own generator. The sight of all that power just miles away made Carter feel sick with envy.

'You see it now,' Tapper went on. 'Not helicopters but industrial fans. Now . . . if we can move in again on the survivors . . .'

The camera did so. They were kneeling or sitting at the edge of the Dome, directly in front of the fans. Carter could see their hair moving in the breeze. Not quite rippling, but definitely moving. Like plants in a lazy underwater current.

'There's Julia Shumway,' Big Jim marveled. 'I should have killed that rhymes-with-witch when I had the chance.'

Carter paid no attention. His eyes were riveted on the TV.

'The combined blast from four dozen fans should be enough to knock those folks over, Charlie,' Jake Tapper said, 'but from here it looks like they're getting just enough air to keep them alive in an atmosphere that has become a poison soup of carbon dioxide, methane, and God knows what else. Our experts are telling us that Chester's Mill's limited supply of oxygen mostly went to feed the fire. One of those experts — chemistry professor Donald Irving of Princeton — told me via cell phone that the air inside the Dome now might not be all that much different from the atmosphere of Venus.'

The picture switched to a concerned-looking Charlie Gibson, safe in New York. (*Lucky bastard,* Carter thought.) 'Any word yet on what may have caused the fire?'

Back to Jake Tapper . . . and then to the survivors in their small capsule of breathable air. 'None, Charlie. It was some sort of explosion, that seems clear, but there's been no further word from the military and nothing from Chester's Mill. Some of the people you see on your screen must have phones, but if they are communicating, it's only with Colonel James Cox, who touched down here about forty-five minutes ago and immediately conferenced with the survivors. While the camera pans this grim scene from our admittedly remote standpoint, let me give concerned viewers in America — and all over

the world – the names of the people now at the Dome who have been positively identified. I think you might have still pictures of several, and maybe you can flash them on the screen as I go. I think my list's alphabetical, but don't hold me to that.'

'We won't, Jake. And we do have some pictures, but go slow.'

'Colonel Dale Barbara, formerly Lieutenant Barbara, United States Army.' A picture of Barbie in desert camo came on the screen. He had his arm around a grinning Iraqi boy. 'A decorated veteran and most recently a short-order cook in the town restaurant.

'Angelina Buffalino . . . do we have a picture of her? . . . no? . . . okay.

'Romeo Burpee, owner of the local department store.' There was a picture of Rommie. In it he was standing beside a backyard barbecue with his wife and wearing a tee-shirt that read KISS ME, I'M FRENCH.

'Ernest Calvert, his daughter Joan, and Joan's daughter, Eleanor Calvert.' This picture looked like it had been taken at a family reunion; there were Calverts everywhere. Norrie, looking both grim and pretty, had her skateboard under one arm.

'Alva Drake . . . her son Benjamin Drake . . .'

'Turn that off,' Big Jim grunted.

'At least they're in the open,' Carter said wistfully. 'Not stuck in a hole. I feel like Saddam fucking Hussein when he was on the run.'

'Eric Everett, his wife, Linda, and their two daughters . . .'

'Another family!' Charlie Gibson said in a voice of approval that was almost Mormonesque. That was enough for Big Jim; he got up and snapped the TV off himself, with a hard twist of the wrist. He was still holding the sardine can, and spilled some of the oil on his pants when he did it.

You'll never get that out, Carter thought but did not say.

I was watching that show, Carter thought but did not say.

'The newspaper woman,' Big Jim brooded, sitting back down. The cushions hissed as they collapsed beneath his weight. 'She was always against me. Every trick in the book, Carter. Every trick in the cotton-picking book. Get me another can of sardines, would you?'

Get it yourself, Carter thought but did not say. He got up and grabbed another can of 'dines.

Instead of commenting on the olfactory association he had made between sardines and deceased female sex organs, he asked what seemed to be the logical question.

'What are we going to do, boss?'

Big Jim removed the key from the bottom of the can, inserted

it in the tab, and unrolled the top to expose a fresh squadron of dead fish. They gleamed greasily in the glow of the emergency lights. 'Wait for the air to clear, then go topside and start picking up the pieces, son.' He sighed, placed a dripping fish on a Saltine, and ate it. Cracker crumbs stuck to his lips in beads of oil. 'It's what people like us always do. The responsible people. The ones who pull the plow.'

'What if the air doesn't clear? The TV said—'

'Oh dear, the sky is falling, oh dear, the sky is falling!' Big Jim declaimed in a strange (and strangely disturbing) falsetto. 'They've been saying it for years, haven't they? The scientists and the bleeding-heart liberals. World War III! Nuclear reactors melting down to the center of the earth! Y2K computer freezes! The end of the ozone layer! Melting ice caps! Killer hurricanes! Global warming! Chickendirt weak-sister atheists who won't trust in the will of a loving, caring God! Who refuse to believe there *is* such a thing as a loving, caring God!'

Big Jim pointed a greasy but adamant finger at the younger man.

'Contrary to the beliefs of the secular humanists, the sky is *not* falling. They can't help the yellow streak that runs up their backs, son – "the guilty man flees where none pursueth," you know, Book of Leviticus – but that doesn't change God's truth: those who believe on Him shall not tire, but shall mount up with wings as eagles – book of Isaiah. That's basically smog out there. It'll just take awhile to clear out.'

But two hours later, at just past four o'clock on that Friday afternoon, a shrill *queep-queep-queep* sound came from the alcove that held the fallout shelter's mechanical support system.

'What's that?' Carter asked.

Big Jim, now slumped on the couch with his eyes partly closed (and sardine grease on his jowls), sat up and listened. 'Air purifier,' he said. 'Kind of like a big Ionic Breeze. We've got one of those in the car showroom down at the store. Good gadget. Not only does it keep the air nice and sweet, it stops those static electricity shocks you tend to get in cold wea—'

'If the air in town's clearing, why did the air purifier start up?'

'Why don't you go upstairs, Carter? Crack the door a little bit and see how things are. Would that ease your mind?'

Carter didn't know if it would or not, but he knew just sitting here was making him feel squirrelly. He mounted the stairs.

As soon as he was gone, Big Jim got up himself and went to the line of drawers between the stove and the little refrigerator. For

such a big man, he moved with surprising speed and quiet. He found what he was looking for in the third drawer. He glanced over his shoulder to make sure he was still alone, then helped himself.

On the door at the top of the stairs, Carter was confronted by a rather ominous sign:

DO YOU NEED TO CHECK THE RADIATION COUNT?

THINK!!!

Carter thought. And the conclusion he came to was that Big Jim was almost certainly full of shit about the air clearing out. Those folks lined up in front of the fans proved that the air exchange between Chester's Mill and the outside world was almost nil.

Still, it wouldn't do any harm to check.

At first the door wouldn't budge. Panic, sparked by dim thoughts of being buried alive, made him push harder. This time the door moved just a little. He heard bricks falling and lumber scraping. Maybe he could open it wider, but there was no reason to. The air coming in through the inch-wide gap he'd opened wasn't air at all, but something that smelled like the inside of an exhaust pipe when the motor it was attached to was running. He didn't need any fancy instruments to tell him that two or three minutes outside the shelter would kill him.

The question was, what was he going to tell Rennie?

Nothing, the cold voice of the survivor inside suggested. *Hearing something like that will only make him worse. Harder to deal with.*

And what exactly did *that* mean? What did it matter, if they were going to die in the fallout shelter when the generator ran out of fuel? If that was the case, what did anything matter?

He went back down the stairs. Big Jim was sitting on the sofa. 'Well?'

'Pretty bad,' Carter said.

'But breathable, right?'

'Well, yeah. But it'd make you damn sick. We better wait, boss.'

'Of course we better wait,' Big Jim said, as if Carter had suggested otherwise. As if Carter were the biggest fool in the universe. 'But we'll be fine, that's the point. God will take care. He always does. In the meantime, we've got good air down here, it's not too hot, and there's plenty to eat. Why don't you see what there is for sweets, son? Candybars and such? I'm still feeling peckish.'

I'm not your son, your son is dead, Carter thought . . . but didn't say. He went into the bunkroom to see if there were any candybars on the shelves in there.

5

Around ten o'clock that night, Barbie fell into a troubled sleep with Julia close beside him, their bodies spooned together. Junior Rennie danced through his dreams: Junior standing outside his cell in The Coop. Junior with his gun. And this time there would be no rescue because the air outside had turned to poison and everyone was dead.

These dreams finally slipped away, and he slept more deeply, his head – and Julia's – cocked toward the Dome and the fresh air seeping through it. It was enough for life, but not enough for ease.

Something woke him around two o'clock in the morning. He looked through the smudged Dome at the muted lights of the Army encampment on the other side. Then the sound came again. It was coughing, low and harsh and desperate.

A flashlight gleamed off to his right. Barbie got up as quietly as he could, not wanting to wake Julia, and walked to the light, stepping over others who lay sleeping in the grass. Most had stripped down to their underwear. The sentries ten feet away were bundled up in duffle coats and gloves, but over here it was hotter than ever.

Rusty and Ginny were kneeling beside Ernie Calvert. Rusty had a stethoscope around his neck and an oxygen mask in his hand. It was attached to a small red bottle marked **CRH AMBULANCE DO NOT REMOVE ALWAYS REPLACE**. Norrie and her mother looked on anxiously, their arms around each other.

'Sorry he woke you,' Joanie said. 'He's sick.'

'How sick?' Barbie asked.

Rusty shook his head. 'I don't know. It sounds like bronchitis or a bad cold, but of course it's not. It's bad air. I gave him some from the ambo, and it helped for awhile, but now . . .' He shrugged. 'And I don't like the sound of his heart. He's been under a lot of stress, and he's not a young man anymore.'

'You have no more oxygen?' Barbie asked. He pointed to the red bottle, which looked quite a lot like the kind of fire extinguisher people keep in their kitchen utility closets and always forget to recharge. 'That's *it?*'

Thurse Marshall joined them. In the beam of the flashlight he looked grim and tired. 'There's one more, but we agreed – Rusty,

Ginny, and me – to save it for the little kids. Aidan's started to cough too. I moved him as close to the Dome – and the fans – as I could, but he's still coughing. We'll start giving Aidan, Alice, Judy, and Janelle the remaining air in rationed whiffs when they wake up. Maybe if the officers brought more fans—'

'No matter how much fresh air they blow at us,' Ginny said, 'only so much comes through. And no matter how close to the Dome we get, we're still breathing in that *crap*. And the people who are hurting are exactly the ones you'd expect.'

'The oldest and the youngest,' Barbie said.

'Go back and lie down, Barbie,' Rusty said. 'Save your strength. There's nothing you can do here.'

'Can you?'

'Maybe. There's also nasal decongestant in the ambo. And epinephrine, if it comes to that.'

Barbie crawled back along the Dome with his head turned to the fans – they were all doing this now, without thinking – and was appalled by how tired he felt when he reached Julia. His heart was pounding and he was out of breath.

Julia was awake. 'How bad is he?'

'I don't know,' Barbie admitted, 'but it can't be good. They were giving him oxygen from the ambulance, and he didn't wake up.'

'Oxygen! Is there more? How much?'

He explained, and was sorry to see the light in her eyes dim a little.

She took his hand. Her fingers were sweaty but cold. 'This is like being trapped in a mine cave-in.'

They were sitting now, facing each other, shoulders leaning against the Dome. The faintest of breezes sighed between them. The steady roar of the Air Max fans had become background noise; they raised their voices to speak over it, but otherwise didn't notice it at all.

We'd notice it if it stopped, Barbie thought. *For a few minutes, anyway. Then we wouldn't notice anything, ever again.*

She smiled wanly. 'Quit worrying about me, if that's what you're doing. I'm okay for a middle-aged Republican lady who can't quite catch her breath. At least I managed to get myself rogered one more time. Right, good, and proper, too.'

Barbie smiled back. 'It was my pleasure, believe me.'

'What about the pencil nuke they're going to try on Sunday? What do you think?'

'I don't think. I only hope.'

'And how high are your hopes?'

He didn't want to tell her the truth, but the truth was what she deserved. 'Based on everything that's happened and the little we know about the creatures running the box, not very.'

'Tell me you haven't given up.'

'That I can do. I'm not even as scared as I probably should be. I think because . . . it's insidious. I've even gotten used to the stench.'

'Really?'

He laughed. 'No. How about you? Scared?'

'Yes, but sad, mostly. This is the way the world ends, not with a bang but a gasp.' She coughed again, curling a fist to her mouth. Barbie could hear other people doing the same thing. One would be the little boy who was now Thurston Marshall's little boy. *He'll get some better stuff in the morning*, Barbie thought, and then remembered how Thurston had put it: *Air in rationed whiffs*. That was no way for a kid to have to breathe.

No way for anyone to have to breathe.

Julia spat into the grass, then faced him again. 'I can't believe we did this to ourselves. The things running the box – the leatherheads – set up the situation, but I think they're only a bunch of kids watching the fun. Playing the equivalent of a video game, maybe. They're outside. We're inside, and we did it to ourselves.'

'You've got enough problems without beating yourself up on that score,' Barbie said. 'If anyone's responsible, it's Rennie. He's the one who set up the drug lab, and he's the one who started raiding propane from every source in town. He's also the one who sent men out there and caused some sort of confrontation, I'm sure of it.'

'But who elected him?' Julia asked. 'Who gave him the power to do those things?'

'Not you. Your newspaper campaigned against him. Or am I wrong?'

'You're right,' she said, 'but only about the last eight years or so. At first the *Democrat* – me, in other words – thought he was the greatest thing since sliced bread. By the time I found out what he really was, he was entrenched. And he had poor smiling stupid Andy Sanders out front to run interference for him.'

'You still can't blame—'

'I can and do. If I'd known that pugnacious, incompetent sonofabitch might end up in charge during an actual crisis, I'd have . . . have . . . I'd have drowned him like a kitten in a sack.'

He laughed, then started coughing. 'You sound less like a Republican all the ti—' he began, then broke off.

'What?' she asked, and then she heard it, too. Something was rattling and squeaking in the dark. It got closer and they saw a shambling figure tugging a child's wagon.

'Who's there?' called Dougie Twitchell.

When the shambling newcomer answered, his voice was slightly muffled. By an oxygen mask of his own, it turned out.

'Well, thank God,' Sloppy Sam said. 'I had me a little nap side of the road, and I thought I'd run out of air before I got up here. But here I am. Just in time, too, because I'm almost tapped out.'

6

The Army encampment at Route 119 in Motton was a sad place that early Saturday morning. Only three dozen military personnel and one Chinook remained. A dozen men were loading in the big tents and a few leftover Air Max fans that Cox had ordered to the south side of the Dome as soon as the explosion had been reported. The fans had never been used. By the time they arrived, there was no one to appreciate the scant air they could push through the barrier. The fire was out by six p.m., strangled by lack of fuel and oxygen, but everyone on the Chester's Mill side was dead.

The medical tent was being taken down and rolled up by a dozen men. Those not occupied with that task had been set to that most ancient of Army jobs: policing up the area. It was make-work, but no one on the shit patrol minded. Nothing could make them forget the nightmare they had seen the previous afternoon, but grubbing up the wrappers, cans, bottles, and cigarette butts helped a little. Soon enough it would be dawn and the big Chinook would fire up. They'd climb aboard and go somewhere else. The members of this ragtag crew absolutely could not wait.

One of them was Pfc Clint Ames, from Hickory Grove, South Carolina. He had a green plastic Hefty bag in one hand and was moving slowly through the beaten-down grass, picking up the occasional discarded sign or flattened Coke can so if that hardass Sergeant Groh glanced over he'd look like he was working. He was nearly asleep on his feet, and at first he thought the knocking he heard (it sounded like knuckles on a thick Pyrex dish) was part of a dream. It almost *had* to be, because it seemed to be coming from the other side of the Dome.

He yawned and stretched with one hand pressing into the small

of his back. As he was doing this, the knocking resumed. It really was coming from behind the blackened wall of the Dome.

Then, a voice. Weak and disembodied, like the voice of a ghost. It gave him the chills.

'Is anybody there? Can anybody hear me? Please . . . I'm dying.'

Christ, did he *know* that voice? It sounded like—

Ames dropped his litter bag and ran to the Dome. He put his hands on its blackened, still-warm surface. 'Cow-kid? Is that you?'

I'm crazy, he thought. *It can't be. No one could have lived through that firestorm.*

'*AMES!*' Sergeant Groh bawled. 'What the hell are you doing over there?'

He was about to turn away when the voice behind the charred surface came again. 'It's me. Don't . . .' There was a ragged series of barking coughs. 'Don't go. If you're there, Private Ames, don't go.'

Now a hand appeared. It was as ghostly as the voice, the fingers smeared with soot. It was rubbing a clean place on the inside of the Dome. A moment later a face appeared. At first Ames didn't recognize the cow-kid. Then he realized the boy was wearing an oxygen mask.

'I'm almost out of air,' the cow-kid wheezed. 'Dial's in the red. Has been . . . for the last half hour.'

Ames stared into the cow-kid's haunted eyes, and the cow-kid stared back. Then a single imperative rose in Ames's mind: he couldn't let the cow-kid die. Not after all he had survived . . . although *how* he had survived was impossible for Ames to imagine.

'Kid, listen to me. Y'all drop down on your knees and—'

'*Ames, you useless fuckdub!*' Sergeant Groh hollered, striding over. 'Stop goldbricking and get busy! I have zero patience for your weakass shit tonight!'

Pfc Ames ignored him. He was entirely fixed on the face that appeared to be staring at him from behind a grimy glass wall. 'Drop down and scrape the gluck off the bottom! Do it now, kid, right now!'

The face dropped from view, leaving Ames to hope the cow-kid was doing as he'd been told, and hadn't just passed out.

Sergeant Groh's hand fell on his shoulder. 'Are you deaf? I told you—'

'Get the fans, Sergeant! We have to get the fans!'

'What are you talking ab—'

Ames screamed into the dreaded Sergeant Groh's face. '*There's somebody alive in there!*'

7

Only a single oxygen tank remained in the red wagon by the time Sloppy Sam arrived at the refugee camp by the Dome, and the needle on the dial was resting just above zero. He made no objection when Rusty took the mask and clapped it over Ernie Calvert's face, only crawled to the Dome next to where Barbie and Julia were sitting. There the new arrival got down on all fours and breathed deeply. Horace the Corgi, sitting at Julia's side, looked at him with interest.

Sam rolled over on his back. 'It ain't much, but better'n what I had. The last little bit in them tanks never tastes good like it does fresh off the top.'

Then, incredibly, he lit a cigarette.

'Put that out, are you insane?' Julia said.

'Been dyin for one,' Sam said, inhaling with satisfaction. 'Can't smoke around oxygen, you know. Blow y'self up, likely as not. Although there's people who does it.'

'Might as well let him go,' Rommie said. 'It can't be any worse than the crap we're breathing. For all we know, the tar and nicotine in his lungs is protectin him.'

Rusty came over and sat down. 'That tank's a dead soldier,' he said, 'but Ernie got a few extra breaths from it. He seems to be resting easier now. Thanks, Sam.'

Sam waved it away. 'My air's your air, doc. Or at least it was. Say, can't you make more with somethin in your ambulance there? The guys who bring my tanks – who did, anyway, before this sack of shit hit the fan – they could make more right in their truck. They had a whatdoyoucallit, pump of some kind.'

'Oxygen extractor,' Rusty said, 'and you're right, we have one on board. Unfortunately, it's broken.' He showed his teeth in what passed for a grin. 'It's been broken for the last three months.'

'Four,' Twitch said, coming over. He was looking at Sam's cigarette. 'Don't suppose you got any more of those, do you?'

'Don't even think about it,' Ginny said.

'Afraid of polluting this tropical paradise with secondary smoke, darlin?' Twitch asked, but when Sloppy Sam held out his battered pack of American Eagles, Twitch shook his head.

Rusty said, 'I put in the request for a replacement O_2 extractor myself. To the hospital board. They say the budget's maxed out, but maybe I can get some help from the town. So I send the request to the Board of Selectmen.'

'Rennie,' Piper Libby said.

'Rennie,' Rusty agreed. 'I get a form letter back saying my request will be taken up at the budget meeting in November. So I guess we'll see then.' He flapped his hands at the sky and laughed.

Others were gathering around now, looking at Sam with curiosity. And at his cigarette with horror.

'How'd you get here, Sam?' Barbie asked.

Sam was more than happy to tell his tale. He began with how, as a result of the emphysema diagnosis, he'd wound up getting regular oxygen deliveries thanks to THE MEDICAL, and how sometimes the full tanks backed up on him. He told about hearing the explosion, and what he'd seen when he went outside.

'I knew what was gonna happen as soon as I saw how big it was,' he said. His audience now included the military on the other side. Cox, dressed in boxer shorts and a khaki undershirt, was among them. 'I seen bad fires before, back when I was workin in the woods. Couple of times we had to drop everything and just outrun em, and if one of those old International Harvester trucks we had in those days hadda bogged down, we never woulda. Crown fires is the worst, because they make their own wind. I seen right away the same was gonna happen with this one. Somethin almighty big exploded. What was it?'

'Propane,' Rose said.

Sam stroked his white-stubbled chin. 'Ayuh, but propane wasn't all. There was chemicals, too, because some of those flames was *green*.

'If it had come my way, I woulda been done. You folks too. But it sucked south instead. Shape of the land had somethin to do with that, I shouldn't wonder. And the riverbed, too. Anyways, I knew what was gonna happen, and I got the tanks out of the oxygen bar—'

'The what?' Barbie asked.

Sam took a final drag on his cigarette, then butted it in the dirt. 'Oh, that's just the name I give to the shed where I kep' them tanks. Anyway, I had five full ones—'

'*Five!*' Thurston Marshall almost moaned.

'Ayuh,' Sam said cheerfully, 'but I never could have drug five. I'm gettin on in years, you know.'

'Couldn't you have found a car or a truck?' Lissa Jamieson asked.

'Ma'am, I lost my drivin license seven years ago. Or maybe it was eight. Too many DUIs. If I got caught behind the wheel of anything bigger'n a go-kart again, they'd put me in County and throw away the key.'

Barbie considered pointing out the fundamental flaw in this,

but why bother wasting breath when breath was now so hard to come by?

'Anyway, four tanks in that little red wagon of mine I thought I could manage, and I hadn't gone but a quarter of a mile before I started pullin on the first one. Had to, don'tcha see.'

Jackie Wettington asked, 'Did you know we were out here?'

'No, ma'am. It was high ground, that's all, and I knew my canned air wouldn't last forever. I didn't guess about you, and I didn't guess about those fans, either. It was just a case of nowhere else to go.'

'What took you so long?' Pete Freeman asked. 'It can't be much more than three miles between God Creek and here.'

'Well, that's a funny thing,' Sam said. 'I was comin up the road – you know, Black Ridge Road – and I got over the bridge okay . . . still suckin on the first tank, although it was gettin almighty hot, and . . . say! Did you folks see that dead bear? The one that looked like it bashed its own brains out on a phone-pole?'

'We saw it,' Rusty said. 'Let me guess. A little way past the bear, you got woozy and passed out.'

'How'd you know that?'

'We came that way,' Rusty said, 'and there's some kind of force working out there. It seems to hit kids and old people hardest.'

'I ain't that old,' Sam said, sounding offended. 'I just went white-hair early, like my mom.'

'How long were you knocked out?' Barbie asked.

'Well, I don't wear no watch, but it was dark when I finally got goin again, so it was quite awhile. I woke up once on account of I couldn't hardly breathe, switched to one of the fresh tanks, and went back to sleep again. Crazy, huh? And the dreams I had! Like a three-ring circus! Last time I woke up I was really awake. It was dark, and I went on to another tank. Makin the switch wasn't a bit hard, because it wasn't *really* dark. Shoulda been, shoulda been darker'n a tomcat's asshole with all the soot that fire flang on the Dome, but there's a bright patch down there where I laid up. You can't see it in daylight, but at night it's like about a billion fireflies.'

'The glow-belt, we call it,' Joe said. He and Norrie and Benny were bunched together. Benny was coughing into his hand.

'Good name for it,' Sam said approvingly. 'Anyway, I knew some-body was up here, because by then I could hear those fans and see the lights.' He nodded toward the encampment on the other side of the Dome. 'Didn't know if I was going to make it before my air ran out – that hill's a bugger and I sucked up the oh-two like nobody's business – but I did.'

He was looking curiously at Cox.

'Hey there, Colonel Klink, I can see your breath. You best either put on a coat or come over here where it's warm.' He cackled, showing a few surviving teeth.

'It's Cox, not Klink, and I'm fine.'

Julia asked, 'What did you dream, Sam?'

'Funny you should ask,' he said, 'because there's only one I can remember out of the whole bunch, and that was about you. You was layin on the bandstand in the Common, and you was cryin.'

Julia squeezed Barbie's hand, and hard, but her eyes never left Sam's face. 'How did you know it was me?'

'Because you was covered with newspapers,' Sam said. 'Issues of the *Democrat*. You was huggin em against you like you was naked underneath, beggin your pardon, but you asked. Ain't that just about the funniest dream you ever heard?'

Cox's walkie-talkie beeped three times: *break-break-break*. He took it off his belt. 'What is it? Talk to me fast, I'm busy over here.'

They all heard the voice that returned: 'We have a survivor on the south side, Colonel. Repeat: *We have a survivor.*'

8

As the sun came up on the morning of October twenty-eighth, 'surviving' was all the last member of the Dinsmore family could claim. Ollie lay with his body pressed against the bottom of the Dome, gasping in just enough air from the big fans on the other side to stay alive.

It had been a race just to get enough of the Dome clear on his side before the remaining oxygen in the tank ran out. It was the one he'd left on the floor when he crawled under the potatoes. He remembered wondering if it would explode. It hadn't, and that was a very good thing for Oliver H. Dinsmore. If it had, he would now be lying dead under a burial mound of russets and long whites.

He had knelt on his side of the Dome, digging off cakes of black crud, aware that some of the stuff was all that remained of human beings. It was impossible to forget when he was being repeatedly stabbed by fragments of bone. Without Private Ames's steady encouragement, he was sure he would have given up. But *Ames* wouldn't give up, just kept hectoring him to dig, goddammit, dig that shit clear, cow-kid, you got to do it so the fans can work.

Ollie thought he hadn't given up because Ames didn't know his

name. Ollie had lived with the kids at school calling him shitkicker and titpuller, but he was goddamned if he was going to die listening to some cracker from South Carolina call him cow-kid.

The fans had started up with a roar, and he had felt the first faint gusts of air on his overheated skin. He tore the mask off his face and pressed his mouth and nose directly against the dirty surface of the Dome. Then, gasping and coughing out soot, he continued scraping at the plated char. He could see Ames on the other side, down on his hands and knees with his head cocked like a man trying to peer into a mousehole.

'That's it!' he shouted. 'We got two more fans we're bringin up. Don't you give up on me, cow-kid! Don't you quit!'

'Ollie,' he had gasped.

'What?'

'Name's . . . Ollie. Stop calling me . . . cow-kid.'

'Ah'll call you Ollie from now until doomsday, if you just keep clearin a space for those fans to work.'

Ollie's lungs somehow managed to suck in just enough of what was seeping through the Dome to keep him alive and conscious. He watched the world lighten through his slot in the soot. The light helped, too, although it hurt his heart to see the rose-glow of dawn dirtied by the film of filth that still remained on his side of the Dome. The light was good, because in here everything was dark and scorched and hard and silent.

They tried to relieve Ames of duty at five a.m., but Ollie screamed for him to stay, and Ames refused to leave. Whoever was in charge relented. Little by little, pausing to press his mouth to the Dome and suck in more air, Ollie told how he had survived.

'I knew I'd have to wait for the fire to go out,' he said, 'so I took it real easy on the oxygen. Grampy Tom told me once that one tank could last him all night if he was asleep, so I just laid there still. For quite a while I didn't have to use it at all, because there was air under the potatoes and I breathed that.'

He put his lips to the surface, tasting the soot, knowing it might be the residue of a person who had been alive twenty-four hours previous, not caring. He sucked greedily and hacked out blackish crud until he could go on.

'It was cold under the potatoes at first, but then it got warm and then it got hot. I thought I'd burn alive. The barn was burning down right over my head. *Everything* was burning. But it was so hot and so quick it didn't last long, and maybe that was what saved me. I don't know. I stayed where I was until the first tank was empty.

Then I had to go out. I was afraid the other one might have exploded, but it didn't. I bet it was close, though.'

Ames nodded. Ollie sucked more air through the Dome. It was like trying to breathe through a thick, dirty cloth.

'And the stairs. If they'd been wood instead of concrete block, I couldn't have gotten out. I didn't even try at first. I just crawled back under the spuds because it was so hot. The ones on the outside of the pile cooked in their jackets – I could smell em. Then it started to get hard to pull air, and I knew the second tank was running out, too.'

He stopped as a coughing fit shook him. When it was under control, he went on.

'Mostly I just wanted to hear a human voice again before I died. I'm glad it was you, Private Ames.'

'My name's Clint, Ollie. And you're not going to die.'

But the eyes that looked through the dirty slot at the bottom of the Dome, like eyes peering through a glass window in a coffin, seemed to know some other, truer truth.

9

The second time the buzzer went off, Carter knew what it was, even though it awakened him from a dreamless sleep. Because part of him wasn't going to *really* sleep again until this was over or he was dead. That was what the survival instinct was, he guessed: an unsleeping watchman deep in the brain.

The second time was around seven thirty on Saturday morning. He knew that because his watch was the kind that lit up if you pressed a button. The emergency lights had died during the night and the fallout shelter was completely black.

He sat up and felt something poke against the back of his neck. The barrel of the flashlight he'd used last night, he supposed. He fumbled for it and turned it on. He was on the floor. Big Jim was on the couch. It was Big Jim who had poked him with the flashlight.

Of course he gets the couch, Carter thought resentfully. *He's the boss, isn't he?*

'Go on, son,' Big Jim said. 'Quick as you can.'

Why does it have to be me? Carter thought . . . but did not say. It had to be him because the boss was *old,* the boss was *fat,* the boss had a *bad heart.* And because he was the boss, of course. James Rennie, the Emperor of Chester's Mill.

Emperor of used cars, that's all you are, Carter thought. *And you stink of sweat and sardine oil.*

'Go on.' Sounding irritable. And scared. 'What are you waiting for?'

Carter stood up, the flashlight-beam bouncing off the fallout shelter's packed shelves (so many cans of sardines!), and made his way into the bunkroom. One emergency light was still on in here, but it was guttering, almost out. The buzzer was louder now, a steady *AAAAAAAAAAAA* sound. The sound of oncoming doom.

We're never getting out of here, Carter thought.

He shone the flashlight beam on the trapdoor in front of the generator, which continued to utter the toneless irritating buzz that for some reason made him think of the boss when the boss was speechifying. Maybe because both noises came down to the same stupid imperative: *Feed me, feed me, feed me. Give me propane, give me sardines, give me premium unleaded for my Hummer. Feed me. I'll still die, and then* you'll *die, but who cares? Who gives a ripe red fuck? Feed me, feed me, feed me.*

Inside the storage bin there were now only six tanks of propane. When he replaced the one that was almost empty, there would be five. Five piss-little containers, not much bigger than Blue Rhino tanks, between them and choking to death when the air purifier quit.

Carter pulled one out of the storage space, but he only set it beside the gennie. He had no intention of replacing the current tank until it was totally empty, in spite of that irritating *AAAAAAA*. Nope. Nope. Like they used to say about Maxwell House coffee, it was good to the last drop.

But that buzzer could certainly get on a person's nerves. Carter reckoned he could find the alarm and silence it, but then how would they know when the gennie was running dry?

Like a couple of rats trapped in an overturned bucket, that's what we are.

He ran the numbers in his head. Six tanks left, each good for about eleven hours. But they could turn off the air-conditioner, and that might stretch it to twelve or even thirteen hours per tank. Stay on the safe side and say twelve. Twelve times six was . . . let's see . . .

The *AAAAAAAA* made the math harder than it should have been, but he finally got there. Seventy-two hours between them and a miserable choking death down here in the dark. And why was it dark? Because no one had bothered to replace the batteries in the emergency lights, that was why. They probably hadn't been changed for twenty years or more. The boss had been *saving money*. And why only seven little shitlicking tanks in the storage cubby when there had

been about a zillion gallons out at WCIK, just waiting to blow up? Because the boss liked to have everything *right where he wanted it.*

Sitting there, listening to the *AAAAAAA*, Carter remembered one of his dad's sayings: *Hoard a penny and lose a dollar.* That was Rennie right down to the floor. Rennie the Emperor of Used Cars. Rennie the bigshot politician. Rennie the drug kingpin. How much had he made with his drug operation? A million dollars? Two? And did it matter?

He probably never would have spent it, Carter thought, *and he's sure as shit not gonna spend it now. Nothing to spend it on down here. He's got all the sardines he can eat, and they're free.*

'Carter?' Big Jim's voice came floating through the darkness. 'Are you going to change that out, or are we just going to listen to it buzz?'

Carter opened his mouth to holler they were going to wait, that every minute counted, but just then the *AAAAAAA* finally quit. So did the *queep-queep-queep* of the air purifier.

'Carter?'

'I'm on it, boss.' With the flashlight clamped in his armpit, Carter pulled the empty, put the full one on a metal platform that was big enough to hold a tank ten times this one's size, and hooked up the connector.

Every minute counted . . . or did it? *Why* did it, if it was going to come down to the same choking conclusion?

But the survival-watchman inside thought that was a bullshit question. The survival-watchman thought seventy-two hours was seventy-two hours, and every minute of those seventy-two hours counted. Because who knew what might happen? The military guys might finally figure out how to crack the Dome open. It might even disappear on its own, going as suddenly and inexplicably as it had come.

'*Carter?* What are you doing back there? My cotton-picking grandmother could move faster, and she's dead!'

'Almost done.'

He made sure the connection was tight and put his thumb on the starter-button (thinking that if the little generator's starter-battery was as old as the batteries that had been powering the emergency lights, they were in trouble). Then he paused.

It was seventy-two hours if it was the *two* of them. But if it was just him, he could stretch it to ninety or maybe even a hundred by shutting down the purifier until the air got really thick. He had broached this idea to Big Jim, who had vetoed it out of hand.

'Got a dickey heart,' he had reminded Carter. 'The thicker the air is, the more likely it is to play up on me.'

'*Carter?*' Loud and demanding. A voice that got up in his ears the way the smell of the boss's sardines got up his nose. '*What's going on back there?*'

'All set, boss!' he called, and pushed the button. The starter-motor whirred, and the gennie fired up at once.

I have to think about this, Carter told himself, but the survival-watchman thought differently. The survival-watchman thought that every minute lost was a minute wasted.

He was good to me, Carter told himself. *He gave me responsibilities.*

Dirty jobs he didn't want to do himself is what he gave you. And a hole in the ground to die in. That too.

Carter made up his mind. He pulled his Beretta from its holster as he walked back into the main room. He considered putting it behind his back so the boss wouldn't know, and decided against it. The man had called him *son*, after all, and might even have meant it. He deserved better than an unexpected shot in the back of the head and going out all unprepared.

10

It wasn't dark at the far northeastern end of town; here the Dome was badly smudged but far from opaque. The sun glared through and turned everything a feverish pink.

Norrie ran to Barbie and Julia. The girl was coughing and out of breath, but she ran anyway.

'My grampy is having a heart attack!' she wailed, and then fell on her knees, hacking and gasping.

Julia put her arms around the girl and turned her face to the roaring fans. Barbie crawled to where the exiles were surrounding Ernie Calvert, Rusty Everett, Ginny Tomlinson, and Dougie Twitchell.

'Give them room, people!' Barbie snapped. 'Give the guy some air!'

'That's the problem,' Tony Guay said. 'They gave him what was left . . . the stuff that was supposed to be for the kids . . . but—'

'Epi,' Rusty said, and Twitch handed him a syringe. Rusty injected it. 'Ginny, start compressions. When you get tired, let Twitch take over. Then me.'

'I want to, too,' Joanie said. Tears were streaming down her cheeks, but she seemed composed enough. 'I took a class.'

'I was in it too,' Claire said. 'I'll help.'

'And me,' Linda said quietly. 'I took the refresher just last summer.'

It's a small town and we all support the team, Barbie thought. Ginny – her face still swollen from her own injuries – began chest compressions. She gave way to Twitch just as Julia and Norrie joined Barbie.

'Will they be able to save him?' Norrie asked.

'I don't know,' Barbie said. But he *did* know; that was the hell of it.

Twitch took over from Ginny. Barbie watched as drops of sweat from Twitch's forehead darkened Ernie's shirt. After about five minutes he stopped, coughing breathlessly. When Rusty started to move in, Twitch shook his head. 'He's gone.' Twitch turned to Joanie and said, 'I'm so sorry, Mrs Calvert.'

Joanie's face trembled, then crumpled. She let out a cry of grief that turned into a coughing fit. Norrie hugged her, coughing again herself.

'Barbie,' a voice said. 'A word?'

It was Cox, now dressed in brown camo and wearing a fleece jacket against the chill on the other side. Barbie didn't like the somber expression on Cox's face. Julia went with him. They leaned close to the Dome, trying to breathe slowly and evenly.

'There's been an accident at Kirtland Air Force Base in New Mexico.' Cox kept his voice pitched low. 'They were running final tests on the pencil nuke we meant to try, and . . . shit.'

'It *exploded*?' Julia asked, horrified.

'No, ma'am, melted down. Two people were killed, and another half dozen are apt to die of radiation burns and/or radiation poisoning. The point is, we lost the nuke. We lost the fucking nuke.'

'Was it a malfunction?' Barbie asked. Almost hoping that it had been, because that meant it wouldn't have worked, anyway.

'No, Colonel, it was not. That's why I used the word *accident*. They happen when people hurry, and we've been hurrying our collective ass off.'

'I'm so sorry for those men,' Julia said. 'Do their relatives know yet?'

'Given your own situation, it's very kind of you to think of that. They'll be informed soon. The accident occurred at one o'clock this morning. Work has already begun on Little Boy Two. It should be ready in three days. Four at most.'

Barbie nodded. 'Thank you, sir, but I'm not sure we have that long.'

A long thin wail of grief – a child's wail – went up from behind them. As Barbie and Julia turned around, the wail turned into a series

of harsh coughs and gasps for air. They saw Linda kneel beside her
elder daughter and fold the girl into her arms.

'*She can't be dead!*' Janelle screamed. '*Audrey can't be dead!*'

But she was. The Everetts' golden retriever had died in the night,
quietly and without fuss, as the Little Js slept on either side of her.

11

When Carter came back into the main room, The Mill's Second
Selectman was eating cereal from a box with a cartoon parrot on the
front. Carter recognized this mythical bird from many childhood
breakfasts: Toucan Sam, the patron saint of Froot Loops.

Must be stale as hell, Carter thought, and had a fleeting moment
of pity for the boss. Then he thought of the difference between
seventy-some hours of air and eighty or a hundred and hardened his
heart.

Big Jim scrummed more cereal from the box, then saw the
Beretta in Carter's hand.

'Well,' he said.

'I'm sorry, boss.'

Big Jim opened his hand and let the Froot Loops cascade back
into the box, but his hand was sticky and some of the brightly colored
cereal-rings clung to his fingers and palms. Sweat gleamed on his
forehead and trickled from his receding hairline.

'Son, don't do this.'

'I have to, Mr Rennie. It's not personal.'

Nor was it, Carter decided. Not even a little bit. They were
trapped in here, that was all. And because it had happened as a result
of Big Jim's decisions, Big Jim would have to pay the price.

Big Jim set the box of Froot Loops on the floor. He did it with
care, as if he were afraid the box might shatter if treated roughly.
'Then what is it?'

'It just comes down to . . . air.'

'Air. I see.'

'I could have come in here with the gun behind my back and
just put a bullet in your head, but I didn't want to do that. I wanted
to give you time to get ready. Because you've been good to me.'

'Then don't make me suffer, son. If it's not personal, you won't
make me suffer.'

'If you keep still, you won't. It'll be quick. Like shooting a
wounded deer in the woods.'

'Can we talk about it?'

'No, sir. My mind is made up.'

Big Jim nodded. 'All right, then. Can I have a word of prayer, first? Would you allow me that?'

'Yes, sir, you can pray if you want. But make it fast. This is hard on me too, you know.'

'I believe it is. You're a good boy, son.'

Carter, who hadn't cried since he was fourteen, felt a prickle in the corners of his eyes. 'Calling me son won't help you.'

'It *does* help me. And seeing you're moved . . . that helps me, too.'

Big Jim shuffled his bulk off the couch and got on his knees. In the act of doing this, he knocked over the Froot Loops and uttered a sad little chuckle. 'Wasn't much of a last meal, I can tell you that.'

'No, probably not. I'm sorry.'

Big Jim, his back now to Carter, sighed. 'But I'll be eating roast beef at the Lord's table in a minute or two, so *that's* all right.' He raised a pudgy finger and pressed it high on the back of his neck. 'Right here. The brain stem. All right?'

Carter swallowed what felt like a large dry ball of lint. 'Yes, sir.'

'Do you want to get kneebound with me, son?'

Carter, who had gone prayerless even longer than he'd gone tearless, almost said yes. Then he remembered how sly the boss could be. He probably wasn't being sly now, was probably beyond that, but Carter had seen the man at work and was taking no chances. He shook his head. 'Say your prayer. And if you want to get all the way to amen, you really have to make it a short one.'

On his knees, back to Carter, Big Jim clasped his hands on the cushion of the sofa, which was still dimpled from the weight of his not inconsiderable fanny. 'Dear God, this is Your servant, James Rennie. I guess I'm coming to you, like it or not. The cup has been raised to my lips, and I can't—'

A large dry sob escaped him.

'Turn out the light, Carter. I don't want to be crying in front of you. That's not how a man should die.'

Carter extended the gun until it was almost touching the nape of Big Jim's neck. 'Okay, but that was your last request.' Then he turned out the light.

He knew it was a mistake the instant he did it, but by then it was too late. He heard the boss move, and he was Christing quick for a big man with a bad heart. Carter fired, and in the muzzle-flash he saw a bullet-hole appear in the dented sofa cushion. Big Jim was no longer kneeling in front of it, but he couldn't have gone far, no

matter how quick he was. As Carter thumbed the button of the flash-light, Big Jim drove forward with the butcher knife he had filched from the drawer next to the fallout shelter's stove, and six inches of steel slid into Carter Thibodeau's stomach.

He screamed in agony and fired again. Big Jim felt the bullet buzz close by his ear, but he didn't pull back. He also had a survival-watchman, one that had served him extremely well over the years, and it was saying now that if he drew back he would die. He staggered to his feet, pulling the knife upward as he rose, eviscerating the stupid boy who had thought he could get the best of Big Jim Rennie.

Carter screamed again as he was split open. Beads of blood sprayed Big Jim's face, driven by what he devoutly hoped was the boy's last breath. He pushed Carter back. In the beam of the dropped flashlight, Carter staggered away, crunching through spilled Froot Loops and holding his belly. Blood poured over his fingers. He pawed at the shelves and fell to his knees in a rain of Vigo Sardines, Snow's Clam Fry-Ettes, and Campbell's Soups. For a moment he stayed that way, as if he had reconsidered and decided to say a prayer after all. His hair hung in his face. Then he lost his grip and went down.

Big Jim considered the knife, but that was too labor-intensive for a man suffering from heart problems (he promised himself again that he would get that taken care of as soon as this crisis was over). He picked up Carter's gun instead, and walked to the foolish boy.

'Carter? Are you still with us?'

Carter moaned, tried to turn over, gave up.

'I'm going to put one high up in the back of your neck, just as you suggested. But I want to give you one final piece of advice first. Are you listening?'

Carter groaned again. Big Jim took this for assent.

'The advice is this: Never give a good politician time to pray.'

Big Jim pulled the trigger.

12

'I think he's dying!' Private Ames shouted. 'I think the kid's dying!'

Sergeant Groh knelt beside Ames and peered through the dirty slot at the bottom of the Dome. Ollie Dinsmore was lying on his side with his lips almost pressed against a surface they could now see, thanks to the filth still clinging to it. In his best drill sergeant's voice, Groh yelled: 'Yo! Ollie Dinsmore! Front and center!'

Slowly, the boy opened his eyes and looked at the two men

crouched less than a foot away but in a colder, cleaner world. 'What?' he whispered.

'Nothing, son,' Groh said. 'Go back to sleep.'

Groh turned to Ames. 'Unbunch your panties, Private. He's fine.'

'He's not. Just look at him!'

Groh took Ames by the arm and helped him – not unkindly – to his feet. 'No,' he agreed in a low voice. 'He's not even slightly okay, but he's alive and sleeping and right now that's the best we can ask for. He'll use up less oxygen that way. You go get yourself something to eat. Did you get any breakfast?'

Ames shook his head. The thought of breakfast hadn't even crossed his mind. 'I want to stay in case he comes back around.' He paused, then plunged. 'I want to be here if he dies.'

'He's not going to for awhile,' Groh said. He had no idea if this was true or not. 'Get something out of the truck, even if it's only a slice of bologna wrapped in a slice of bread. You look like shit, soldier.'

Ames jerked his head toward the boy sleeping on charred ground with his mouth and nose cocked to the Dome. His face was streaked with filth, and they could barely see the rise and fall of his chest. 'How long do you think he's got, Sarge?'

Groh shook his head. 'Probably not long. Someone in the group on the other side already died this morning, and several of the others aren't doing well. And it's better over there. Cleaner. You have to prepare yourself.'

Ames felt close to tears. 'Kid lost his whole family.'

'Go get yourself something to eat. I'll watch until you come back.'

'But after that I can stay?'

'The kid wants you, Private, the kid gets you. You can stay until the end.'

Groh watched Ames double-time to the table near the helicopter, where some food was laid out. Out here, it was ten o'clock on a pretty late-fall morning. The sun was shining and melting off the last of a heavy frost. But only a few feet away there was a bubble-world of perpetual twilight, a world where the air was unbreathable and time had ceased to have any meaning. Groh remembered a pond in the local park where he'd grown up. Wilton, Connecticut, that had been. There had been golden carp in the pond, big old things. The kids used to feed them. Until one day when one of the groundskeepers had an accident with some fertilizer, that was. Goodbye, fishies. All ten or a dozen of them, floating dead on the surface.

Looking at the dirty sleeping boy on the other side of the Dome,

it was impossible not to think of those carp . . . only a boy was not a fish.

Ames came back, eating something he obviously didn't want. Not much of a soldier, in Groh's opinion, but a good kid with a good heart.

Private Ames sat down. Sergeant Groh sat with him. Around noon, they got a report from the north side of the Dome that another of the survivors over there had died. A little boy named Aidan Appleton. Another kid. Groh believed he might have met his mother the day before. He hoped he was wrong about that, but didn't think he was.

'Who did it?' Ames asked him. 'Who wound this shit up, Sarge? And why?'

Groh shook his head. 'No idea.'

'It makes no *sense!*' Ames cried. Beyond them, Ollie stirred, lost his air, and moved his sleeping face once more to the scant breeze seeping through the barrier.

'Don't wake him up,' Groh said, thinking: *If he goes in his sleep, it'll be better for all of us.*

13

By two o'clock all of the exiles were coughing except – incredible but true – Sam Verdreaux, who seemed to be thriving in the bad air, and Little Walter Bushey, who did nothing but sleep and suck the occasional ration of milk or juice. Barbie sat against the Dome with his arm around Julia. Not far away, Thurston Marshall sat beside the covered corpse of little Aidan Appleton, who had died with terrifying suddenness. Thurse, now coughing steadily, was holding Alice on his lap. She had cried herself to sleep. Twenty feet further on, Rusty was huddled with his wife and girls, who had also cried themselves to sleep. Rusty had taken Audrey's body to the ambulance so the girls wouldn't have to look at it. He held his breath throughout; even fifteen yards inland from the Dome, the air became choking, deadly. Once he got his wind back, he supposed he should do the same with the little boy. Audrey would be good company for him; she'd always liked kids.

Joe McClatchey plopped down beside Barbie. Now he really did look like a scarecrow. His pale face was dotted with acne and there were circles of bruised-looking purple flesh under his eyes.

'My mom's sleeping,' Joe said.

'Julia too,' Barbie said, 'so keep your voice down.'

Julia opened one eye. 'Nah sleepin,' she said, and promptly closed the eye again. She coughed, stilled, then coughed some more.

'Benny's really sick,' Joe said. 'He's running a fever, like the little boy did before he died.' He hesitated. 'My mom's pretty warm, too. Maybe it's only because it's so hot in here, but . . . I don't think that's it. What if *she* dies? What if we all do?'

'We won't,' Barbie said. 'They'll figure something out.'

Joe shook his head. 'They won't. And you know it. Because they're outside. Nobody outside can help us.' He looked over the blackened wasteland where there had been a town the day before and laughed – a hoarse, croaking sound that was worse because there was actually some amusement in it. 'Chester's Mill has been a town since 1803 – we learned that in school. Over two hundred years. And a week to wipe it off the face of the earth. One fucking week is all it took. How about that, Colonel Barbara?'

Barbie couldn't think of a thing to say.

Joe covered his mouth, coughed. Behind them, the fans roared and roared. 'I'm a smart kid. You know that? I mean, I'm not bragging, but . . . I'm smart.'

Barbie thought of the video feed the kid had set up near the site of the missile strike. 'No argument, Joe.'

'In a Spielberg movie, it's the smart kid who'd come up with the last-minute solution, isn't that right?'

Barbie felt Julia stir again. Both eyes were open now, and she was regarding Joe gravely.

Tears were trickling down the boy's cheeks. 'Some Spielberg kid I turned out to be. If we were in Jurassic Park, the dinosaurs would eat us for sure.'

'If only they'd get tired,' Julia said dreamily.

'Huh?' Joe blinked at her.

'The leatherheads. The leatherhead *children*. Kids are supposed to get tired of their games and go on to something else. Or' – she coughed hard – 'or their parents call them home for dinner.'

'Maybe they don't eat,' Joe said gloomily. 'Maybe they don't have parents, either.'

'Or maybe time is different for them,' Barbie said. 'In their world, maybe they only just sat down around their version of the box. For them the game might only be starting. We don't even know for sure they're children.'

Piper Libby joined them. She was flushed, and her hair was sticking to her cheeks. 'They're kids,' she said.

'How do you know?' Barbie asked.

'I just do.' She smiled. 'They're the God I stopped believing in about three years ago. God turned out to be a bunch of bad little kids playing Interstellar X-Box. Isn't that funny?' Her smile widened, and then she burst into tears.

Julia was looking toward the box with its flashing purple light. Her face was thoughtful and a little dreamy.

14

It's Saturday night in Chester's Mill. That's the night the Eastern Star ladies used to meet (and after the meeting they'd often go to Henrietta Clavard's house and drink wine and break out their best dirty jokes). It's the night when Peter Randolph and his buddies used to play poker (and also break out their best dirty jokes). The night when Stewart and Fern Bowie often went to Lewiston to rent a couple of whores at a pussy-parlor on Lower Lisbon Street. The night when the Reverend Lester Coggins used to hold teen prayer meetings in the parsonage hall at Holy Redeemer and Piper Libby used to host teen dances in the basement of the Congo Church. The night when Dipper's used to roar until one (and around twelve-thirty the crowd would begin chanting drunkenly for their anthem, 'Dirty Water,' a song all bands from Boston know well). The night when Howie and Brenda Perkins used to walk, hand-in-hand, on the Town Common, saying hello to the other couples they knew. The night when Alden Dinsmore, his wife, Shelley, and their two sons had been known to play catch by the light of a full moon. In Chester's Mill (as in most small towns where they all support the team), Saturday nights were usually the best nights, made for dancing and fucking and dreaming.

Not this one. This one is black and seemingly endless. The wind has died. The poisoned air hangs hot and still. Out where Route 119 used to be until the furnace heat boiled it away, Ollie Dinsmore lies with his face pressed to his slot in the slag, still holding stubbornly onto life, and only a foot and a half away, Private Clint Ames continues his patient watch. Some bright boy wanted to shine a spotlight on the kid; Ames (supported by Sergeant Groh, not such an ogre after all) managed to keep it from happening, arguing that shining spotlights on sleeping people was what you did to terrorists, not teenage kids who would probably be dead before the sun rose. But Ames has a flashlight, and every now and then he shines it on the kid, making sure that he's still breathing. He is, but each time Ames uses the flashlight again, he expects it to show him that those shallow respirations have stopped. Part of him has actually started to hope for that. Part

of him has started to accept the truth: no matter how resourceful Ollie Dinsmore has been or how heroically he's struggled, he has no future. Watching him fight on is terrible. Not long before midnight, Private Ames falls asleep himself, sitting up, with the flashlight clutched loosely in one hand.

Sleepest thou? Jesus is said to have enquired of Peter. *Couldst thou not watch one hour?*

To which Chef Bushey might have added, *book of Matthew, Sanders.*

At just past one o'clock, Rose Twitchell shakes Barbie awake.

'Thurston Marshall is dead,' she says. 'Rusty and my brother are putting the body under the ambulance so the little girl won't be too upset when she wakes up.' Then she adds: '*If* she wakes up. Alice is sick too.'

'We're all sick now,' Julia says. 'All except Sam and that dopey little baby.'

Rusty and Twitch hurry back from the huddle of vehicles, collapse in front of one of the fans, and begin breathing in large, whooping gasps. Twitch starts coughing and Rusty shoves him even closer to the air, so hard that Twitch's forehead strikes the Dome. They all hear the bonk.

Rose has not quite finished her inventory. 'Benny Drake's bad too.' She lowers her voice to a whisper. 'Ginny says he may not last until sunup. If only there was something we could *do.*'

Barbie doesn't reply. Neither does Julia, who is once more looking in the direction of a box which, although less than fifty square inches in area and not even an inch thick, cannot be budged. Her eyes are distant, speculative.

A reddish moon finally clears the accumulated filth on the eastern wall of the Dome and shines down its bloody light. This is the end of October and in Chester's Mill, October is the cruelest month, mixing memory with desire. There are no lilacs in this dead land. No lilacs, no trees, no grass. The moon looks down on ruination and little else.

15

Big Jim awoke in the dark, grabbing at his chest. His heart was misfiring again. He pounded at it. Then the alarm on the generator went off as the current tank of propane reached the danger point: *AAAAAAAAAAA. Feed me, feed me.*

Big Jim jumped and cried out. His poor tortured heart was lurching, missing, skipping, then running to catch up with itself. He

felt like an old car with a bad carburetor, the kind of rattletrap you might take in trade but would never sell, the kind that was good for nothing but the junkheap. He gasped and pounded. This was as bad as the one that had sent him to the hospital. Maybe even worse.

AAAAAAAAAAAA: the sound of some huge, gruesome insect – a cicada, maybe – here in the dark with him. Who knew what might have crept in here while he was sleeping?

Big Jim fumbled for the flashlight. With the other hand he alternately pounded and rubbed, telling his heart to settle down, not to be such a cotton-picking *baby*, he hadn't gone through all of this just to die in the dark.

He found the flashlight, struggled to his feet, and stumbled over the body of his late aide-de-camp. He cried out again and went to his knees. The flashlight didn't break but went rolling away from him, casting a moving spotlight on the lowest lefthand shelf, which was stacked with boxes of spaghetti and cans of tomato paste.

Big Jim crawled after it. As he did, Carter Thibodeau's open eyes *moved*.

'Carter?' Sweat was running down Big Jim's face; his cheeks felt coated with some light, stinking grease. He could feel his shirt sticking to him. His heart took another of those looping larrups and then, for a wonder, settled into its normal rhythm again.

Well. No. Not exactly. But at least into something more like a normal rhythm.

'Carter? Son? Are you alive?'

Ridiculous, of course; Big Jim had gutted him like a fish on a riverbank, then shot him in the back of the head. He was as dead as Adolf Hitler. Yet he could have sworn . . . well, *almost* sworn . . . that the boy's *eyes*—

He fought back the idea that Carter was going to reach out and seize him by the throat. Telling himself it was normal to feel a little bit *(terrified)* nervous, because the boy had nearly killed him, after all. And still expecting Carter to sit up and draw him forward and bury hungry teeth in his throat.

Big Jim pressed his fingers under Carter's jaw. The blood-sticky flesh was cold and no pulse moved there. Of course not. The kid was dead. Had been dead for twelve hours or more.

'You're eating dinner with your Savior, son,' Big Jim whispered. 'Roast beef and mashed. Apple cobbler for dessert.'

This made him feel better. He crawled after the flashlight, and when he thought he heard something move behind him – the whisper of a hand, perhaps, slipping across the concrete floor, blindly questing

– he didn't look back. He had to feed the generator. Had to silence the *AAAAAA*.

While he was pulling one of the four remaining tanks out of the storage cubby, his heart went into arrhythmia again. He sat beside the open trapdoor, gasping and trying to cough his heart back into a regular rhythm. And praying, unaware that his prayer was basically a series of demands and rationalizations: make it stop, none of it was my fault, get me out of here, I did the best I could, put everything back the way it was, I was let down by incompetents, heal my heart.

'For Jesus' sake, amen,' he said. But the sound of the words chilled rather than comforted. They were like bones rattling in a tomb.

By the time his heart had settled a little, the hoarse cicada-cry of the alarm had stilled. The current tank had run dry. Save for the glow of the flashlight, it was now as dark in the fallout shelter's second room as in the first; the remaining emergency light in here had flickered its last seven hours ago. Struggling to remove the empty tank and get the fresh one onto the platform beside the generator, Big Jim had a faint memory of stamping NO ACTION on a shelter-maintenance requisition that had come across his desk a year or two ago. That requisition had probably included the price of fresh batteries for the emergency lights. But he couldn't blame himself. There was only so much money in a town budget and people always had their hands out: *Feed me, feed me.*

Al Timmons should have done it on his own initiative, he told himself. *For God's sake, is a little initiative too much to ask? Isn't that part of what we pay the maintenance staff for? He could have gone to that frog Burpee and asked for them as a donation, for heaven's sake. That's what I would have done.*

He connected the tank to the generator. Then his heart stuttered again. His hand jerked, and he knocked the flashlight into the storage bin, where it clanged against one of the remaining tanks. The lens shattered and he was left once more in total darkness.

'*No!*' he screamed. '*No, goddammit, NO!*'

But from God there was no answer. The quiet and the dark pressed in on him as his overstrained heart choked and struggled. Traitorous thing!

'Never mind. There'll be another flashlight in the other room. Matches, too. I'll just have to find them. If Carter had stockpiled them to begin with, I could go right to them.' It was true. He had overestimated that boy. He had thought the kid was a comer, but in the end he had turned out to be a goer. Big Jim laughed, then made himself stop. The sound in such total darkness was a little spooky.

Never mind. Start the generator.

Yes. Right. The generator was job one. He could double-check the connection once it was running and the air purifier was queeping away again. By then he'd have another flashlight, maybe even a Coleman lantern. Plenty of light for the next tank switchover.

'That's the ticket,' he said. 'If you want something done right in this world, you have to do it yourself. Just ask Coggins. Just ask the Perkins rhymes-with-witch. They know.' He laughed some more. He couldn't help it, because it really *was* rich. 'They found out. You don't tease a big dog if you only have a little stick. Nosir. Nosirree.'

He felt around for the starter-button, found it, pushed it. Nothing happened. Suddenly the air in the room seemed thicker than ever.

I pushed the wrong button, that's all.

Knowing better but believing it because some things have to be believed. He blew on his fingers like a crap-shooter hoping to heat up a cold pair of dice. Then he felt around until his fingers found the button.

'God,' he said, 'this is Your servant, James Rennie. Please let this darned old thing start. I ask it in the name of Your Son, Jesus Christ.'

He pushed the starter-button.

Nothing.

He sat in the dark with his feet dangling in the storage compartment, trying to push back the panic that wanted to descend and eat him raw. He had to think. It was the only way to survive. But it was hard. When you were in the dark, when your heart was threatening full revolt at any second, thinking was hard.

And the worst of it? Everything he'd done and everything he'd worked for during the last thirty years of his life seemed unreal. Like the way people looked on the other side of the Dome. They walked, they talked, they drove cars, they even flew in airplanes and helicopters. But none of it mattered, not under the Dome.

Get hold of yourself. If God won't help you, help yourself.

Okay. The first thing was light. Even a book of matches would do. There *had* to be something on one of the shelves in the other room. He would just feel along – very slowly, very methodically – until he found it. And then he would find batteries for the cotton-picking starter-motor. There *were* batteries, of that he was sure, because he needed the generator. Without the generator he would die.

Suppose you do get it started again? What happens when the propane runs out?

Ah, but something would intervene. He wasn't meant to die

down here. Roast beef with Jesus? He'd pass on that meal, actually. If he couldn't sit at the head of the table, he'd just as soon skip the whole thing.

That made him laugh again. He made his way very slowly and carefully back to the door leading into the main room. He held his hands out in front of him like a blind man. After seven steps they touched the wall. He moved to the right, trailing his fingertips over the wood, and . . . ah! Emptiness. The doorway. Good.

He shuffled through it, moving more confidently now in spite of the blackness. He remembered the layout of this room perfectly: shelves to either side, couch dead ahea—

He tripped over the goddam cotton-picking *kid* again and went sprawling. He hit his forehead on the floor and screamed – more in surprise and outrage than in pain, because there was a carpet to pad the blow. But oh God, there was a dead hand between his legs. It seemed to be clutching at his balls.

Big Jim got to his knees, crawled forward, and hit his head again, this time on the couch. He let out another yell, then crawled up onto it, pulling his legs after him quickly, the way a man might pull his legs from water he's just realized is infested with sharks.

He lay there trembling, telling himself to calm down, he had to calm down or he really *would* have a heart attack.

When you feel these arrhythmias, you need to center yourself and take long deep breaths, the hippy doctor had told him. At the time, Big Jim had considered this New Age bullshit, but now there was nothing else – he didn't have his verapamil – so he'd have to try it.

And it seemed to work. After twenty deep breaths and long, slow exhales, he could feel his heart settling. The coppery taste was leaving his mouth. Unfortunately, a weight seemed to be settling on his chest. Pain was creeping down his left arm. He knew these were heart attack symptoms, but he thought indigestion from all the sardines he'd eaten was just as likely. *More* likely. The long, slow breaths were taking care of his heart just fine (but he would still get it looked at when he was out of this mess, maybe even give in and get that bypass surgery). The heat was the problem. The heat and the thick air. He had to find that flashlight and get the gennie going again. Just one more minute, or maybe two—

Someone was breathing in here.

Yes, of course. I'm *breathing in here.*

And yet he was quite sure he heard someone else. More than just one someone. It seemed to him that there were several people in here with him. And he thought he knew who they were.

That's ridiculous.

Yes, but one of the breathers was behind the couch. One was lurking in the corner. And one was standing not three feet in front of him.

No. Stop it!

Brenda Perkins behind the couch. Lester Coggins in the corner, his jaw unhinged and hanging.

And standing dead ahead—

'No,' Big Jim said. 'That's crap. That's *bullshit.*'

He closed his eyes and tried to concentrate on taking those long slow breaths.

'It sure smells good in here, Dad,' Junior droned from in front of him. 'It smells like the pantry. And my girlfriends.'

Big Jim shrieked.

'Help me up, bro,' Carter said from where he lay on the floor. 'He cut me up pretty bad. Shot me, too.'

'Stop it,' Big Jim whispered. 'I don't hear any of that, so just *stop it.* I'm counting breaths. I'm settling my heart.'

'I still have the papers,' Brenda Perkins said. 'And lots of copies. Soon they'll be tacked to every telephone pole in town, the way Julia tacked up the last issue of her newspaper. "Be sure your sin will find you out" – Numbers, chapter thirty-two.'

'You're not there!'

But then *something* – it felt like a finger – kissed its way down his cheek.

Big Jim shrieked again. The fallout shelter was full of dead people who were nevertheless breathing the increasingly foul air, and they were moving in. Even in the dark he could see their pale faces. He could see his dead son's eyes.

Big Jim bolted up from the couch, flailing at the black air with his fists. 'Get away! All of you get away from me!'

He charged for the stairs and tripped over the bottom one. This time there was no carpet to cushion the blow. Blood began to drip into his eyes. A dead hand caressed the back of his neck.

'You killed me,' Lester Coggins said, but with his broken jaw it came out *Ooo ill eee.*

Big Jim ran up the stairs and hit the door at the top with all his considerable weight. It squalled open, pushing charred lumber and fallen bricks in front of it. It went just far enough for him to squeeze through.

'*No!*' he barked. '*No, don't touch me! None of you touch me!*'

It was almost as dark in the ruins of the Town Hall conference

room as in the shelter, but with one big difference: the air was worthless.

Big Jim realized this when he pulled in his third breath. His heart, tortured beyond endurance by this final outrage, once more rose into his throat. This time it stuck there.

Big Jim suddenly felt as if he were being crushed from throat to navel by a terrible weight: a long burlap sack filled with stones. He struggled back to the door like a man moving through mud. He tried to squeeze through the gap, but this time he stuck fast. A terrible sound began to emerge from his gaping mouth and closing throat, and the sound was *AAAAAAA: feed me feed me feed me.*

He flailed once, again, then once more: a hand reaching out, grasping for some final rescue.

It was caressed from the other side. '*Daaaddy,*' a voice crooned.

16

Someone shook Barbie awake just before dawn on Sunday morning. He came to reluctantly, coughing, turning instinctively to the Dome and the fans beyond. When the coughing finally eased, he looked to see who had awakened him. It was Julia. Her hair hung lankly and her cheeks were blooming with fever, but her eyes were clear. She said, 'Benny Drake died an hour ago.'

'Oh, Julia. Jesus. I'm sorry.' His voice was cracked and hoarse, not his own voice at all.

'I have to get to the box that's making the Dome,' she said. 'How do I get to the box?'

Barbie shook his head. 'It's impossible. Even if you could do something to it, it's on the ridge, almost half a mile from here. We can't even go to the vans without holding our breaths, and they're only fifty feet away.'

'There's a way,' someone said.

They looked around and saw Sloppy Sam Verdreaux. He was smoking the last of his cigarettes and looking at them with sober eyes. He *was* sober; entirely sober for the first time in eight years.

He repeated, 'There's a way. I could show you.'

WEAR IT HOME,
IT'LL LOOK LIKE A DRESS

1

It was seven thirty a.m. They had all gathered round, even the late Benny Drake's wretched, red-eyed mother. Alva had her arm around Alice Appleton's shoulders. All that little girl's former sass and spunk were gone now, and as she breathed, rales rattled in her narrow chest.

When Sam finished what he had to say, there was a moment of silence . . . except, of course, for the omnipresent roar of the fans. Then Rusty said: 'It's crazy. You'll die.'

'If we stay here, will we live?' Barbie asked.

'Why would you even try to do such a thing?' Linda asked. 'Even if Sam's idea works and you make it—'

'Oh, I t'ink it'll work,' Rommie said.

'Sure it will,' Sam said. 'Guy named Peter Bergeron told me, not long after the big Bar Harbor fire back in forty-seven. Pete was a lot of things, but never a liar.'

'Even if it does,' Linda said, '*why?*'

'Because there's one thing we haven't tried,' Julia said. Now that her mind was made up and Barbie had said he would go with her, she was composed. 'We haven't tried begging.'

'You're crazy, Jules,' Tony Guay said. 'Do you think they'll even *hear*? Or listen if they do?'

Julia turned her grave face to Rusty. 'That time your friend George Lathrop was burning ants alive with his magnifying glass, did *you* hear them beg?'

'Ants can't beg, Julia.'

'You said, "It occurred to me that ants also have their little lives." *Why* did it occur to you?'

'Because . . .' He trailed off, then shrugged.

'Maybe you did hear them,' Lissa Jamieson said.

'With all due respect, that's bullshit,' Pete Freeman said. 'Ants are *ants*. They can't beg.'

'But people can,' Julia said. 'And do we not also have our little lives?'

To this no one replied.

'What else is there to try?'

From behind them, Colonel Cox spoke up. They had all but forgotten him. The outside world and its denizens seemed irrelevant

now. 'I'd try it, in your shoes. Don't quote me, but . . . yes. I would. Barbie?'

'I've already agreed,' Barbie said. 'She's right. There's nothing else.'

2

'Let's see them sacks,' Sam said.

Linda handed over three green Hefty bags. In two of them she had packed clothes for herself and Rusty and a few books for the girls (the shirts, pants, socks, and underwear now lay carelessly discarded behind the little group of survivors). Rommie had donated the third, which he'd used to carry two deer rifles. Sam examined all three, found a hole in the bag that had held the guns, and tossed it aside. The other two were intact.

'All right,' he said, 'listen close. It should be Missus Everett's van that goes out to the box, but we need it over here first.' He pointed to the Odyssey. 'You sure about the windows bein rolled up, Missus? You gotta be sure, because lives are gonna depend on it.'

'They were rolled up,' Linda said. 'We were using the air-conditioner.'

Sam looked at Rusty. 'You're gonna drive it over here, Doc, but the first thing you do is *turn off the fac'try air.* You understand why, right?'

'To protect the environment inside the cabin.'

'Some of the bad air'll get in when you open the door, sure, but not much if you're quick. There'll be good air inside still. *Town* air. The folks inside can breathe easy all the way to the box. That old van's no good, and not just because the windows're open—'

'We *had* to,' Norrie said, looking at the stolen phone company van. 'The air-conditioning was busted. G-Grampy *said.*' A tear rolled slowly out of her left eye and cut through the dirt on her cheek. There was dirt everywhere now, and soot, almost too fine to see, sifting down from the murky sky.

'That's fine, honey,' Sam told her. 'The tires ain't worth a tin shit, anyway. One look and you know whose used car lot *that* pup came from.'

'Guess that means my van if we need another vehicle,' Rommie said. 'I'll get it.'

But Sam was shaking his head. 'It better be Missus Shumway's car, on account of the tires are smaller and easier to handle. Also, they're brand-new. The air inside them'll be fresher.'

Joe McClatchey broke into a sudden grin. 'The air from the tires! Put the air from the tires in the garbage bags! Homemade scuba tanks! Mr Verdreaux, that is *genius!*'

Sloppy Sam grinned himself, showing all six of his remaining teeth. 'Can't take the credit, son. Pete Bergeron gets the credit. He told about a couple of men got trapped behind that fire in Bar Harbor after it went and crowned. They were okay, but the air wasn't fit to breathe. So what they did was bust the cap off a pulp-truck tire and took turns breathin right from the stem until the wind cleared the air. Pete said they told him it was nasty-tasting, like old dead fish, but it kep em alive.'

'Will one tire be enough?' Julia asked.

'Might be, but we dassn't trust the spare if it's one of those little emergency doughnuts built to get you twenty miles down the highway and no more.'

'It's not,' Julia said. 'I hate those things. I asked Johnny Carver to get me a new one, and he did.' She looked toward town. 'I suppose Johnny's dead now. Carrie, too.'

'We better take one off the car as well, just to be safe,' Barbie said. 'You've got your jack, right?'

Julia nodded.

Rommie Burpee grinned without much humor. 'I'll race you back here, Doc. Your van against Julia's hybrid.'

'*I'll* drive the Prius over,' Piper said. 'You stay where you are, Rommie. You look like shit.'

'Nice talk from a minister,' Rommie grumbled.

'You ought to be thankful I still feel lively enough to talk some trash.' In truth Reverend Libby looked far from lively, but Julia handed over her keys anyway. None of them looked ready to go out drinking and juking, and Piper was in better shape than some; Claire McClatchey was as pale as milk.

'Okay,' Sam said. 'We got one other little problem, but first—'

'What?' Linda asked. 'What other problem?'

'Don't worry about that now. First let's get our rollin iron over here. When do you want to try it?'

Rusty looked at The Mill's Congregational minister. Piper nodded. 'No time like the present,' Rusty said.

3

The remaining townies watched, but not alone. Cox and almost a hundred other soldiers had gathered on their side of the Dome, looking on with the silent attention of spectators at a tennis match.

Rusty and Piper hyperventilated at the Dome, loading their lungs with as much oxygen as possible. Then they ran, hand-in-hand, toward the vehicles. When they got there they separated. Piper stumbled to one knee, dropping the Prius keys, and all the watchers groaned.

Then she snatched them from the grass and was up again. Rusty was already in the Odyssey van with the motor running as she opened the door of the little green car and flung herself inside.

'Hope they remembered to turn off the air-conditioning,' Sam said.

The vehicles turned in almost perfect tandem, the Prius shadowing the much larger van like a terrier herding a sheep. They drove quickly to the Dome, bouncing over the rough ground. The exiles scattered before them, Alva carrying Alice Appleton and Linda with a coughing Little J under each arm.

The Prius stopped less than a foot away from the dirty barrier, but Rusty swung the Odyssey around and backed it in.

'Your husband's got a good set of balls on him and an even better set of lungs,' Sam told Linda matter-of-factly.

'It's because he gave up smoking,' Linda said, and either did not hear Twitch's strangled snort or affected not to.

Good lungs or not, Rusty didn't linger. He slammed the door behind him and hustled to the Dome. 'Piece of cake,' he said . . . and began to cough.

'Is the air inside the van breathable, like Sam said?'

'Better than what's here.' He laughed distractedly. 'But he's right about something else – every time the doors open, a little more good air gets out and a little more bad air gets in. You probably *can* get out to the box without tire-air, but I don't know if you can get back without it.'

'They ain't gonna be driving, neither one of them,' Sam said. '*I'm* gonna drive.'

Barbie felt his lips turn up in the first genuine grin to grace his face in days. 'Thought you lost your license.'

'Don't see any cops out here,' Sam said. He turned to Cox. 'What about you, Cap? See any local yokels or County Mounties?'

'Not a one,' Cox said.

Julia drew Barbie aside. 'Are you sure you want to do this?'

'Yes.'

'You know the chances hover somewhere between slim and none, right?'

'Yes.'

'How are you at begging, Colonel Barbara?'

He flashed back to the gym in Fallujah: Emerson kicking one prisoner's balls so hard they flew up in front of him, Hackermeyer pulling another up by his *hijab* and putting a gun to his head. The blood had hit the wall like it always hits the wall, right back to the time when men fought with clubs.

'I don't know,' he said. 'All I know is it's my turn.'

4

Rommie, Pete Freeman, and Tony Guay jacked up the Prius and pulled off one of the working tires. It was a small car, and under ordinary circumstances they might have been able to lift the rear end with their bare hands. Not now. Although the car was parked close to the fans, they had to run back to the Dome repeatedly for air before the job was done. In the end, Rose took over for Tony, who was coughing too hard to continue.

Finally, though, they had two new tires leaning against the Dome.

'So far, so good,' Sam said. 'Now for that other little problem. I hope somebody's got an idear, because I sure don't.'

They looked at him.

'My friend Peter said those guys busted off the valve and breathed direct from the tire, but that ain't gonna work here. Gotta fill up those garbage bags, and that means a bigger hole. You can punch into the tires, but without somethin to stick in the holes – somethin like a straw – you're gonna lose more air than you catch. So . . . what's it gonna be?' He looked around hopefully. 'Nobody brought a tent, I don't suppose? One of them with the hollow aluminum poles?'

'The girls have a play-tent,' Linda said, 'but it's back home in the garage.' Then she remembered that the garage was gone, along with the house it was attached to, and laughed wildly.

'How about the barrel of a pen?' Joe asked. 'I've got a Bic . . .'

'Not big enough,' Barbie said. 'Rusty? What about the ambulance?'

'A trach tube?' Rusty asked doubtfully, then answered his own question. 'No. Still not big enough.'

Barbie turned. 'Colonel Cox? Any ideas?'

Cox shook his head reluctantly. 'We've probably got a thousand things over here that would work, but that doesn't help much.'

'We can't let this stop us!' Julia said. Barbie heard frustration and a raw edge of panic in her voice. 'Never *mind* the bags! We'll take the tires and breathe directly from them!'

Sam was already shaking his head. 'Not good enough, Missus. Sorry, but it's not.'

Linda bent close to the Dome, took several deep breaths, held the last. Then she went to the back of her Odyssey van, rubbed some of the soot from the back window, and peered in. 'The bag's still there,' she said. 'Thank God.'

'What bag?' Rusty asked, taking her by the shoulders.

'The one from Best Buy with your birthday present in it. November eighth, or did you forget?'

'I did. On purpose. Who the hell wants to turn forty? What is it?'

'I knew if I brought it in the house before I was ready to wrap it, you'd find it . . .' She looked at the others, her face solemn and as dirty as a street-urchin's. 'He's a nosy old thing. So I left it in the van.'

'What did you get him, Linnie?' Jackie Wettington asked.

'I hope a present for all of us,' Linda said.

5

When they were ready, Barbie, Julia, and Sloppy Sam hugged and kissed everybody, even the kids. There was little hope in the faces of the nearly two dozen exiles who would remain behind. Barbie tried to tell himself it was just because they were exhausted and now chronically short of breath, but he knew better. These were goodbye kisses.

'Good luck, Colonel Barbara,' Cox said.

Barbie gave him a brief nod of acknowledgment, then turned to Rusty. Rusty who really mattered, because he was under the Dome. 'Don't give up hope, and don't let them give up hope. If this doesn't work, take care of them as long as you can and as well as you can.'

'I hear you. Give it your best shot.'

Barbie tilted his head toward Julia. 'It's mostly her shot, I think. And hell, maybe we'll make it back even if it doesn't work.'

'Sure you will,' Rusty said. He sounded hearty, but what he believed was in his eyes.

Barbie slapped him on the shoulder, then joined Sam and Julia at the Dome, once more taking deep breaths of the fresh air that came trickling through. To Sam he said, 'Are you sure you really want to do this?'

'Ayuh. I got somethin to make up for.'

'What would that be, Sam?' Julia asked.

'I druther not say.' He smiled a little. 'Specially not to the town newspaper lady.'

'You ready?' Barbie asked Julia.

'Yes.' She grabbed his hand, gave it one brief hard squeeze. 'As much as I can be.'

6

Rommie and Jackie Wettington stationed themselves at the rear doors of the van. When Barbie shouted '*Go!*' Jackie opened the doorgate and Rommie threw the two Prius tires inside. Barbie and Julia hurled themselves in directly after, and the doors were slammed behind them a split-second later. Sam Verdreaux, old and booze-raddled but still spry as a cricket, was already behind the Odyssey's wheel and revving the engine.

The air inside the van stank of what was now the outside world – an aroma that was charred wood on top and a painty, turpentine-y stench beneath – but it was still better than what they had been breathing at the Dome, even with dozens of fans blasting.

Won't be better for long, Barbie thought. *Not with three of us sucking it up.*

Julia grabbed the distinctive yellow-and-black Best Buy sack and turned it over. What fell out was a plastic cylinder with the words PERFECT ECHO on it. And, beneath that: 50 RECORDABLE CDS. She began to pick at the sealed cellophane overwrap with no immediate success. Barbie reached for his pocketknife, and his heart sank. The knife wasn't there. Of course not. It was now just a hunk of slag under whatever remained of the PD.

'Sam! Please tell me you have a pocketknife!'

Without a word, Sam tossed one back. 'That was my dad's. I been carryin it my whole life, and I want it back.'

The knife's sides were wood-inlay rubbed almost smooth with age, but when he opened it, the single blade was sharp. It would work on the overwrap, and it would make nice neat punctures in the tires.

'Hurry up!' Sam yelled, and revved the Odyssey's engine harder. 'We ain't goin till you tell me you got the right thing, and I doubt the engine'll run forever in this air!'

Barbie slit the overwrap. Julia stripped it away. When she rotated the plastic cylinder half a turn to the left, it came off the base. The blank CDs that had been meant for Rusty Everett's birthday sat on a black plastic spindle. She dumped the CDs on the floor of the van, then closed her fist around the spindle. Her mouth tightened with effort.

'Let me do tha—' he said, but then she snapped it off.

'Girls are strong, too. Especially when they're scared to death.'

'Is it hollow? If it isn't, we're back to square one.'

She held the spindle up to her face. Barbie looked down one end and saw her blue eye staring back from the other. 'Go, Sam,' he said. 'We're in business.'

'You sure it'll work?' Sam shouted back, dropping the van's transmission into drive.

'You bet!' Barbie returned, because *How the hell should I know* would cheer nobody up. Including himself.

7

The survivors at the Dome watched silently as the van tore down the dirt track that led back to what Norrie Calvert had taken to calling 'the flash-box.' The Odyssey dimmed into the hanging smog, became a phantom, and then disappeared.

Rusty and Linda were standing together, each carrying a child. 'What do you think, Rusty?' Linda asked.

He said, 'I think we need to hope for the best.'

'And prepare for the worst?'

'That too,' he said.

8

They were passing the farmhouse when Sam called back, 'We're goin into the orchard now. You want to hold onto your jockstraps, kiddies, because I ain't stoppin this bitch even if I rip the undercarriage right out'n it.'

'Go for it,' Barbie said, and then a vicious bump tossed him in the air with his arms wrapped around one of the spare tires. Julia was clutching the other one like a shipwreck victim clutching a life ring. Apple trees flashed by. The leaves looked dirty and dispirited. Most of the fruit had fallen to the ground, shaken free by the wind that had sucked through the orchard after the explosion.

Another tremendous bump. Barbie and Julia went up and came down together, Julia sprawling across Barbie's lap and still holding onto her tire.

'Where'd you get your license, you old fuck?' Barbie shouted. 'Sears and Roebuck?'

'Walmart!' the old man shouted back. '*Everything's* cheaper at Wally World!' Then he stopped cackling. 'I see it. I see the blinky-ass whoremaster. Bright purple light. Gonna pull right up beside it. You

wait until I stop before you go carvin on those tires, less you want to tear em wide open.'

A moment later he stamped on the brake and brought the Odyssey to a scrunching halt that sent Barbie and Julia sliding into the back of the rear seat. *Now I know what a pinball feels like*, Barbie thought.

'You drive like a Boston cabbie!' Julia said indignantly.

'You just make sure you tip' – Sam was stopped by a hard fit of coughing – 'twenty percent.' His voice sounded choked.

'Sam?' Julia asked. 'Are you all right?'

'Maybe not,' he said matter-of-factly. 'I'm bleedin somewhere. Could be throat, but it feels deeper. B'lieve I might have ruptured a lung.' Then he was coughing again.

'What can we do?' Julia asked.

Sam got the coughing under control. 'Make em shut off their fuckin jammer so we can get out of here. I got no more smokes.'

9

'This is all me,' Julia said. 'Just so you know that.'

Barbie nodded. 'Yessum.'

'You're strictly my air-boy. If what I try doesn't work, we can change jobs.'

'It might help if I knew exactly what you had in mind.'

'There's nothing exact about it. All I have is intuition and a little hope.'

'Don't be such a pessimist. You've also got two tires, two garbage bags, and a hollow spindle.'

She smiled. It lit up her tense, dirty face. 'Duly noted.'

Sam was coughing again, doubled over the wheel. He spat something out. 'Dear God and sonny Jesus, don't that taste nasty,' he said. 'Hurry *up*.'

Barbie punctured his tire with the knife and heard the *pwoosh* of air as soon as he pulled the blade free. Julia slapped the spindle into his hand as efficiently as an OR nurse. Barbie jammed it into the hole, saw the rubber grip it . . . and then felt a divine rush of air spurt into his sweaty face. He breathed deeply once, unable to help himself. The air was much fresher, much *richer*, than that pushed through the Dome by the fans. His brain seemed to wake up, and he came to an immediate decision. Instead of putting a garbage bag over their makeshift nozzle, he tore a large, ragged swatch from one of them.

'What are you *doing*?' Julia screamed.

There was no time to tell her she wasn't the only one with intuitions.

He plugged the spindle with the plastic. 'Trust me. Just go to the box and do what you have to do.'

She gave him a final look that seemed to be all eyes, then opened the Odyssey's doorgate. She half fell to the ground, picked herself up, stumbled over a hummock, and went to her knees beside the flashbox. Barbie followed her with both tires. He had Sam's knife in his pocket. He fell on his knees and offered Julia the tire with the black spindle sticking out of it.

She yanked the plug, breathed in – her cheeks hollowing with the effort – exhaled to one side, then breathed in again. Tears were rolling down her cheeks, cutting clean places there. Barbie was crying, too. It had nothing to do with emotion; it was as if they had been caught out in the world's nastiest acid rain. This was far worse than the air at the Dome.

Julia sucked in more. 'Good,' she said, speaking on the exhale and almost whistling the word. 'So good. Not fishy. Dusty.' She breathed in again, then tilted the tire toward him.

He shook his head and pushed it back, although his lungs were beginning to pound. He patted his chest, then pointed at her.

She took another deep breath, then sucked in one more. Barbie pushed down on top of the tire to help her along. Faintly, in some other world, he could hear Sam coughing and coughing and coughing.

He'll rip himself apart, Barbie thought. He felt as if he might come apart himself if he didn't breathe soon, and when Julia pushed the tire at him a second time, he bent over the makeshift straw and sucked in deeply, trying to draw the dusty, wonderful air all the way to the bottom of his lungs. There wasn't enough, it seemed there could never be enough, and there was a moment when panic

(*God I'm drowning*)

almost engulfed him. The urge to bolt back to the van – never mind Julia, let Julia take care of herself – was nearly too strong to resist . . . but he did resist it. He closed his eyes, breathed, and tried to find the cool, calm center that had to be there someplace.

Easy. Slow. Easy.

He dragged in a third long, steady inhale from the tire, and his pounding heart began to slow a little. He watched Julia lean forward and grip the box on either side. Nothing happened, and this didn't surprise Barbie. She had touched the box when they first came up here, and was now immune to the shock.

Then, suddenly, her back arched. She moaned. Barbie tried to offer her the spindle-straw, but she ignored it. Blood burst from her nose and began to trickle from the corner of her right eye. Red drops slid down her cheek.

'What's happenin?' Sam called. His voice was muffled, choked.

I don't know, Barbie thought. *I don't know what's happening.*

But he knew one thing: if she didn't take more air soon, she'd die. He pulled the spindle out of the tire, clamped it between his teeth, and plunged Sam's knife into the second tire. He drove the spindle into the hole and plugged it with the swatch of plastic.

Then he waited.

10

This is the time that is no time:

She's in a vast white roofless room with an alien green sky above. It's . . . what? The playroom? Yes, the playroom. *Their* playroom.

(*No, she's lying on the floor of the bandstand.*)

She's a woman of a certain age.

(*No, she's a little girl.*)

There is no time.

(*It's 1974 and there's all the time in the world.*)

She needs to breathe from the tire.

(*She doesn't.*)

Something is looking at her. Something terrible. But *she* is terrible to *it*, as well, because she's bigger than she's supposed to be, and she's here. She's not supposed to be here. She's supposed to be in the box. Yet she is still harmless. It knows that, even though it is

(*just a kid*)

very young; barely out of the nursery, in fact. It speaks.

—*You are make-believe.*

—*No, I'm real. Please, I'm real. We all are.*

The leatherhead regards her with its eyeless face. It frowns. The corners of its mouth turn down, although it has no mouth. And Julia realizes how lucky she is to have found one of them alone. There are usually more, but they have

(*gone home to dinner gone home to lunch gone to bed gone to school gone on vacation, doesn't matter they're gone*)

gone somewhere. If they were here together, they would drive her back. This one could drive her back alone, but she is curious.

She?

Yes.

This one is female, like her.

—*Please let us go. Please let us live our little lives.*

No answer. No answer. No answer. Then:

—*You aren't real. You are—*

What? What does she say? *You are toys from the toyshop?* No, but it's something like that. Julia has a flicker-memory of the ant farm her brother had when they were kids. The recollection comes and goes in less than a second. Ant farm isn't right, either, but like *toys from the toyshop*, it's close. It's in the ballpark, as they say.

—*How can you have lives if you aren't real?*

—*WE ARE SO REAL!* she cries, and this is the moan Barbie hears.—*AS REAL AS YOU!*

Silence. A thing with a shifting leather face in a vast white roofless room that is also somehow the Chester's Mill bandstand. Then:

—*Prove it.*

—*Give me your hand.*

—*I have no hand. I have no body. Bodies aren't real. Bodies are dreams.*

—*Then give me your mind!*

The leatherhead child does not. Will not.

So Julia takes it.

11

This is the place that is no place:

It's cold on the bandstand, and she's so scared. Worse, she's . . . humiliated? No, it's much worse than humiliation. If she knew the word *abased*, she would say *Yes, yes, that's it, I'm abased.* They took her slacks.

(*And somewhere soldiers are kicking naked people in a gym. This is someone else's shame all mixed up with hers.*)

She's crying.

(*He feels like crying, but doesn't. Right now they have to cover this up.*)

The girls have left her now, but her nose is still bleeding – Lila slapped her and promised to cut her nose off if she told and they all spit on her and now she is lying here and she must have cried really hard because she thinks her eye is bleeding as well as her nose and she can't seem to catch her breath. But she doesn't care how much she bleeds or from where. She'd rather bleed to death on the band-stand floor than walk home in her stupid baby underpants. She'd gladly bleed to death from a hundred places if it meant she didn't have to see the soldier

(After this Barbie tries not to think of that soldier but when he does he thinks 'Hackermeyer the hackermonster.')

pull the naked man up by the thing

(hajib)

he's wearing on his head, because she knows what comes next. It's what always comes next when you're under the Dome.

She sees that one of the girls has come back. Kayla Bevins has come back. She's standing there and looking down at stupid Julia Shumway who thought she was smart. Stupid little Julia Shumway in her baby pannies. Has Kayla come back to take the rest of her clothes and throw them up onto the bandstand roof, so she has to walk home naked with her hands over her woofie? Why are people so mean?

She closes her eyes against tears and when she opens them again, Kayla has changed. Now she has no face, just a kind of shifting leather helmet that shows no compassion, no love, not even hate.

Only . . . *interest*. Yes, that. What does it do when I do . . . *this*?

Julia Shumway is worthy of no more. Julia Shumway doesn't matter; find the least of the least, then look below that, and there she is, a scurrying Shumway-bug. She is a naked prisoner-bug, too; a prisoner-bug in a gymnasium with nothing left but the unraveling hat on his head and beneath the hat a final memory of fragrant, freshly baked *khubz* held out in his wife's hands. She is a cat with a burning tail, an ant under a microscope, a fly about to lose its wings to the curious plucking fingers of a third-grader on a rainy day, a game for bored children with no bodies and the whole universe at their feet. She is Barbie, she is Sam dying in Linda Everett's van, she is Ollie dying in the cinders, she is Alva Drake mourning her dead son.

But mostly she is a little girl cowering on the splintery boards of the Town Common bandstand, a little girl who was punished for her innocent arrogance, a little girl who made the mistake of thinking she was big when she was small, that she mattered when she didn't, that the world cared when in reality the world is a huge dead locomotive with an engine but no headlight. And with all her heart and mind and soul she cries out:

—*PLEASE LET US LIVE! I BEG YOU, PLEASE!*

And for just one moment *she* is the leatherhead in the white room; *she* is the girl who has (for reasons she cannot even explain to herself) come back to the bandstand. For one terrible moment Julia is the one who did it instead of the one who was done by. She is even the soldier with the gun, the hackermonster Dale Barbara still dreams about, the one he didn't stop.

Then she is only herself again.

Looking up at Kayla Bevins.

Kayla's family is poor. Her father cuts pulp on the TR and drinks down at Freshie's Pub (which will, in the fullness of time, become Dipper's). Her mother has a big old pink mark on her cheek, so the kids call her Cherry Face or Strawberry Head. Kayla doesn't have any nice clothes. Today she is wearing an old brown sweater and an old plaid skirt and scuffed loafers and white socks with saggy tops. One knee is scraped where she fell or was pushed down on the playground. It's Kayla Bevins, all right, but now her face is made of leather. And although it shifts through many shapes, none of them is even close to human.

Julia thinks: *I'm seeing how the child looks to the ant, if the ant looks up from its side of the magnifying glass. If it looks up just before it starts to burn.*

—*PLEASE, KAYLA! PLEASE! WE ARE ALIVE!*

Kayla looks down at her without doing anything. Then she crosses her arms in front of her – they are human arms in this vision – and pulls her sweater over her head. There is no love in her voice when she speaks; no regret or remorse.

But there might be pity.

She says

12

Julia was hurled away from the box as if a hand had swatted her. The held breath blew out of her. Before she could take another one, Barbie seized her by the shoulder, pulled the swatch of plastic from the spindle, and pushed her mouth onto it, hoping he wouldn't cut her tongue, or – God forbid – skewer the hard plastic into the roof of her mouth. But he couldn't let her breathe the poisoned air. As oxygen-starved as she was, it might send her into convulsions or kill her outright.

Wherever she'd been, Julia seemed to understand. Instead of trying to struggle away, she wrapped her arms around the Prius tire in a deathgrip and began sucking frantically at the spindle. He could feel huge, shuddering tremors racing through her body.

Sam had finally stopped coughing, but now there was another sound. Julia heard it, too. She sucked in another vast breath from the tire and looked up, eyes wide in their deep, shadowed sockets.

A dog was barking. It had to be Horace, because he was the only dog left. He—

Barbie grabbed her arm in a grip so strong she felt he would break it. On his face was an expression of pure amazement.

The box with the strange symbol on it was hovering four feet above the ground.

13

Horace was first to feel the fresh air, because he was lowest to the ground. He began to bark. Then Joe felt it: a breeze, startlingly cold, against his sweaty back. He was leaning against the Dome, and the Dome was moving. Moving *up*. Norrie had been dozing with her flushed face resting on Joe's chest, and now he saw a lock of her dirty, matted hair begin to flutter. She opened her eyes.

'What—? Joey, what's happening?'

Joe knew, but was too stunned to tell her. He could feel a cool sliding sensation against his back, like an endless sheet of glass being raised.

Horace was barking madly now, his back bowed, his snout on the ground. It was his *I-want-to-play* position, but Horace wasn't playing. He stuck his nose beneath the rising Dome and sniffed cold sweet fresh air.

Heaven!

14

On the south side of the Dome, Pfc Clint Ames was also dozing. He sat cross-legged on the soft shoulder of Route 119 with a blanket wrapped around him Indian-style. The air suddenly darkened, as if the bad dreams flitting through his head had assumed physical form. Then he coughed himself awake.

Soot was swirling up around his booted feet and settling on the legs of his khaki everydays. Where in God's name was it coming from? All the burning had been inside. Then he saw. The Dome was going up like a giant windowblind. It was impossible – it went miles down as well as up, everybody knew that – but it was happening.

Ames didn't hesitate. He crawled forward on his hands and knees and seized Ollie Dinsmore by the arms. For a moment he felt the rising Dome scrape the middle of his back, glassy and hard, and there was time to think *If it comes back down now, it'll cut me in two.* Then he was dragging the boy out.

For a moment he thought he was hauling a corpse. '*No!*' he

shouted. He carried the boy up toward one of the roaring fans. '*Don't you dare die on me, cow-kid!*'

Ollie began coughing, then leaned over and vomited weakly. Ames held him while he did it. The others were running toward them now, shouting jubilantly, Sergeant Groh in the forefront.

Ollie puked again. 'Don't call me cow-kid,' he whispered.

'Get an ambulance!' Ames shouted. 'We need an ambulance!'

'Nah, we'll take him to Central Maine General in the helicopter,' Groh said. 'You ever been in a helicopter, kid?'

Ollie, his eyes dazed, shook his head. Then he puked on Sergeant Groh's shoes.

Groh beamed and shook Ollie's filthy hand. 'Welcome back to the United States, son. Welcome back to the world.'

Ollie put an arm around Ames's neck. He was aware that he was passing out. He tried to hold on long enough to say thank you, but he didn't make it. The last thing he was aware of before the darkness took him again was the southern soldier kissing him on the cheek.

15

On the north end, Horace was the first one out. He raced directly to Colonel Cox and began to dance around his feet. Horace had no tail, but it didn't matter; his entire hind end was wig-wagging.

'I'll be damned,' Cox said. He picked the Corgi up and Horace began to lick his face frantically.

The survivors stood together on their side (the line of demarcation was clear in the grass, bright on one side and listless gray on the other), beginning to understand but not quite daring to believe. Rusty, Linda, the Little Js, Joe McClatchey and Norrie Calvert, with their mothers standing to either side of them. Ginny, Gina Buffalino, and Harriet Bigelow with their arms around each other. Twitch was holding his sister Rose, who was sobbing and cradling Little Walter. Piper, Jackie, and Lissa were holding hands. Pete Freeman and Tony Guay, all that remained of the *Democrat's* staff, stood behind them. Alva Drake leaned against Rommie Burpee, who was holding Alice Appleton in his arms.

They watched as the Dome's dirty surface rose swiftly into the air. The fall foliage on the other side was heartbreaking in its brilliance.

Sweet fresh air lifted their hair and dried the sweat on their skin.

'For we saw as if through a glass darkly,' Piper Libby said. She was weeping. 'But now we see as if face to face.'

Horace jumped from Colonel Cox's arms and began turning figure eights through the grass, yapping, sniffing, and trying to pee on everything at once.

The survivors looked unbelievingly up at the bright sky arching over a late fall Sunday morning in New England. And above them, the dirty barrier that had held them prisoner still rose, moving faster and faster, shrinking to a line like a long dash of pencil on a sheet of blue paper.

A bird swooped through the place where the Dome had been. Alice Appleton, still being carried by Rommie, looked up at it and laughed.

16

Barbie and Julia knelt with the tire between them, taking alternate breaths from the spindle-straw. They watched as the box began to rise again. It went slowly at first, and seemed to hover a second time at a height of about sixty feet, as if doubtful. Then it shot straight up at a speed far too fast for the human eye to follow; it would have been like trying to see a bullet in flight. The Dome was either flying upward or somehow being *reeled in.*

The box, Barbie thought. *It's drawing the Dome up the way a magnet draws iron filings.*

A breeze came beating toward them. Barbie marked its progress in the rippling grass. He shook Julia by the shoulder and pointed dead north. The filthy gray sky was blue again, and almost too bright to look at. The trees had come into bright focus.

Julia raised her head from the spindle and breathed.

'I don't know if that's such a good—' Barbie began, but then the breeze arrived. He saw it lift Julia's hair and felt it drying the sweat on his grime-streaked face, as gentle as a lover's palm.

Julia was coughing again. He pounded her back, taking his own first breath of the air as he did so. It still stank and clawed at his throat, but it was breathable. The bad air was blowing south as fresh air from the TR-90 side of the Dome – what *had* been the TR-90 side of the Dome – poured in. The second breath was better; the third better still; the fourth a gift from God.

Or from one leatherhead girl.

Barbie and Julia embraced next to the black square of ground where the box had been. Nothing would grow there, not ever again.

17

'Sam!' Julia cried. 'We have to get Sam!'

They were still coughing as they ran to the Odyssey, but Sam wasn't. He was slumped over the wheel, eyes open, breathing shallowly. His lower face was bearded with blood, and when Barbie pulled him back, he saw that the old man's blue shirt had turned a muddy purple.

'Can you carry him?' Julia asked. 'Can you carry him to where the soldiers are?'

The answer was almost certainly no, but Barbie said, 'I can try.'

'Don't,' Sam whispered. His eyes shifted toward them. 'Hurts too much.' Fresh blood seeped from his mouth with each word. 'Did you do it?'

'Julia did,' Barbie said. 'I don't know exactly how, but she did.'

'Part of it was the man in the gym,' she said. 'The one the hackermonster shot.'

Barbie's mouth dropped open, but she didn't notice. She put her arms around Sam and kissed him on each cheek. 'And you did it, too, Sam. You drove us out here, and you saw the little girl on the bandstand.'

'You 'us no little girl in my dream,' Sam said. 'You 'us grown up.'

'The little girl was still there, though.' Julia touched her chest. 'Still here, too. She lives.'

'Help me out of the van,' Sam whispered. 'I want to smell some fresh air before I die.'

'You're not going to—'

'Hush, woman. We both know better'n that.'

They both took an arm, gently lifted him from behind the wheel, and laid him on the ground.

'Smell that air,' he said. 'Good Lord.' He breathed in deeply, then coughed out a spray of blood. 'I'm gettin a whiff of honeysuckle.'

'Me too,' she said, and brushed his hair back from his brow.

He put his hand over hers. 'Were they . . . were they sorry?'

'There was only one,' Julia said. 'If there had been more, it never would have worked. I don't think you can fight a crowd that's bent on cruelty. And no – she wasn't sorry. She took pity, but she wasn't sorry.'

'Not the same things, are they?' the old man whispered.

'No. Not at all.'

'Pity's for strong people,' he said, and sighed. 'I can only be sorry. What I done was because of the booze, but I'm still sorry. I'd take it back if ever I could.'

'Whatever it was, you made up for it in the end,' Barbie said. He took Sam's left hand. The wedding ring hung on the third finger, grotesquely large for the scant flesh.

Sam's eyes, faded Yankee blue, shifted to him, and he tried to smile. 'Maybe I did . . . for the *doin*. But I was *happy* in the doin. I don't think you can ever make up for a thing like—' He began to cough again, and more blood flew from his mostly toothless mouth.

'Stop now,' Julia said. 'Stop trying to talk.' They were kneeling on either side of him. She looked at Barbie. 'Forget about carrying him. He tore something inside. We'll have to go for help.'

'Oh, the *sky*!' Sam Verdreaux said.

That was the last. He sighed his chest flat, and there was no next breath to lift it. Barbie moved to close his eyes but Julia took his hand and stopped him.

'Let him look,' she said. 'Even if he's dead, let him look as long as he can.'

They sat beside him. There was birdsong. And somewhere, Horace was still barking.

'I suppose I ought to go and find my dog,' Julia said.

'Yes,' he said. 'The van?'

She shook her head. 'Let's walk. I think we can handle half a mile if we go slow – don't you?'

He helped her up. 'Let's find out,' he said.

18

As they walked, hands linked above the grassy crown of the old supply road, she told him as much as she could about what she called 'being inside the box.'

'So,' he said when she had finished. 'You told her about the terrible things we're capable of – or showed them to her – and she still let us go.'

'They know all about terrible things,' she said.

'That day in Fallujah is the worst memory of my life. What makes it so bad is . . .' He tried to think how Julia had put it. 'I was the doer instead of the one done by.'

'You *didn't* do it,' she said. 'That other man did.'

'It doesn't matter,' Barbie said. 'The guy's just as dead no matter who did it.'

'Would it have happened if there had only been two or three of you in that gym? Or if it had been just you alone?'

'No. Of course not.'

'Then blame fate. Or God. Or the universe. But stop blaming yourself.'

He might not ever be able to do that, but he understood what Sam had said at the end. Sorrow for a wrong was better than nothing, Barbie supposed, but no amount of after-the-fact sorrow could ever atone for joy taken in destruction, whether it was burning ants or shooting prisoners.

He had felt no joy in Fallujah. On that score he could find himself innocent. And that was good.

Soldiers were running toward them. They might have another minute alone. Perhaps two.

He stopped and took her by the arms.

'I love you for what you did, Julia.'

'I know you do,' she said calmly.

'What you did was very brave.'

'Do you forgive me for stealing from your memories? I didn't mean to; it just happened.'

'Totally forgiven.'

The soldiers were closer. Cox was running with the rest, Horace dancing at his heels. Soon Cox would be here, he'd ask how Ken was, and with that question the world would reclaim them.

Barbie looked up at the blue sky, breathed deeply of the clearing air. 'I can't believe it's gone.'

'Will it ever come back, do you think?'

'Maybe not to this planet, and not because of that bunch. They'll grow up and leave their playroom, but the box will stay. And other kids will find it. Sooner or later, the blood always hits the wall.'

'That's awful.'

'Maybe, but can I tell you something my mother used to say?'

'Of course.'

He recited, '"For every night, twice the bright."'

Julia laughed. It was a lovely sound.

'What did the leatherhead girl say to you at the end?' he asked. 'Tell me quick, because they're almost here and this belongs just to us.'

She seemed surprised that he didn't know. 'She said what Kayla said. "Wear it home, it'll look like a dress."'

'She was talking about the brown sweater?'

She took his hand again. 'No. About our lives. Our little lives.'

He thought it over. 'If she gave it to you, let's put it on.'

Julia pointed. 'Look who's coming!'

Horace had seen her. He put on speed and wove through the running men and, once he was past them, dropped low to the ground and hit fourth gear. A large grin wreathed his chops. His ears were laid back flat to his skull. His shadow raced along beside him on the soot-stained grass. Julia knelt and held out her arms.

'Come to mama, sweetheart!' she shouted.

He leaped. She caught him and sprawled backward, laughing. Barbie helped her to her feet.

They walked back into the world together, wearing the gift that had been given them: just life.

Pity was not love, Barbie reflected . . . but if you were a child, giving clothes to someone who was naked had to be a step in the right direction.

November 22, 2007 – March 14, 2009

AUTHOR'S NOTE

I first tried to write *Under the Dome* in 1976, and crept away from it with my tail between my legs after two weeks' work that amounted to about seventy-five pages. That manuscript was long lost on the day in 2007 when I sat down to start again, but I remembered the opening section – 'The Airplane and the Woodchuck' – well enough to re-create it almost exactly.

I was overwhelmed not by the large cast of characters – I like novels with generous populations – but by the technical problems the story presented, especially the ecological and meteorological consequences of the Dome. The fact that those very concerns made the book seem important to me made me feel like a coward – and lazy – but I was terrified of screwing it up. So I went on to something else, but the idea of the Dome never left my mind.

In the years since, my good friend Russ Dorr, a physician's assistant from Bridgeton, Maine, has helped me with the medical details in many books, most notably *The Stand*. In the late summer of 2007, I asked him if he would be willing to take on a much larger role, as head researcher on a long novel called *Under the Dome*. He agreed, and thanks to Russ, I think most of the technical details here are right. It was Russ who researched computer-guided missiles, jet stream patterns, methamphetamine recipes, portable generators, radiation, possible advances in cell phone technology, and a hundred other things. It was also Russ who invented Rusty Everett's homemade radiation suit and who realized people could breathe from tires, at least for a while. Have we made mistakes? Sure. But most will turn out to be mine, either because I misunderstood or misinterpreted some of his answers.

My first two readers were my wife, Tabitha, and Leanora Legrand, my daughter-in-law. Both were tough, humane, and helpful.

Nan Graham edited the book down from the original dinosaur to a beast of slightly more manageable size; every page of the manuscript was marked with her changes. I owe her a great debt of thanks for all the mornings when she got up at six a.m. and took her pencil in her hand. I tried to write a book that would keep the pedal consistently to the metal. Nan understood that, and whenever I weakened,

she jammed her foot down on top of mine and yelled (in the margins, as editors are wont to do), 'Faster, Steve! Faster!'

Surendra Patel, to whom the book is dedicated, was a friend and an unfailing source of comfort for thirty years. In June of 2008 I got the news that he had died of a heart attack. I sat on the steps of my office and cried. When that part was over, I went back to work. It was what he would have expected.

And *you*, Constant Reader. Thanks for reading this story. If you had as much fun as I did, we're both well off.

S.K.

If you didn't want *Under the Dome* to end, then pick up *The Stand*, Stephen King's epic novel in its original form, with a foreword by the author himself.

First came the days of the plague . . .
Then came the dreams . . .

Dreams that warned of the coming of the dark man. The apostate of death, his worn-down boot heels tramping the night roads. The warlord of the charnel house and Prince of Evil. His time is at hand. His empire grows in the west and the Apocalypse looms . . .

Visit: *www.stephenking.co.uk* for a list of all Stephen King's exciting titles published by Hodder

Visit *www.hodder.co.uk* and *www.stephenking.co.uk* for related material, links and more exciting information about the author and his other titles.